HOKUSAI MANGA Katsushika Hokusai

Art direction Takaoka Kazuya
Text Uragami Mitsuru, Nakamura Hideki
Published by PIE International

PIE International Inc.
2-32-4, Minami-Otsuka, Toshima-ku, Tokyo 170-0005 Japan
sales@pie.co.jp

©2011 Kazuya Takaoka / PIE International / PIE BOOKS
ISBN978-4-7562-4069-9
Printed in China

北斎漫画

画　　　　　　　　アートディレクション　　　文

葛飾北斎　　　　高岡一弥　　　　　　浦上　満　　中村英樹

HOKUSAI MANGA
Katsushika Hokusai
Art direction
Takaoka Kazuya
Text
Uragami Mitsuru
Nakamura Hideki

HOKUSAI MANG

MAN

HOKUSAI MA

HOKUSAI MANGA

KUSAI MANGA

OKUSAI

HOKUSAI MANGA

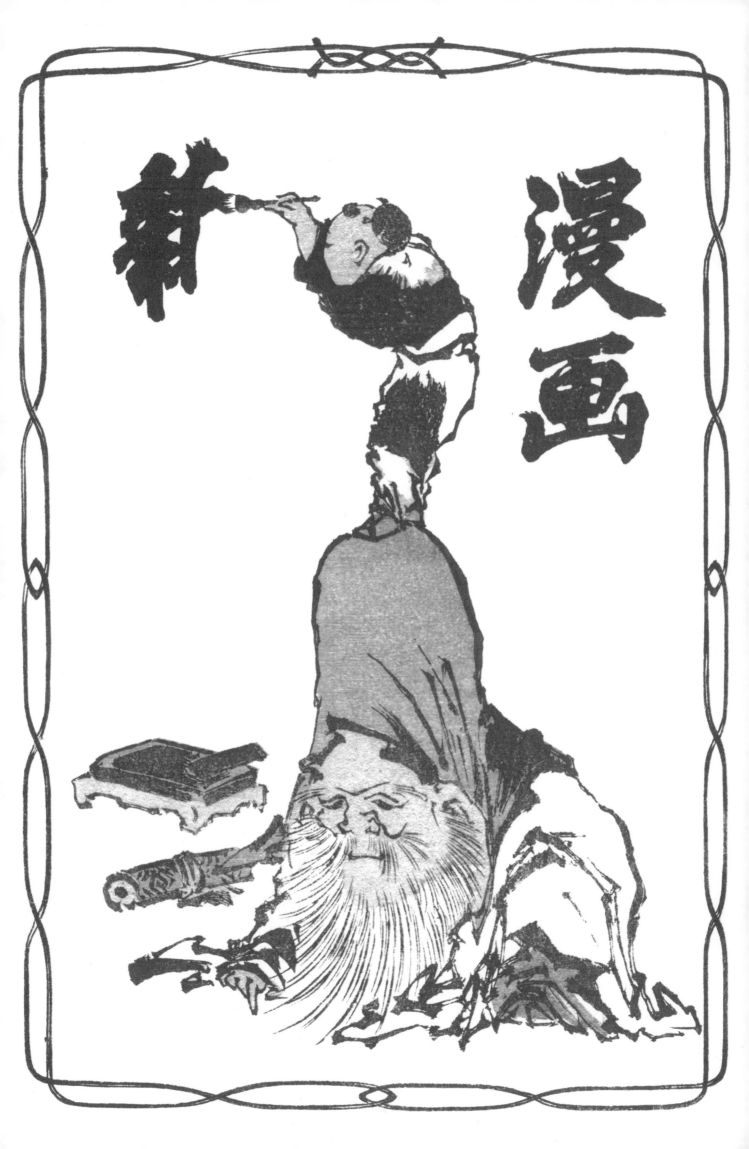

To mark the beginning of the 21st century, *LIFE* magazine conducted a special survey entitled *LIFE*'s 100 Most Important People of the Second Millennium. The only Japanese person to make the final list, at number 86, was Hokusai, of all people. (Incidentally, number one was Thomas Edison.) That Hokusai has come to be internationally recognized in this way is due none other than to the fact that *Hokusai manga* (Hokusai's sketches) had such a great influence on the French

21世紀を迎えるに当たって『ライフ』誌が行った「この1000年間で最も重要な業績を残した人物100名(*LIFE*'s 100 Most Important People of the Second Millennium)」という特別アンケートで、日本人として唯一人86位にランクインされたのが、誰あろう葛飾北斎であった(ちなみに1位はトーマス・エジソン)。北斎がこのように世界で認められるようになった契機は、『北斎漫画』がフ

世界で最も有名な日本人

Impressionist painters and culturati. The circumstances surrounding how *Hokusai manga* came to the attention of the impressionist painters are detailed in a famous anecdote concerning the French etcher Félix Bracquemond. According to this story, Bracquemond came across pages of *Hokusai manga* that had been used as packaging for a consignment of porcelain sent from Japan, and was so impressed that he took great pains to obtain a copy and began promoting it. With that, *Hokusai*

ランス印象派の画家や文化人たちに大きな影響を与えたからにほかならない。

『北斎漫画』が印象派の画家たちに知られるようになったいきさつには、フランスの銅版画家フェリックス・ブラックモンの有名な話がある。日本から送られてきた陶磁器のパッキングに使われていた『北斎漫画』をたまたま発見して衝撃を受け、それを苦心の末、入手して喧伝

The most famous Japanese person in the world

manga came to the attention of the likes of Manet, Monet, Degas, and Whistler, who were astonished and impressed by what they saw. In fact, Manet copied *Hokusai manga* and Monet is said to have been so fascinated with it that he came to be known as "Hokusai's true rival."

Interest in Japanese art heightened following the Exposition Universelle in Paris in 1867, giving rise to the movement known as Japonisme, a movement whose origins can be

したというのである。その影響で『北斎漫画』はマネやモネ、ドガ、ホイッスラーなどの知るところとなり、彼らに新鮮な驚きと感動を与えた。実際マネは『北斎漫画』を模写し、モネは「北斎の忠実なライバル」と評されるほど北斎に強い関心を持っていたといわれる。

1867年のパリ万博を契機に日本美術に対する関心は高まり、ジャポニズムの流行を生み出すが、『北斎漫画』は

traced to *Hokusai manga*. Interest in Hokusai grew and he became familiar to people through art magazine articles, books, and so on.

Of these publications, Edmond de Goncourt's *Hokusai* played a major part in enhancing Hokusai's reputation. De Goncourt described Hokusai as "one of the most creative artists on earth."

——— Uragami Mitsuru

その端緒となった。北斎への関心は高く、美術雑誌の記事や本となって人々に紹介された。

中でも1896年に出版されたエドモン・ド・ゴンクールの『北斎』は、北斎の名を高める上で大きな役割を果たした。ゴンクールは北斎のことを「地上で最も独創的な画家の一人」と評している。

——— 浦上 満

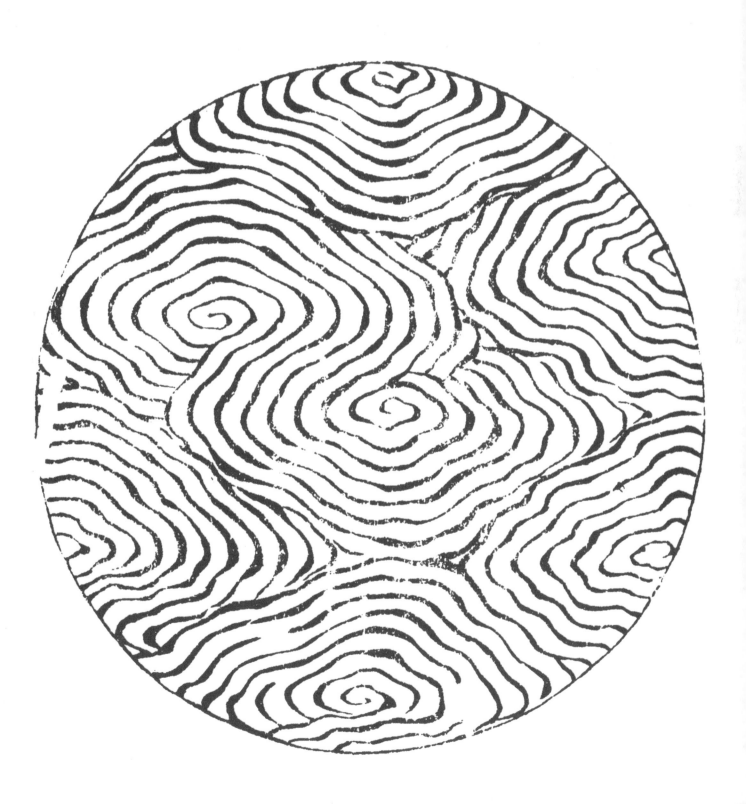

『北斎漫画』の現代的意義

中村英樹

『北斎漫画』の大きな魅力は、万物のあらゆる部類の諸相、特に刻々と変わる万人の瞬間的な姿や表情を細かくとらえ尽くそうとするところにある。現存の森羅万象に限らず、空想の動物や歴史上の人物なども詳細に描かれる。同種の事物の列挙や、連続する異時点における同一人物の動作の並列が、無数の知覚・記憶・想像の働きからなる人間の生の現場を浮き彫りにする。移り変わる風景をありのままに描く印象派とある点で似る。その万物の力動感の裏には、描こうとする対象を円や三角形などの幾何学的な基本形体に還元して組み立てる方法が隠されている。『北斎漫画』初編の下絵を名古屋で描いた時期と同じ1812年に、作画の手ほどきの教科書ともいうべき『略画早指南』が出版された。そこには、円の重なりが

The modern significance of *Hokusai manga*
Nakamura Hideki

Part of the appeal of *Hokusai manga* (Hokusai's sketches) stems from the artist's endeavor to capture in detail various aspects of each and every category of thing on earth, and in particular the continually changing, fleeting appearances and expressions of different kinds of people. The illustrations depict in detail not only all things in nature but also things like imaginary creatures and historical figures. The cataloging of similar things and arrangement on the same page of sketches of movements carried out by the same person at consecutive moments in time reveal our daily lives to be the exercising of an infinite number of perceptions, memories and suppositions. In some respects this approach resembles that of the impressionists, who sought to depict the changing scenery around them as it was.

Given the sense of dynamism of all these things, it is easy to overlook the method used to construct the subjects the artist wishes to depict by reducing them to basic

もたらす量感や、円の並列による多
中心的な平面性など、コンパスと定
規を使う描き方の実例が豊富に示さ
れていて、セザンヌとは別の基本形
体への還元が見られる。

北斎は、西洋の透視図法と陰影法の
統括的な視点に学びながら、絵画が
あくまで平面であることをはっきり
と感じさせる日本の絵画の良さを見
失わず、双方の利点を活かした第三
のハイブリッド・アートを探究した。
その一端が、平面的な円の重なりに
よる量感である。描かれる対象の性
質を集約して表す毛筆の描線の自由
自在な太さや速さの変化、さらには
張りや伸びの多様性も、奥行きや量
感と平面性を両立させる要因になっ
ている。

日本の絵画には、もうひとつの特徴
がある。無限の宇宙と向き合う人間

geometrical shapes such as circles and
triangles. Hokusai's *etehon*, or art manual,
Ryakuga hayaoshie (Quick Lessons in
Simplified Drawing) was published in
1812, the year he made the drawings for
volume 1 of *Hokusai manga* while in
Nagoya. This guide includes a wealth of
examples of how to draw using compass
and ruler showing the sense of volume
created by overlapping circles and the
polycentric flatness created by arranging
circles in a row, for example. Here one can
observe the reduction of things to basic
forms that are different to those of Cézanne.
While familiarizing himself with the
Western concept of a unified viewpoint
based on the use of perspective and
shading, Hokusai never lost sight of the
merits of Japanese paintings, which make
it obvious to the viewer that they are
above all two-dimensional, exploring a
third "hybrid art" that made the best use
of the advantages of both. One result of
this is the sense of volume created through

ぶんまわしにて
なまずをかくの法

ほんもんのとおり
ちがいなし

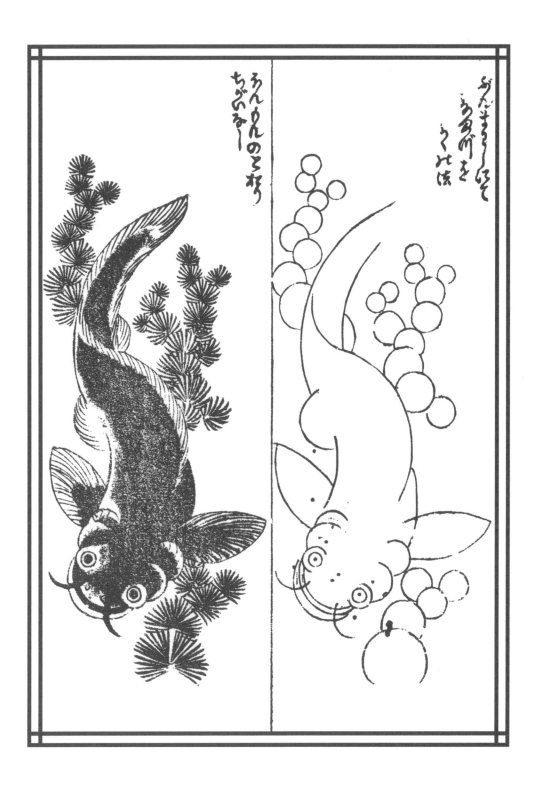

How to draw catfish

with a compass.

It can turn out just like

the finished drawing.

the overlapping of flat circles. The fluent command of thickness and changes in speed of the brush strokes used to depict the subject by condensing its inherent characteristics along with variety in tension and looseness are important factors in enabling the artist to produce both depth and a sense of volume and flatness. Japanese paintings have another distinguishing feature. Given the finiteness of humans in the face of the infinite universe, paintings and drawings with a high degree of perfection reveal their own incomplete fragmentariness as mere manifestations of a very limited view of the world. *Gunmo zo wo naderu* (Blind men stroking an elephant) in volume eight of *Hokusai manga* is based on an old proverb warning of the narrow-mindedness of blind people mistakenly believing that the feel of different parts of an elephant represent the real elephant in its entirety. The image, however, teaches us that for everyone the realization that their view is narrow is the

の有限性を踏まえて、むしろ完成度の高い画面が、世界のわずかな見方の表れに過ぎない自らの未完結な断片性を顕わにする。『北斎漫画』8編「群盲象を撫でる」は、象の各部分の異なった手触りを真の全体像と思い込む目の不自由な人たちに関する旧来のたとえに基づく。しかし、画面は、誰にとっても見方の狭さの自覚こそ広い視野への道だと教えている。

だが、北斎は自文化に根差しながら、既存の様式の継承を重視するその伝統に反して、〈自己救済〉の力としての絵画を目指した。その根底には、幼くして養子に出されて両親の愛情に欠け、6歳の頃から絵を描き始めた原体験がある。呪文アダンダイを一心に唱えて歩く姿や、北斗七星を神とする妙見信仰への関心も〈自己

おにのわりかた
しほふきのかきかた
おかめのわりやう

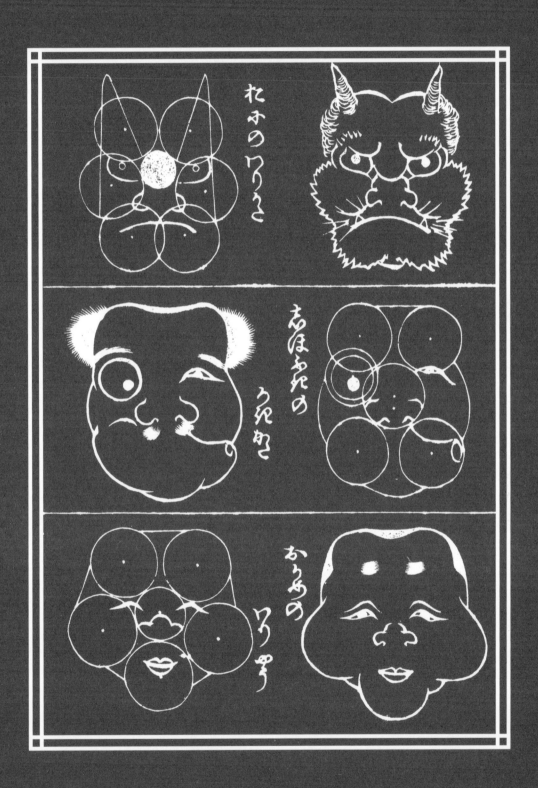

Proportions for a demon.

How to draw a sea water blower.

Composition for an *Okame*.

人ぶつ　まる三かく二法にて
かく事なれど　ばせうゆへこん
ざつの法なり
からまつ　せっちうにかぎら
ず　まるをくバリ　十もんじを
かける　ミきハ三がいびしをふ
たへにとるなり

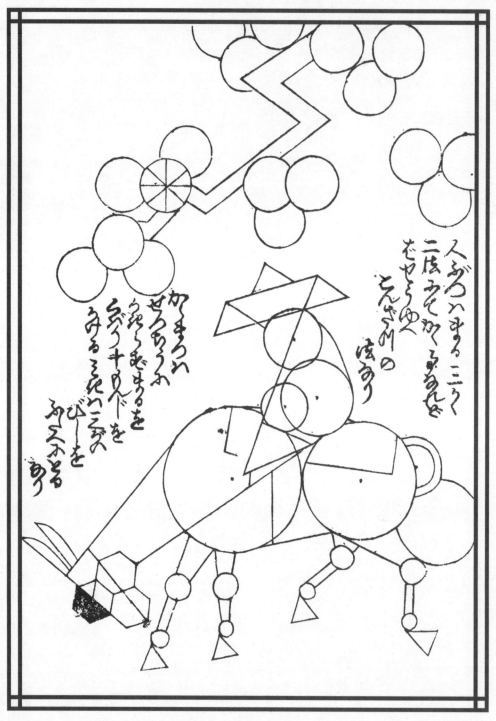

People are drawn with circles and triangles,
but when drawn on a horse the method is complex.
For Japanese larch, snow-laden or not, lay out circles and
draw crosses on them. The trunk is drawn
as a double-lined, three-stepped rhombus.

せつちうとうバのかきかた
もつとも　まるときつこうと三
かく四かく　ひし　おのおのこ
んざつの法

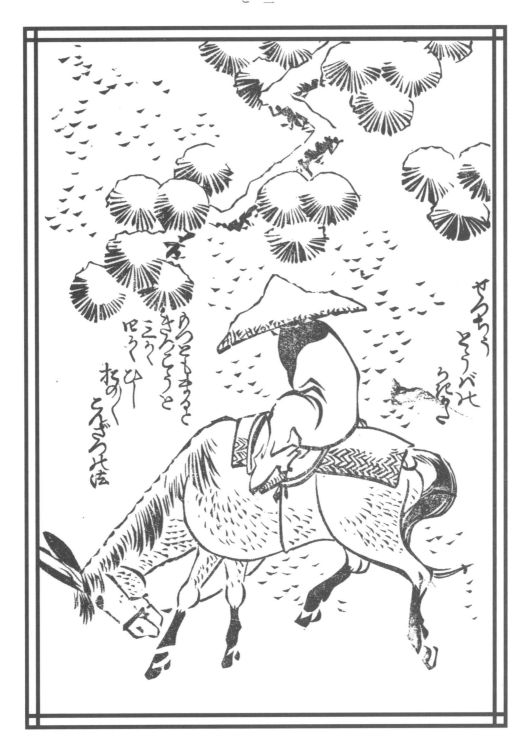

Drawing a horse climbing through snow

involves an especially complex

use of circles and hexagons and triangles, squares,

and rhombuses respectively.

救済〉の願いを裏づける。

一方、北斎は庶民的な存在に徹しな
がら、社会的な広がりへの意欲と反
骨精神のたくましさを保ちつづけ
た。『北斎漫画』の版元を地方都市・
名古屋で開拓し、1817年には再び
当地を訪れて大きな達磨の絵（18
× 10.8 m）を描くイベントで名を
広めた。将軍の前で鶏の足に絵具を
つけて紙の上を歩かせ、その足跡が
紅葉の絵だと平然と言い放った。
『略画早指南』に例示される幾何学
的な基本構造を駆使しつつ、万人の
瞬間的な姿などを無数に描き出す
『北斎漫画』は、この北斎の強靭な精
神の基盤としてとても重要な意味を
持つ。個別的な現象をことごとく列
挙することは、生々しい現象に留ま
りながら、現象と現象の間に〈超越
的な不変〉を直観させる。『北斎漫画』

first step towards a broader view.

But while he remained rooted in his own culture, Hokusai went against this culture with its emphasis on the continuation of existing styles by pursuing art as an expression of the power of "self-help." This approach was based on his formative experience as a child of being put up for adoption, lacking parental affection, and turning to painting at the age of six. His habit of walking around mumbling the incantation "Adandai" and his interest in the Myoken faith, which regards the Great Dipper as a deity, are further evidence of this desire for "self-help."

At the same time, while he dedicated himself to a plebeian existence, Hokusai always maintained a desire for wider social recognition and an uncompromising strength of character. The first volume of *Hokusai manga* was issued by a publisher in the provincial city of Nagoya, and in 1817 he attracted further attention when he revisited that city to take part in an

かくまる　十もんじ　三ツわり

かくべいじしを　こしらゆるの
　　しかた

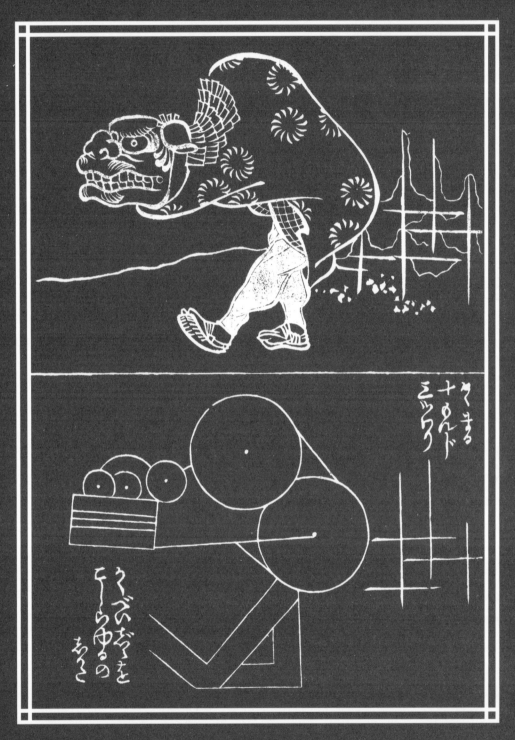

Lay out squares,

circles, crosses, triple lines

– to make a lion dancer.

event that involved painting a large portrait of Bodhidharma (18 x 10.8m). In the presence of the Shogun, he dabbed paint on the feet of a chicken and made it walk over a sheet of paper, matter-of-factly declaring the result to be a painting of red maple leaves floating down a river.

Hokusai manga, which makes full use of the basic geometrical construction illustrated by *Ryakuga haya-oshie* but also includes countless drawings of all sorts of people in fleeting poses, is also enormously significant in terms of Hokusai's strong mental constitution. While limited to vivid phenomena, his thorough cataloging of individual phenomena provides insights into the transcendental immutability from phenomenon to phenomenon. *Yuami suru onna* (Woman taking a bath) from the first volume of *Hokusai manga,* for example, combines a variability of thickness and speed of brush strokes with an invariability of basic geometrical construction.

If *Yuami suru onna* represents the depiction

初編の「湯浴みする女」は、毛筆の線の太さ・速さの可変性と幾何学的な基本構造の不変性を併せ持つ。「湯浴みする女」が無数の瞬間的動作の描写だとすれば、『北斎漫画』8編「盲人たちの列挙」は、さまざまな顔立ちと表情の類例である。いずれにしても、このような〈あらゆる場合〉への関心は、とらえ切れない外界をとらえようとする眼差しそのものを意識させる。身辺の同種の事物を執拗に接写して列挙した20世紀後半アメリカの美術家ソル・ルウィットの写真集『オートバイオグラフィ（自伝）』が思い起こされる。同一人物の連続する動作の異なった瞬間をいくつも並べて描いた典型的な例は、『北斎漫画』初編の「鉦をたたく僧」に見られる。北斎は、多くの版画にこの〈異なった時点の同

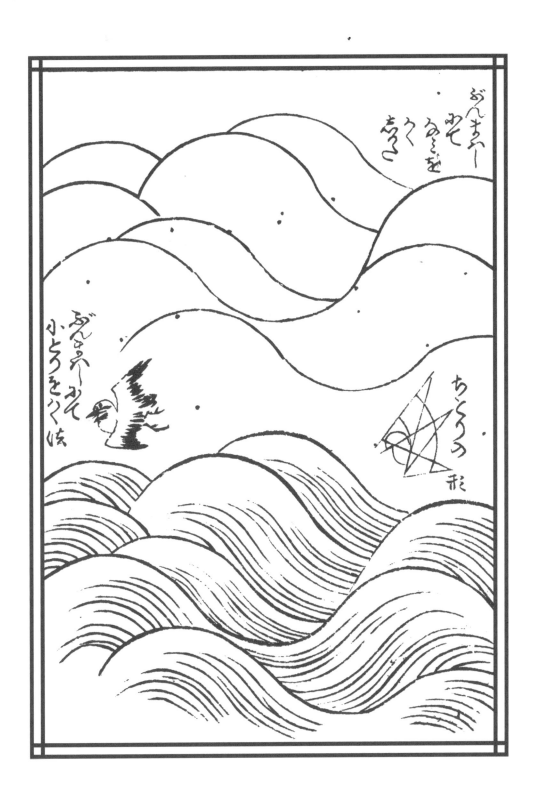

How to draw waves with a compass.

Pattern for a plover.

How to draw a small bird with a compass.

時化〉を取り入れた。人物や動物の動きの連続写真で知られ、20世紀の美術家マルセル・デュシャンやフランシス・ベーコン、ソル・ルウィットに影響を与えた1830年イギリス生まれの写真家エドワード・マイブリッジによる〈時間の流れの視覚化〉が先取りされている。

北斎は、隠されたS字状の基本構造の視覚的な力動感と緊張感を〈自己救済〉のための精神力にする。『略画早指南』の事例で明らかなように、人物や動物、花などを描くときに、逆向きの円弧を接合したS字状の構造が用いられる。実際には、円弧はスパイラルに変形され、無限に外へと広がり、求心的に内へと集中する力動感が生まれる。逆向きの回転モメントがせめぎ合う変曲点には、お互いに譲らない力関係による緊張

of myriad fleeting movements, then *Mojintachi no rekkyo* (Catalog of blind people) from volume eight of *Hokusai manga* represents a similar treatment of various countenances and expressions. In either case, this kind of interest in "every possible case" focuses one's attention on the artist's gaze itself as he strives to view an external outside world that cannot be viewed in its entirety. The result is reminiscent of *Autobiography*, the photo book published by the late American artist Sol LeWitt, who was active in the second half of the 20th century, in which he relentlessly catalogs by photographing in close-up similar kinds of things around him. A typical example of drawings of different moments in a continuous series of movements made by the same individual can be seen in *Kane wo tataku so* (Priest striking a gong) from volume one of *Hokusai manga*. Hokusai incorporated this "synchronization of different moments in time" in many of his woodblock prints.

感が漂う。

『略画早指南』が示す、円など数多くの幾何学的図形の集合を土台とする描法は、人の目を多中心的な細部へと引き寄せる。例えば、小さな円弧の反復からなるムカデの絵では、全体を見渡すマクロの視点と、細部から細部へとたどるミクロの視点が交錯する。北斎は、広く風景画や挿絵などでもいろいろな方法でミクロの視点を仕掛けている。マクロの視点とミクロの視点間の往復運動は、絵と向き合う人自身の足もとを意識させる。

幾何学的図形を巧みに駆使する北斎の腕前は、今日の美術とデザインの領域を一体化したような彼の仕事の幅広さを可能にした。挿絵はもちろんのこと、着物の紋様や建築意匠など、活動は多岐にわたる。染色デザイン集として『新形小紋帳』が残っていて、『北斎漫画』の建造物や機械、武器などの図解もデザインに通じる。70歳過ぎに花開く北斎の代表作の基礎は、50歳代の『北斎漫画』出版の頃にかなり出来上がっている。後ろ姿の人物などとともに代表作に頻出する、笠で顔を隠した人物が、『略画早指南』にすでに印象深く登場する。隠された顔は、その人物を

With these he anticipated the "visualization of the passage of time" by the English photographer Eadweard James Muybridge (1830-1904), who is best known for his sequence photographs of people and animals in motion and who influenced such 20th century artists as Marcel Duchamp, Francis Bacon and Sol LeWitt. Hokusai gained spiritual strength for his "self-help" from the visual dynamism and feeling of tension of the basic construction of hidden S-shapes. As is clear from the examples in *Ryakuga haya-oshie*, Hokusai employed the construction of S-shapes made by joining circular arcs facing in opposite directions when drawing people, animals, flowers, and so on. In effect the circular arcs are transformed into spirals that expand relentlessly in an outward direction, giving rise to a sense of dynamism that concentrates centripetally towards the center. The points of inflexion where moments of rotation in opposite directions fight against each other are charged with an atmosphere of tension due to the power relationship in which neither yields to the other.

The drawing technique based on the assemblage of multiple circles and other geometrical figures demonstrated in *Ryakuga haya-oshie* draws the viewer's eyes to the polycentric details. In the drawing of the centipede consisting of the repetition of small circular arcs, for example, the macroscopic viewpoint taking in the whole and microscopic viewpoint that tracks from detail to detail mingle together. Hokusai also plays

無に等しく消し去る反面、知りえな
いがゆえの強い存在感をもたらす。
それは、北斎の人間観と重なる。
絵を見る人自身の存在に気づかせる
マクロとミクロの視点の交錯は、後
年、版画シリーズ「冨嶽三十六景」
を中心にして興味深い方法に発展す
る。見定めがたいほど小さな超遠景
の富士山を近景の大きな事物が取り
囲む構図が数多く採用される。富士
山が巨大な桶のなかにすっぽりと収
まる「冨嶽三十六景・尾州不二見原」
は、その一例である。それを見る人
は、親指と人差し指で作った輪に入
れて本物の富士山を間近に感じなが
ら眺めたときのように、広大な風景
に包み込まれる自分の微かさと、真
正面からそれを見つめる自分の確か
さの双方を実感する。「冨嶽三十六
景・東海道程ヶ谷」では、近景の松
林が富士山を囲み、絵を見る人は画
中の旅人の後ろ姿に自分を重ねる。
ポール・セザンヌの「大松のあるサ
ント・ヴィクトワール山の遠望」（1
885 - 87）の山と松の関係は、そ
の構図に似ている。
後ろ姿の人物には、顔を見せないこ
とによる心理的効果以外に、見る人
に自分の背中を感じさせる働きがあ
る。例えば、富士山を見ている自分

around with microscopic viewpoints using various methods in many of his landscapes, illustrations and other works. The reciprocation between these macroscopic and microscopic viewpoints makes the viewer aware of their own position.

Hokusai's ability to skillfully use geometrical figures to the full enabled him to produce work of great breadth that in a sense combined the modern fields of art and design. His activities were wide-ranging, including not only illustration but also kimono patterns and architectural designs. He left behind a collection of dying designs entitled *Shingata komoncho* (New models for kimono patterns), while the explanatory diagrams of buildings, machinery and weapons in *Hokusai manga* also indicate a familiarity with design.

The foundations for the most important works of Hokusai, who blossomed after he reached the age of 70, were already in place around the time he published *Hokusai manga* in his 50s. It is striking that as well as the views of people from behind, the kinds of figures hiding their faces with conical straw hats that appear frequently in these important works had already appeared in *Ryakuga haya-oshie*. Hidden faces consign the people concerned to almost complete oblivion, but they also give these figures a strong presence precisely because they are unknowable. This corresponds to Hokusai's view of human beings.

The mingling of macroscopic and microscopic viewpoints that makes viewers of the drawings aware of their own

むかでのほんもん
づのごとく　よくく
かんべんすべし

からこのゆきこかしのかきかた
ぶんまハしのいつしきのくミかた

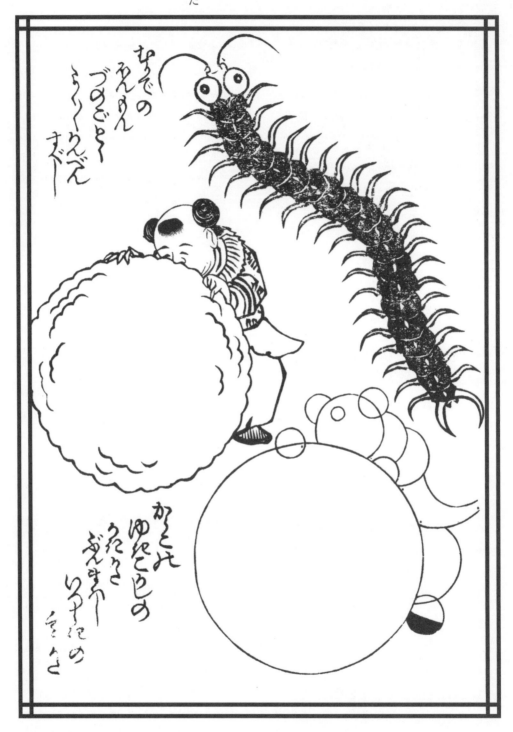

The finished centipede drawing looks like this.

Observe it carefully.

How to draw a Chinese child rolling a snowball.

– using a combination of only circles drawn with a compass.

ぶんまハしにて
むかでをかくしかたなり
ぶんまわしいっしきにて
へびをかく法也
まるきわりにて
ながきものをかくに
これにてかんべんすべし

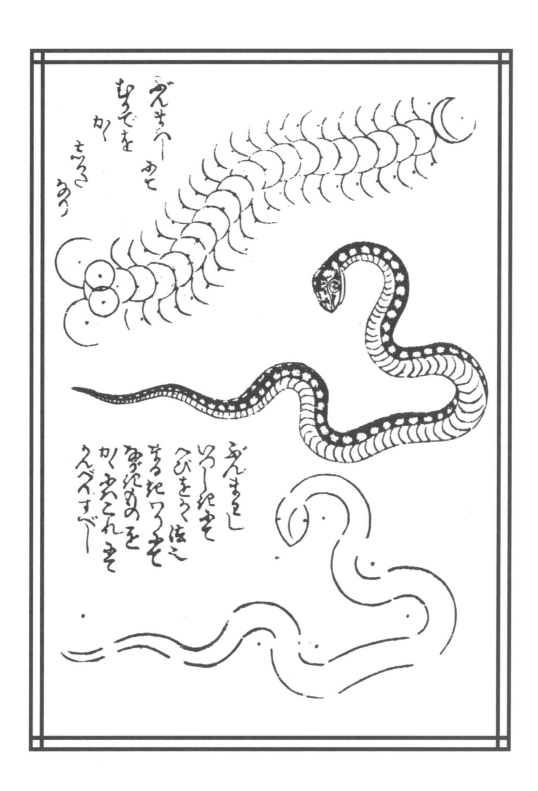

How to draw a centipede with a compass.

There's also a way to draw a snake using only a compass.

Considering it makes circles,

this is a good approach to adapt to drawing long things.

自身の後ろ姿を、もう一人の自分の目が背後から見ている。離れて自分を見る〈内なる他者の目〉こそ、北斎にとって真の心の拠り所であった。死後の自分をユーモラスに突き放して見つめた、「人魂になって、気楽な散歩に出かけよう、ふらりと夏の原へ」という意味の彼の辞世の句は、その良い証しだろう。1808年刊行の「鎮西八郎為朝外伝・椿説弓張月」の挿絵「新垣を殺して阿公胎内の子を奪ふ」の殺人現場で遊ぶ蛙たちの目や、同挿絵「従弟女の他室に長女妖怪を刺」の幼児略奪現場のあちこちに潜むねずみたちの目は、視覚化された〈内なる他者の目〉の先駆けだと言える。

『略画早指南』にわかりやすく紹介され、『北斎漫画』の支えとなったコンパスと定規による制作方法の集大成

presence later developed into onto an extremely interesting method that is particularly evident in the woodblock print series *Thirty-six Views of Mount Fuji*. Many of the prints in this series employ a composition in which large objects viewed at close range surround Mount Fuji, which is viewed from so far away that it is difficult to make out. One example of this is *Bishu Fujimigahara* (Fuji view field in Owari province), in which Mount Fuji is completely enclosed within a large tub. Just as if they were viewing Mount Fuji through a ring formed by their thumb and forefinger, viewers get a real sense both of their own insignificance in the midst of the vast landscape that surrounds them and of the certainty of themselves staring at the mountain right in front of them. In *Tokaido Hodogaya* (Hodogaya on the Tokaido) from the same series, Mount Fuji is framed by a row of pine trees in the foreground and viewers put themselves in the position of the travelers seen from behind in the print.

ぶんまわしにて
あめのかハづの
おやこづれなり

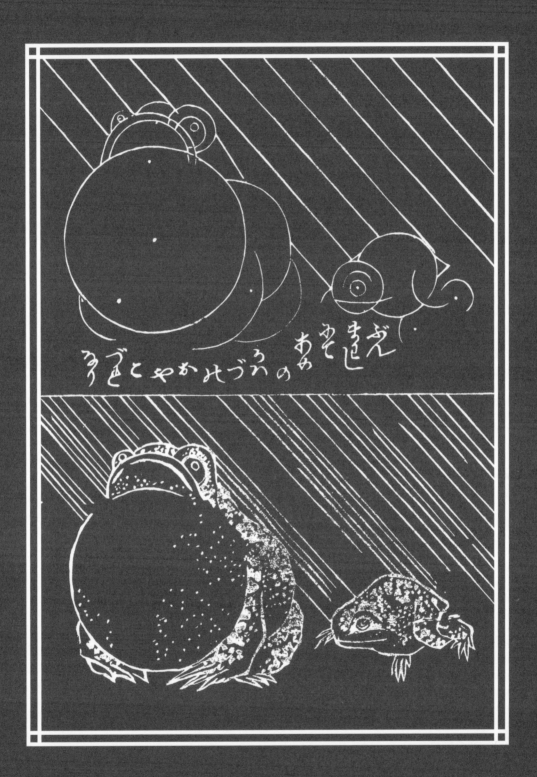

How to draw a parent and
child pair of frogs
in the rain with a compass.

の一つが、「冨嶽三十六景・神奈川沖浪裏」である。画面四隅を結ぶ2本の対角線と、画面左下隅を中心にして画面縦の長さを半径とする円弧との2つの交点は、それぞれ大波の先端と富士山頂の位置に当たり、円弧の回転モメントは、大波が富士山にかぶさる勢いを演出する。画面は、以下20本近くの見えない円弧によって多中心的に構成されていて、その多視点構造が、見る人の目を画面の内側へと誘い込む。大波は見上げる視点で、小舟上の人物は見下ろす視点で描かれ、見る人の目はどちらにも立つ。この描き方は、『北斎漫画』2編の「寄浪　引浪」から始まる。『北斎漫画』は北斎の本格的な自己探究の原点であり、これまでに指摘したように、その斬新な試みの現代的意義は計り知れない。

The relationship between the mountain and the pine trees in Cézanne's *Mont Sainte-Victoire with Large Pine* (1885-1887) is similar to this composition.

In addition to having a psychological effect due to the fact that their faces are invisible, the figures viewed from behind serve to make the viewer conscious of their own back. The effect is as if another self is viewing one's back from behind as one looks at Mount Fuji. For Hokusai, these "eyes of the other inside oneself" that view the self from a distance are his true emotional mainstay. His farewell poem, in which he vowed to turn into a will-o'-the-wisp and head off without any definite purpose for a leisurely stroll through the summer fields, is good proof of this. The eyes of the frogs playing at a murder scene in *Niigaki wo koroshite kumagimi tainai no ko wo ubau* (Killing Niigaki and stealing the child from inside Niigaki's womb), an illustration in *Chinzei Hachiro Tametomo*

ぶんまハしにて
こいぬのかくのわり
よくよくほんもんと
ひきくらべかくべし
おゝいぬハ　かくとまると
こんざつしてかくの法
もつとも　すじひきのところと
まるのかたちと
もちあハせてするのところを
こゝろをつけべし

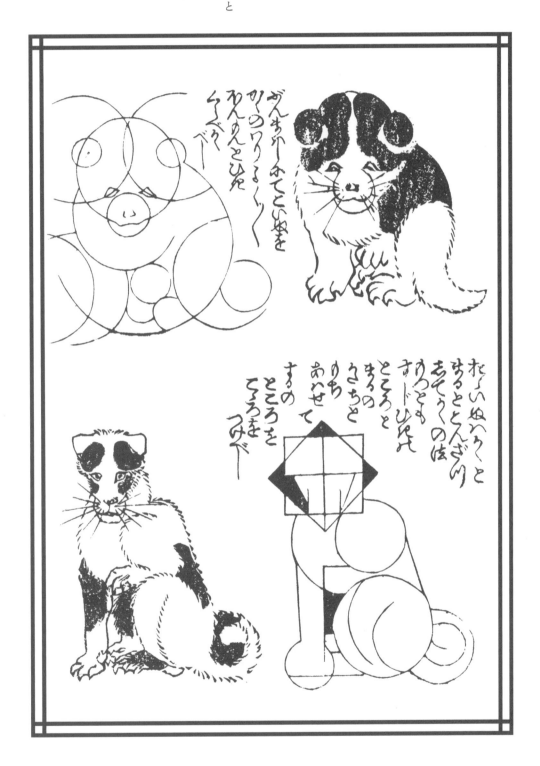

Composition for drawing a puppy with a compass.

Compare it closely with the completed drawing.

A method of drawing a large dog using a combination of
squares and circles. Take special care in drawing the areas
where straight lines and circles combine.

Gaiden, Chinsetsu Yumiharizuki (Strange tales of the expert archer), published in 1808, and the eyes of the mice visible here and there in the child plundering scene in the illustration *Itokome no koya ni nyoko yokai wo sasu* (A courageous, sword-wielding woman slashes a demon attempting to spirit away her cousin's baby.) from the same publication could be described as harbingers of the visualized "eyes of the other inside oneself."

One work that represents a compilation of the creative techniques using compass and ruler that are introduced in an easy-to-understand way in *Ryakuga haya-oshie* and underpin *Hokusai manga* is *Kanagawa oki nami-ura* (The great wave off Kanagawa) from the *Thirty-six Views of Mount Fuji*. The two points of intersection between the two diagonal lines that join the four corners of the image and the circular arc centered on the lower left hand corner of the image whose radius is equivalent to the height of the print correspond to the locations of the crest of the great wave and the top of Mount Fuji, with the moment of rotation of the circular arc producing the momentum whereby the great wave hangs over Mount Fuji. The image is rendered polycentrically with up to 20 invisible circular arcs, this multi-viewpoint composition leading the viewer's eyes towards the interior of the image. The great wave is depicted from a viewpoint looking up at it, while the people in the boats are depicted from a viewpoint looking down on them, meaning that the viewer may place themselves in either position. Hokusai began experimenting with this kind of portrayal in *Yosenami, hikinami* (Incoming waves, outgoing waves) from volume two of *Hokusai manga*. *Hokusai manga* represents the starting point of Hokusai's true self-inquiry, and as pointed out above, the modern significance of this innovative project is unfathomable.

かくと　まるをまじへて
ふくろくじゆ
からこをかくのしかた
ほんもんにみあわせ
すこしづゝきみあいを
つけるなり

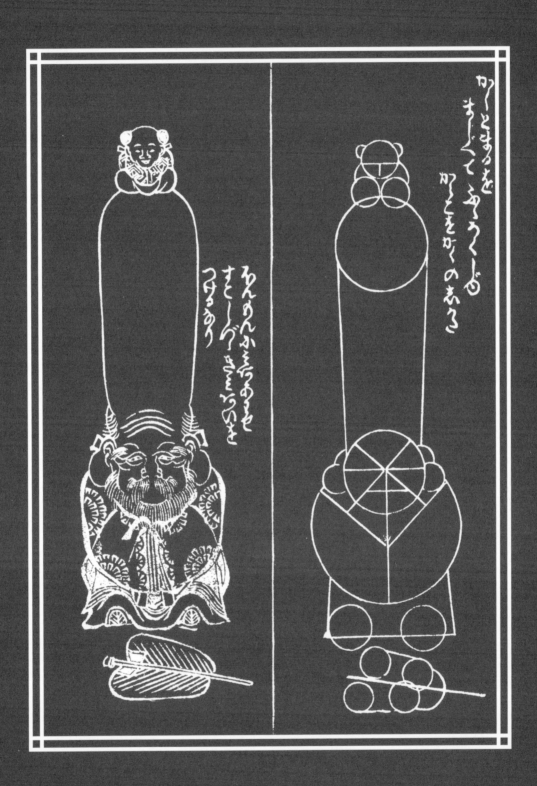

How to draw the God of Wealth and Longevity and
a Chinese child by combining squares and circles.
Reference the completed drawing and
gradually add in the features.

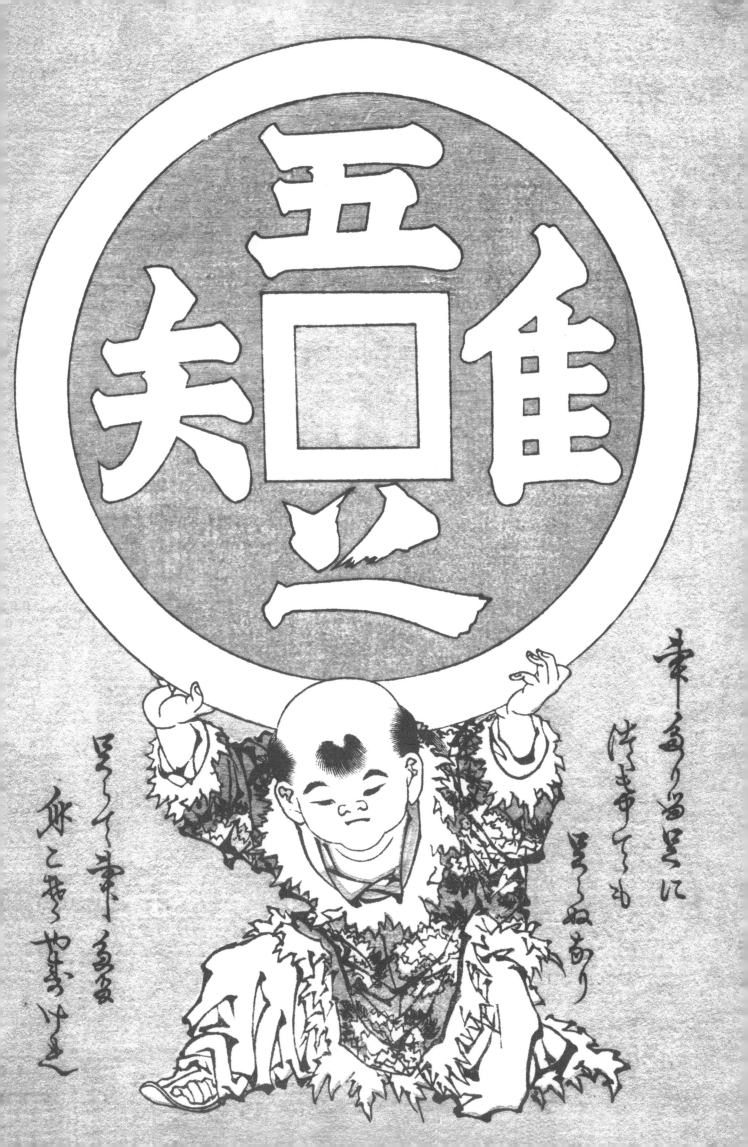

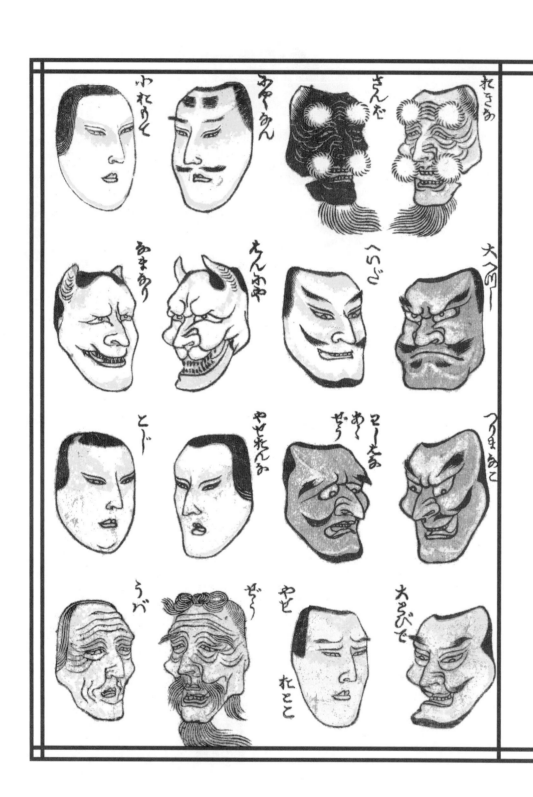

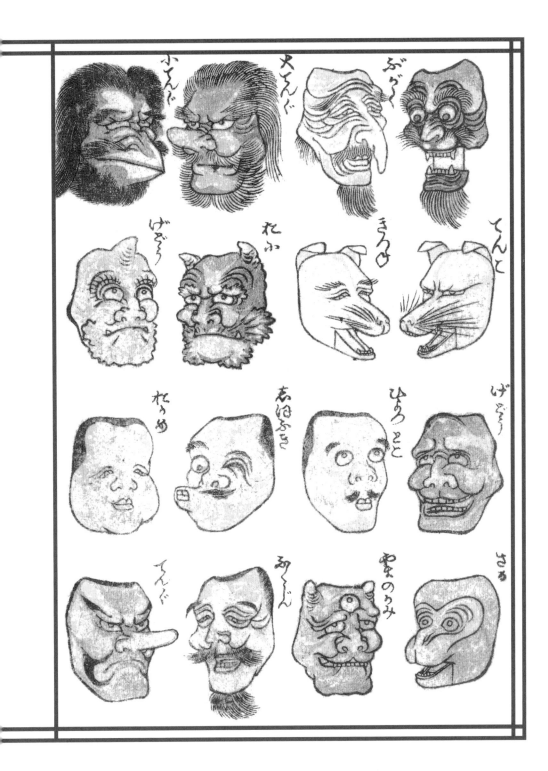

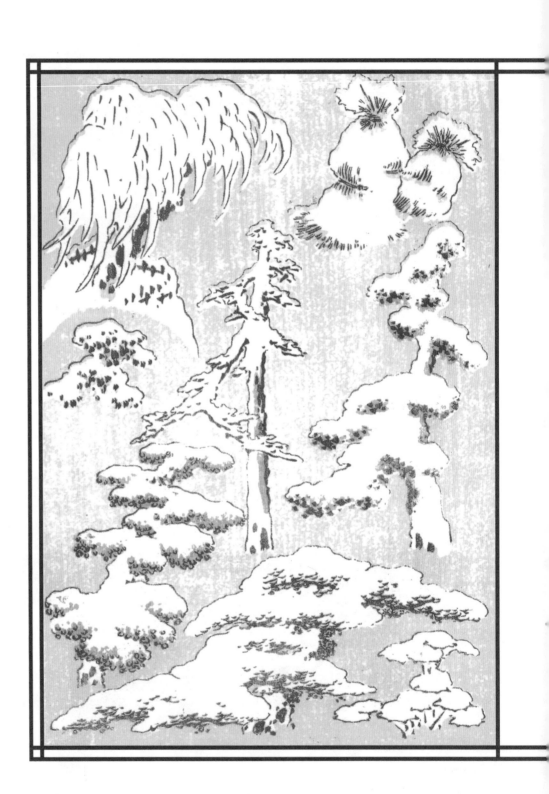

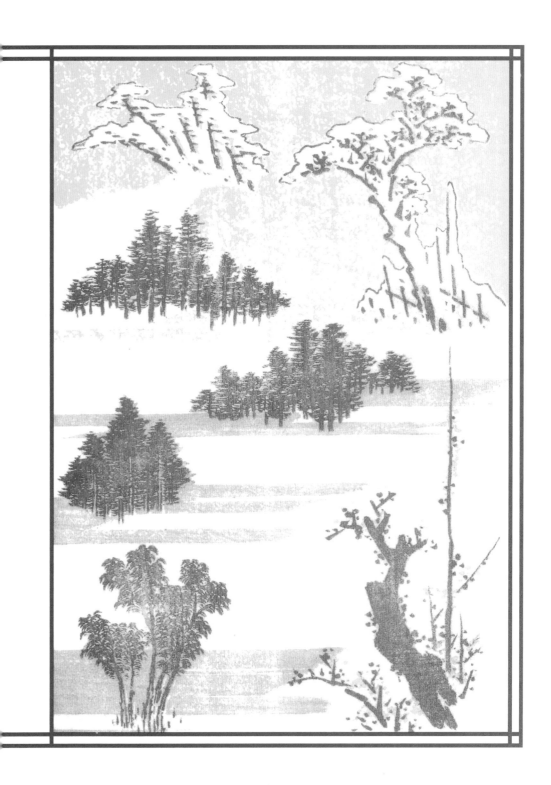

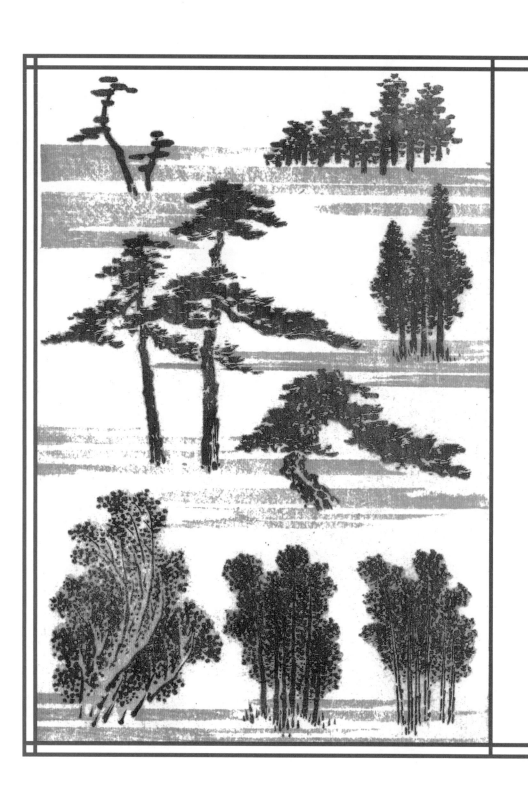

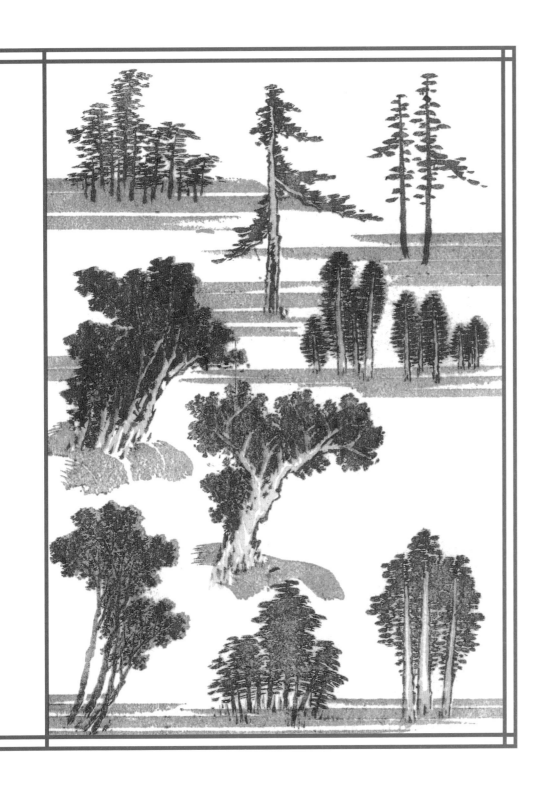

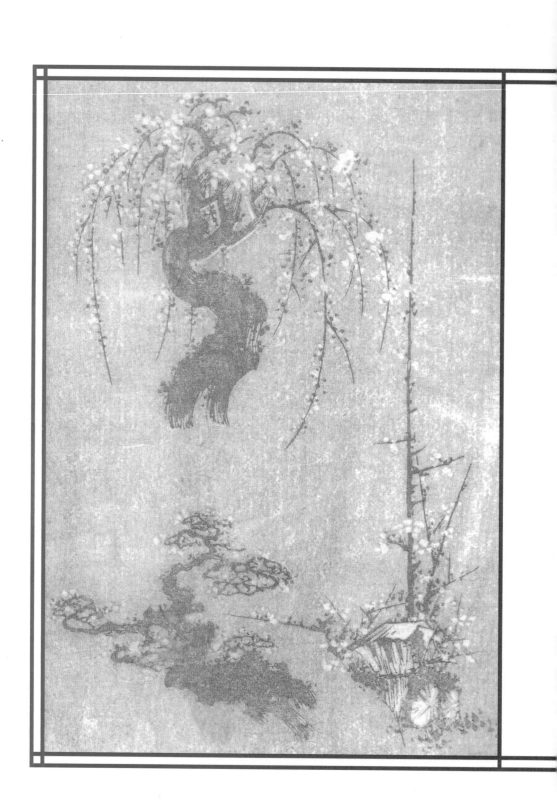

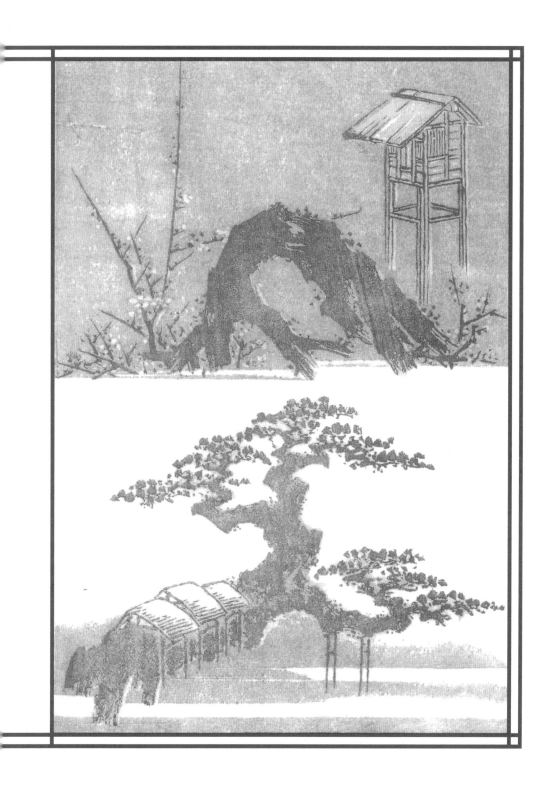

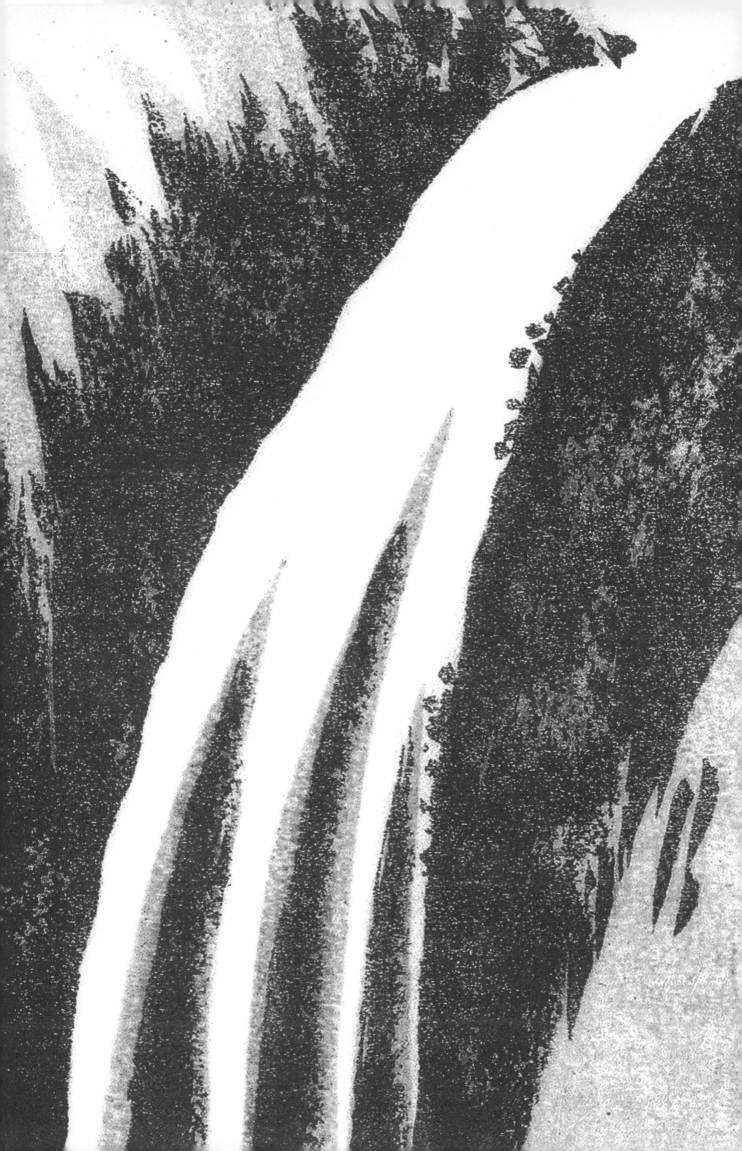

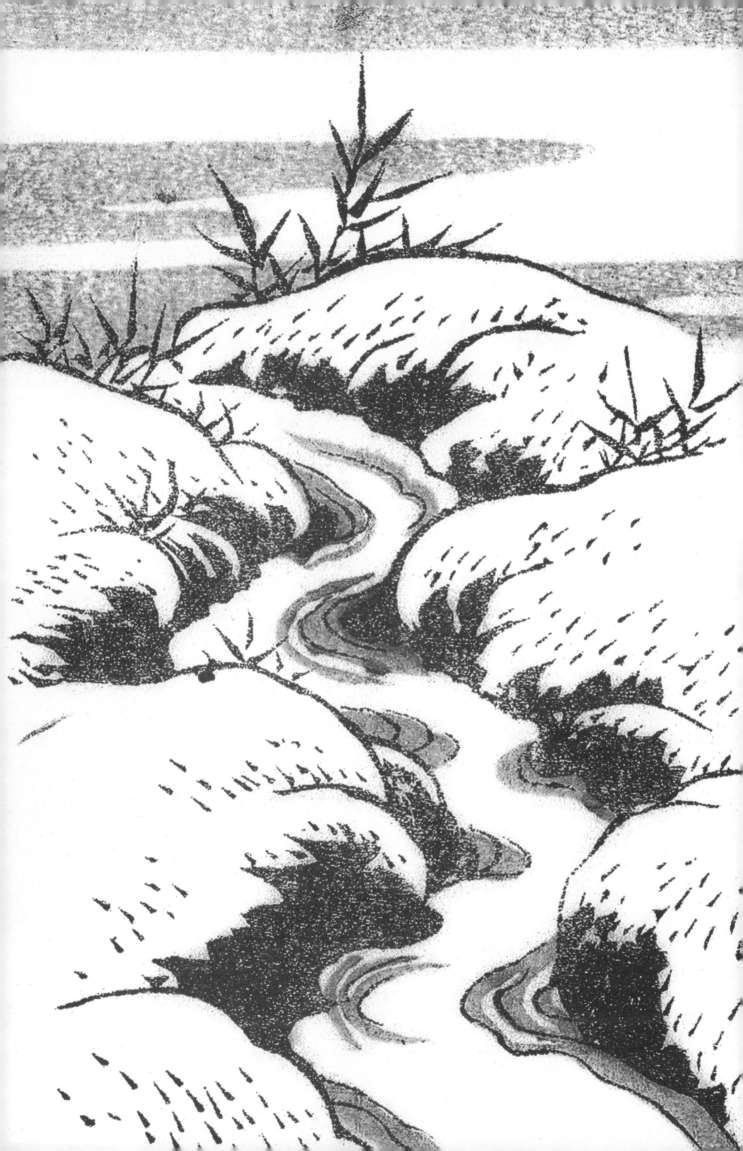

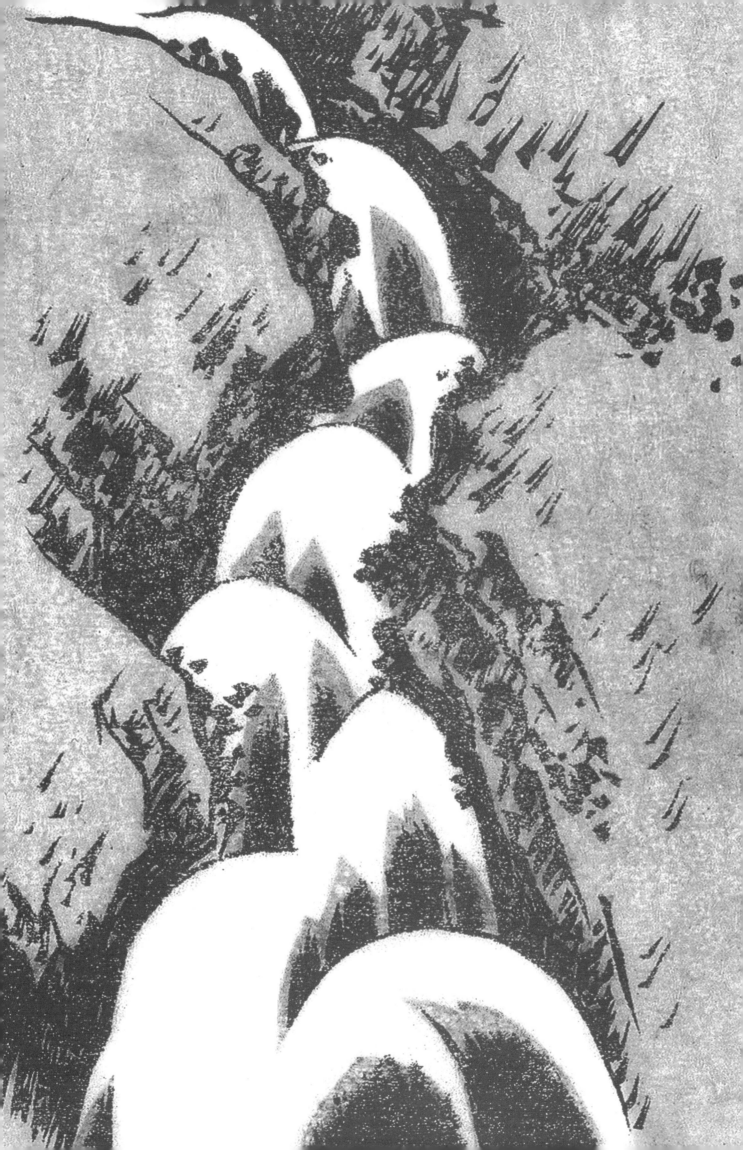

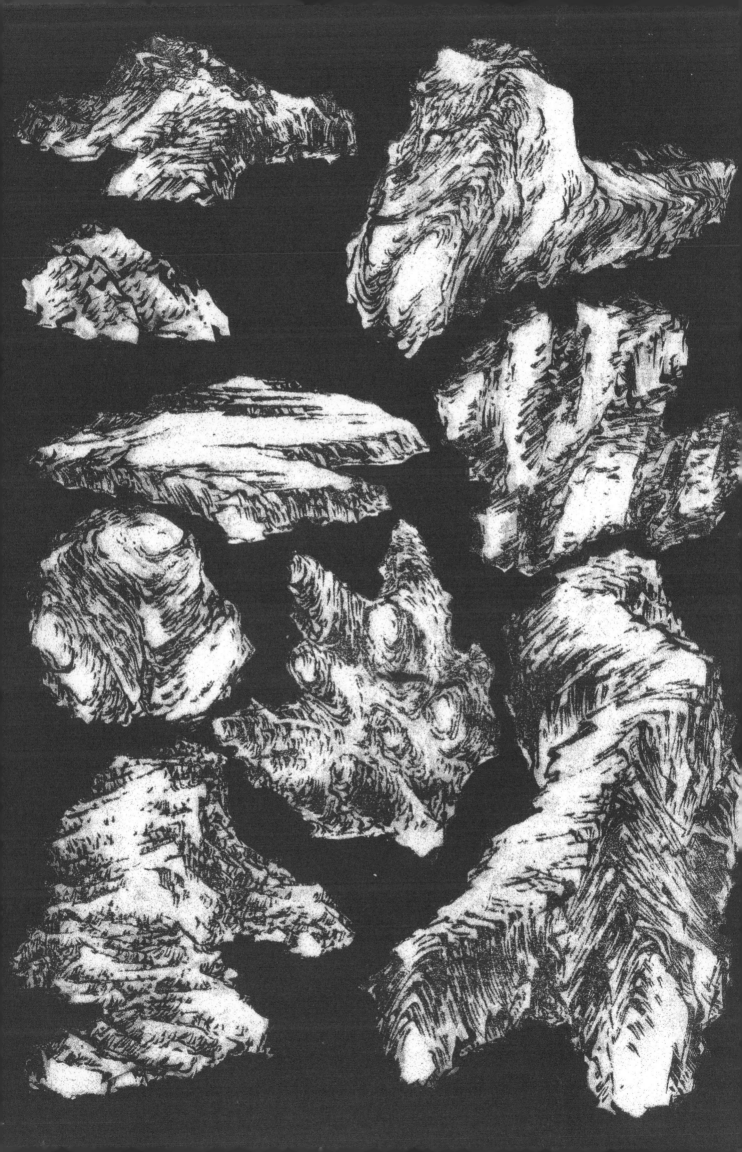

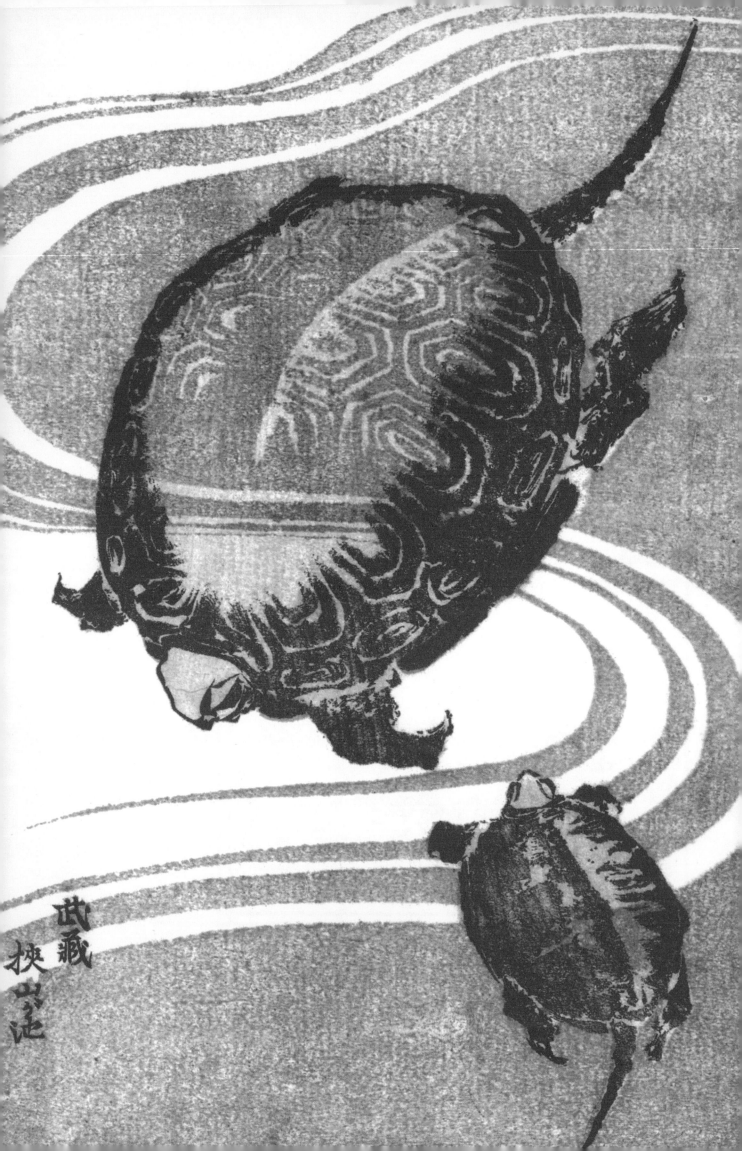

武藏
狹山ノ池

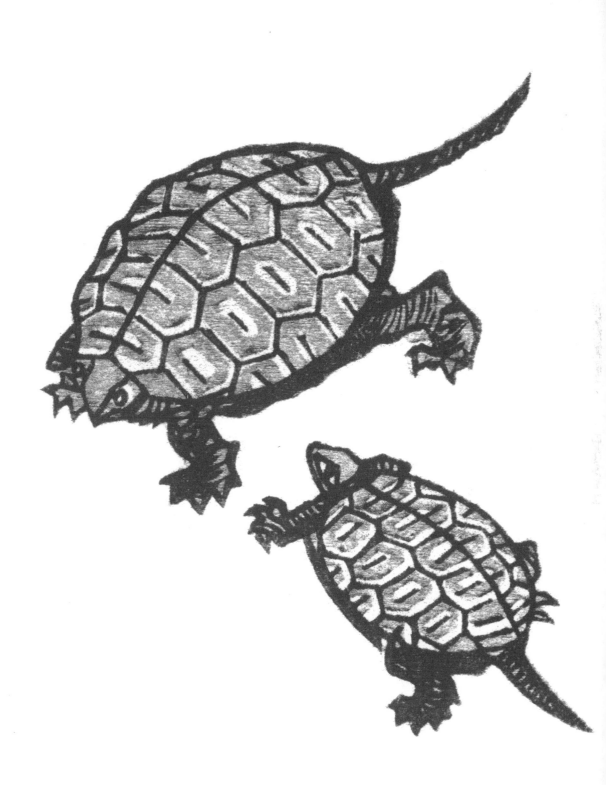

浦して

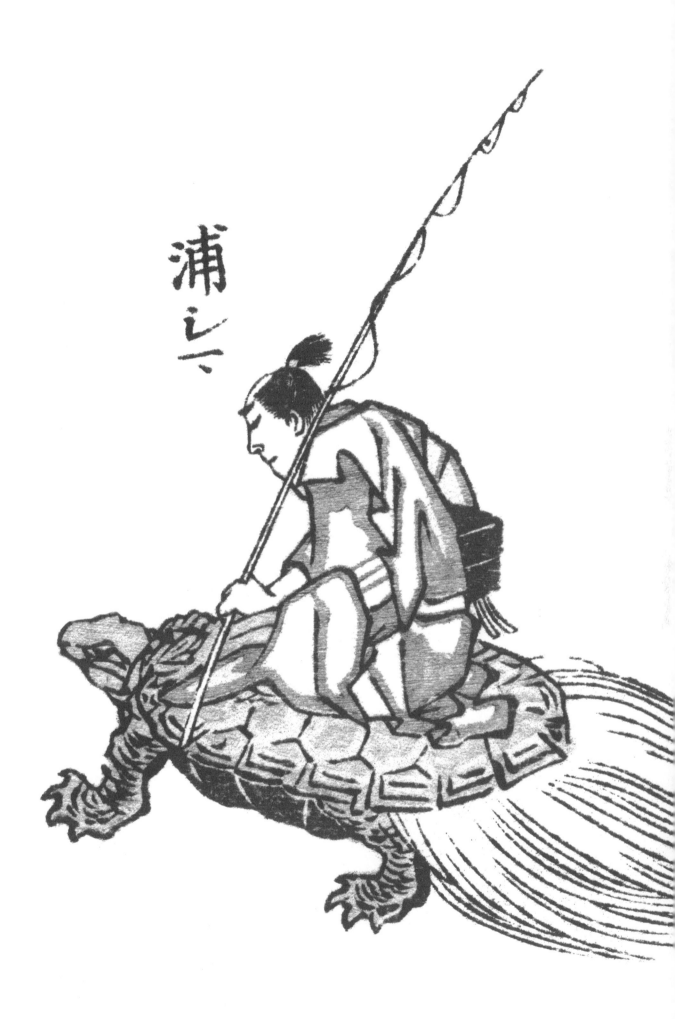

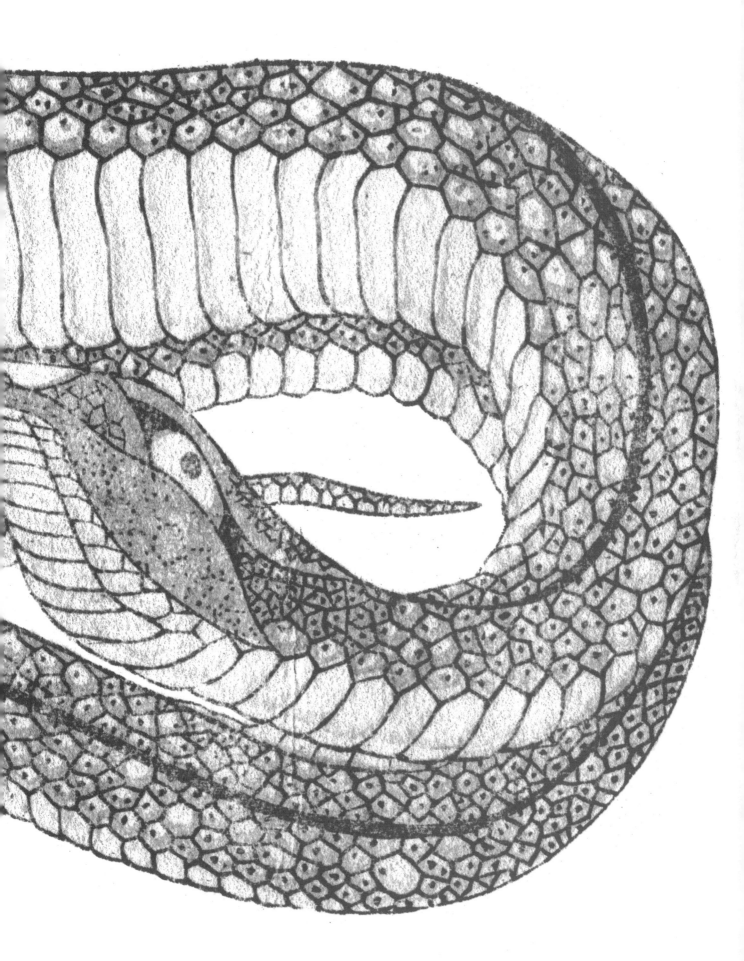

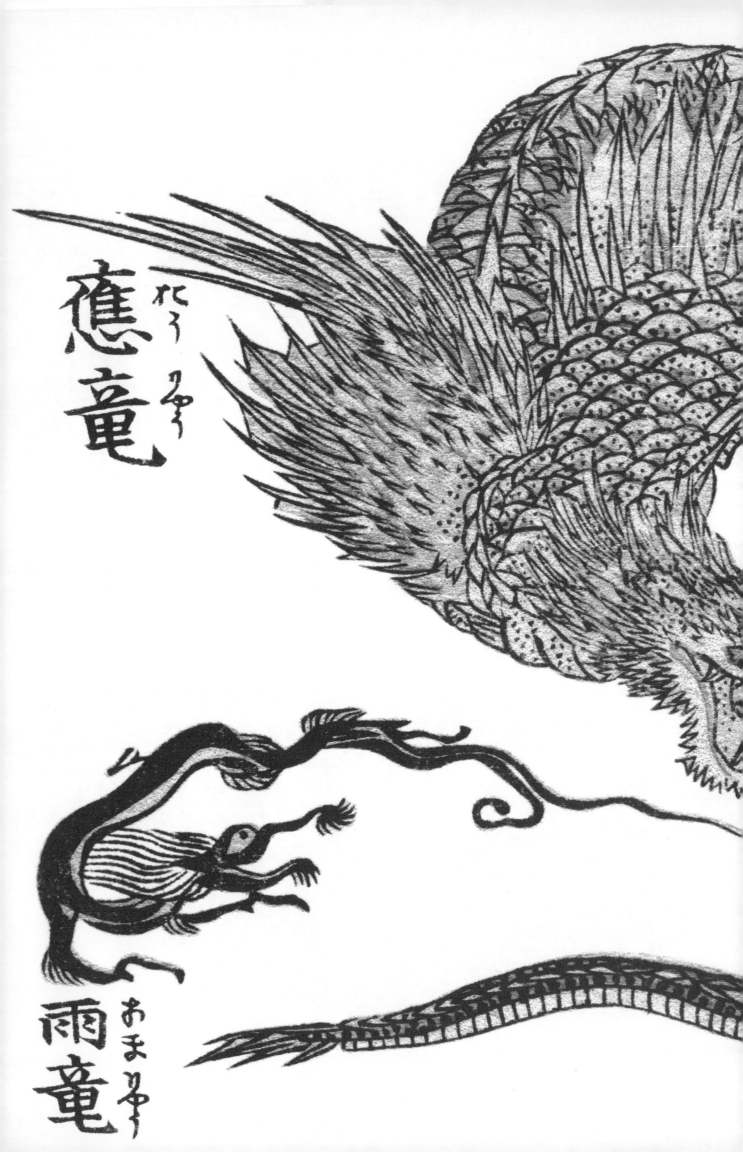

應竜
おうりう

雨竜
あまりう

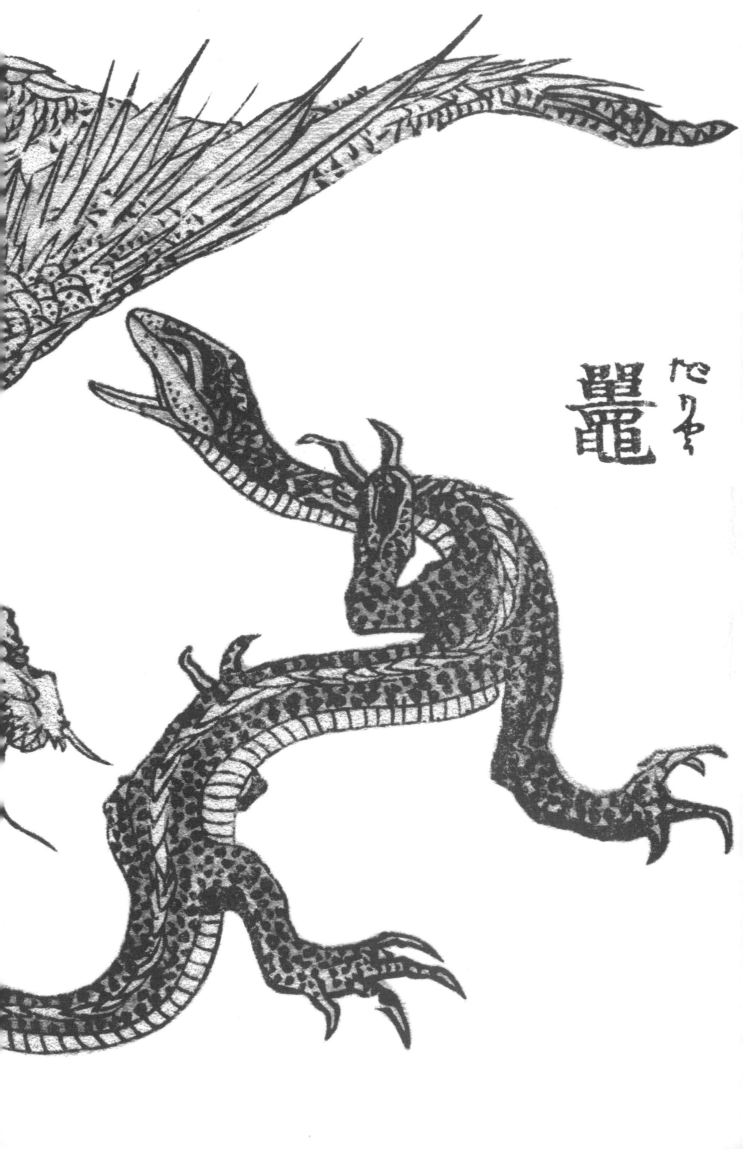

たつや

龘

頭香
づくり

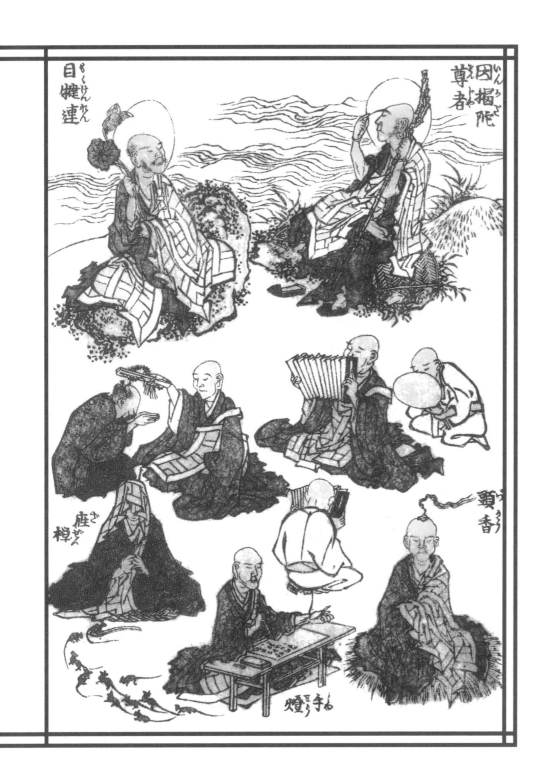

目犍連

因掲陀尊者

塵禅

頻香

燈手

鳳凰

くうかい
空海

滋賀坊

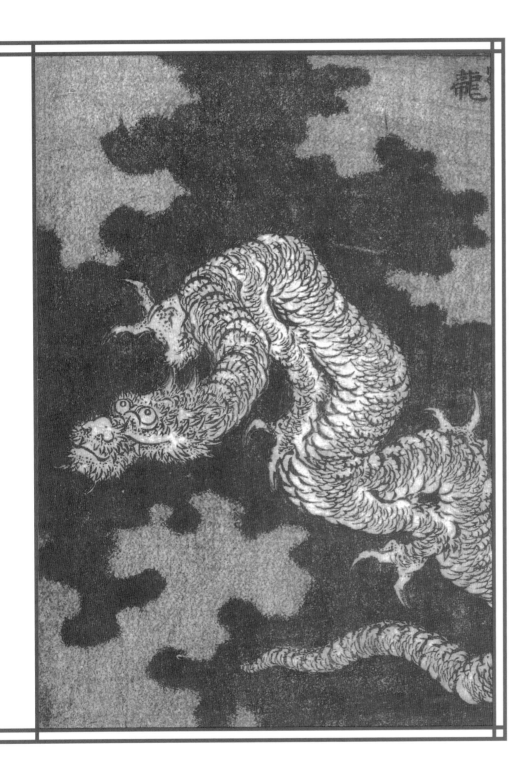

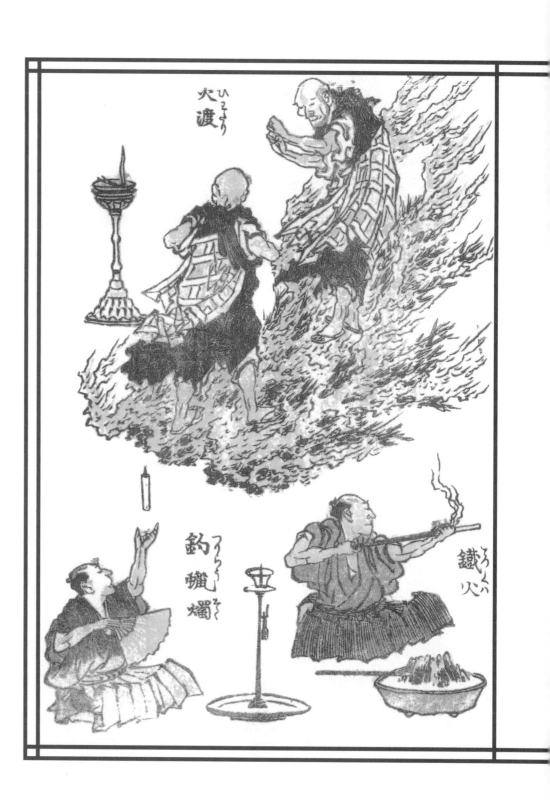

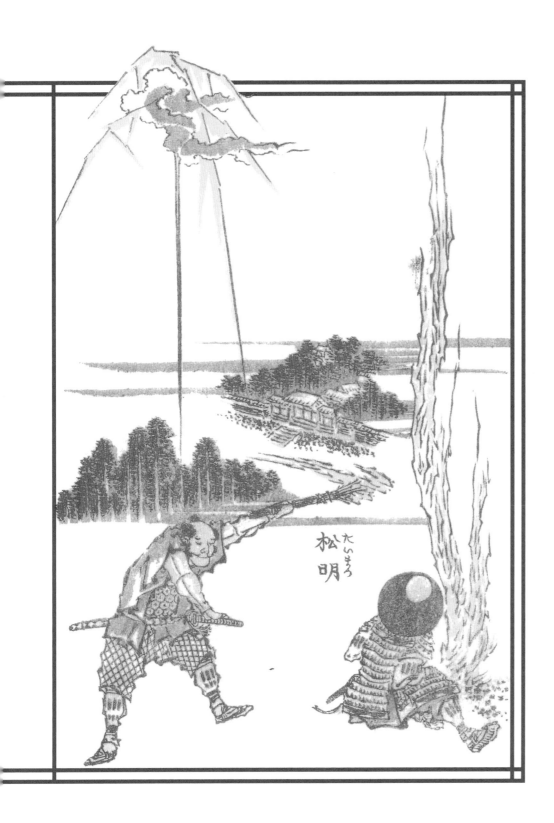

松明
たいまつ

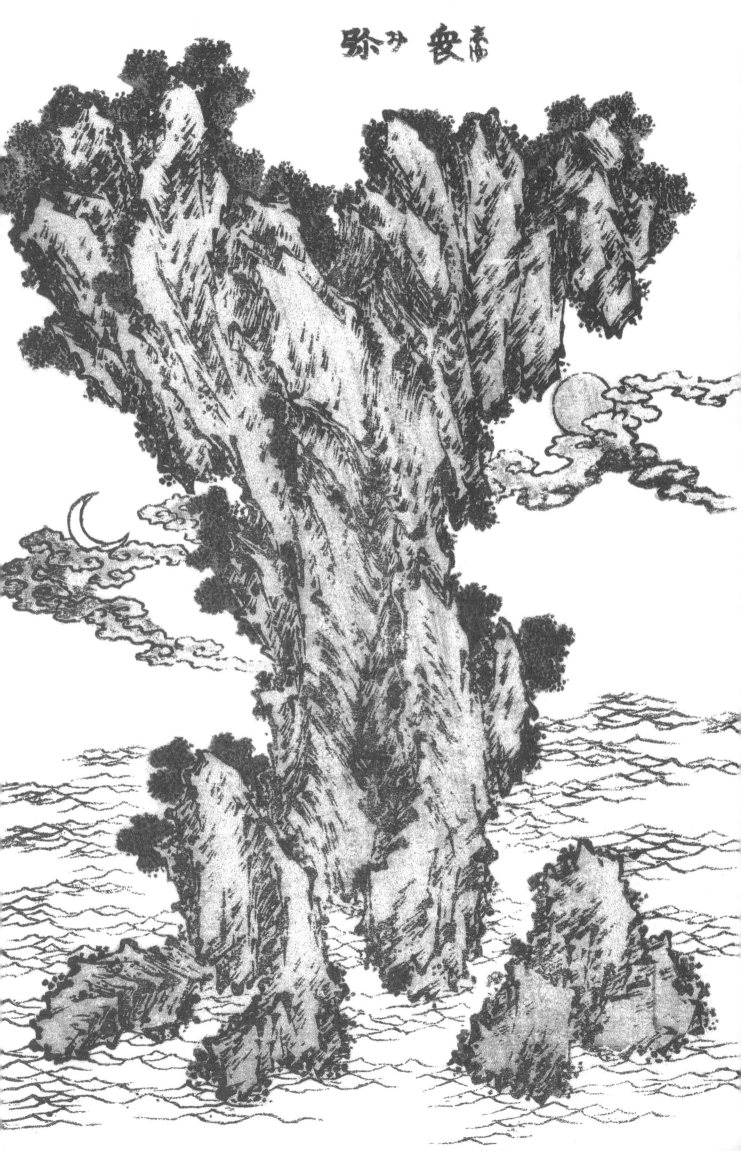

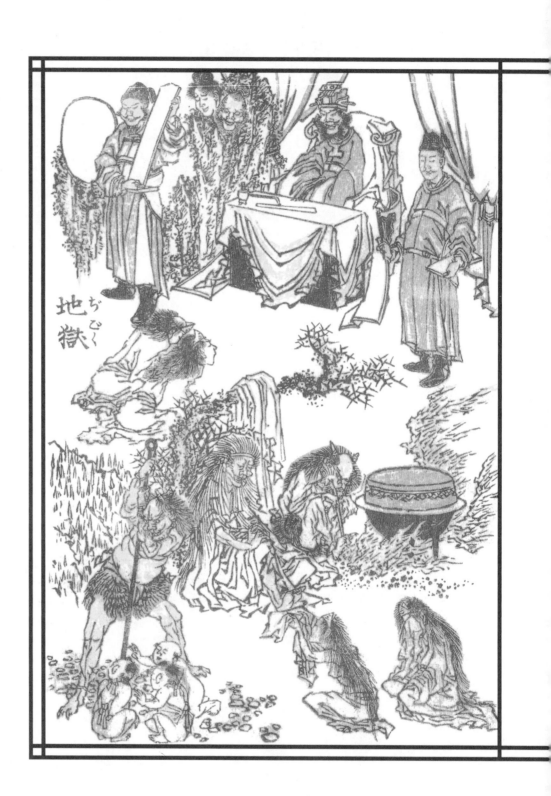

地獄

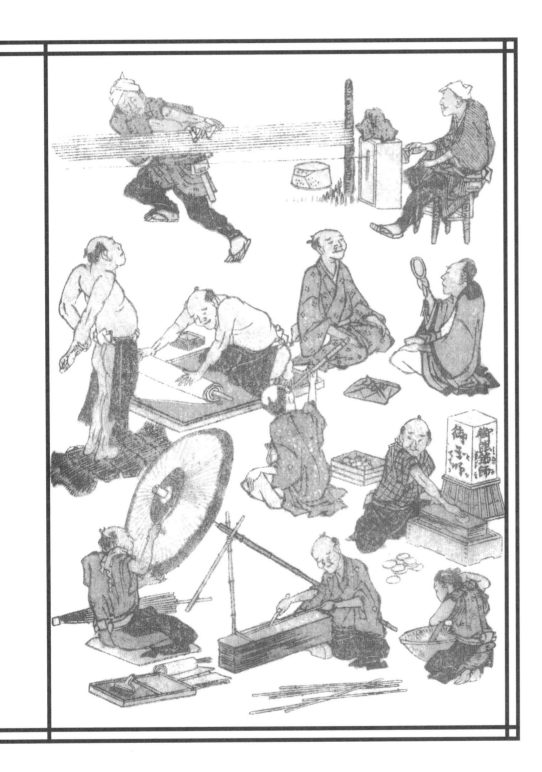

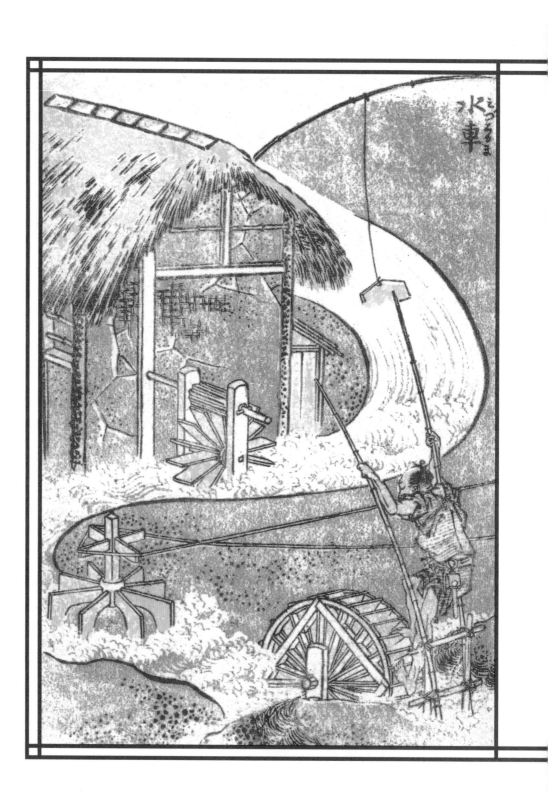
水車
みづくるま

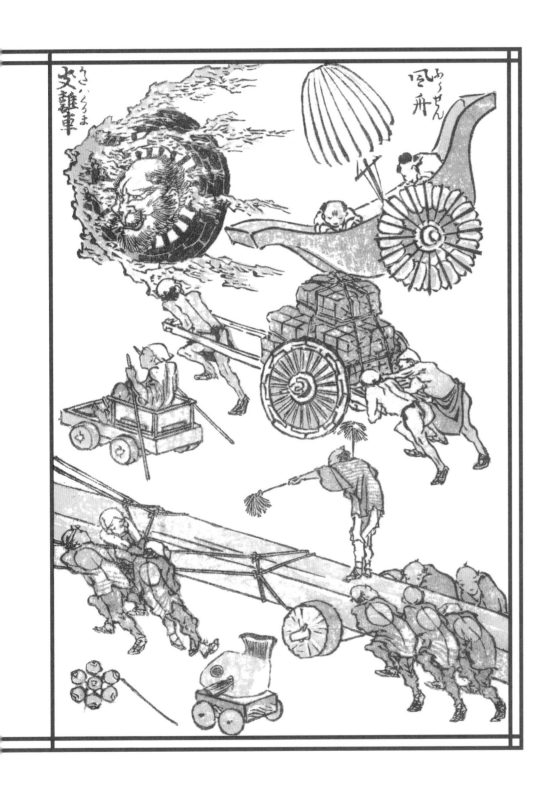

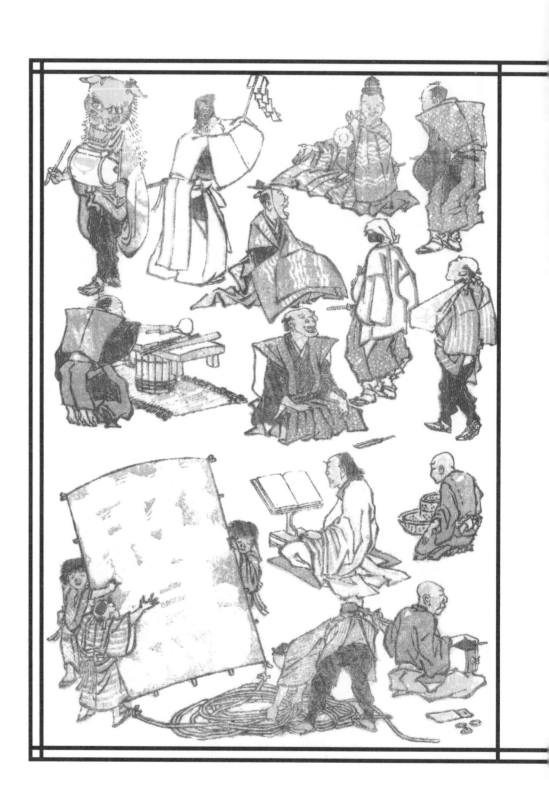

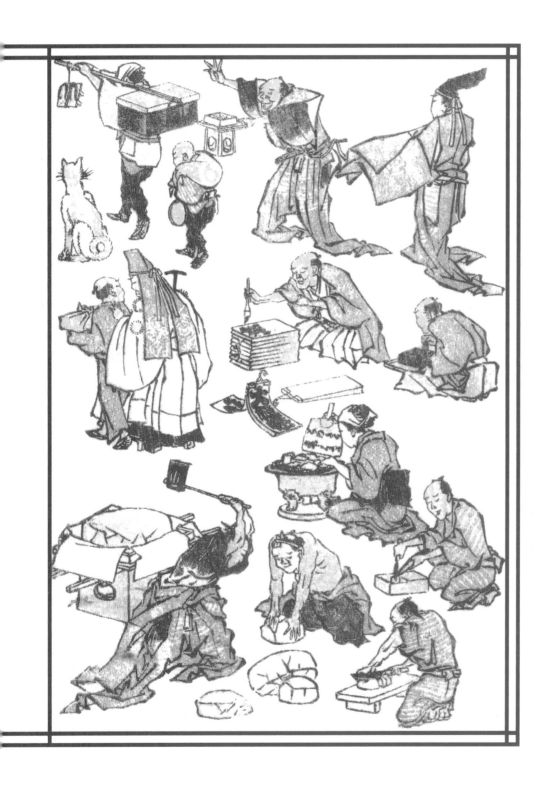

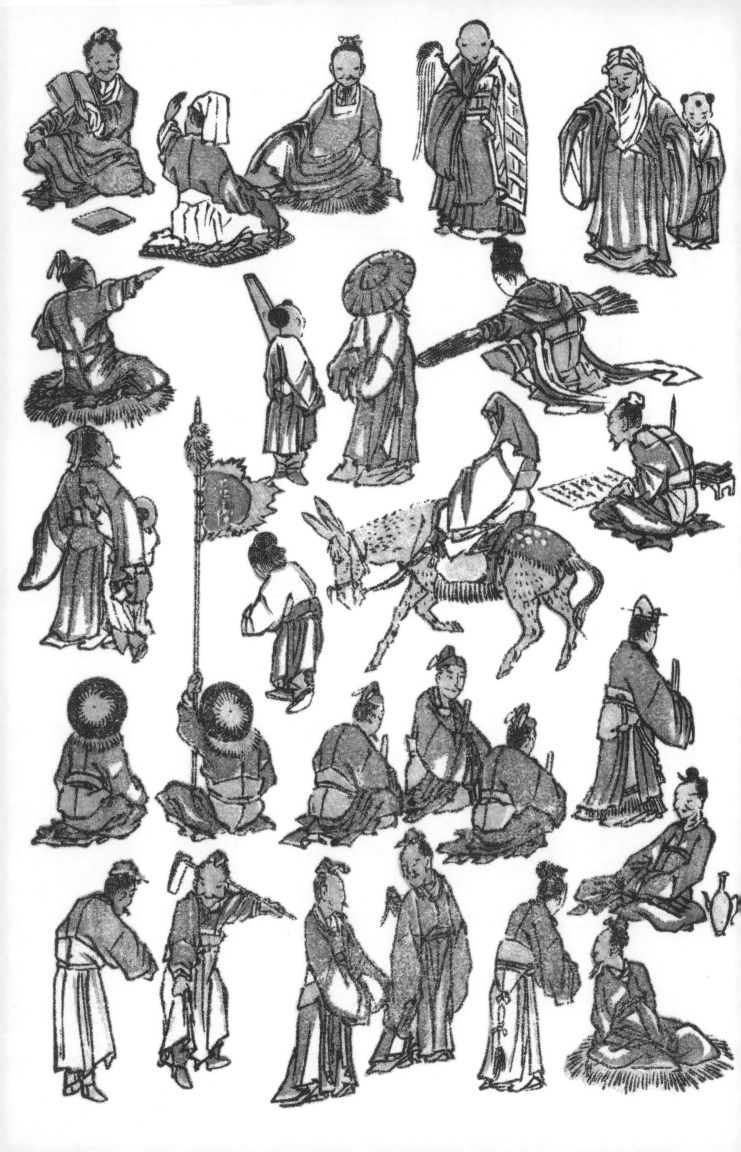

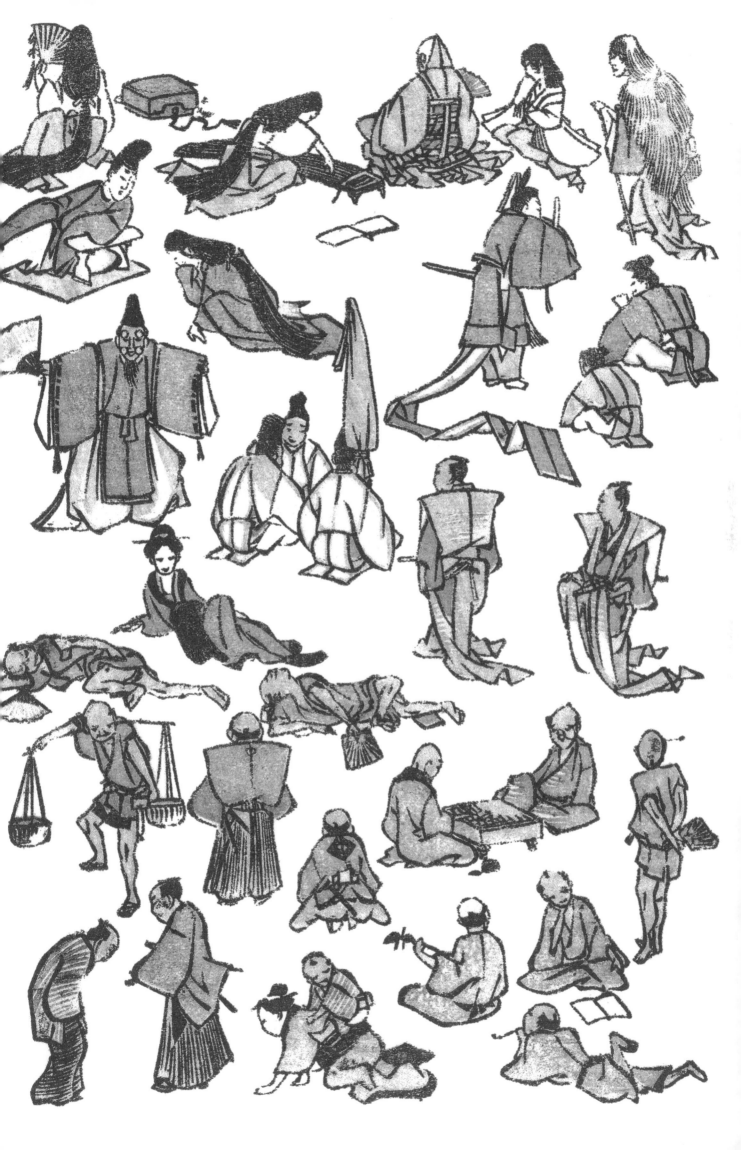

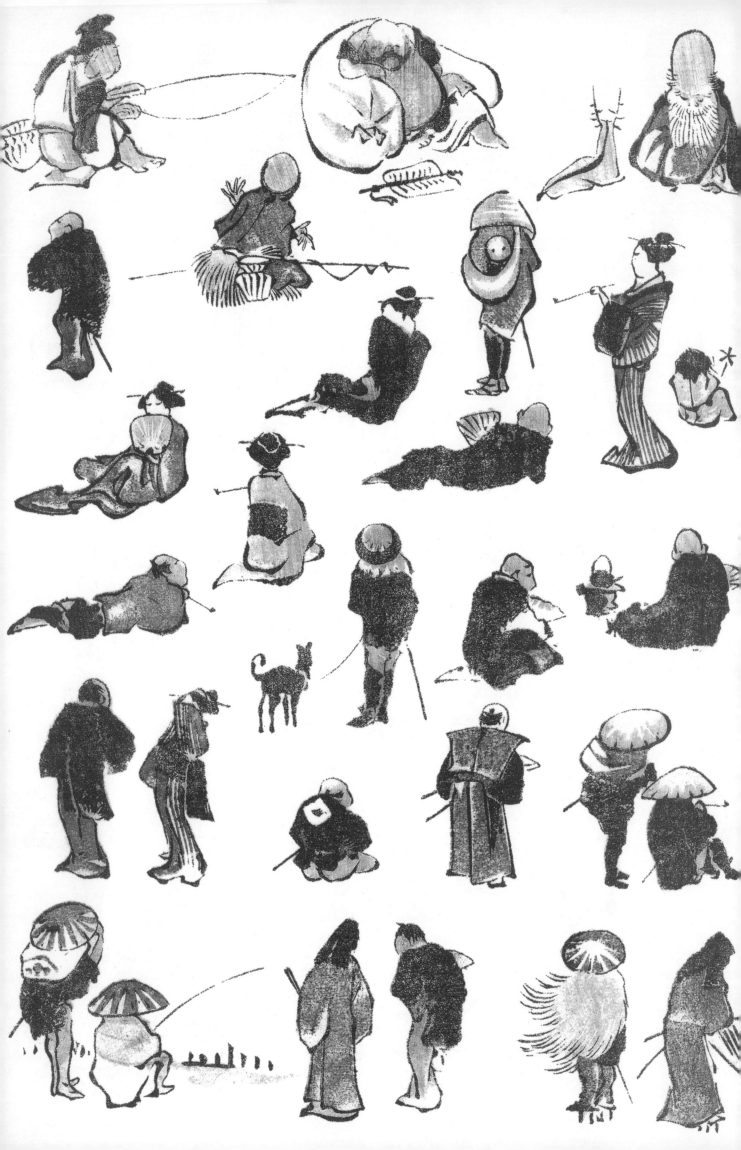

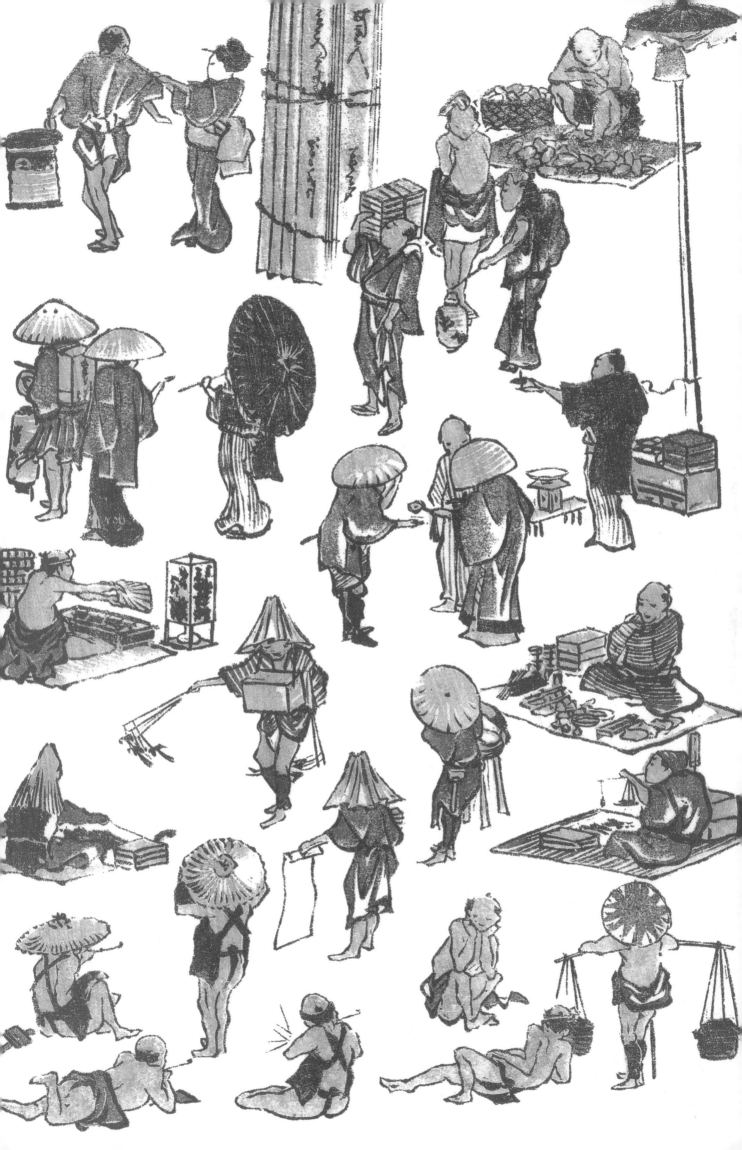

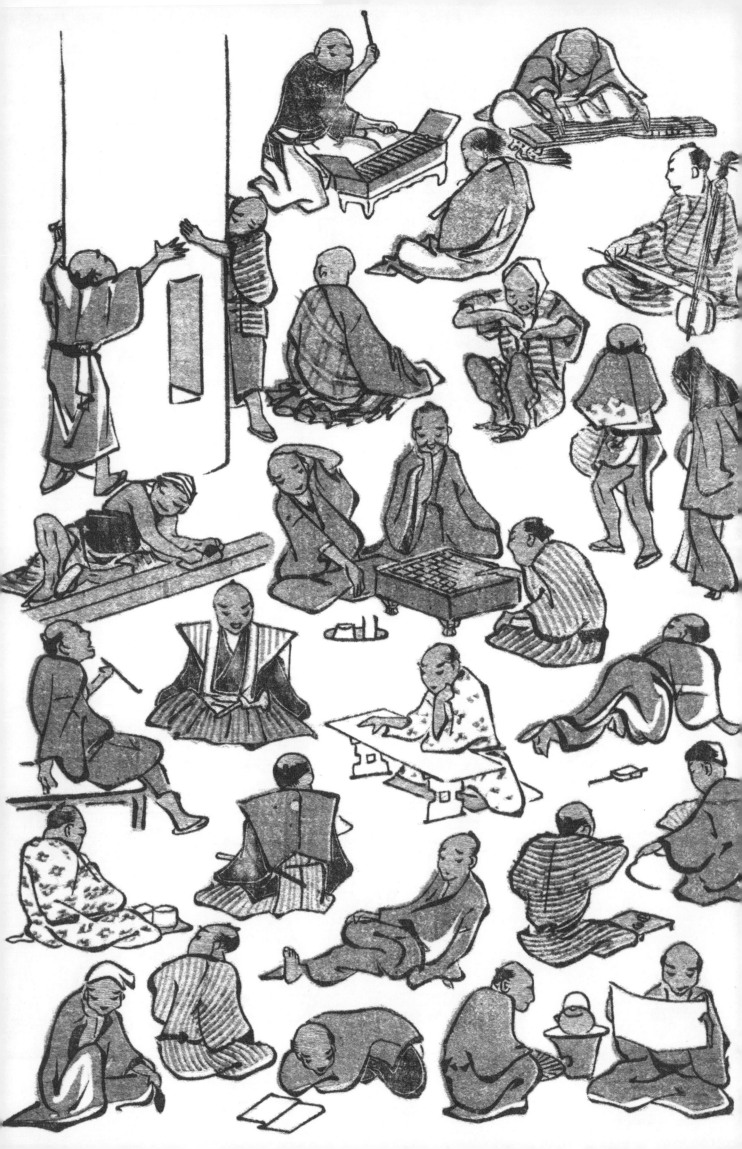

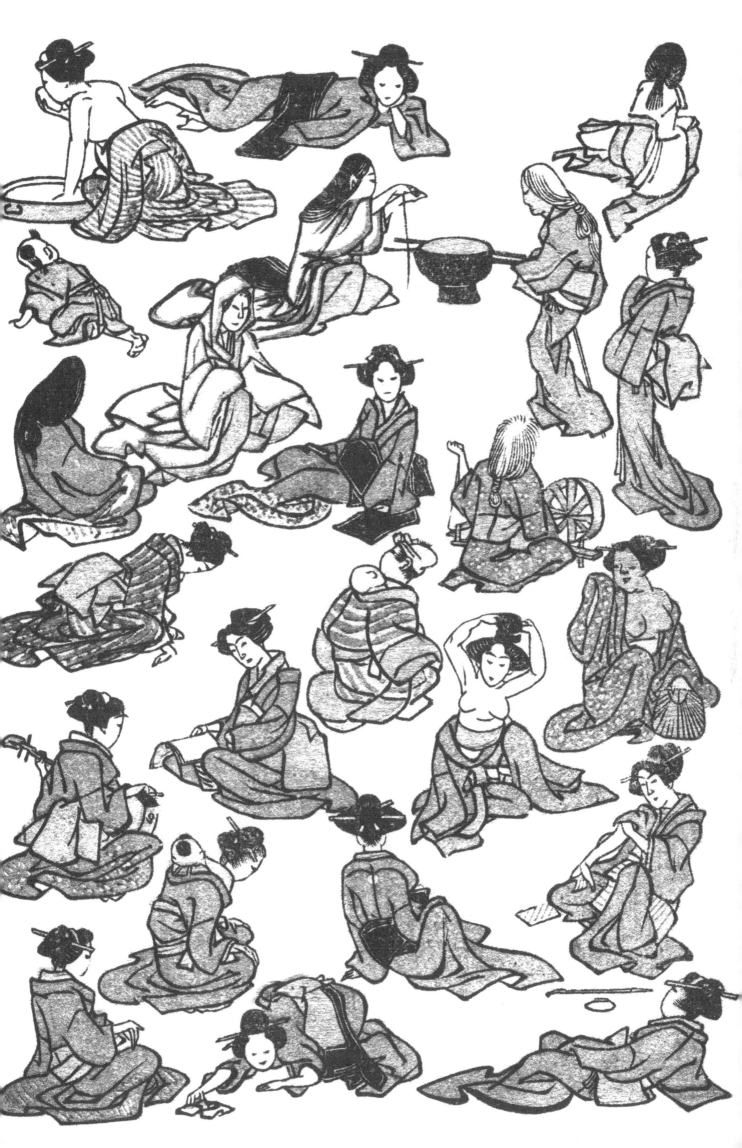

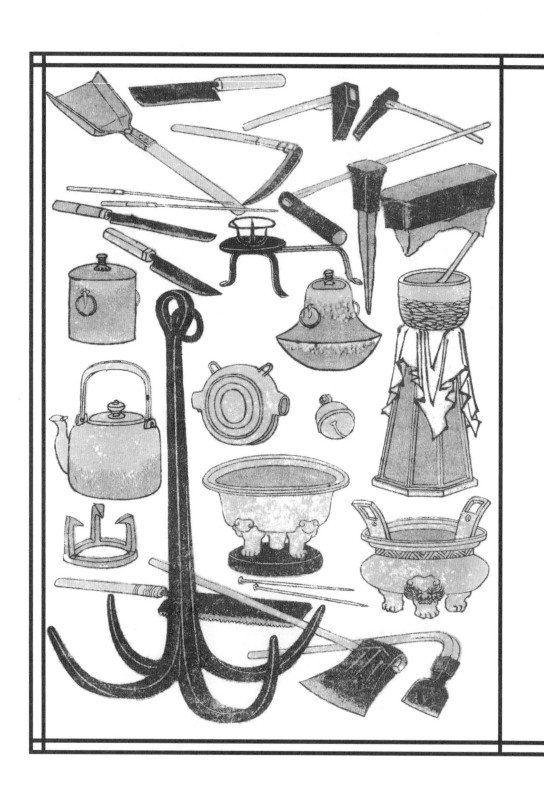

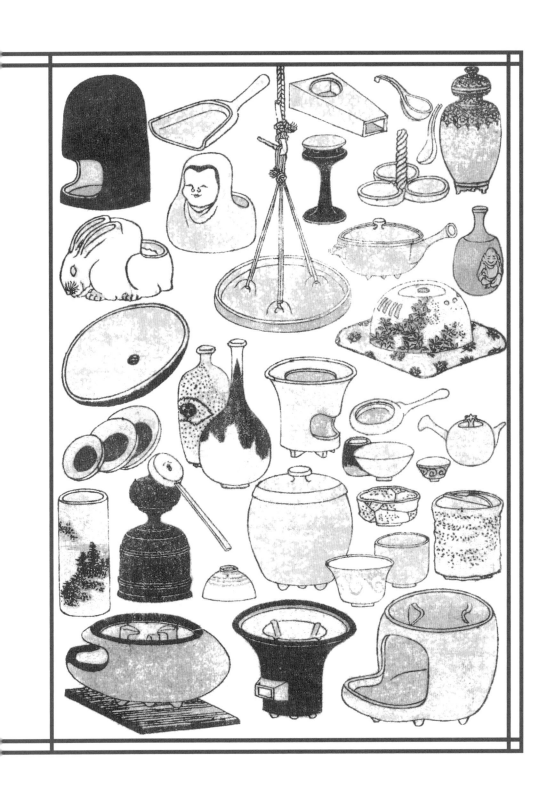

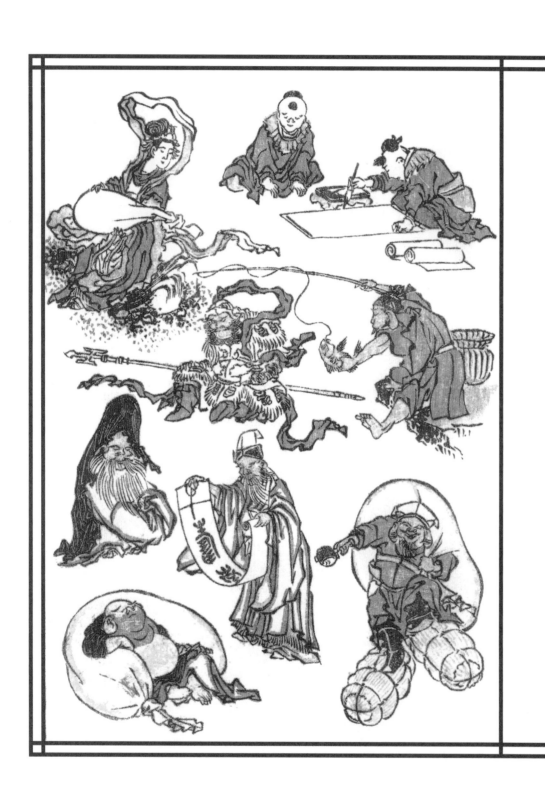

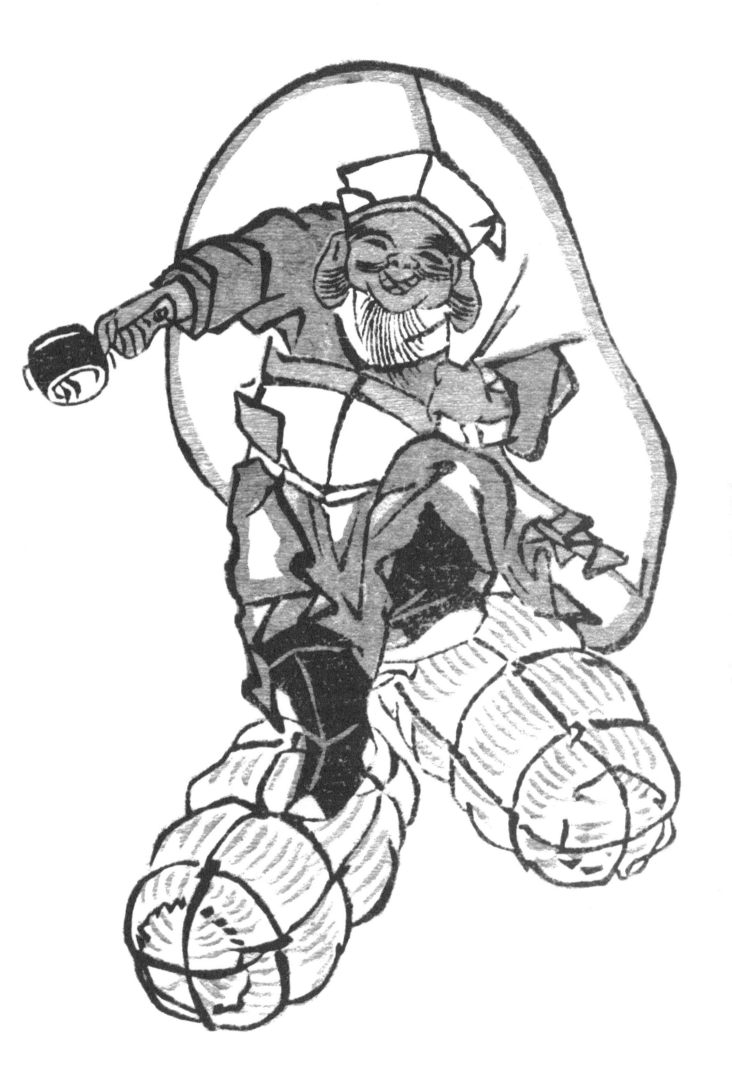

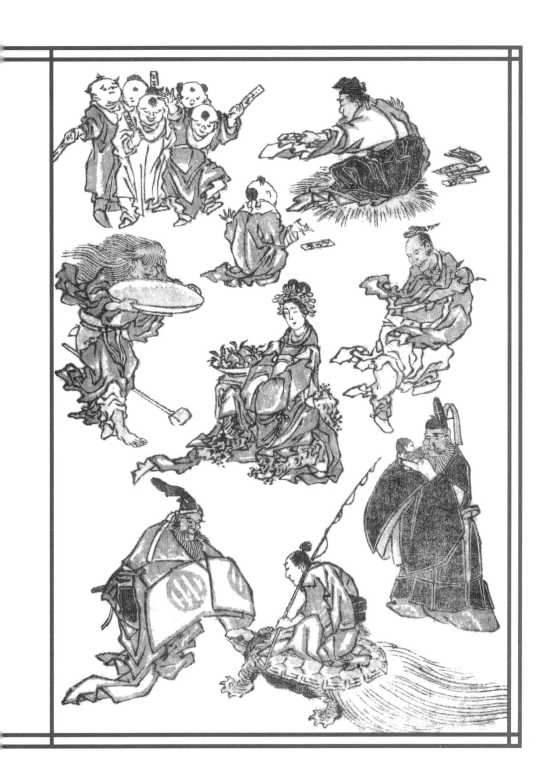

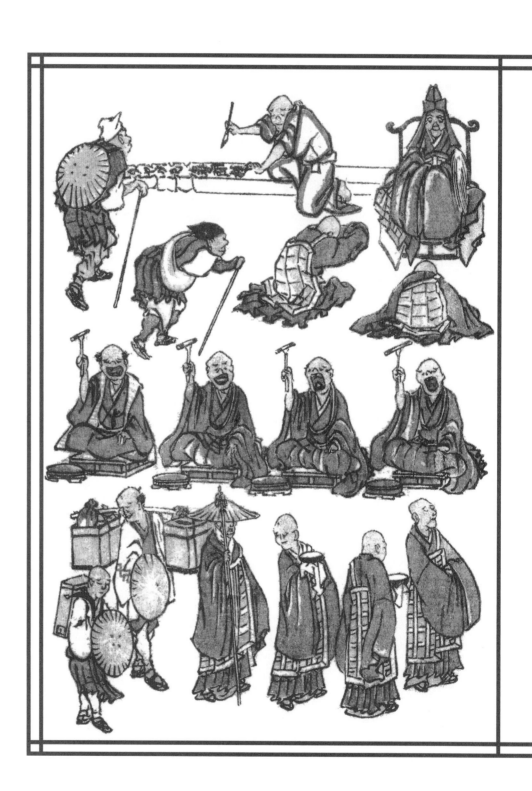

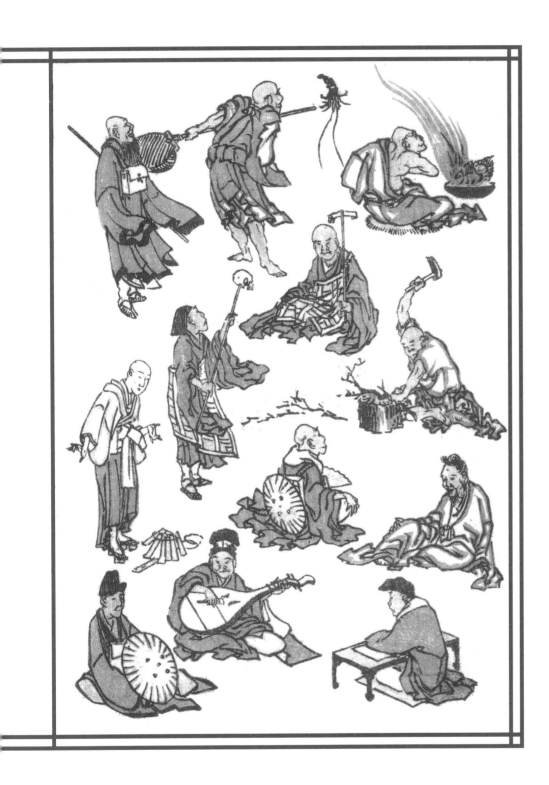

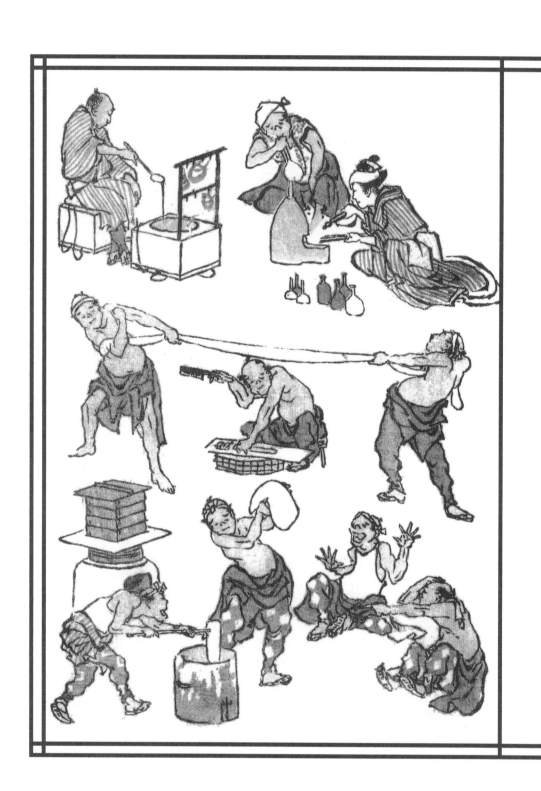

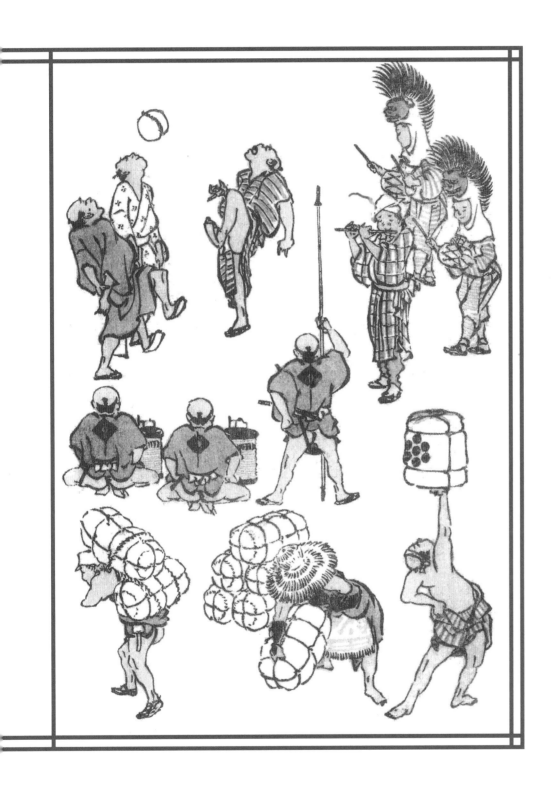

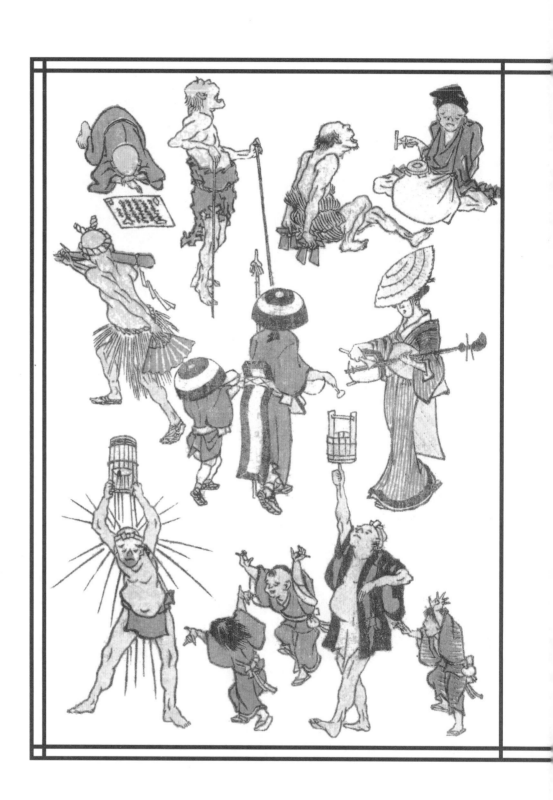

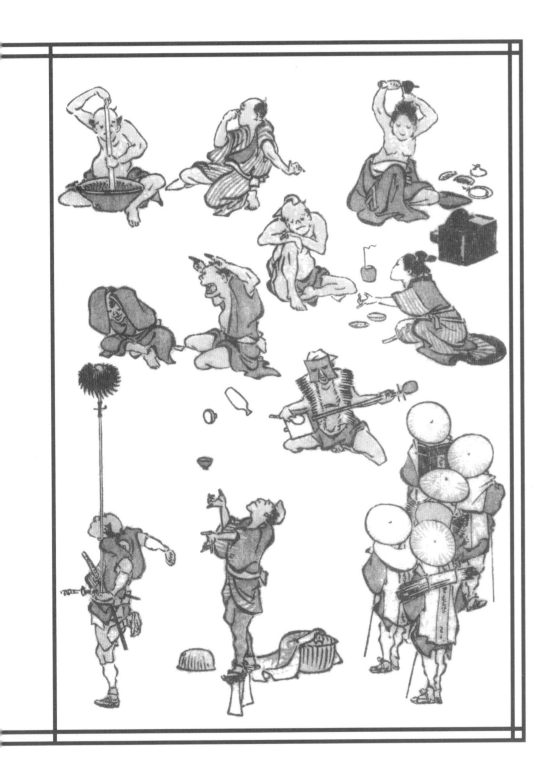

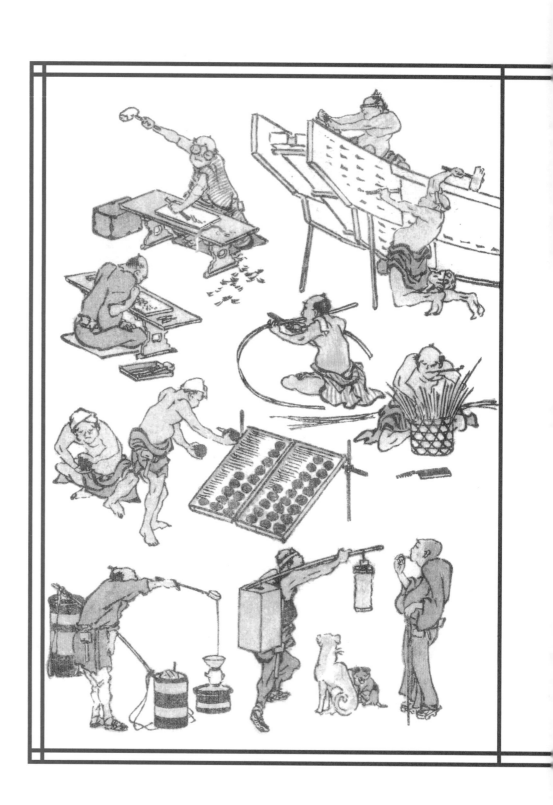

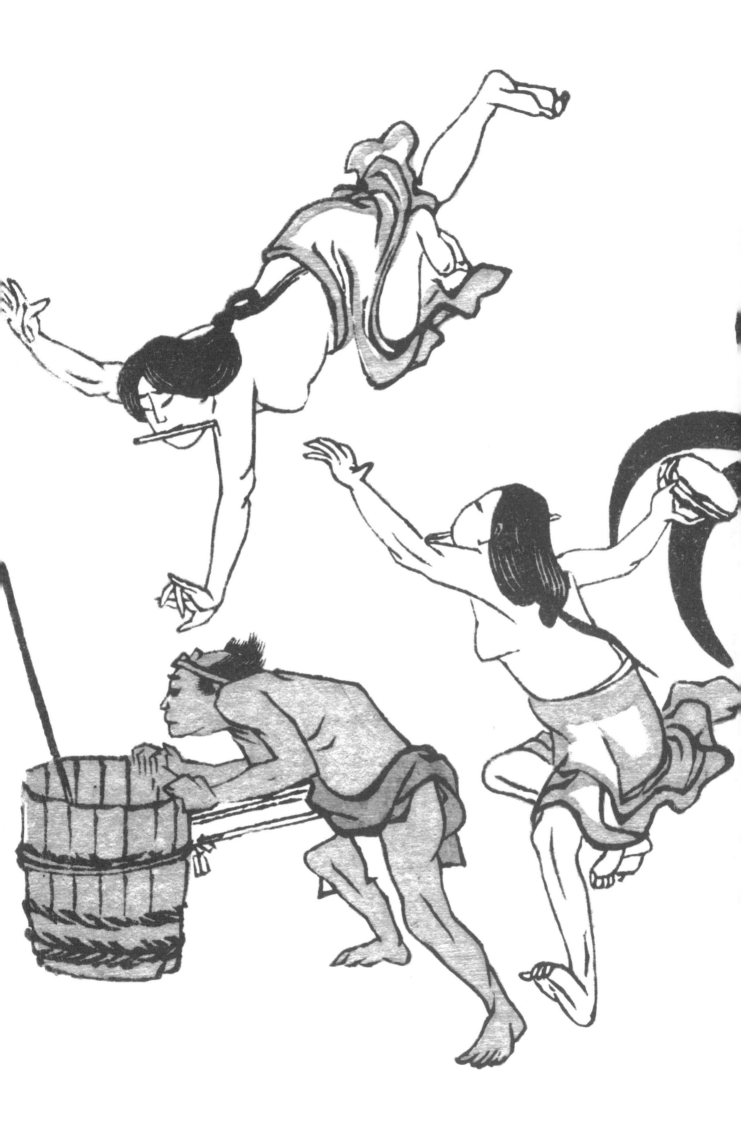

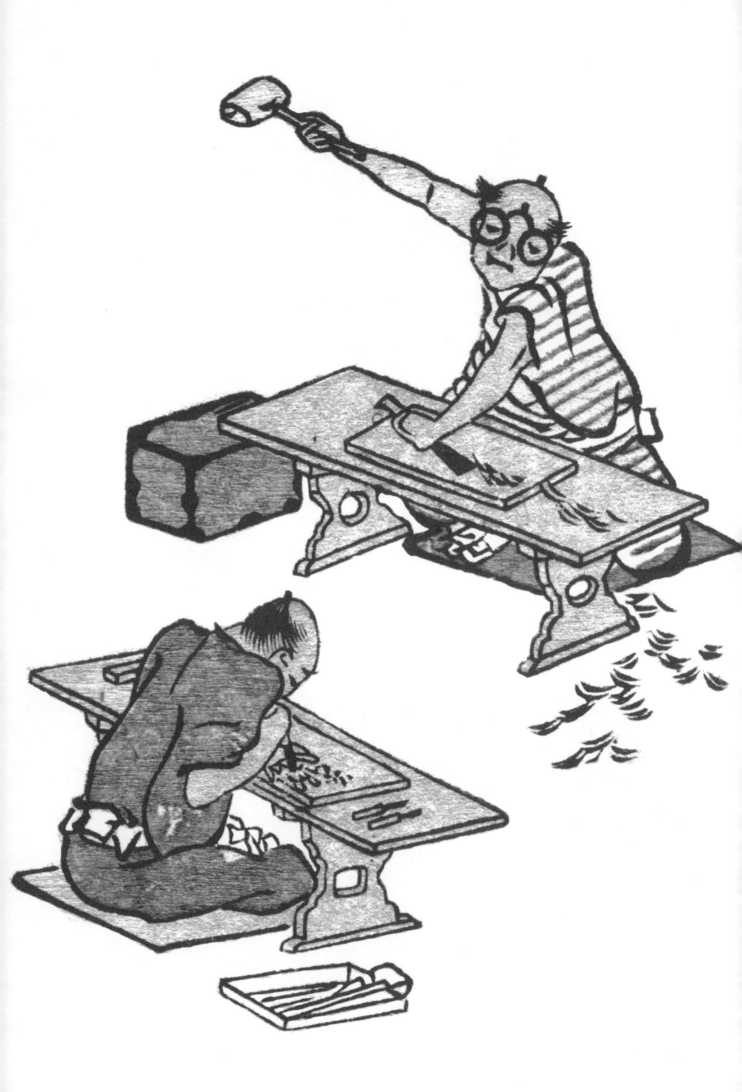

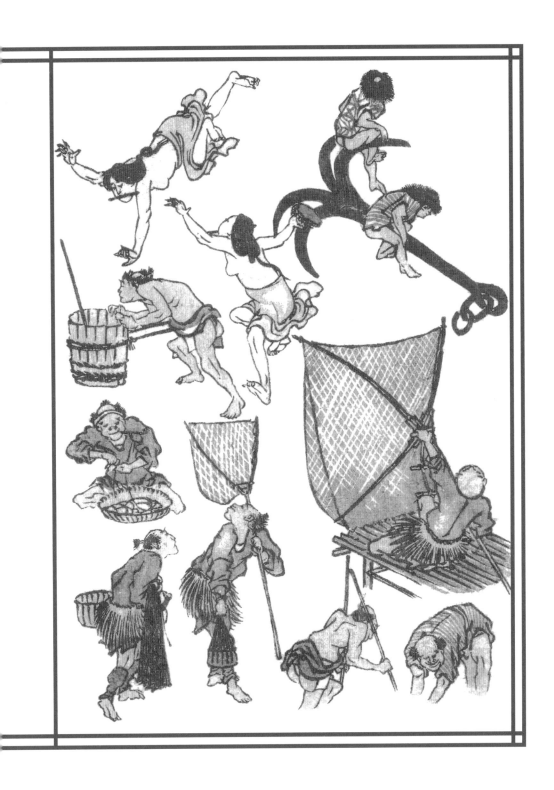

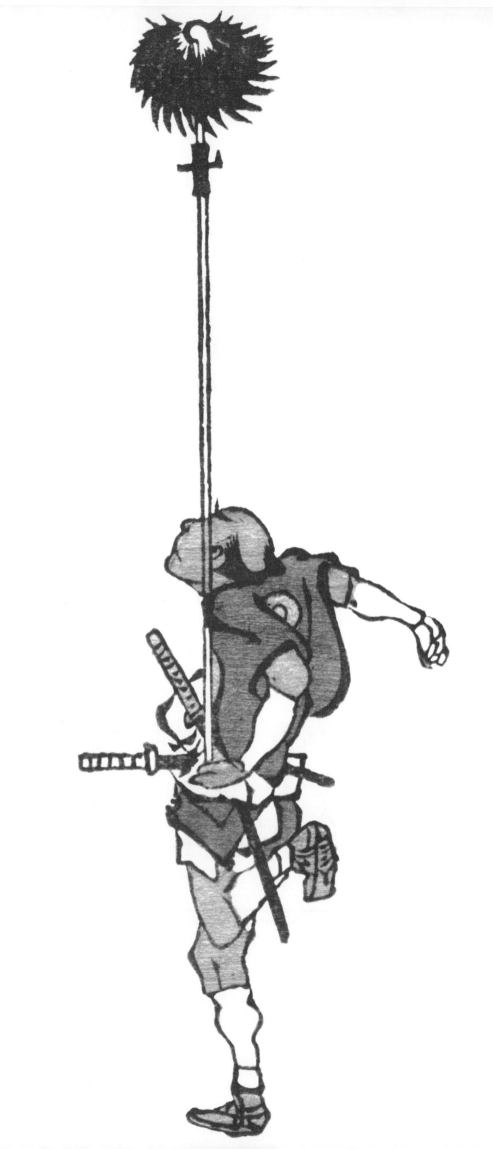

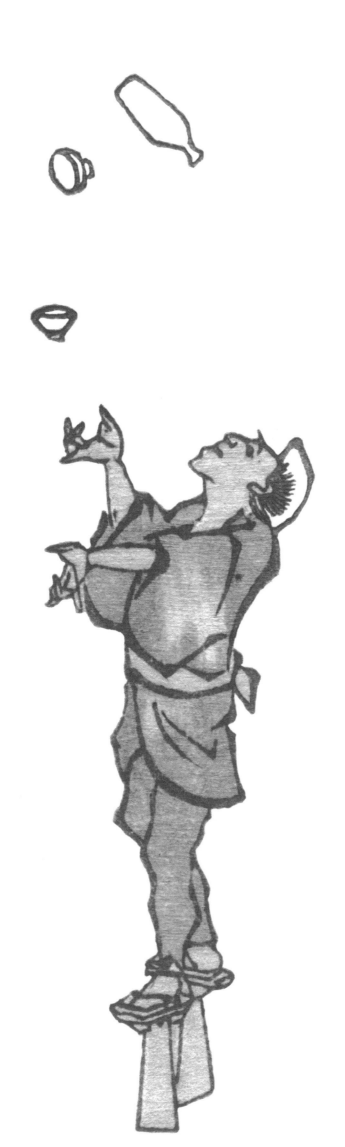

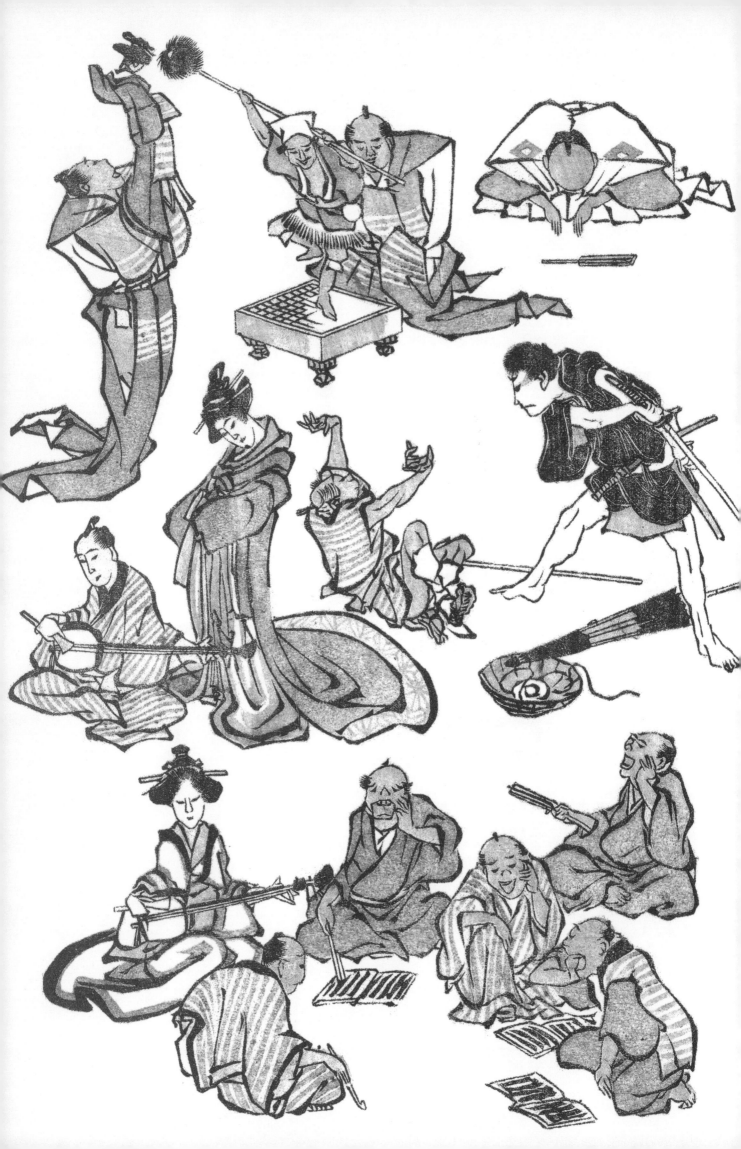

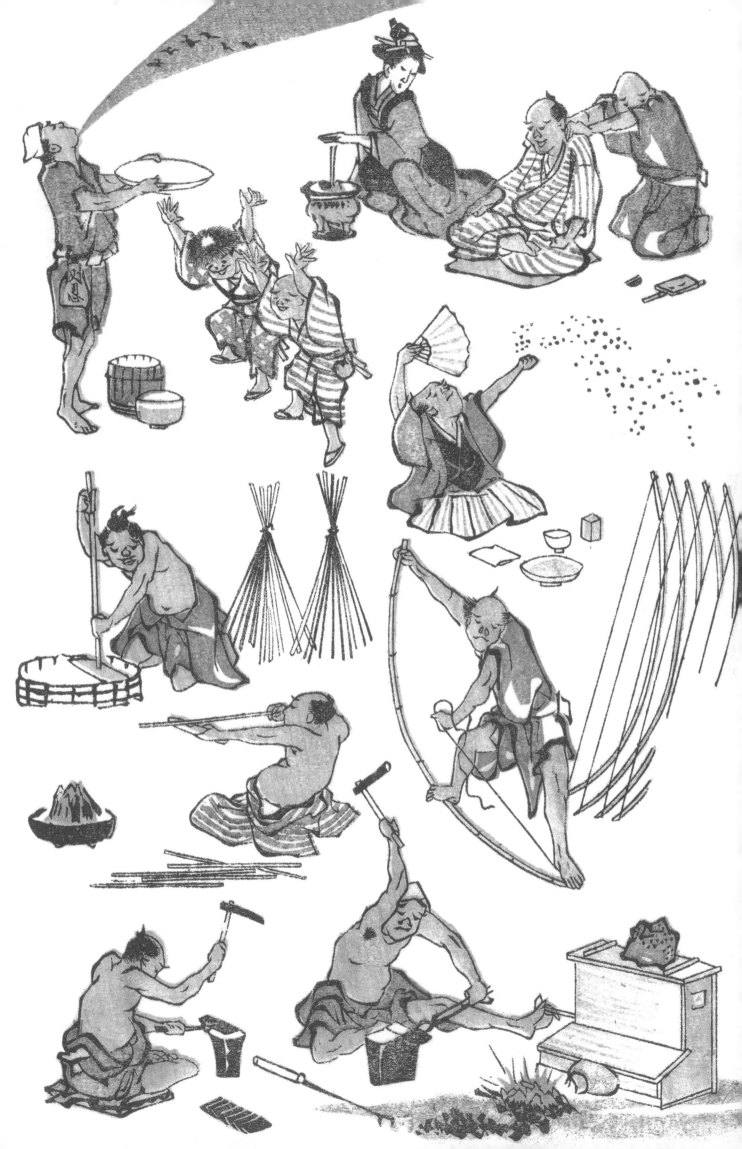

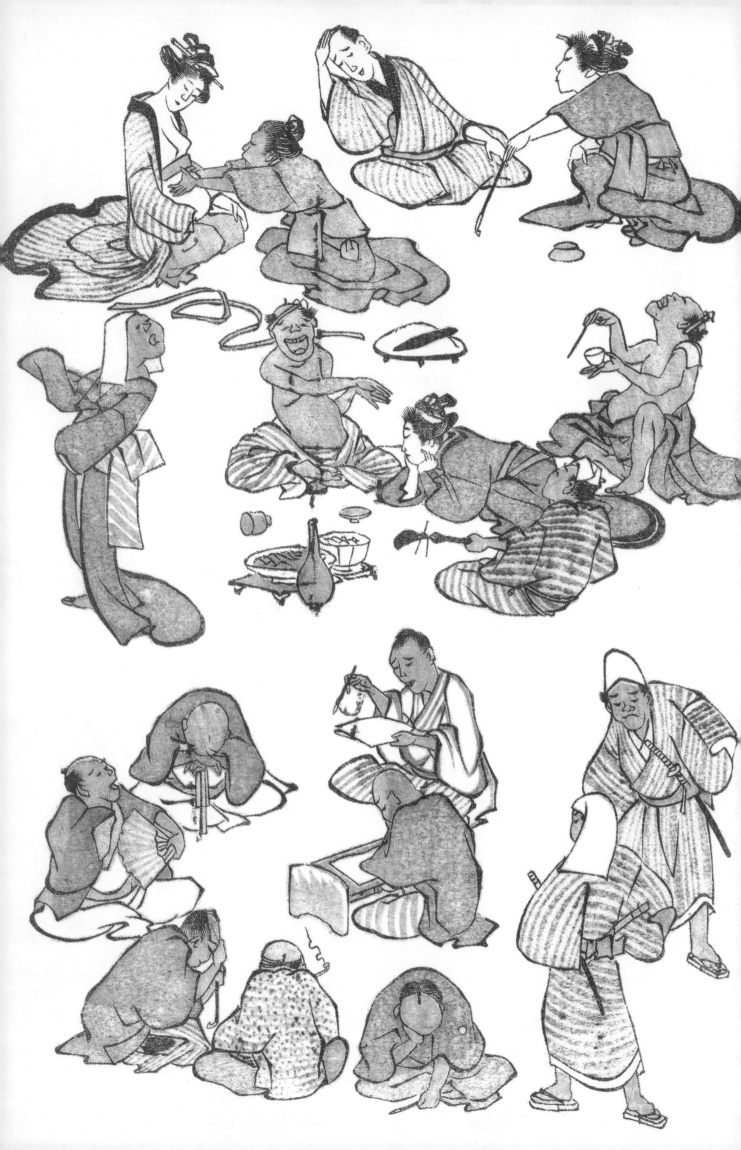

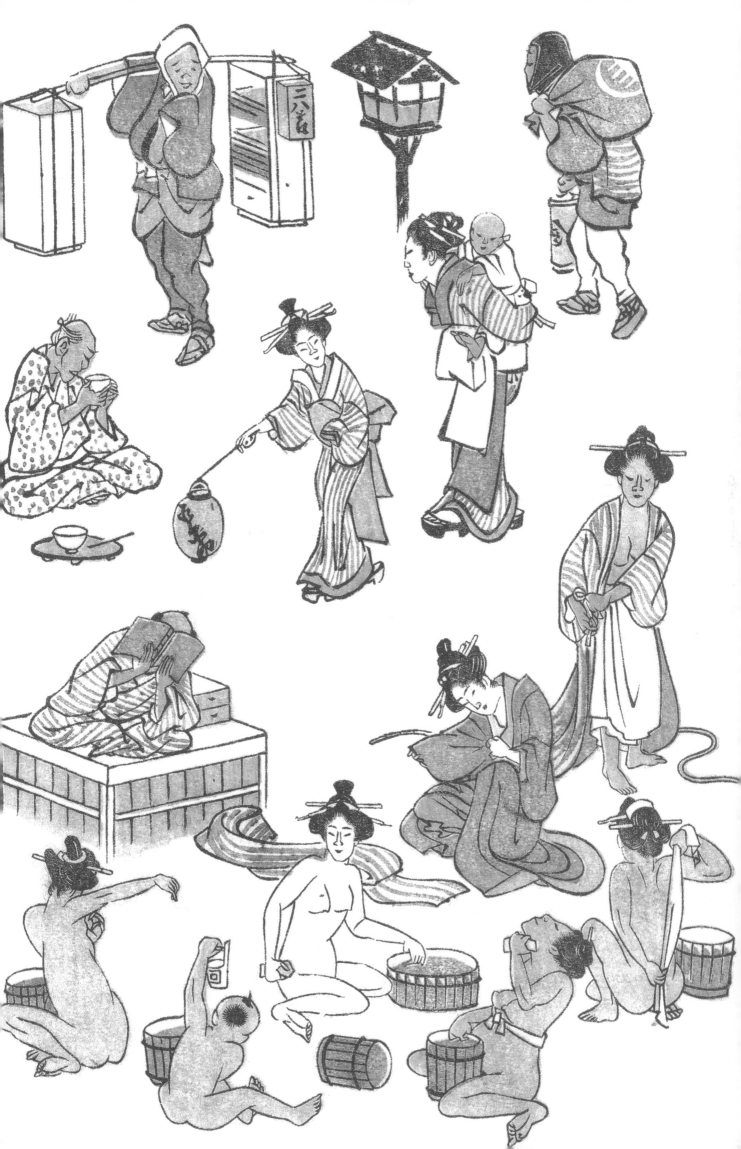

Hokusai (1760-1849) had some eccentric habits. Famed among these were his habit of moving house and his habit of changing his name. He moved house a total of 93 times during his 90 years. At its worst, this habit saw him shift as many as three times in one day. Even considering his social circumstances, which meant it was possible to move house easily using a single two-wheeled handcart, this was quite out of the ordinary. It seems it was simply a case of Hokusai disliking cleaning, as a result of which whenever his room became too messy he moved house. It may also be that Hokusai, who liked the number 100, aimed to

北斎（1760-1849）は奇癖の持ち主だった。中でも有名なのが引っ越し癖と改名癖である。引っ越しは90年の生涯で93回を数えた。ひどい時は1日に3回に及んだ。大八車ひとつで簡単に引っ越せたという社会状況があったとはいえ尋常ではない。ちなみに北斎は掃除が嫌いで部屋がゴミだらけになると引っ越したようである。それに100という数が好きだった北斎は、100回の転居を目

北斎の奇癖

change his address 100 times. If only he'd lived a few more years, perhaps he would have been able to fulfill this wish.

Hokusai only owned his own home once, otherwise moving from row house to row house, but he also spent a lot of time traveling. This was particularly the case after he turned 50, when he traveled to Kansai and Nagoya, and after he turned 80 he made a number of journeys to the town of Obuse in Shinshu province. Perhaps this fondness for travel explains why in the *Koeki shoka jinmeiroku*, a kind of Who's Who of the Edo period, Hokusai is registered as having no permanent address.

指していたようだ。だから、もう少し長生きをしていたら望みをかなえていたかもしれない。

自宅を持ったのは1度きりで長屋から長屋への転居を繰り返した北斎だが、旅にもよく出た。特に50歳を過ぎてからが多く、関西や名古屋へも行き、80歳を過ぎても何度か信州の小布施へ旅をしている。そのためか、江戸時代の紳士録ともいえる『広益諸家人名録』に、

Hokusai's eccentricities

As for Hokusai's other great habit of changing his name, this occurred as many as 30 times during his lifetime. However, since taking the name Shunro at the age of 20 after becoming an apprentice to Katsukawa Shunsho, there were five main name changes: to Sori, Hokusai, Taito, Iitsu, and Manji. Regarding Hokusai, the author Takizawa Bakin, who himself used multiple pennames, once wrote in astonishment, "No one changes their name or moves house as often as this man." Incidentally, the reason the name Hokusai, which he used for just 18 years between the ages of 38 and 56, became immortalized is due solely to

住所不定と記されたりもした。

もうひとつの改名については生涯で30回に及んだ。ただし、主な改名は勝川春章に弟子入りし20歳で春朗の名を与えられて以来、宗理、北斎、戴斗、為一、卍の5回といわれる。自らも多くのペンネームを持つ滝沢馬琴が北斎について「居を転ずると名を変ゆるとは、この男ほどしばしばなるはなし」とあきれて記している。とこ

the fact that it was under this name that he suddenly shot to prominence as a book illustrator. The success of *Hokusai manga* also helped. Hokusai knew more than anyone else the utility value of the name Hokusai, and even after passing it on to his apprentice he continued to use it, signing his works "Hokusai aratame Iitsu hitsu" (Iitsu, formerly known as Hokusai), "Zen Hokusai aratame Iitsu hitsu" (the former Hokusai, now known as Iitsu), and "Zen Hokusai Iitsu aratame Gakyo Rojin Manji hitsu" (Manji, the old man mad about art, formerly known as Hokusai and Iitsu), and so on.

ろで、38歳から56歳までの18年間だけ使用した北斎号が後世に伝えられたのは、読本（よみほん）の挿絵画家としての「北斎」が一躍有名になったからである。『北斎漫画』の成功も後押しをした。北斎号の利用価値は北斎自身が一番よく知っており、北斎号を弟子に譲った後も「北斎改為一筆」「前北斎改為一筆」「前北斎為一改画狂老人卍」などと北斎名を記している。

Hokusai manga contains a number of examples of idioms, proverbs, and the like turned into sketches. In volume 11, for example, the idiom kao ni doro wo nuru (literally "to paint mud on one's face"), meaning to sully somebody's name, is depicted literally and quite unpretentiously. A woman is shown painting mud on the face of a man that appears to be her husband with a "trowel." It's the kind of clever sketch typical of Hokusai that makes one want to exclaim, You've got me there. It's just a small sketch, but volume 8 contains across

『北斎漫画』には慣用句や諺を画にしたものが何図かある。たとえば11編には「顔に泥を塗る」が、何のてらいもなくストレートに描かれている。女が亭主らしき男の顔に"こて"で泥を塗っているのである。北斎ならではの人を食ったというか、思わず恐れ入りましたと言いたくなるような画である。これは小さなカットに過ぎな

群盲象を撫でる

facing pages a sketch called *Gunmo zo wo nederu* (Blind men stroking an elephant). Eleven blind men are shown touching the body of an elephant that is so huge it takes up two whole pages. Each touches a different part, with one touching a tusk, one holding the elephant's trunk, several wrapping their arms around its legs, several clambering up the elephant's back, and one gripping its tail. The hugeness of the elephant, the smallness of the people, and the annoyed expression on the face of the elephant are all add to the charm.

いが、8編には見開きで「群盲象を撫でる」の画がある。2ページにわたって大きく描かれた象の体を11人の盲人が触っている。牙を触る者、鼻にしがみつく者、脚に手を回したり、背によじ登ったり、尻尾を握ったり、それぞれが思い思いの部分に触れている。象の巨大さと人間の小ささ、そして象の表情がいかにも迷惑そうなの

Blind men stroking an elephant

"Blind men stroking an elephant" is a proverb expressing the idea that "just like when a large number of blind people stroke an elephant, each one gauges the entirety of the huge elephant based on the part they have touched, narrow-minded people are unable to appreciate the entirety of great people or large undertakings." When one looks at this sketch, the elephant takes on the appearance of Hokusai himself. Hokusai's world was incredibly vast, and it is difficult to grasp its entirety. As suggested by the frequency with which he changed his name

が面白い。
「群盲象を撫でる」とは、「大勢の盲人たちが象の体を撫でて、それぞれが自分の触れた部分だけで大きな象の全体を判断するように、小人には大人物や大事業の全体を見渡すことができないたとえ」である。この画を見ると象が北斎自身に見えてくることがある。北斎の世界は途

and address, Hokusai was never satisfied with a single school or style of drawing and was continually changing, converting his overflowing creativity into energy and devoting himself to drawing. One could say that *Hokusai manga* is a kind of databank of this activity. Hidden inside *Hokusai manga* is the key to understanding the vast, elusive world of Hokusai himself.

方もなく大きく、全体を掴むことは難しい。転居や改名を繰り返したように、ひとつの流派や描き方に満足することなく変化し続け、あふれ出る創造力をエネルギーにひたすら描いた。『北斎漫画』はその北斎のデータバンクとも言えよう。広大でとらえどころのない北斎の世界を理解する鍵が、『北斎漫画』にはあるように思える。

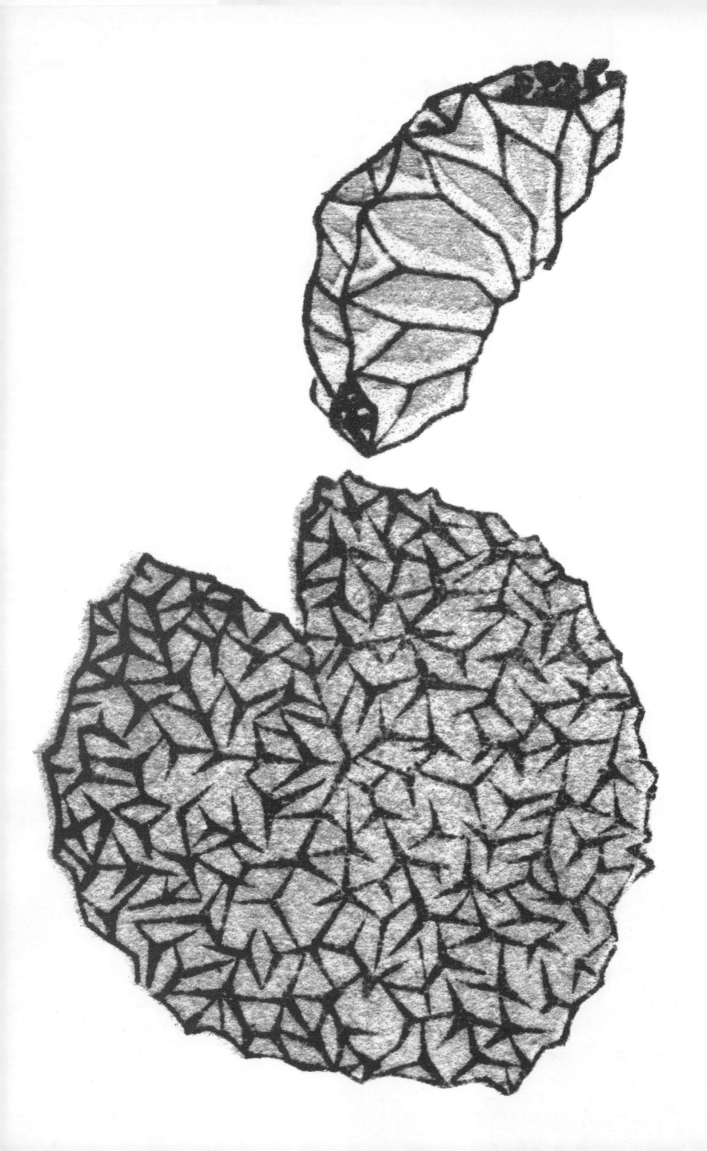

もくれん

れふむす

ばらん

れうと

たあおほひ

さうぎくすプ

くさふじ

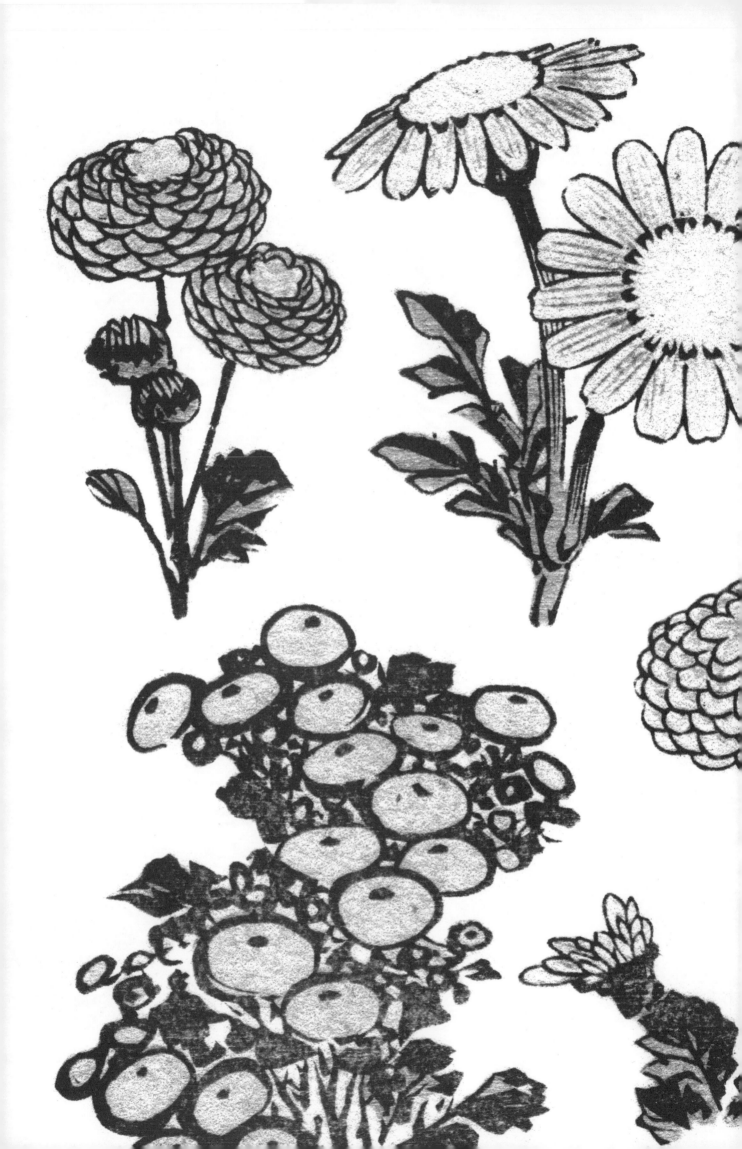

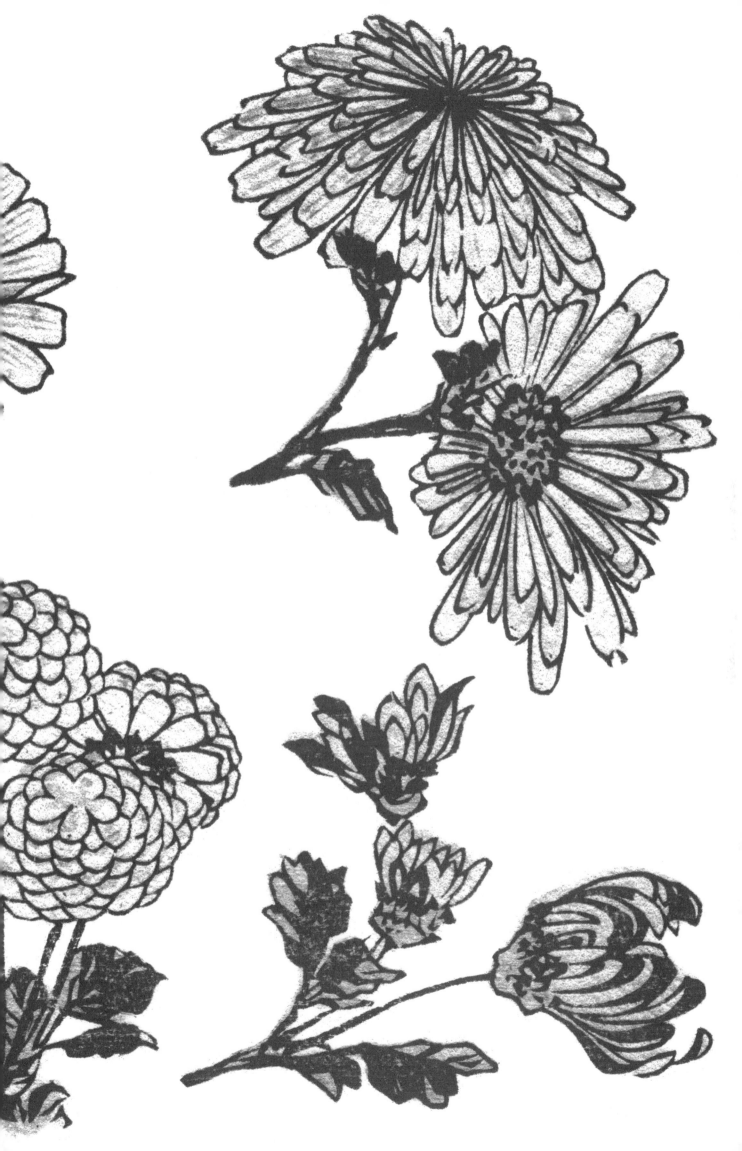

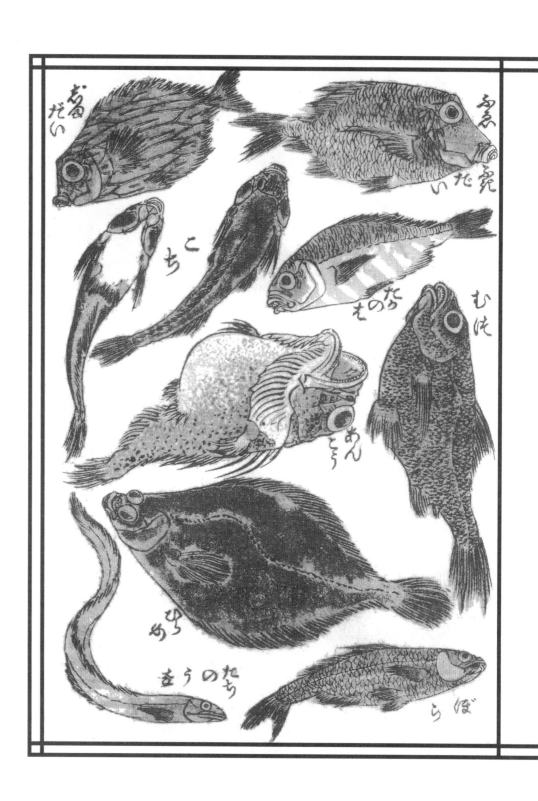

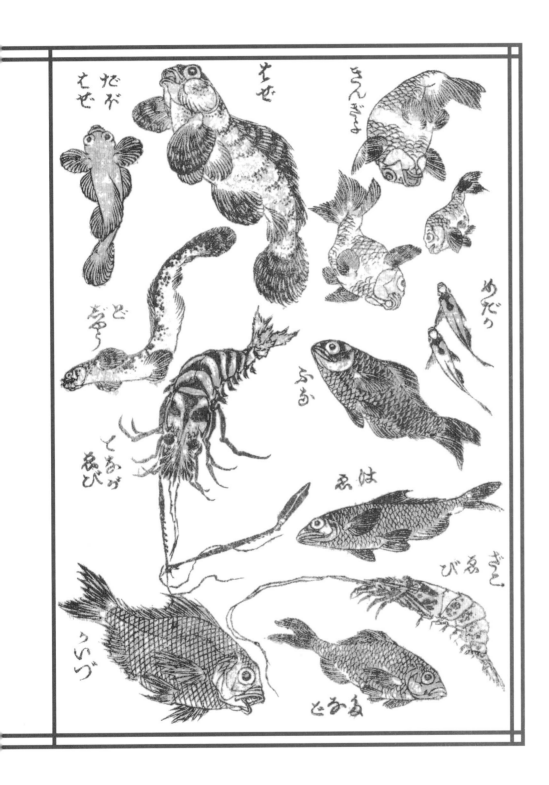

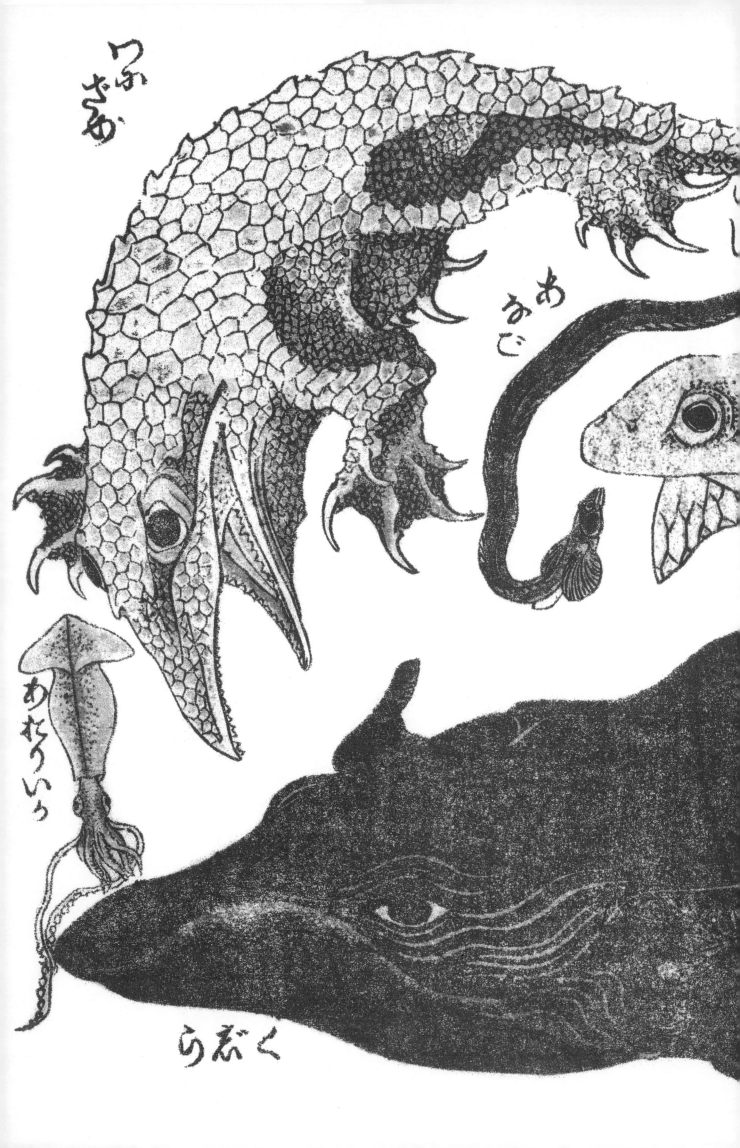

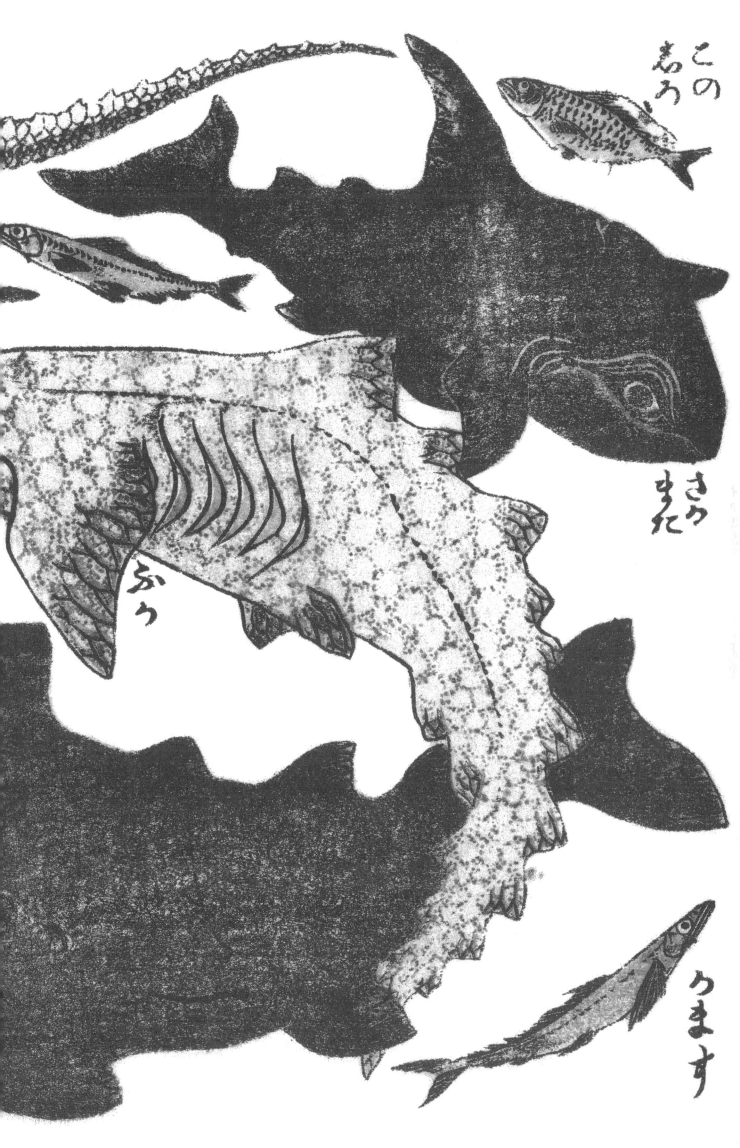

このあろ

さけ
また

ぶり

らます

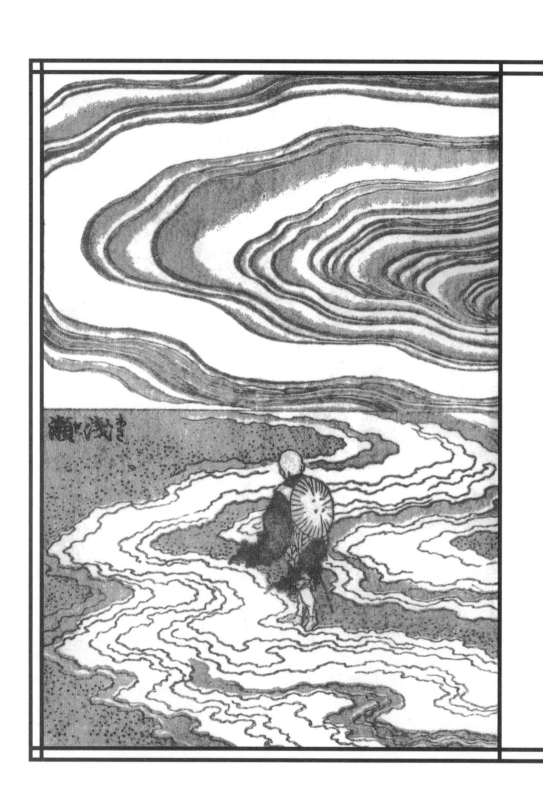

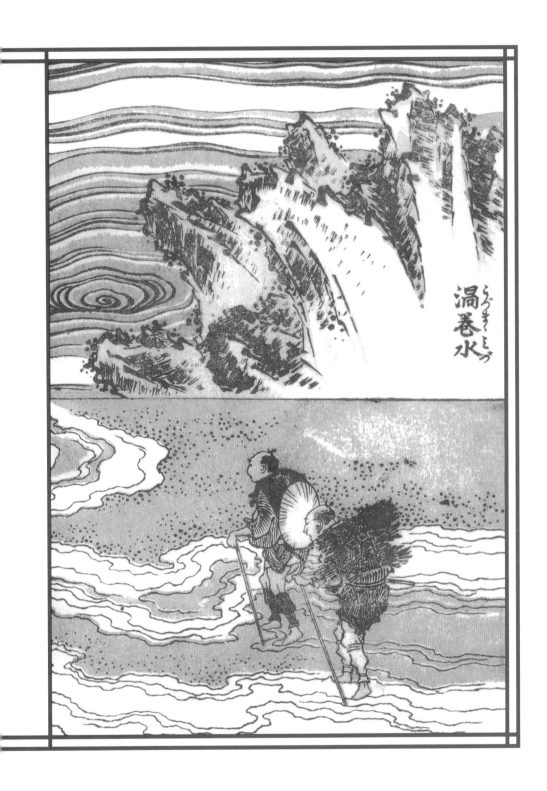

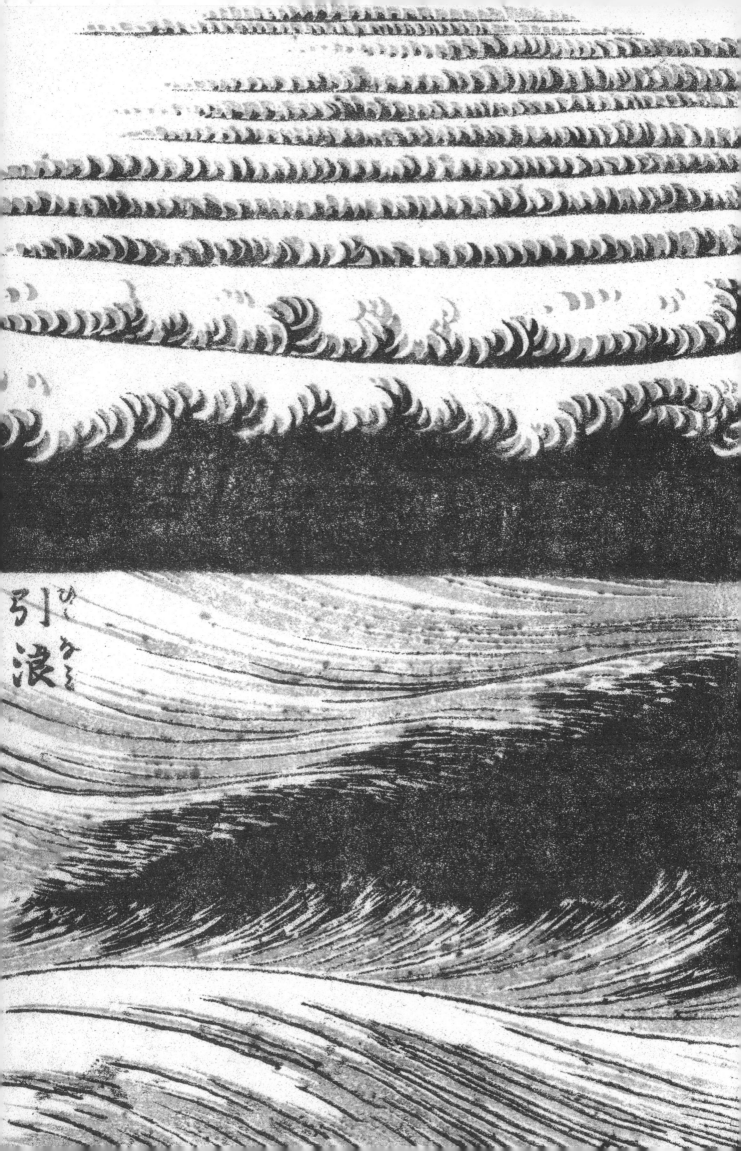

引浪（ひきなみ）

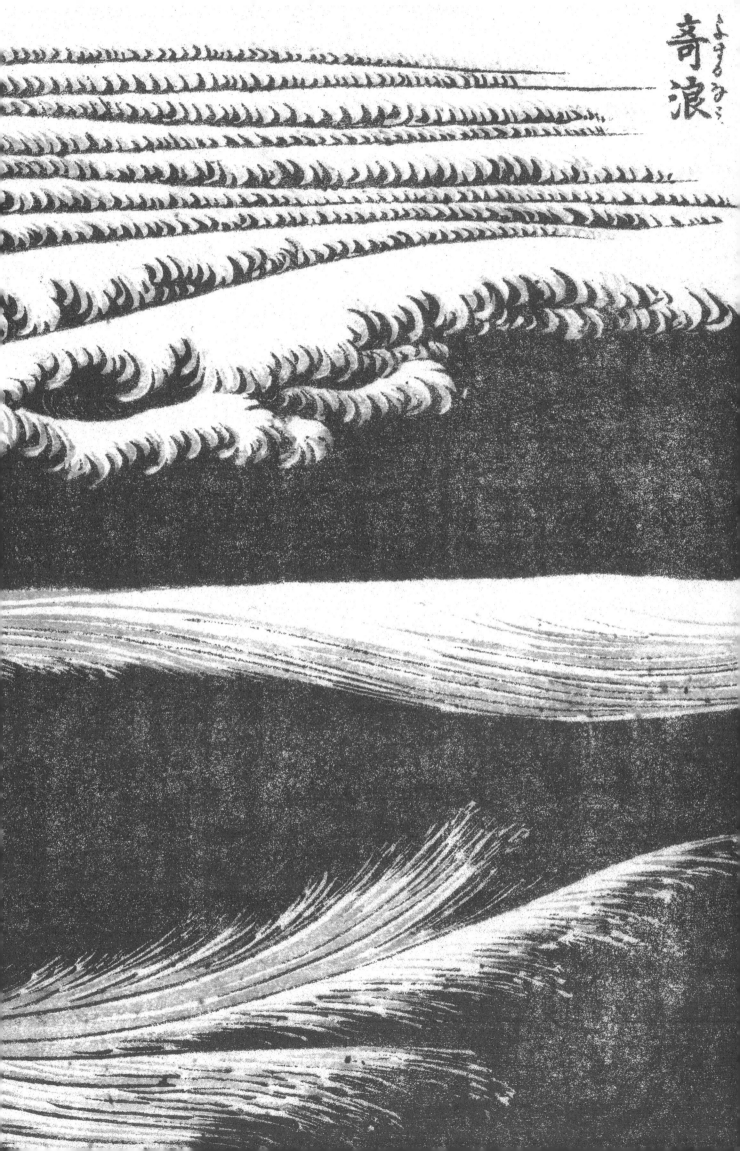

寄浪

陳南

王倪

張志和

罕風子

尹喜

盧敖

蕭牽

獯登

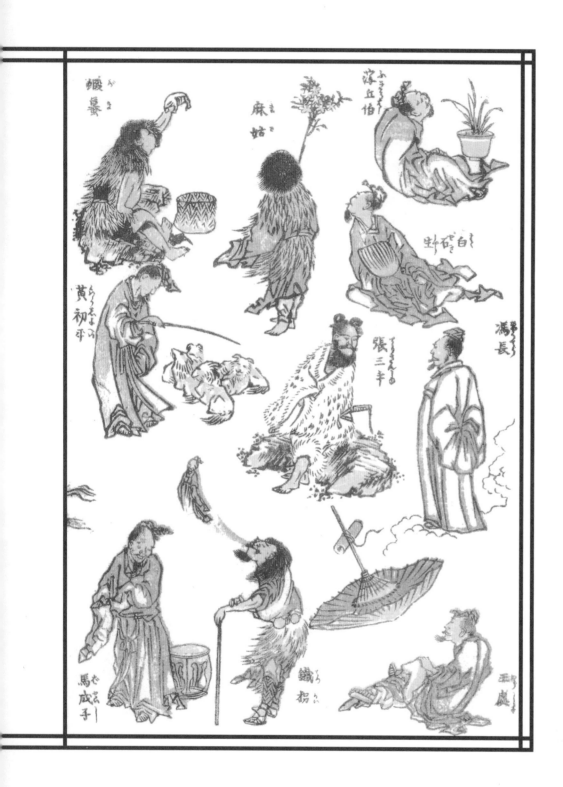

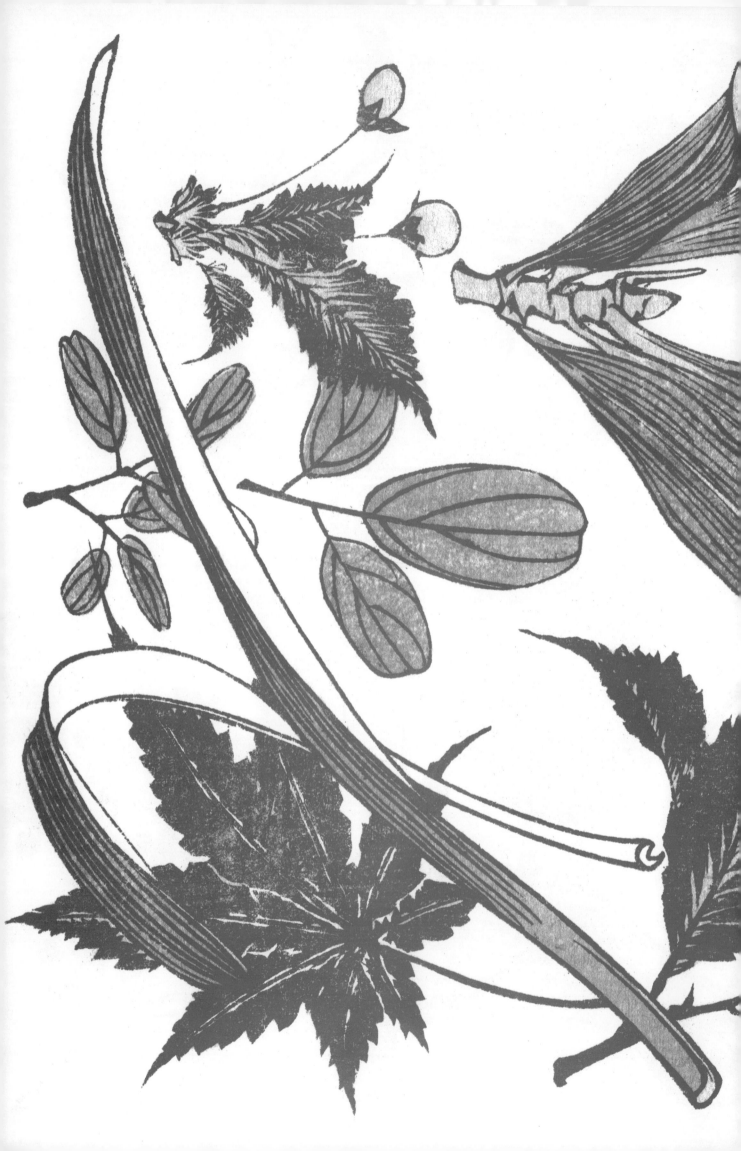

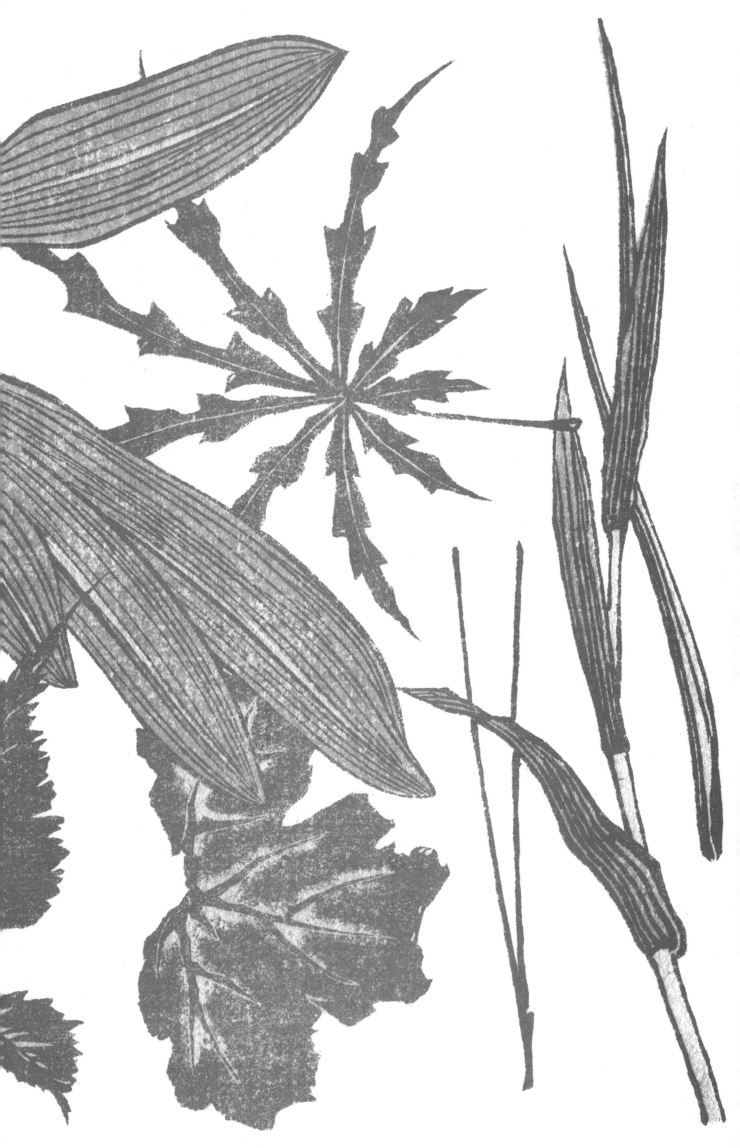

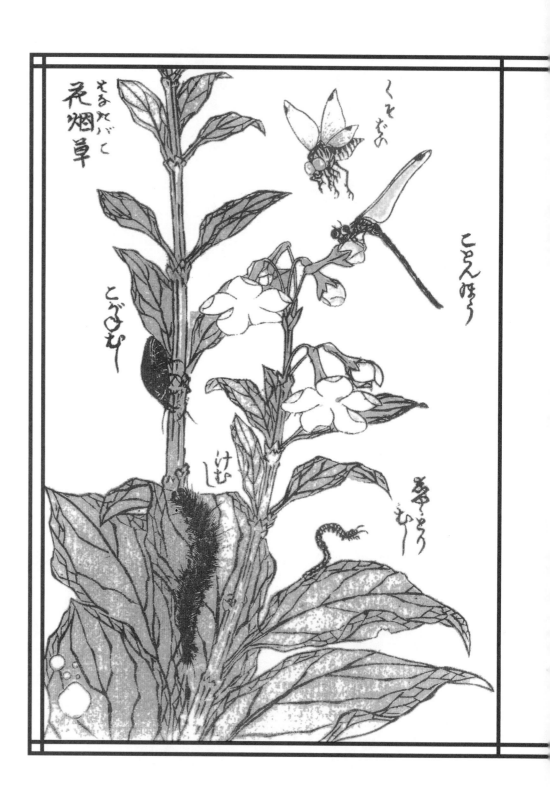

さるたばこ
花烟草

くそむし

とんぼう

とぐ♡む〜

けむし

青むしより
む〜

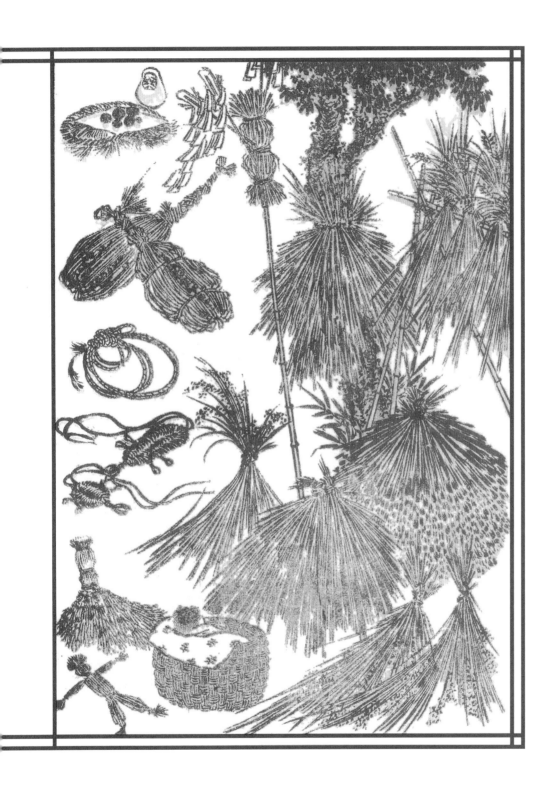

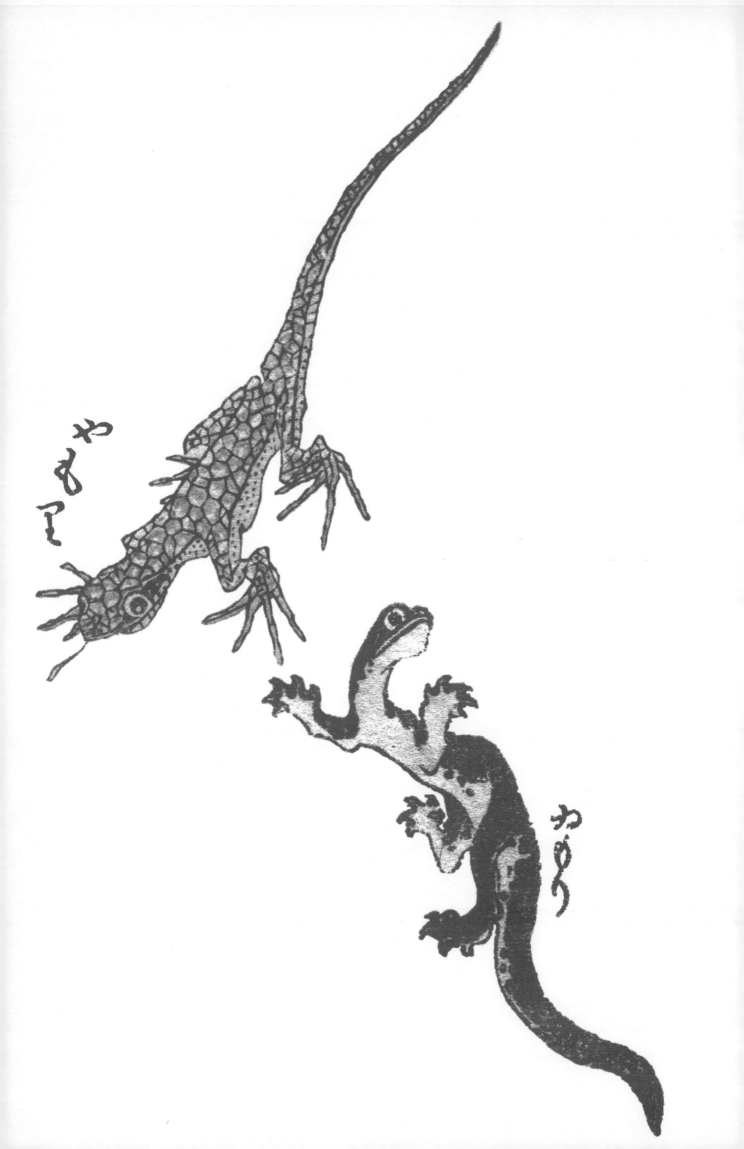

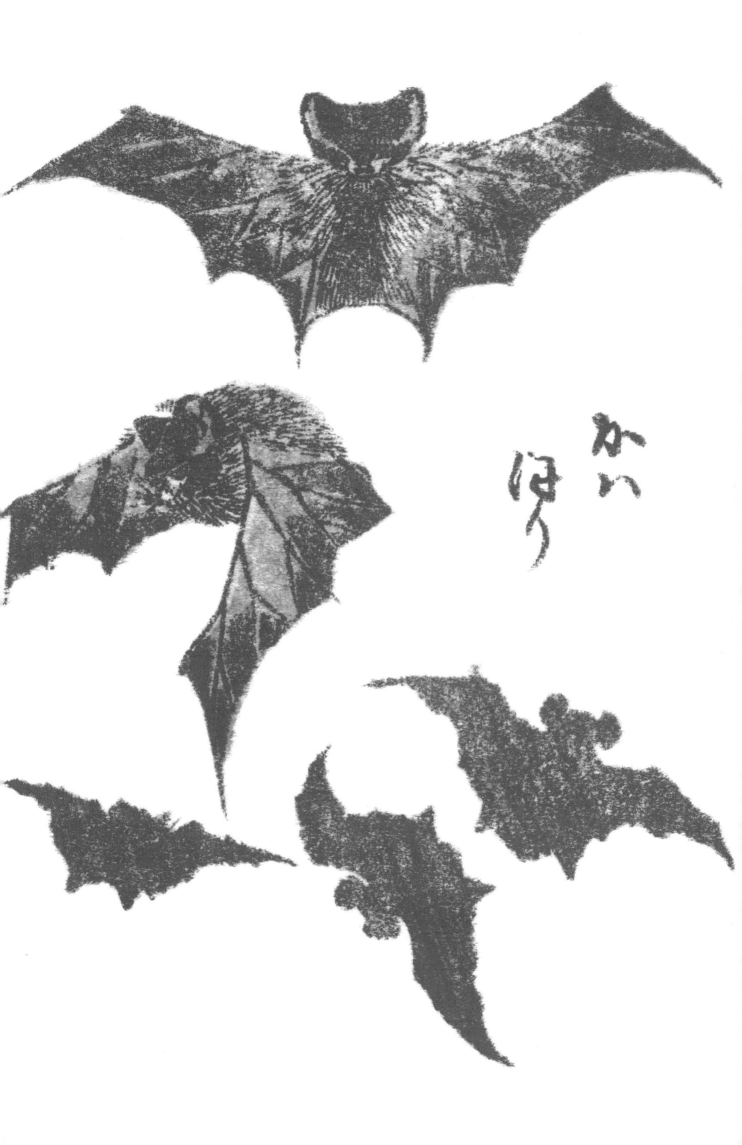

かい
ほり

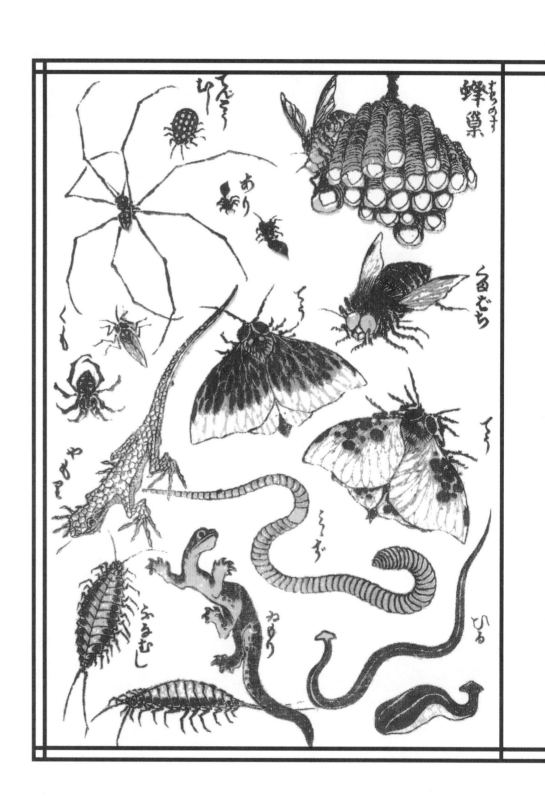

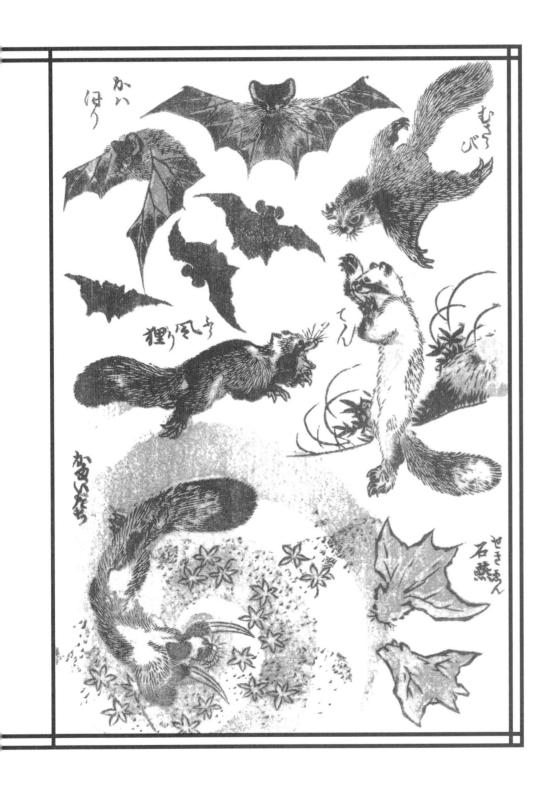

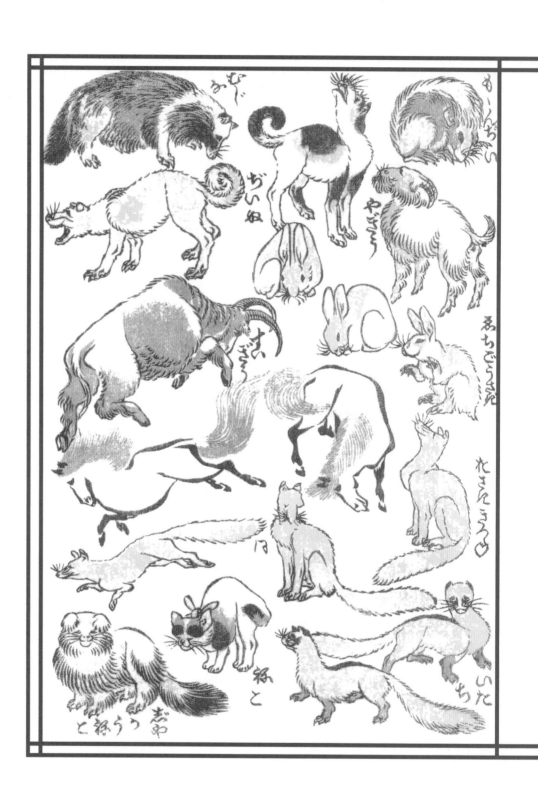

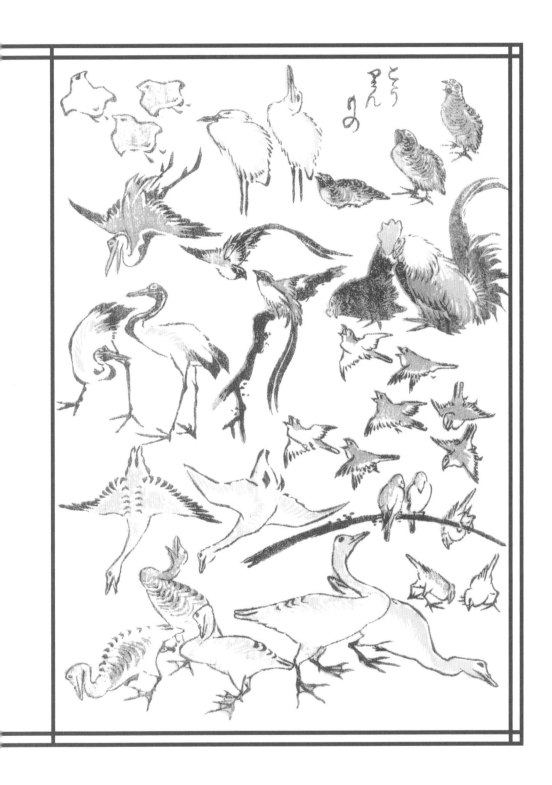

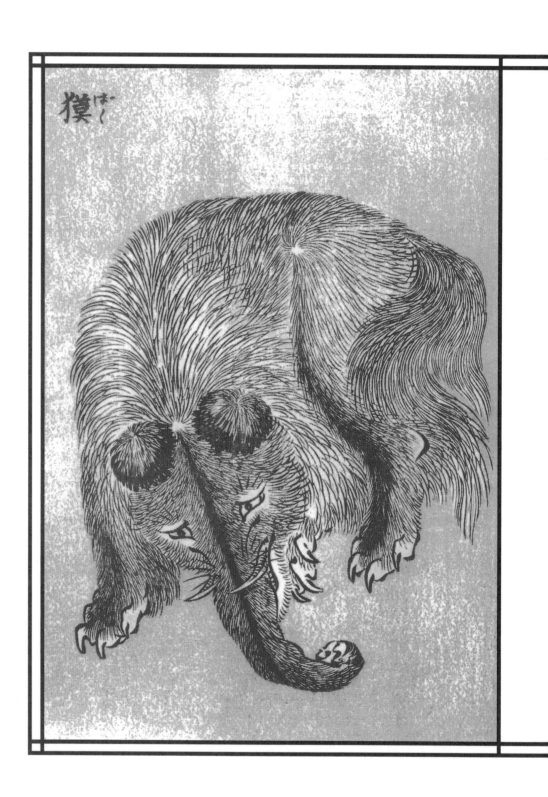
獏ばく

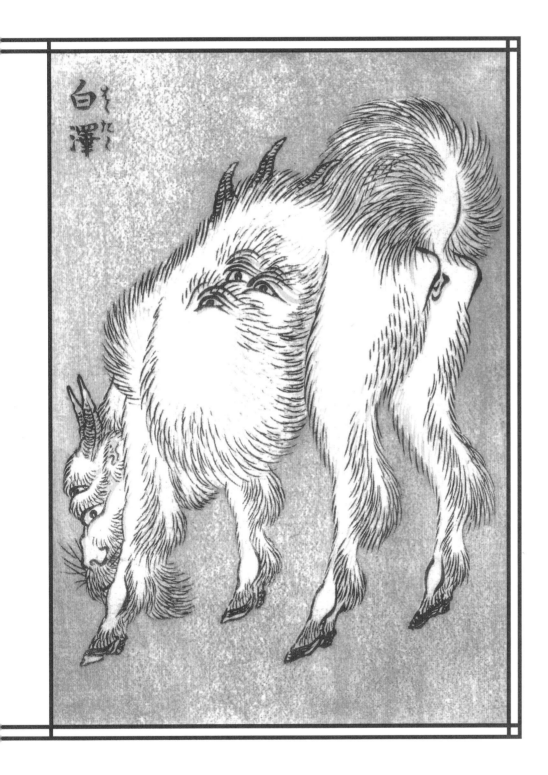

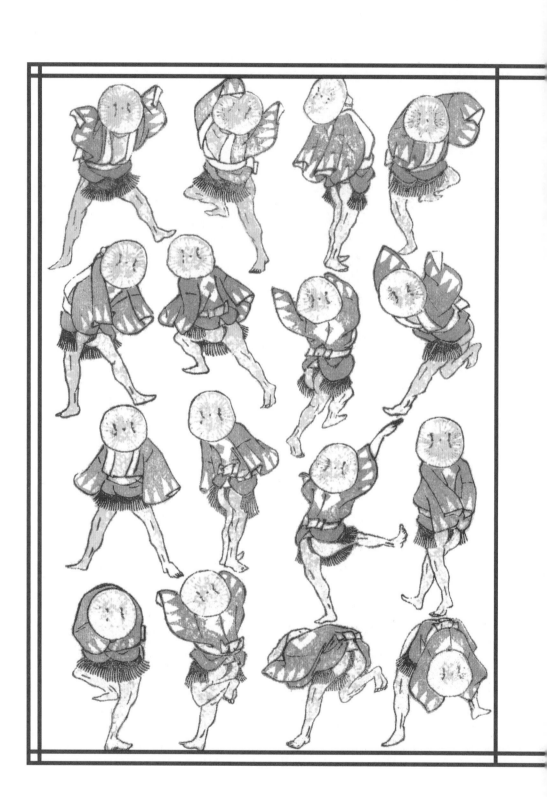

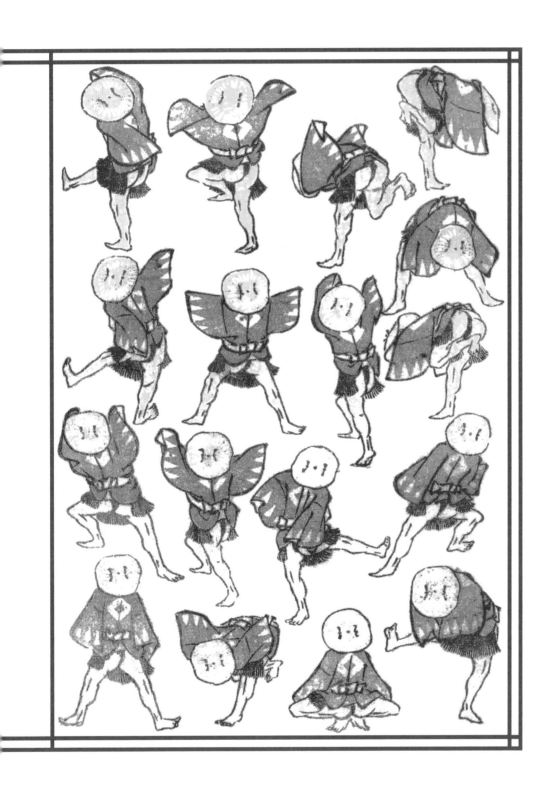

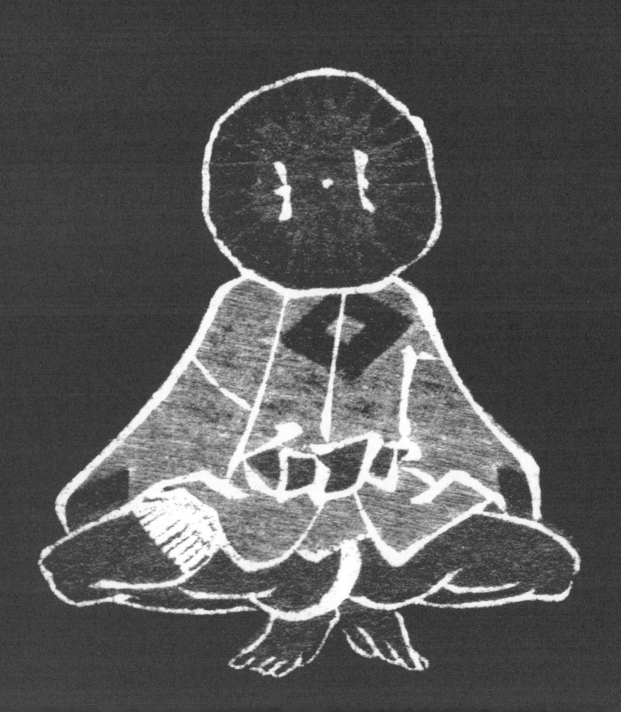

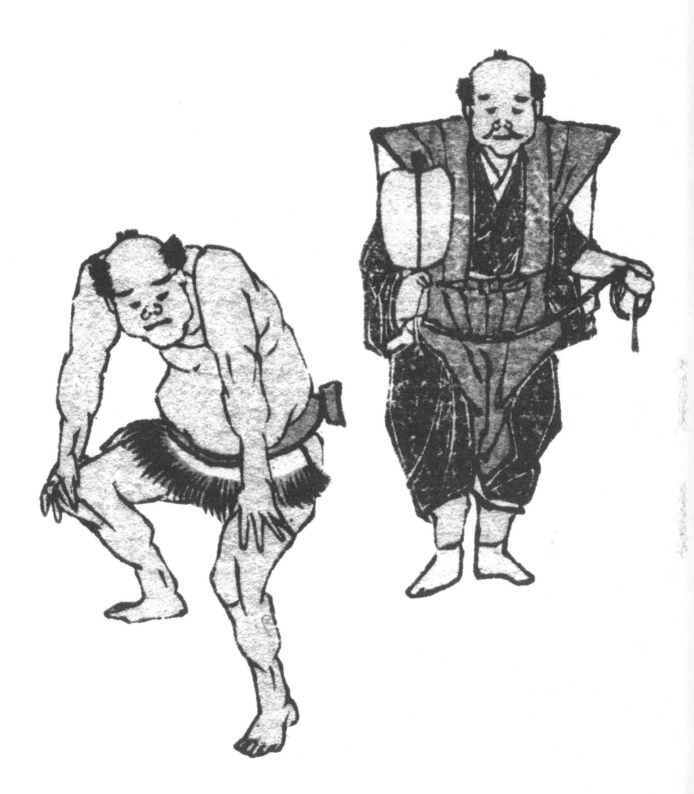

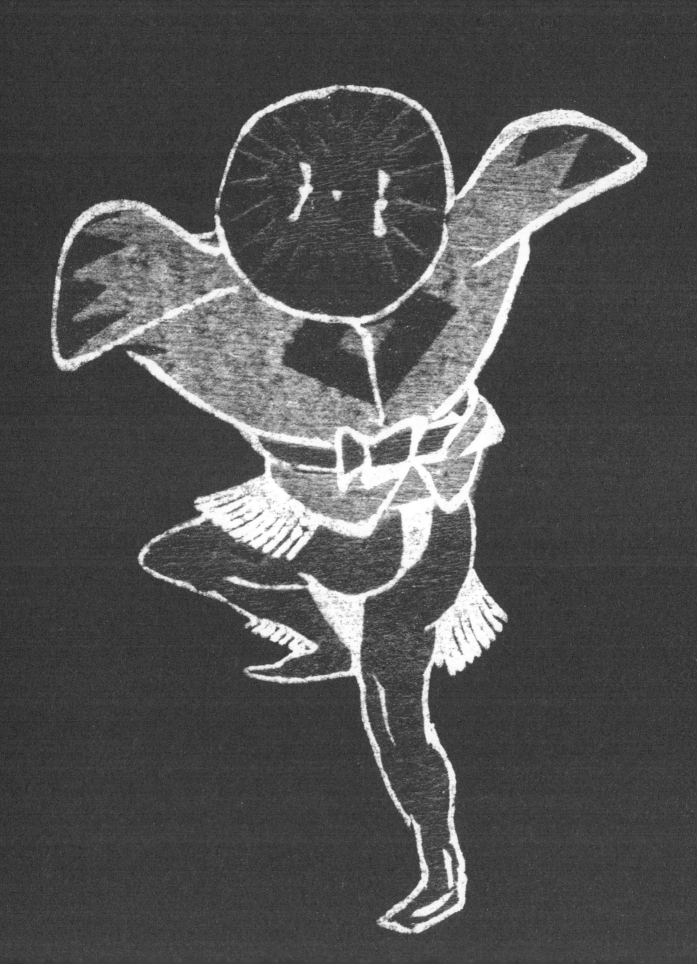

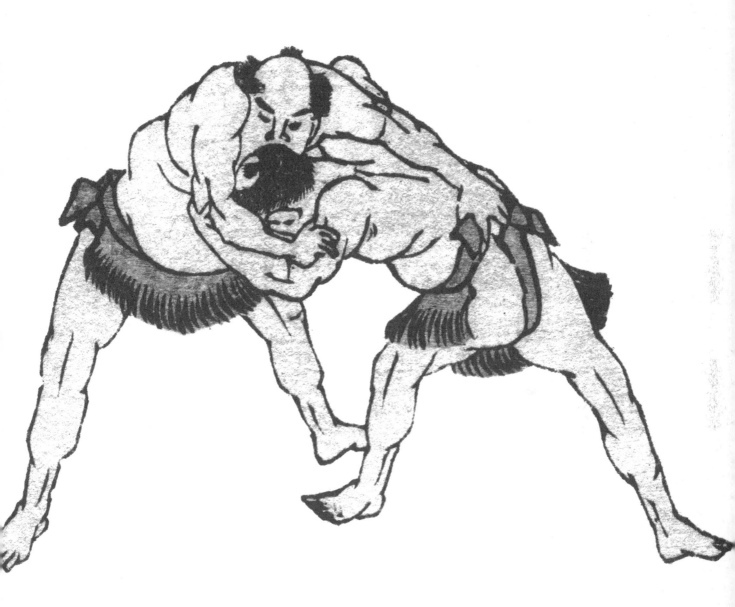

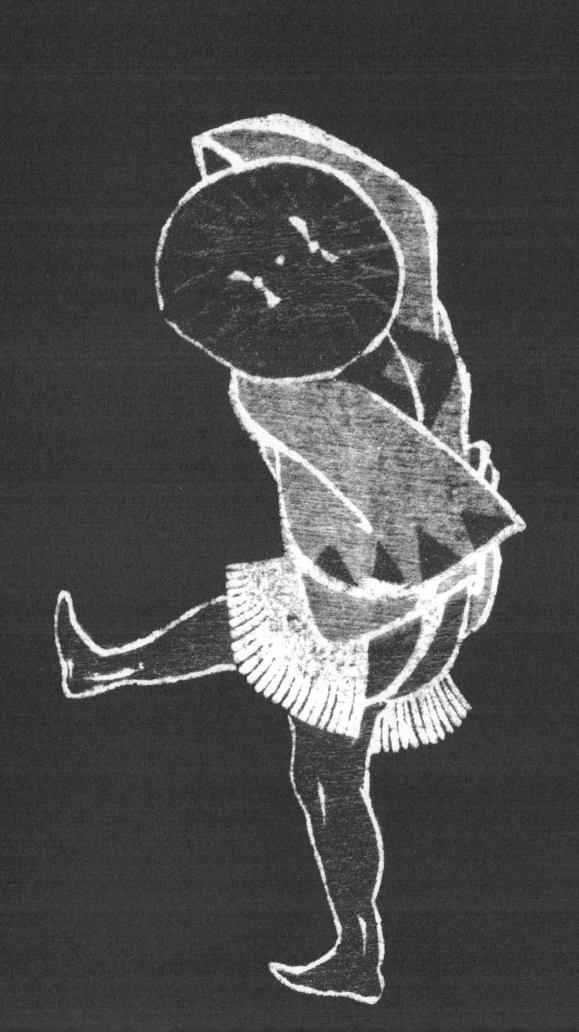

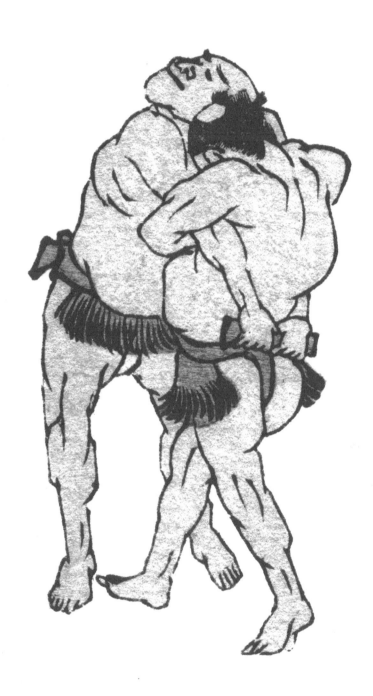

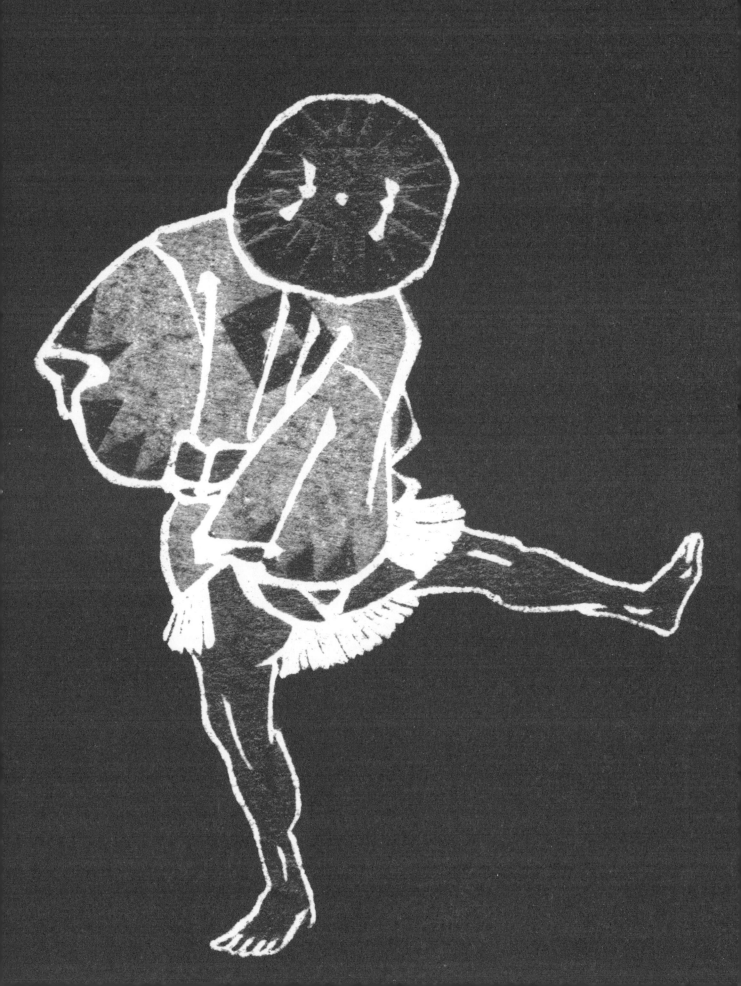

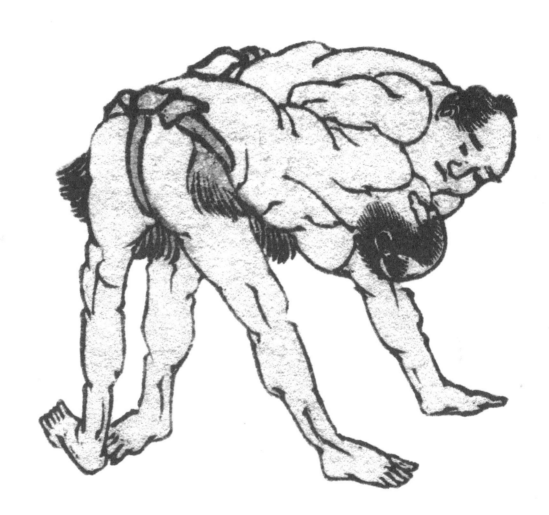

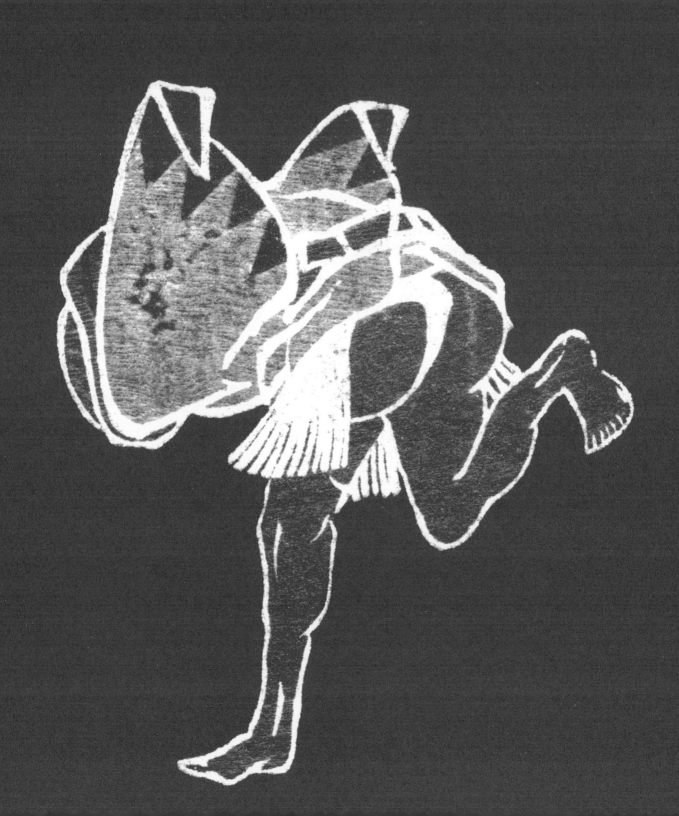

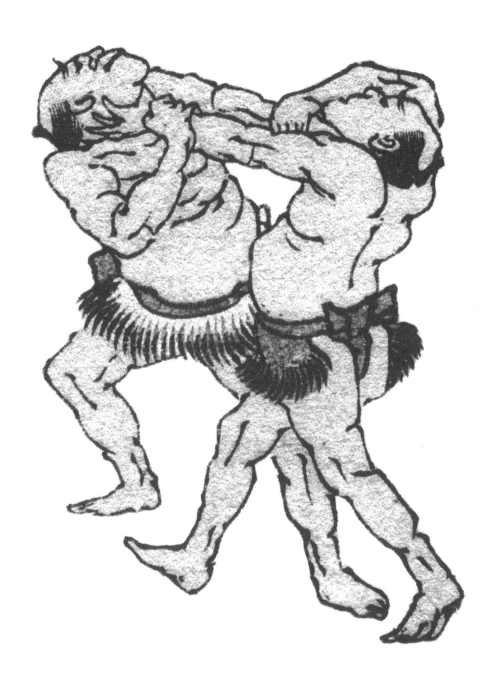

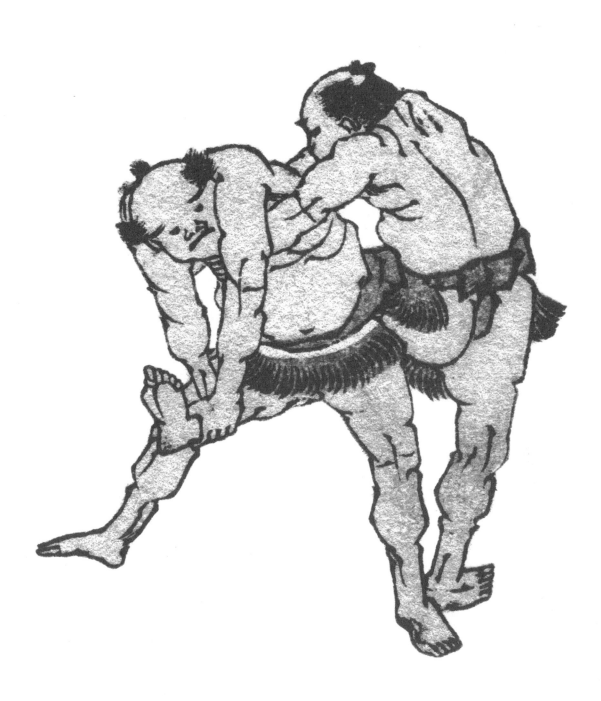

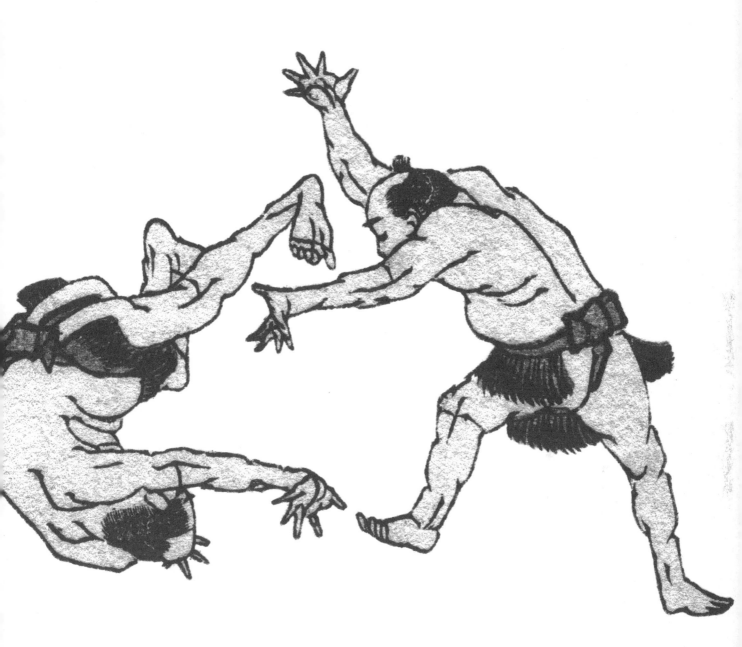

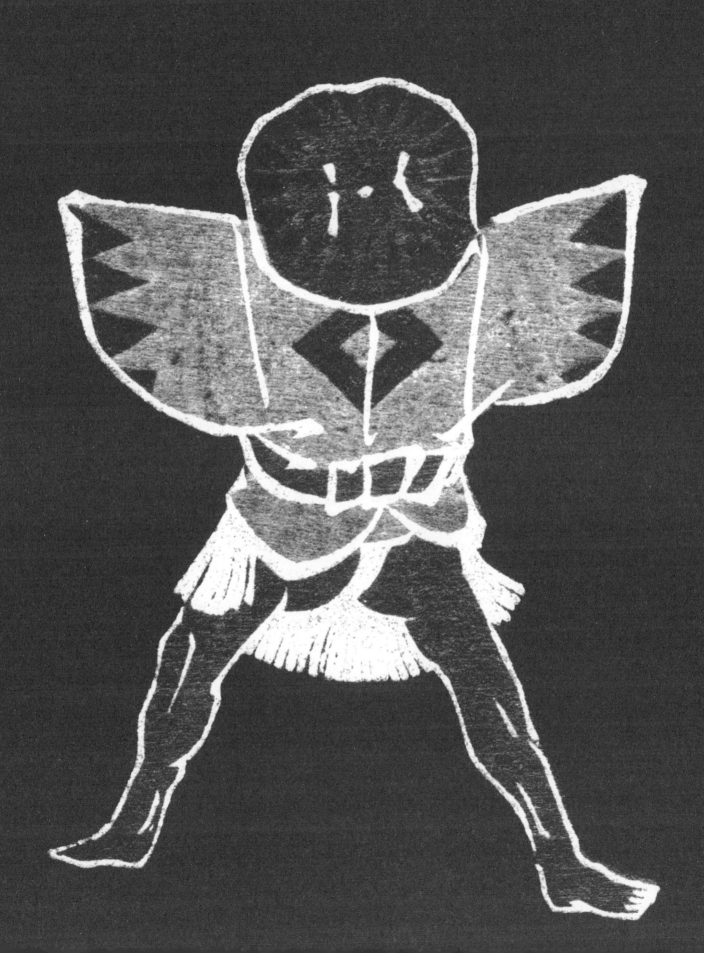

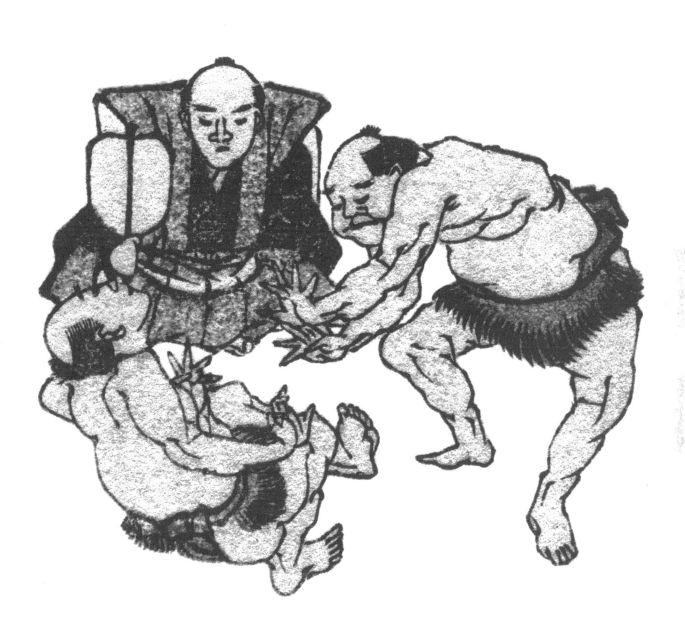

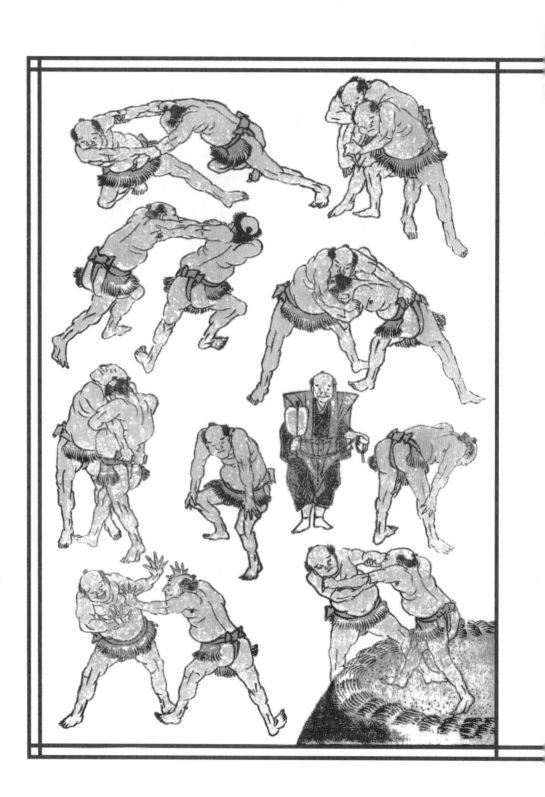

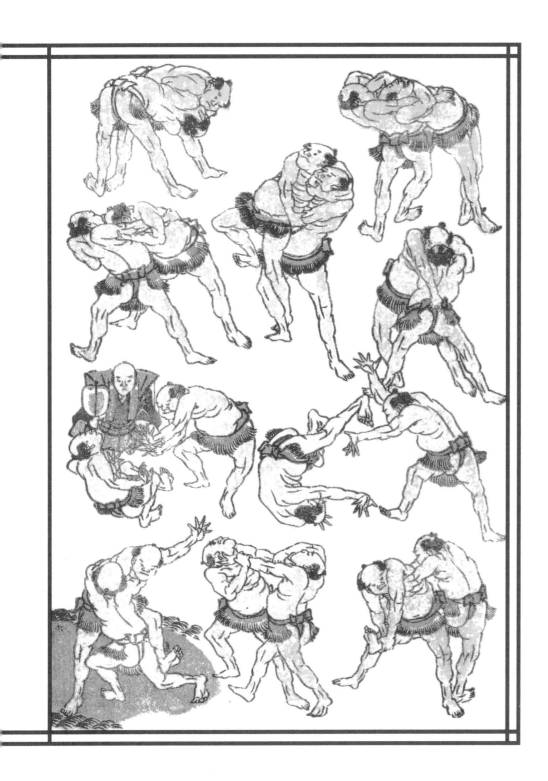

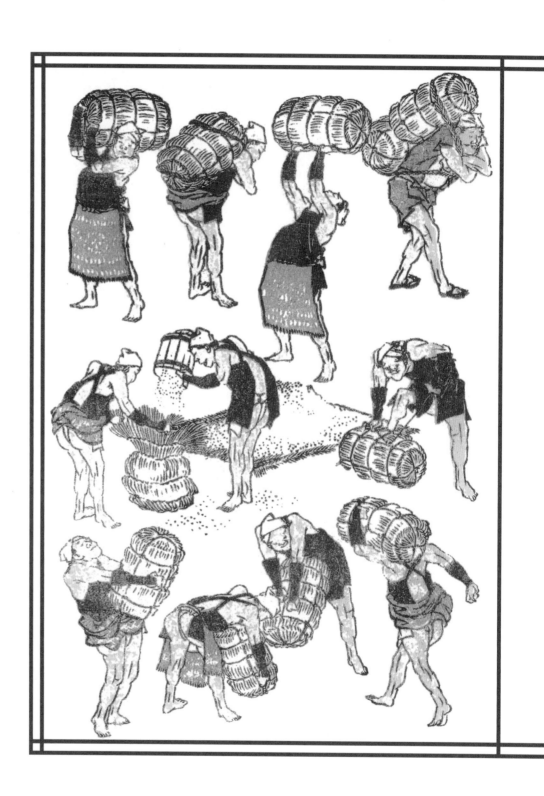

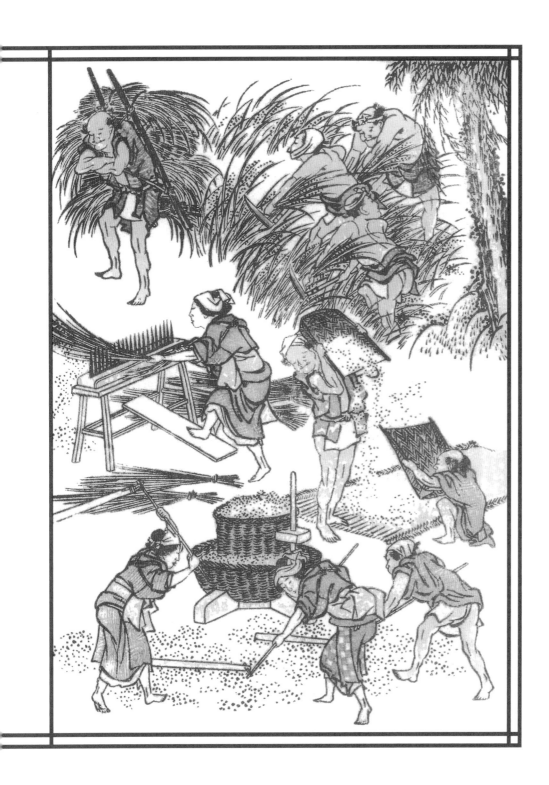

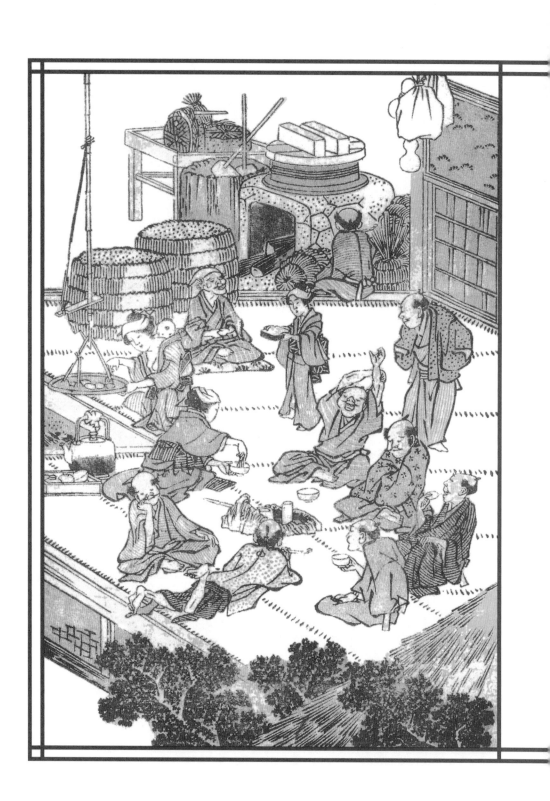

吒
き
に
て
ん
吒枳尼天

稲荷大明神

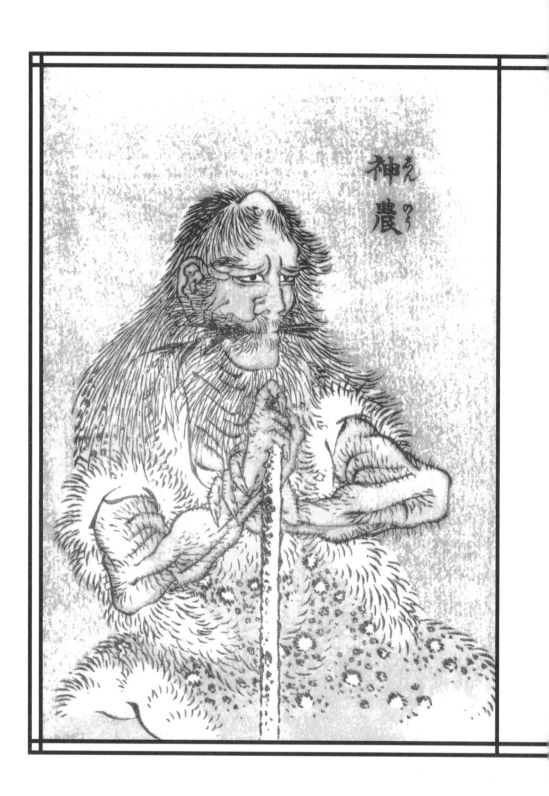

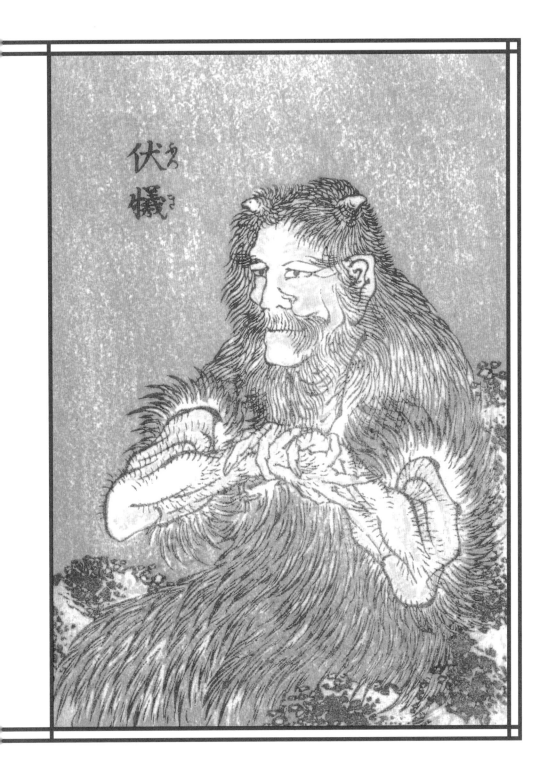

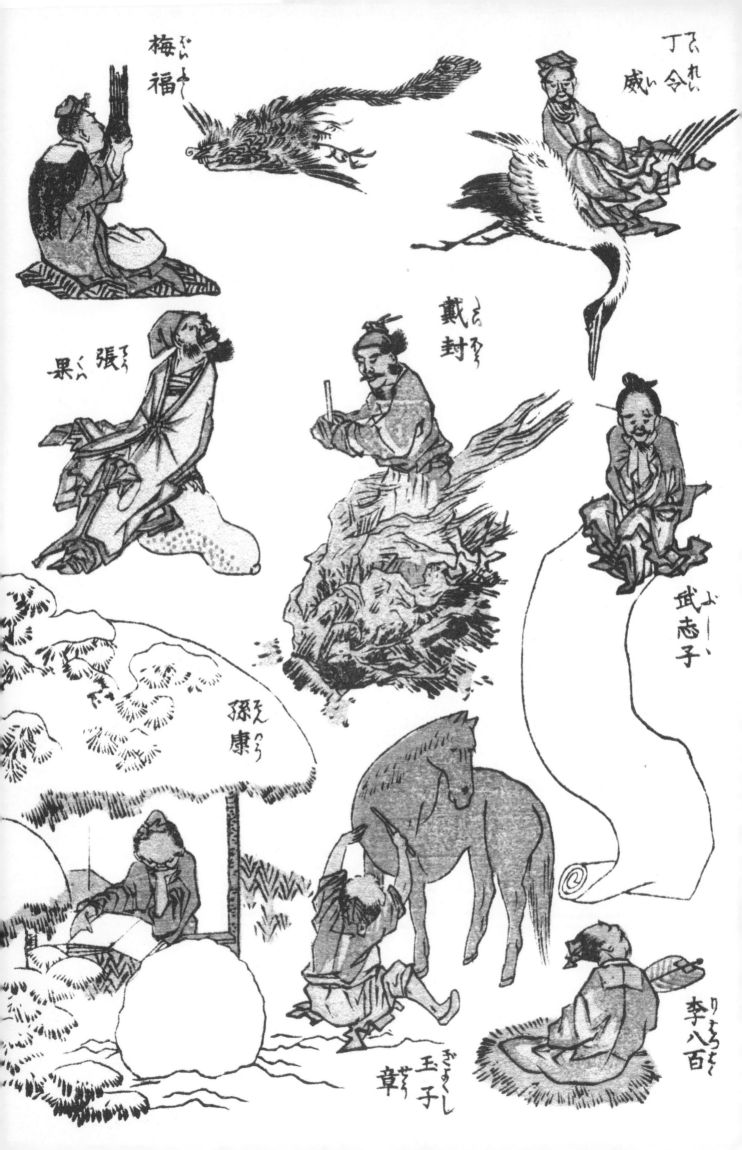

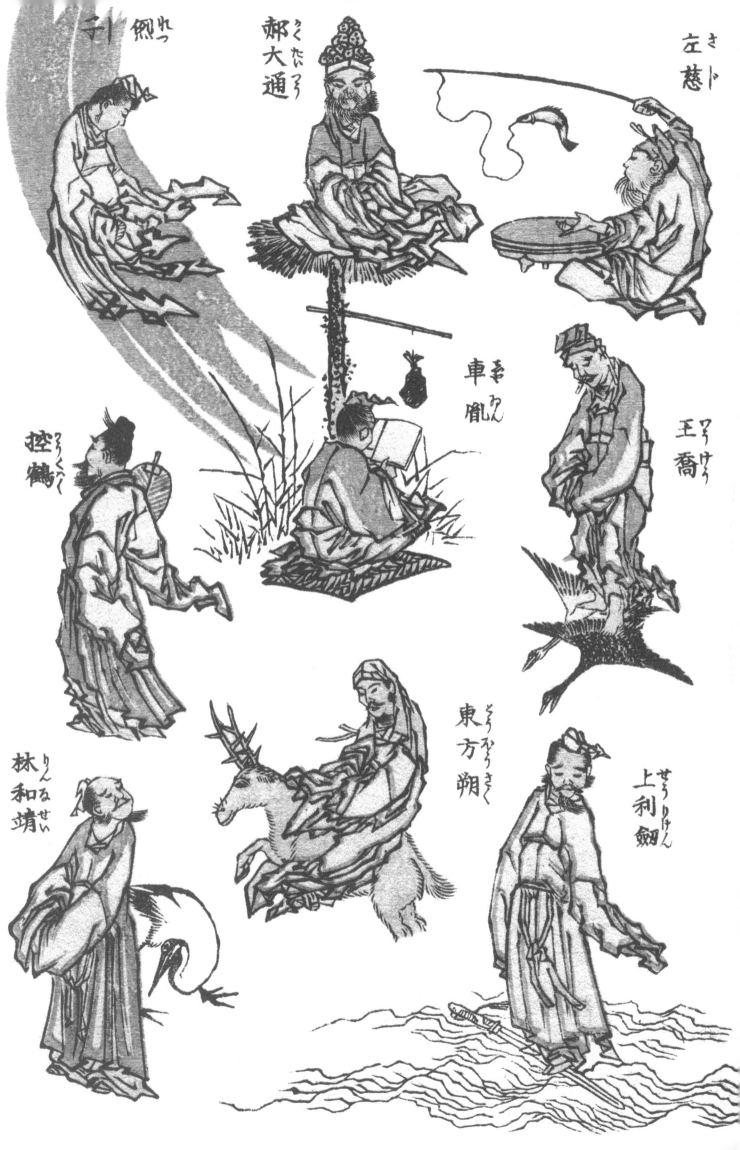

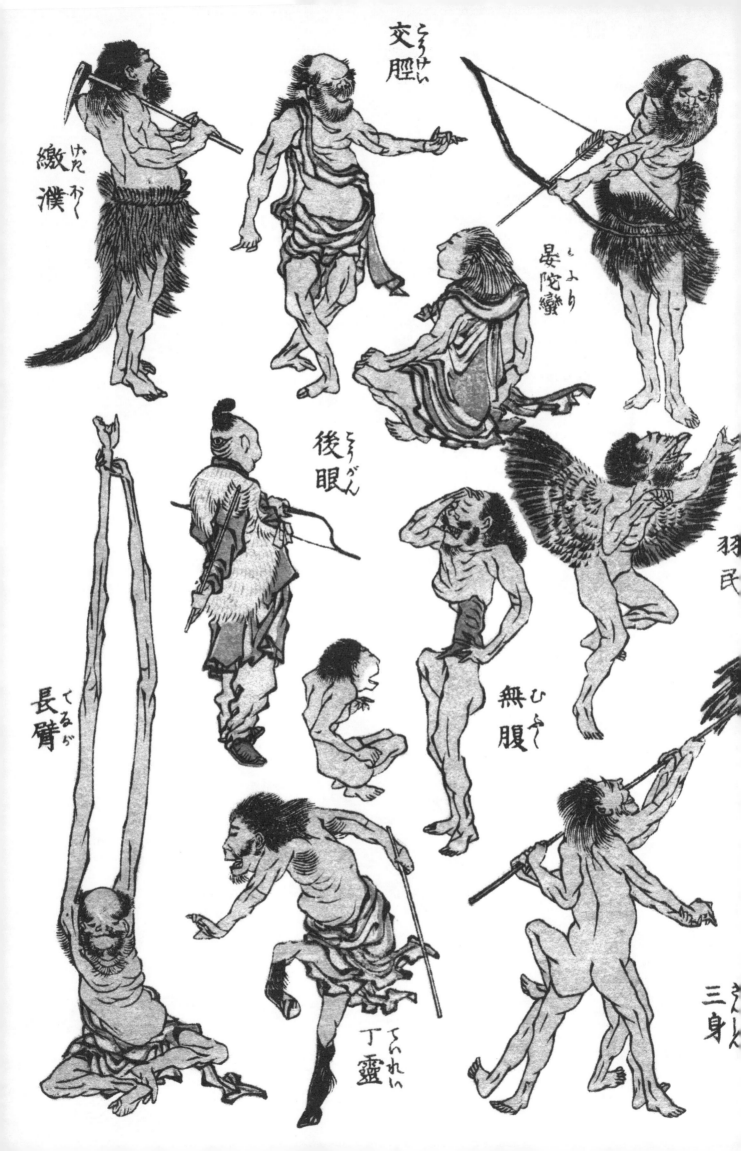

交脛

繳獌

晏陀蠻

後眼

羽民

長臂

無腹

丁靈

三身

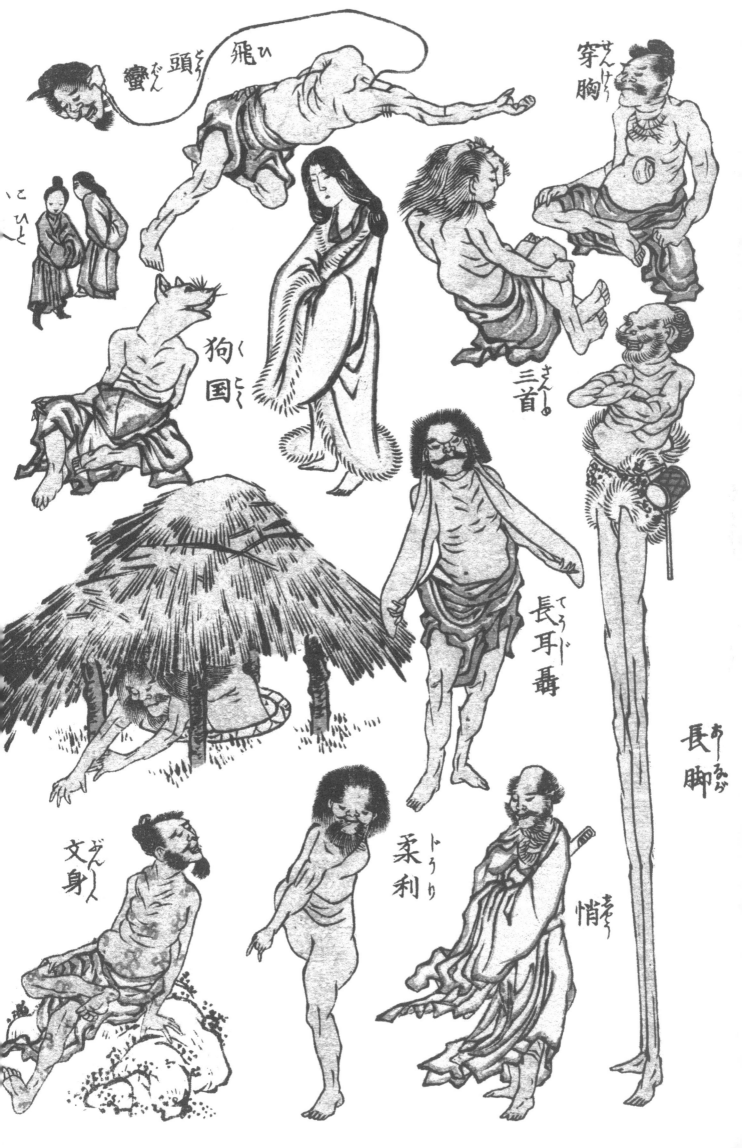

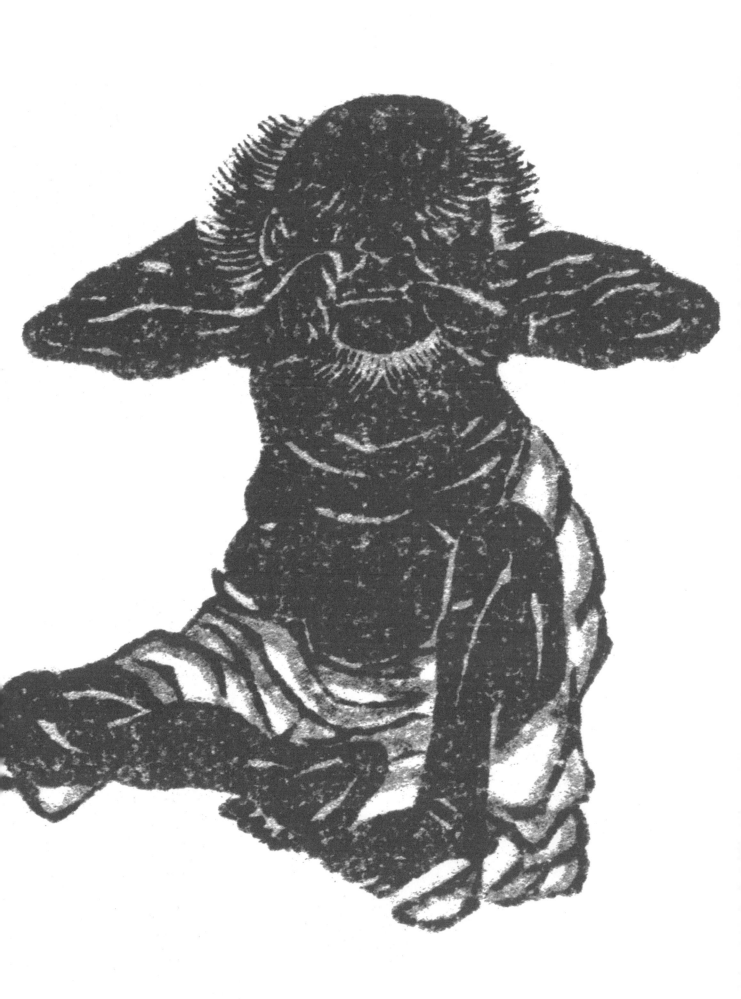

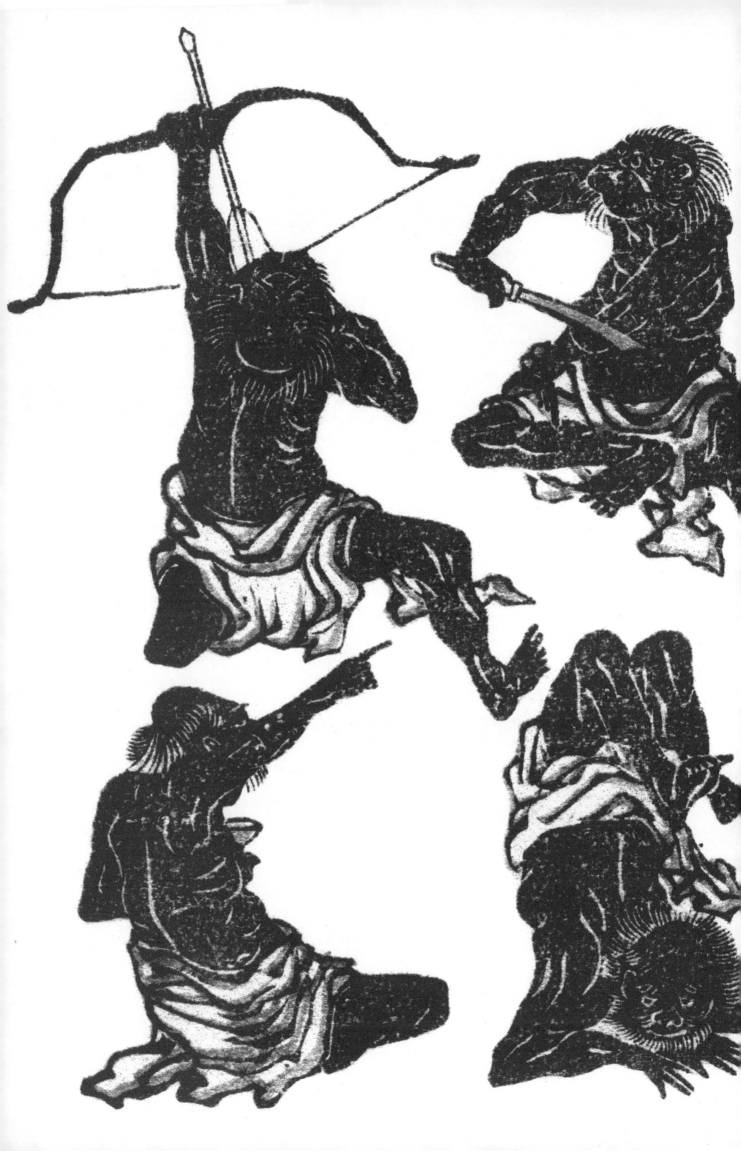

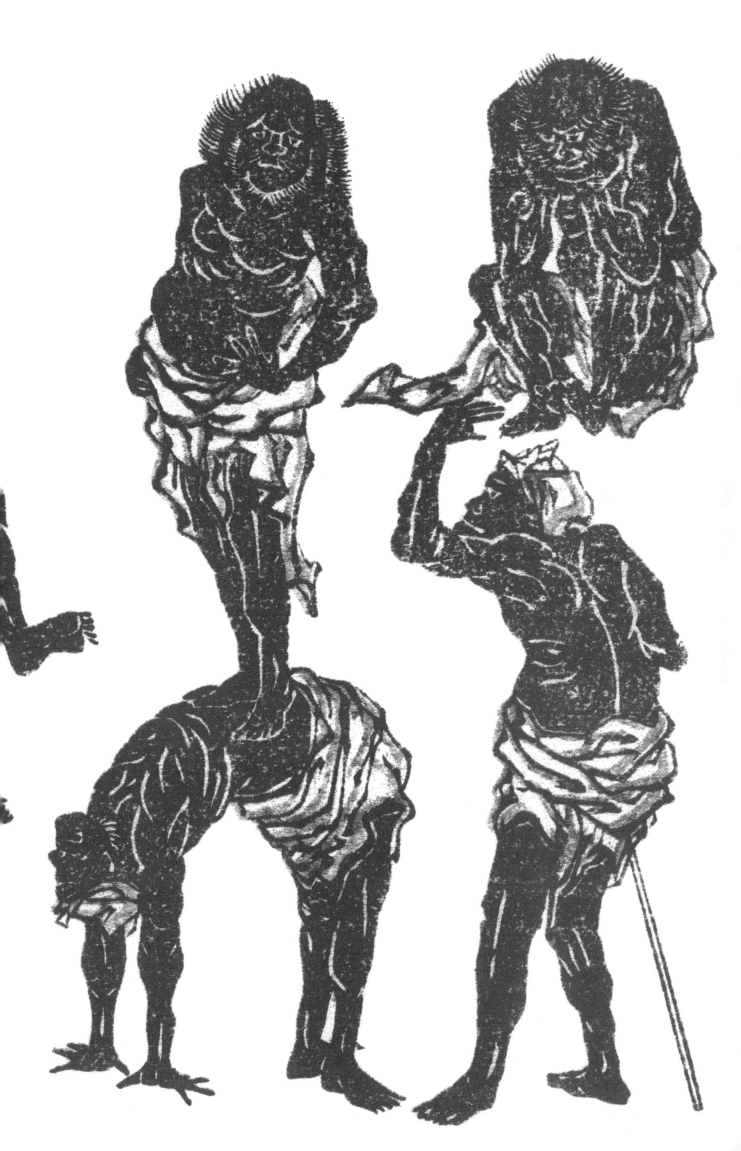

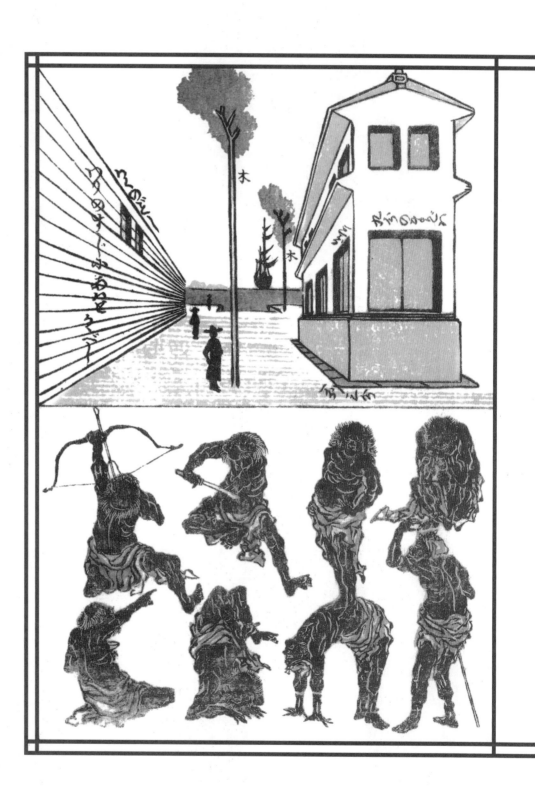

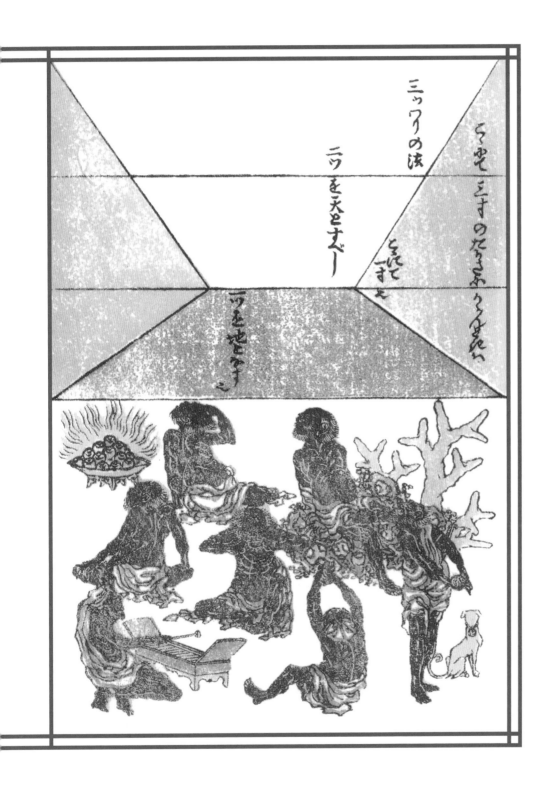

ニッワリの法

ニツを天とすべし

一ツを也とすべし

幽霊（ゆうれい）

姥（うば）が山（やま）

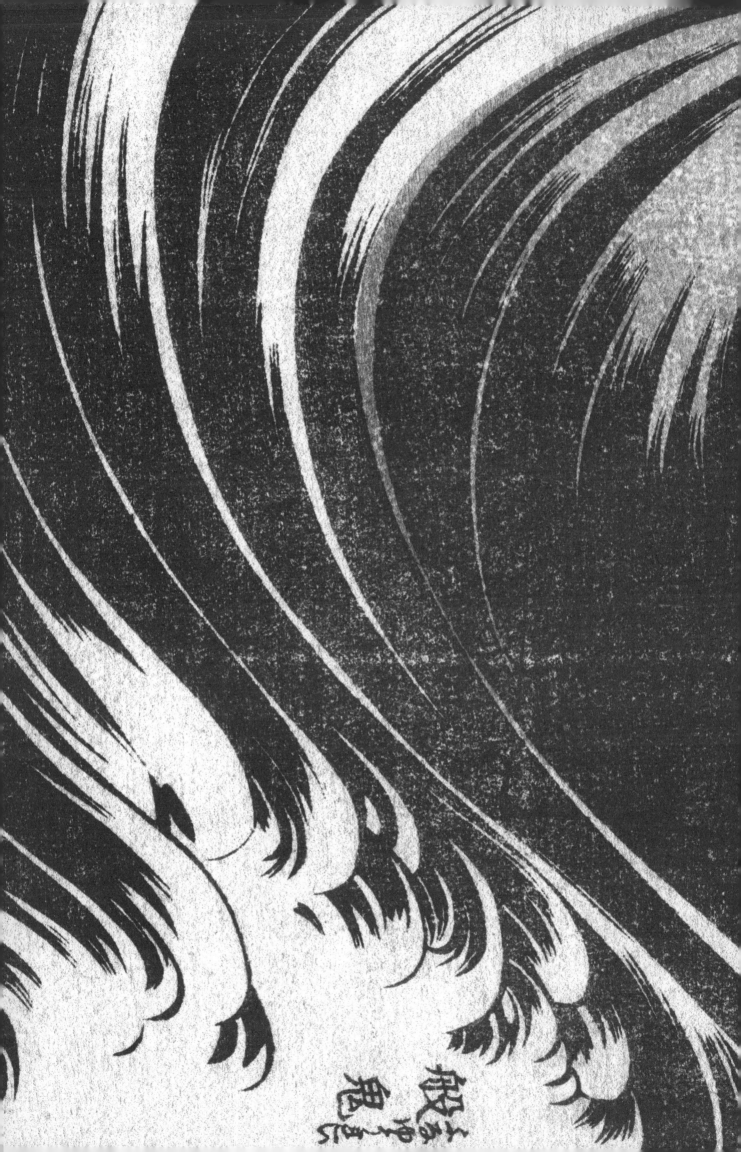

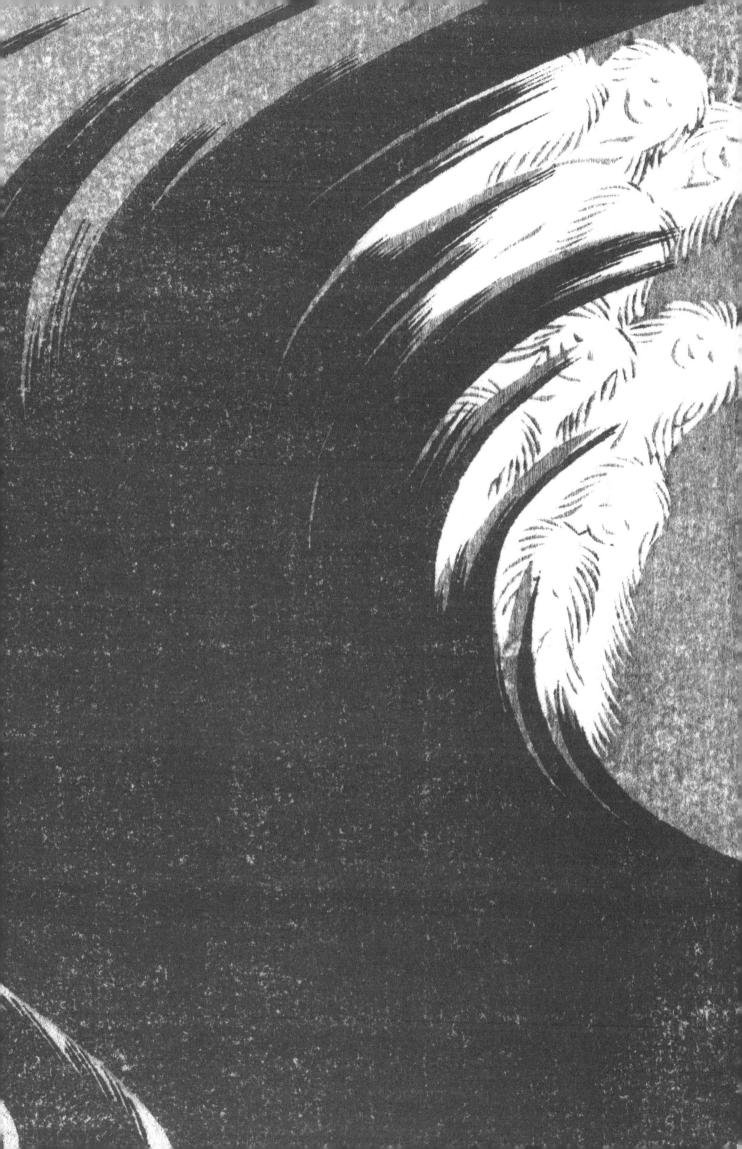

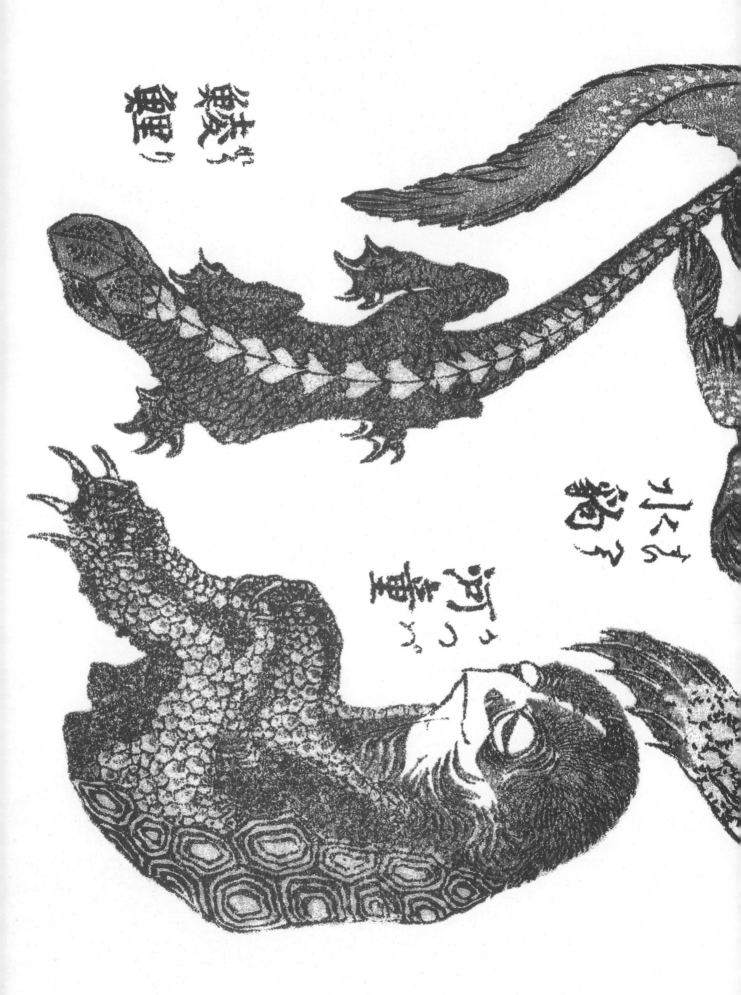

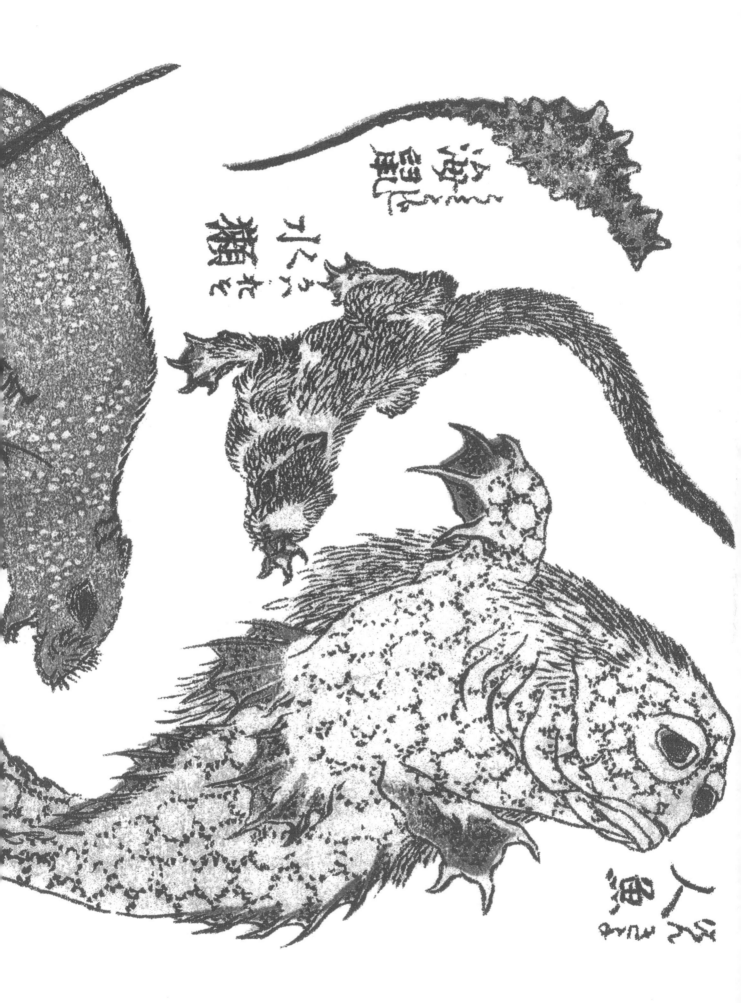

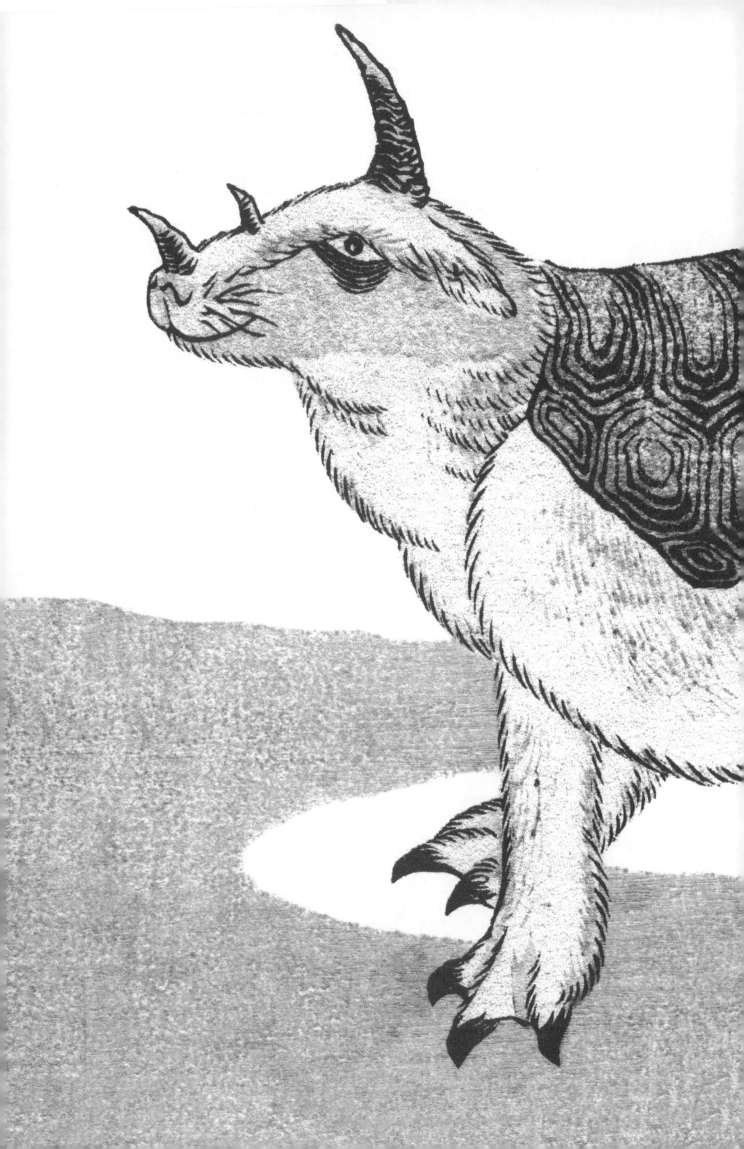

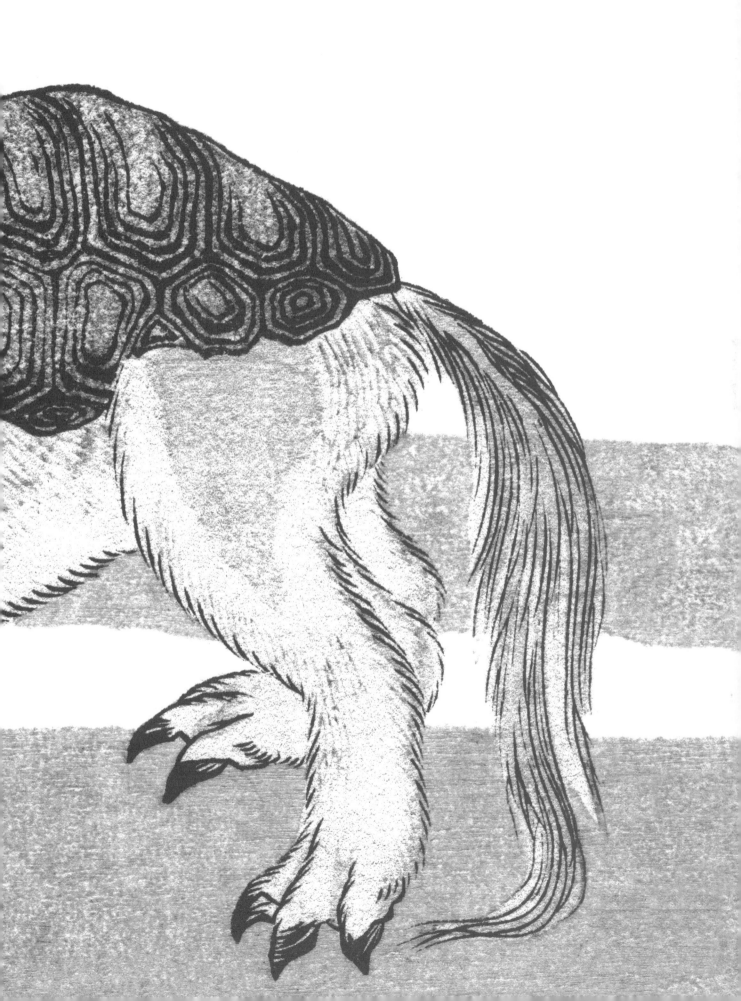

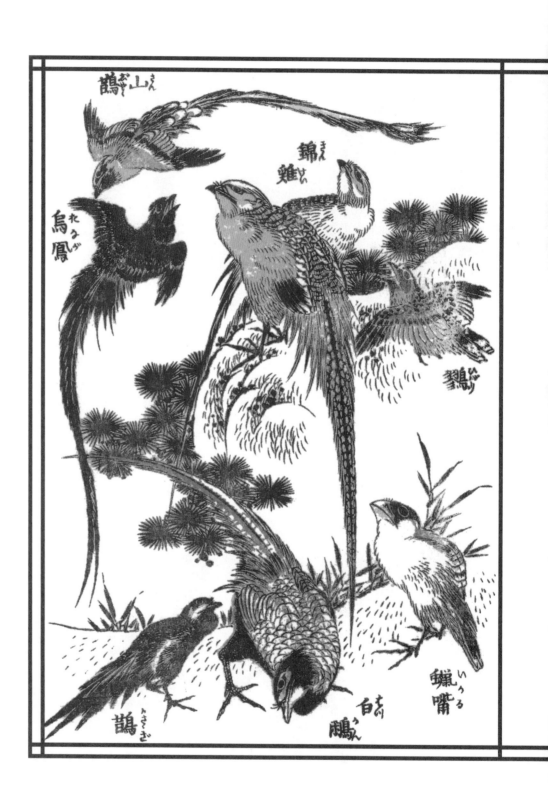

鸑鷟山 えん

錦鶏 きん けい

烏鳳 れんかく

鸐 やまどり

鵲 かささぎ

白鷳 はっかん

蠟嘴 いかる

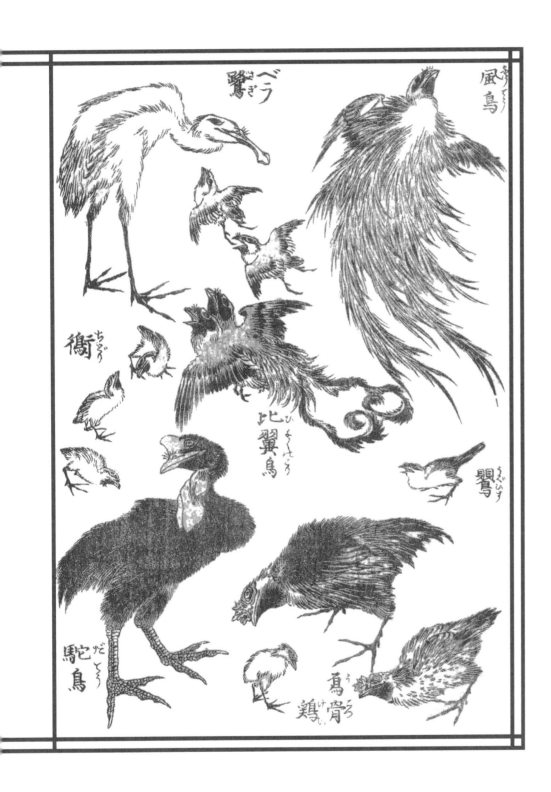

鷺べ鷺ラ

風鳥

衞ちどり

比翼鳥ひよくてう

鶯うぐひす

駝鳥だてう

烏骨鶏うこつけい

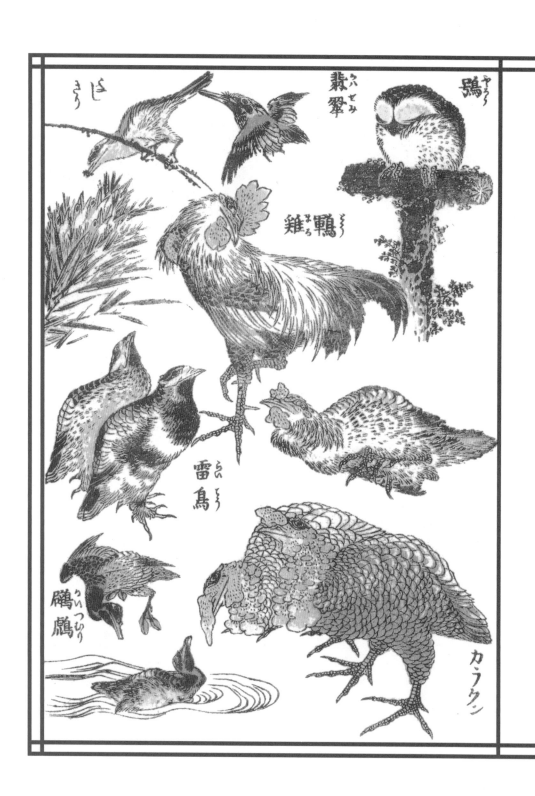

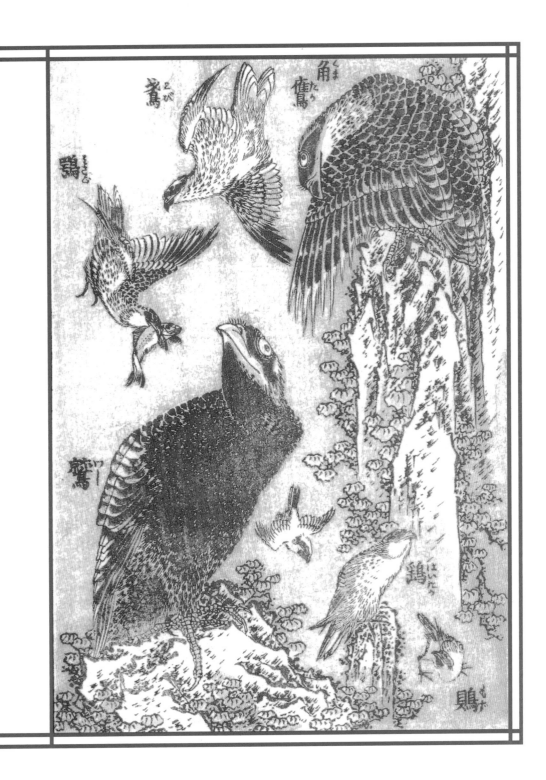

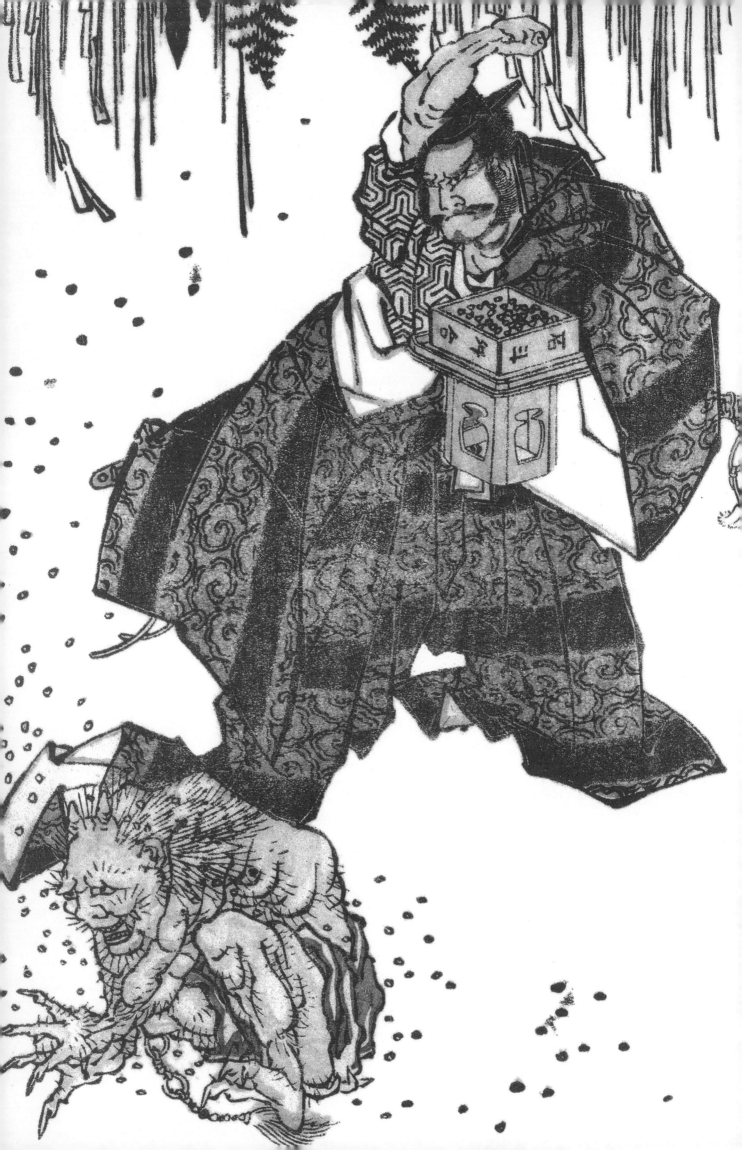

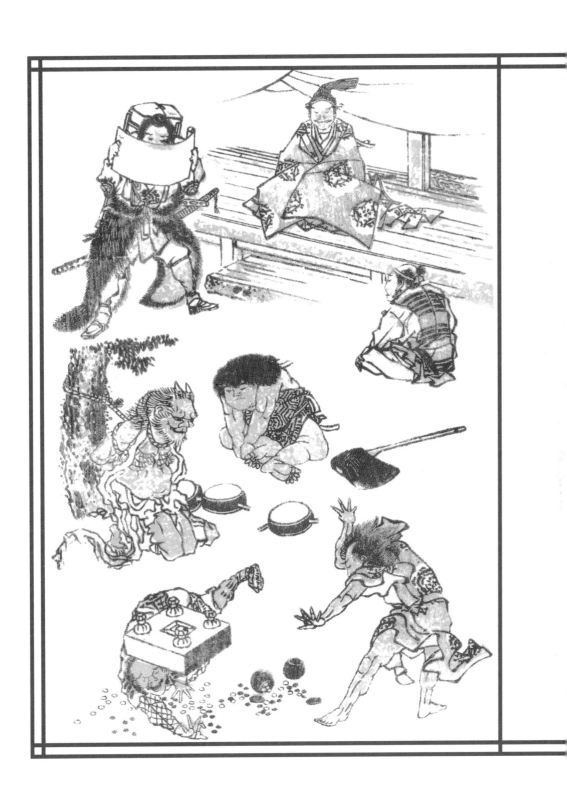

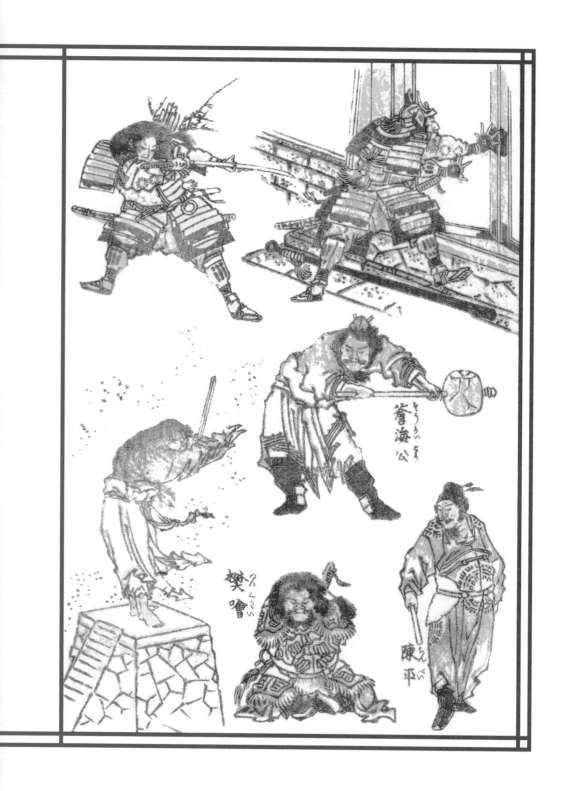

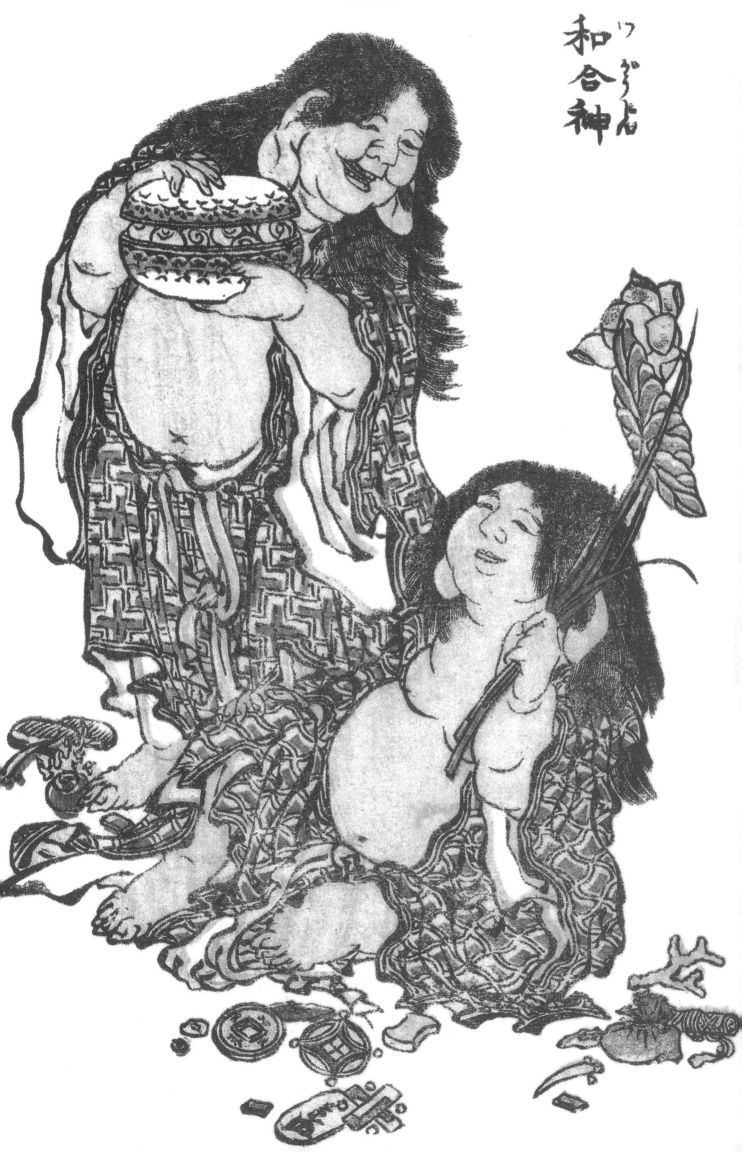

和合神
わごうじん

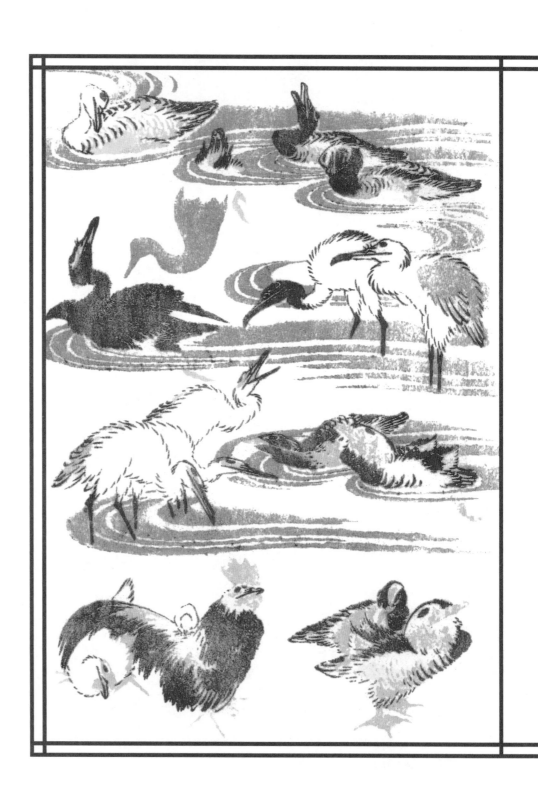

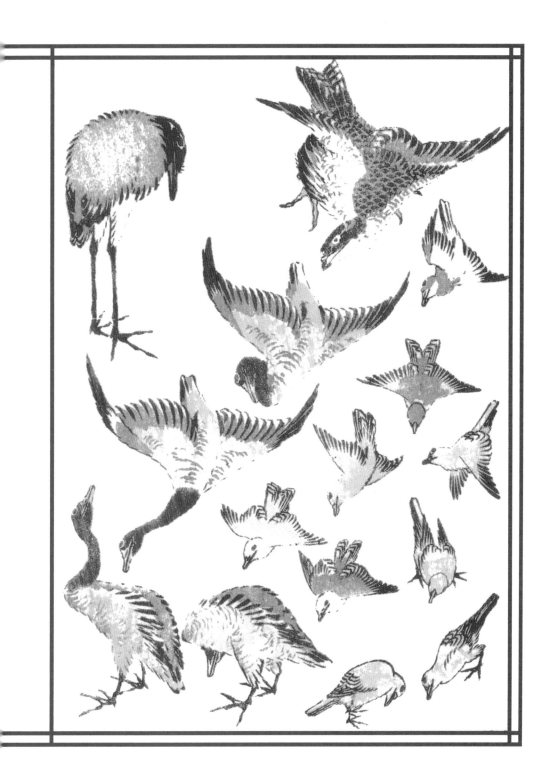

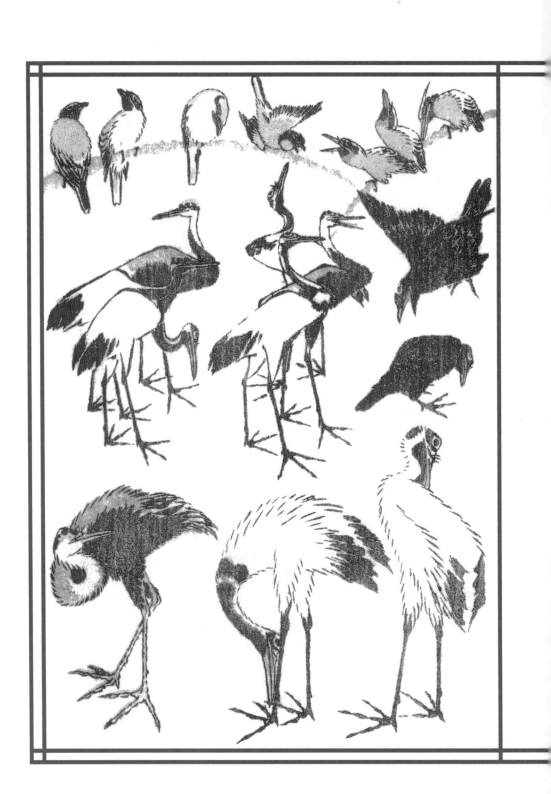

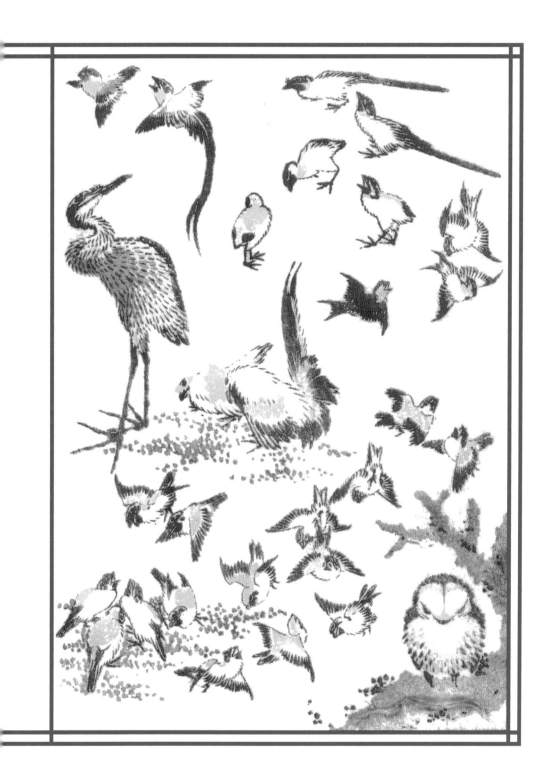

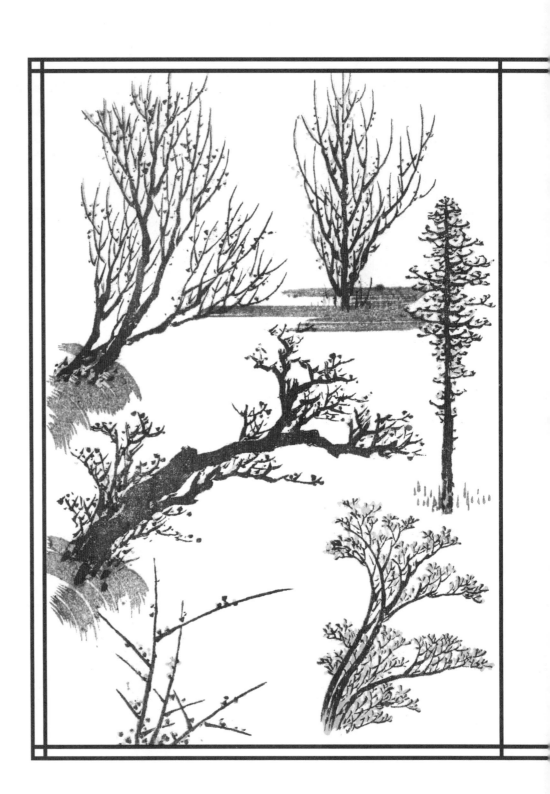

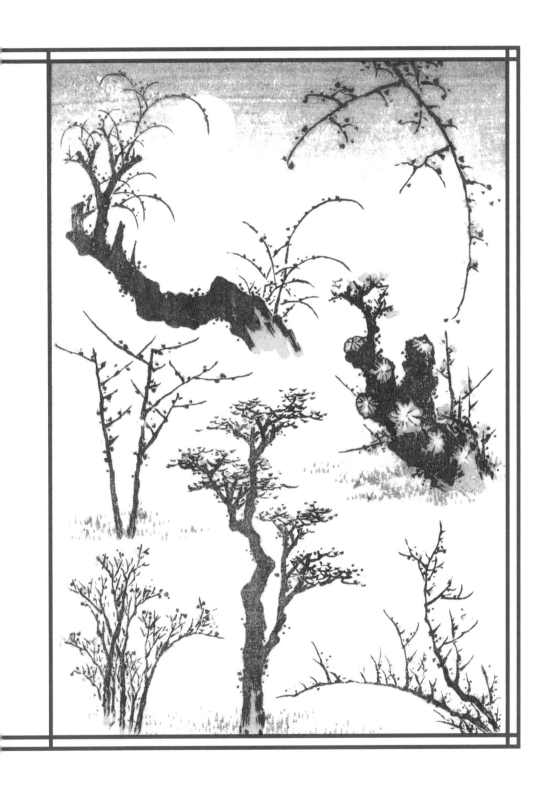

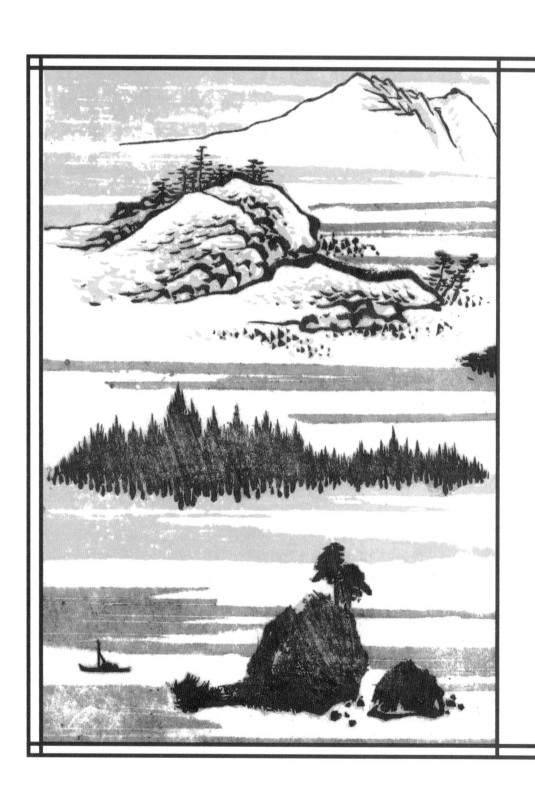

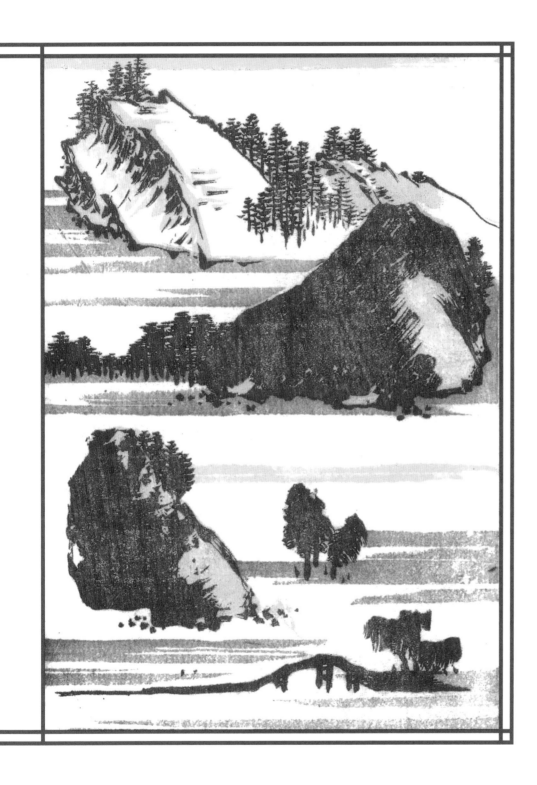

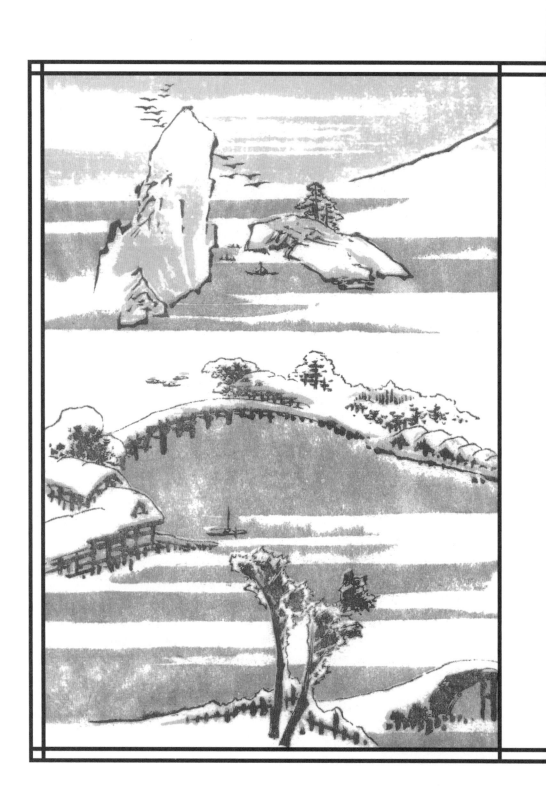

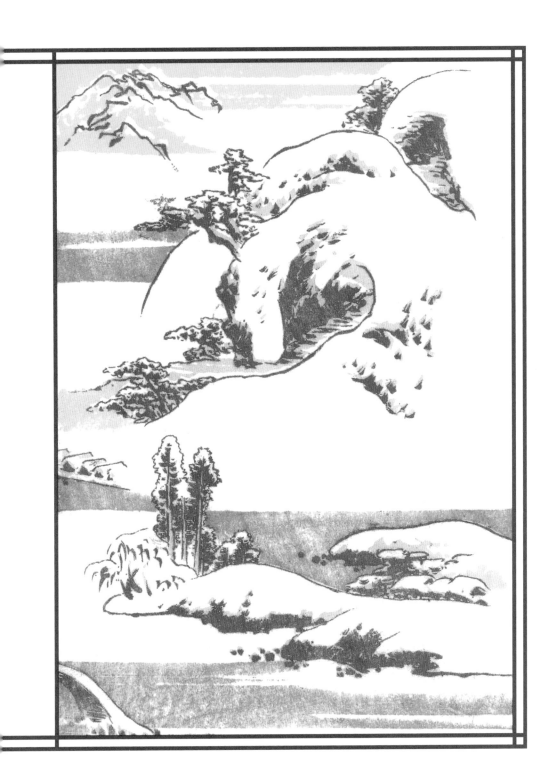

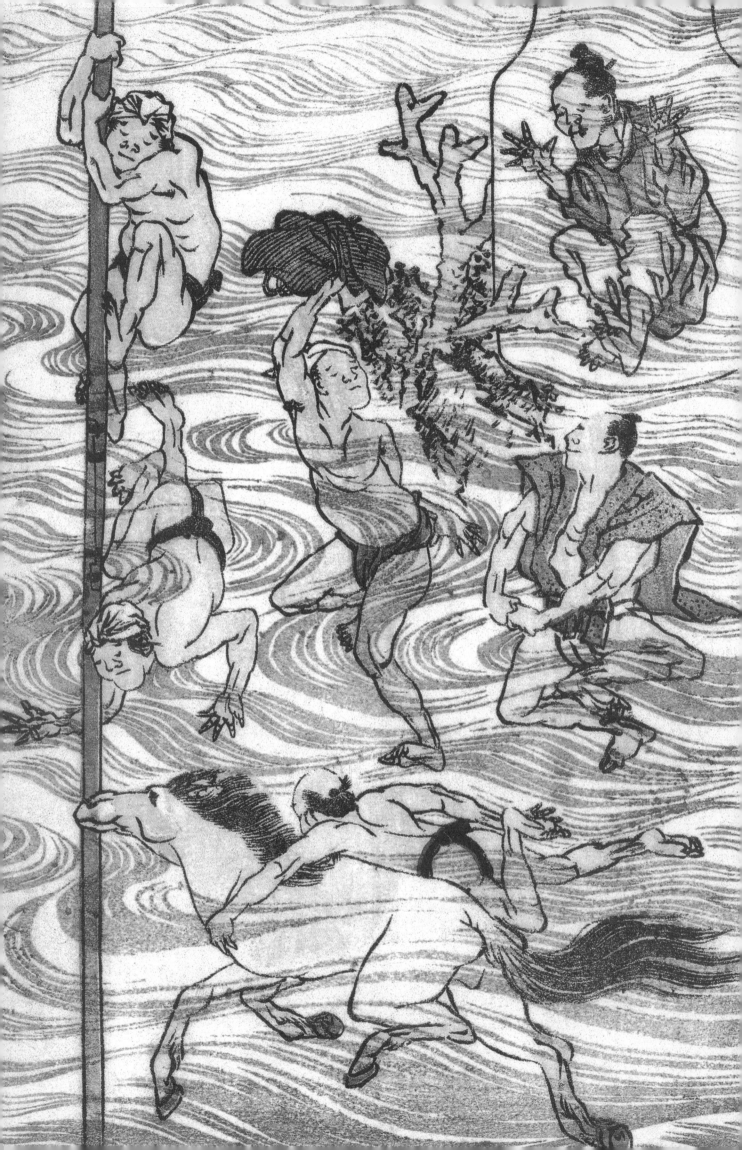

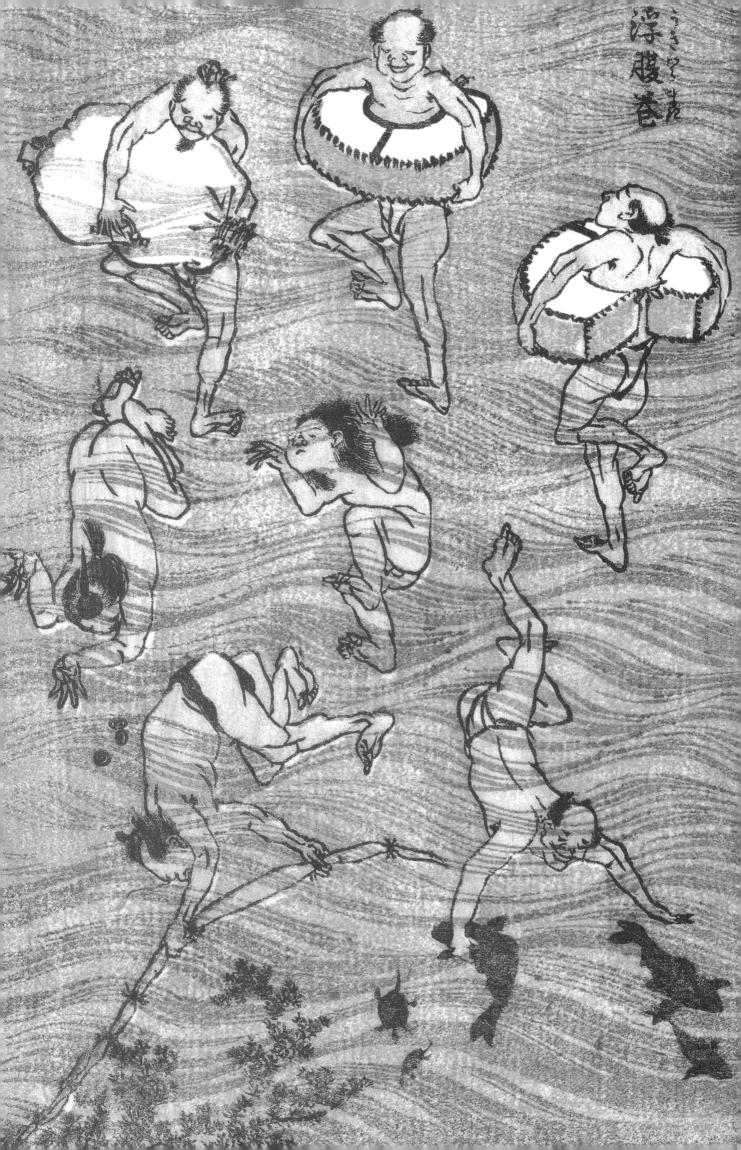

程子

孟子

周子

歐陽永叔

邵康節

韓退之

子思　曽子　顔子

朱子　張子　周公

手彊帆員命

日本木近祖神

あらきとりゐ

根本鹿香鳥居

くしねのとりゐ

宮室を画く事

通家の流く其秘せる所あらく漫説するを

せぎ且ぞ尺寸の相違をおさまして古人も

只紙絆か画くるをせまぞ滴を形を必

とろといへども多く蜜画して俗眼を悦む

そも己が不知の妄を庶の只臨本もどり

て古人のあやまり紙我上ふ引うけ後世の

纖をそらざるの族画を学ぶどとして古人を

まなぶとりべ一

両儀　日月星　四季　五行
二　　　三　　　四　　五

七星　八課　九曜
七　　八　　九

この数を眼前の形其長短み引書て考る

ときさん宮殿樓閣といへども画す安うべし

黒　白　黄　赤　青

水　金　土　火　水

儀　榕　朱雀　炯

白鹿　　　　青竜

弐　玄武　沈

五行
三光
両儀

乾　兌
坤　離
艮　震
坎　巽

九太とりゐ

日吉花表

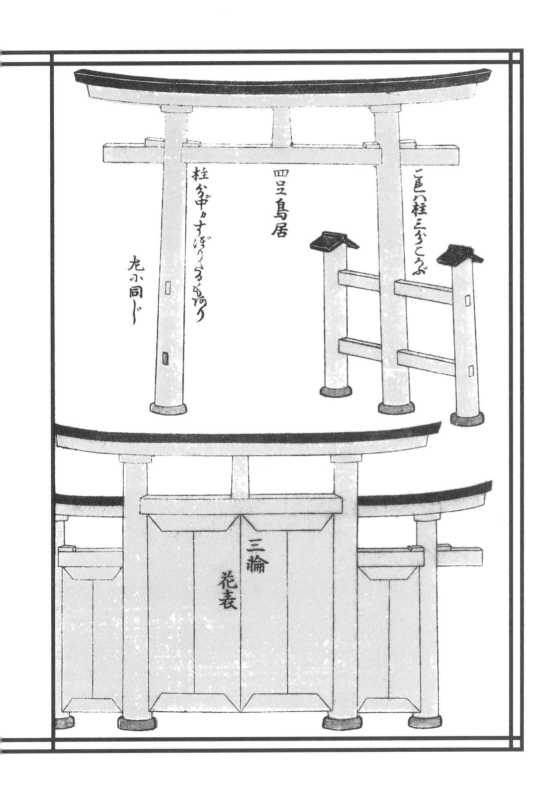

此色ハ柱三分ところぶ

四足鳥居

柱分シ中ヵすぼくくるもへり

尤小同じ

三輪

花表

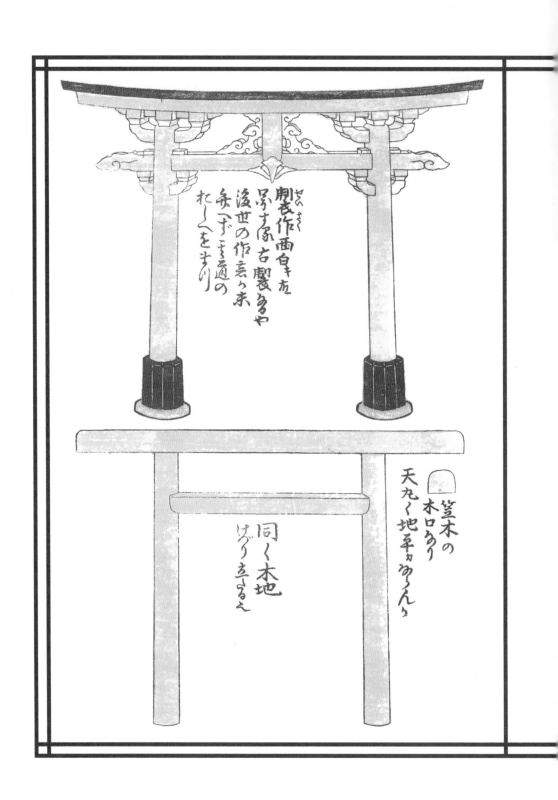

劇長作面白き左
写す図　右製多や
後世の作云々来
氷へずま通の
れ〳〵をまり

笠木の
木口あり
天丸く地平々ふうん。

同く木地
けづり立する え

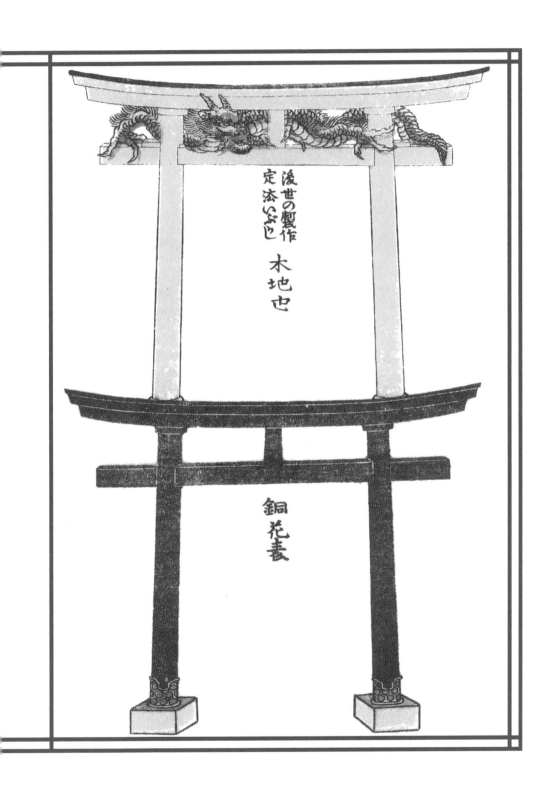

後世の製作
定法いぶし　木地也

銅花表

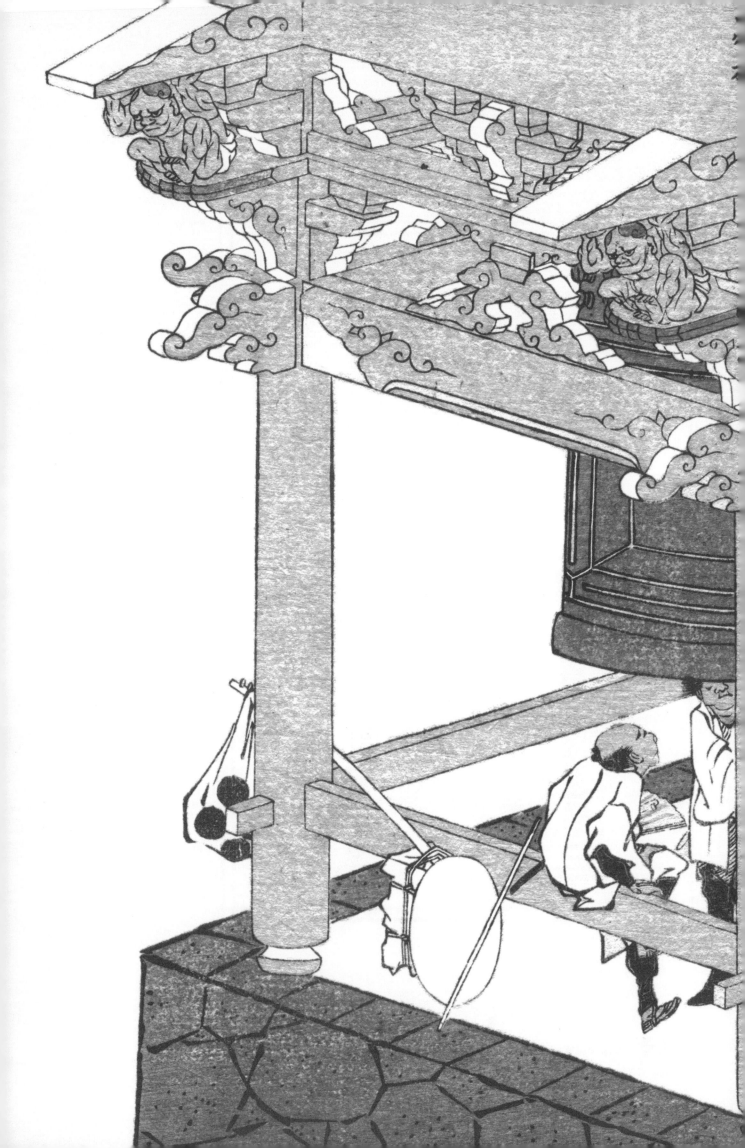

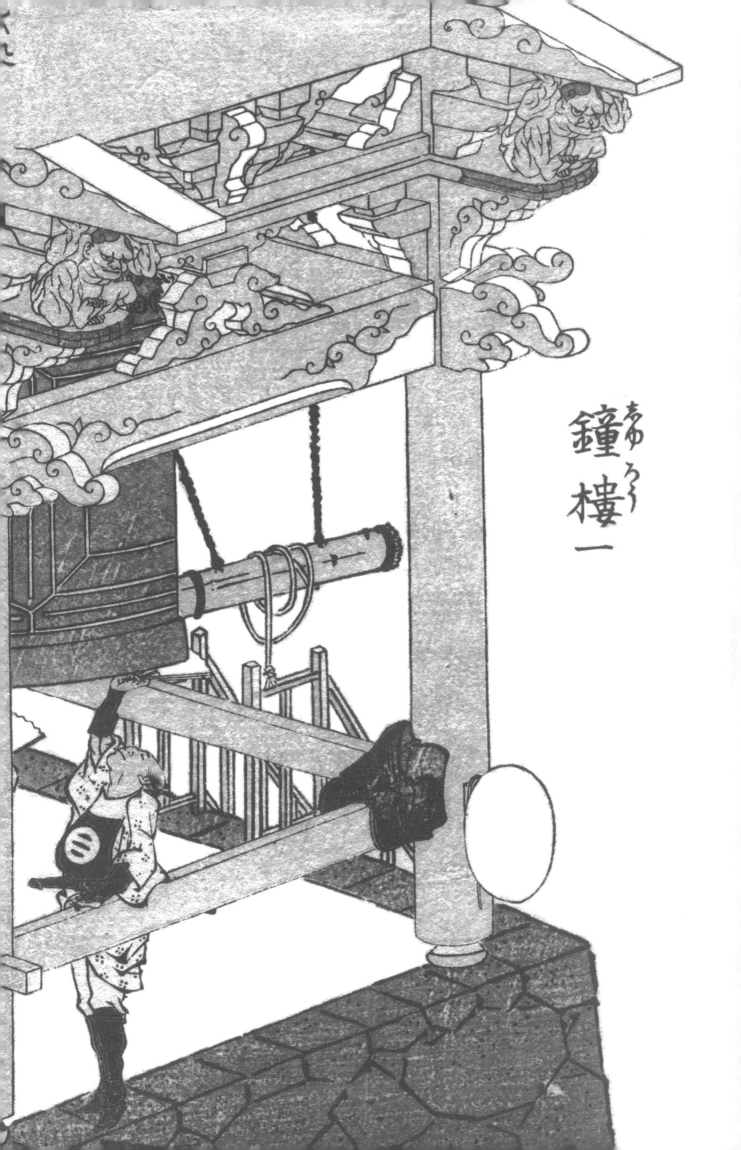

鐘楼
しゆ
ろ
う
一

や祢の
ほう
るり

其二

ちゆうの
鐘樓
之
や祢
家根

りんぞうのうち
輪藏ノ内

一切經を見やすからしめんを
一柱八面の輪蔵を作り
末世ふ淺し今

大建元年四月廿七日
本州ふ遷化

<ruby>普<rt>ふぢやう</rt></ruby>成

傅大士
ふなぞし

晋ふ
建けん

此処や祢こ

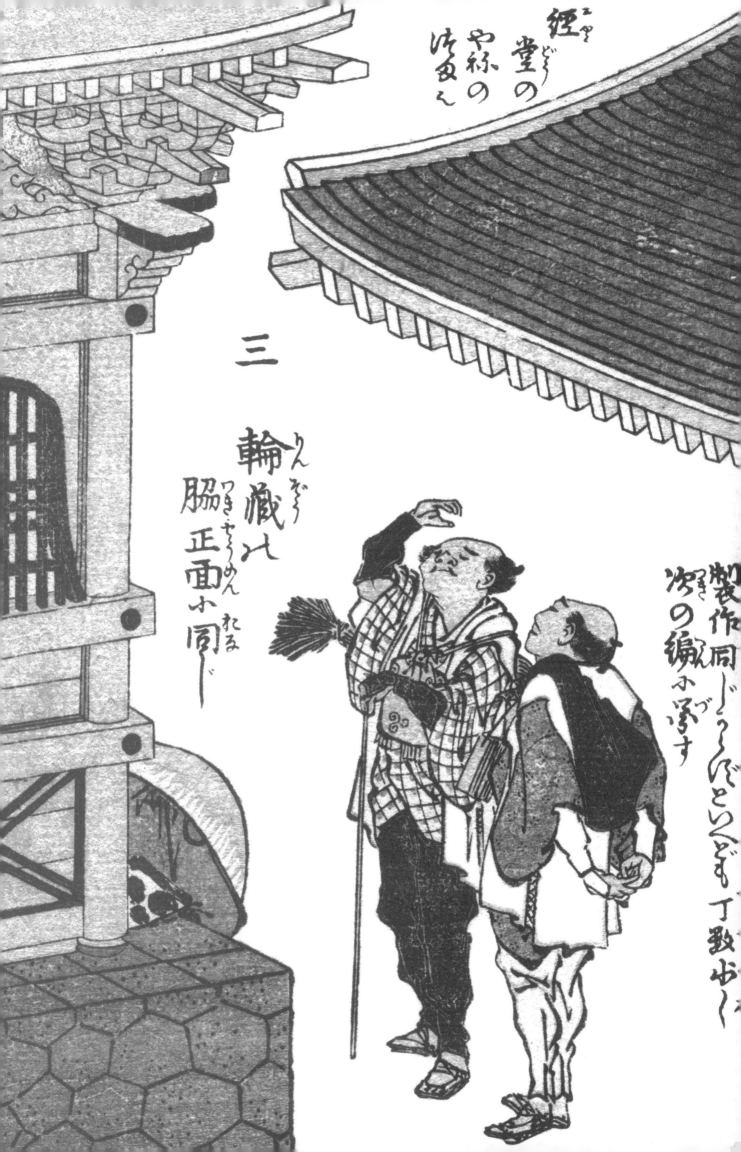

経堂の
やね
の
清水

三

輪蔵
りんざう
脇
正面
ワキ
しやうめん
小
ちいさ
れる
同じ

製作同じく
どう〳〵にどくども丁数ふへ
次の編ふゑす

寂滅爲樂

四句之

文刹鬼

諸行無常

古鐘

生滅之己

是生滅法

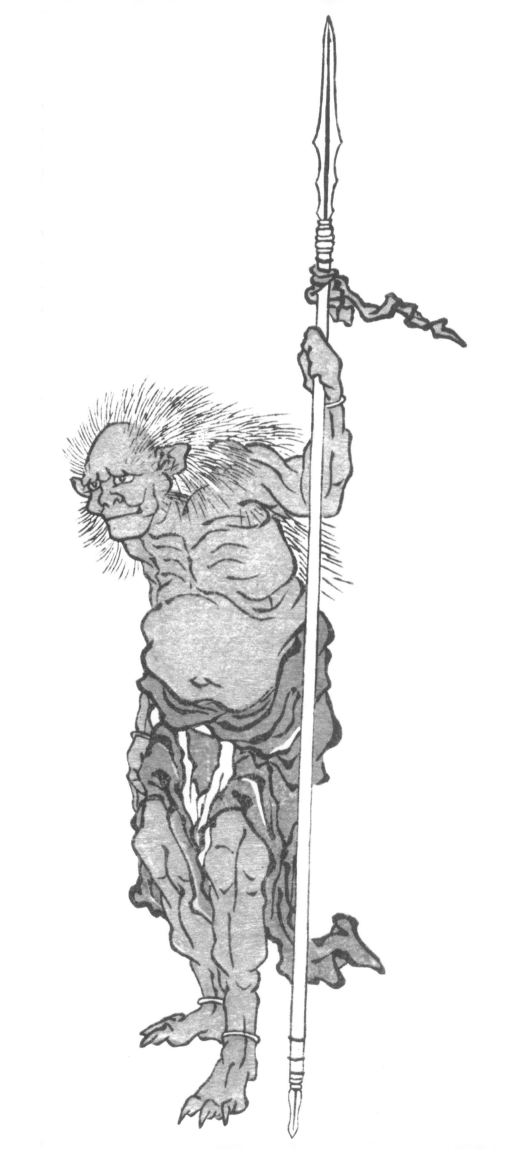

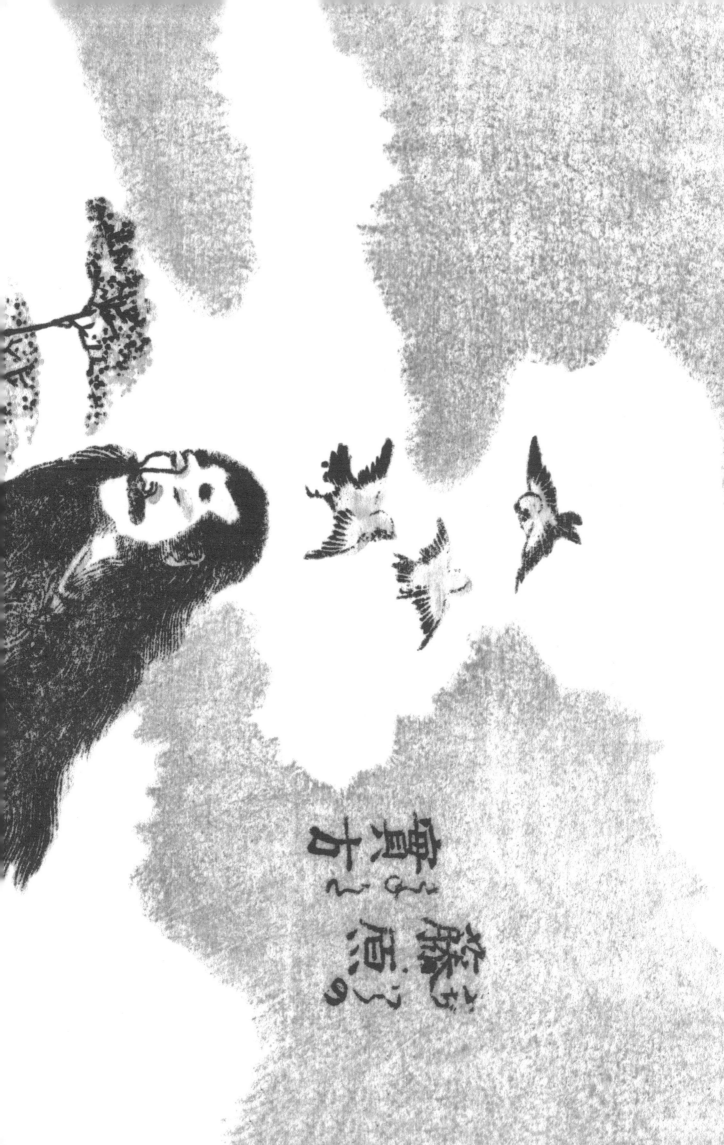

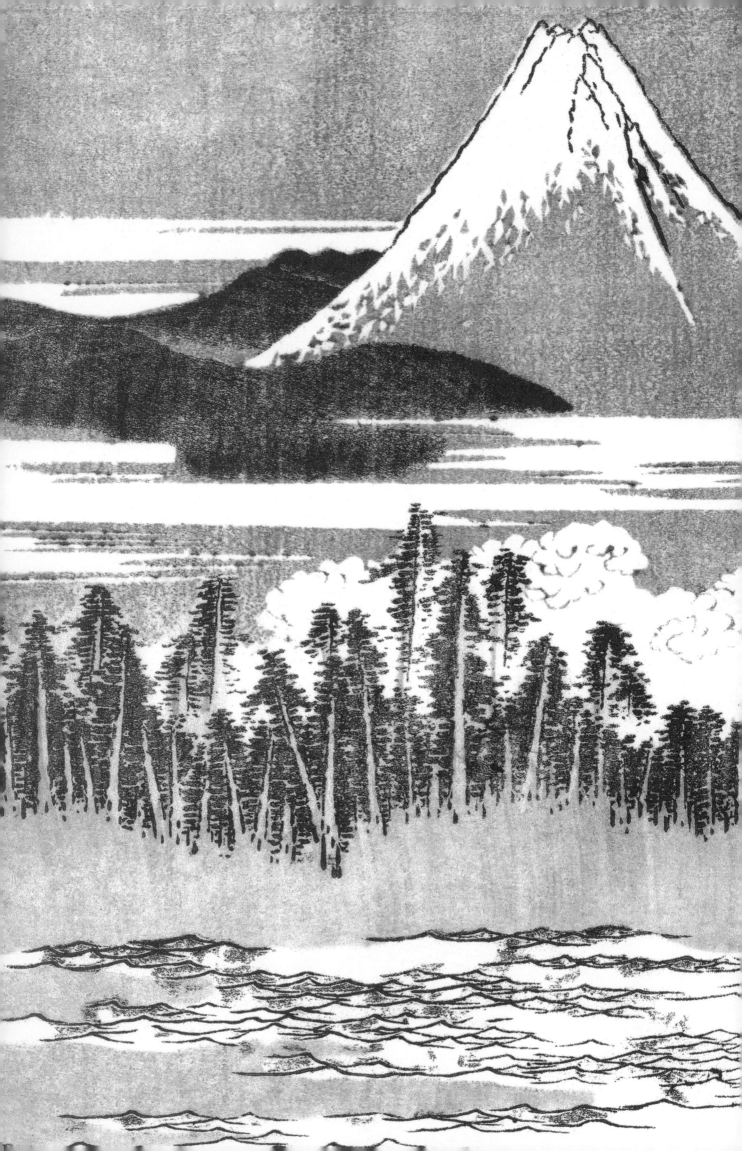

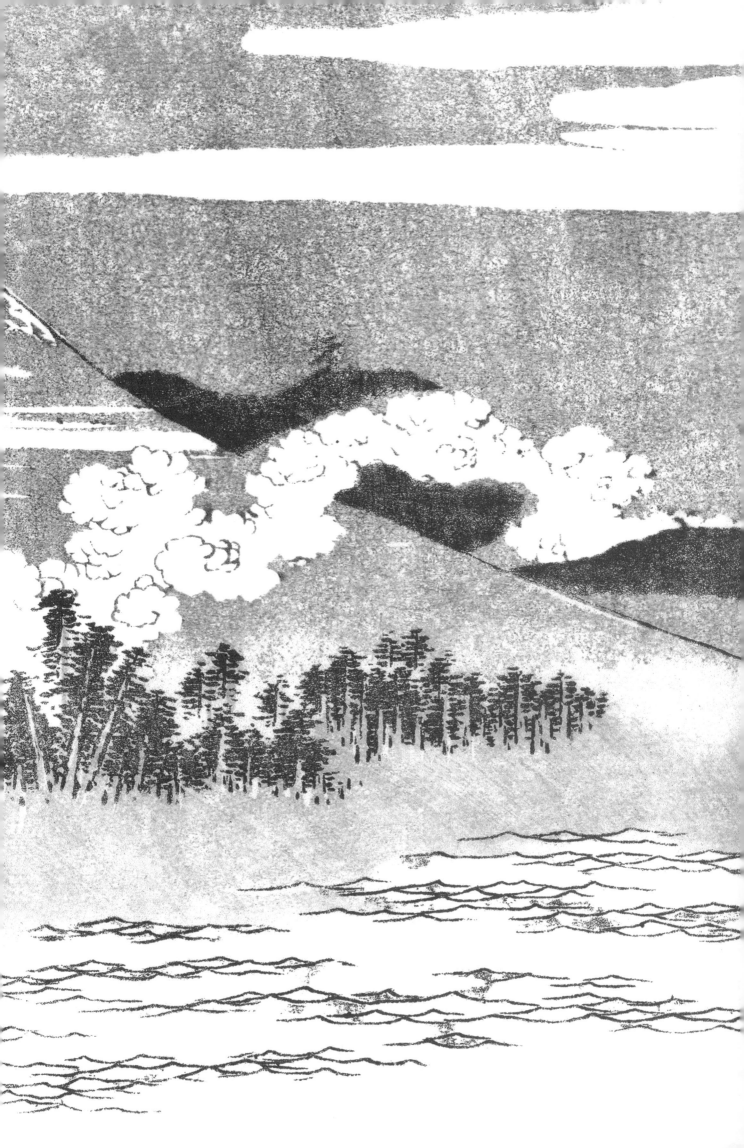

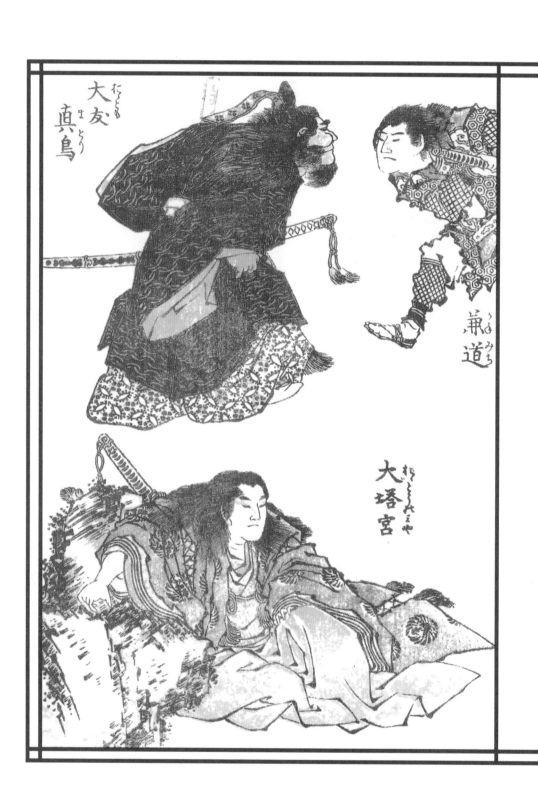

大友
真鳥

兼道

大塔宮

あまのうすめのひとこ

天臼女命

猿田彦太神
さるたひこだいじん

大元之像
（だいげんのぞう）

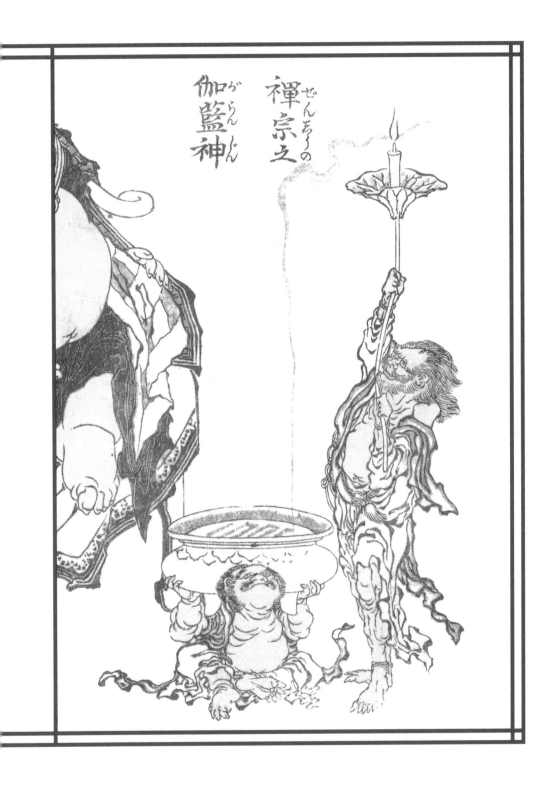

禅宗之伽藍神
ぜんそう
がらん

楠正成

天下泰平

During the *Hokusai* exhibition at the Edo-Tokyo Museum,
fifteen volumes (volumes 1 through 15) of *Hokusai manga*
from the National Museum of Ethnology in Leiden, Holland
and fifteen from my own collection were displayed alongside
each other. Of those belonging to the National Museum of
Ethnology, volumes 1 through 10 are valuable in that they
were the first to be brought to Europe, having been brought
back from Japan by Philipp Franz von Siebold himself.
While the exhibition was on, a number of experts had the

かつて江戸東京博物館で「北斎展」が開催された時、オ
ランダのライデン国立民族学博物館蔵の『北斎漫画』と
私のコレクションが、それぞれ初編から15編の15冊ずつ
並んで展示された。民族学博物館の本のうち、初編から
10編まではシーボルトが自ら日本から持ち帰ったもので、
ヨーロッパに最初にもたらされた貴重品である。その会
期中に関係者何人かで両者を手にとって見比べる機会が

蒐集家のさが

opportunity to inspect both collections and compare them. It was found that those from the Siebold collection had clearly been handled carefully and were intact and in a good state of preservation, although in the case of volumes 1 through 6 of the ten, those in my collection were all printed slightly earlier. Siebold arrived in Japan in 1823. Volume 10 was published in 1819, and so the first edition may well have sold out. What's interesting is that the volumes from my collection had been bought by me in Europe. In other words, they had found their

あった。シーボルトのコレクションはきれいで保存状態が良く、大切に扱われていたことがわかったが、10冊中6冊までは私のものの方が少し摺りの早いことが判明した。シーボルトが来日したのは文政6年（1823）、10編は文政2年に刊行されていて、すでに初摺本が売り切れていたのかもしれない。面白いのは、展示した本を私がヨーロッパで買ったということである。つまり、シーボル

The nature of collectors

way into Europe after those in Siebold's collection. This is also an indication of the extent to which *Hokusai manga* sparked a boom leading to the importation of large numbers of copies that had been printed earlier and were in good condition.

The appeal of *Hokusai manga* knows no bounds. I've collected 1400 copies, and my collection has been recognized by researchers and experts as one of the best in the world in terms of both quality and quantity. Essentially, woodblock-printed works like *Hokusai manga* can be printed in as many impressions as can be

トのものより後でヨーロッパに渡ったのだ。それは『北斎漫画』がかの地でブームを巻き起こし、摺りの早い良質なものが数多く輸出されたことを示してもいるのである。

『北斎漫画』の魅力は尽きることがない。私が蒐集した本の数は1400冊を超え、研究者や専門家から質量ともに世界一のコレクションと評価されるようになった。元々『北斎漫画』のような木版画は摺れば摺るだけの数がで

physically produced. However, as more and more are printed, the woodblocks wear down and the lines lose their sharpness. As well, many copies of *Hokusai manga* are in a poor state of preservation, with wormholes, wearing, scribbling, and other forms of damage. So it's important to find copies that were printed early and are still in a good state of preservation. Because this is how one can get the closest to what Hokusai intended to portray and experiences the original emotional impact of his work, the pursuit of which is also in the "nature" of collectors.

きる。しかし多く摺れば版木がすり減り、線が甘くなる。また傷みや虫食い、スレ、落書きなど保存状態の悪いものが多い。だから早い時期の摺りで、保存状態のよい作品を見つけることが大切なのだ。それが北斎が描きたかったことに一番近づくことができ、本来の感動を伝えてくれるからで、それを追い求めるのが蒐集家の"さが"でもある。

Volume 12 of *Hokusai manga*, published in 1834, contains a sketch entitled *Hokorobi* (A torn seam). A middle-aged woman with her well-developed breasts exposed is lying on her side as if taking a nap. The back of her kimono has come apart at the seam exposing her buttocks, and two children are shown pointing and shrieking with delight. It is an extremely commonplace scene from the lives of commoners with absolutely no hint of obscenity. Yet this sketch was immediately altered, with a wooden plug added to obscure the crucial area with the

天保 5 年（1834）に刊行された『北斎漫画』12 編の中に「綻」という図がある。豊かな胸をはだけたおばちゃんが昼寝でもしているのかコロッと横になっている。その女の着物の尻の部分が綻んでいて、臀部が露出しているのを指差しながら 2 人の子どもがキャッキャッと喜んでいる。猥褻感など全く感じさせない、ごくありふれた庶民の生活の 1 シーンである。しかし、この図はすぐに肝

torn seam. In the lead-up to the full-scale censorship under
the Tempo Reforms, the Shogunate went as far as censoring
even relatively innocent sketches like this one. I currently own
72 copies of volume 12, and even among fairly early edition
impressions we find this plug, with just two featuring the
sketch with its "torn seam." As well, volume 6, published
in 1817, includes a sketch of two Portuguese responsible for
introducing firearms to Japan when they landed on the island
of Tanegashima. The names of the two were removed in the

心な綻びの部分に埋め木がされて繕われてしまう。本格
的な天保の改革を前に、幕府はこんな図にまで検閲の手
を伸ばしていたのである。12編は現在72冊ほど所有し
ているが、かなり早い摺りでも埋め木がされていて、「綻」
のある図はわずか2冊だけである。また文化14年(1817)
に刊行された6編には種子島に鉄砲を伝えた2人のポル
トガル人が描かれている。その2人の名前が2番摺り以

Censorship and errors

second and later editions. It is thought this is because the name of one of the men, Kirishita Mota, was suggestive of the Japanese word for Christians (*kirishitan*), who were prohibited at the time. I own 92 copies of Volume 6, of which only six contain the original name.

Hokusai manga also contains some "mistakes." Volume 5 contains a sketch depicting a scene from the Noh play *Aoi no Ue* (Lady of the Court) in which the main character, Lady Aoi, is shown wearing a *hannya* (female demon) mask. In fact it is

降では消されている。喜利志多孟太（キリシタモウタ）という1人の男の名が禁制のキリシタンを連想させたからと思われる。6編は92冊ほど所有しているが、名前があるのは希少で6冊のみである。

「間違い」もある。5編には謡曲「葵上」の1場面を描いた画があるが、葵上が般若と化している。般若になったのは「六条御息所」であるから明らかな間違いといえ

Lady Rokujo who turns into a female demon, so this is clearly a mistake. Even today it is standard practice to correct such proofing mistakes when reprints are issued. The first edition of volume 5 appeared in the early summer of 1816. Yet by early spring of the following year the sketch had already been altered to identify the character as Lady Rokujo. It is clear from this just how quickly the correction was made, and how well this volume of *Hokusai manga* sold. I own 101 copies of volume 5, of which only eight identify the character as Lady Aoi.

る。校正ミスは今でも増刷された時に訂正するのが普通である。5編の初摺りは文化13年(1816)子夏刊。しかし翌年の孟春刊では「六条御息所」に訂正されている。いかに迅速に訂正されたか、またいかに本が売れていたかがよくわかる。5編は101冊所有しているが、「葵上」とあるのは8冊のみである。

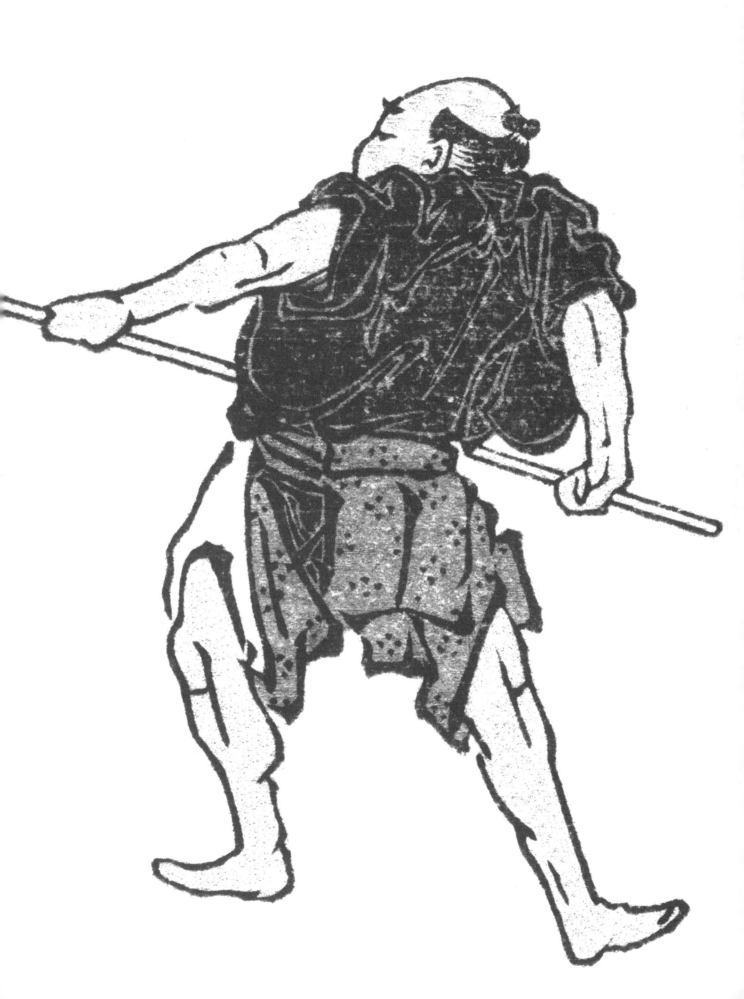

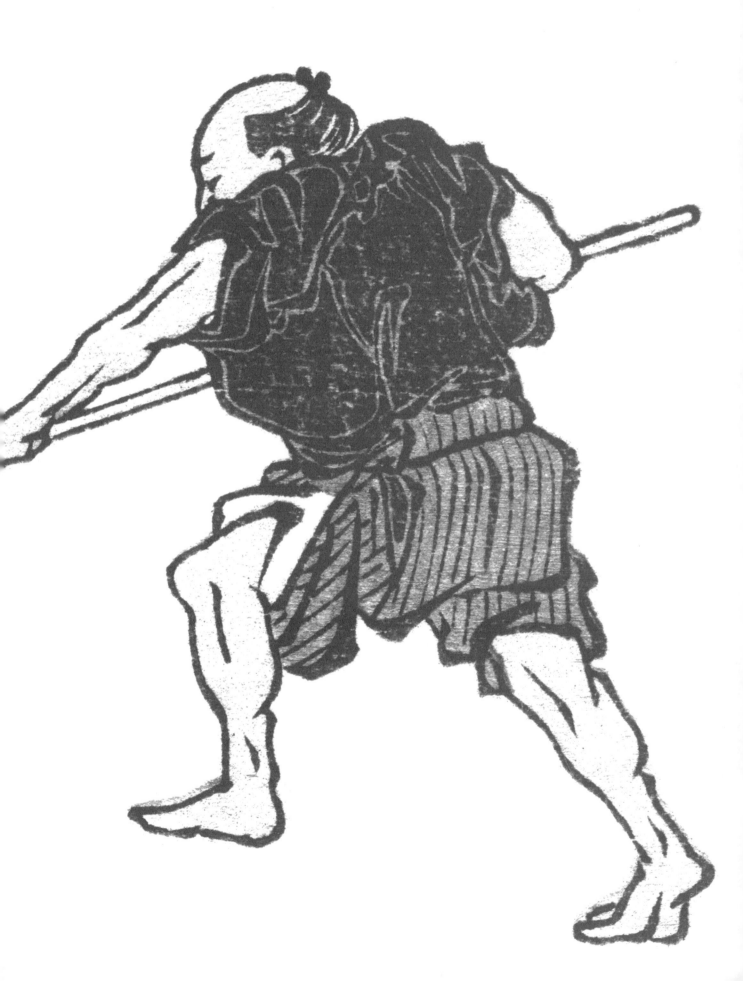

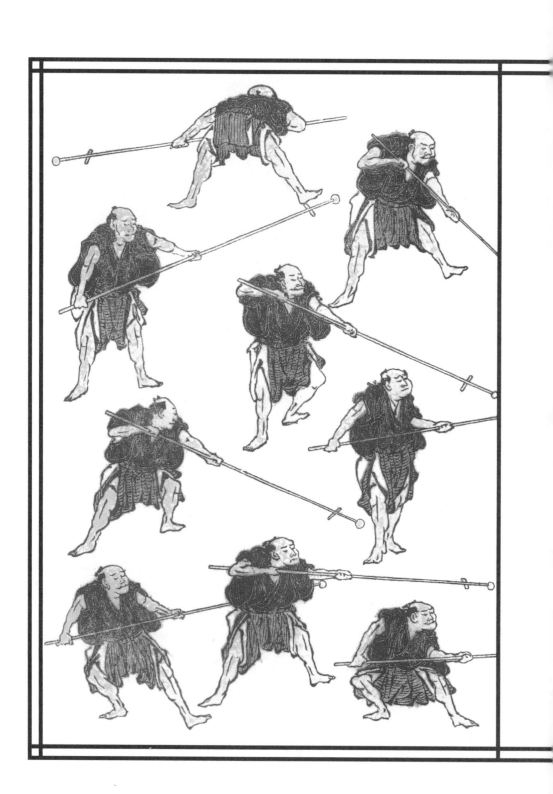

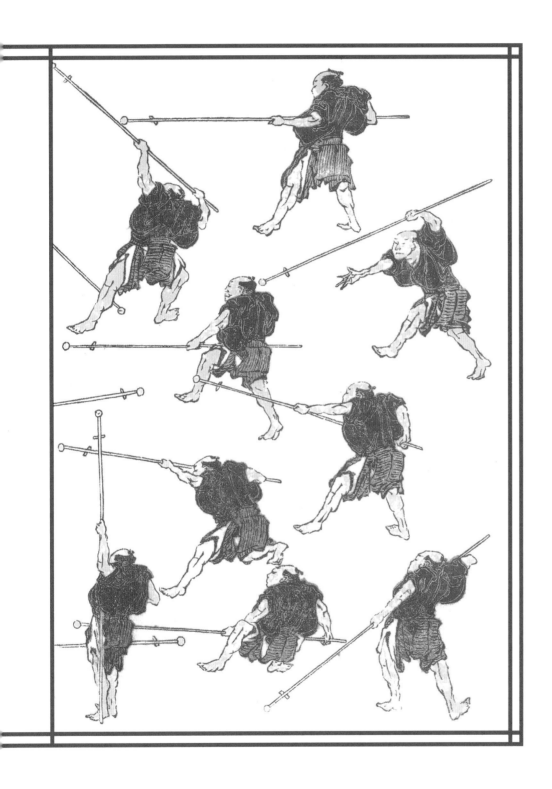

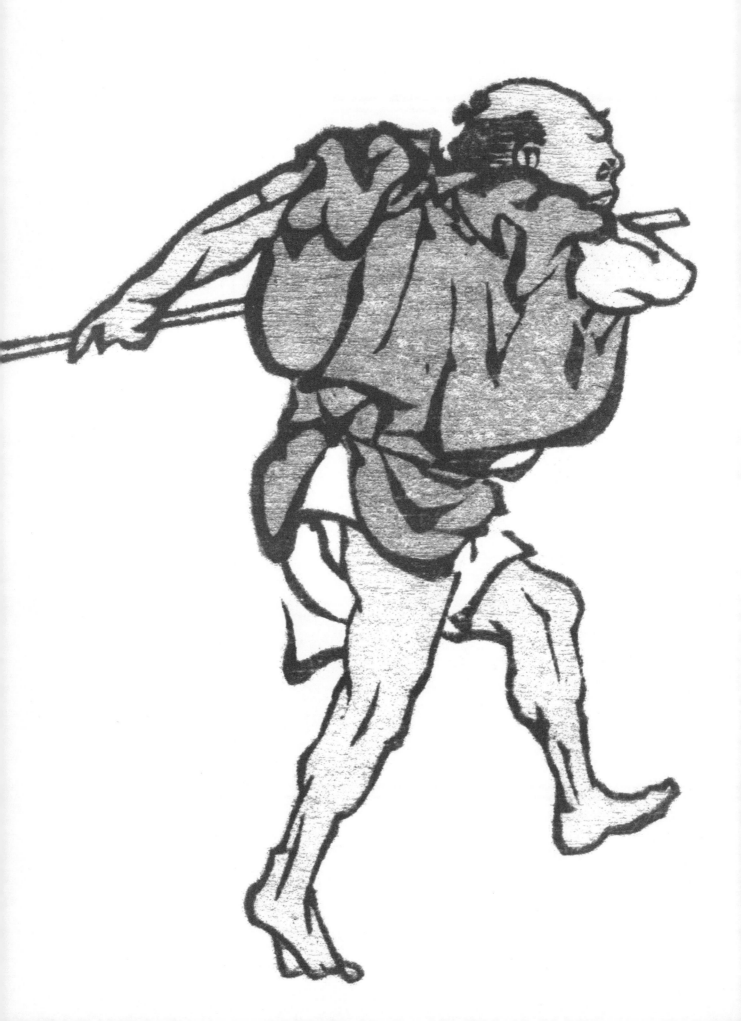

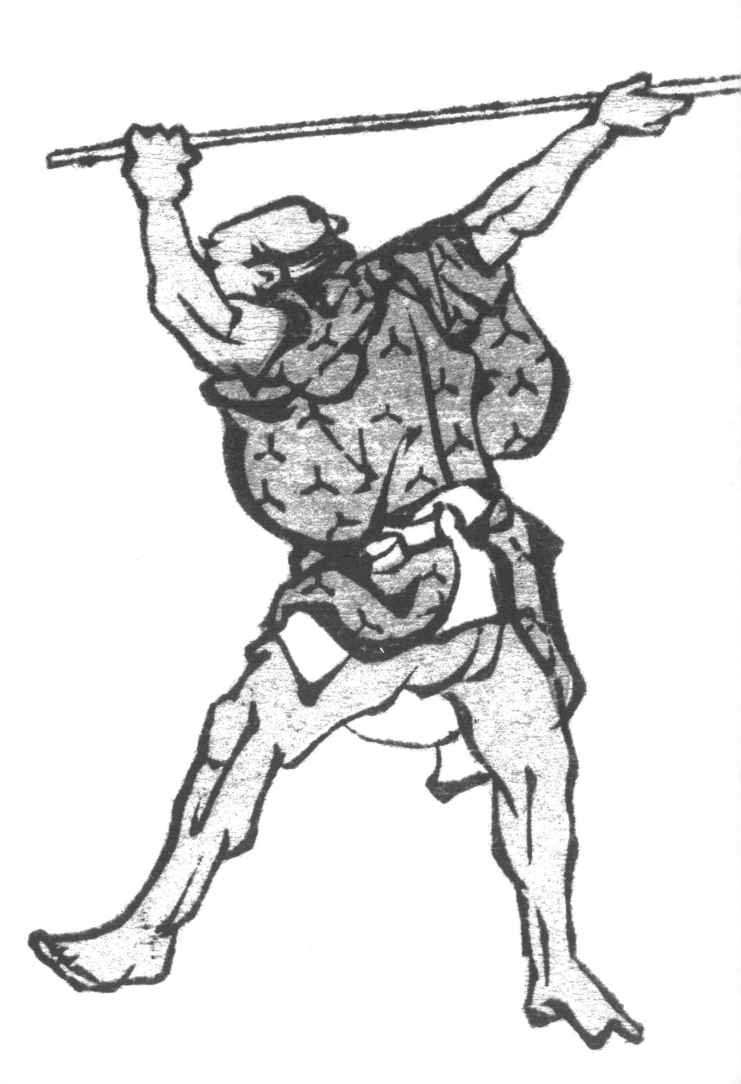

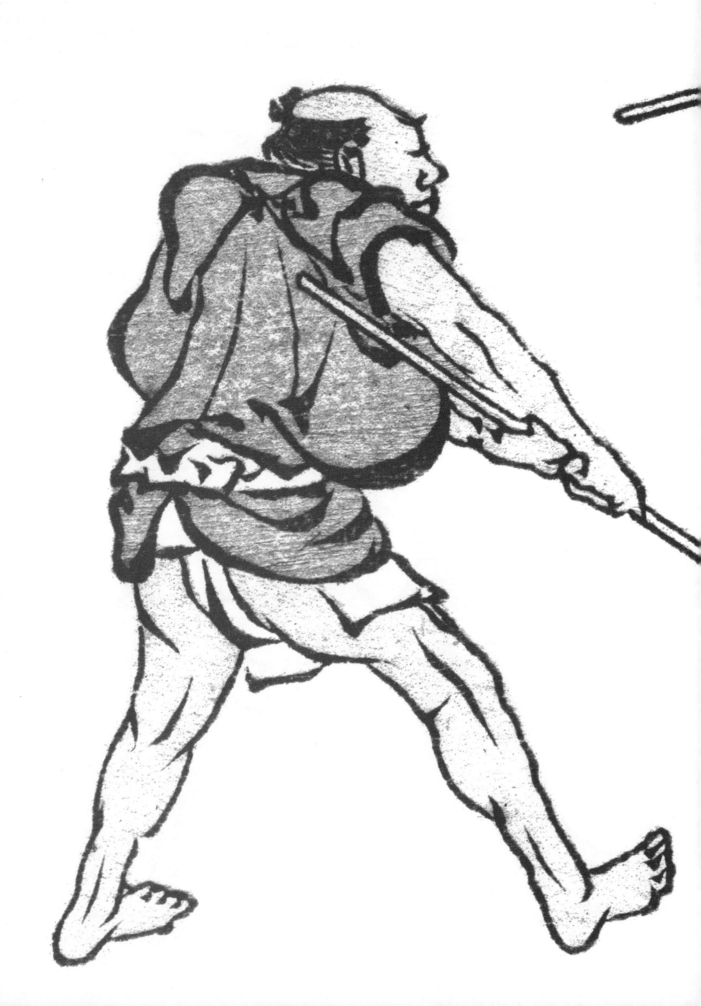

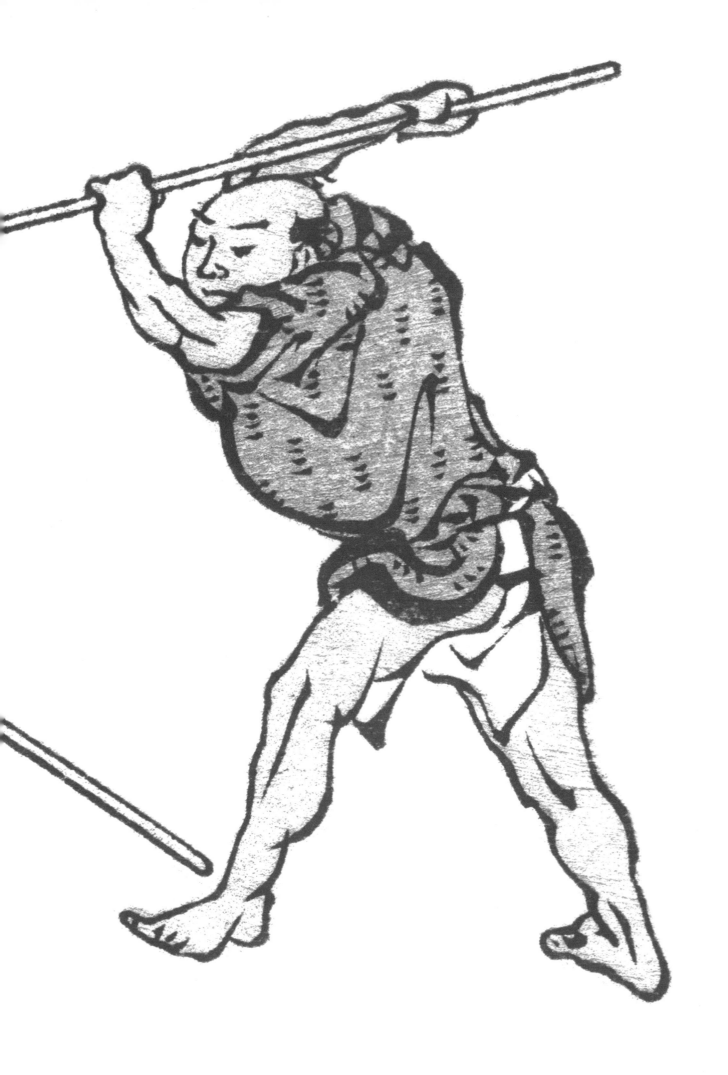

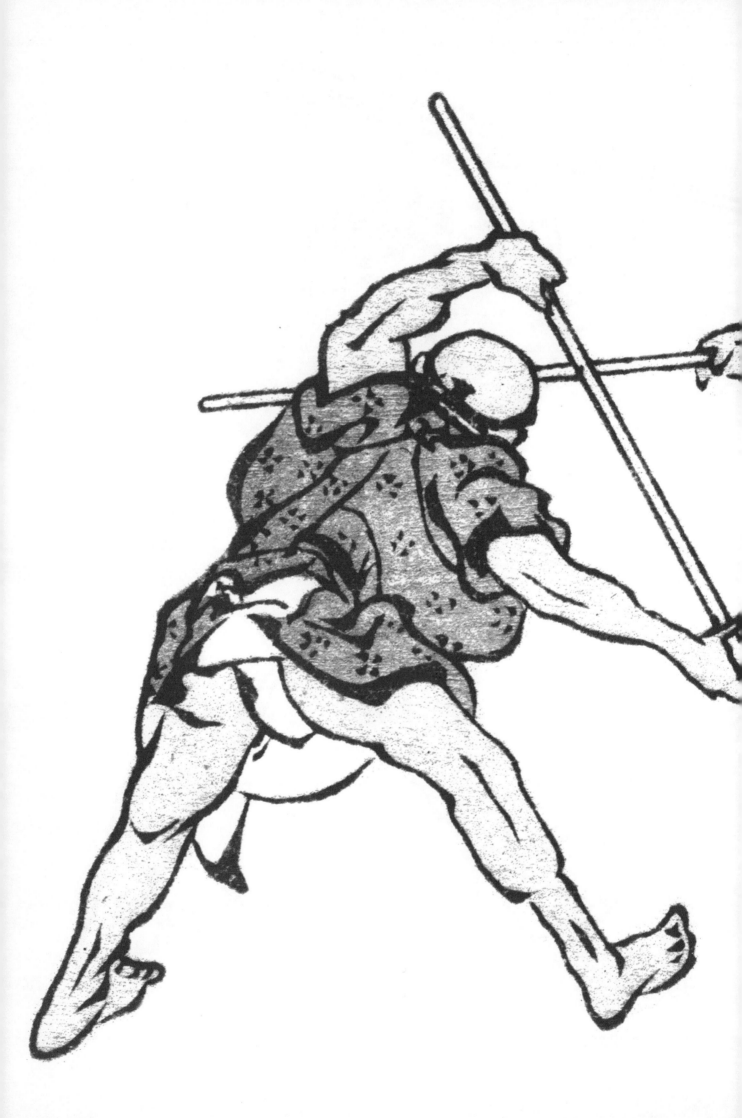

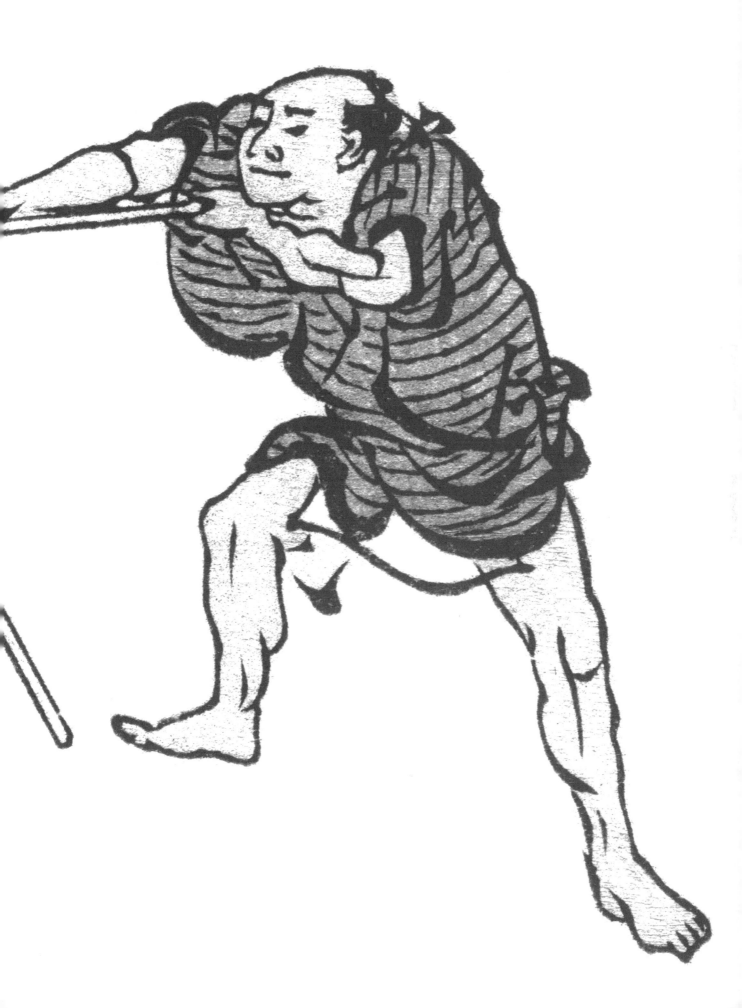

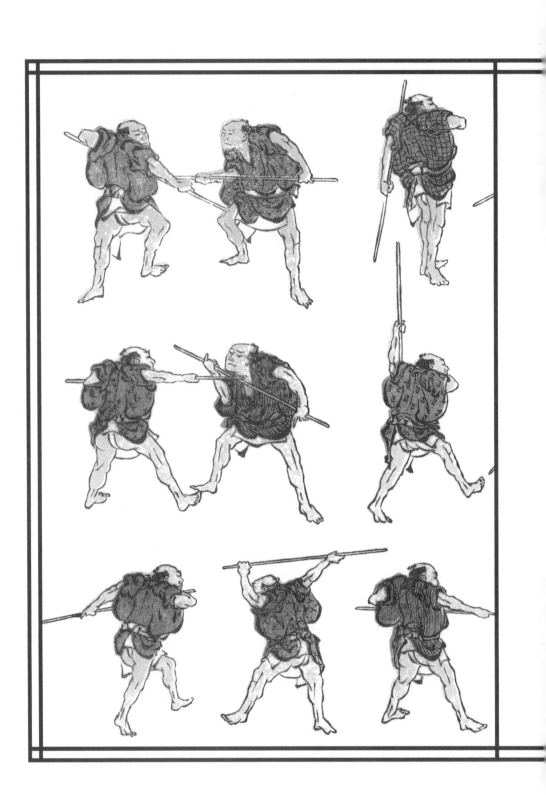

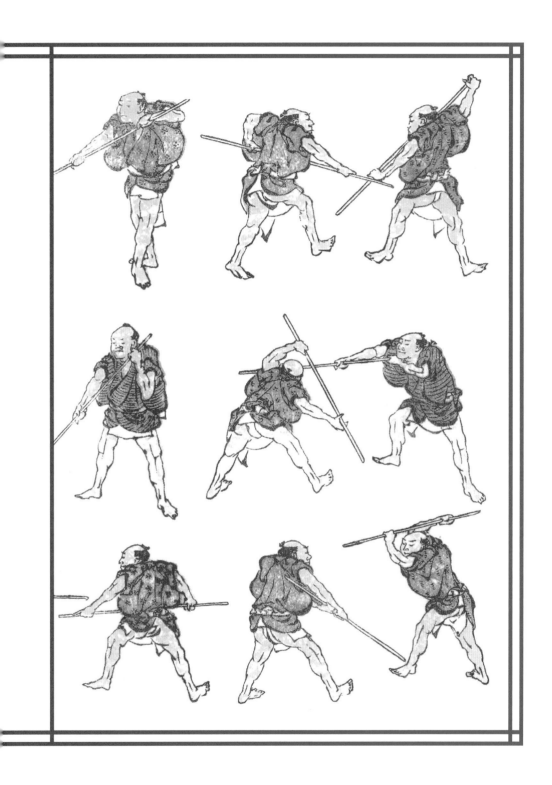

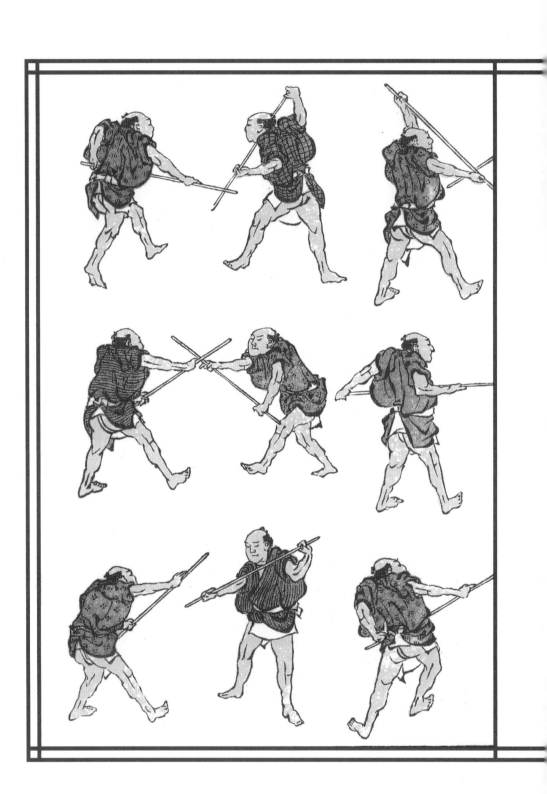

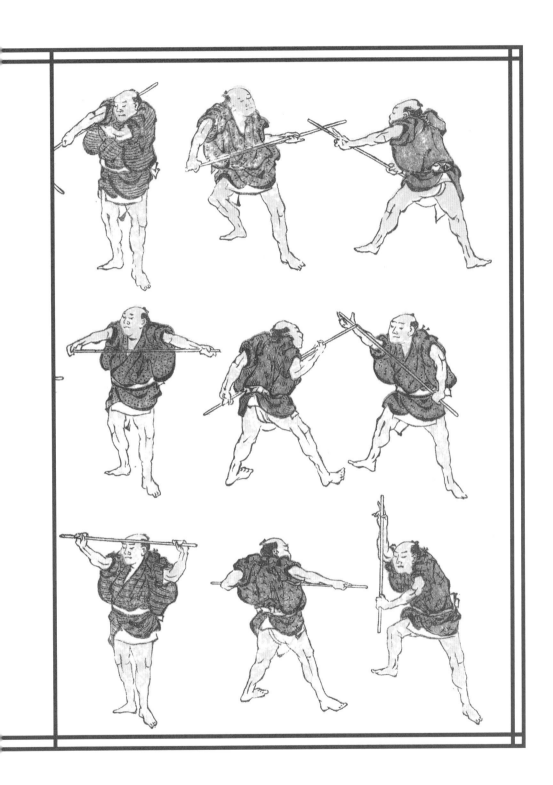

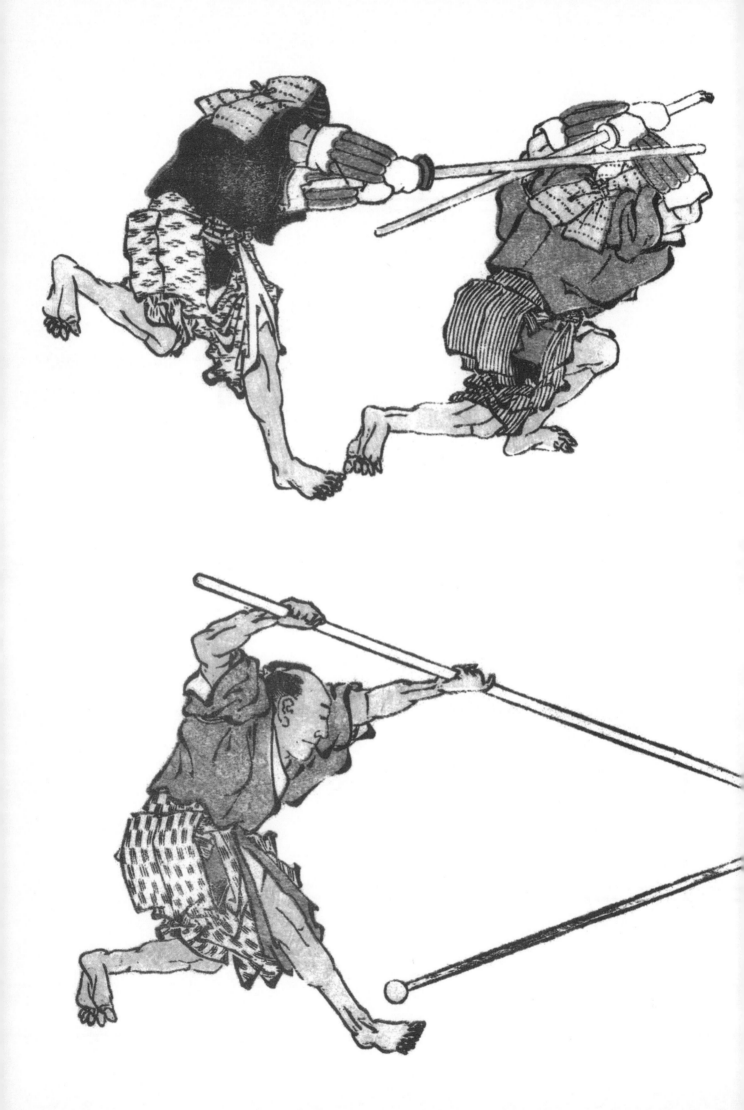

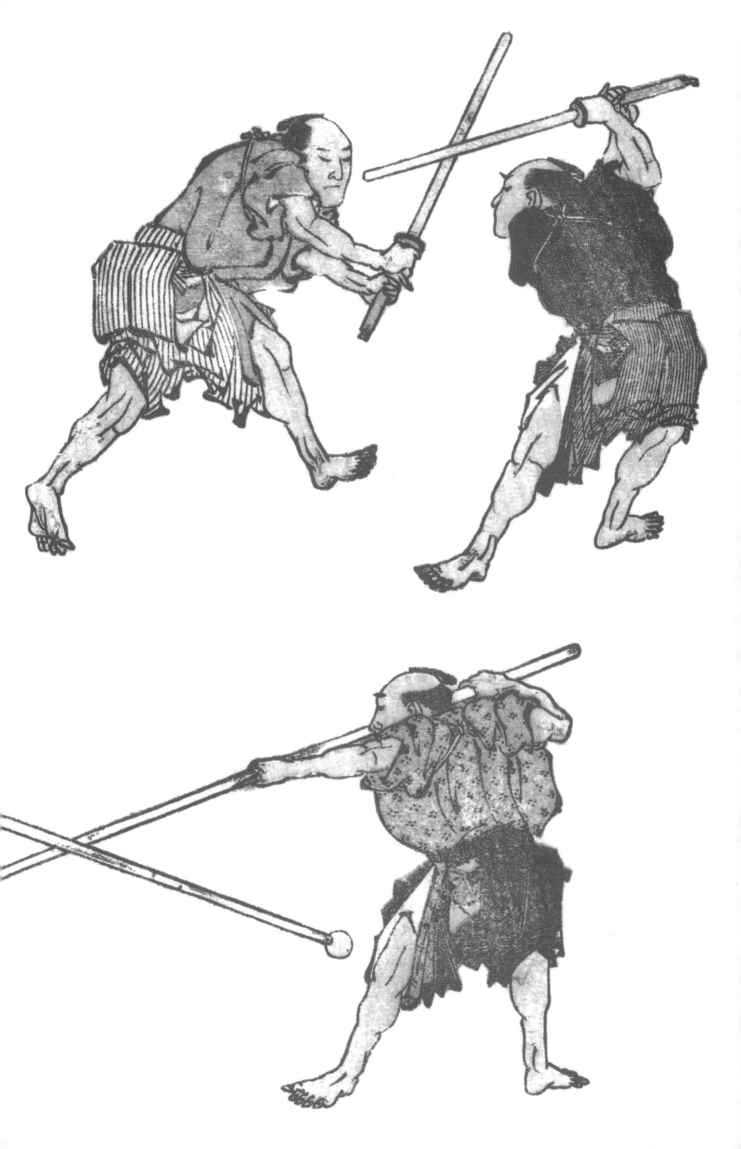

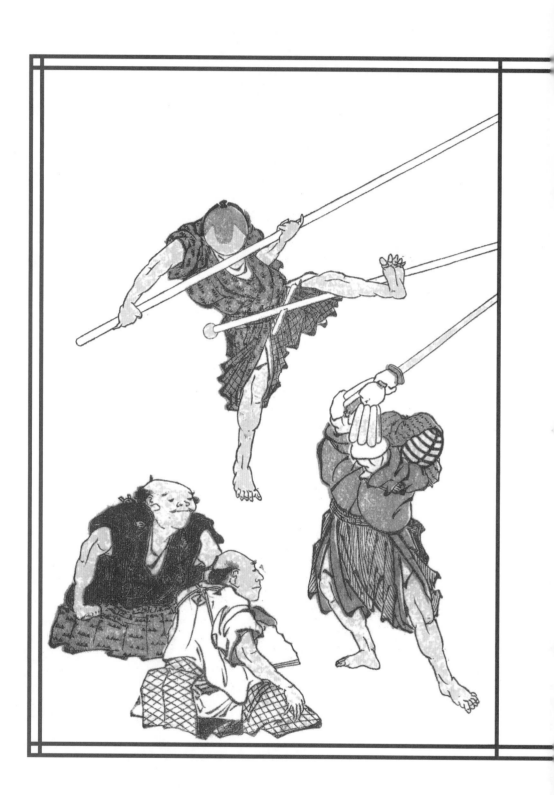

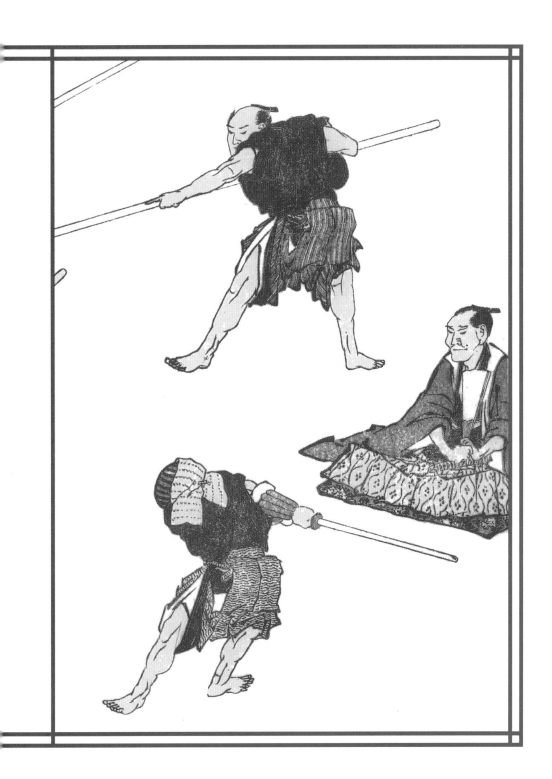

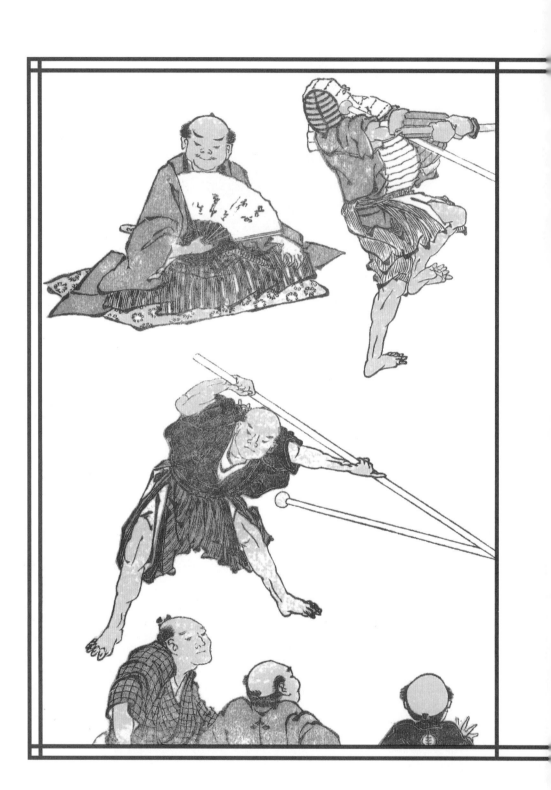

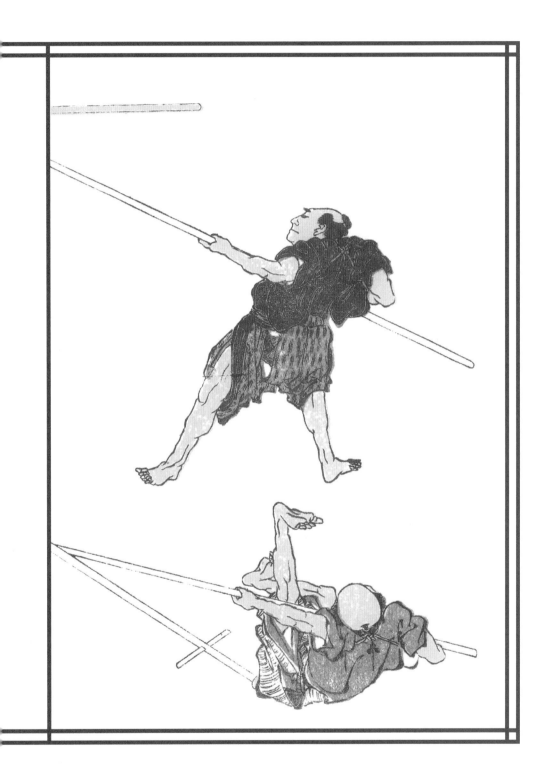

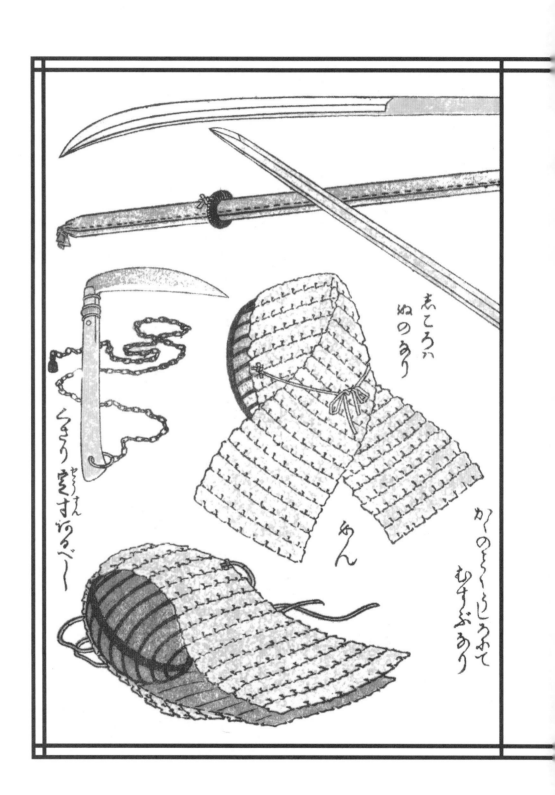

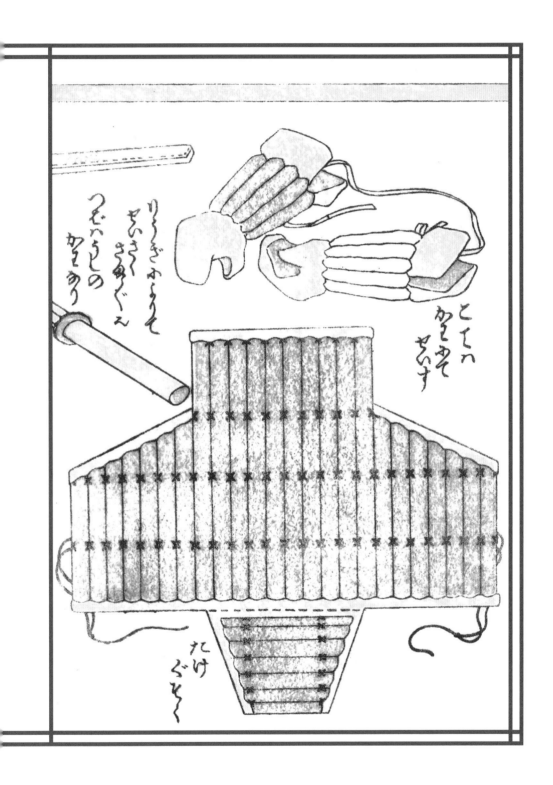

こてのかこめてをいす

りうぎふうそ
さいきさめぐん
つないうしの
かこあり

たけ
ぐそく

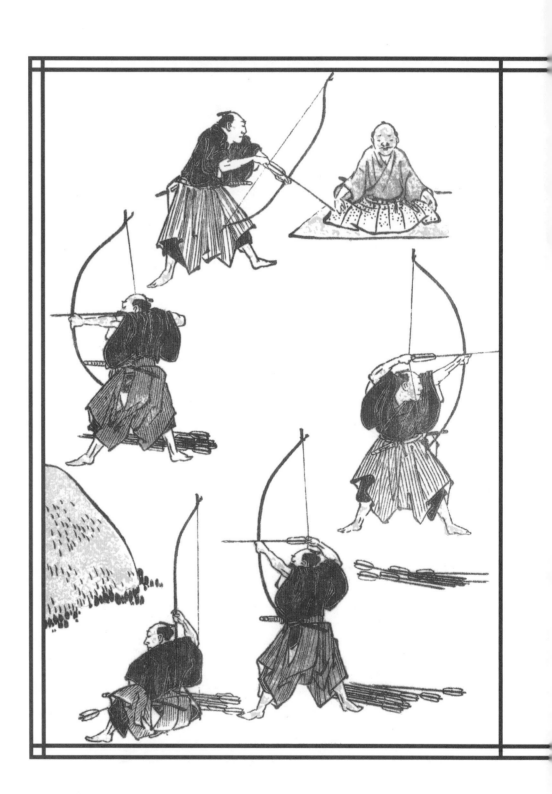

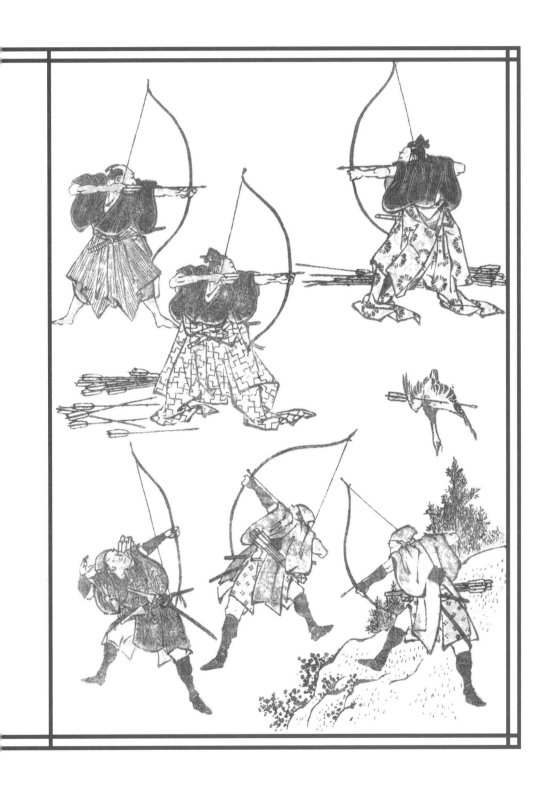

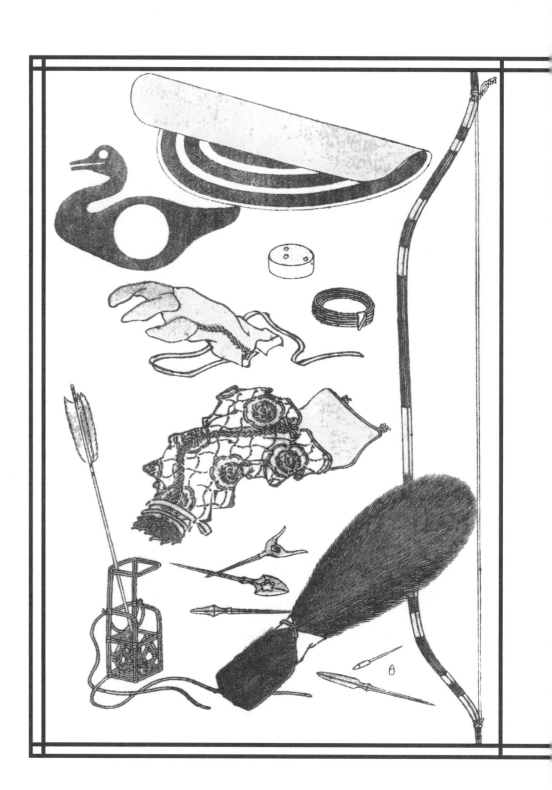

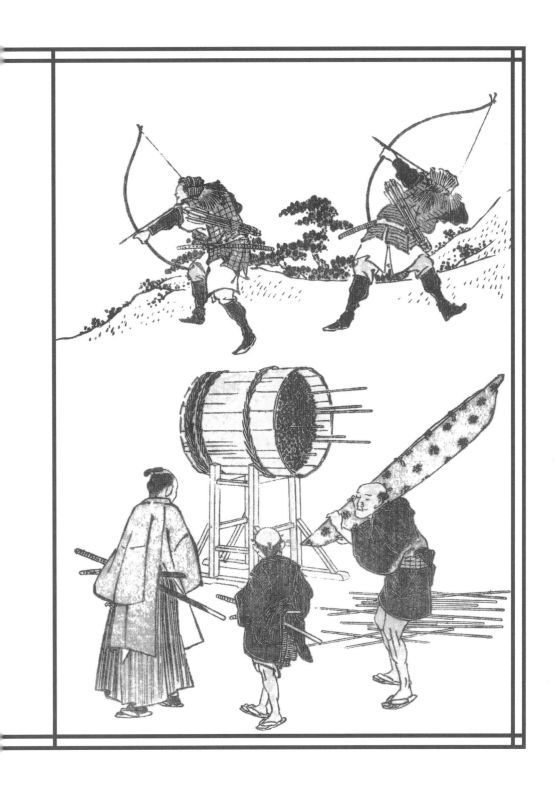

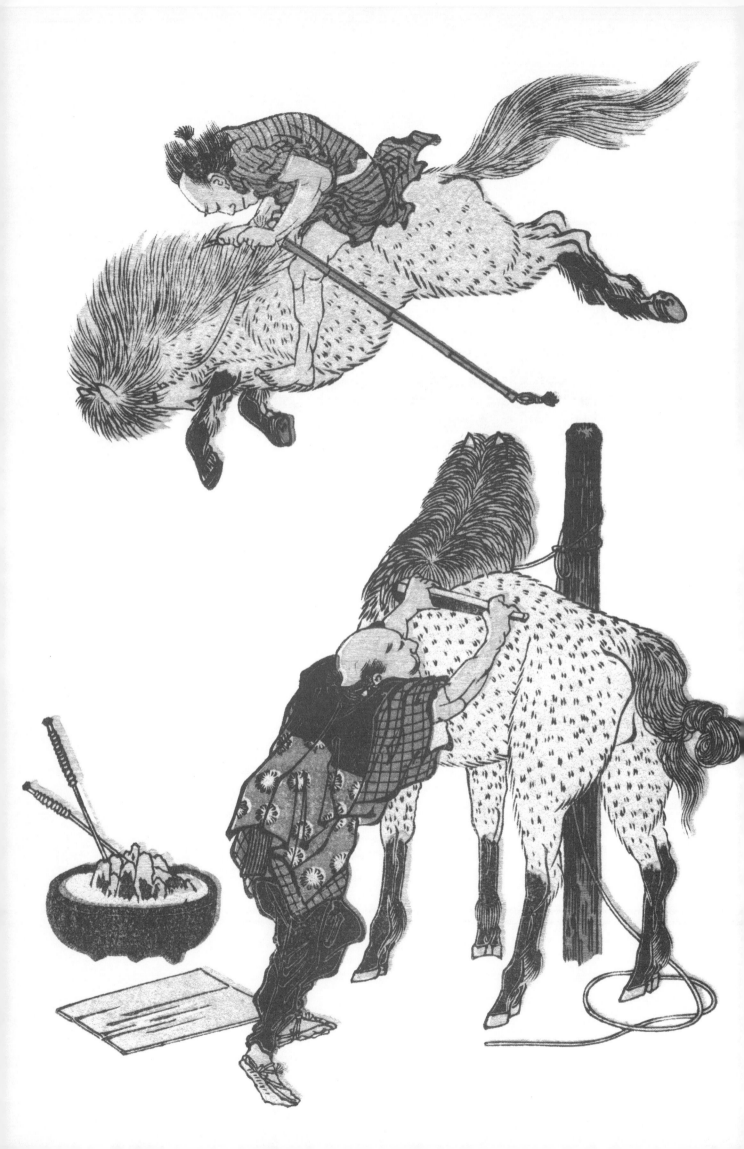

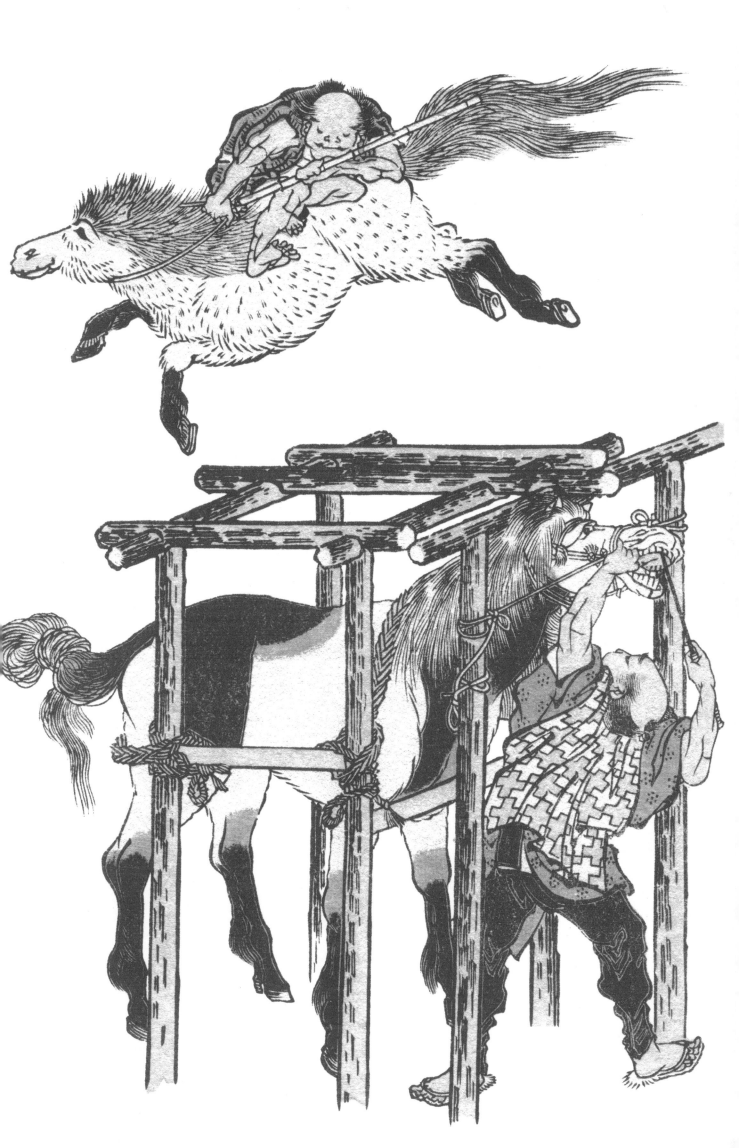

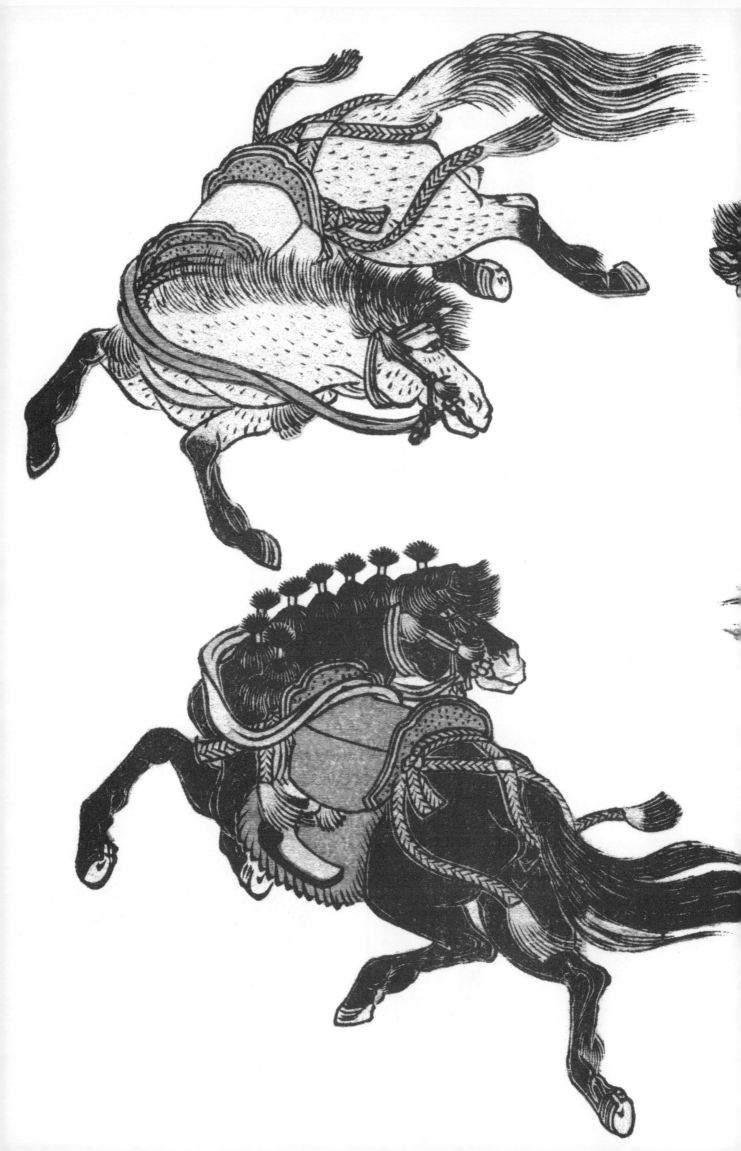

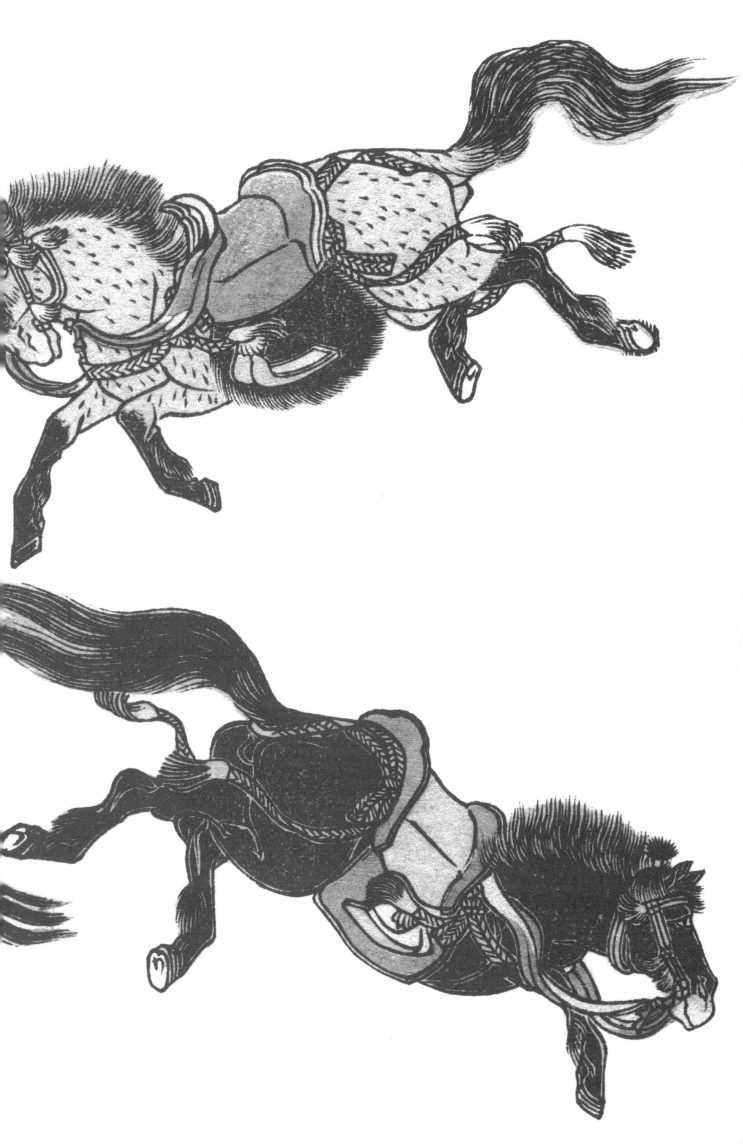

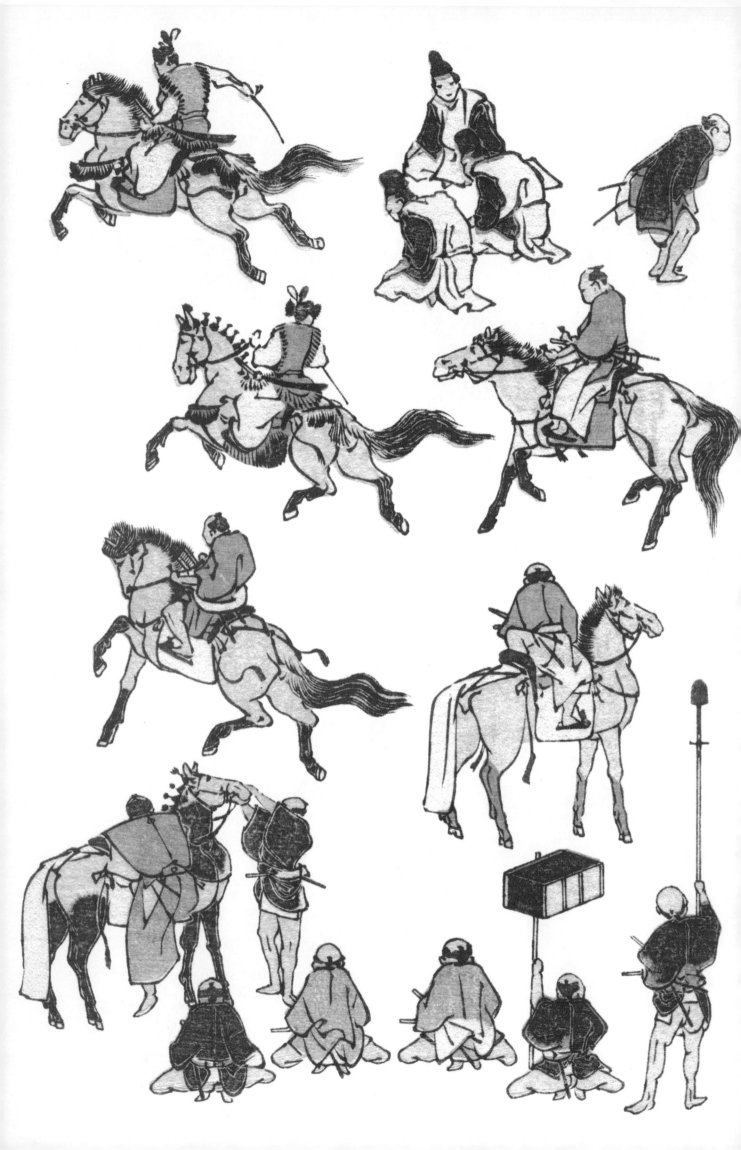

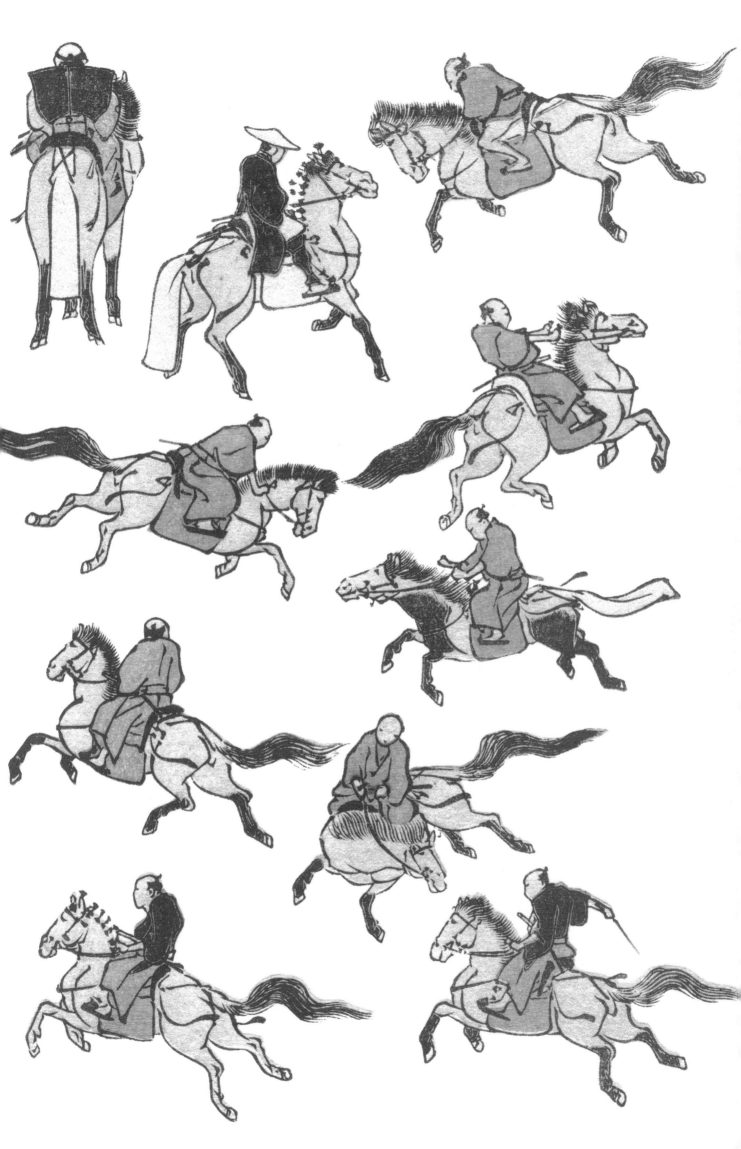

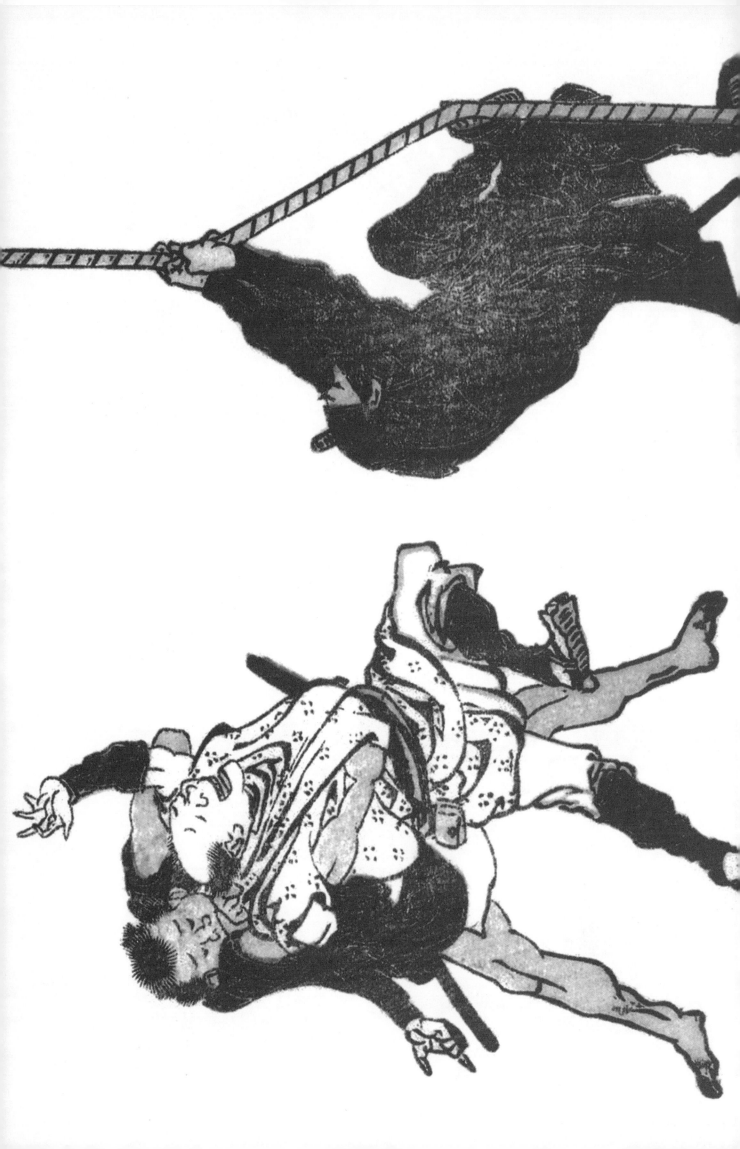

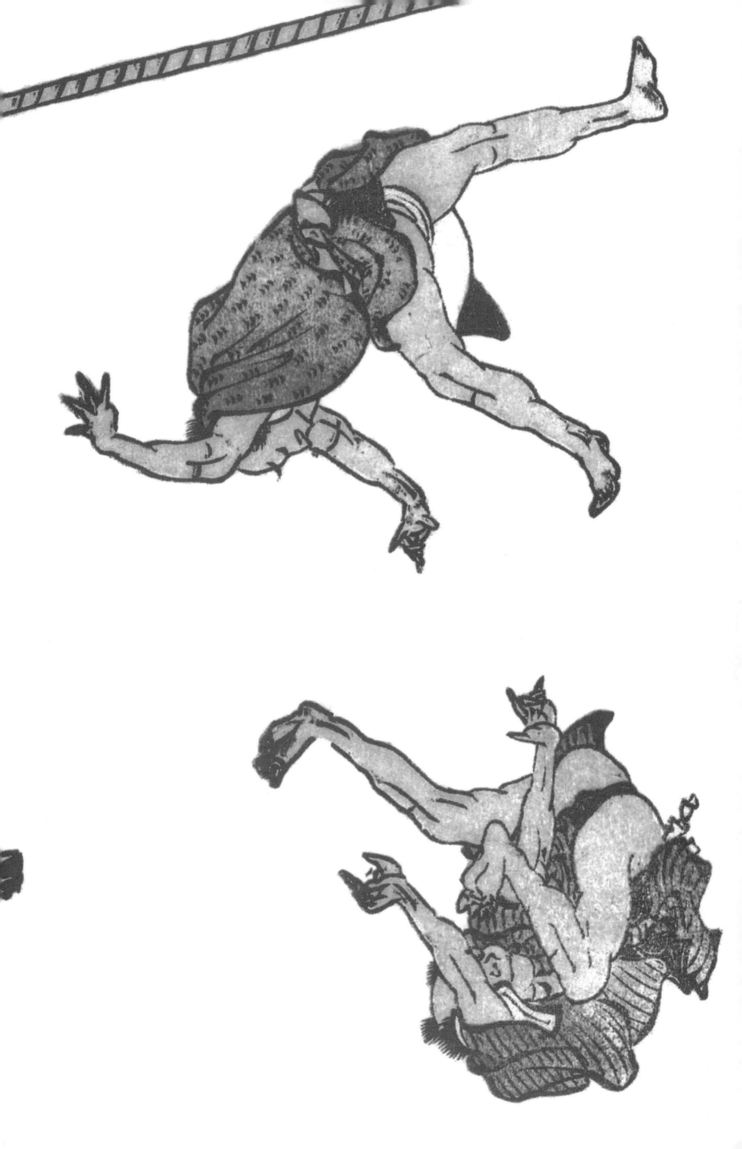

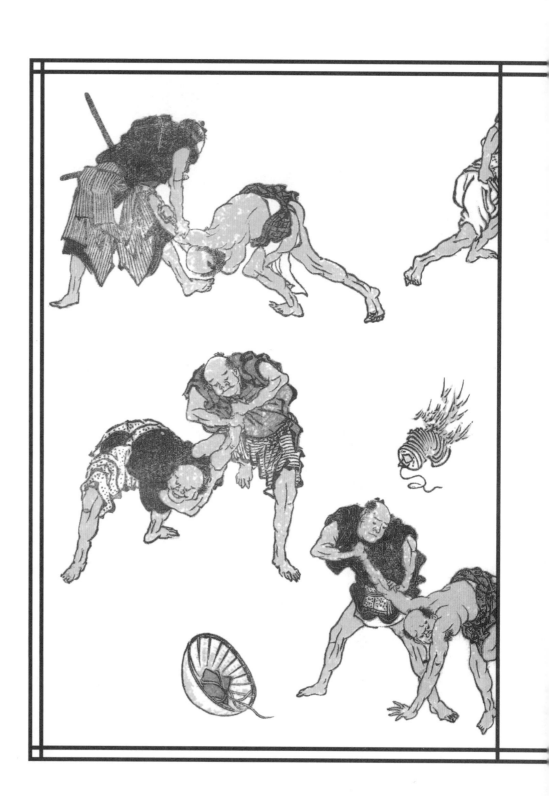

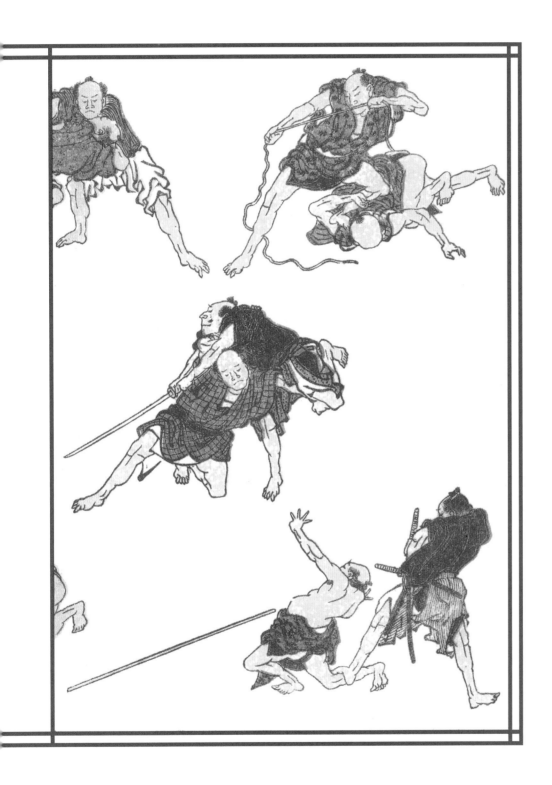

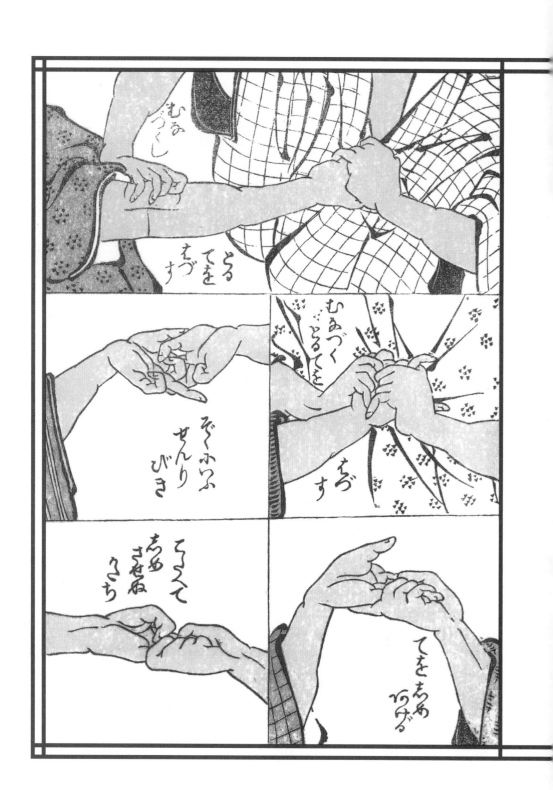

尾鶠　櫻田七雀

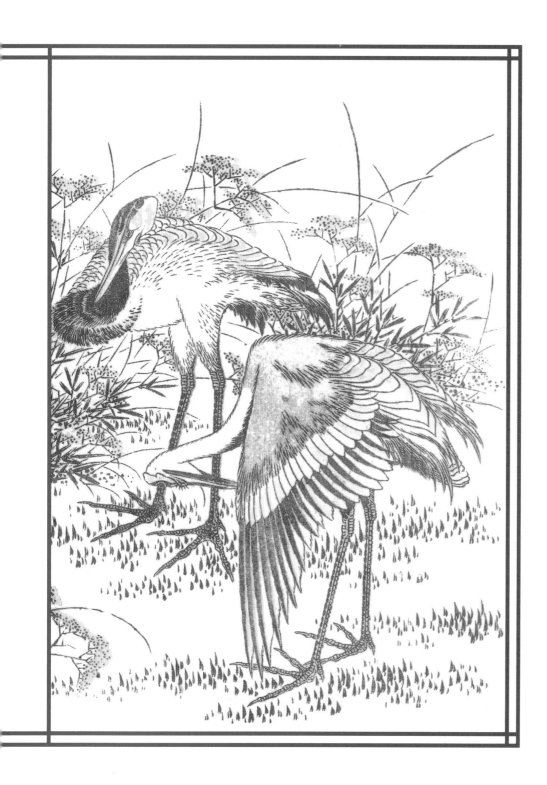

常陸
筑波の積雪

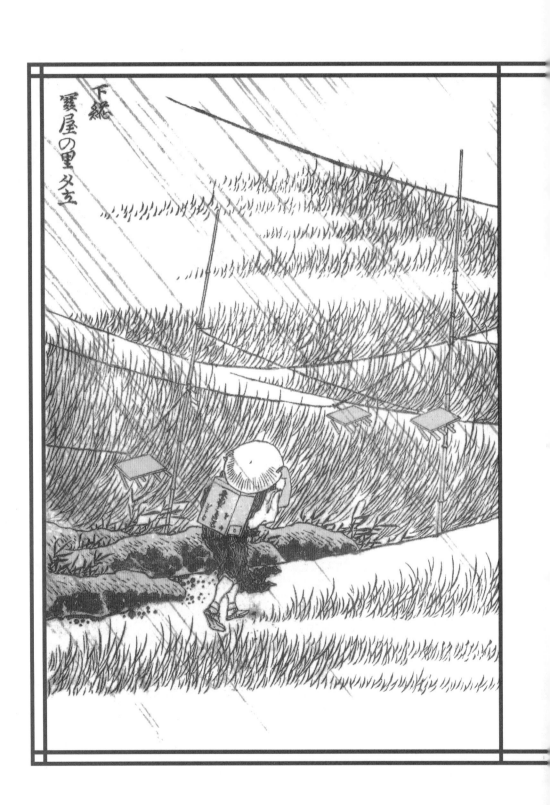

下総
簑屋の里夕立

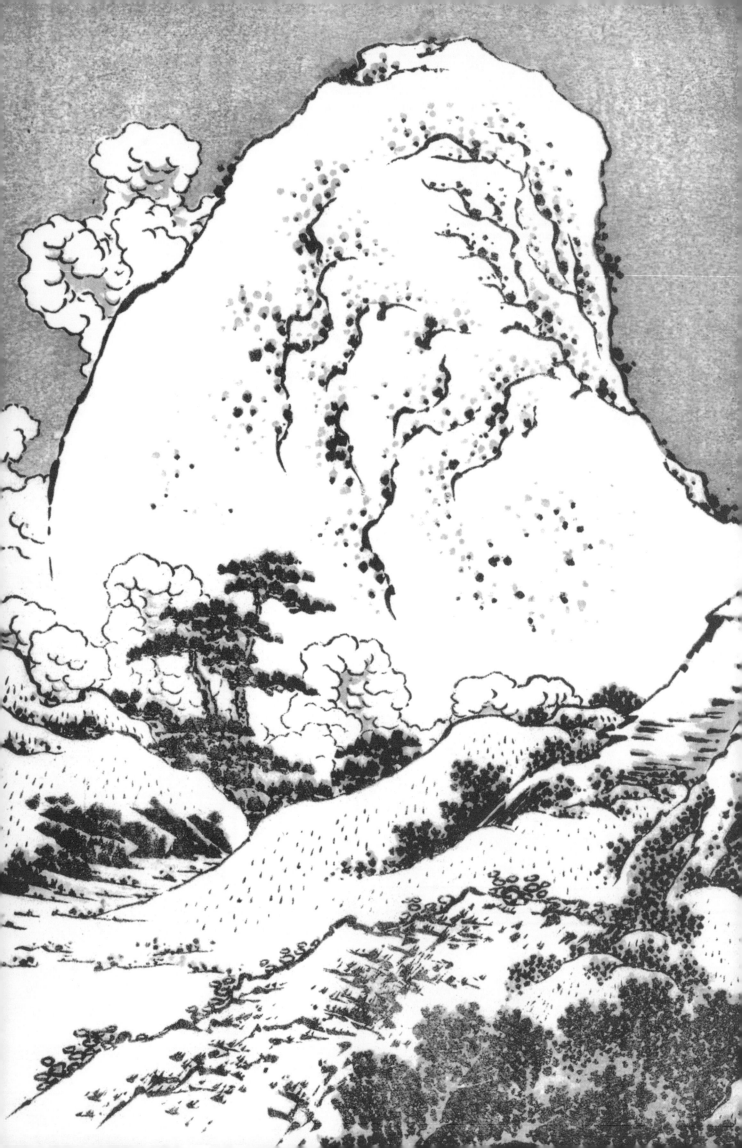

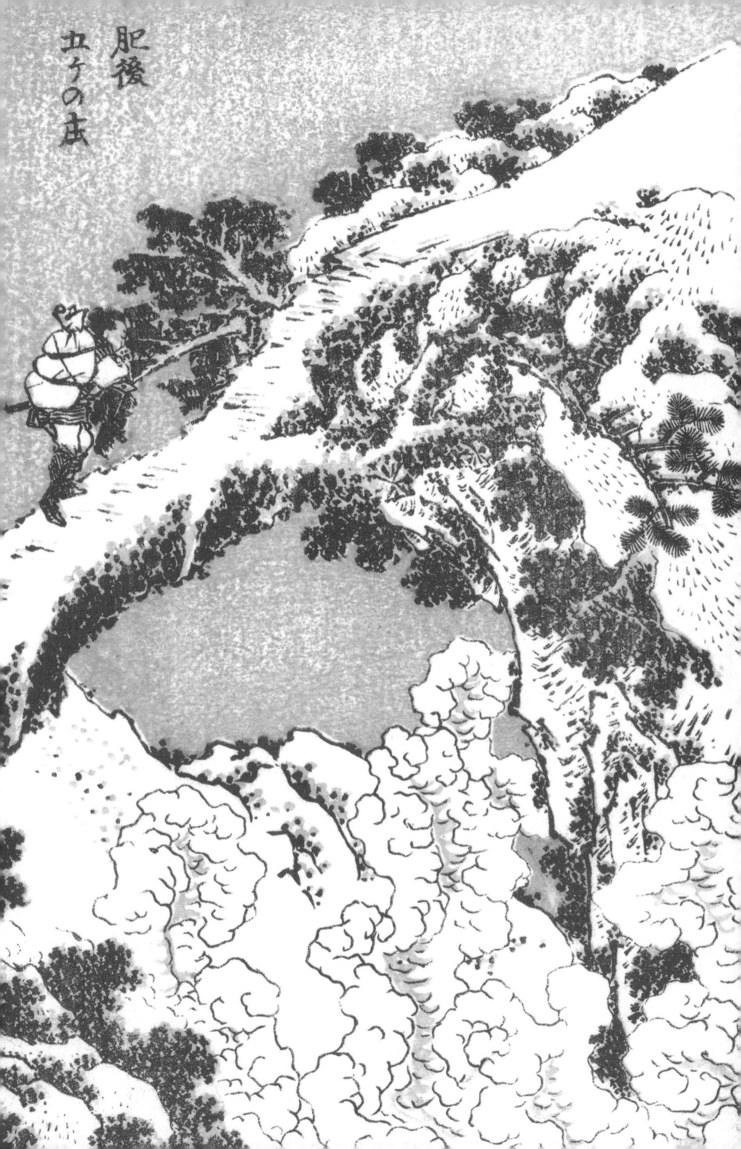

肥後
五ケの圧

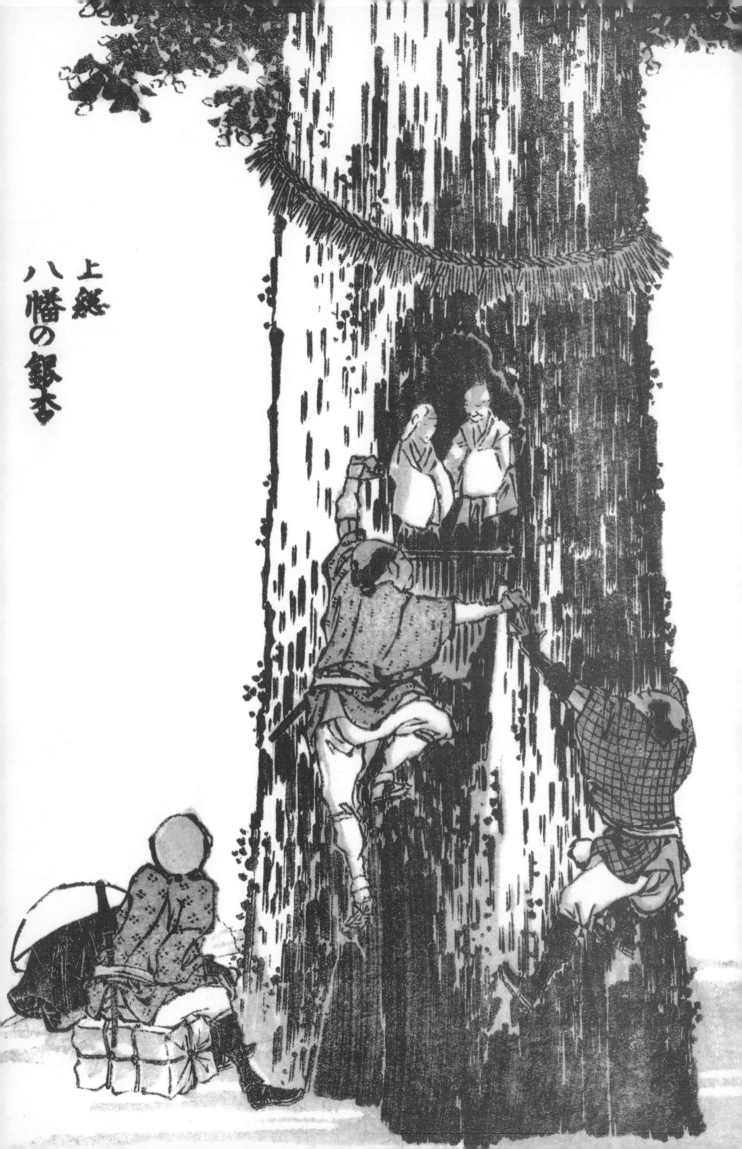

上総 八幡の銀杏

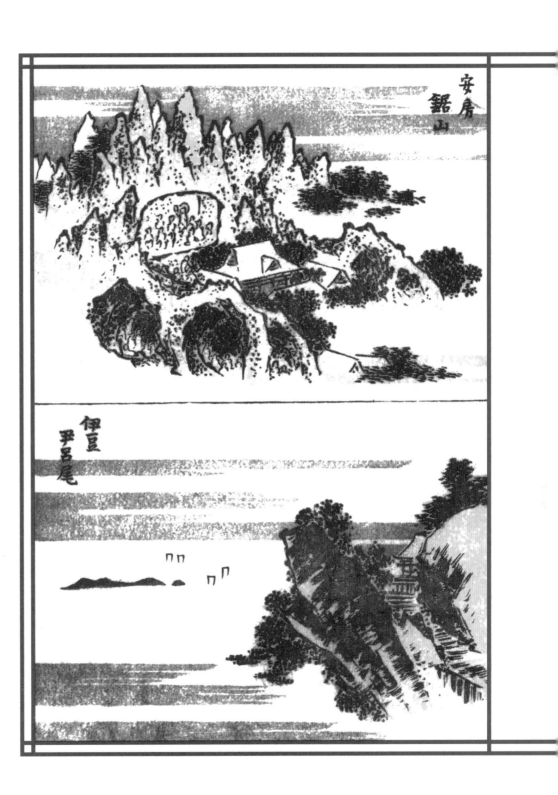

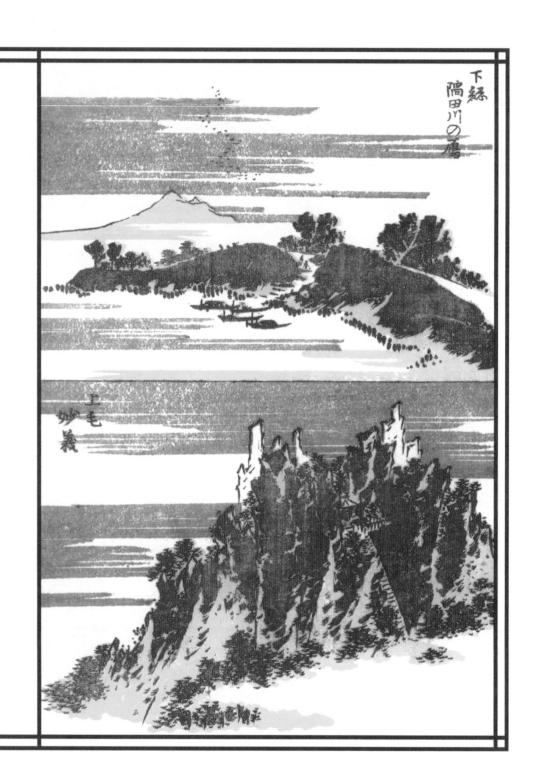

下総　隅田川の鷹

上毛　妙義

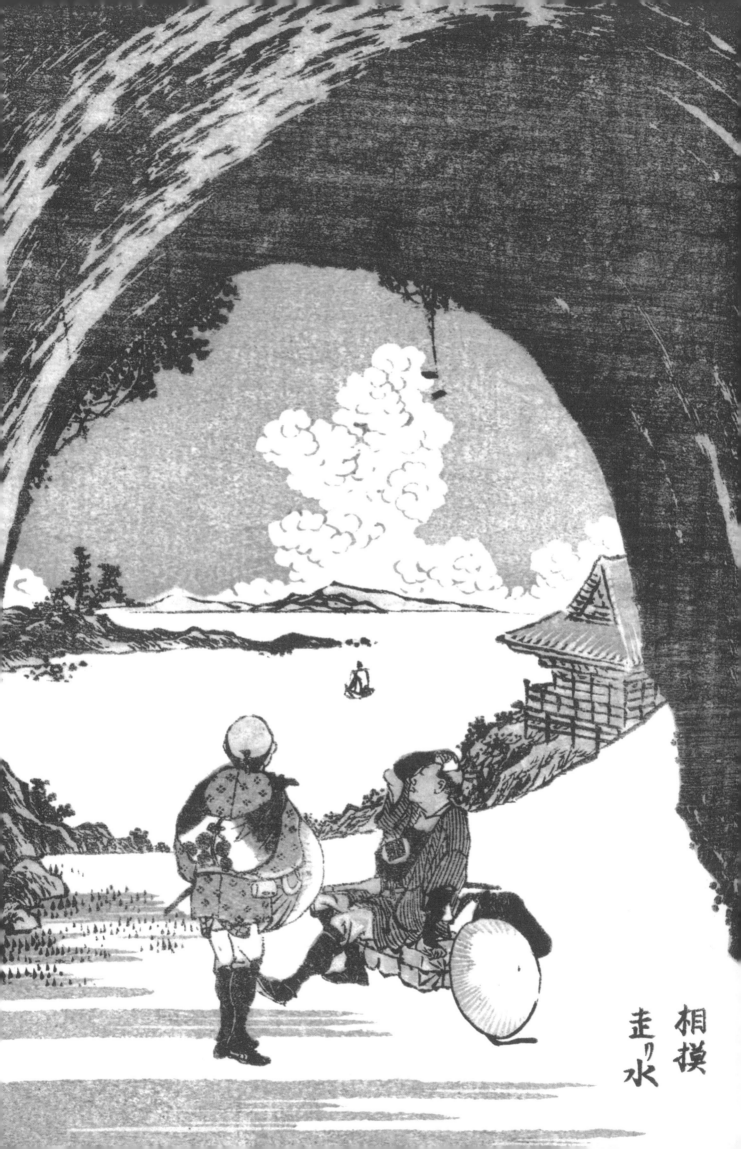

相模
走り水

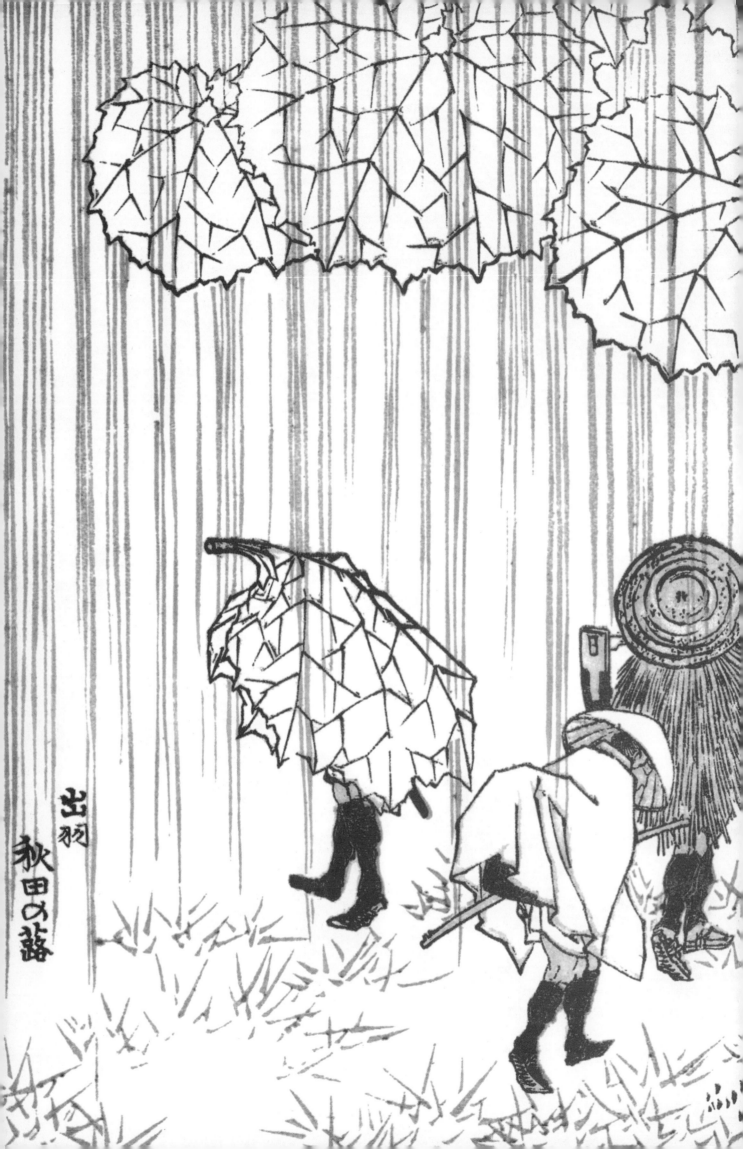

出羽

秋田の蕗

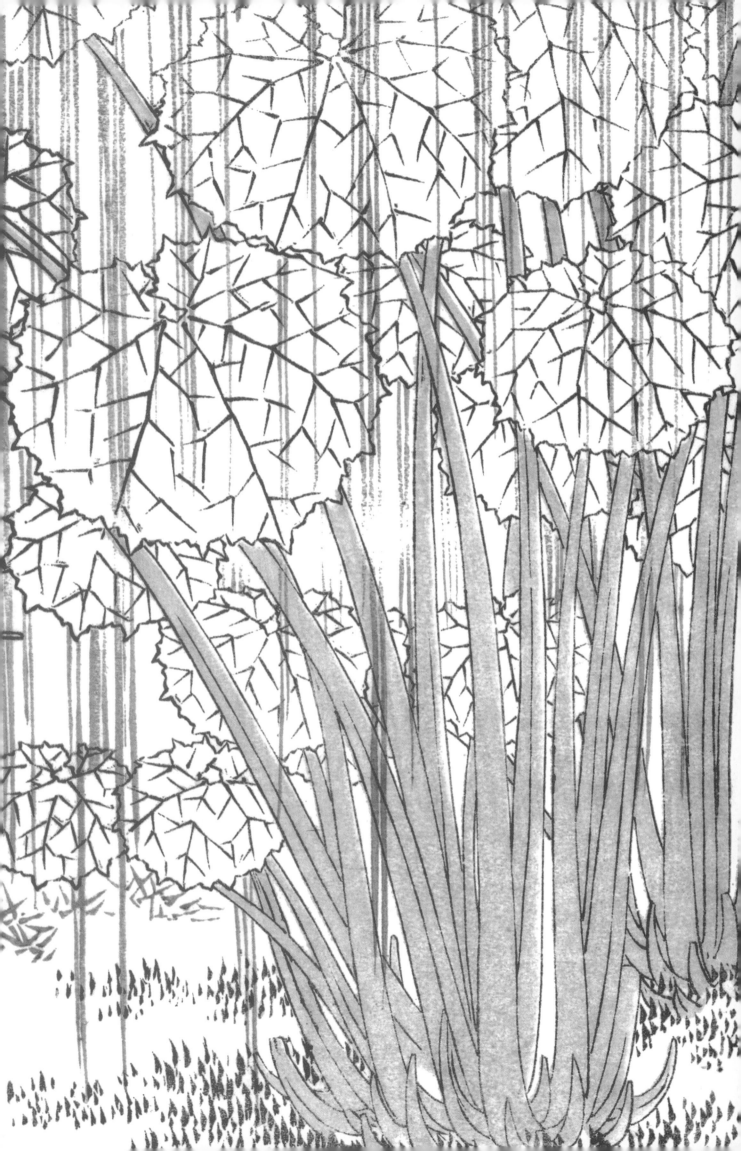

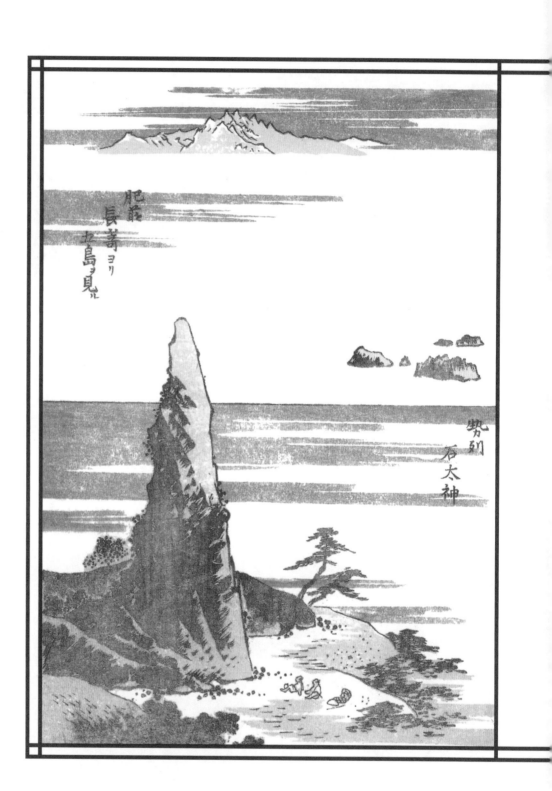

肥前 長壽女島ヨリ見ル

勢別 石太神

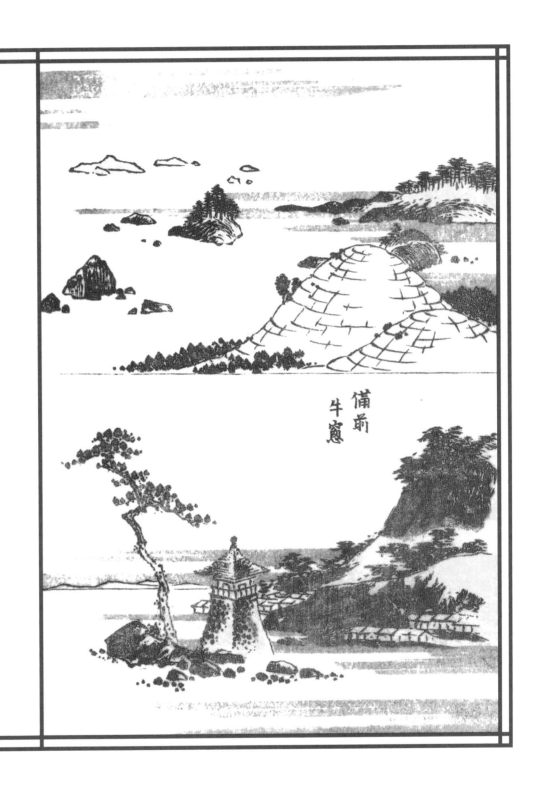

備前
牛窓

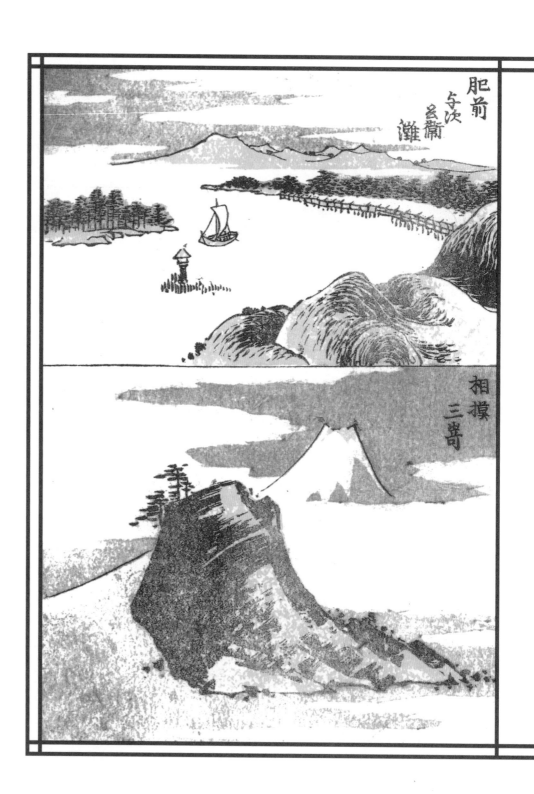

肥前
与次
ゑ蘭
灘

相摸
三崎

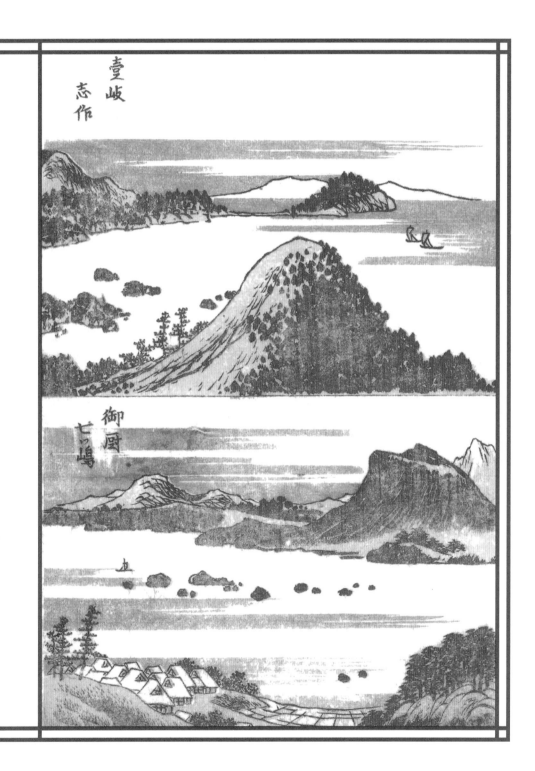

壹岐
志作

御厨
七つ嶋

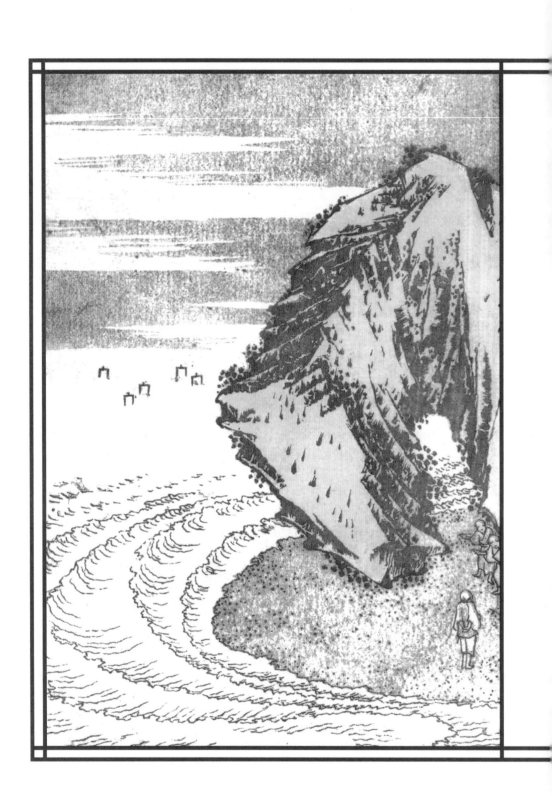

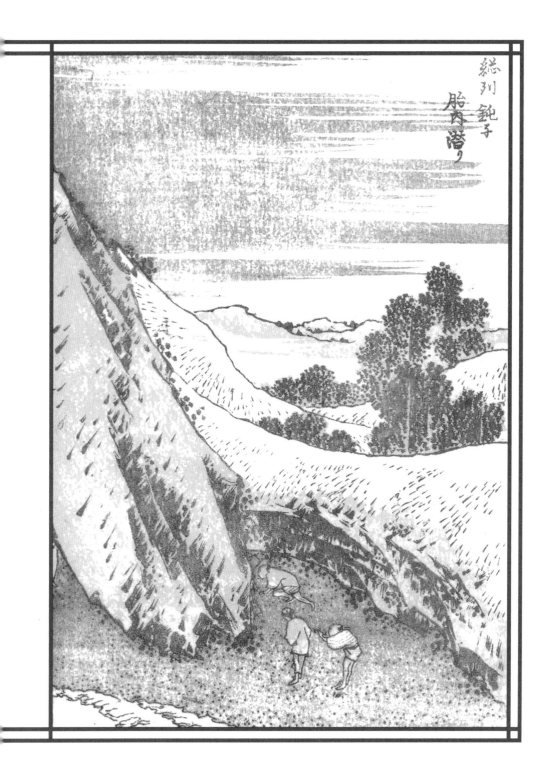

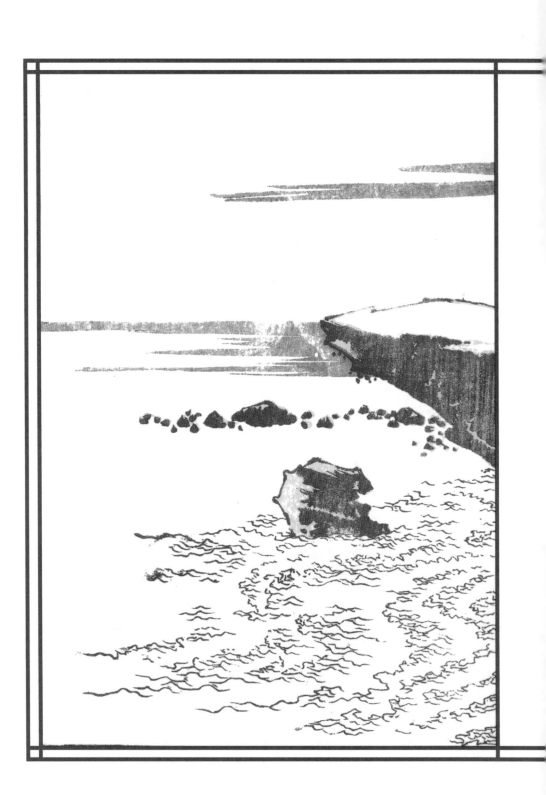

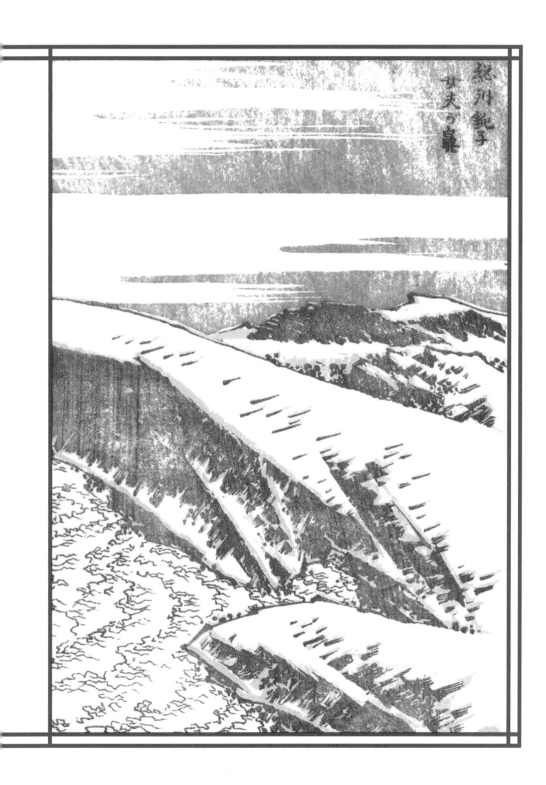
総州銚子
女夫ヶ鼻

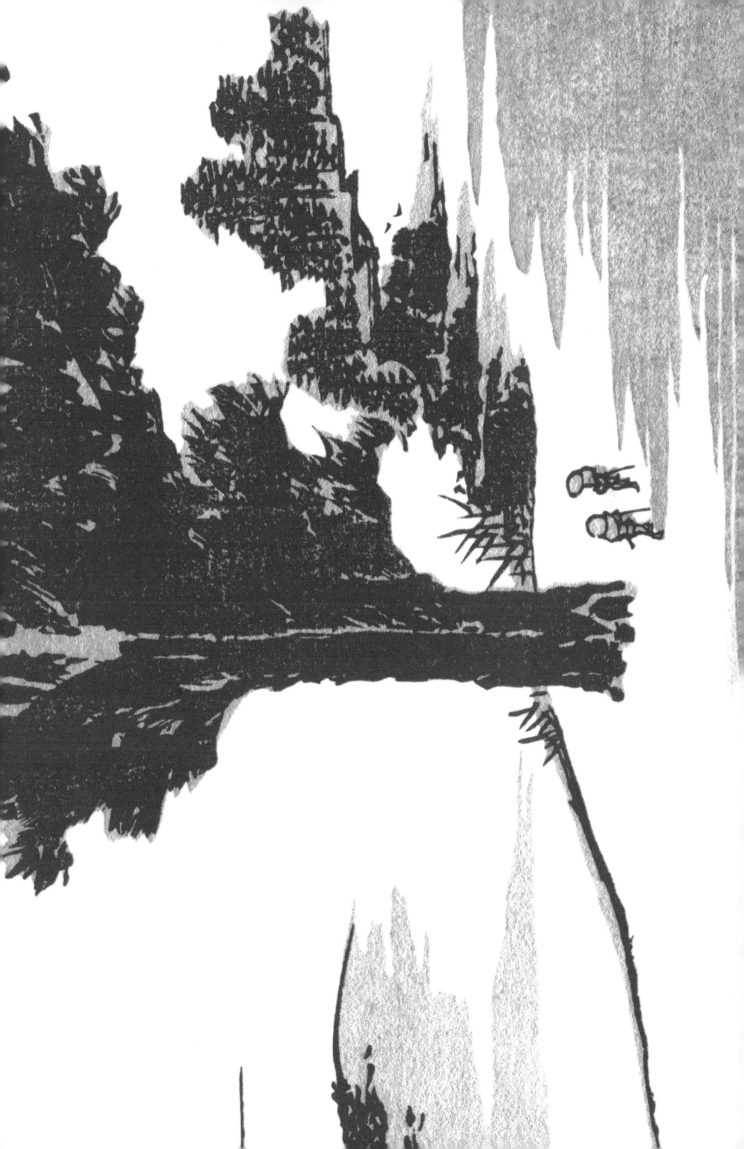

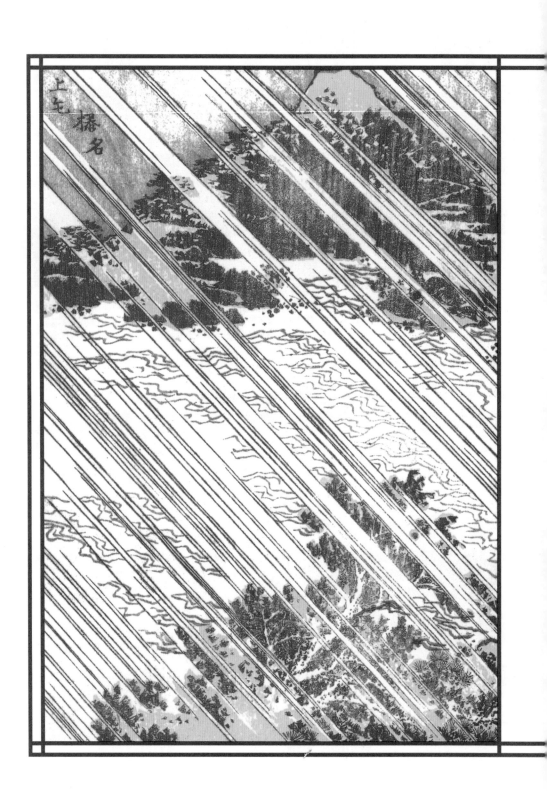

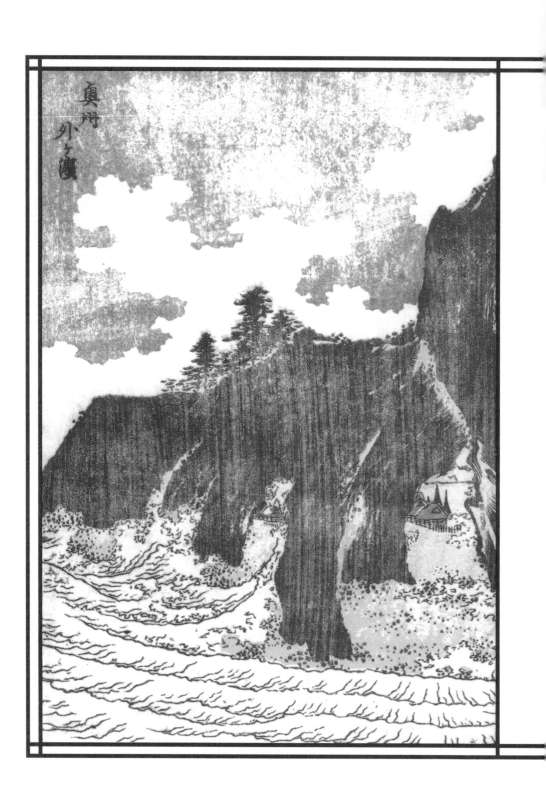

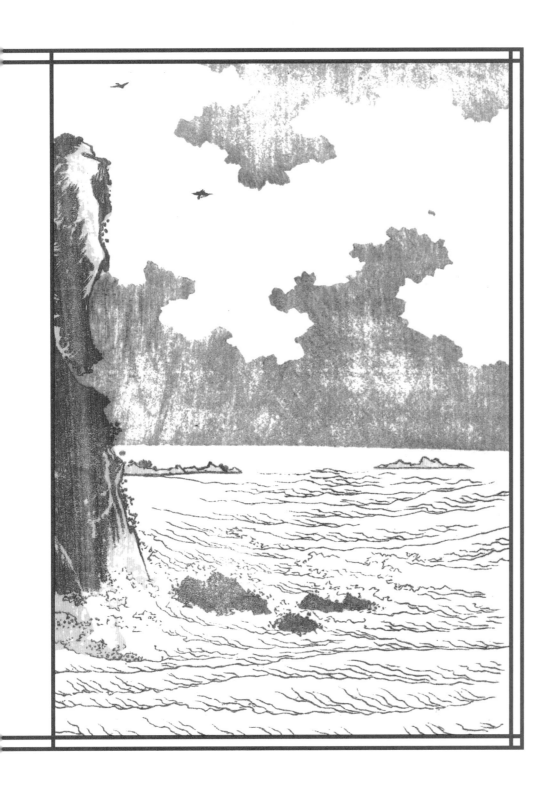

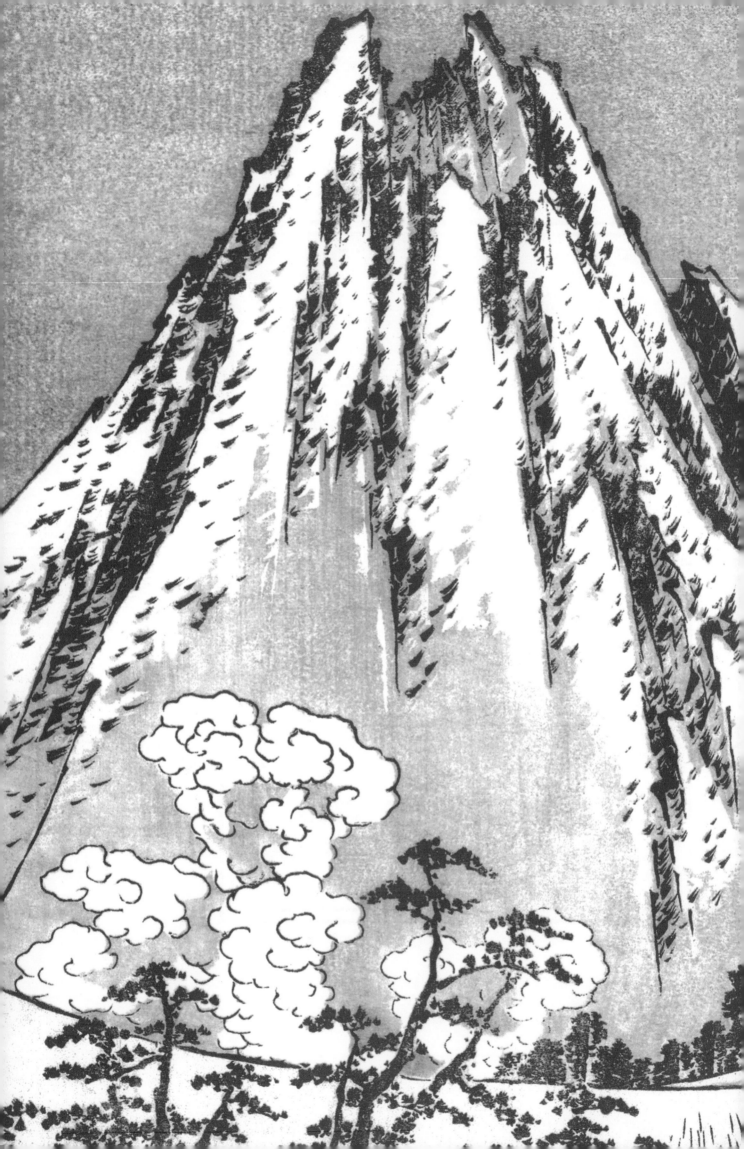

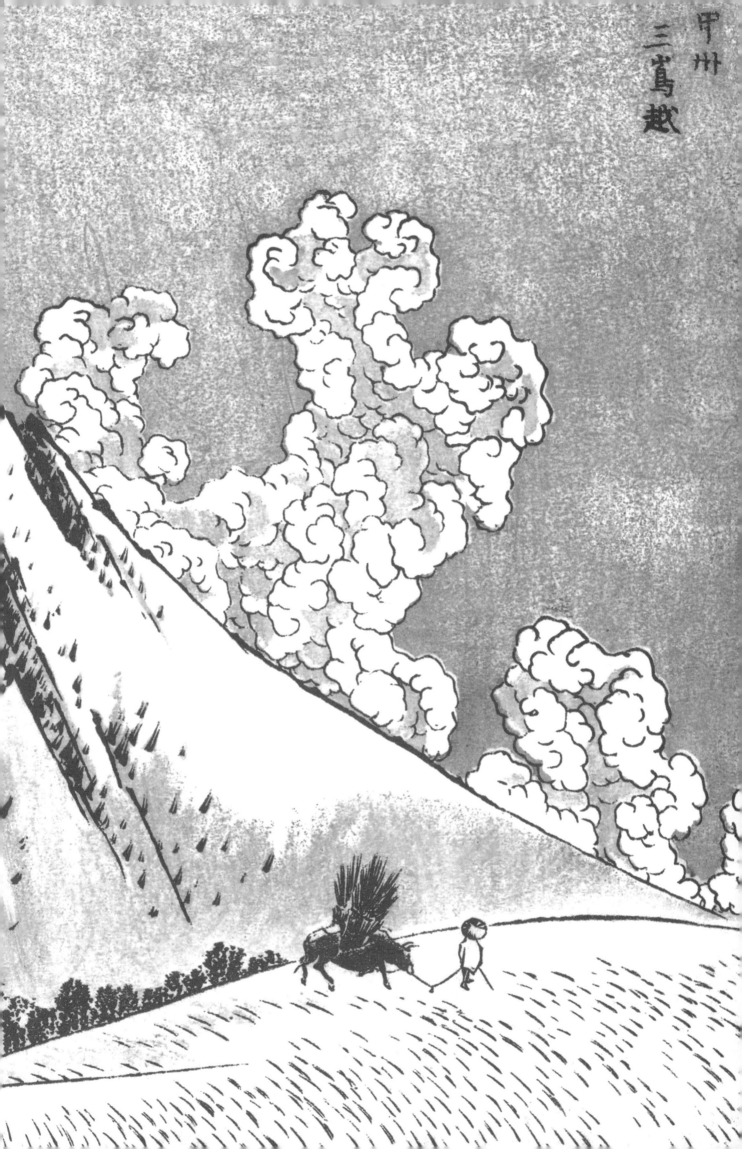

提秤
ちぎ
たくり
勝男木
かつをぎ
七起
ななおこし

大苫邊尊
あ と と あ べ の み こ と

黄帝元妃西陵氏

稚産霊日神
わくむすびのかみ

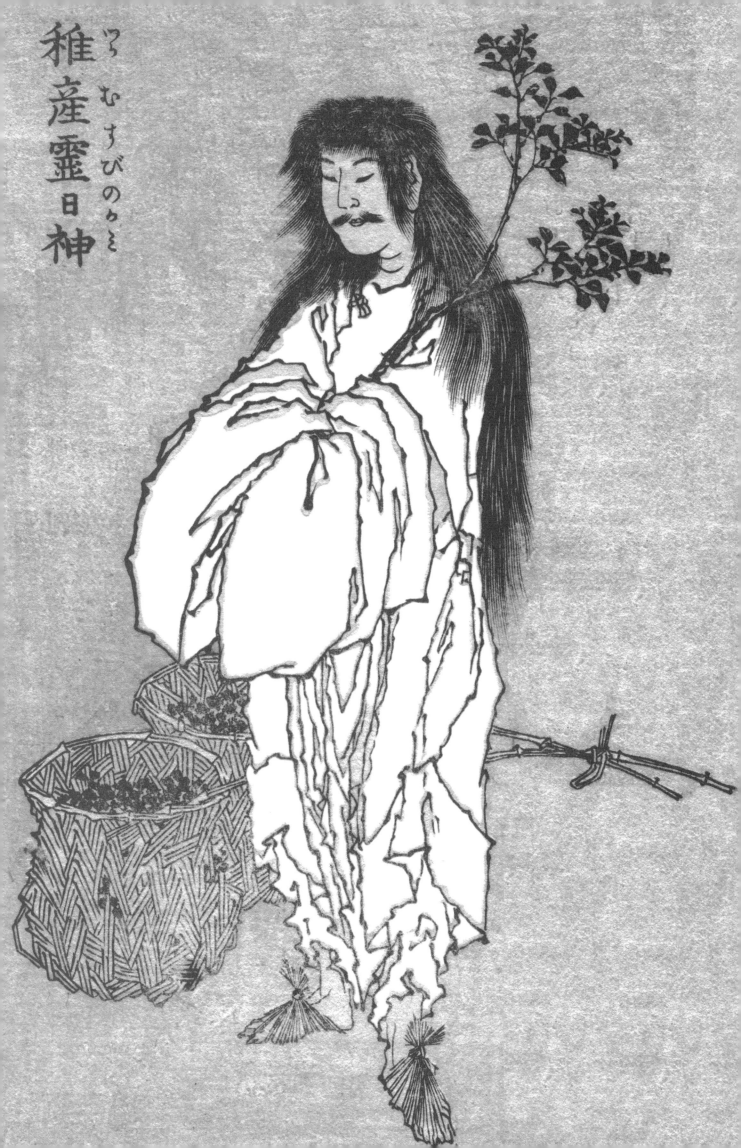

唯一御造

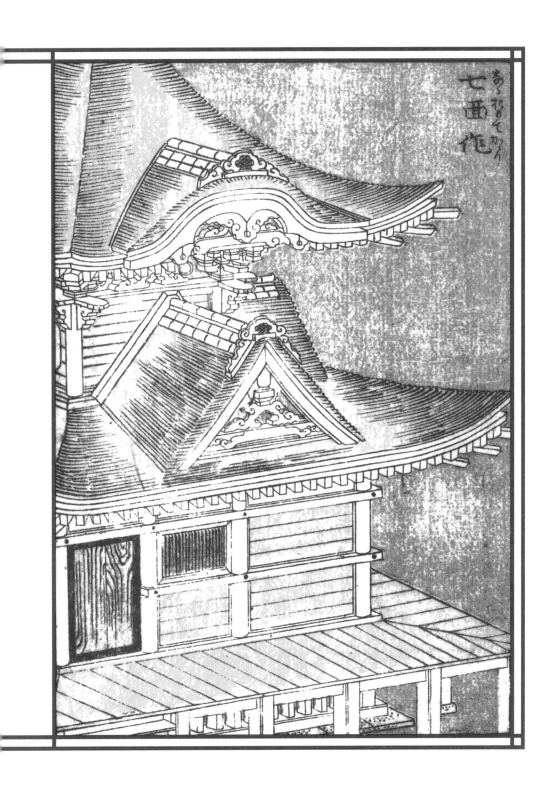

七面作
あくやねそかく

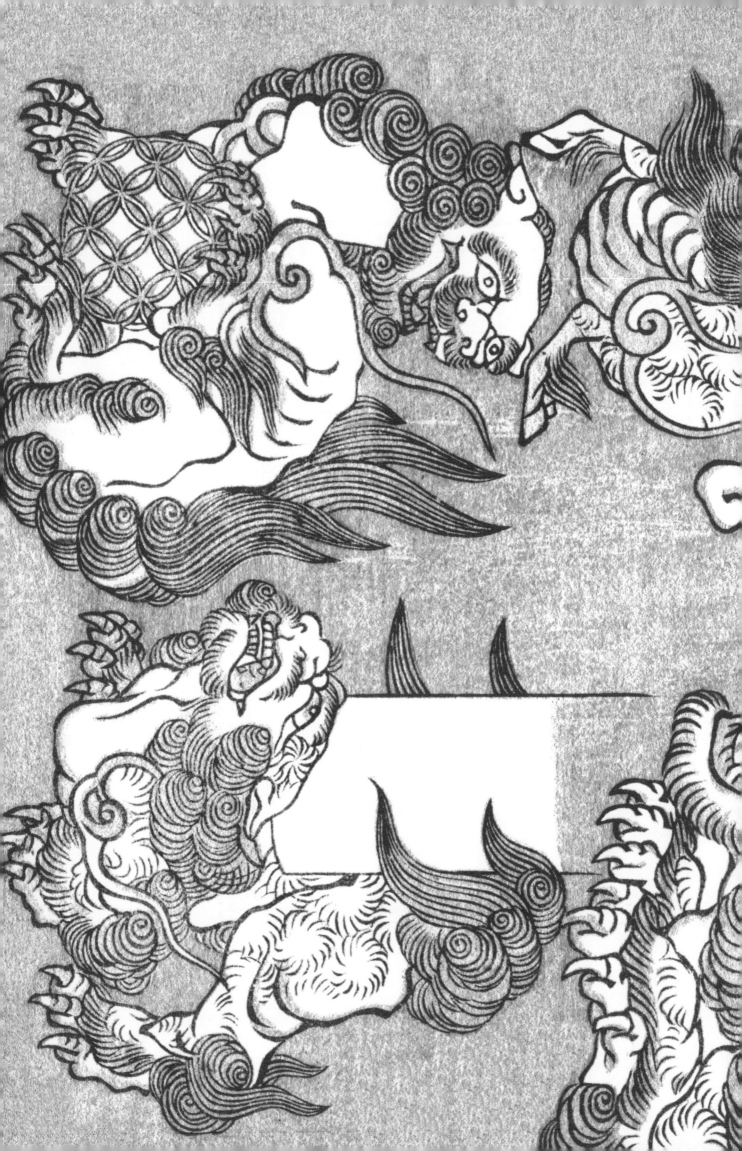

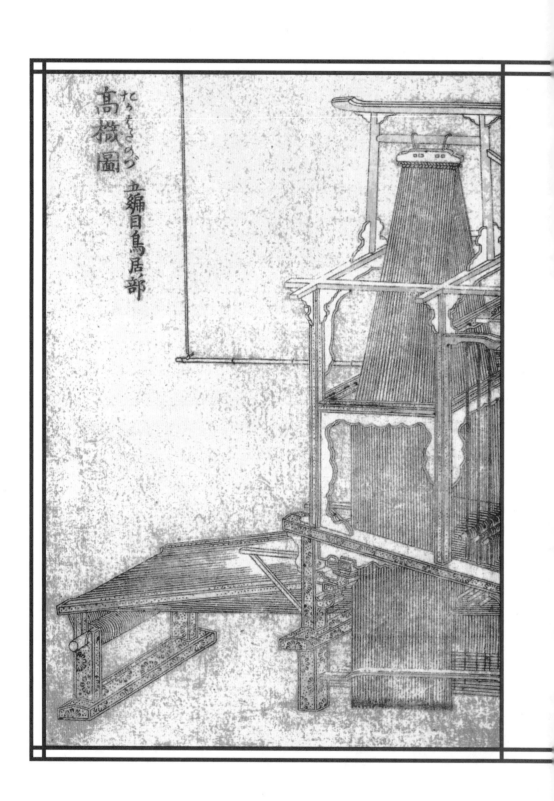

高機圖 五編目鳥居部

漢土

絹機 みがち

五編目鳥居ノ部

車ノ部

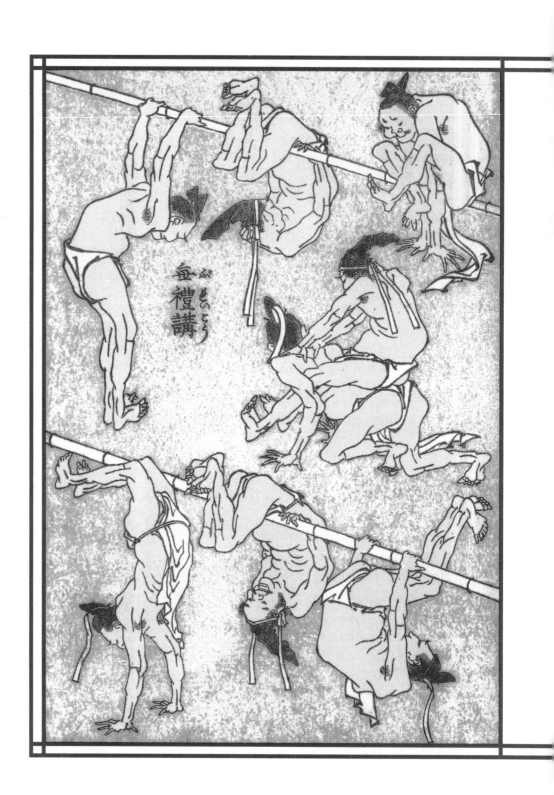

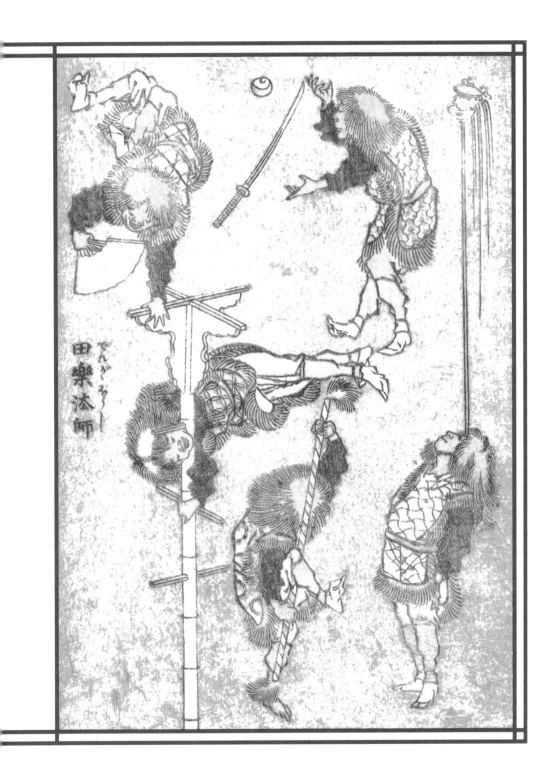

でんがくほうし
田樂法師

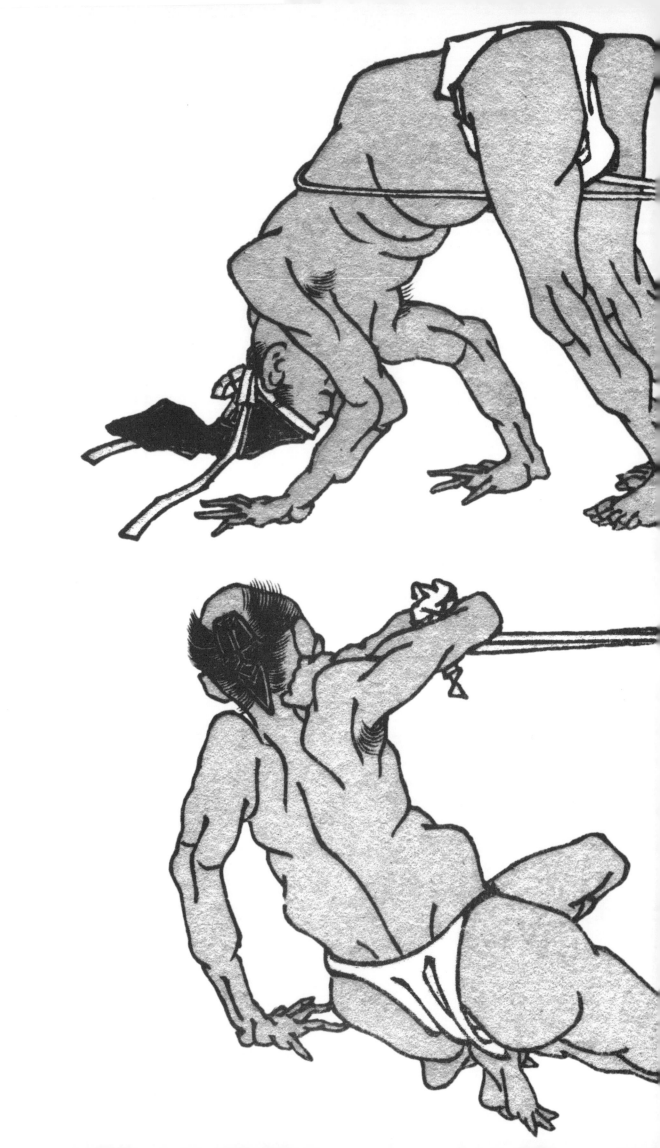

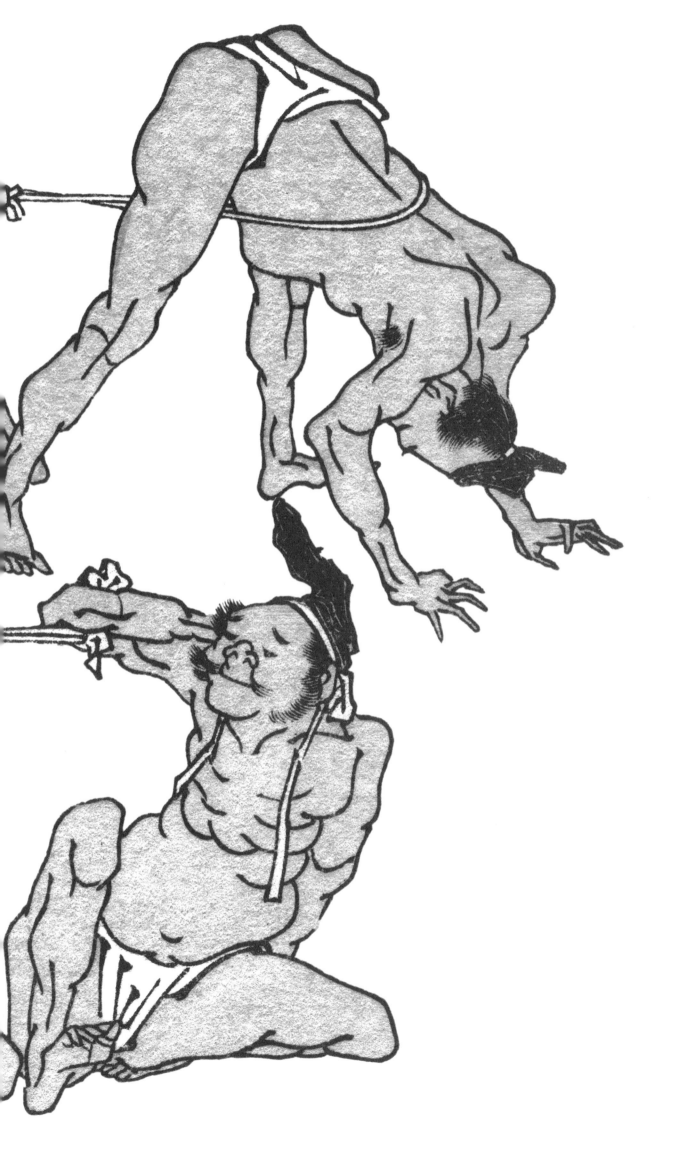

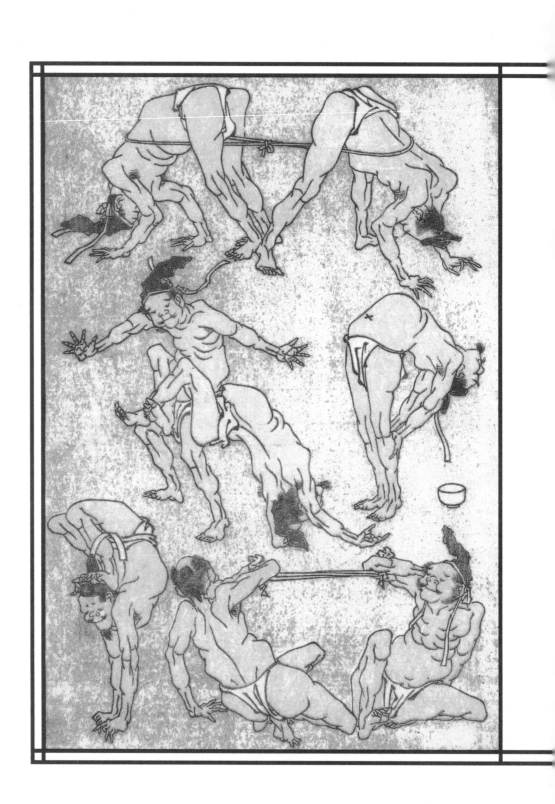

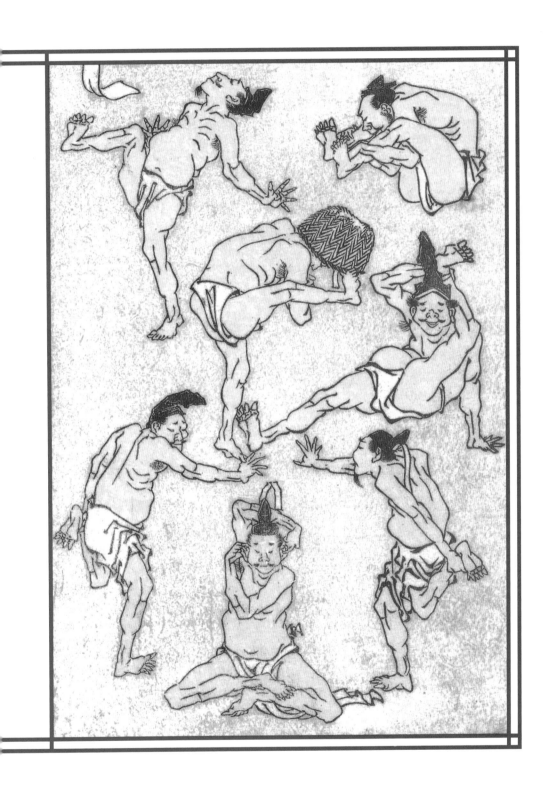

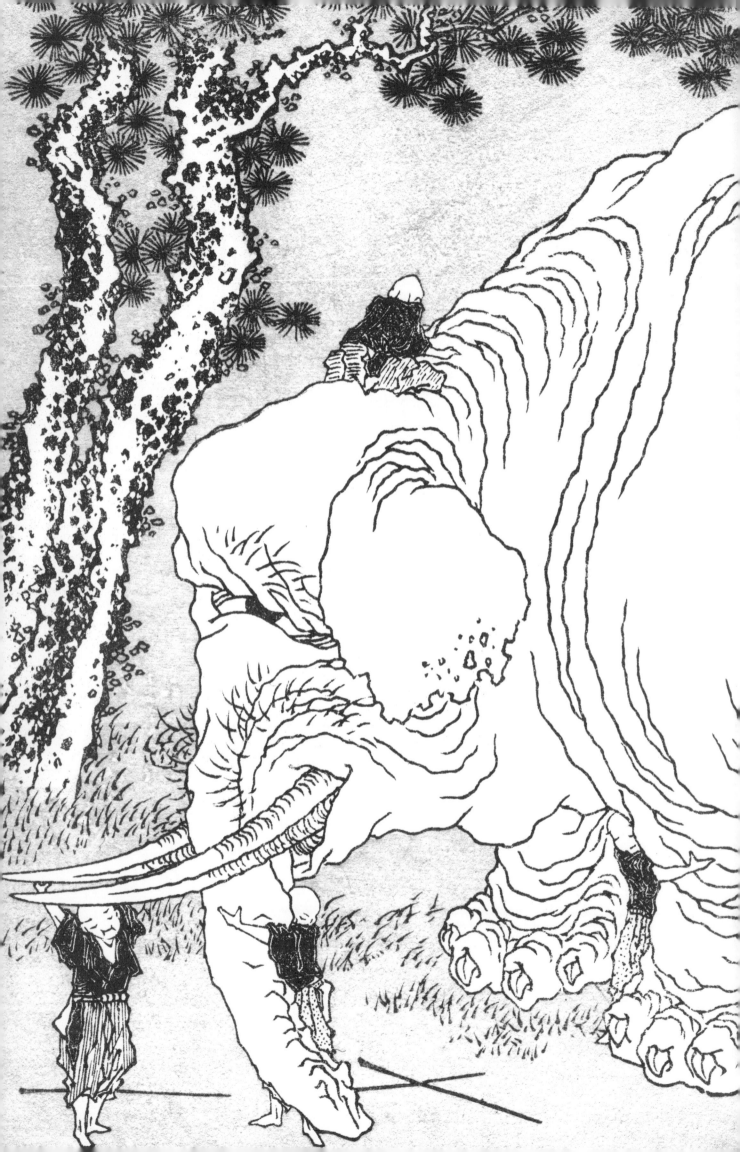

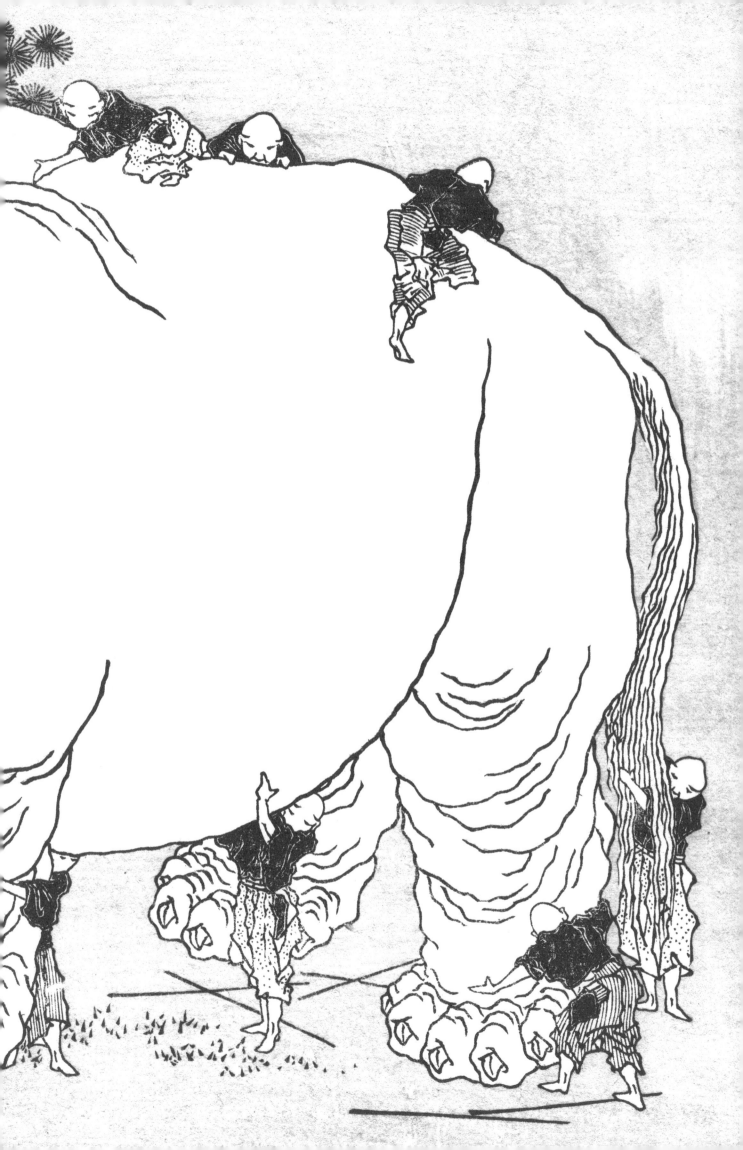

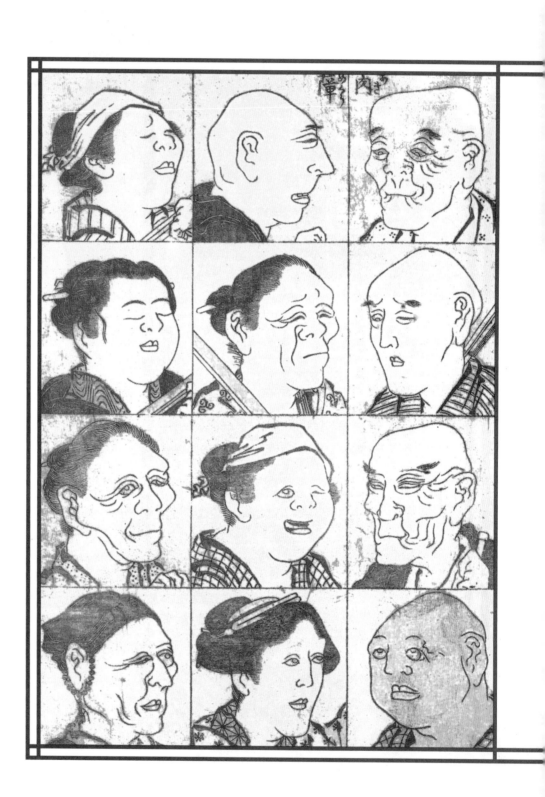

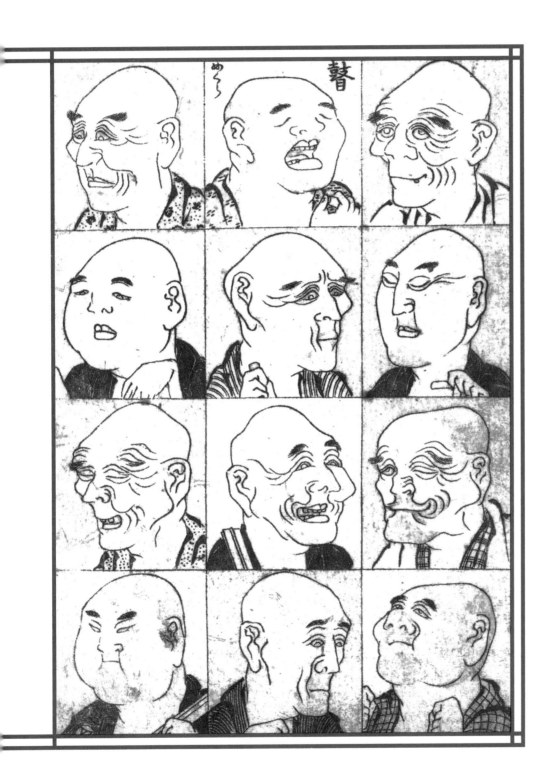

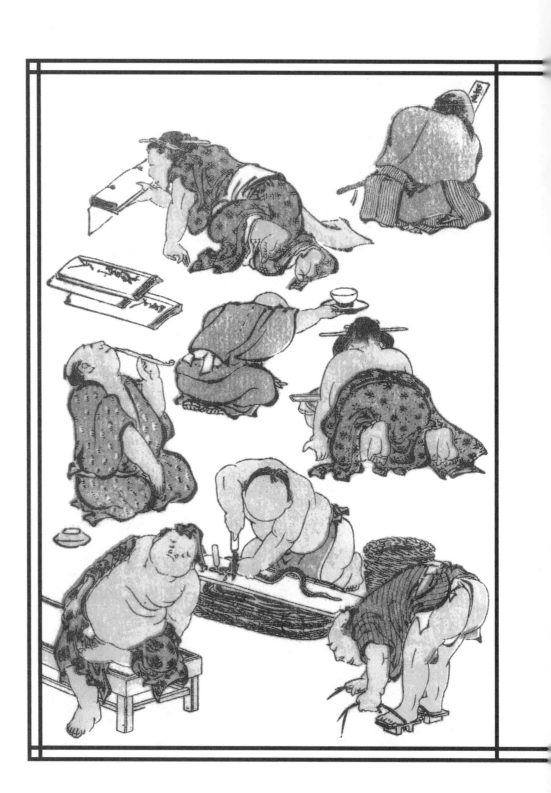

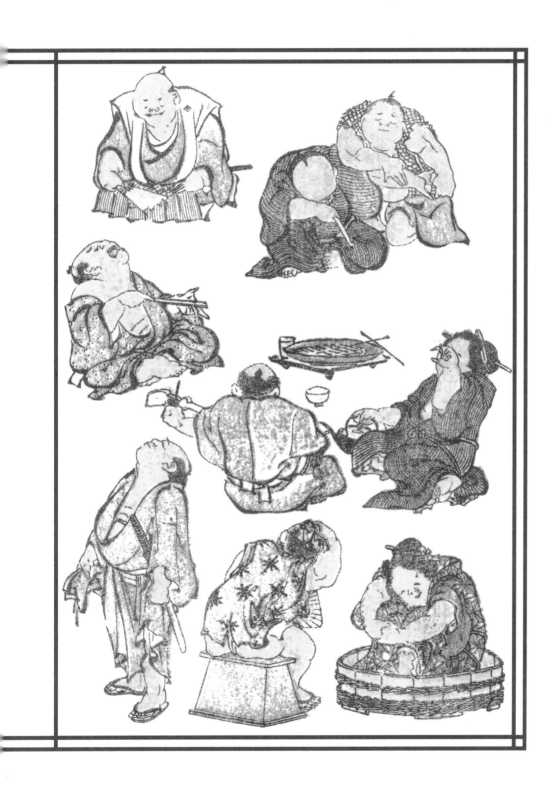

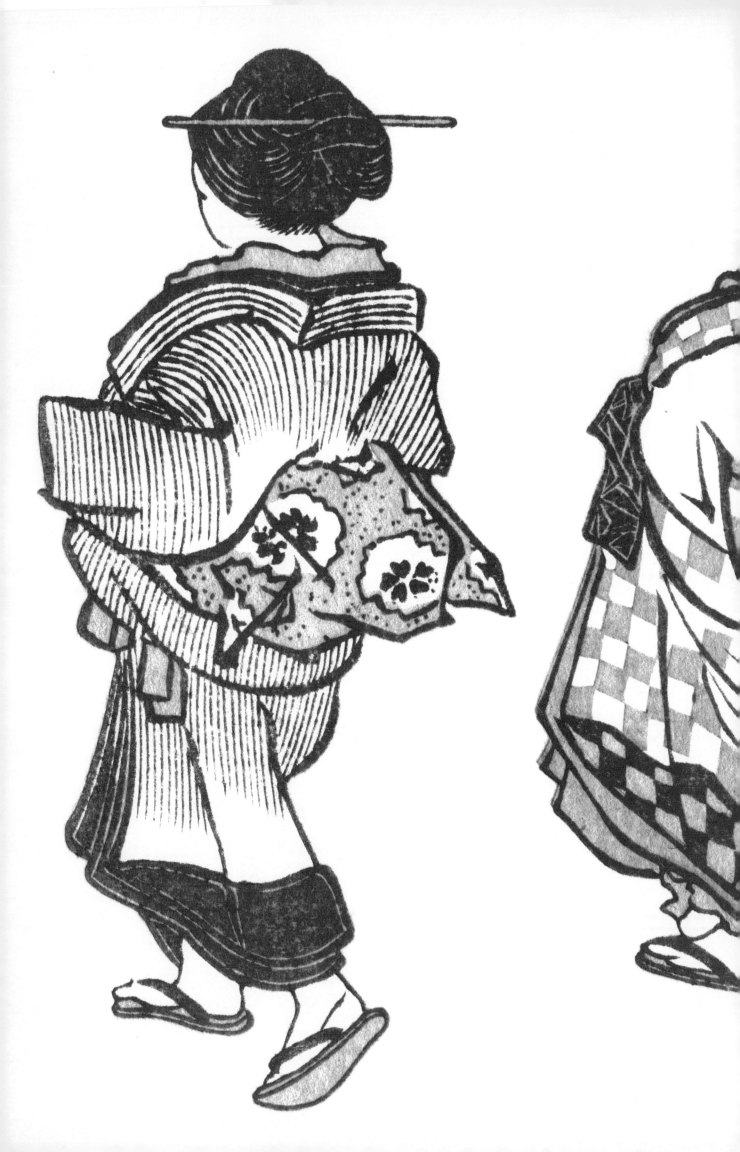

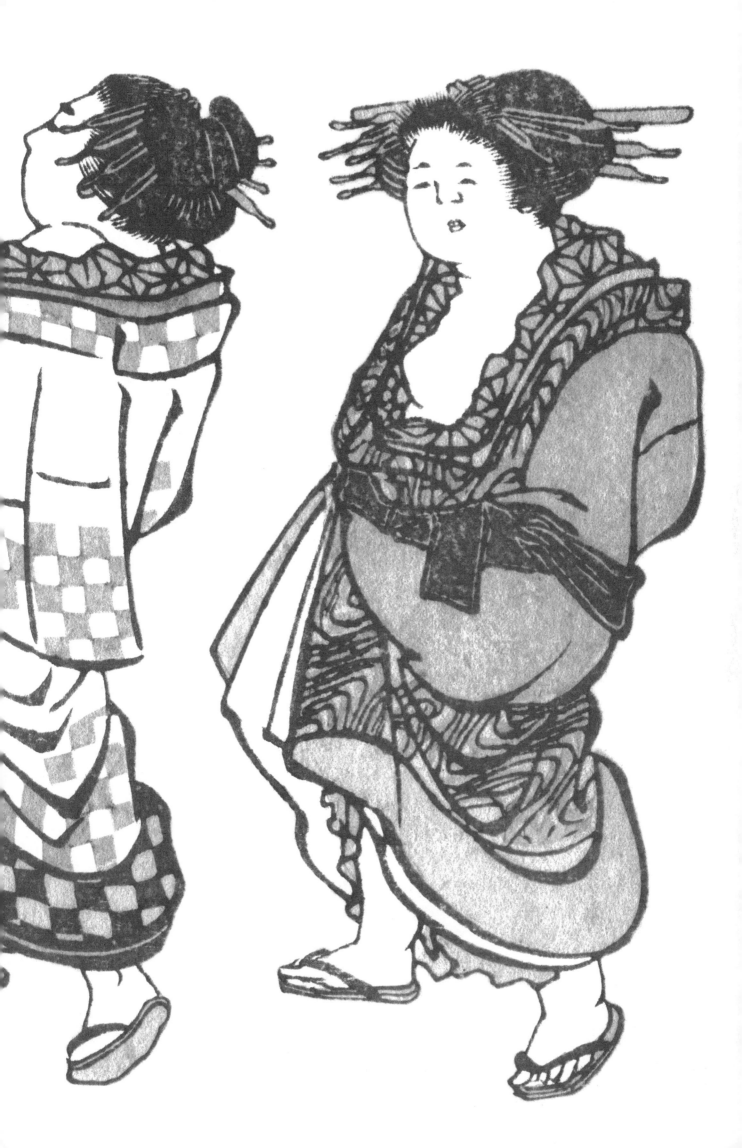

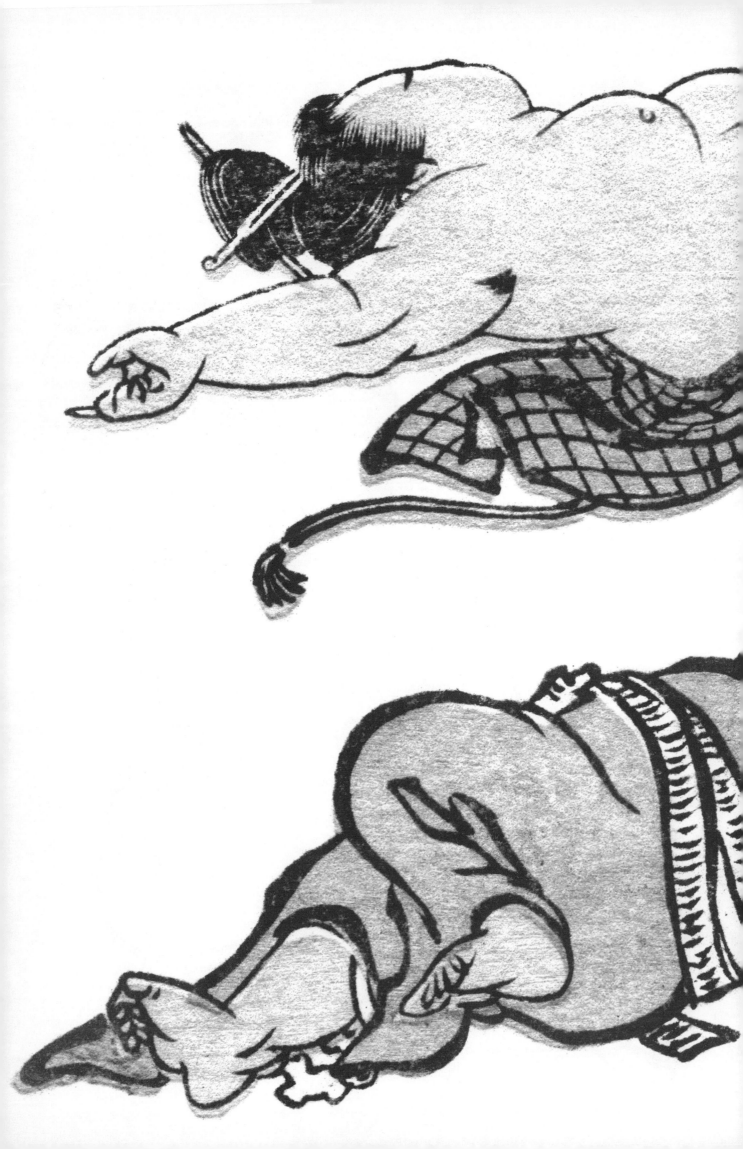

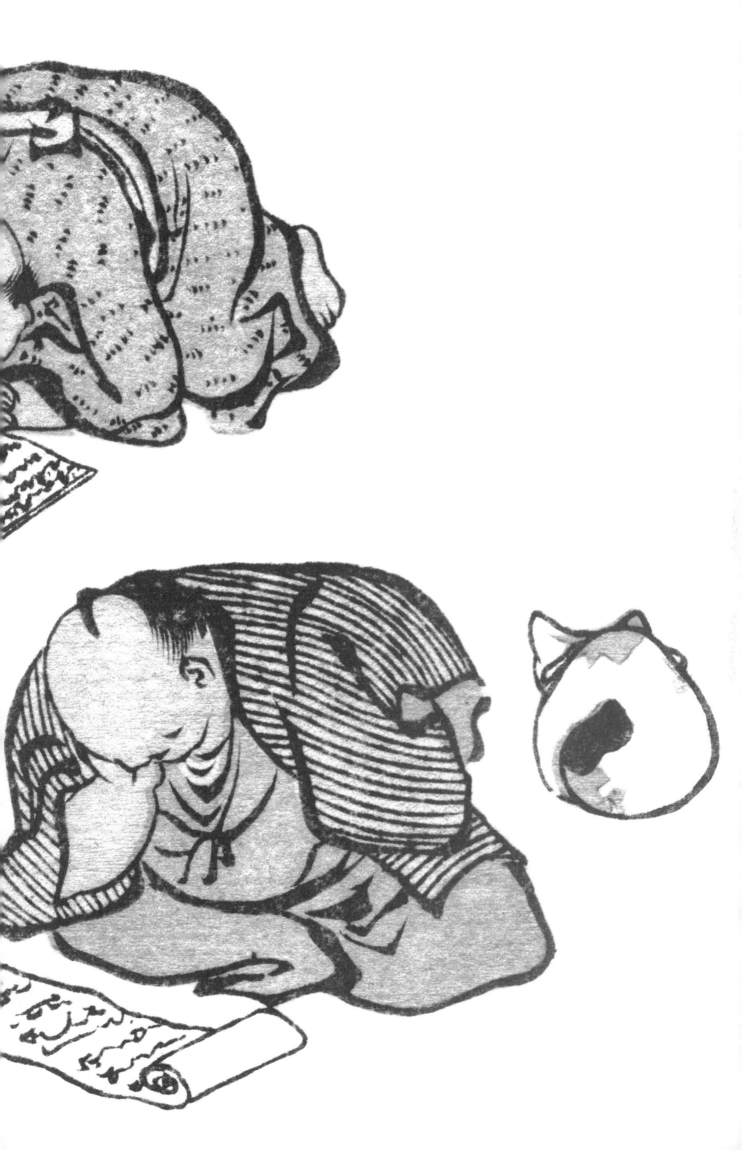

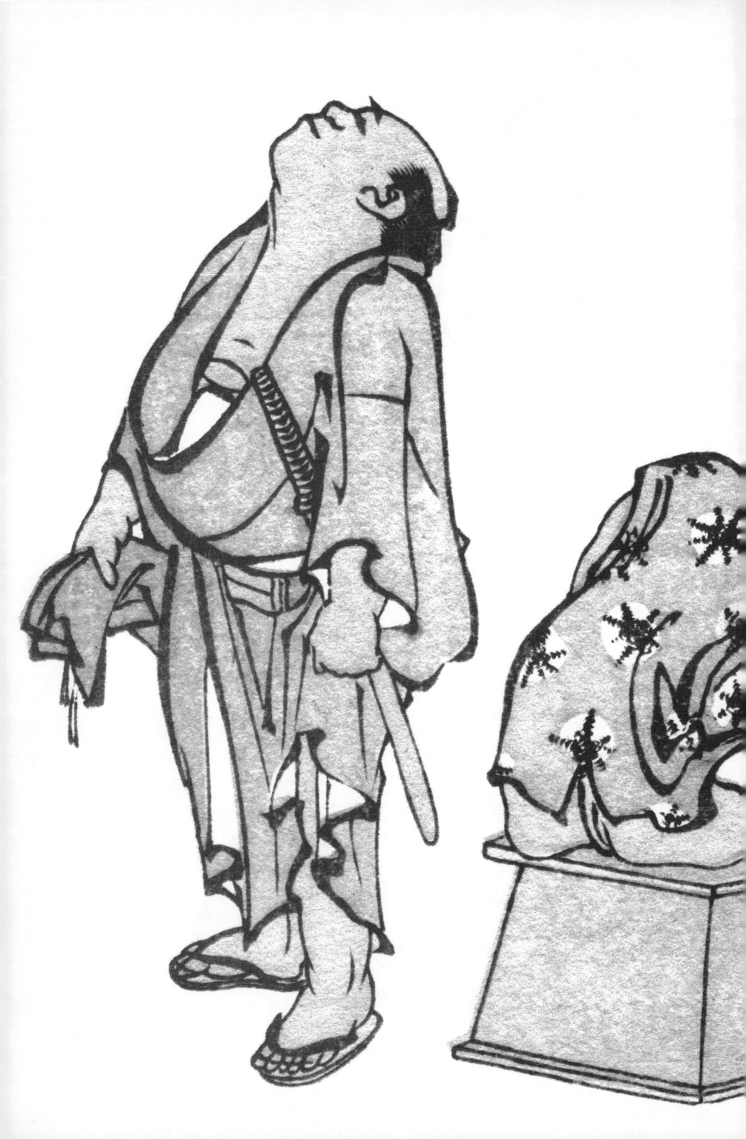

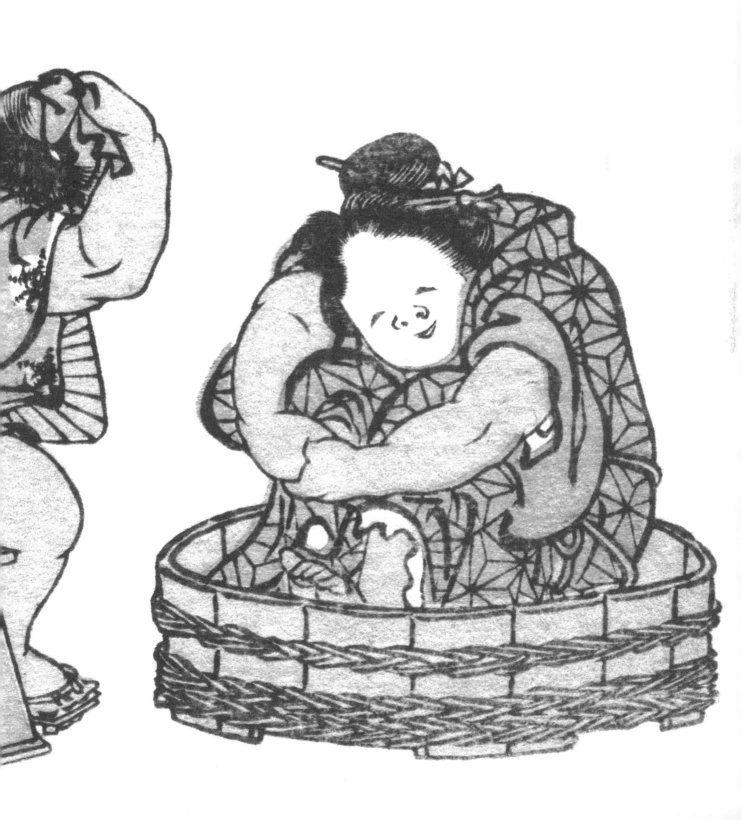

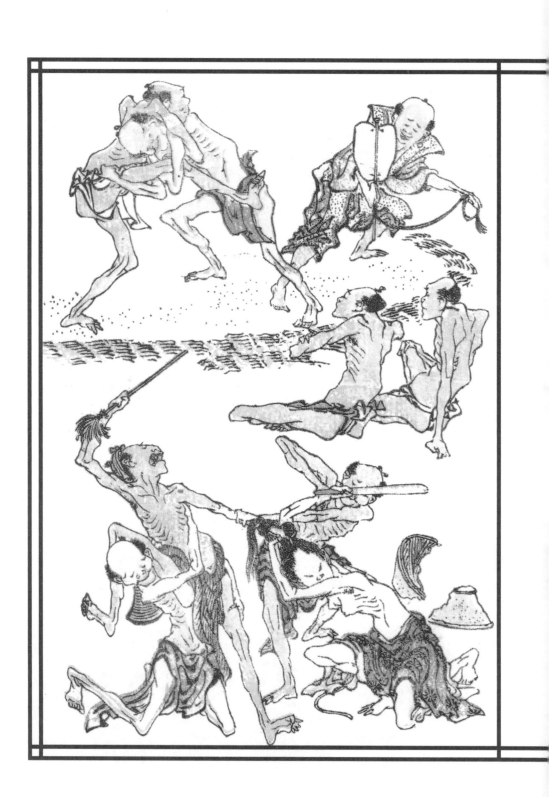

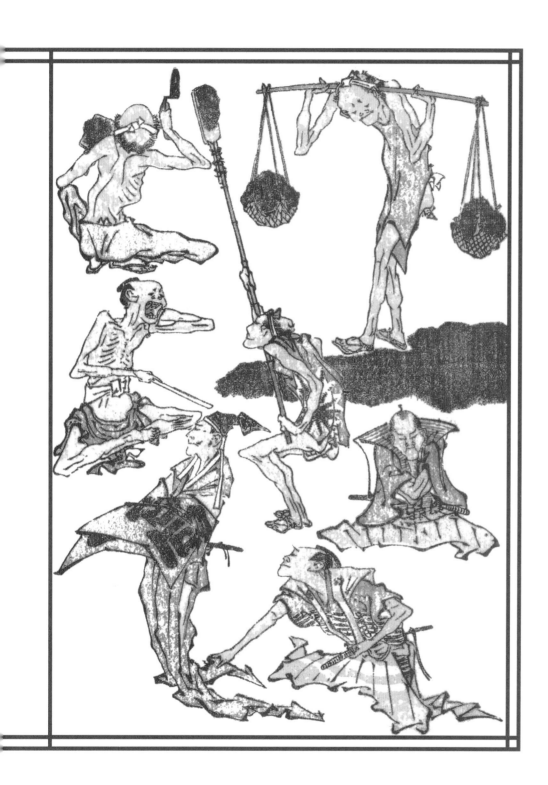

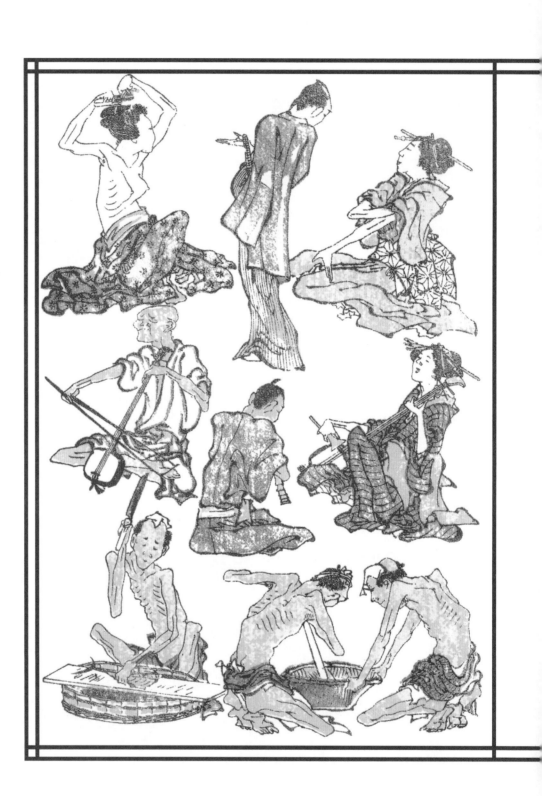

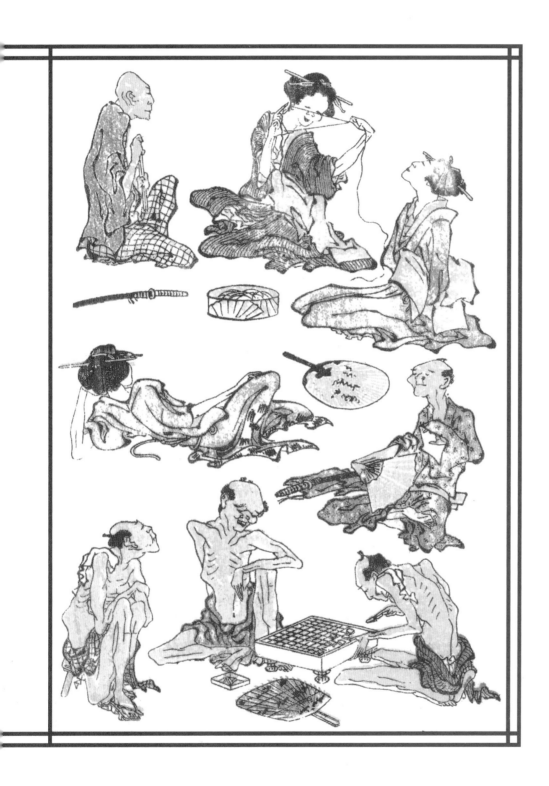

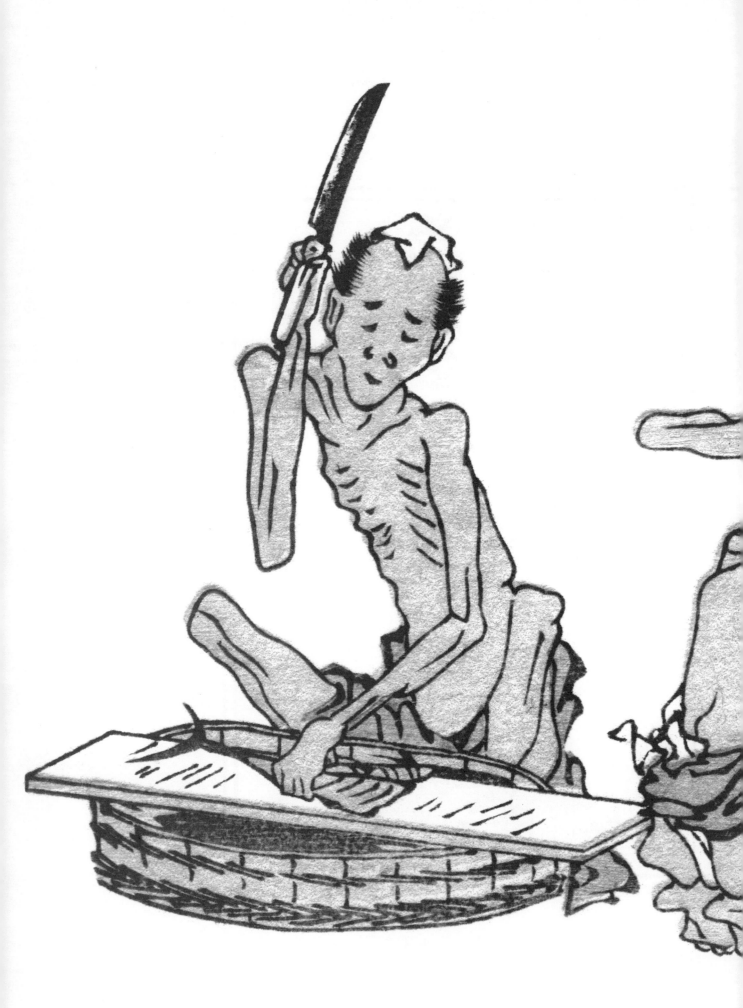

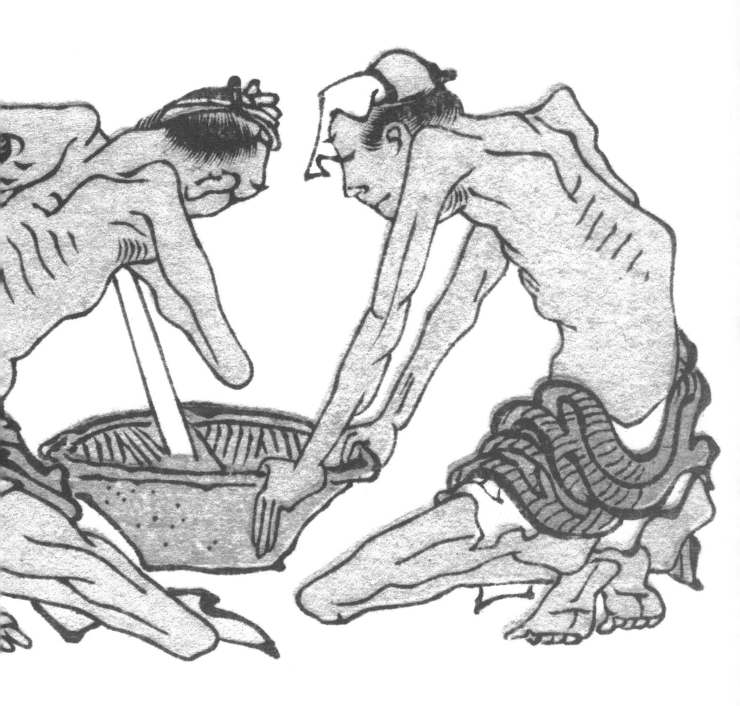

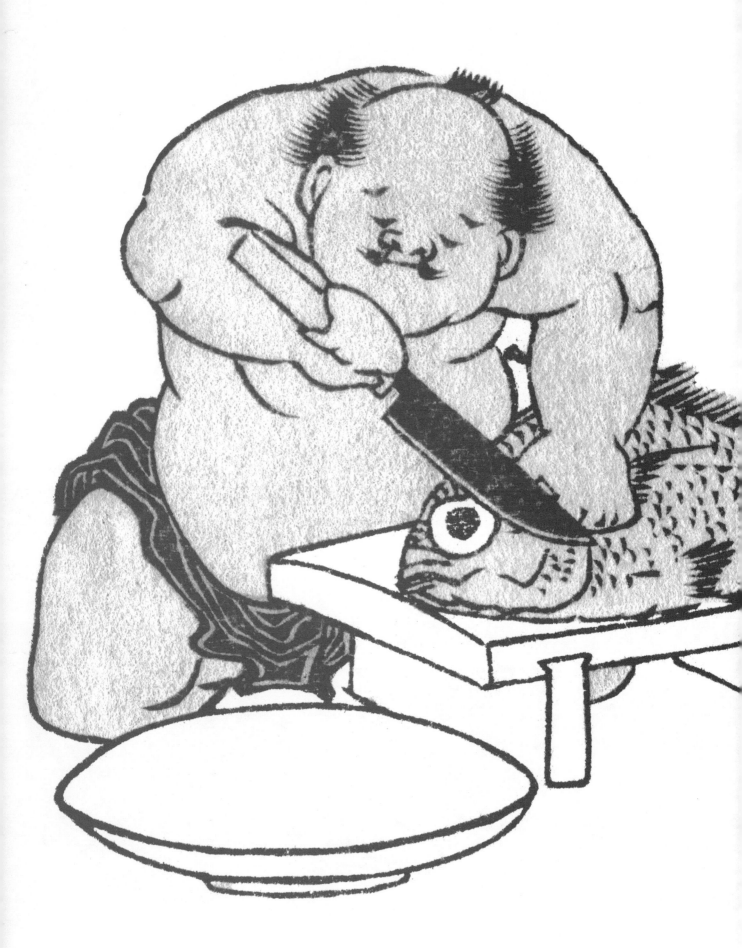

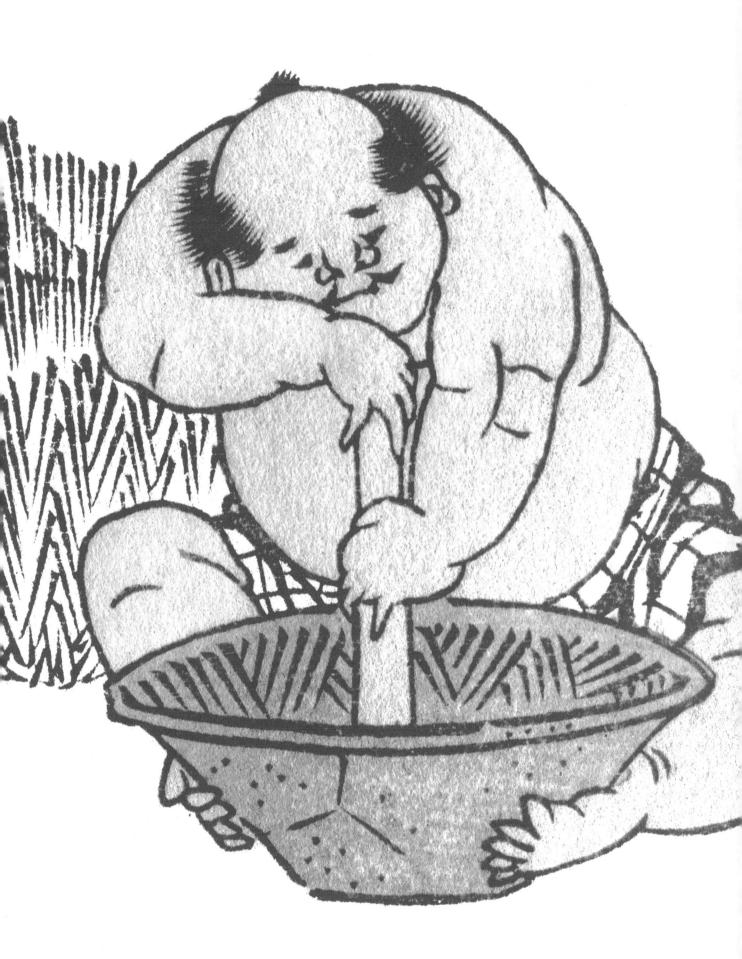

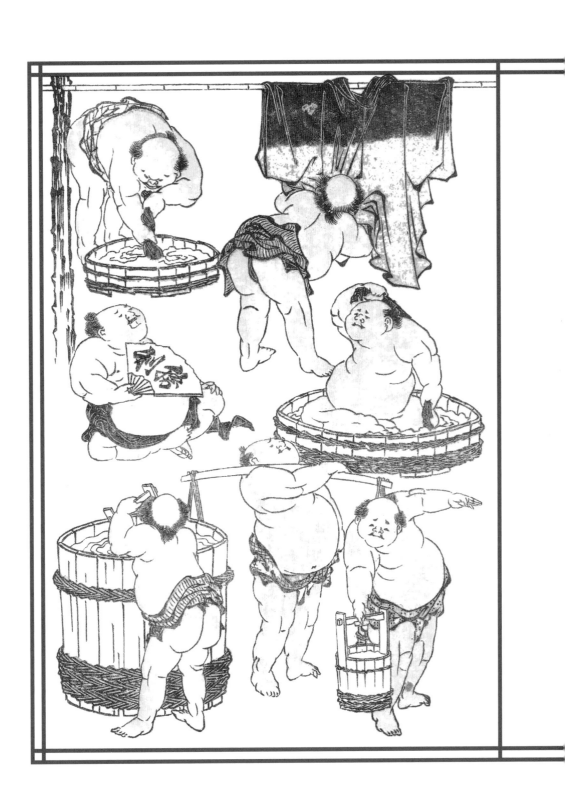

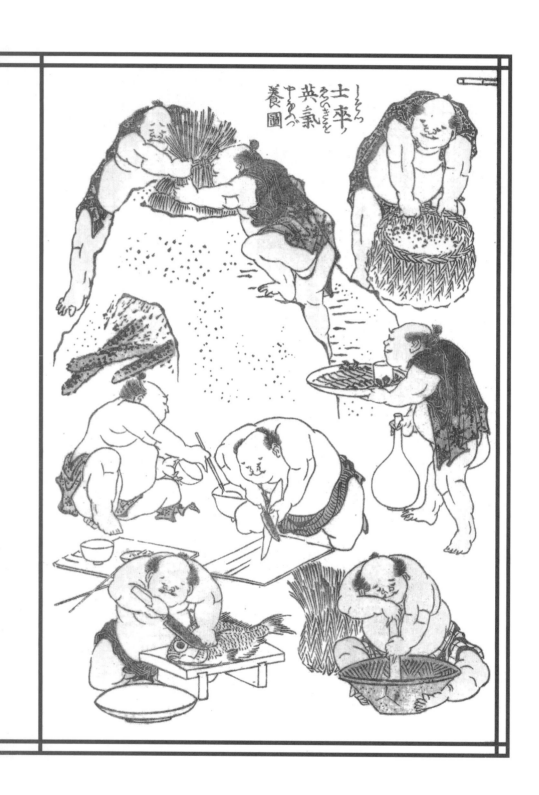

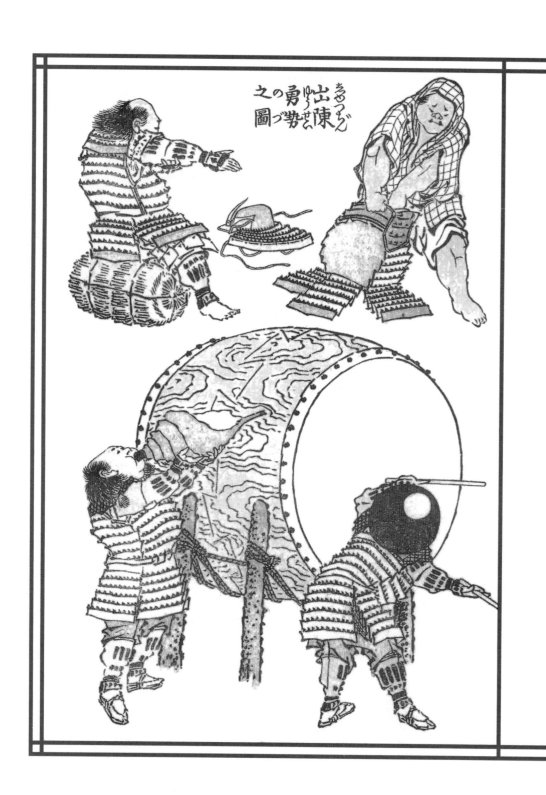

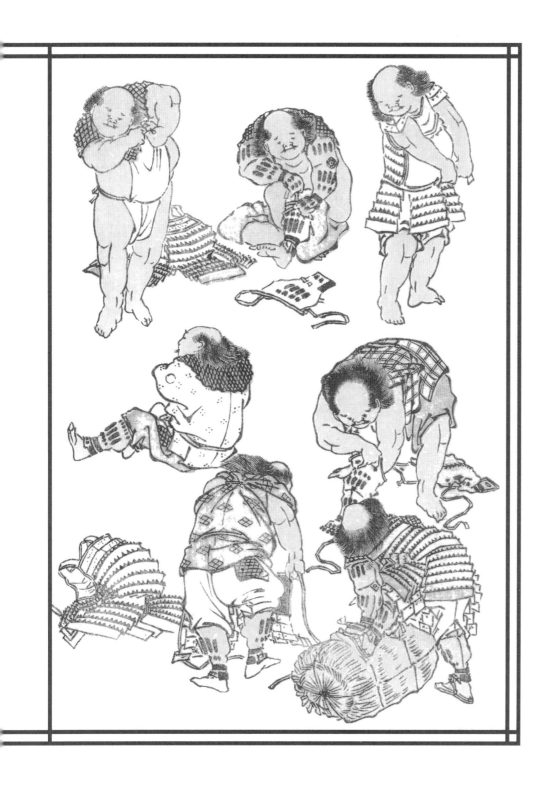

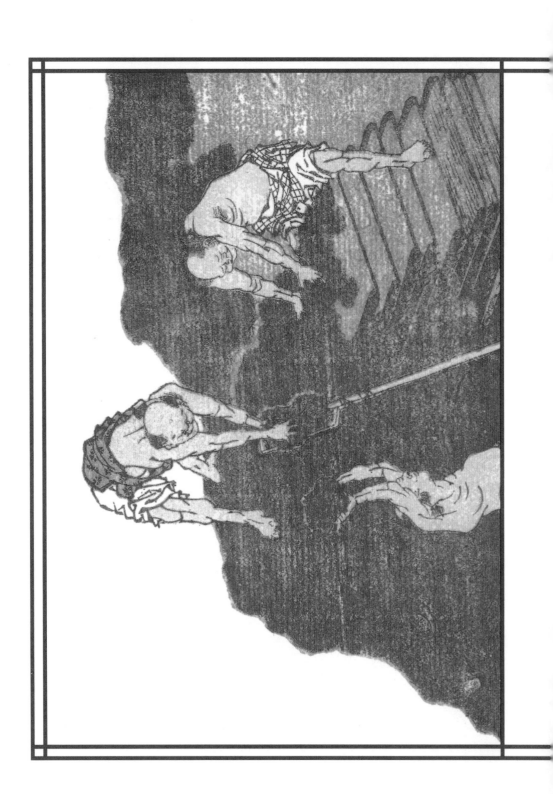

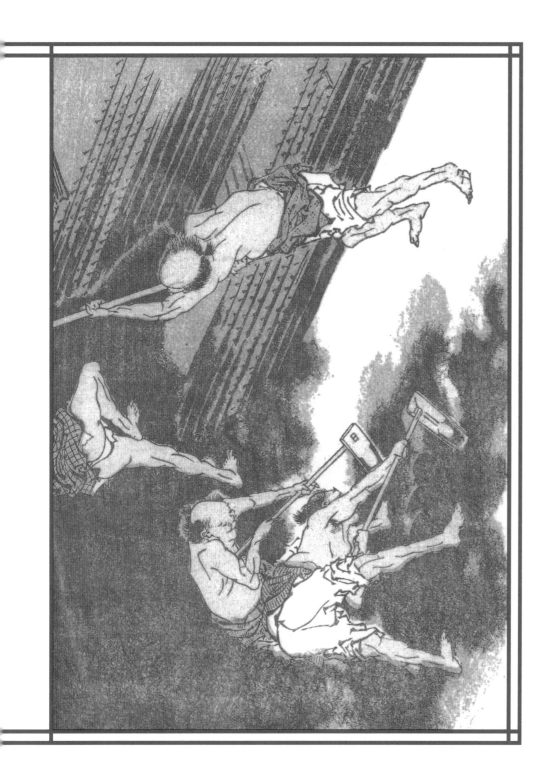

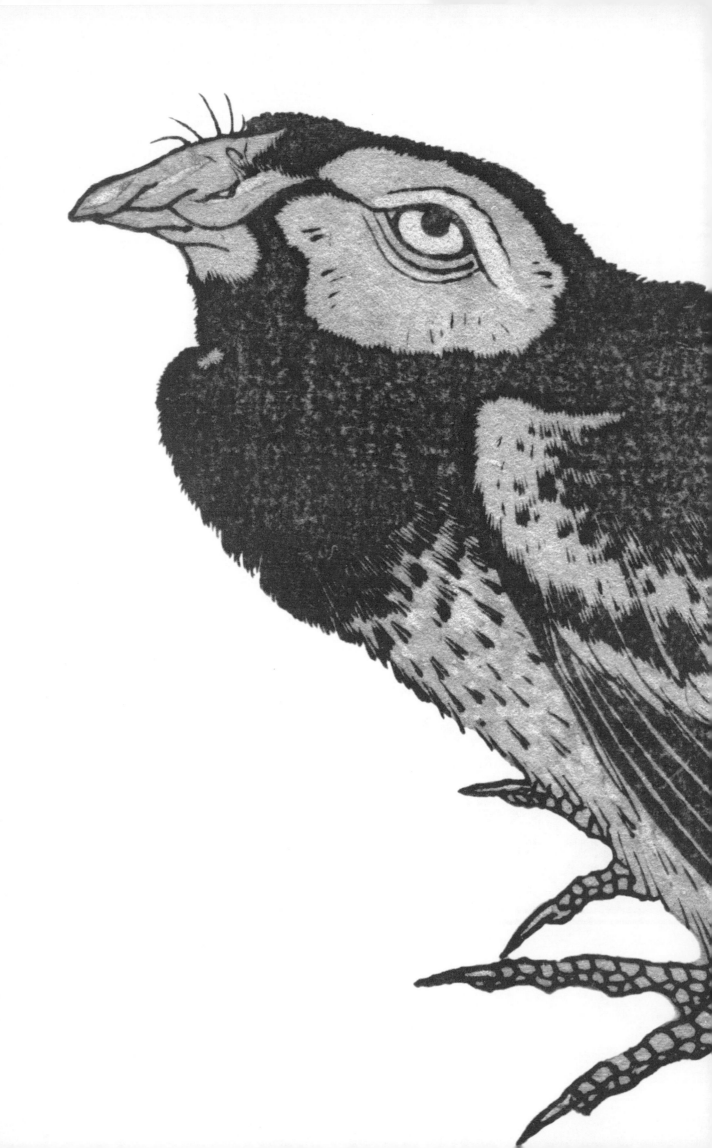

カリピトヱ　　　　蝦夷ノ産

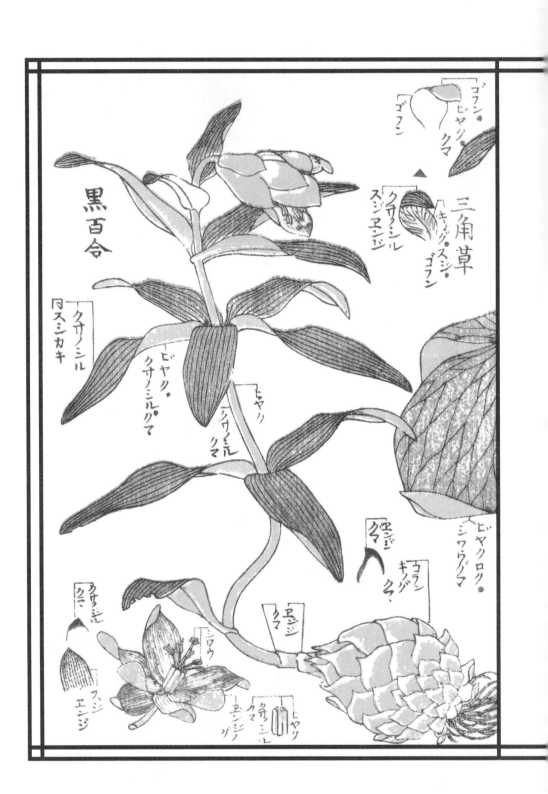

三角草

黒百合

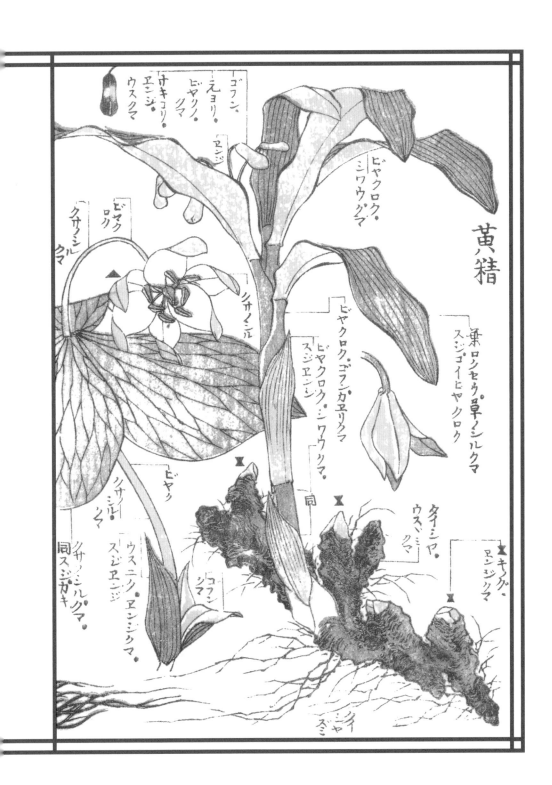

黄精

相州
虎石

釋迦石

文珠石

信州

總州

千騎ヶ巖

鷁鵤石

野州

松浦
暮夫谷

武陽

石牛

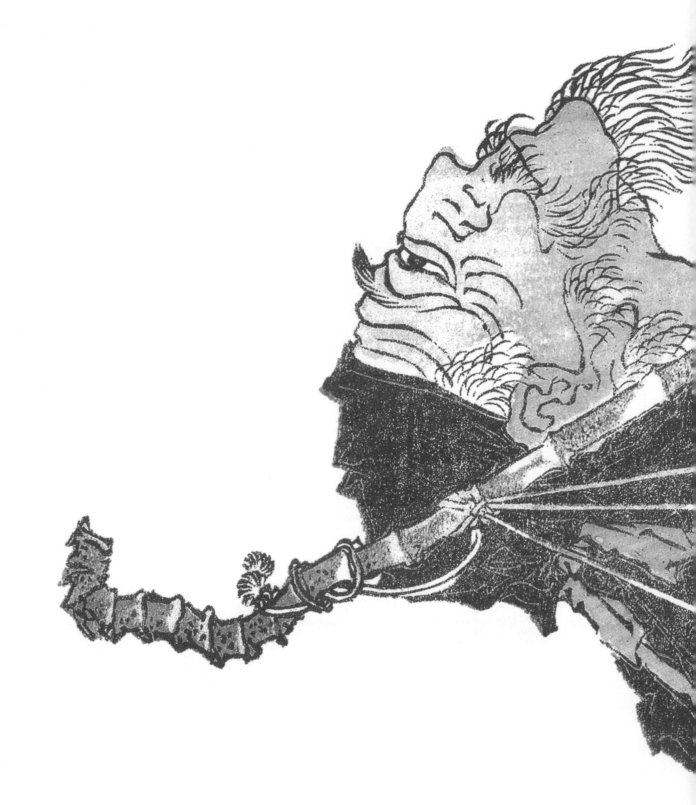

鍾馗図

しょうきず

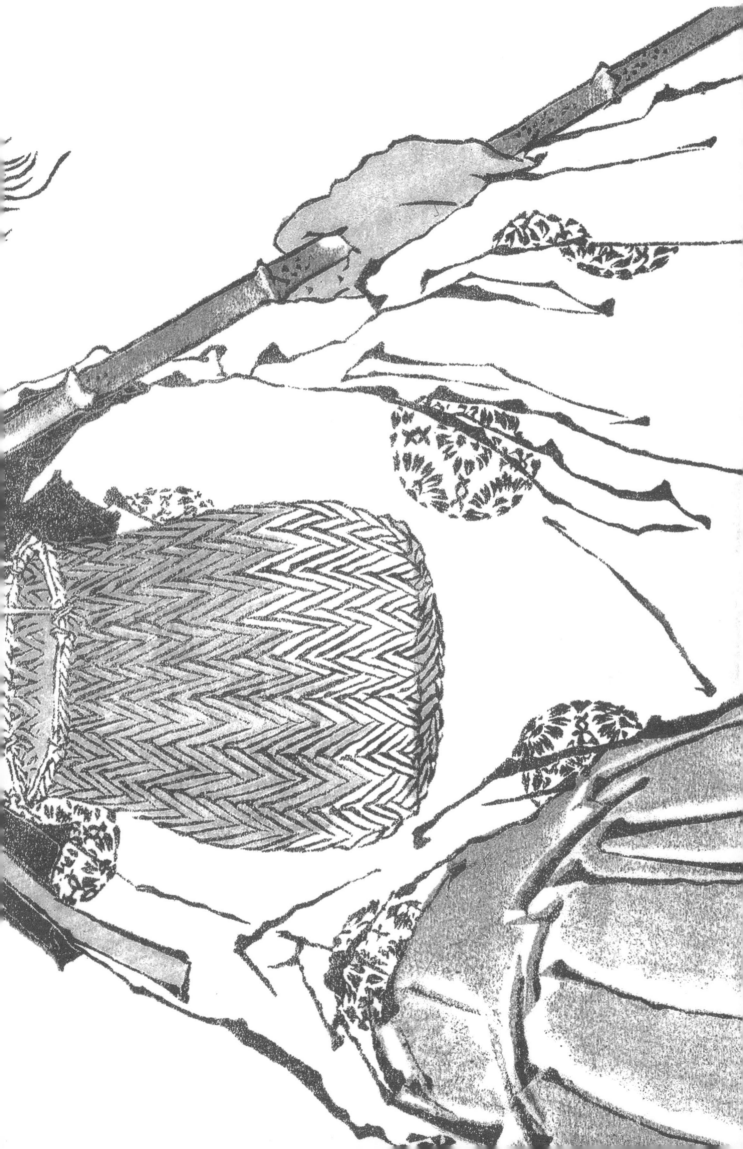

In October 1817, Hokusai carried out a performance in Nagoya to promote *Hokusai manga*. This involved sketching a giant Bodhidharma on a piece of paper the size of a 120-mat room (18 meters long and more than 10 meters wide). Hokusai's publisher, Eirakuya, had been selling a poster advertising the event for 12 mon, so on the day, the venue, Nishikakari-in (a branch temple of Nishi-Honganji), was abuzz with onlookers who had been streaming in since early in the morning. Details of the event are recorded in works

文化14年（1817）10月、北斎は名古屋において『北斎漫画』のプロモーションを兼ねたパフォーマンスを行った。畳120畳（縦18メートル、横10メートル余）の大きさの紙に大達磨の画を描いて見せたのである。版元の永楽屋が予告ポスターを12文で売り出していたから、当日の会場となった西掛院（にしかかりいん）（西本願寺別院）の広場は早朝から見物人が押しかけ大騒ぎとなった。当日の模様は尾張

北斎のパフォーマンス

such as *Hokusai taiga sokusho saizu* by the Owari clan artist Koriki Enkoan. Appearing in full dress of crested *haori* and *hakama* and accompanied by his apprentices, Hokusai dipped his brush of bundled straw into a bucket of ink and quickly drew Bodhidharma's eyes and the outline of his body. The finished portrait was hoisted up with pulleys onto two cedar posts, whereupon cries of astonishment rose from the onlookers, who until then had been unable to see the work in its entirety. This, however, was not the first time Hokusai

藩士の画家、高力猿猴庵の『北斎大画即書細図』などに詳しいが、北斎は紋付羽織袴姿の正装で弟子たちを従え登場し、わらを束ねた筆を墨桶に浸し、目や輪郭線など一気に描き上げたという。作品が2本の杉柱に滑車で引き上げられると、全貌を初めて知った見物人から驚きの声があがった。しかし北斎の大画制作はこのときが初めてではなかった。

Hokusai's performances

had attempted to draw on such a massive scale.

His first such performance took place in 1804 when Hokusai was 45 years old, and involved painting a giant portrait of Bodhidharma in the grounds of the Gokokuji temple in Edo's Otowa district on a piece of paper similar in size to that used during the Nagoya performance. Hokusai later went on to paint a giant painting of a horse at Honjo Kappa Hoshiba and a giant portrait of Hotei at Ekoin temple in Ryogoku, following which he painted two sparrows on a

初めて行ったのは文化元年(1804)北斎が 45 歳の時で、江戸音羽の護国寺境内で名古屋と同じような大きさの紙に大達磨を描いている。その後も本所合羽干場では馬を、また両国の回向院では布袋の大画を描いた後に、1 粒の米に 2 羽の雀を描いてみせた。居合わせた人々は肉眼でこれを見るのに苦労したという。極大と極小を自在に描いた北斎のパフォーマンス。そこからは誇張による形の

single grain of rice. Those present had difficulty viewing the two sparrows with the naked eye. These performances demonstrate Hokusai's ability to scale up and scale down his subjects at will. They also offer glimpses of the innovative forms he achieved through exaggeration, his brush skills in depicting minute detail, and his outlook on the universe. At the same time, they also reveal the theatrical side of Hokusai's personality as well as the fact that he had a keen nose for profit.

斬新さや微細なものを描く筆力のすごさ、そして北斎の宇宙観が垣間見える。と同時に、北斎には興行師的なところや、商売っ気がたっぷりあったところも見えてくるのである。

At the end of the first volume of Hokusai's *Fugaku hyakkei* (One Hundred Views of Mt Fuji), published in 1834 when the artist was 74 years old, there is a famous postscript. In it, Hokusai writes, "From around the age of six, I had the habit of sketching from life. I became an artist, and from fifty on began producing works that won some reputation, but nothing I did before the age of seventy was worthy of attention. At seventy-three, I began to grasp the structures of birds and beasts, insects and fish, and of the way plants

北斎は天保5年（1834）、75歳の時に刊行した『富嶽百景』初編の巻末に、有名なあとがきを残している。「自分は6歳の時から物の形を写生する癖があり、50歳の頃からよく画図を発表してきたが、70歳前のものは取るに足らないものだった。73歳にしてやや禽獣虫魚の骨格や草木の出生がわかってきた。だから80歳になればもっと深まり、90歳になればその本当の意味もわかり、

生涯絵師

grow. If I go on trying, I will surely understand them still better by the time I am eighty, so that by ninety I will have penetrated to their essential nature. At one hundred, I may well have a positively divine understanding of them, while at one hundred and ten I will have reached the stage where every dot and every stroke I paint will be alive." It is signed "Gakyo -Rojin Manji" (Manji, the old man mad about art).

Reading this postscript, one gets a real sense of Hokusai's extraordinarily deep attachment to art. It also shows what an

100歳になれば初めて神妙の域に達するだろう。110歳では一点一画、すべてが生きているように見えるだろう」と述べ、最後に「画狂老人卍述」と記している。

北斎の画に対するなみなみならぬ執念が感じられ、まさに画狂老人の面目躍如というところだが、だからといって北斎を画聖のように扱うのは間違っているのではないだろうか。自らの号を弟子に売ったり、山っ気たっぷり

An artist for life

"old man mad about art" he really was, but I think it would be wrong to treat him as the great artist saint. This is because there is another side to Hokusai in the form of his vulgarity in selling his name to his apprentices, conducting speculative performances, and continually thinking of ways to impress his audience, a side that is also part of his appeal.

On the morning of April 18, 1849, Hokusai's life came to a close surrounded by apprentices, friends, his daughter Oei, and others. In *Hokusai-den* (A Biography of Hokusai), Iijima

のパフォーマンスを行ったり、人の度肝を抜くことを絶えず考えたりしている俗っぽさが、北斎のもうひとつの顔であり魅力でもあるからだ。

嘉永2年（1849）4月18日朝、北斎は門人や旧友、娘の阿栄らが見守るなか90歳の生涯を閉じた。「翁死に臨み、大息し天我をして10年の命を長らふせしめばといひ、暫くして更に謂て曰く、天我をして5年の命を保た

Kyoshin writes, "On his deathbed, Hokusai, now an old man, gave a deep sigh and said, 'If only Heaven could extend my life by another ten years,' and then a while later, 'If only Heaven could keep me alive for five more years, I could become a true painter,' whereupon he passed away."
There are some people who speak of Hokusai as an inspiration in our aging society, such was his devotion to painting right up until his death, his unwillingness to be content in his pursuit of perfection, and his desire to master his art.

しめば、真正の画工となるを得べしと、言吃りて死す」と飯島虚心の『北斎伝』は書いている。「あと10年、いや5年でも生かしてくれたら、本物の画描きになれるのに……」
北斎を高齢化社会の励みになると評する人もいるが、まさに死ぬ直前まで画一筋、求めて足ることを知らず、常に真髄を極めようと志向した人生だった。

天より
山へ
画此起り
地へ
水り

乾
坤
艮
坎
天
山
地
水

周の文王

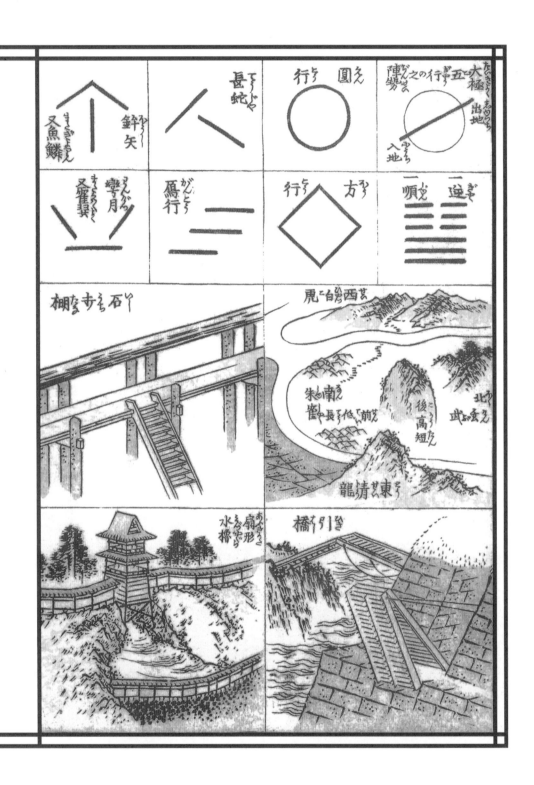

大元帥之像

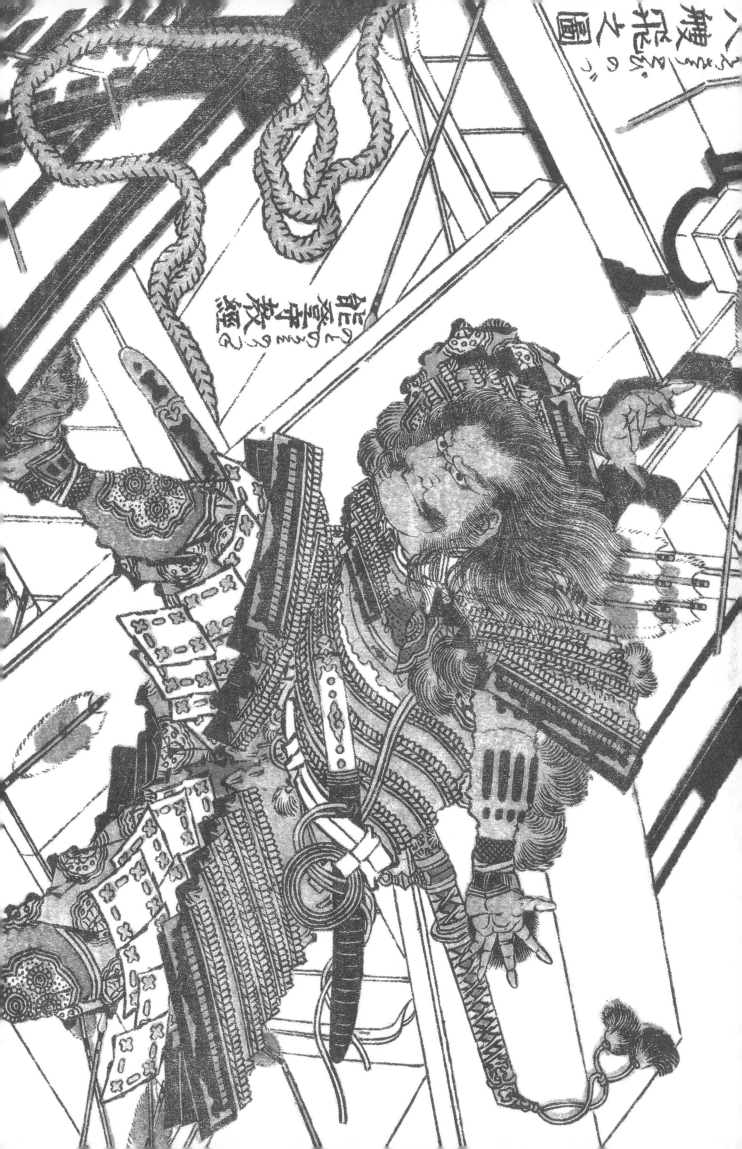

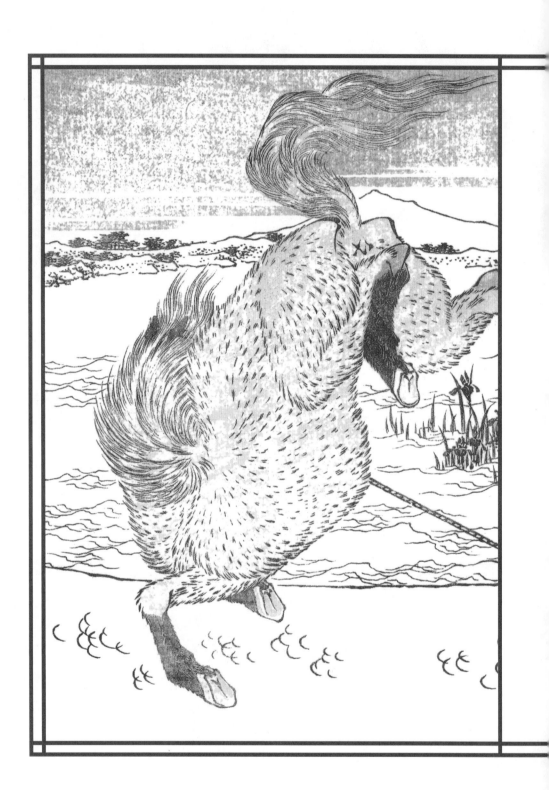

あふみのくにかいつのさと
近江國貝津ノ里
紅つめ
傀儡女金子カ
力量
あきらのちから

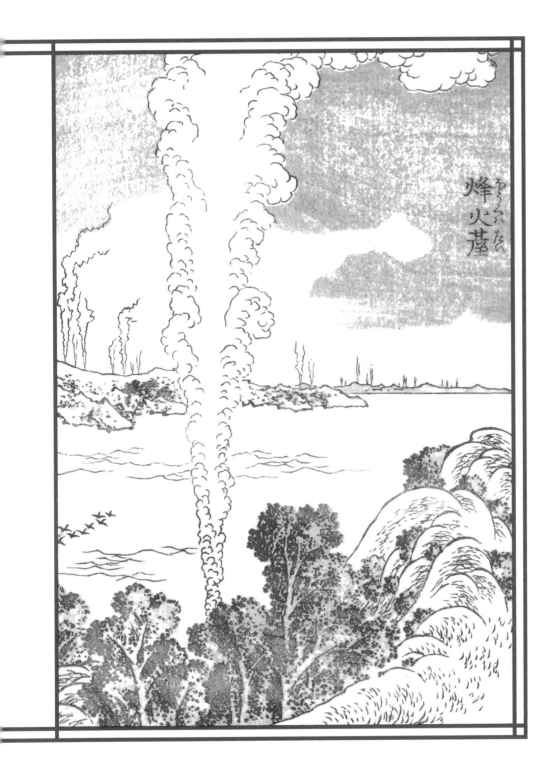

烽火薹

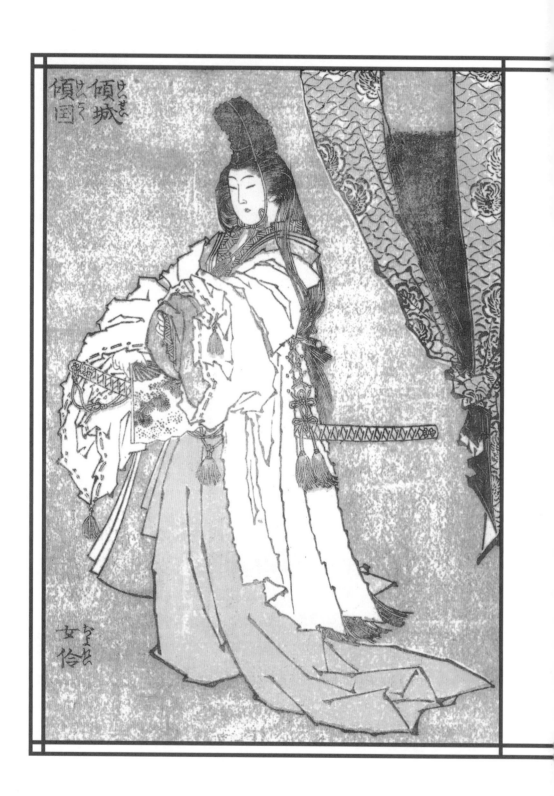

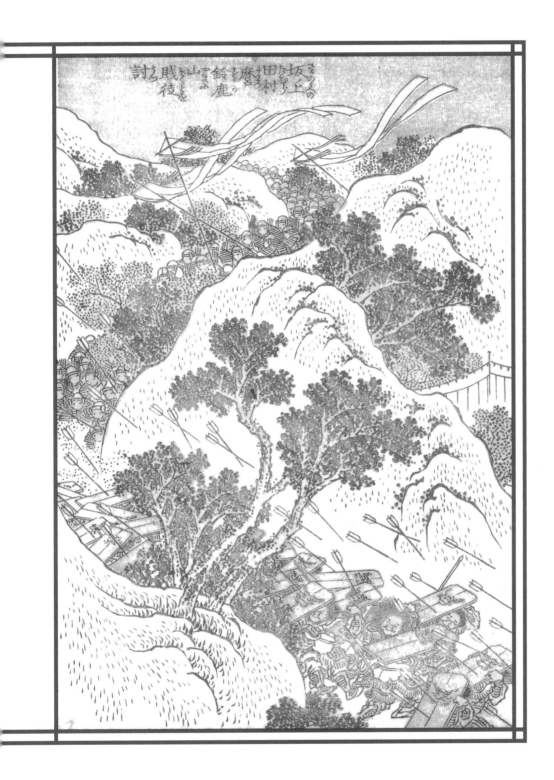
坂上田村麿鈴鹿山の賊を討の徒

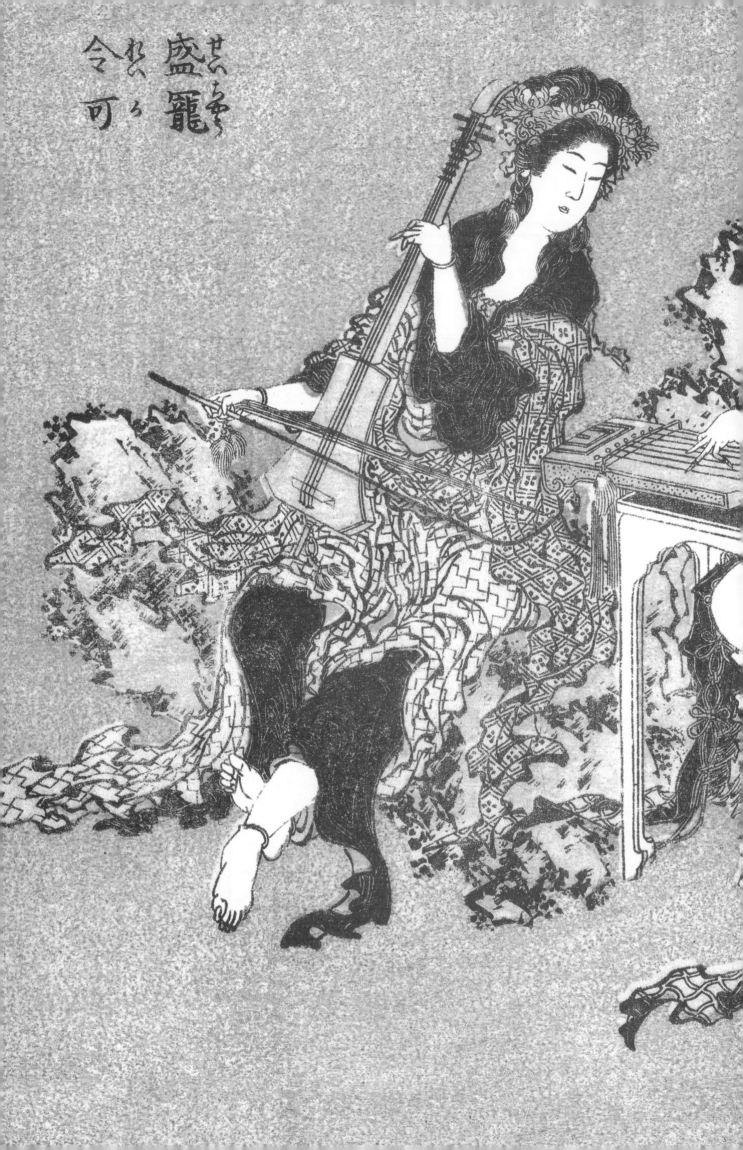

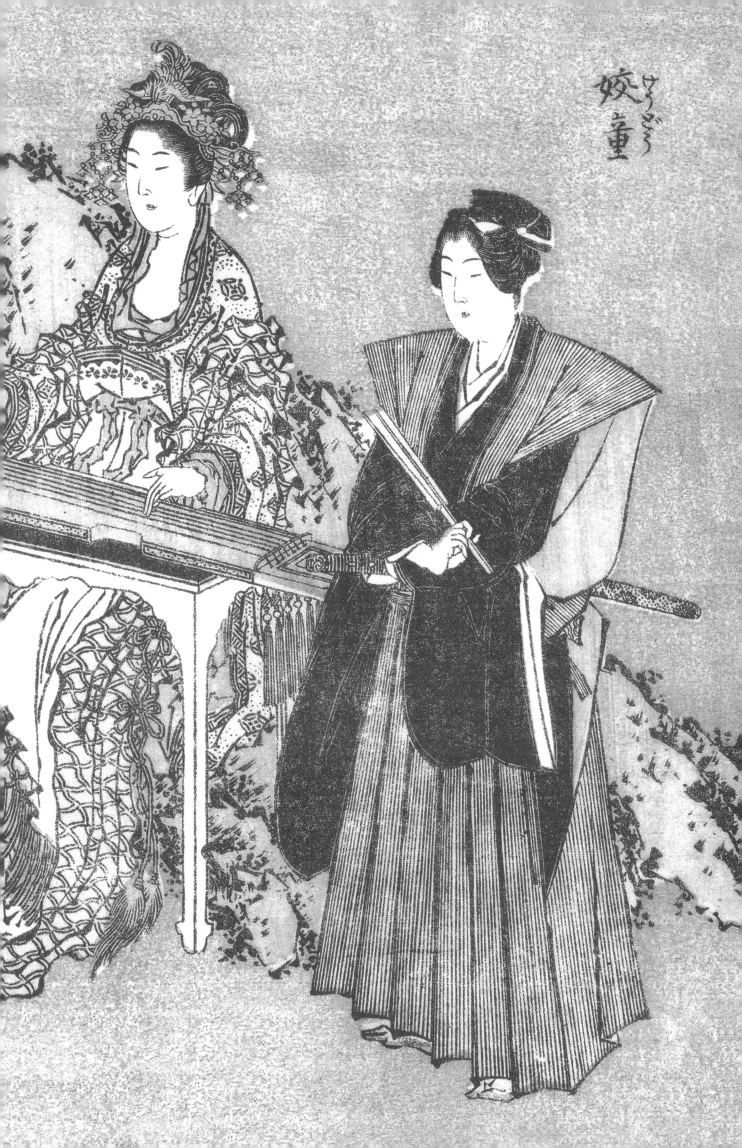

佛御前が花の嵯峨野の小
祇王と
祇女を
妓女を吊フ

寡女
大井子怪力

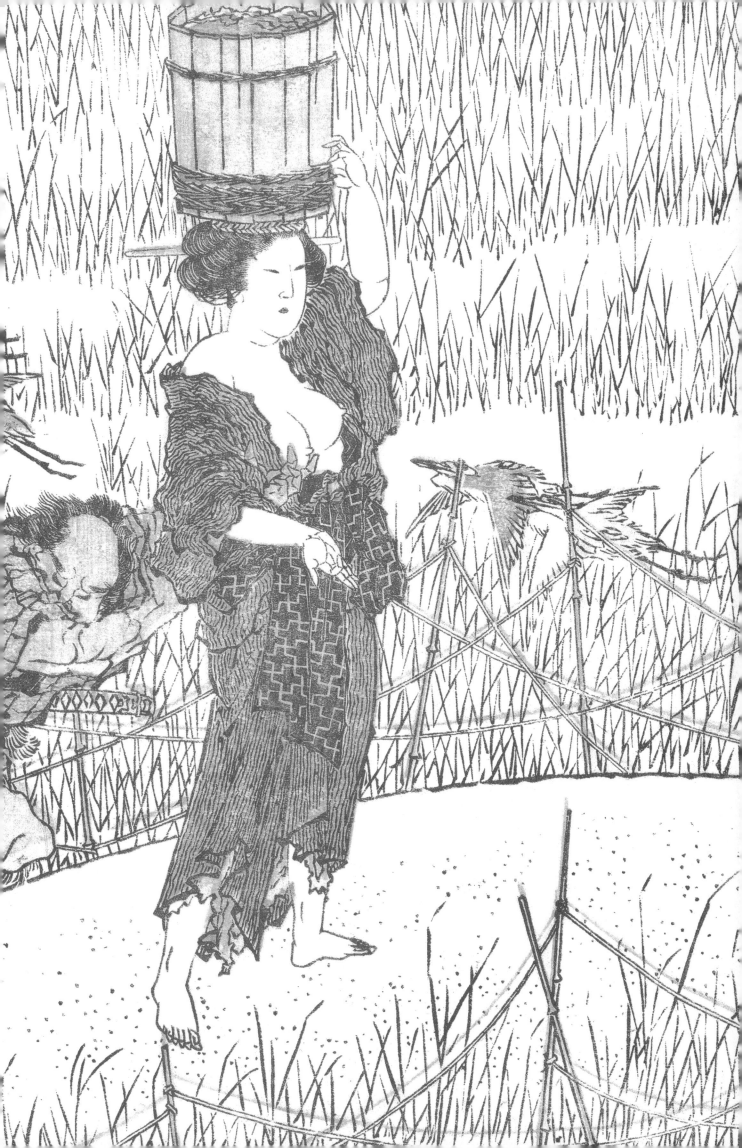

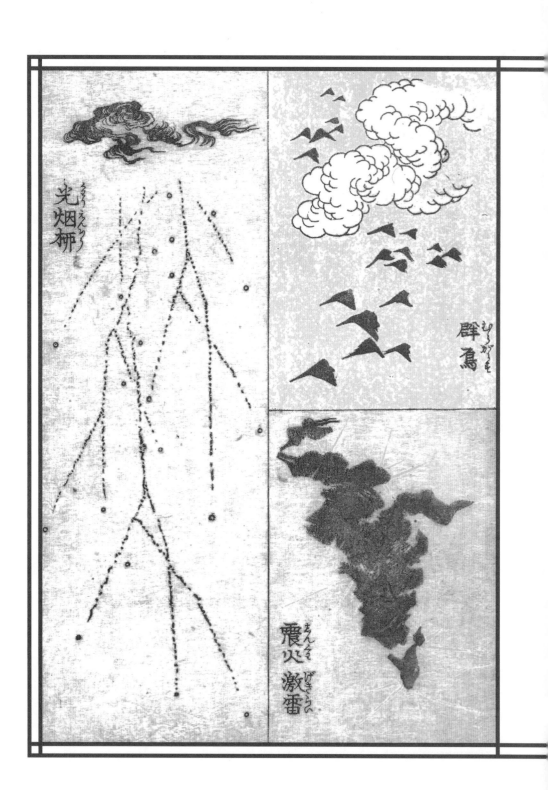

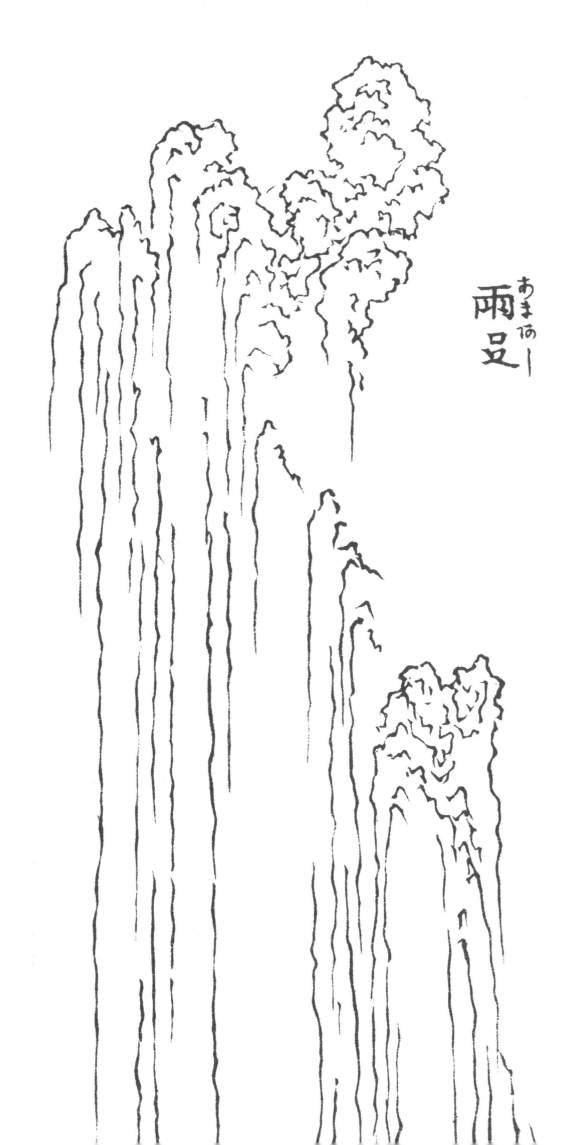

雨
足

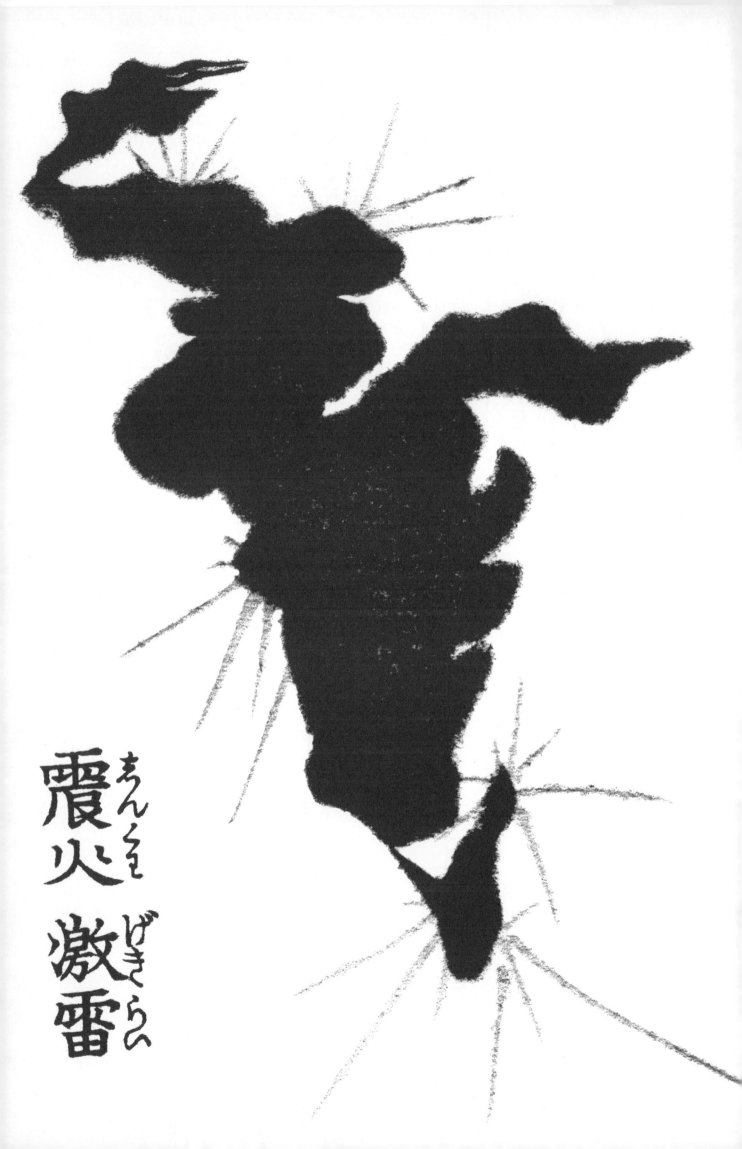

震火　激雷

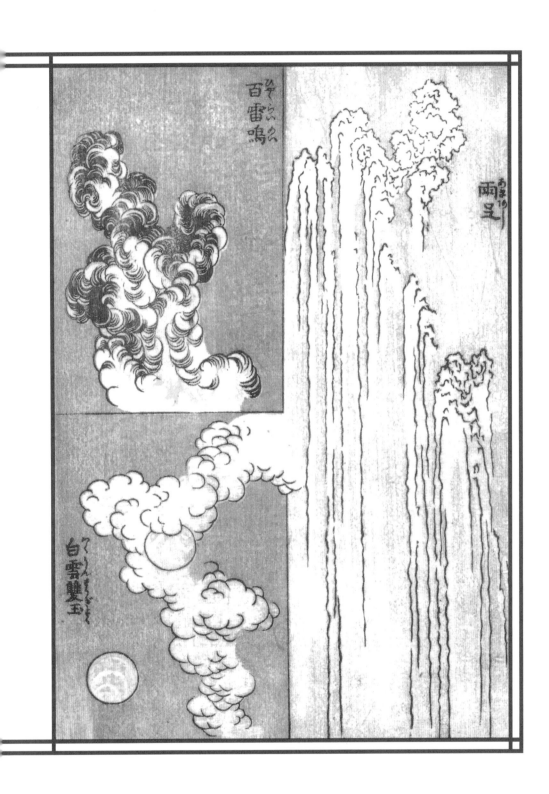

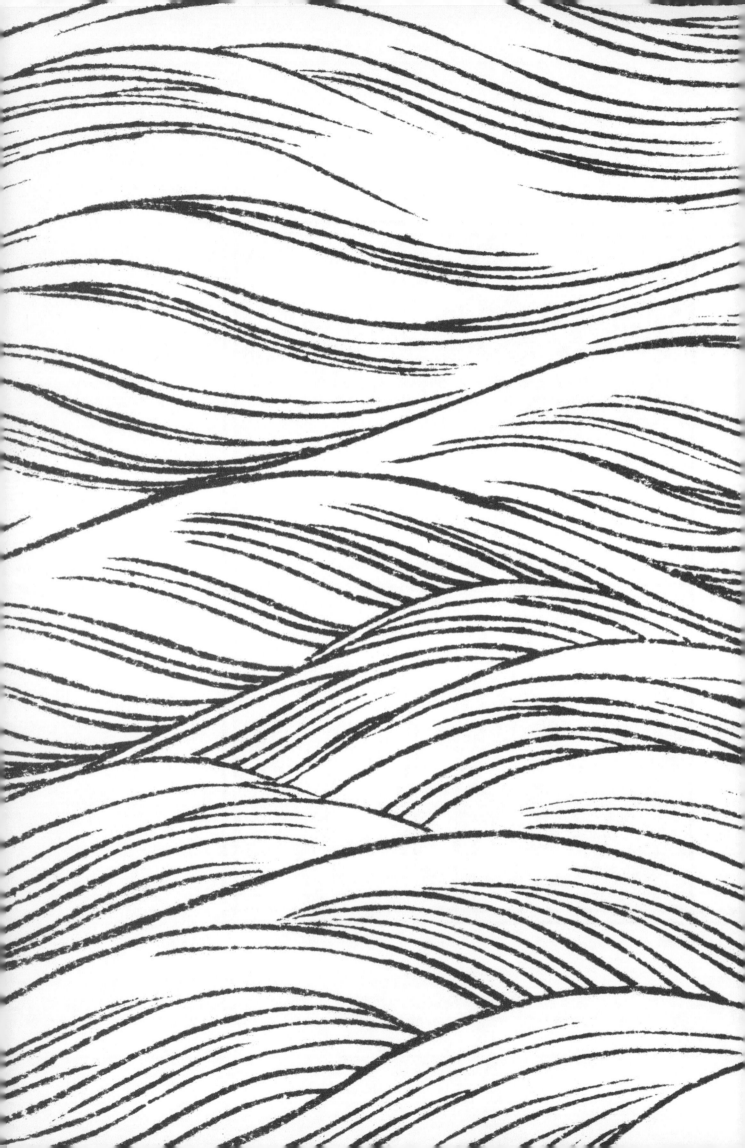

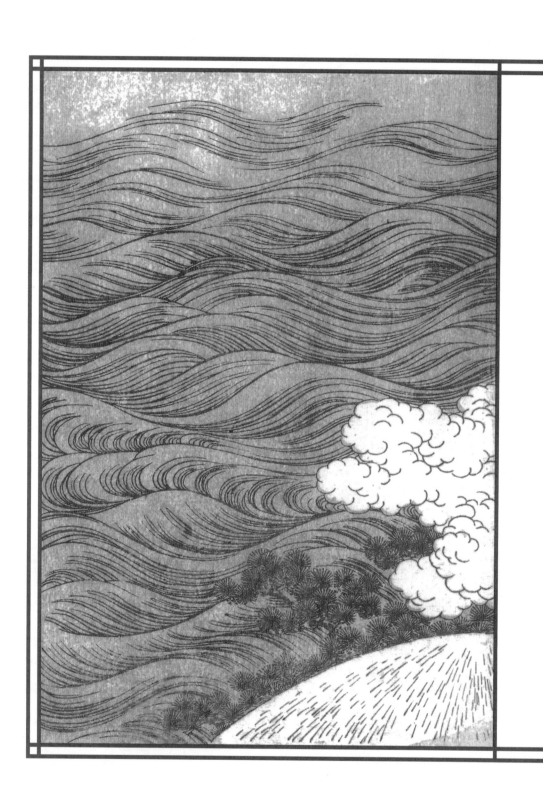

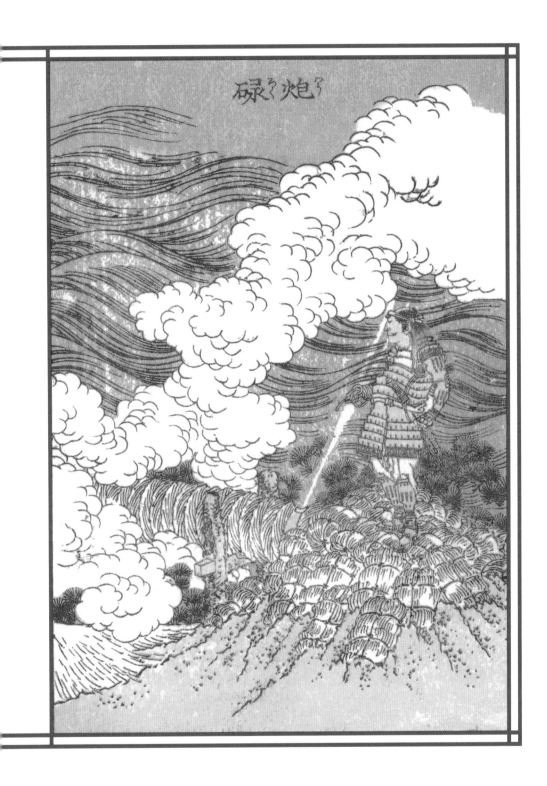

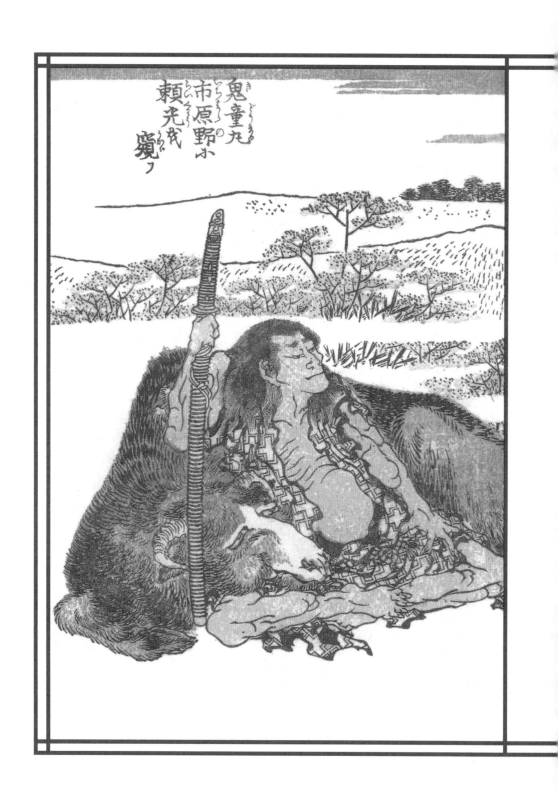
鬼童丸
市原野小
頼光成
窺

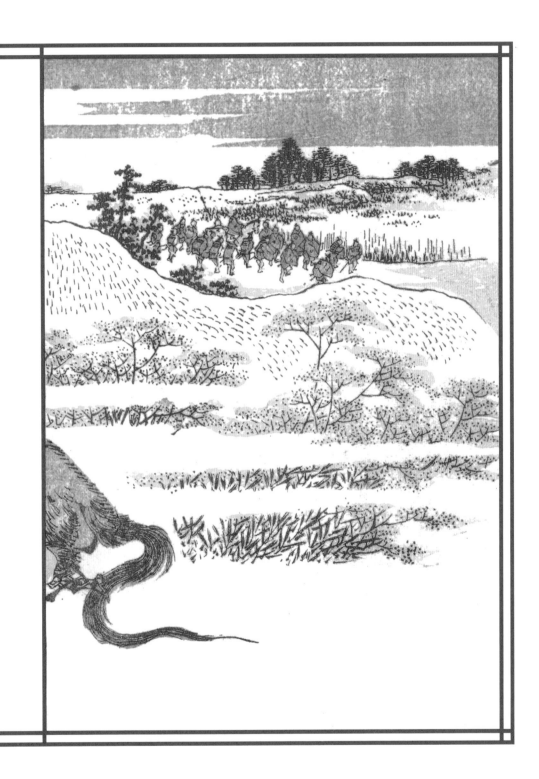

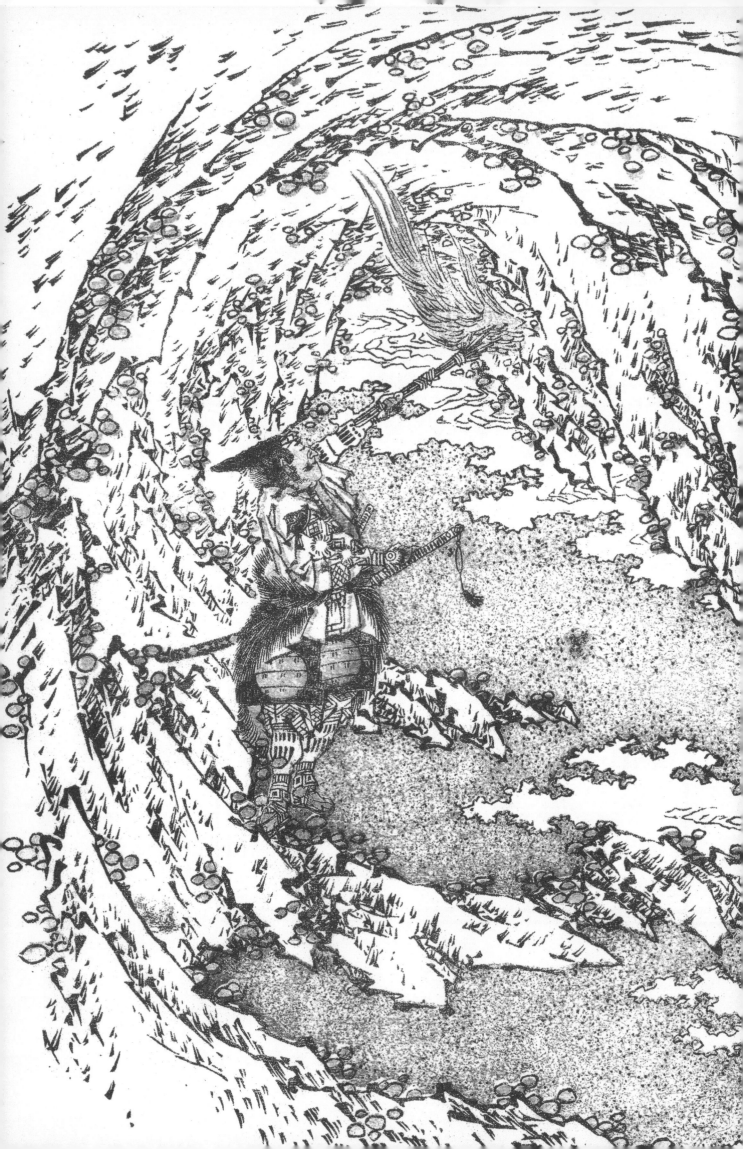

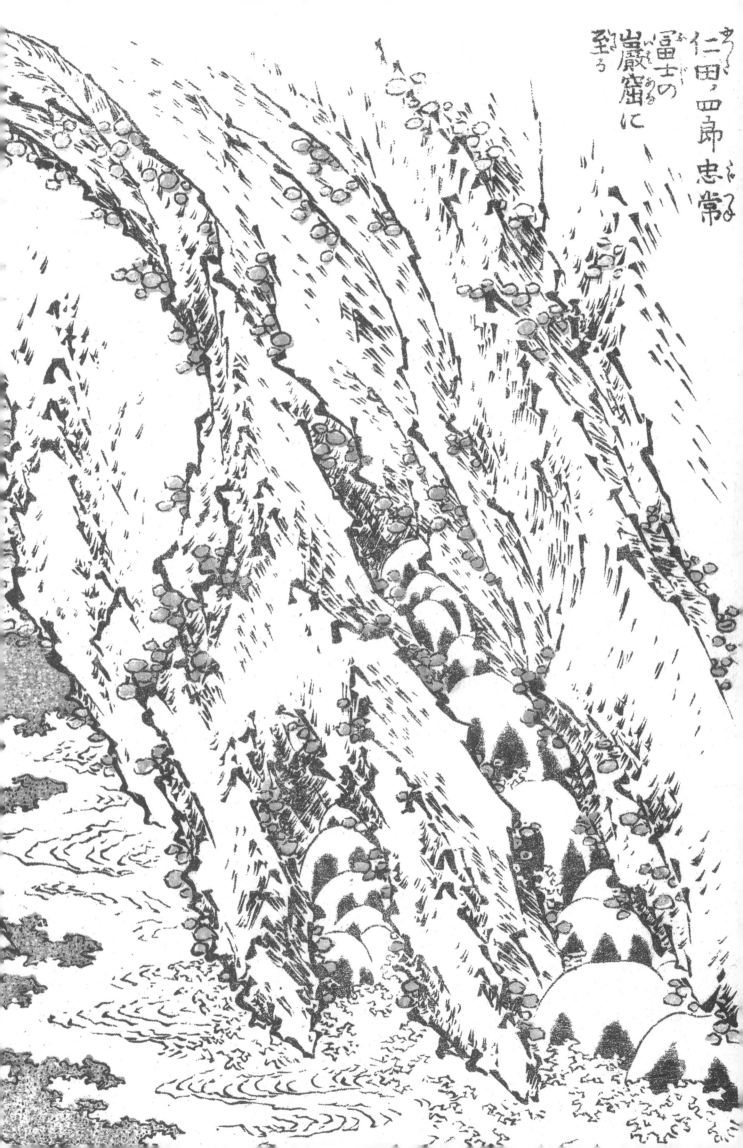

仁田ノ四郎忠常
冨士の
巖窟に
到る

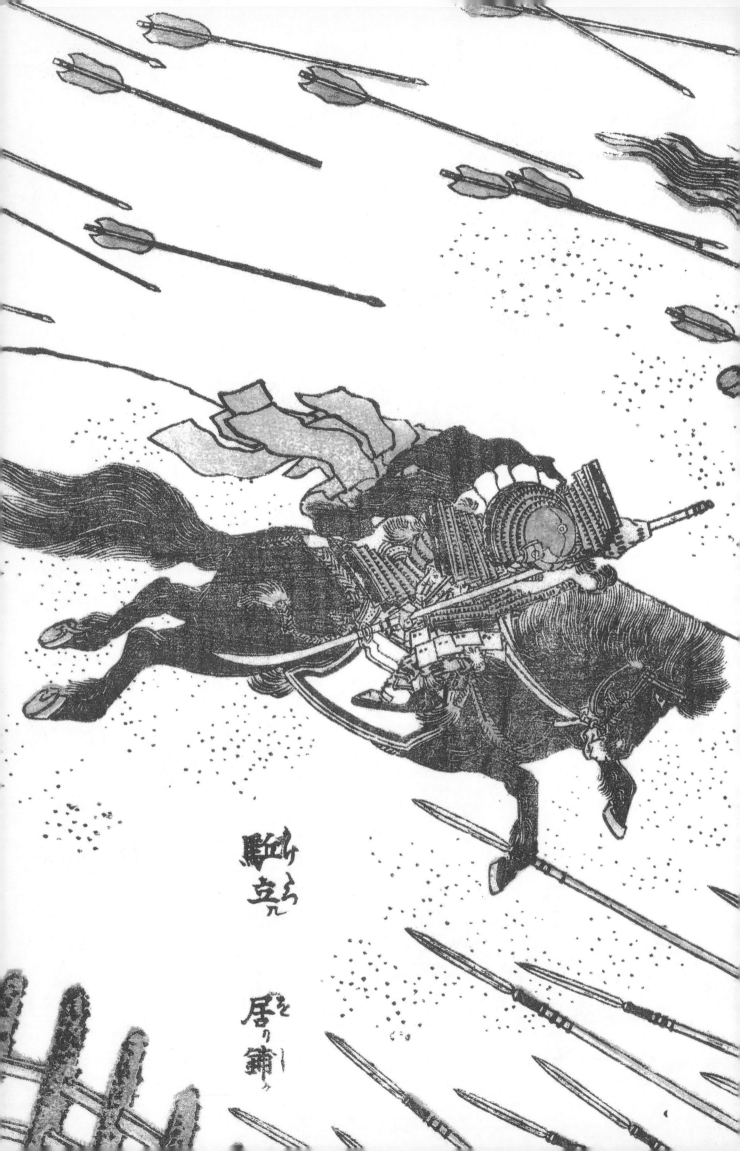

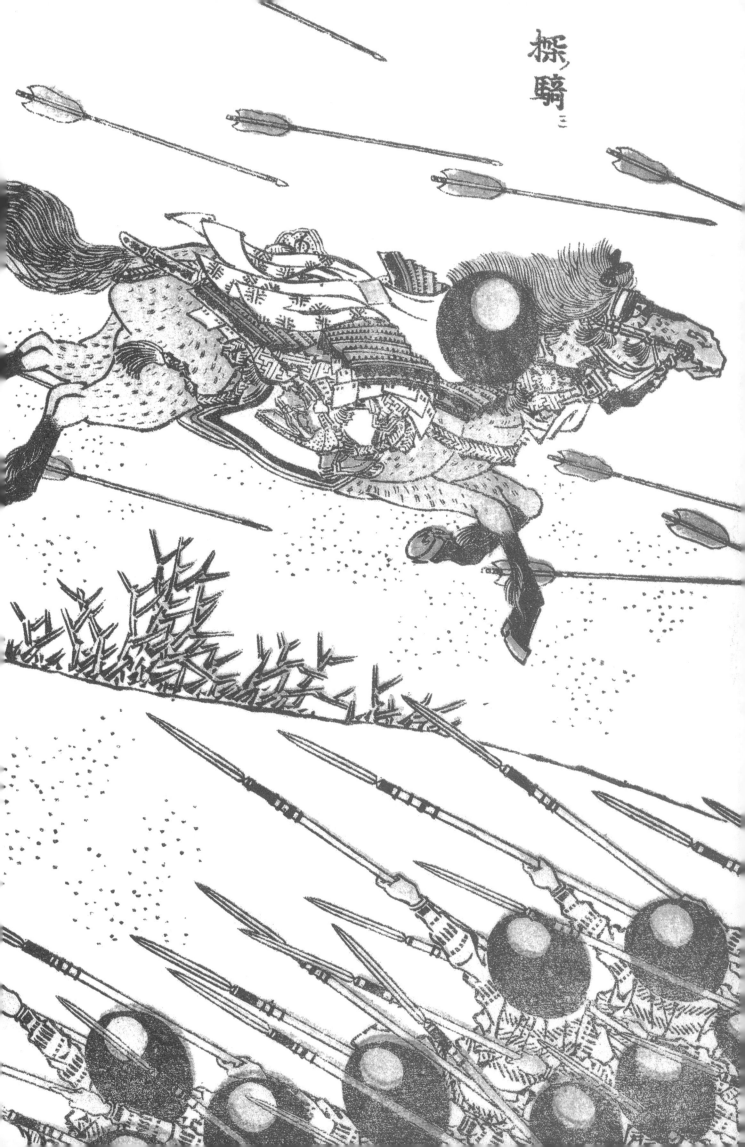

探ノ騎

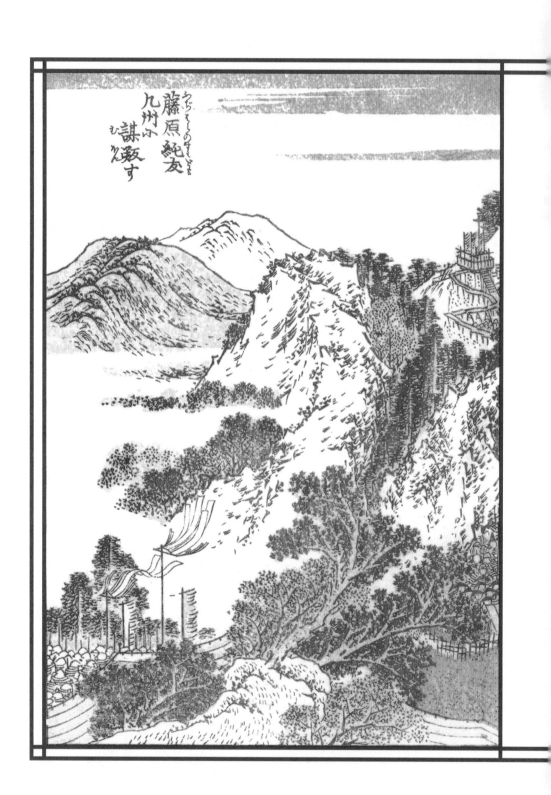

藤原純友
九州ふ謀叛す

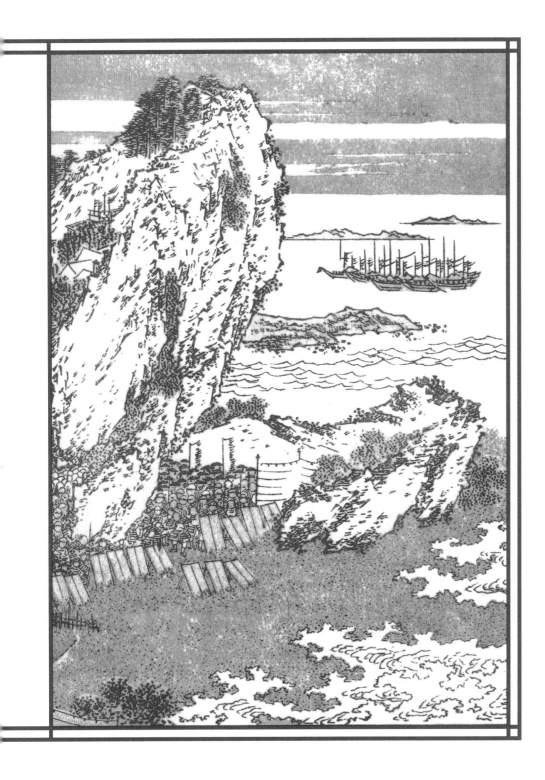

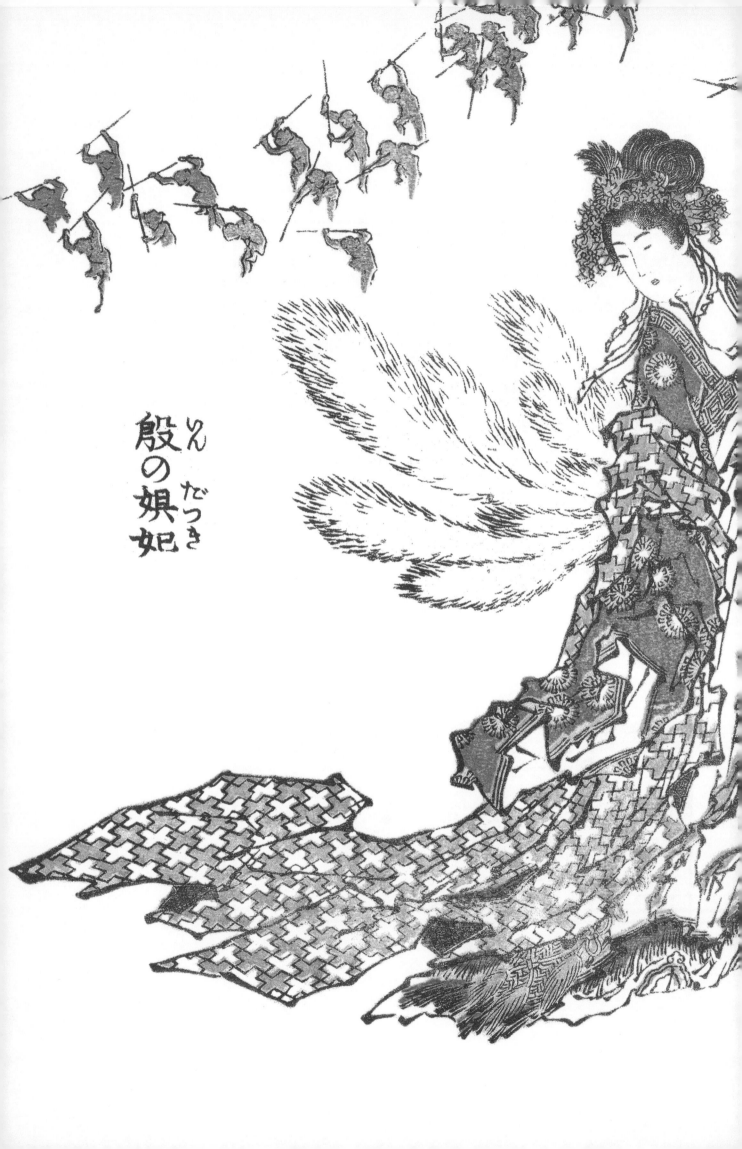

殷の娘妃
いんだっき

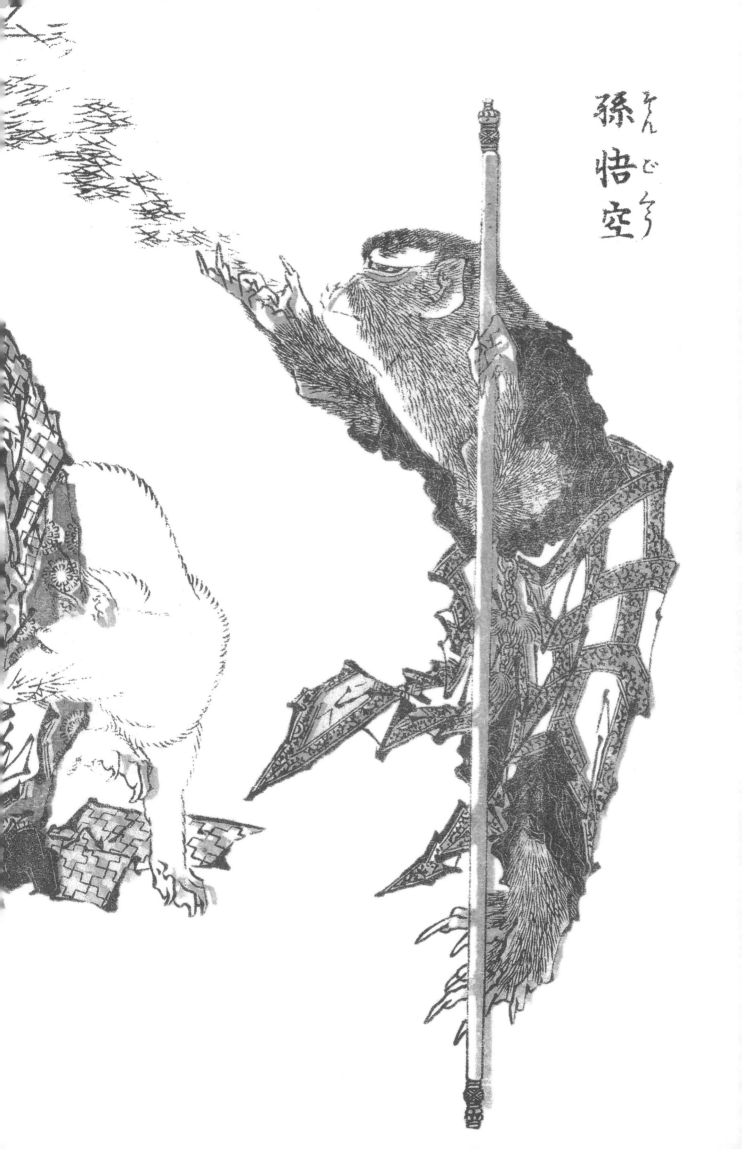

孫悟空
そんごくう

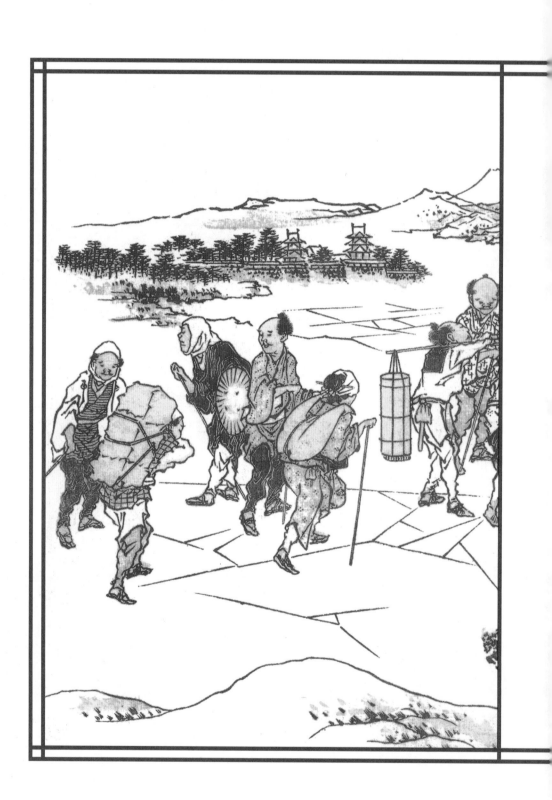

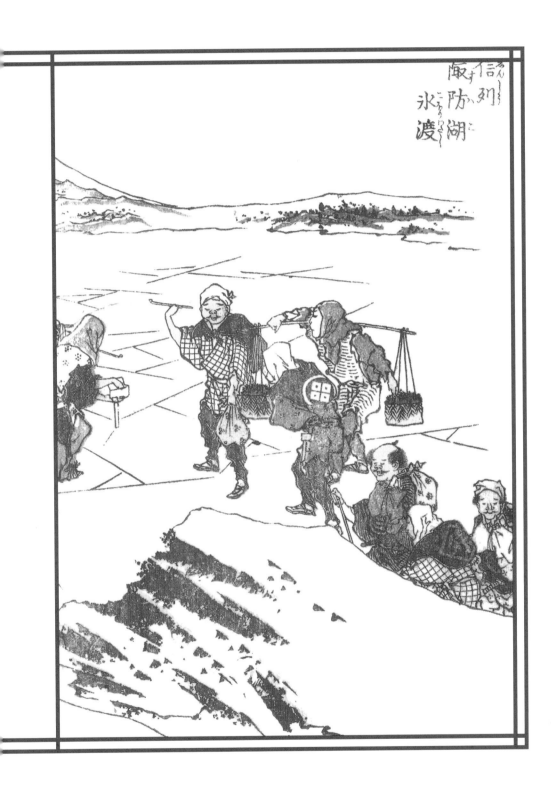

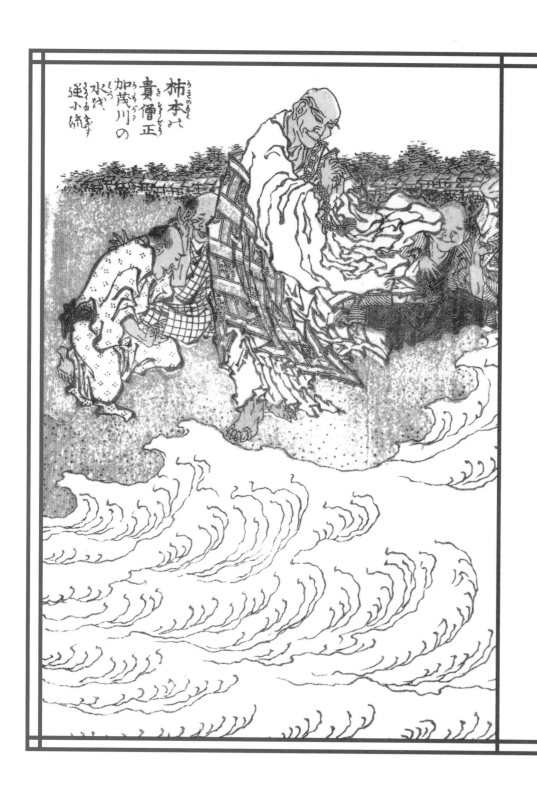

柿本の
貴僧正
加茂川の
水汲かまず
逆小流

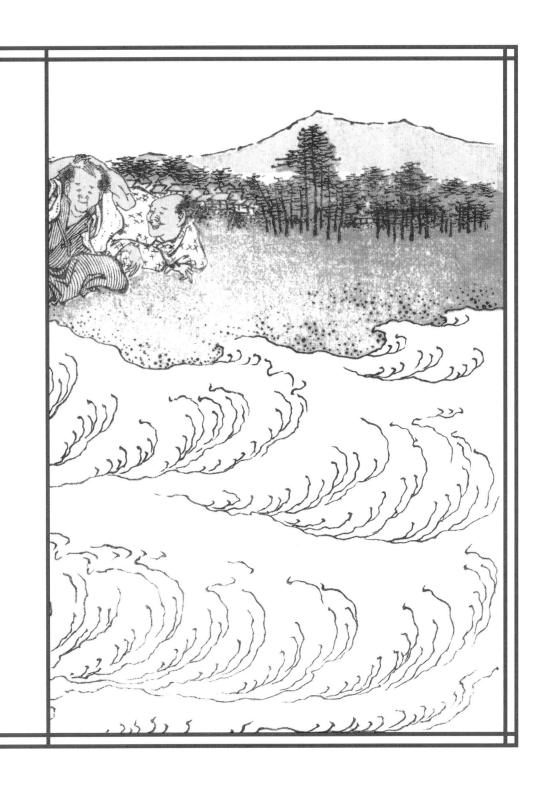

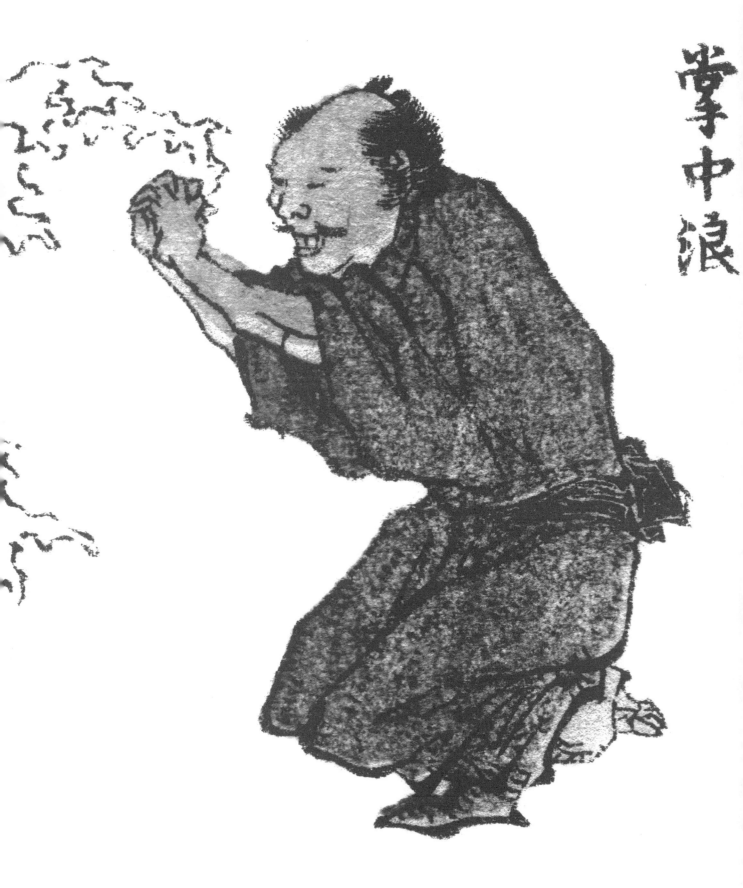

掌中浪

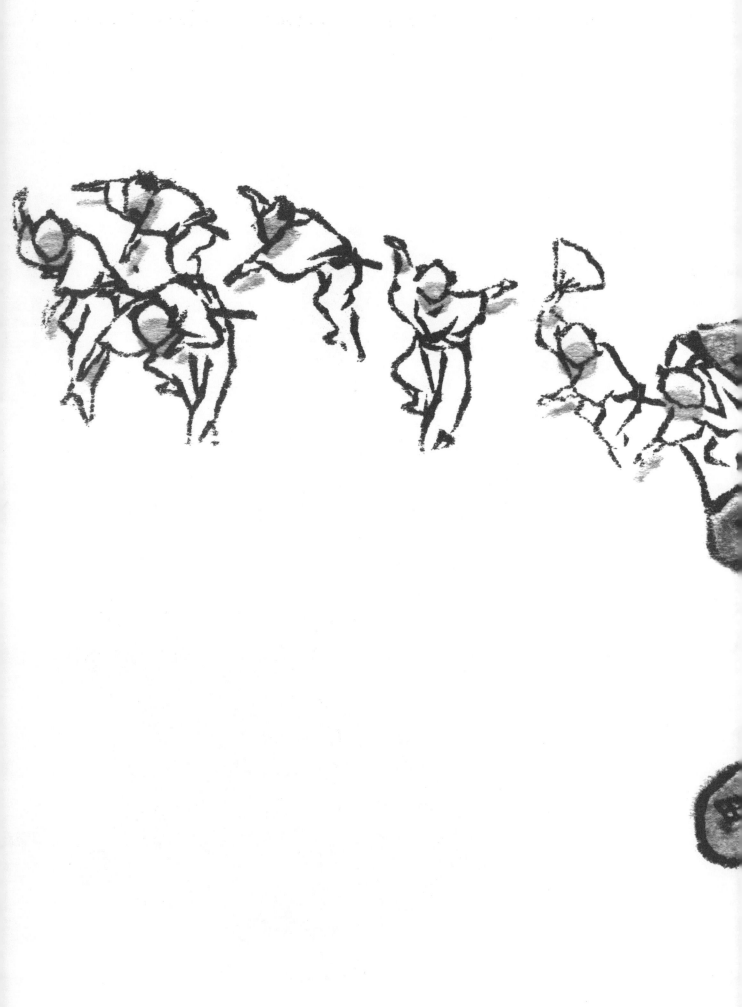

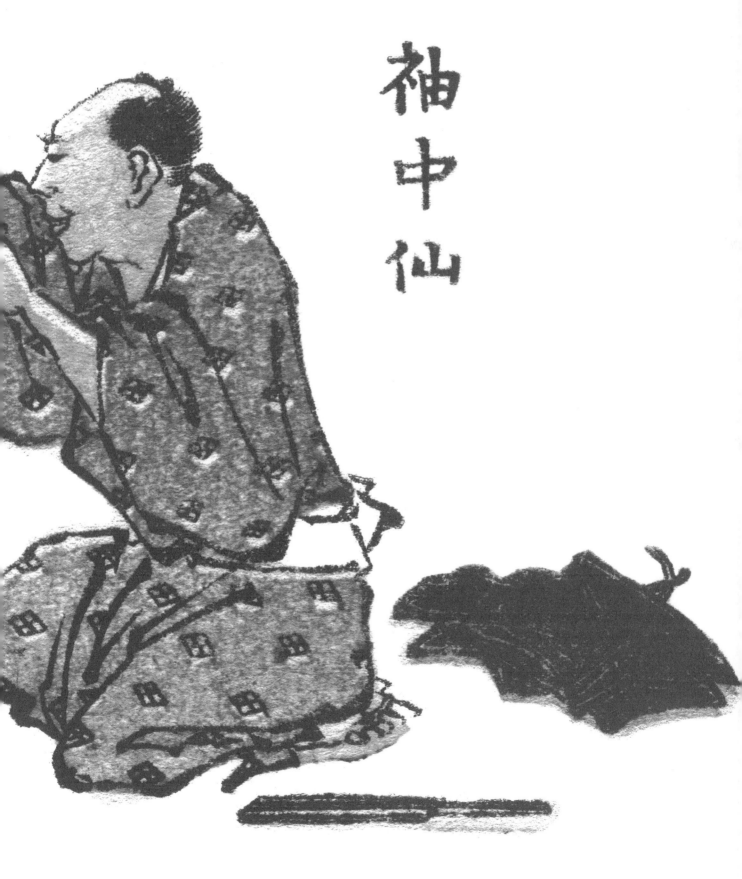

袖中仙

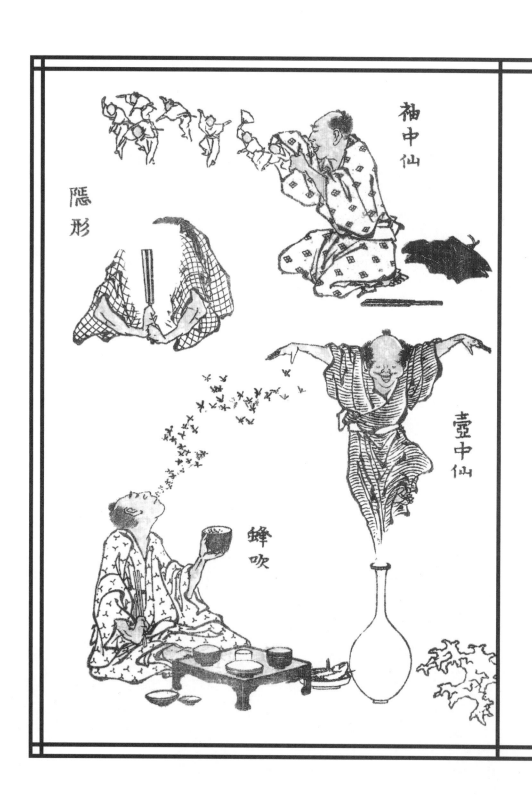

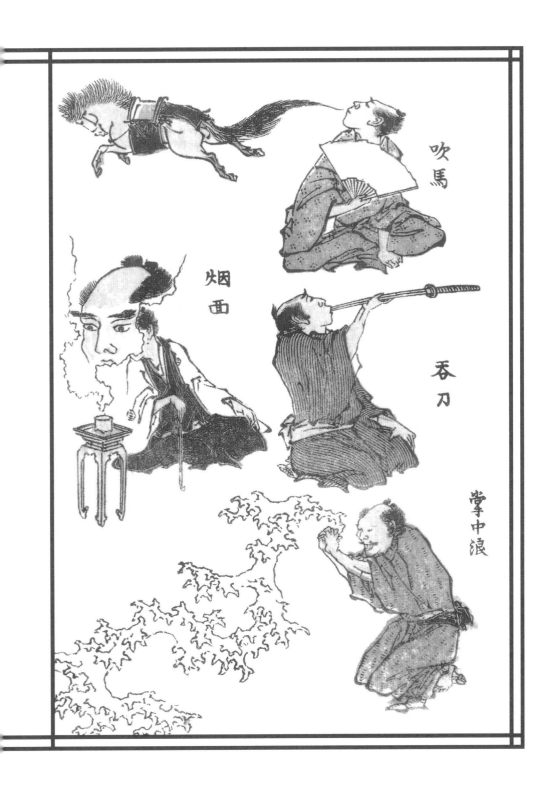

吹馬

烟面

吞刀

掌中浪

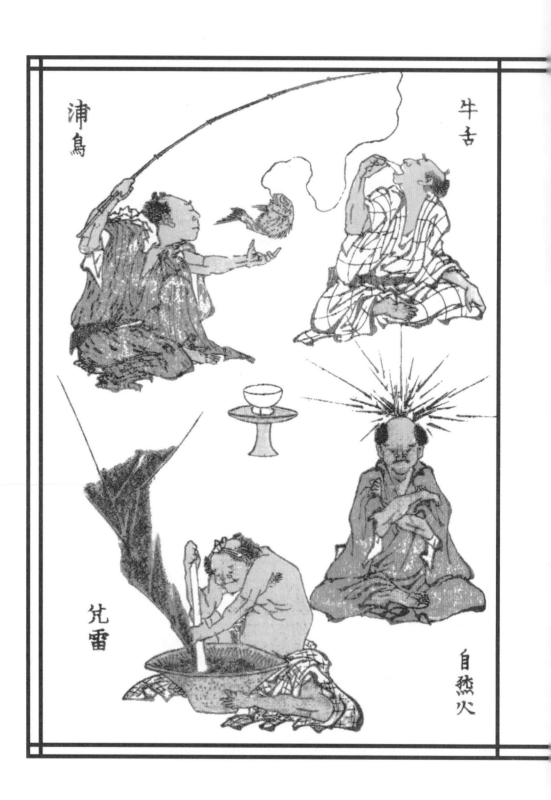

浦鳥

牛舌

兌雷

自然火

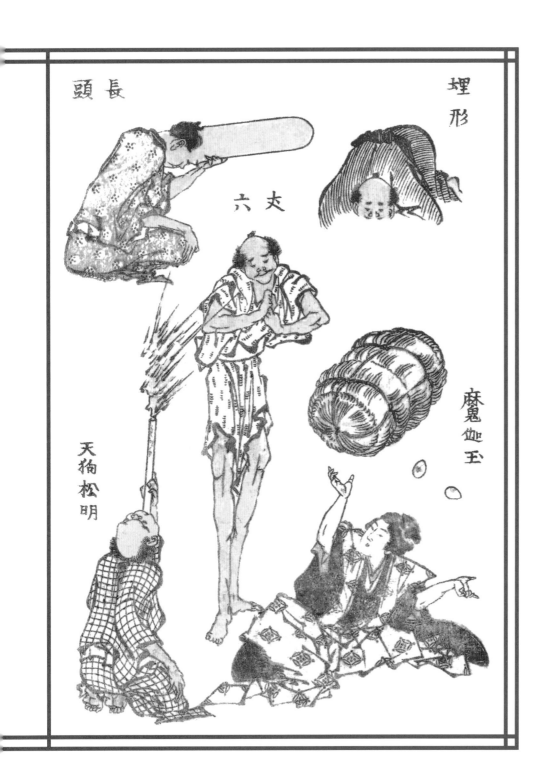

長頭

埋形

六丈

麻魔伽玉

天狗松明

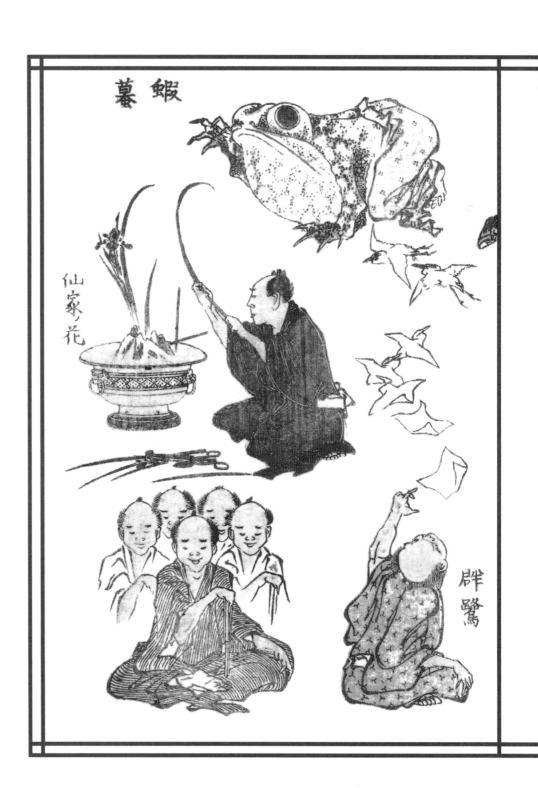

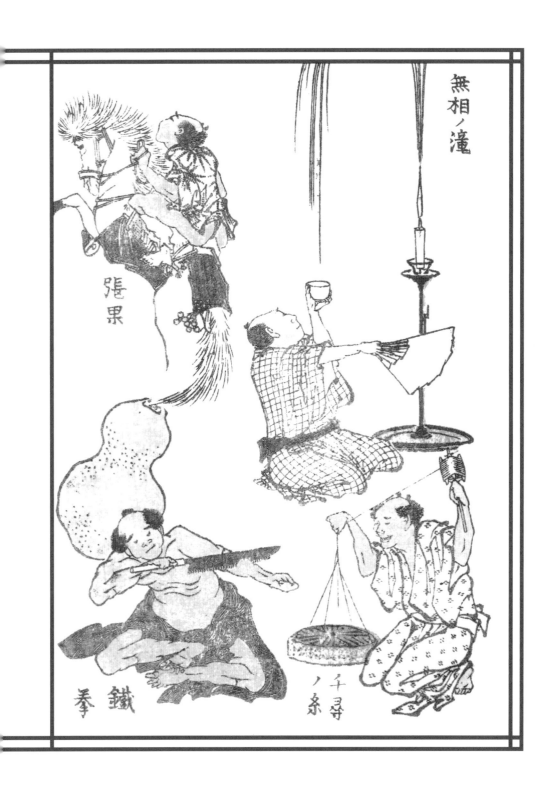

無相ノ滝

張果

鐵拳

千尋ノ糸

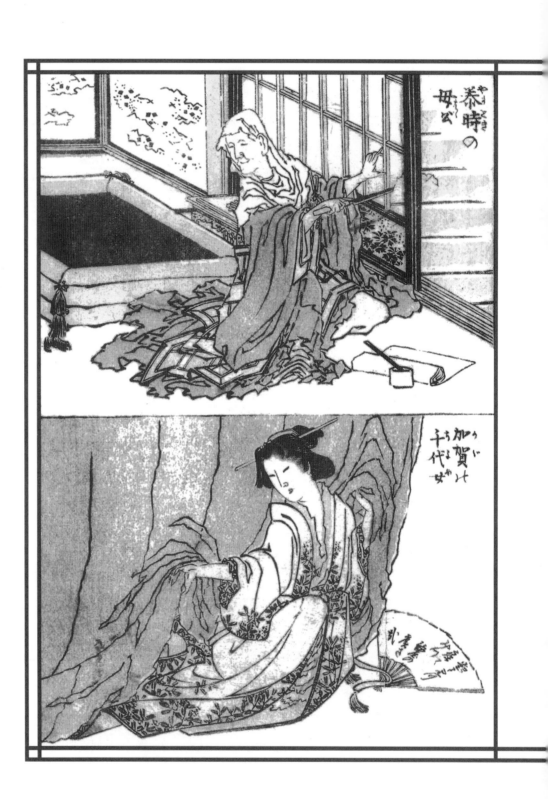

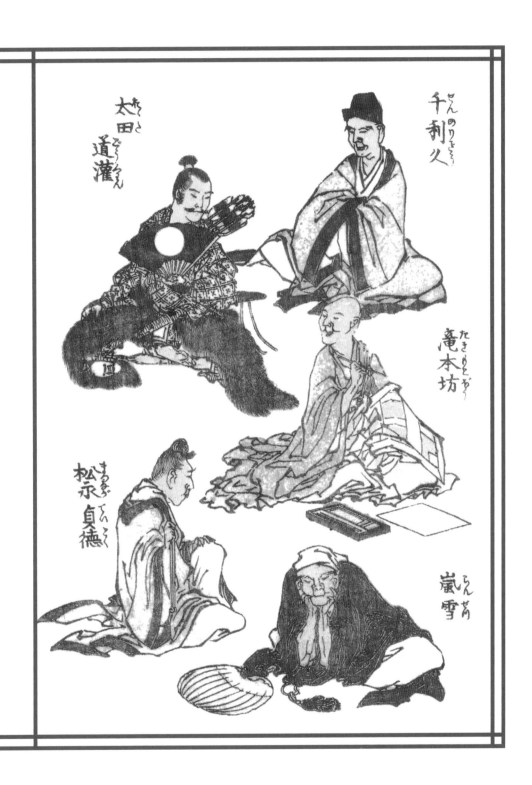

太田
道灌

千利久

竜本坊

松永
貞徳

嵐雪

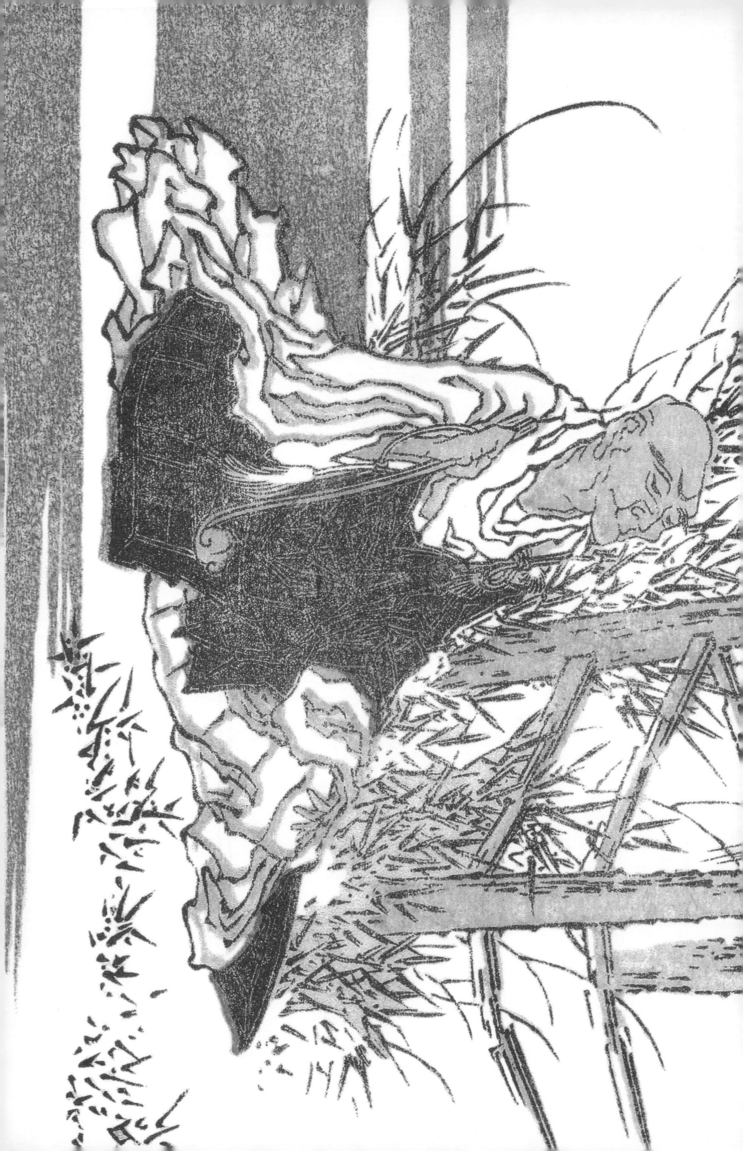

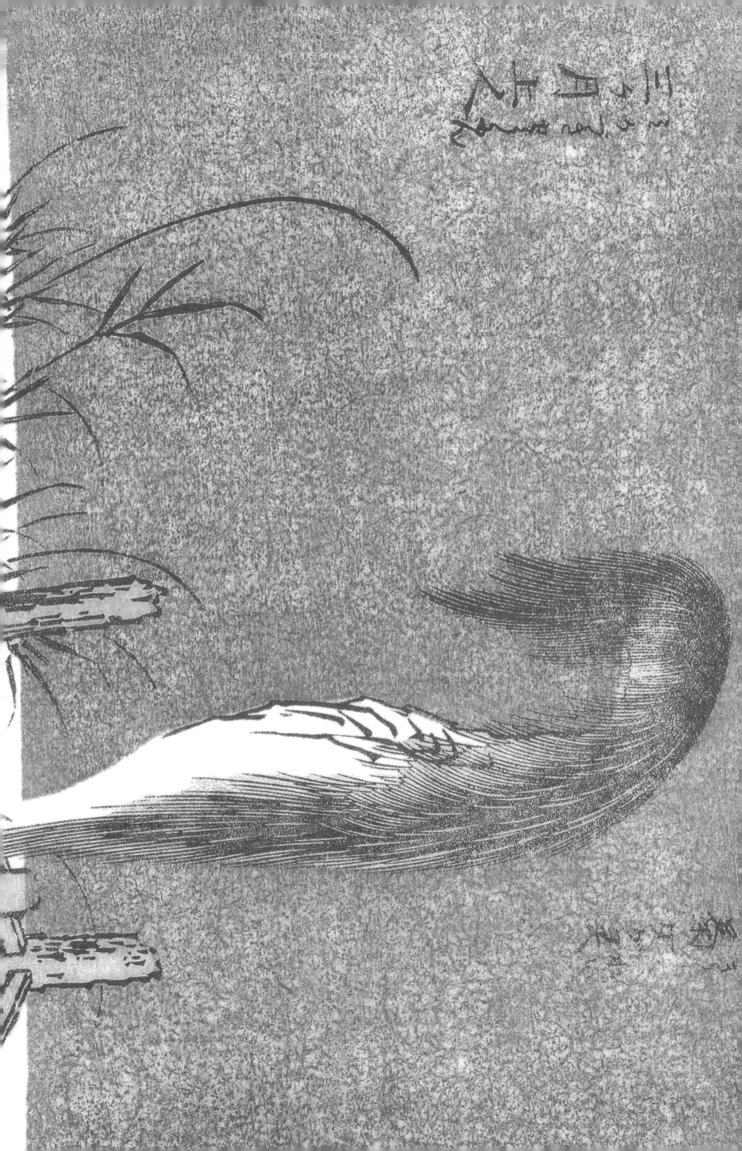

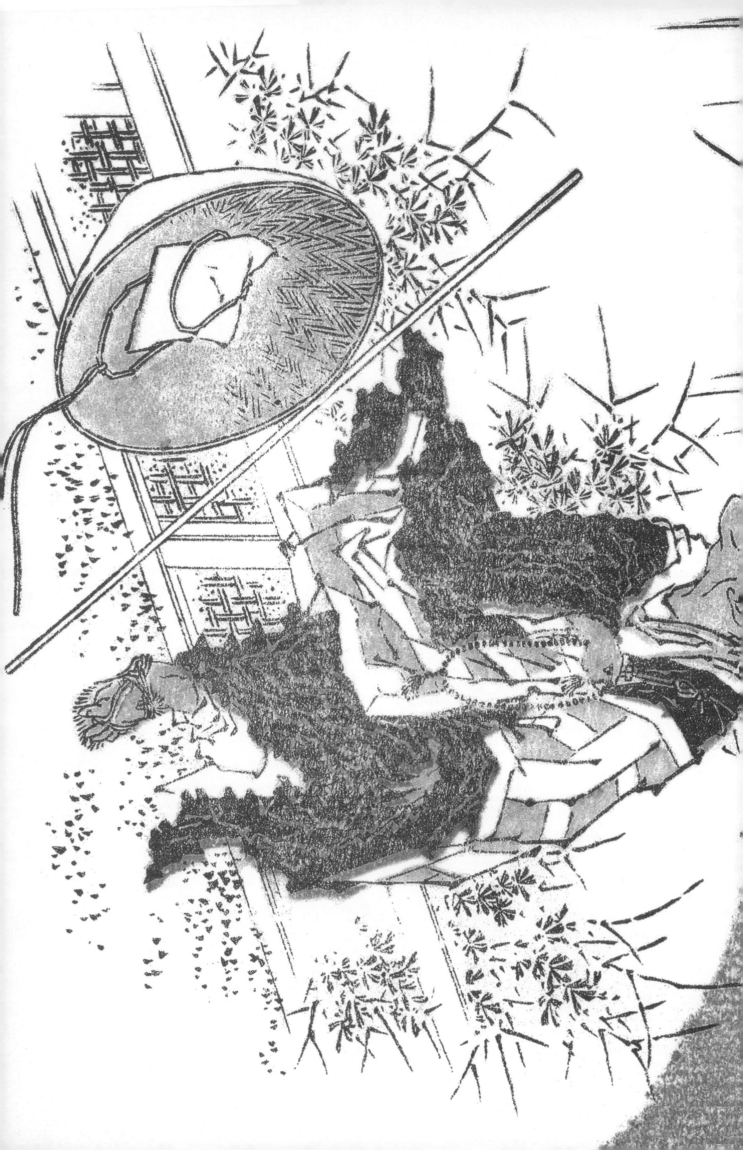

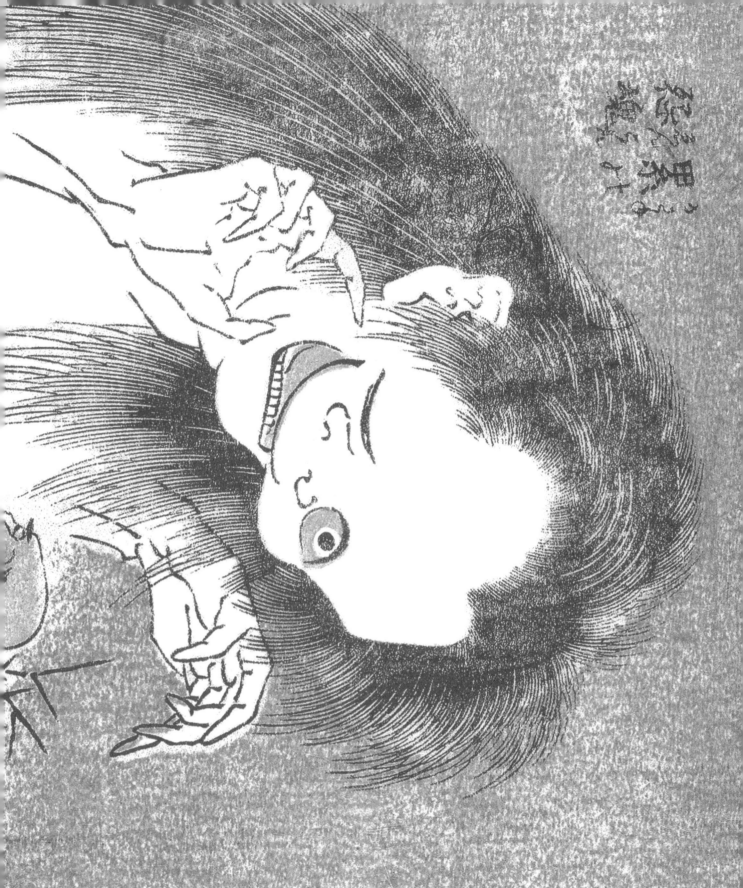

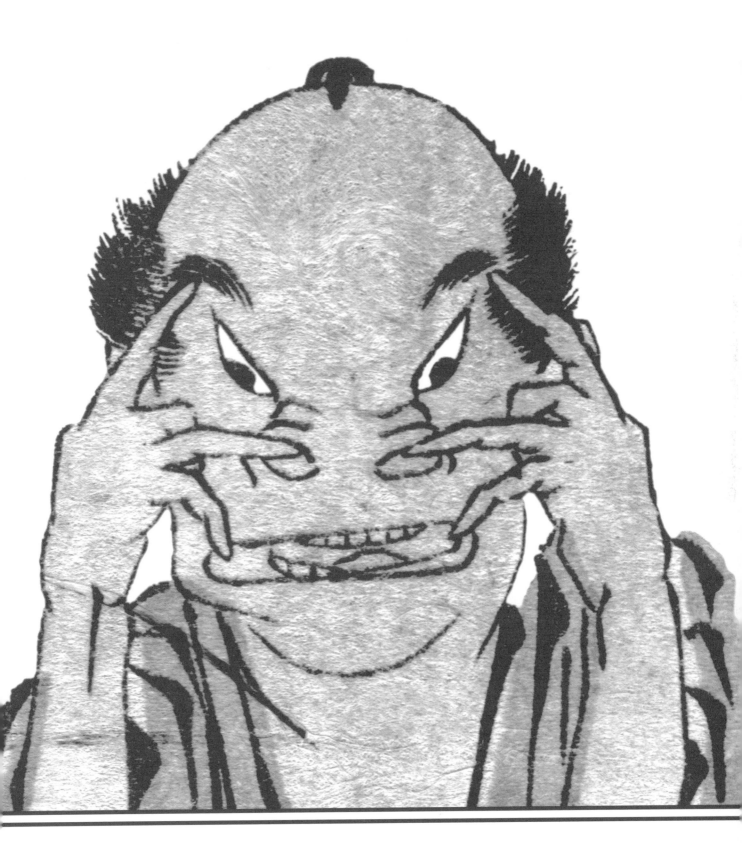

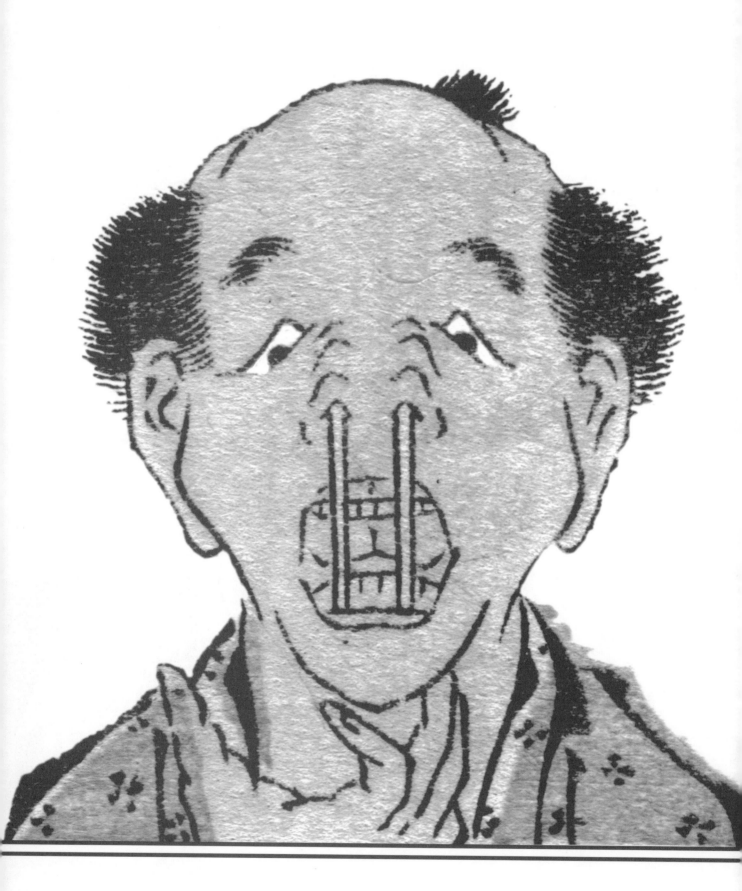

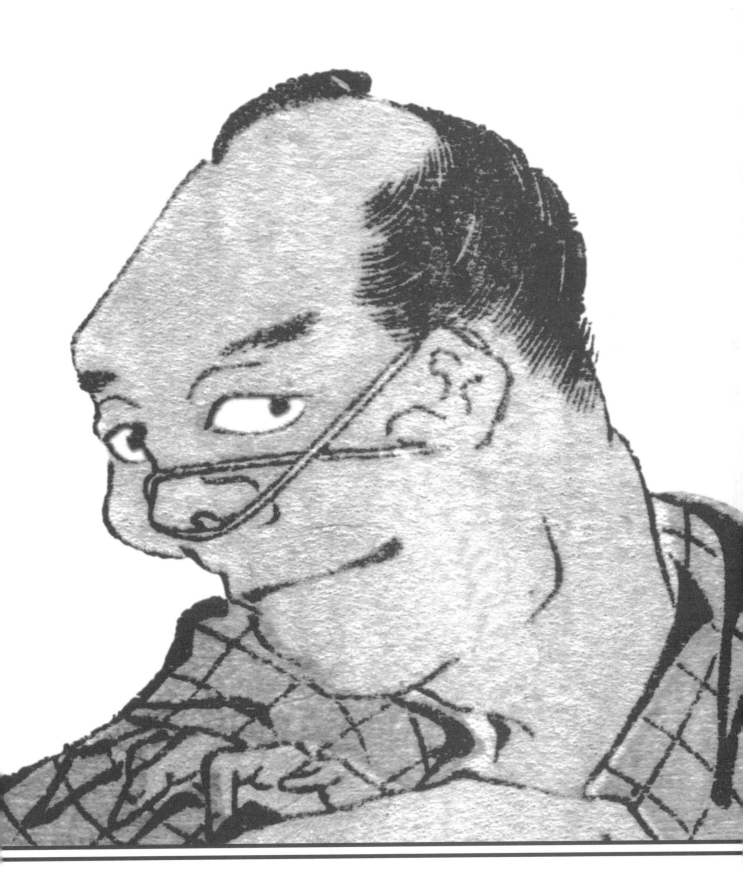

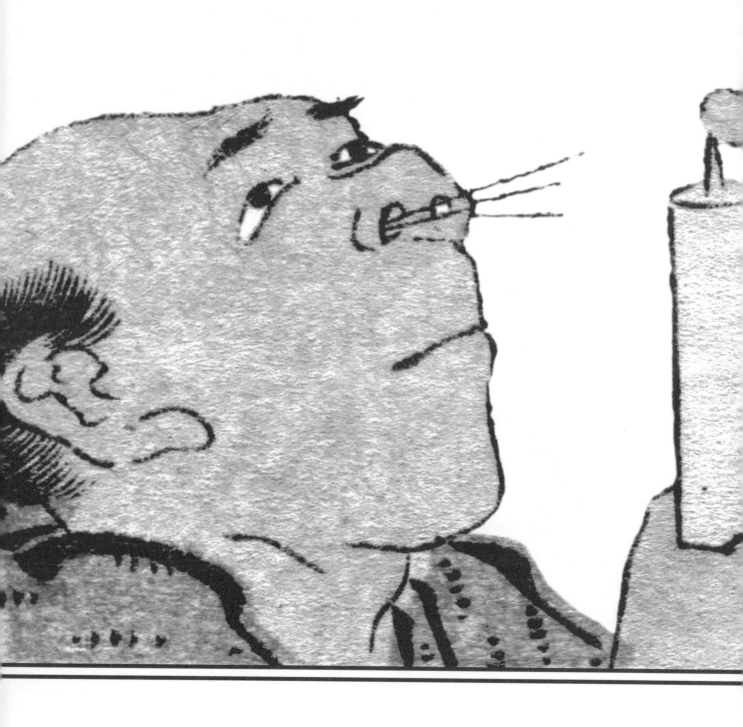

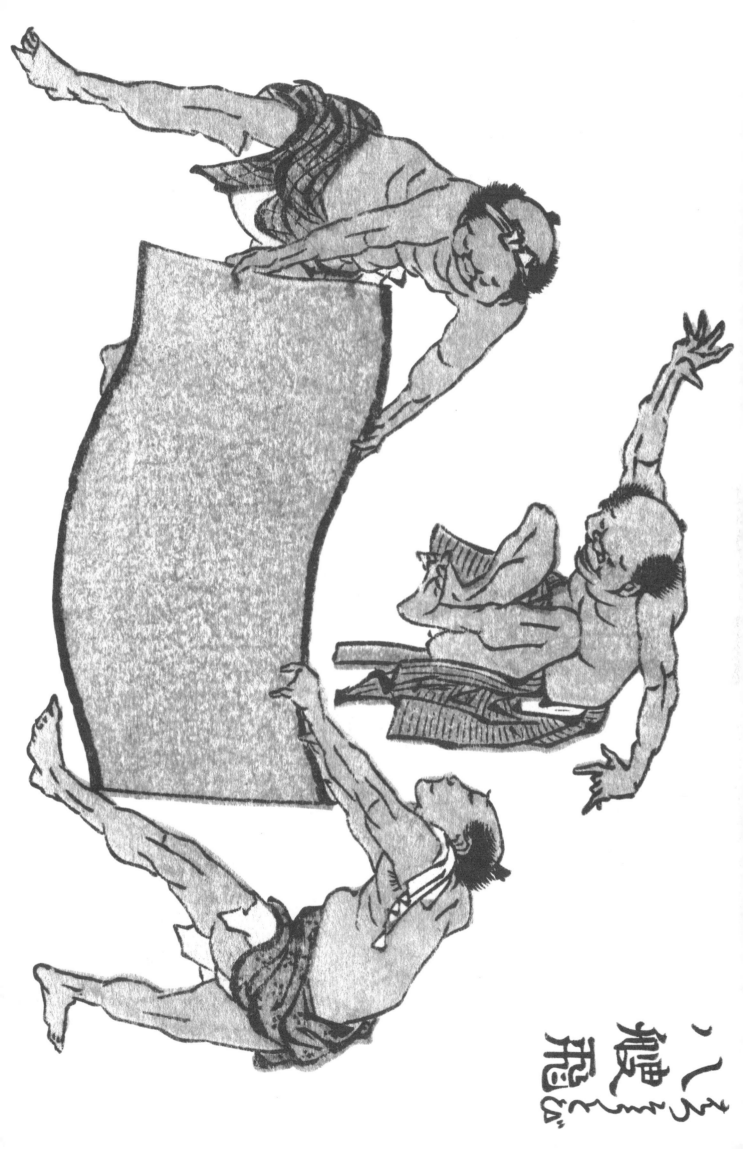

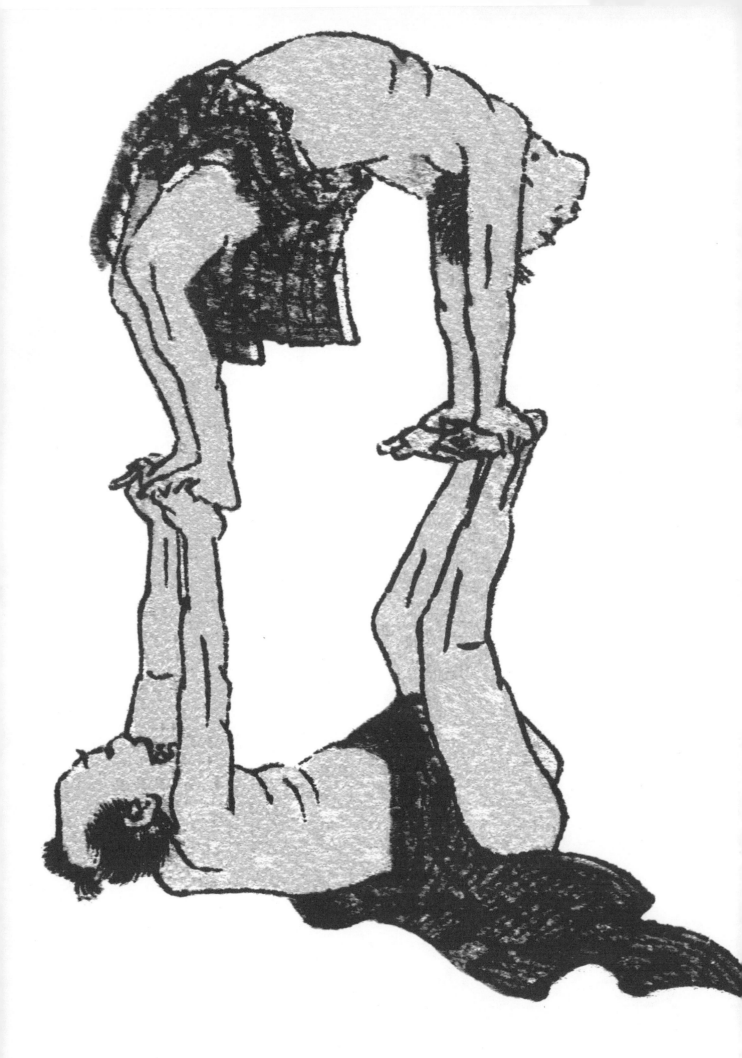

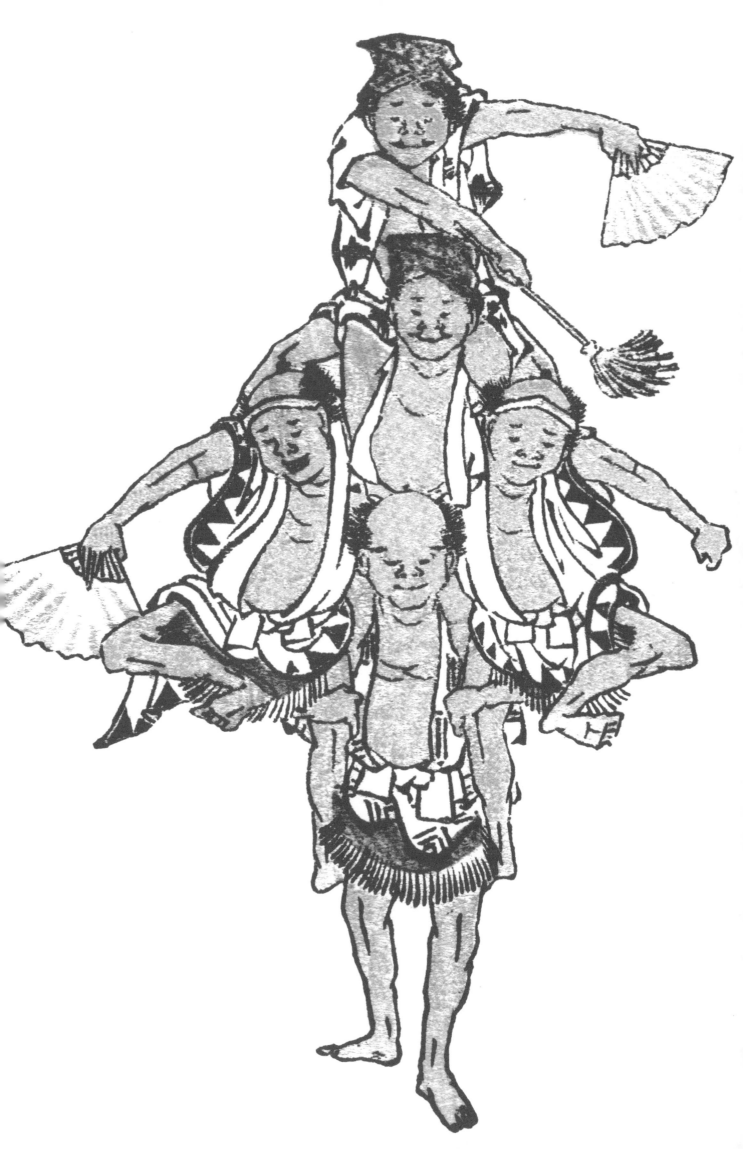

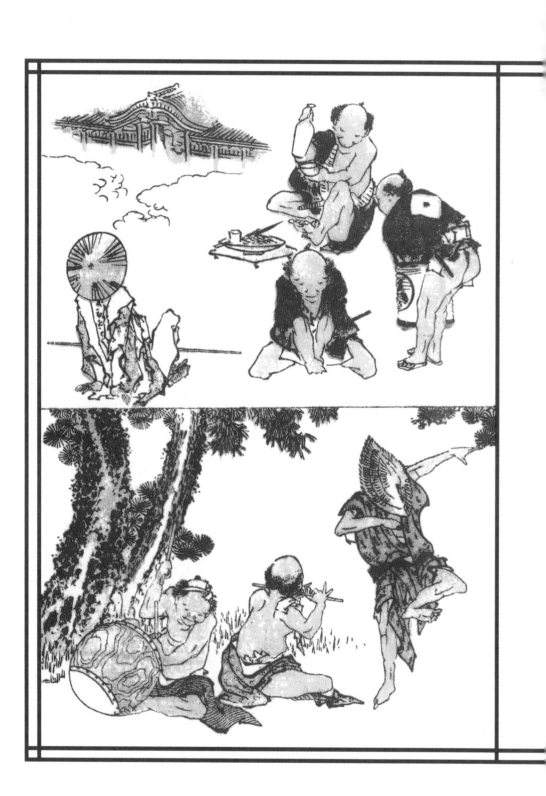

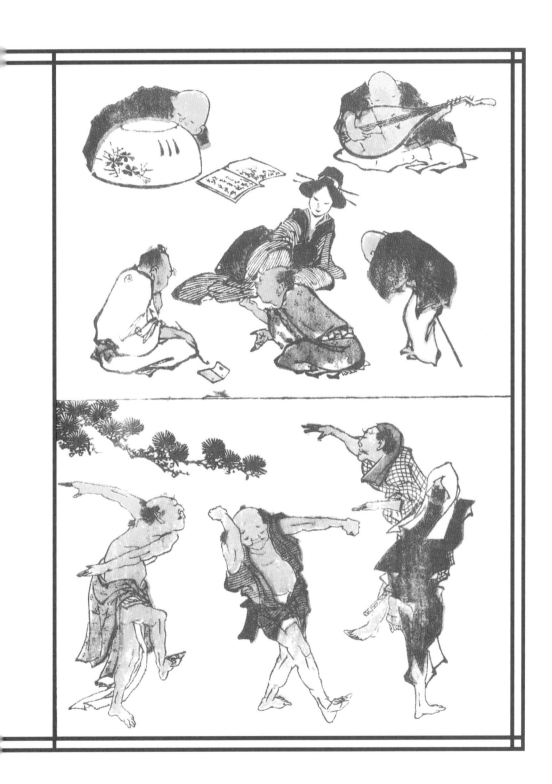

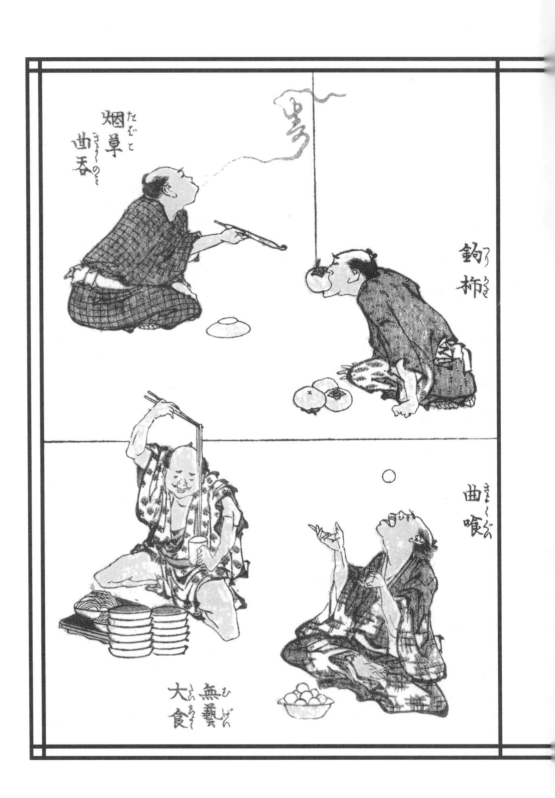

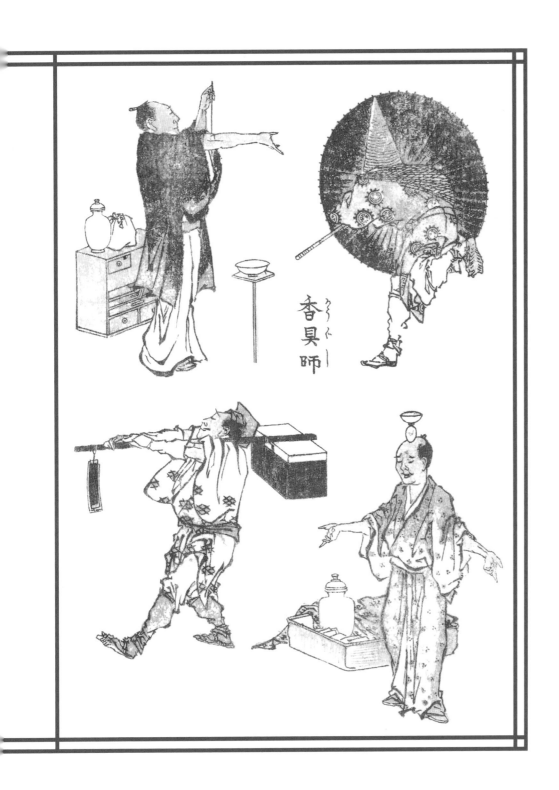

香具師

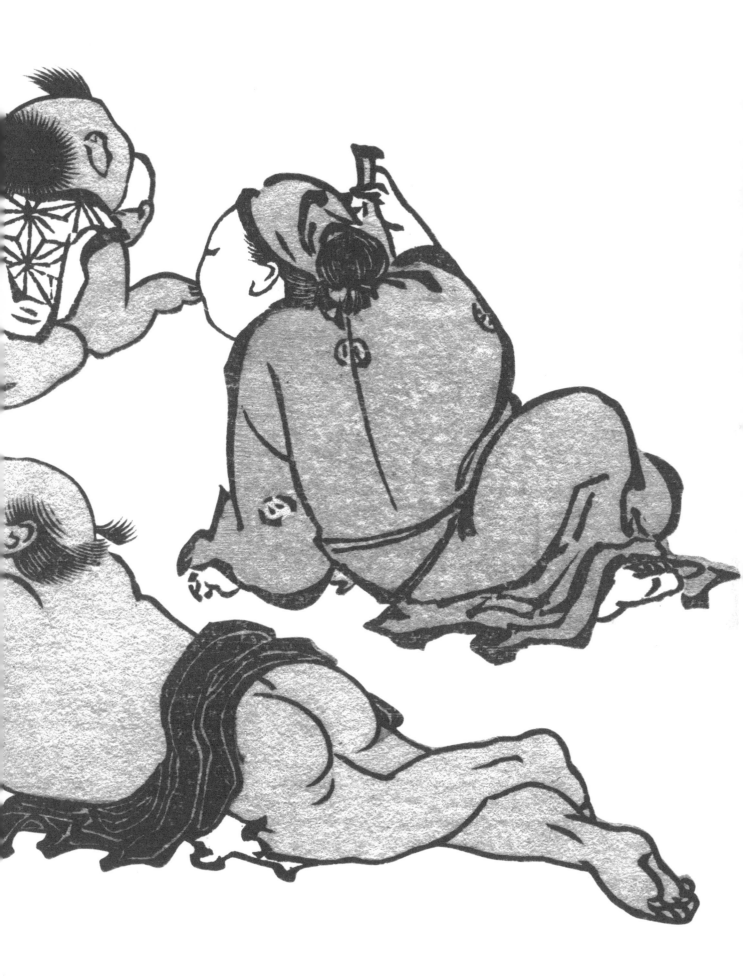

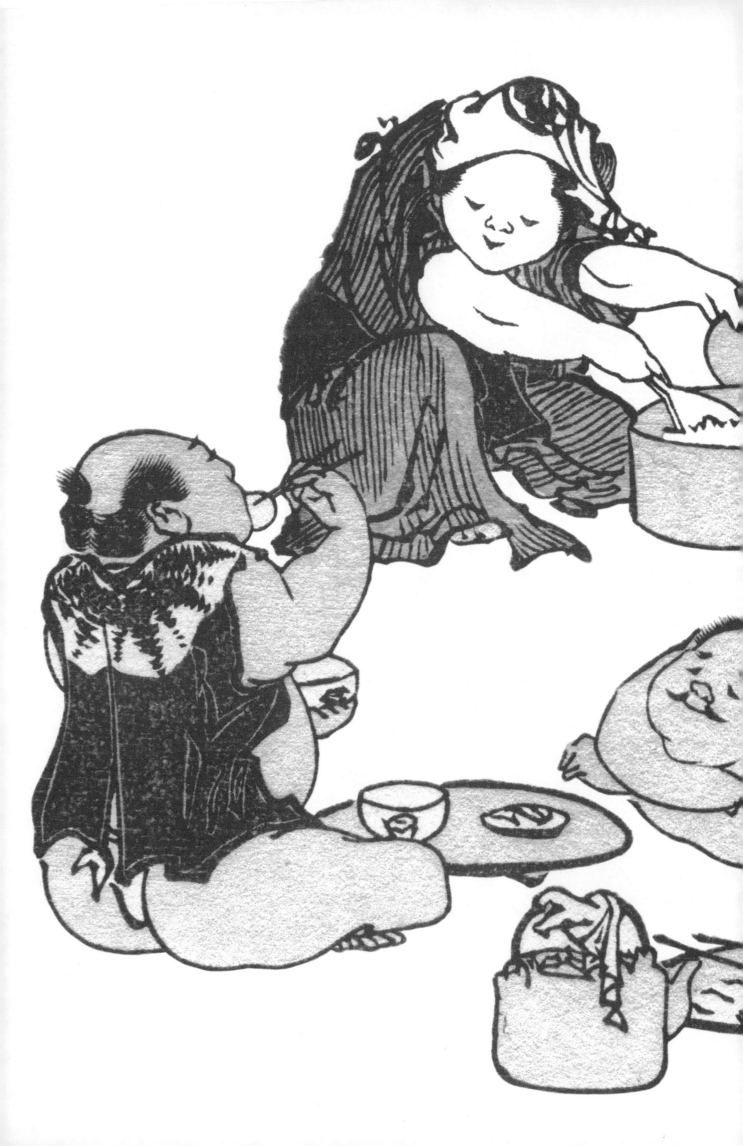

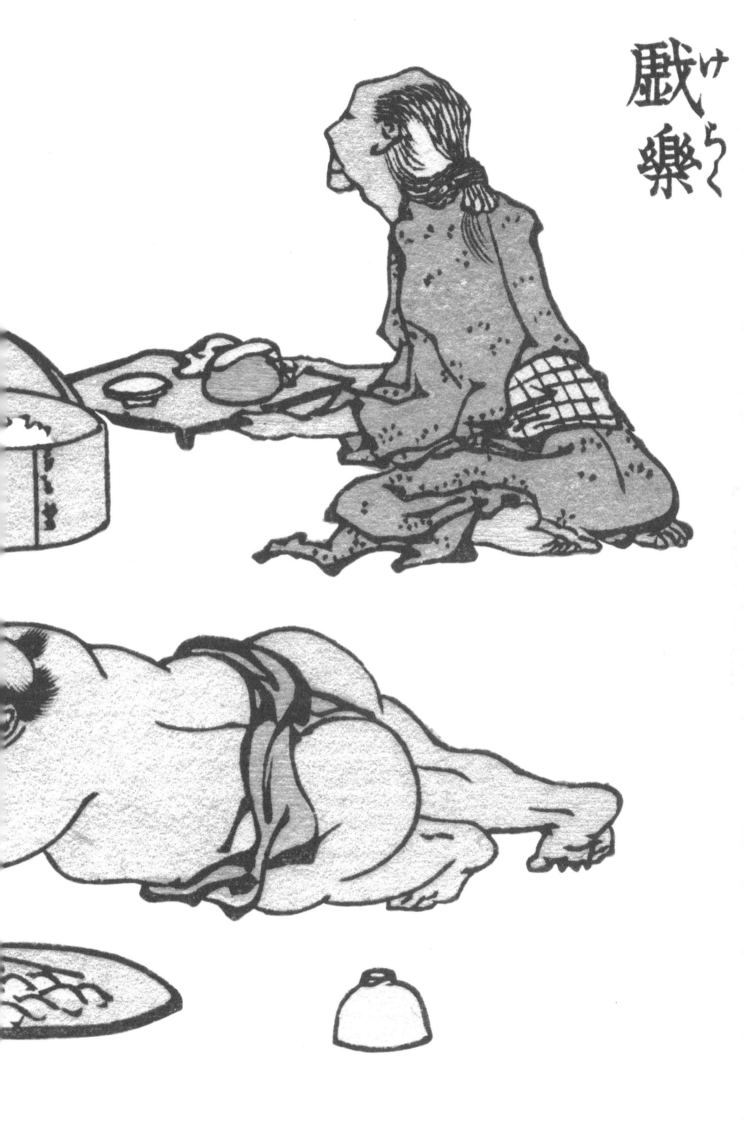

戯楽
けらく

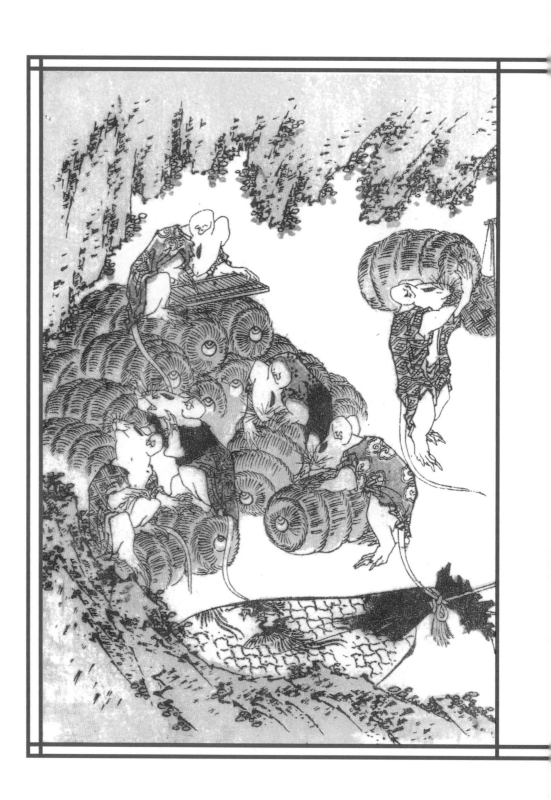

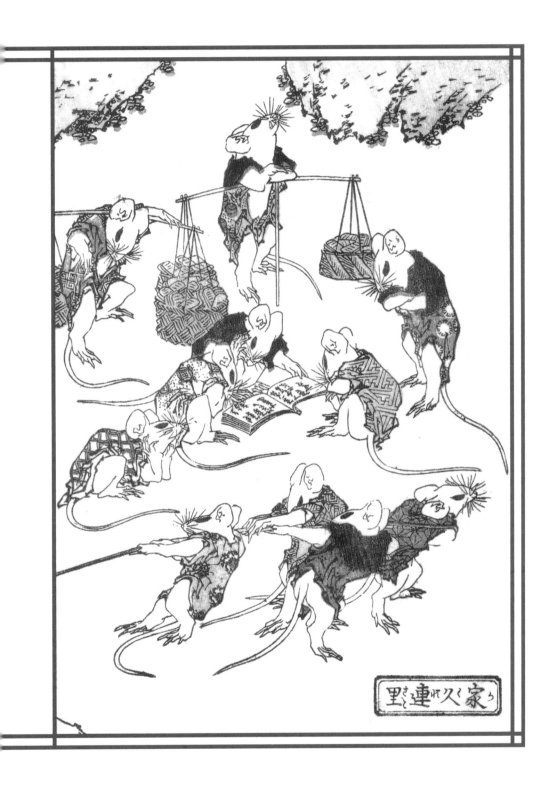

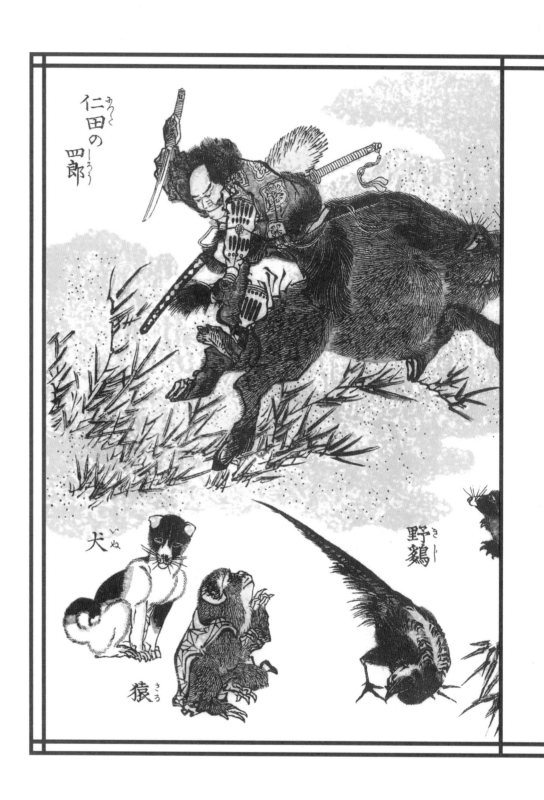

仁田の四郎

犬

猿

野鶏

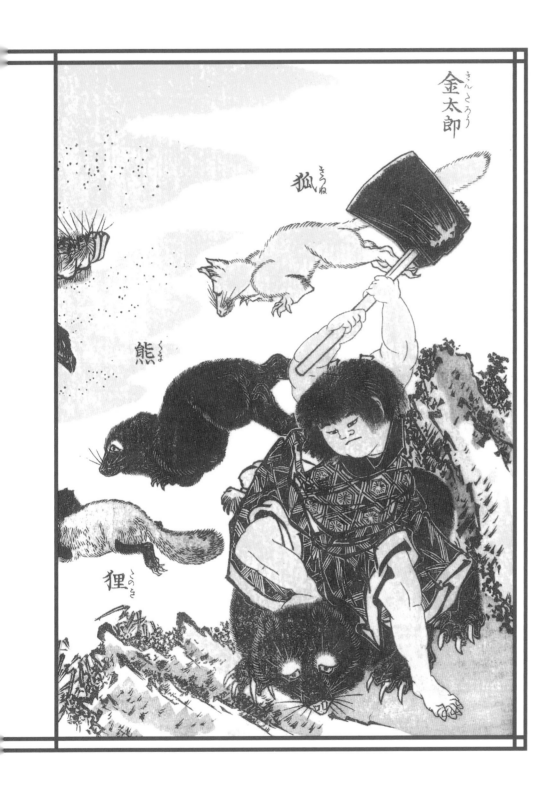

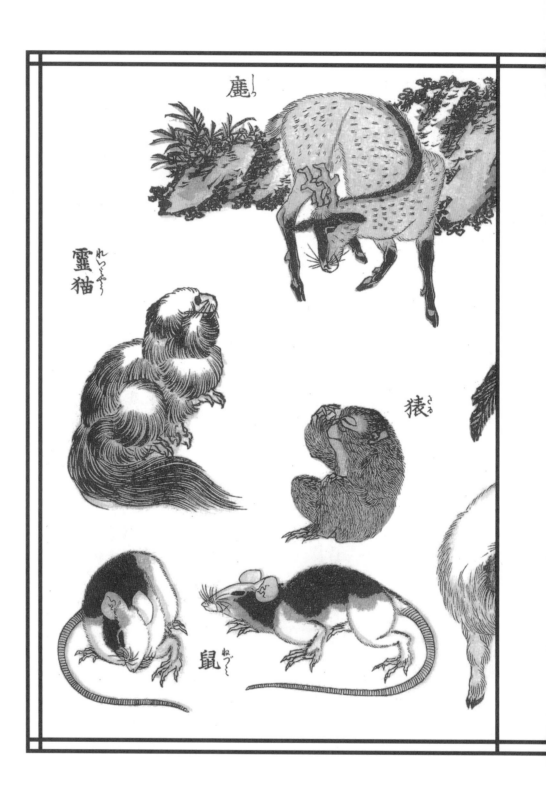

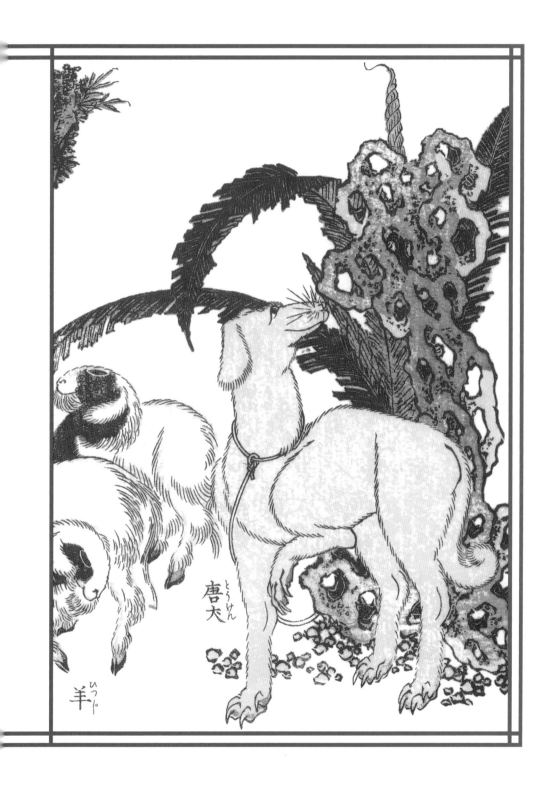

とうけん
唐犬

ひつじ
羊

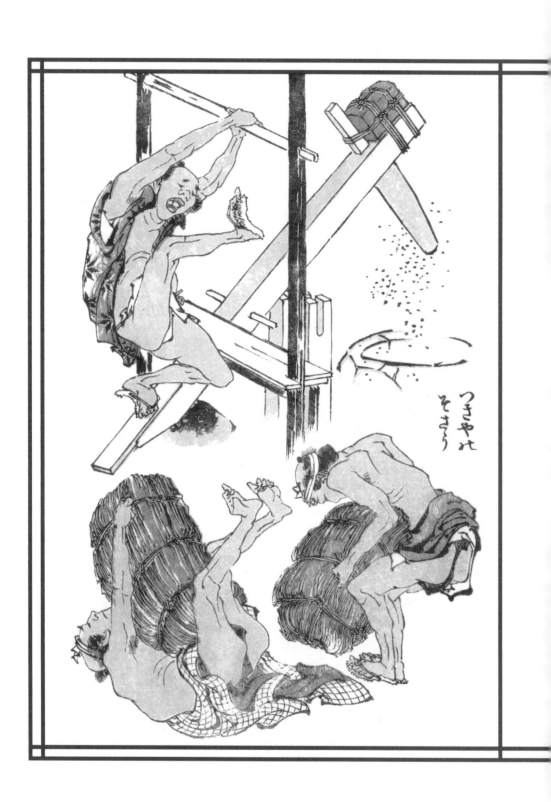

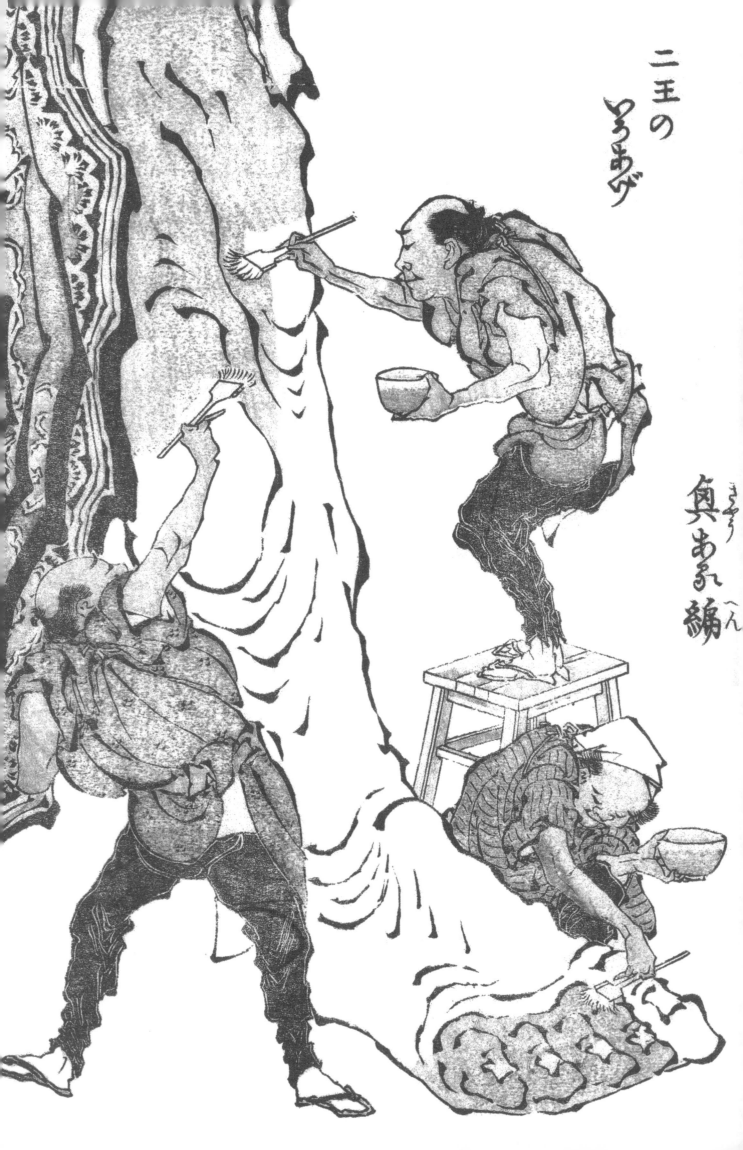

二王の
とうふ

奥
絵
へん

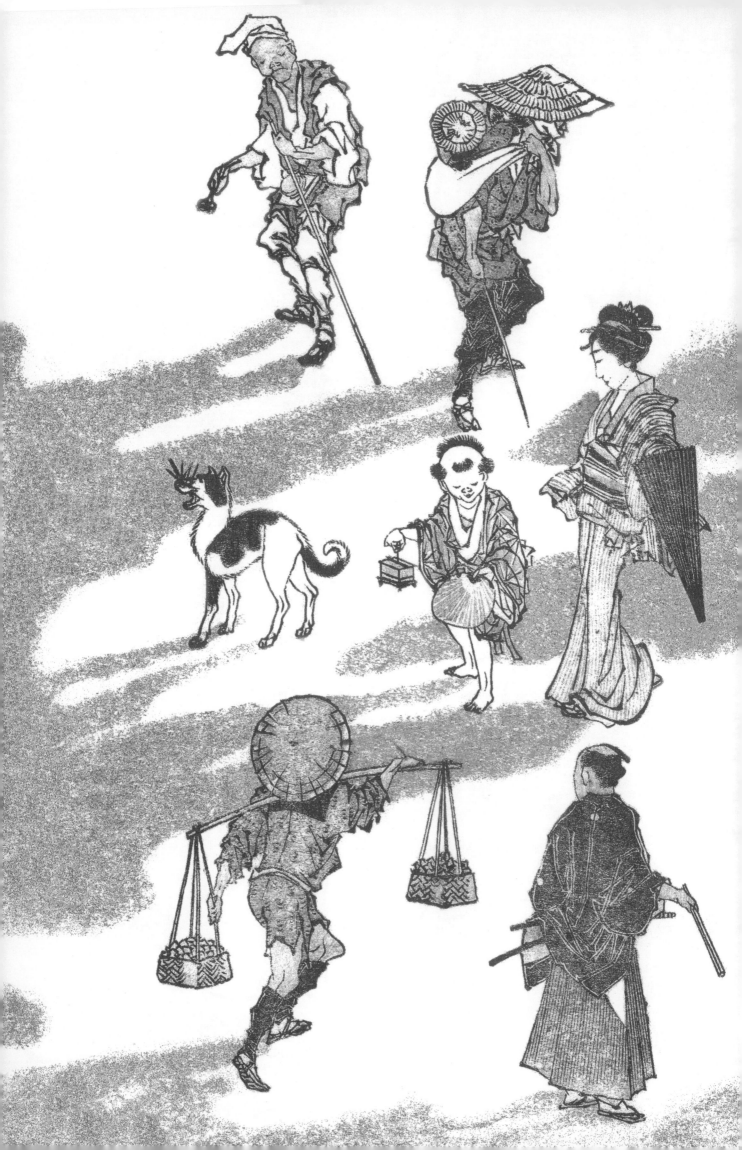

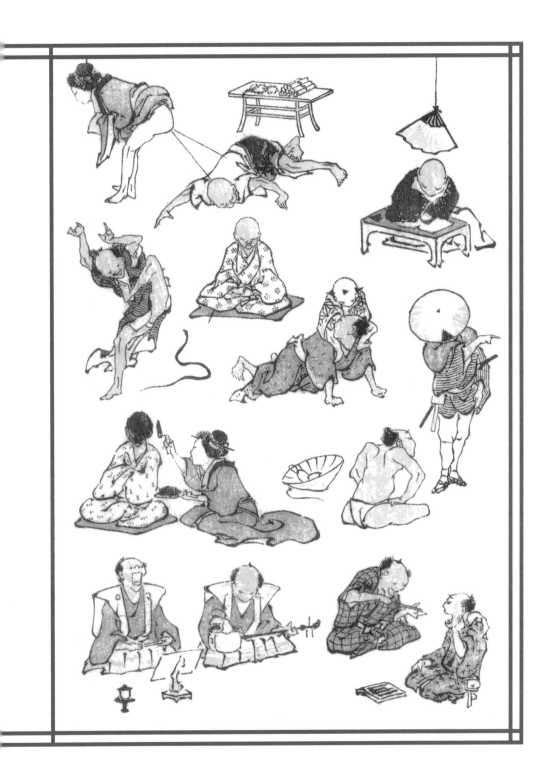

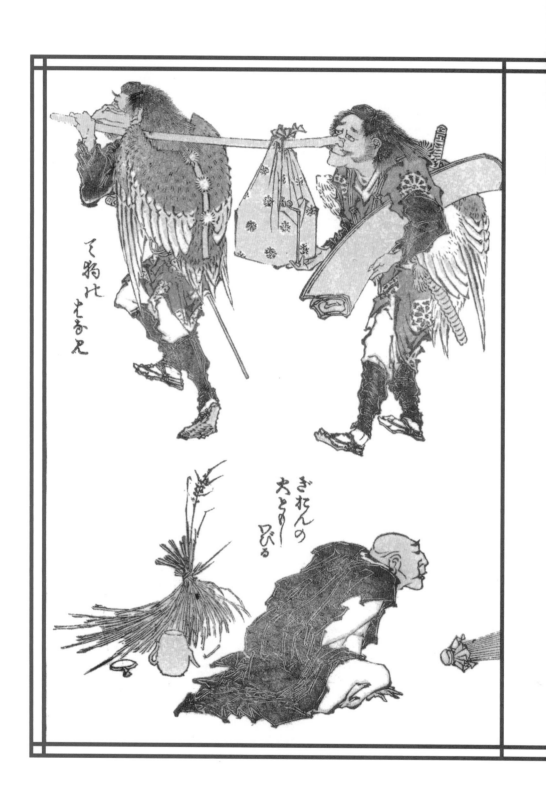

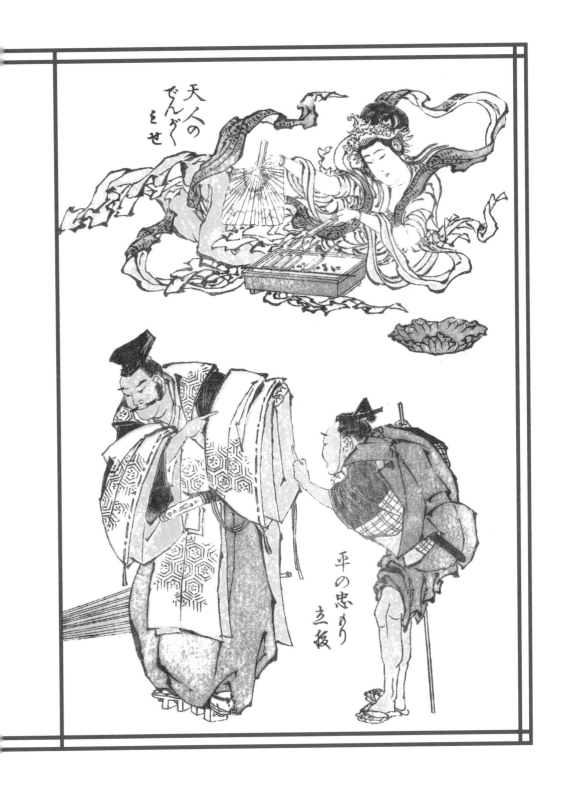

天人の
でんがく
をせ

平の忠りり
立坂

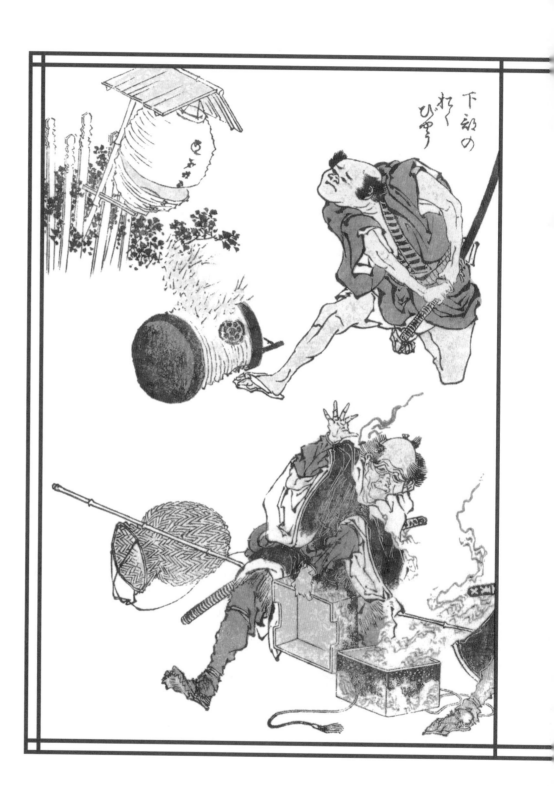

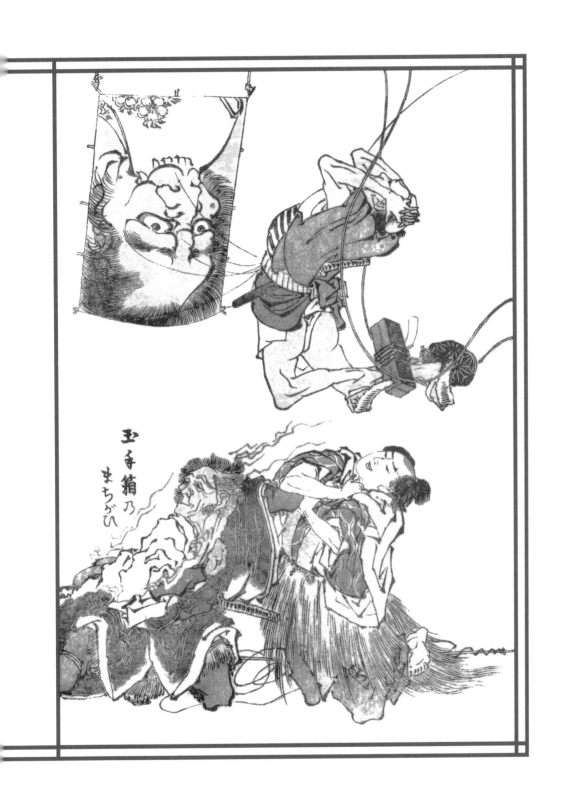

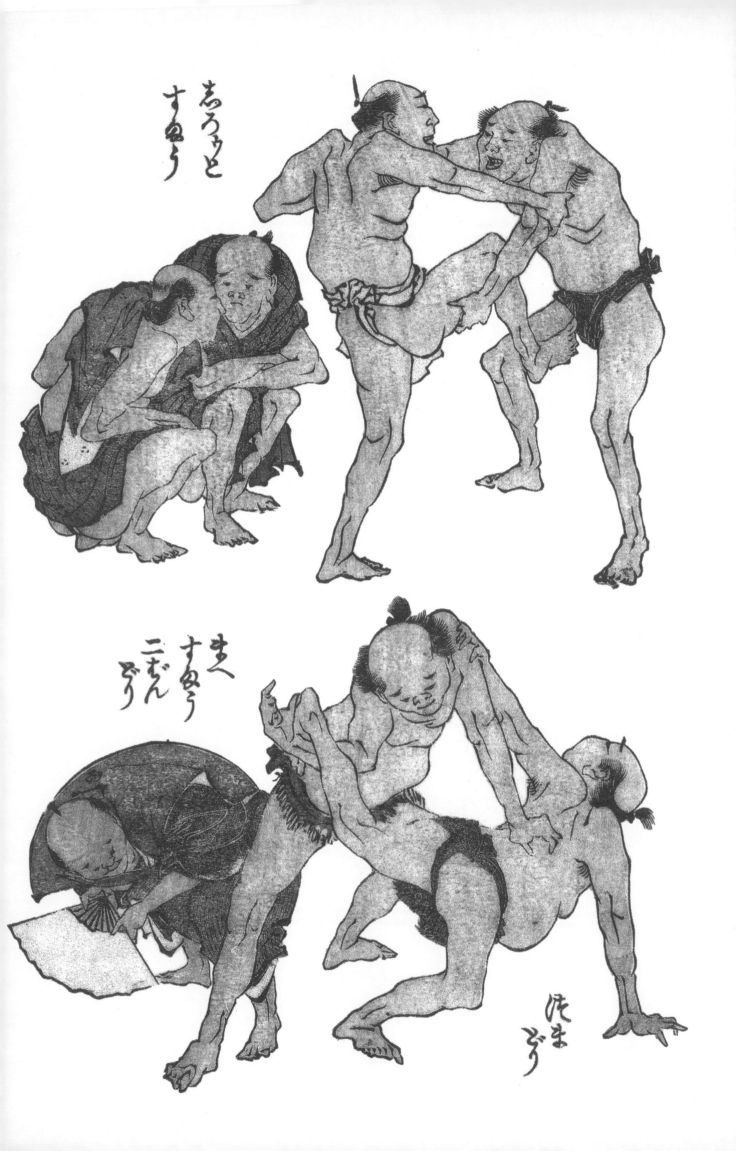

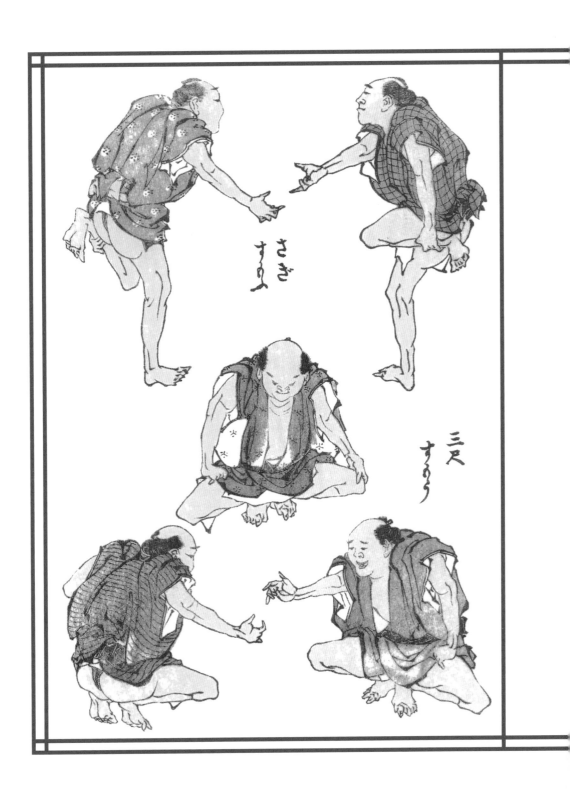

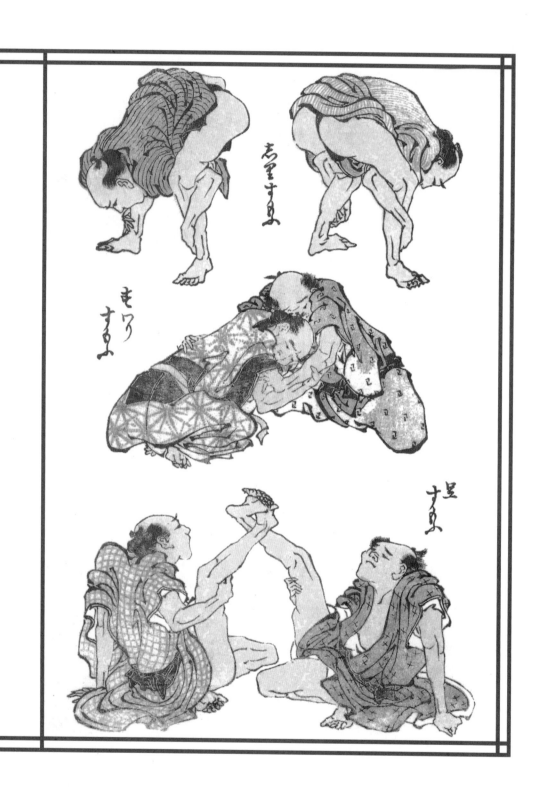

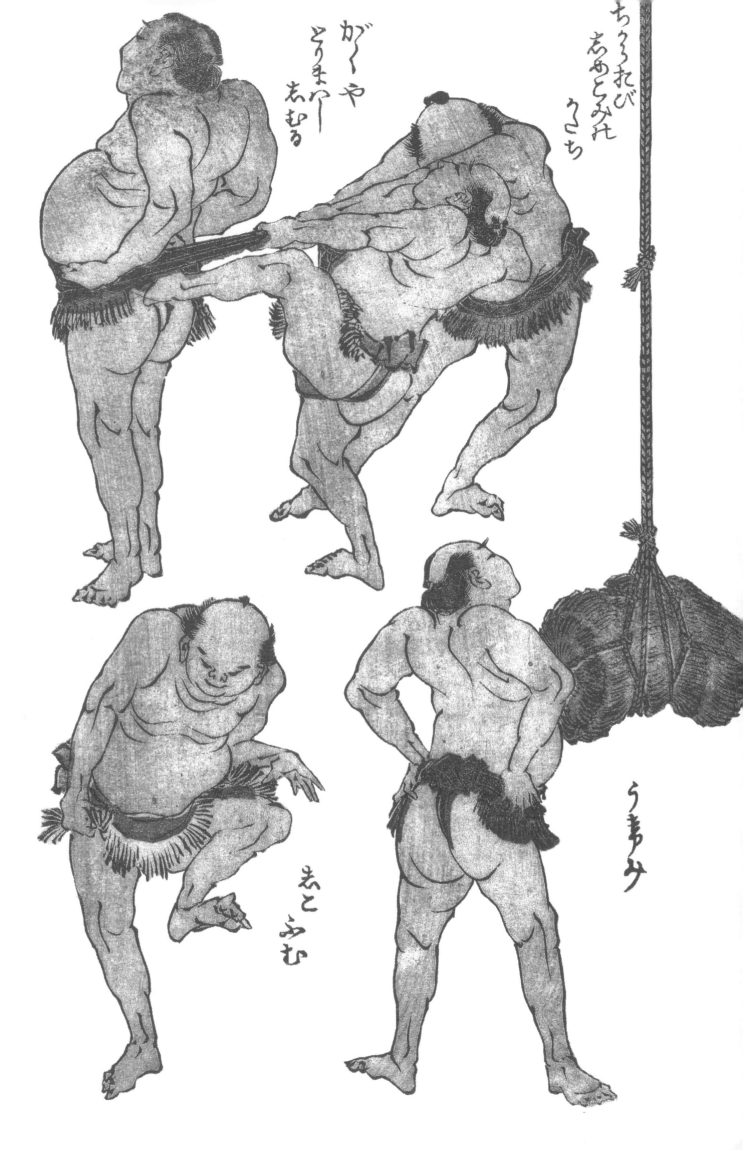

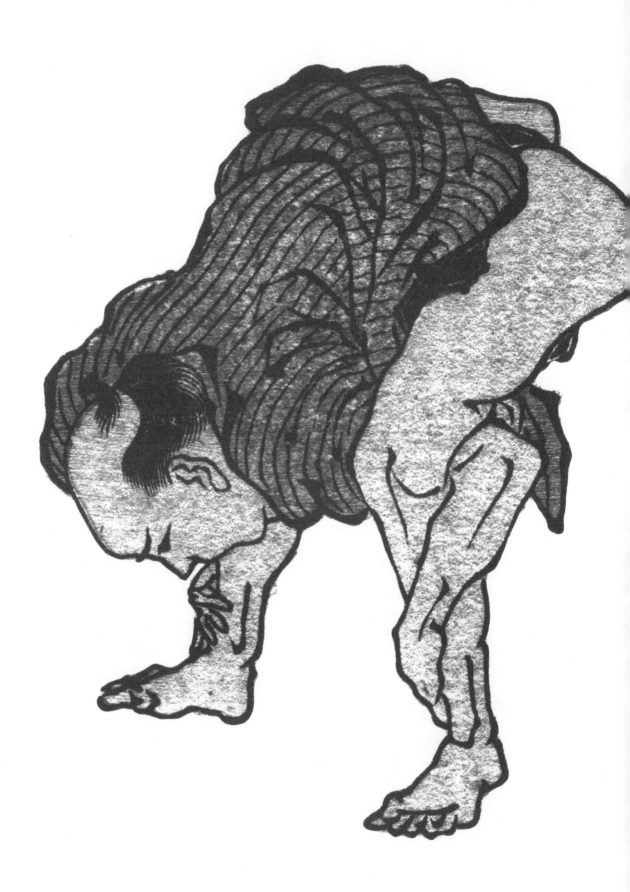

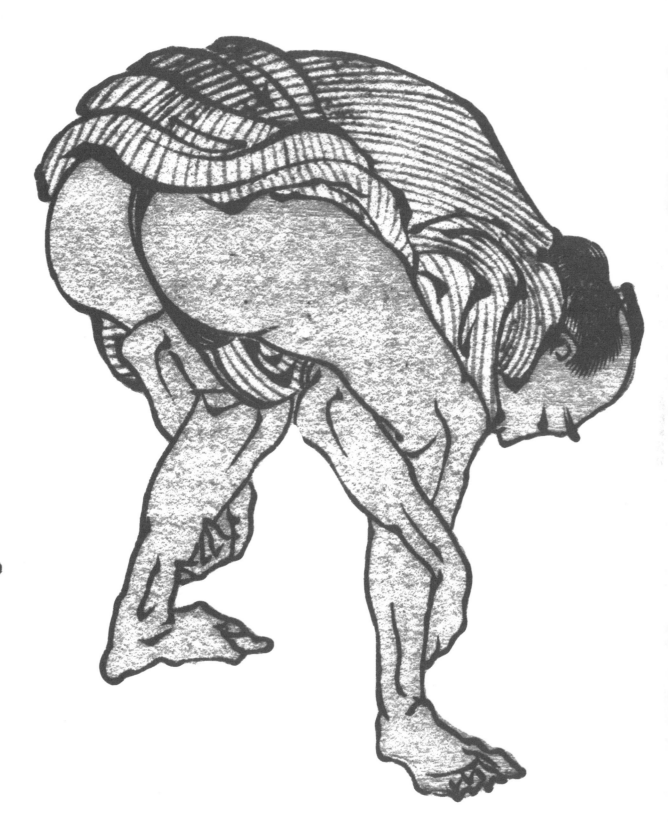

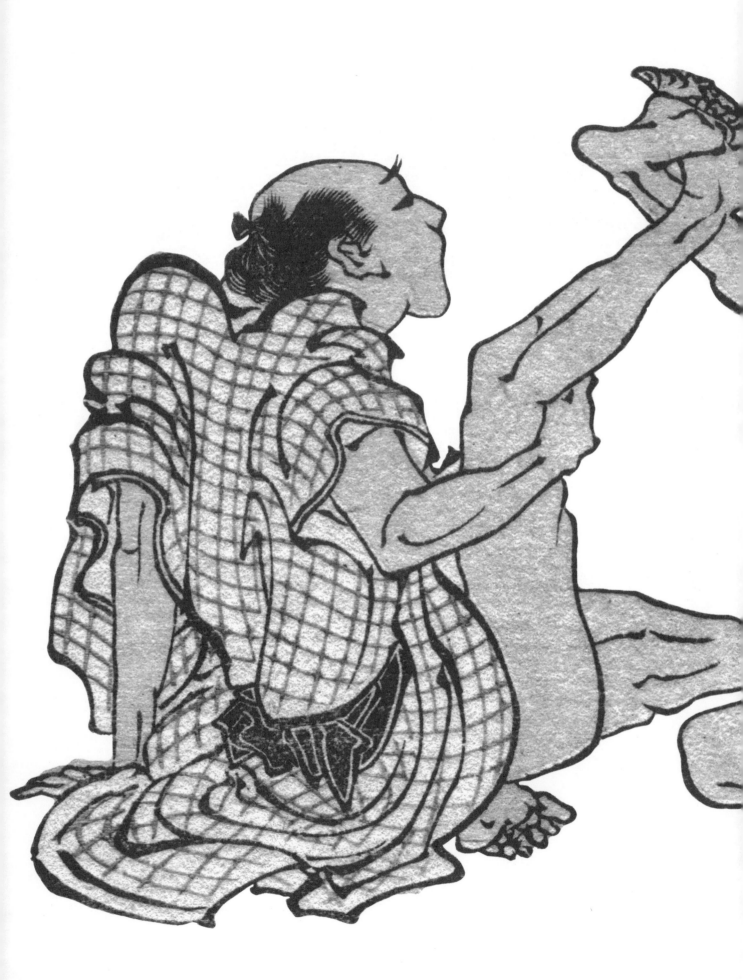

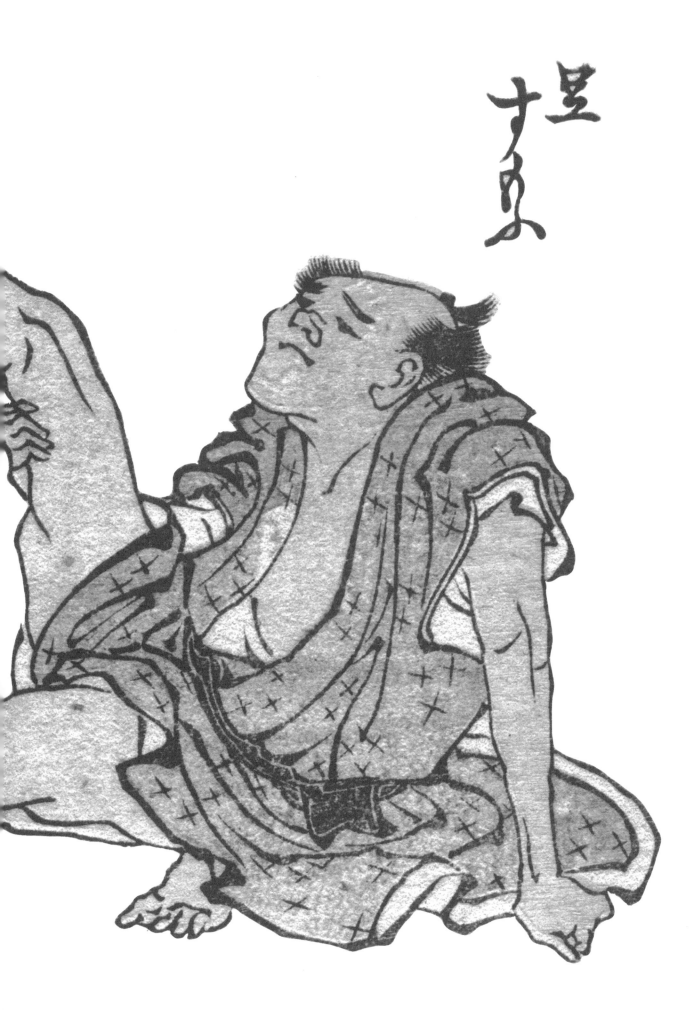

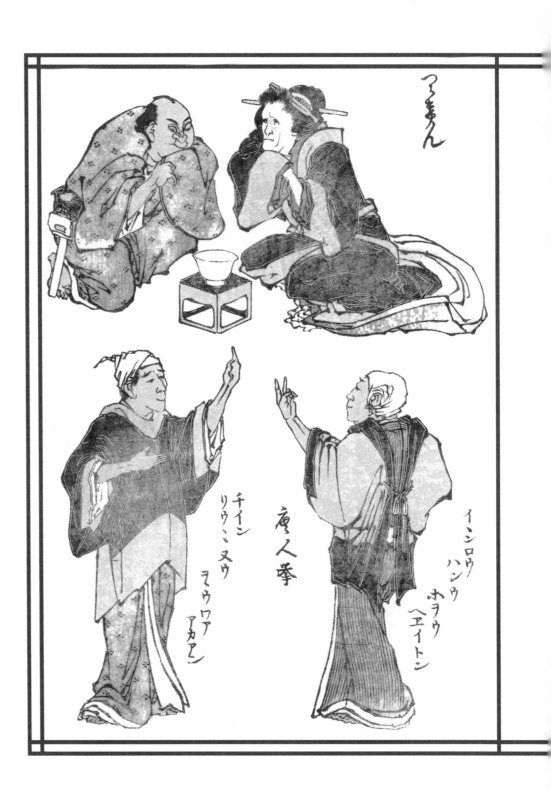

つるまん

唐人拳

チイン
リウハヌウ
ミウワア
アカン

インロウ
ハンウ
ホヲウ
ヘエイトン

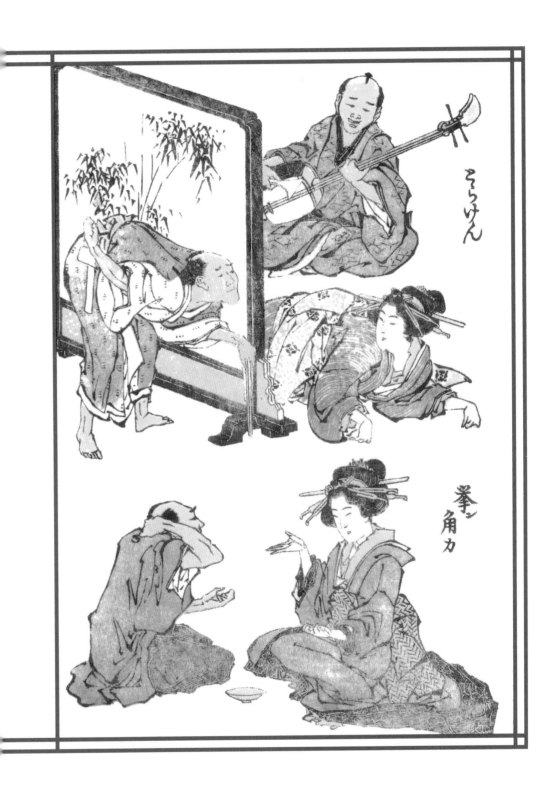

そらけん

拳ン
角力

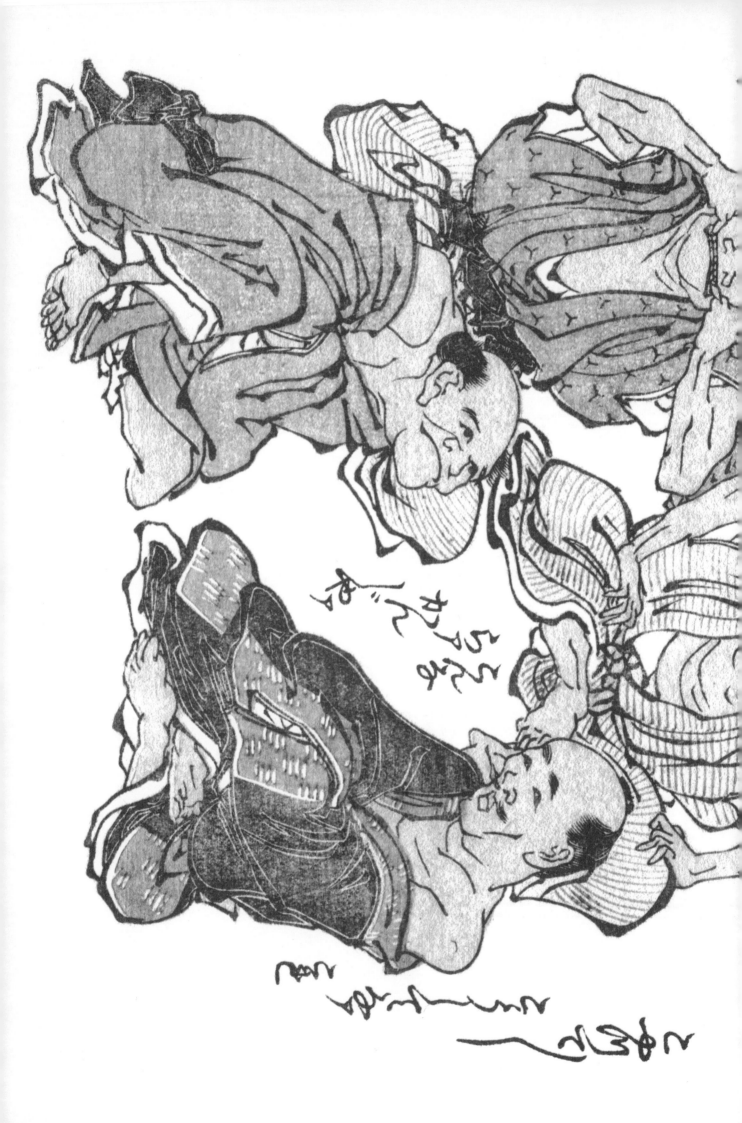

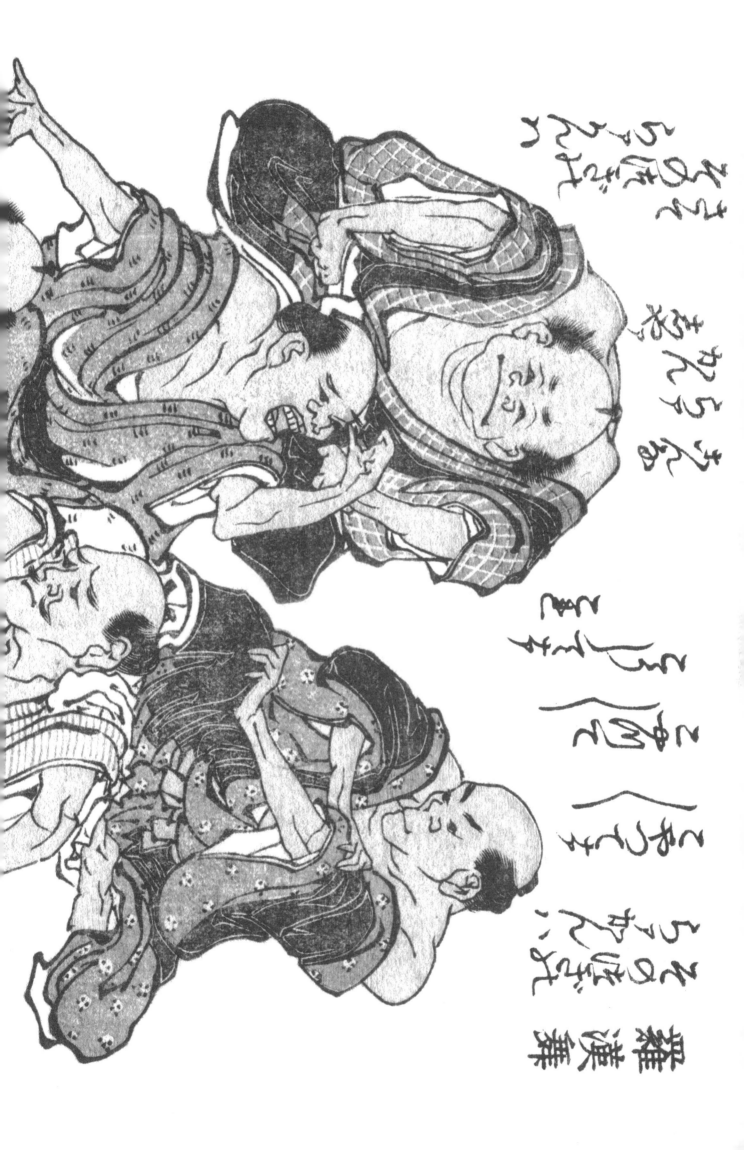

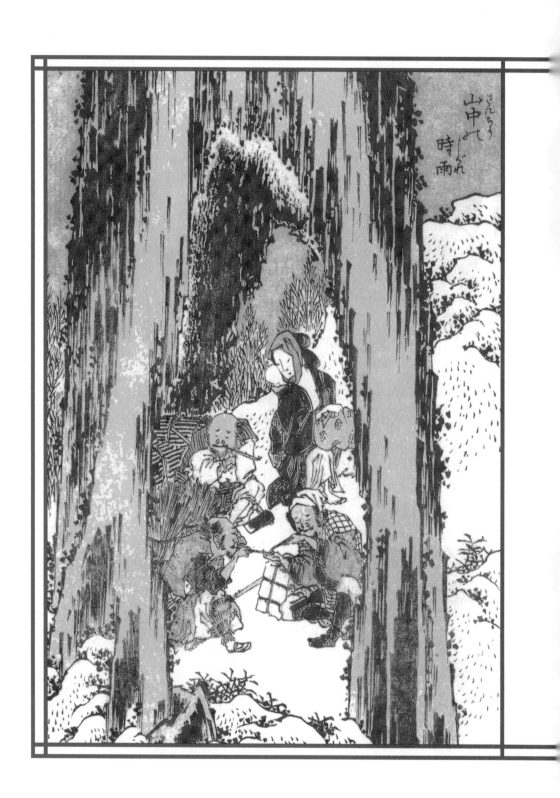

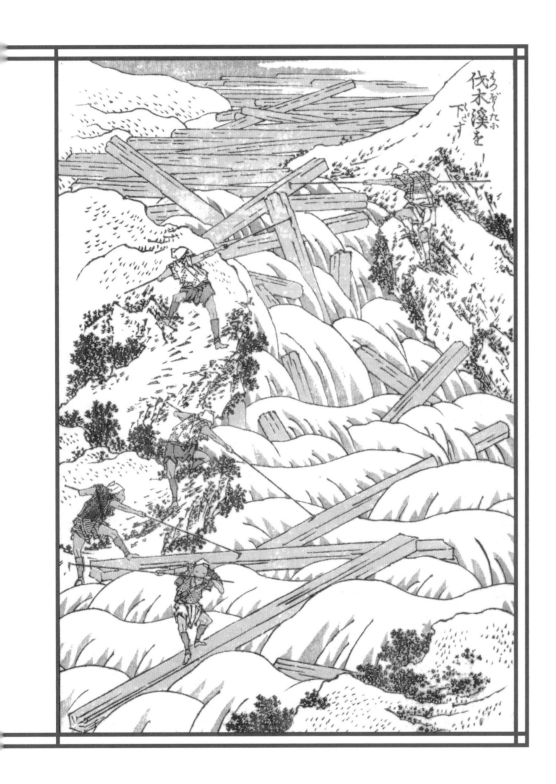

もろおちくれふ
伐木溪を
下だす

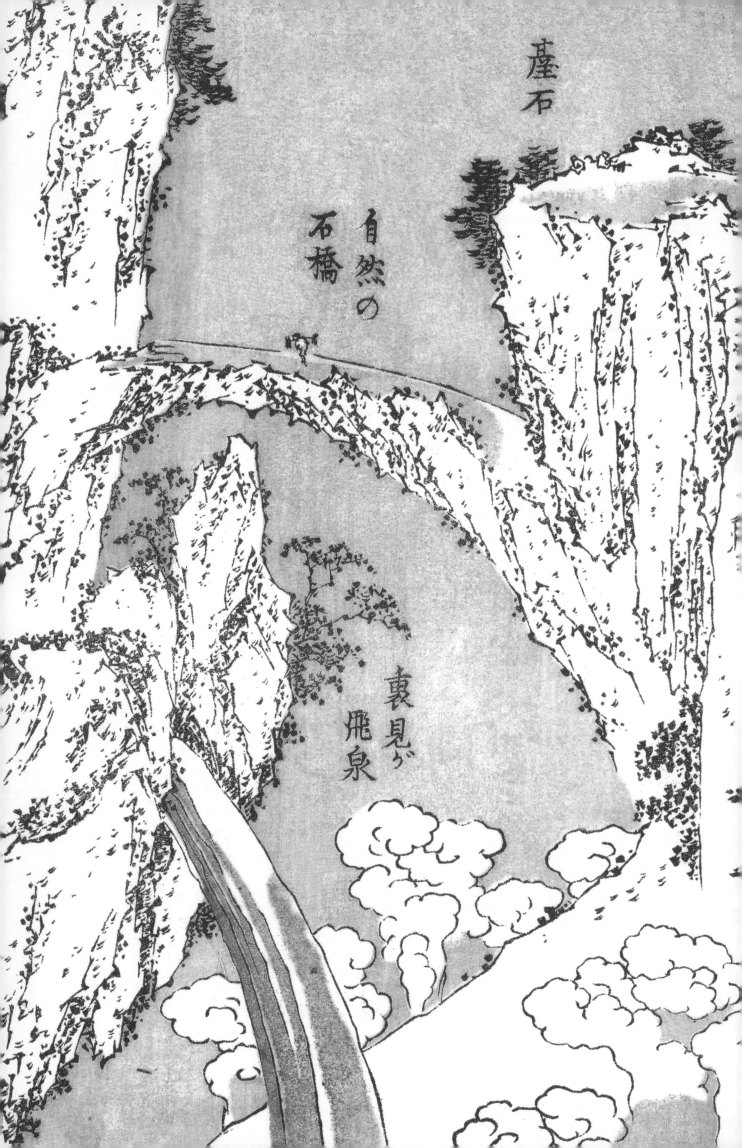

塵石

自然の
石橋

裏見が
飛泉

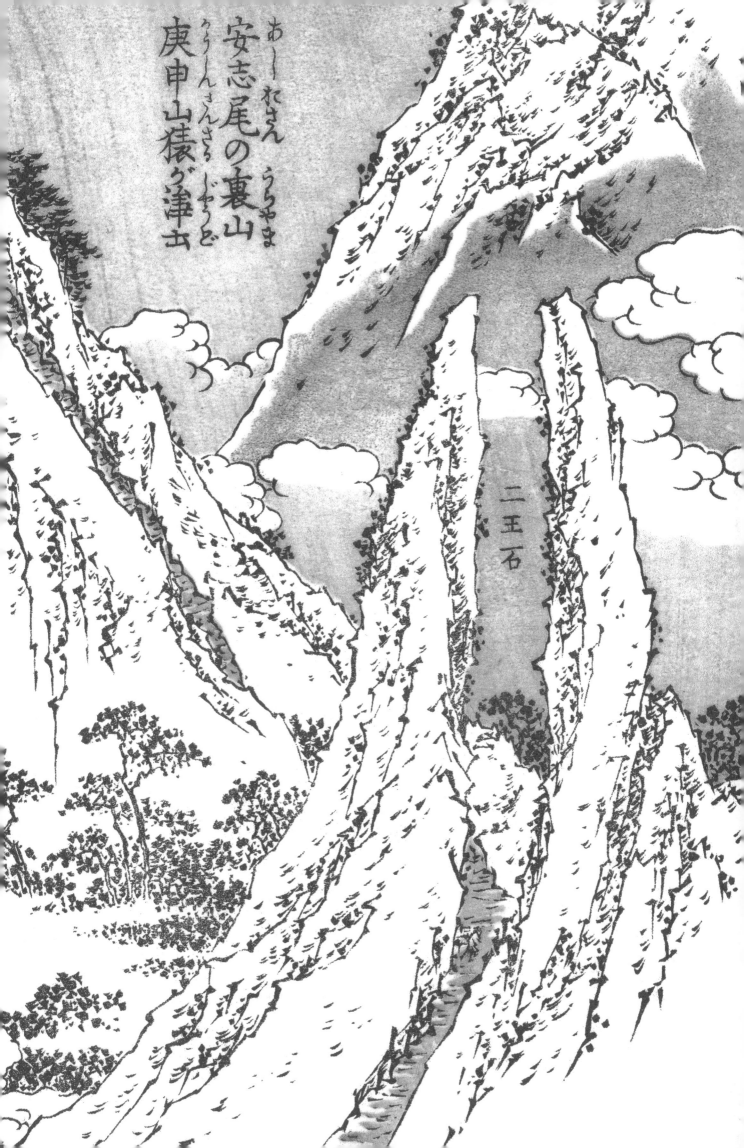

安志尾の裏山
庚申山猿ヶ津去

二王石

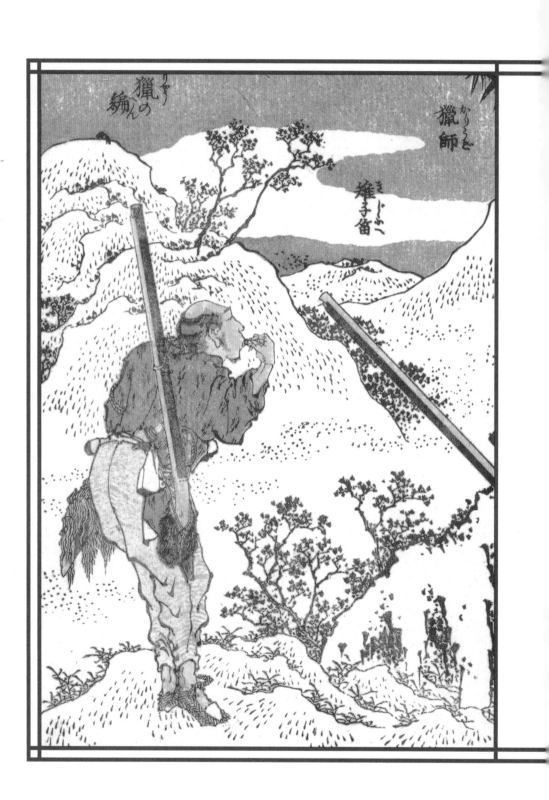

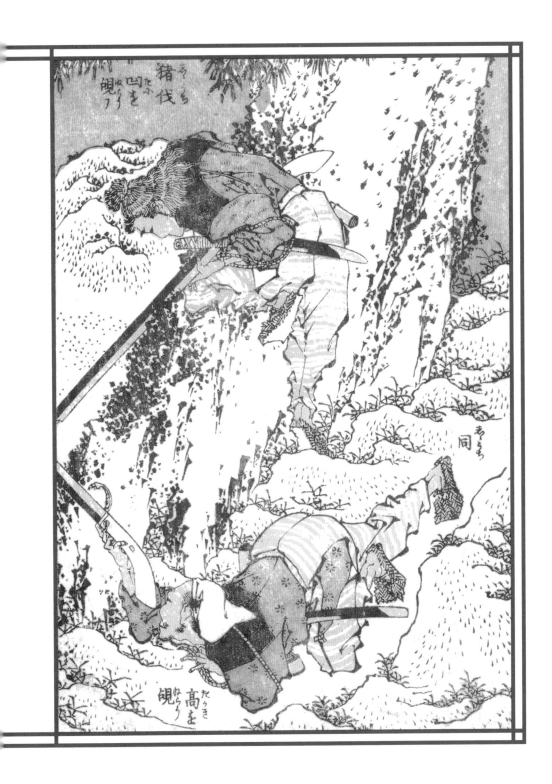

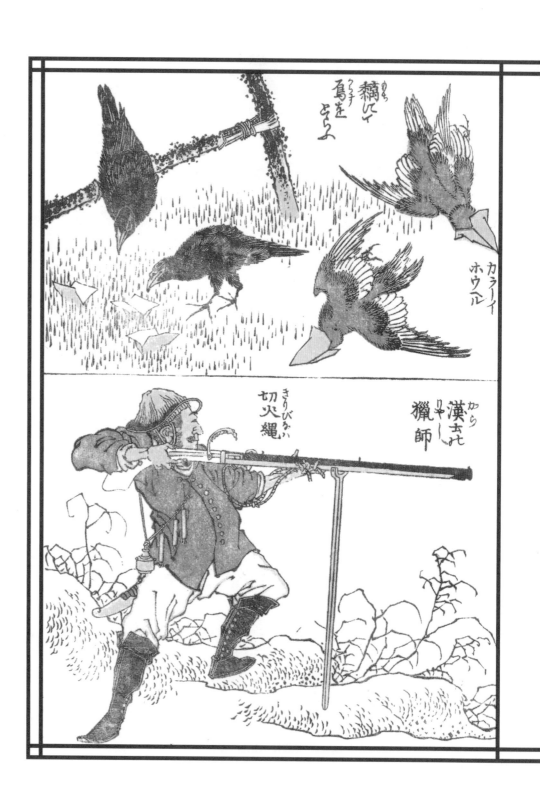

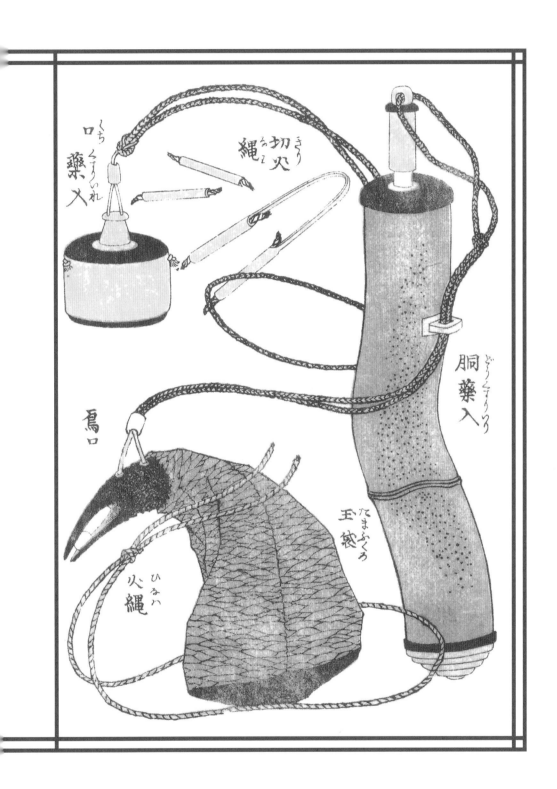

口薬入 くちくすりいれ

切火縄 きりひなわ

鳥口 とりくち

火縄 ひなわ

胴薬入 どうくすりいれ

玉袋 たまぶくろ

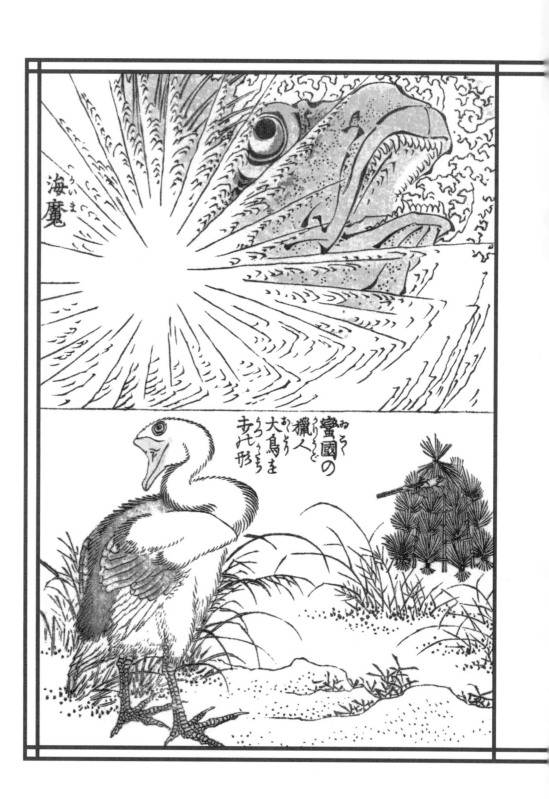

海魔
（こう）（ま）
（い）

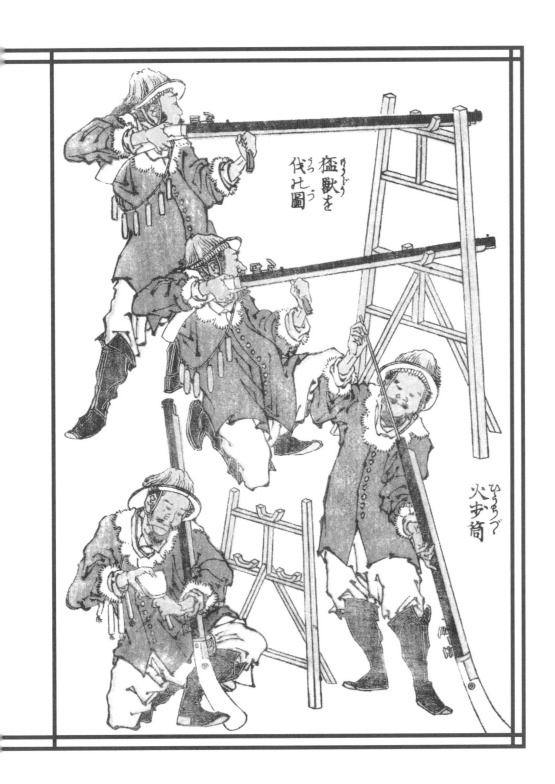

猛獣を伐せ圖

火歩筒

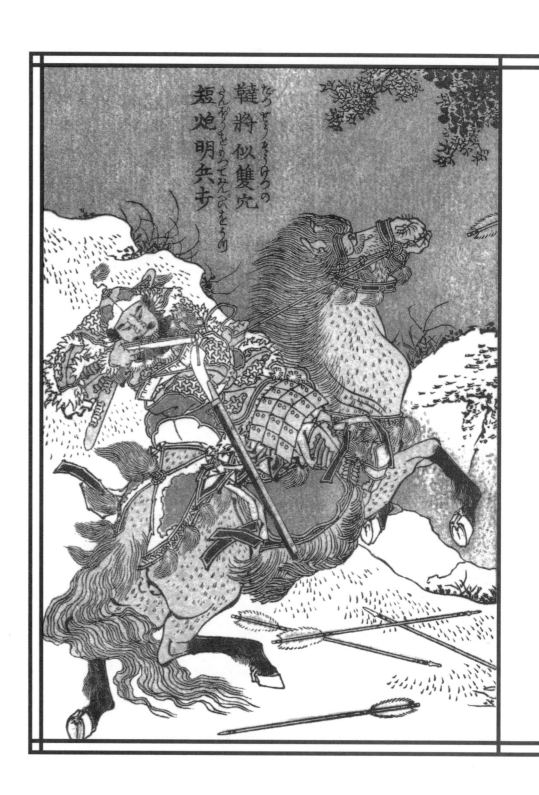

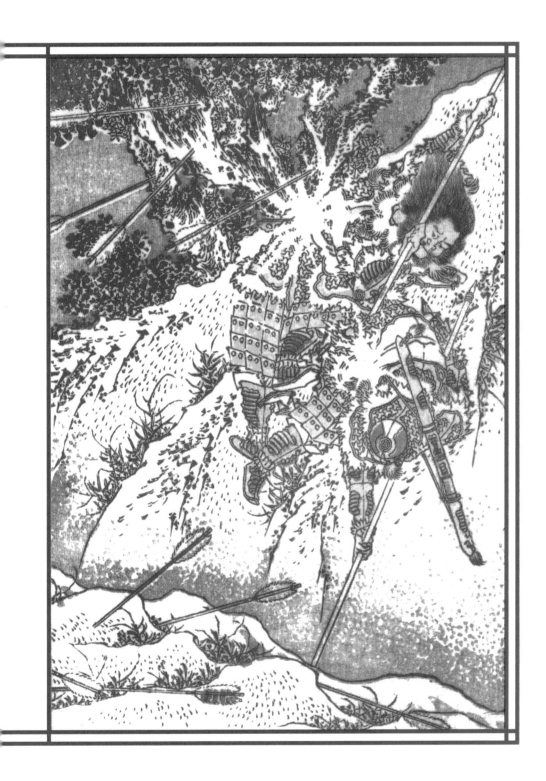

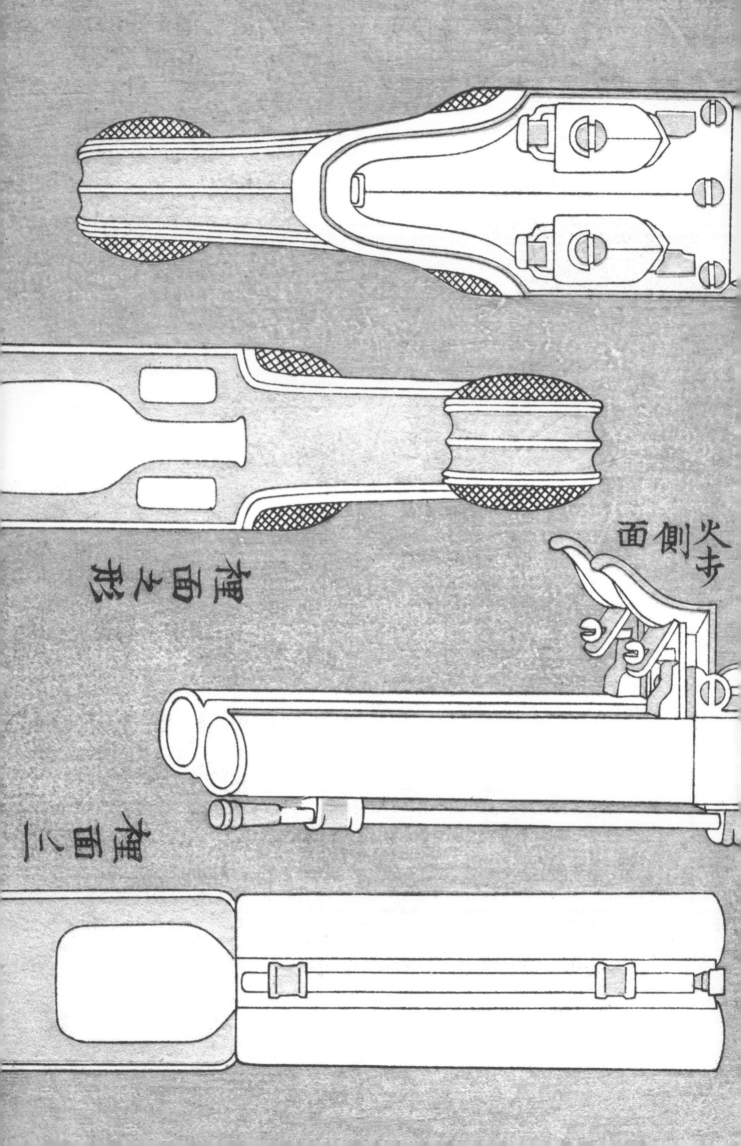

裏面之形

火歩側面

八面裏面

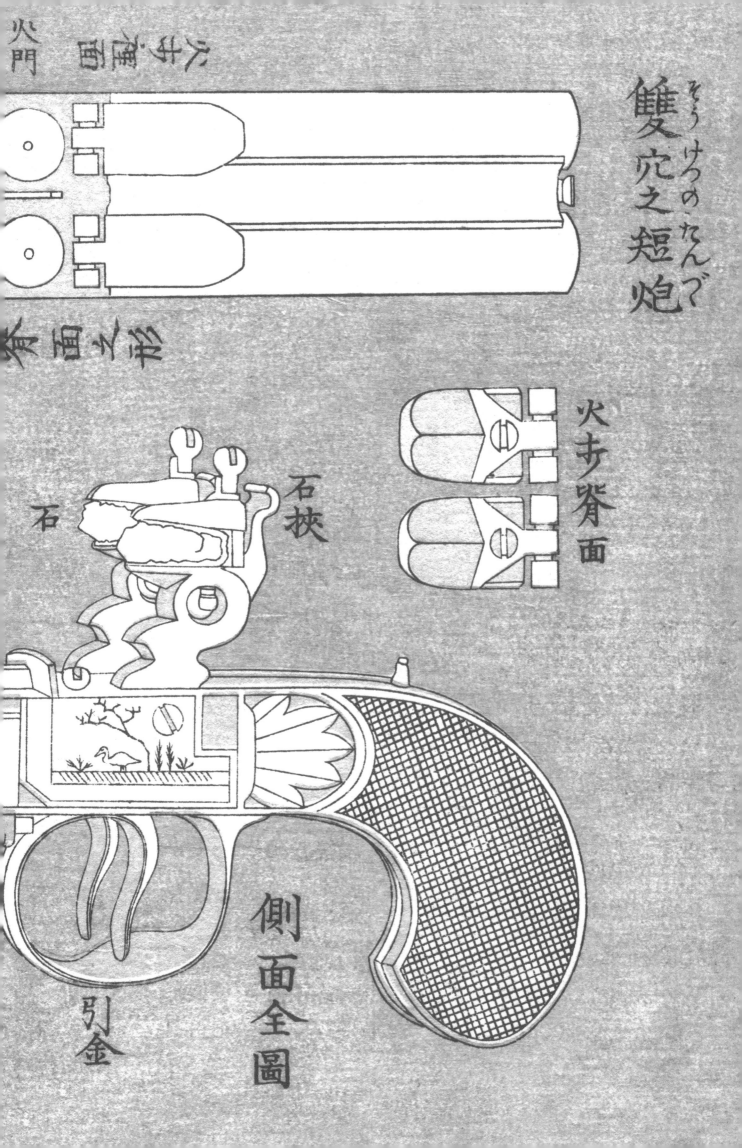

雙穴之短炮
そうけつのたんで

火門
火井蓮面
火井蓮面之形

有面之形

石
石挾

火步脊面

側面全圖

引金

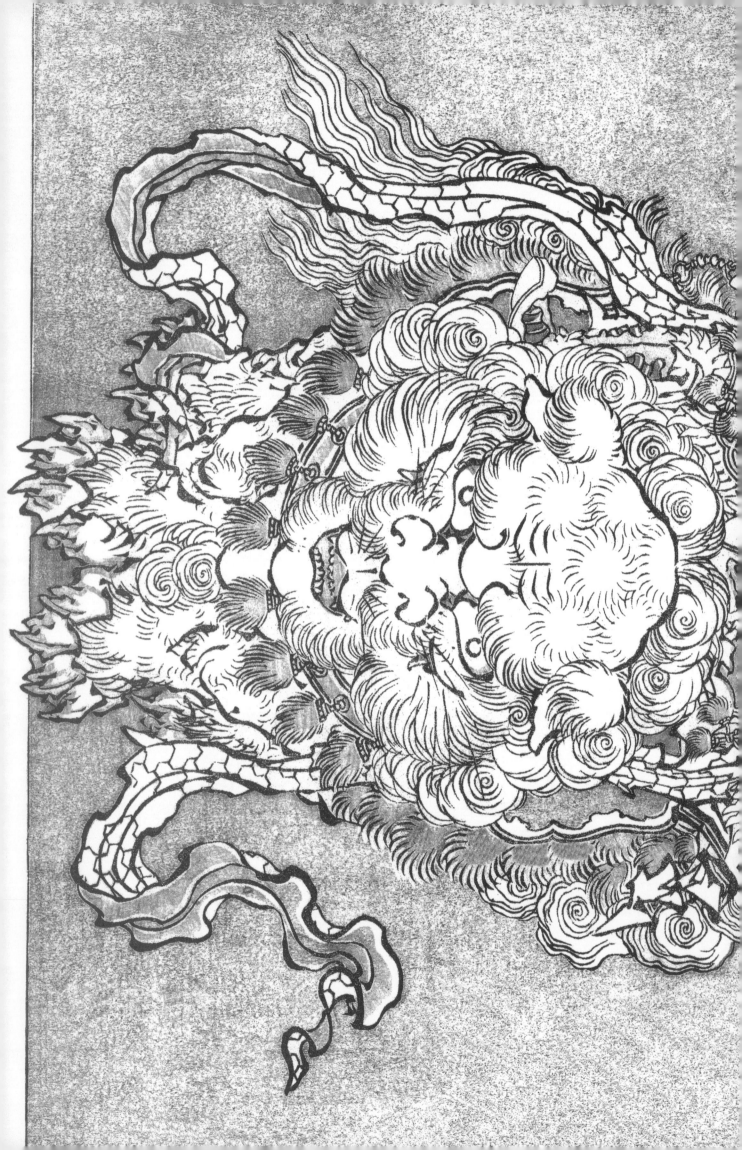

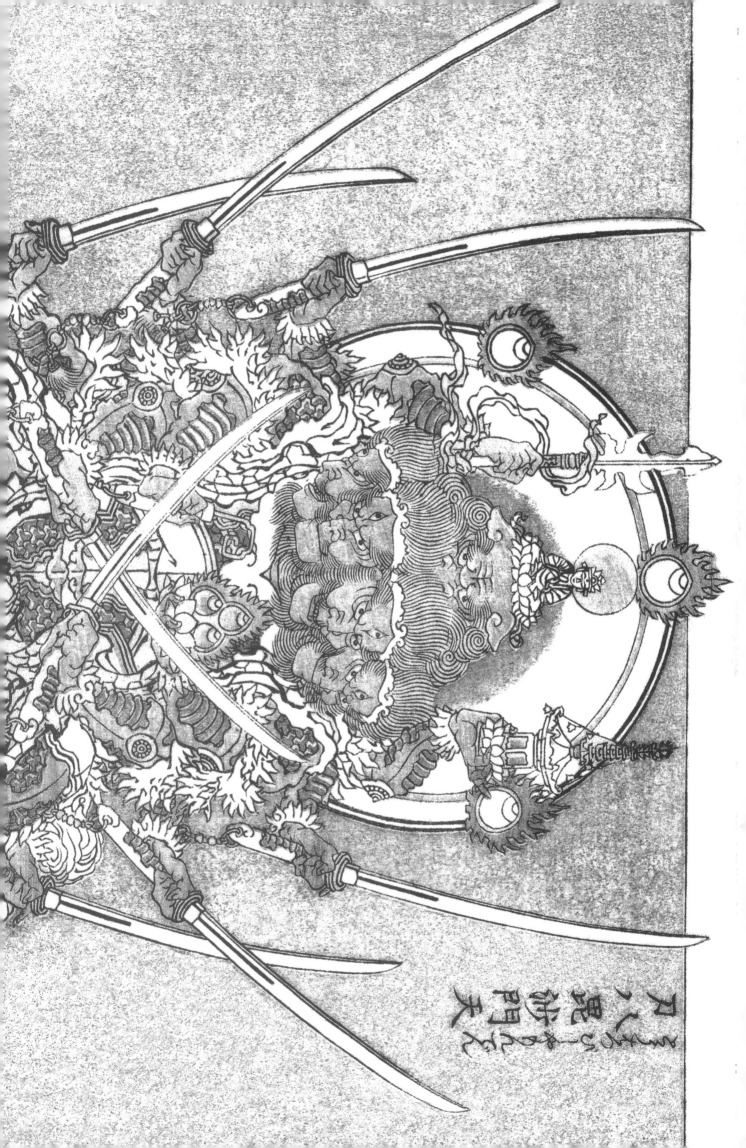

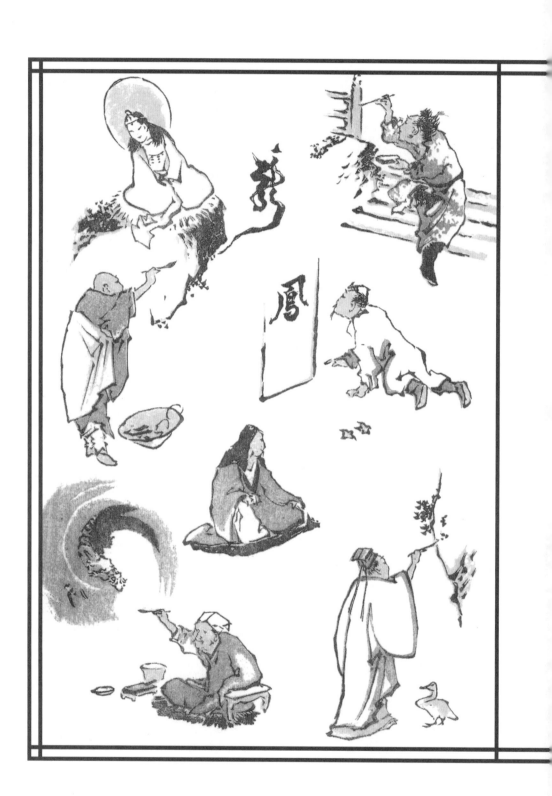

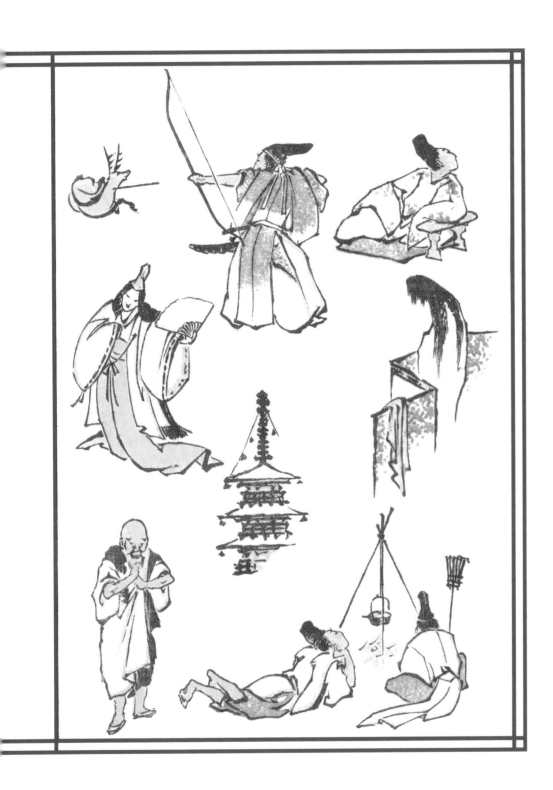

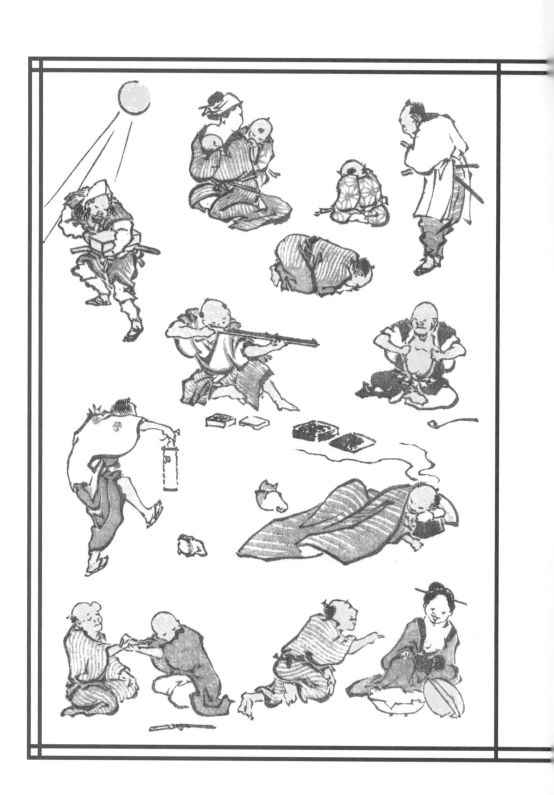

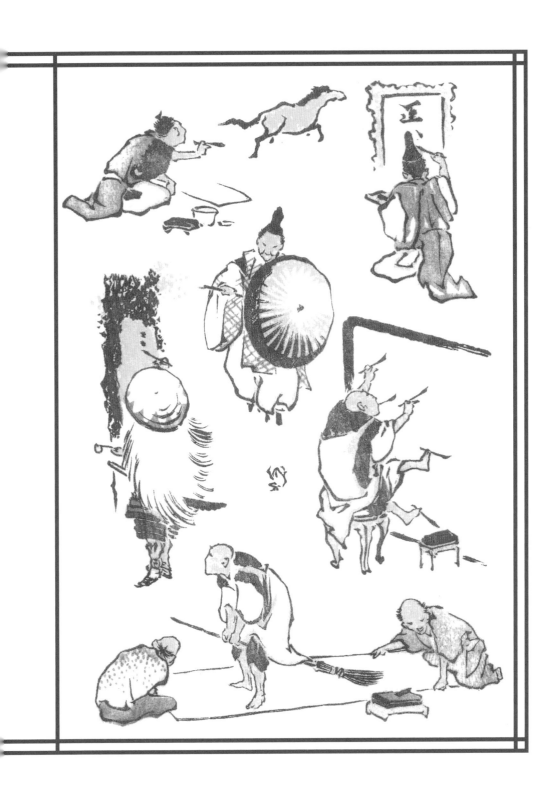

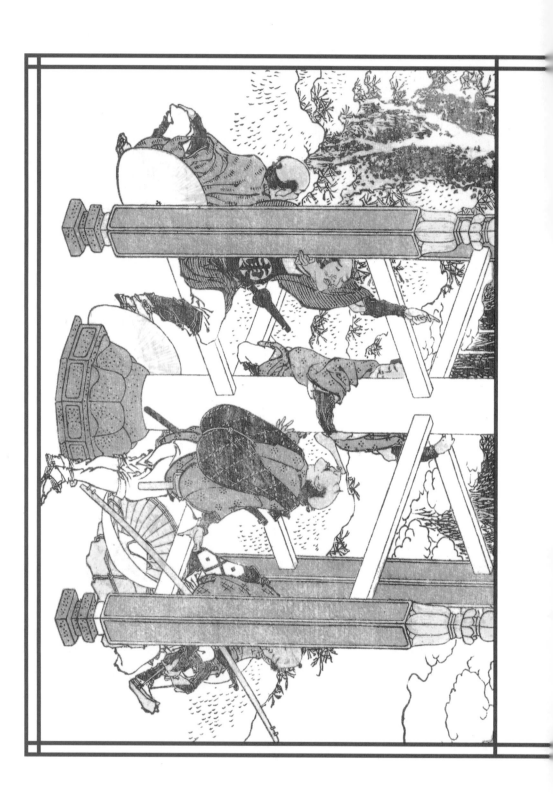

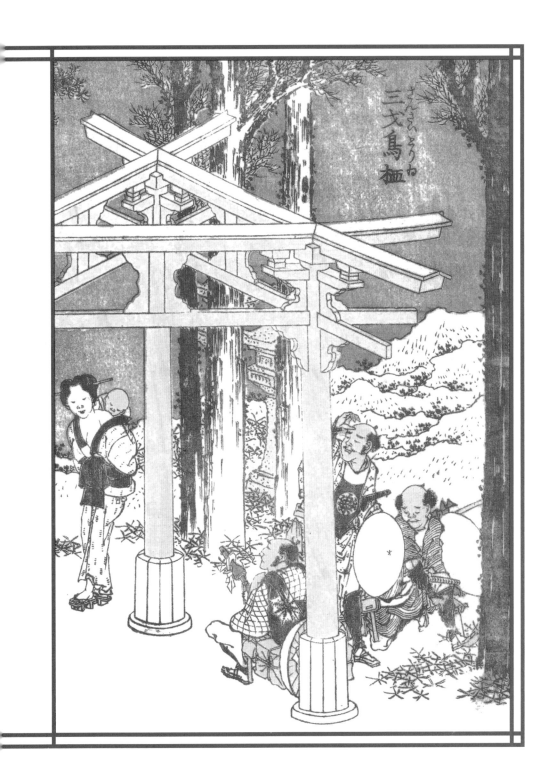

Katsushika Hokusai (1760-1849) and Utagawa Hiroshige (1797-1858), both artists who achieved greatness in the field of ukiyo-e landscapes, are often compared. Hokusai was by the far the elder, but the first volume of *Fugaku sanjurokkei* (Thirty-six Views of Mount Fuji) was published in 1831 when Hokusai was 72 years old, whereas the Hoeido edition of Hiroshige's *Tokaido gojusan-tsugi* (The Fifty-three Stages of the Tokaido) was published in 1833 when Hiroshige was 37 years old. The two appeared just two years apart, with *Tokaido*

葛飾北斎（1760-1849）と歌川広重（1797-1858）は、浮世絵の風景画を大成した画師として比較されることが多い。北斎の方がはるかに歳は上だが、『冨嶽三十六景』が刊行され始めたのは北斎72歳の天保2年（1831）であり、広重の保永堂版『東海道五拾三次』が刊行されたのは広重37歳の天保4年（1833）のことである。2年の違いであり、『東海道五拾三次』は当時空前の大ヒットとなった。

北斎と広重

gojusan-tsugi turning into an unprecedented smash hit. As if provoked by the young Hiroshige, the following year Hokusai pursued Mount Fuji with renewed vigor and published *Fugaku hyakkei* (One Hundred Views of Mt Fuji).

Because the dates of sale of the most important works of the two overlapped, there is a tendency for people to want to compare various aspects of their work all the more, but their styles are completely different. Whereas Hiroshige depicted scenes gently and with an abundance of emotion,

若い広重に刺激されたのか、北斎は翌年さらに富士を追求した『富嶽百景』を刊行している。

２人の代表作の発売時期が重なっているので、余計色々比較したくなるのだろうが作風は全く異なっている。広重は風景を情感たっぷりにしっとりと描き上げたのに対し、北斎は大胆な構図で様々な角度から対象に迫った。片やウェットで、一方はドライ。日本人には広重が好き

Hokusai and Hiroshige

Hokusai used bold composition and approached his subjects from a variety of different angles. One is "wet" while the other is "dry." Most Japanese say they prefer Hiroshige, while Hokusai is the overwhelming favorite among foreigners. One reason for this is that Hokusai studied Western painting, and there are aspects of his work that appear "exotic" to a Japanese audience, which is why he is sometimes called "blue-eyed Hokusai." The two also led contrasting personal lives, Hiroshige being serious-minded and Hokusai living a life of

だという人が多いが、外国人は圧倒的に北斎を好む。北斎が西洋画を学んでいたこともその一因で、作品はある意味でバタ臭く「青い目の北斎」と呼ばれる所以である。人間的にも対照的で、広重が真面目一方なのに対し北斎は自由で型破りな人生を送った。

2人にライバル心があったかどうかはわからないが、広重は北斎の『富嶽百景』を「絵組みのおもしろきを専ら

freedom and unconventionality.

Although it is unclear whether the two viewed each other as rivals, Hiroshige criticized Hokusai's *Fugaku hyakkei* as "being all about interesting composition, with Mount Fuji often playing only an accompanying role." On the other hand, it is thought that Hiroshige did show Hokusai some respect, learning from him by copying the composition in works such as *Hokusai manga* and *Fugaku sanjurokkei*, for example.

とし、不二はそのあしらいにいたる（添え物にすぎない）も多し」と批判している。しかし、一方で広重は『北斎漫画』や『冨嶽三十六景』の構図を真似て描くなど北斎を学んでおり、実際には北斎には一目も二目も置いていたと思われる。

The first volume of *Hokusai manga* was published in 1814 when Hokusai was 55 years old. It was originally intended to finish with this one volume, but it became so popular a series of ten volumes was hastily planned, with around two volumes a year appearing from the next year onwards. However, such was its popularity that another ten volumes were planned. Despite not reaching twenty volumes, it was not until 1878 – some 30 years after Hokusai's death – that the final volume, volume 15, appeared, making *Hokusai manga*

『北斎漫画』の初編が刊行されたのは文化11年（1814）、北斎55歳の時である。当初は1編だけで終わる予定だったが、人気を博したため急遽10編のシリーズ化が企画され、翌年よりほぼ1年に2編ずつ出版された。ところがあまりにも人気があったため再度11編から20編までが企画された。20編までは刊行されなかったが、最終編となる15編が世に出たのは明治11年（1878）のことで、

北斎漫画

a major publishing project spanning 64 years from volume 1 to volume 15. This also shows the extent to which *Hokusai manga* won public acceptance for so long.

Hokusai manga was originally produced as a guide to sketching, or in other words a textbook, aimed at Hokusai's apprentices, who numbered around 200 at the time, and his fans throughout the country. The "manga" of the title refers to drawings "sketched randomly and in a carefree manner,"and in this sense *Hokusai manga* could be called a sketch book

北斎の死後約30年が経っていた。初編から15編まで実に64年にわたる一大出版事業であった。それは『北斎漫画』がいかに長期にわたり世に受け入れられていたかを示してもいる。

『北斎漫画』は、当時200人はいたという北斎の弟子や全国のファンに向けた絵手本、つまり教科書として作られた。タイトルの「漫画」とは「漫然と気ままに描いた」とい

Hokusai manga

or sketch collection in which Hokusai drew anything under the sun that interested him. So while they are different from the manga of today, there are many similarities between the two, such as the inclusion of many drawings that cause one to burst out laughing. Above all, however, *Hokusai manga* is a masterpiece in which common people are depicted in a vivid way. Together the fifteen volumes contain 970 pages and over 3900 individual drawings. Notwithstanding the small, roughly A5 format, each individual drawing is surprising

う意味で、北斎が興味を持ったありとあらゆるものが描かれているスケッチ帖、デッサン集と言えよう。だから現代のマンガとは違うが、思わず笑ってしまう図があるなど共通点も多い。とりわけ庶民が生き生きと描かれているのは圧巻である。15編全体の総ページ数は970、総図数は3900あまり。Ａ5判程度の小さな画帖であるが、一つひとつの図に驚きと感動があり、次は何かとページ

and moving, and few books rival it in terms of the feeling of anticipation one experiences in turning the pages, not quite knowing what will come next.

It is well known that *Hokusai manga* had an influence on the Impressionist painters, but its original intention, that of serving as a guide to sketching, was also achieved on foreign shores. Not only the Impressionist painters but artists such as Picasso and, as has recently come to light, Paul Klee, were inspired by and learned a great deal from it.

をめくる期待感をこれほど与えてくれる本も少ない。
『北斎漫画』が印象派の画家たちに影響を与えたことは周知の事実だが、絵手本として作られた当初の意図は海を越えた外国でも達成されたことになる。印象派の画家たちに限らずピカソや、最近わかったところではパウル・クレーまでがこの本からインスピレーションを受け、大いに学んでいたのである。

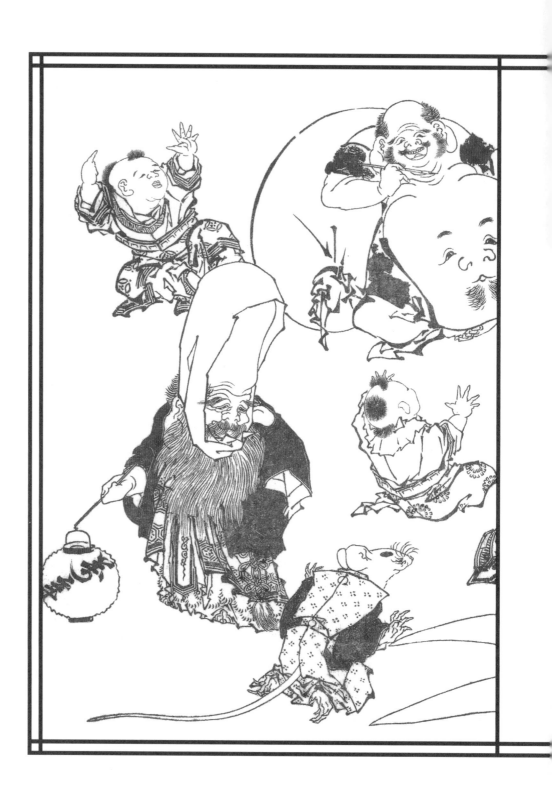

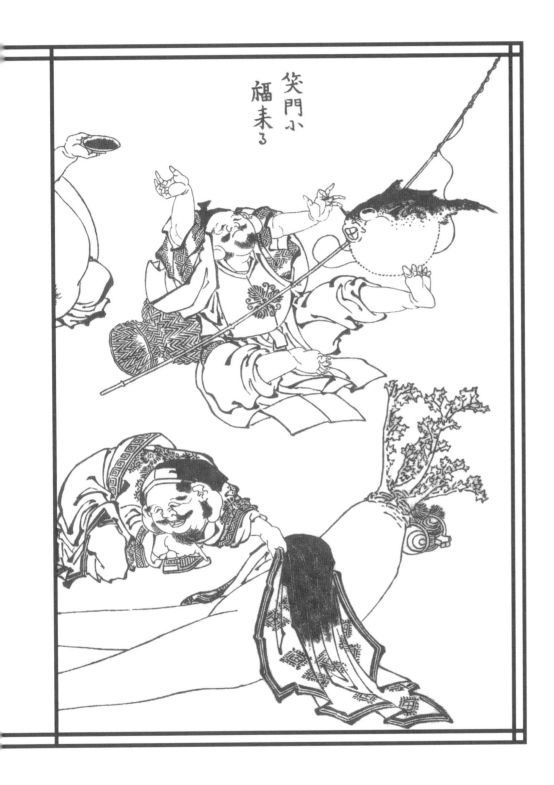

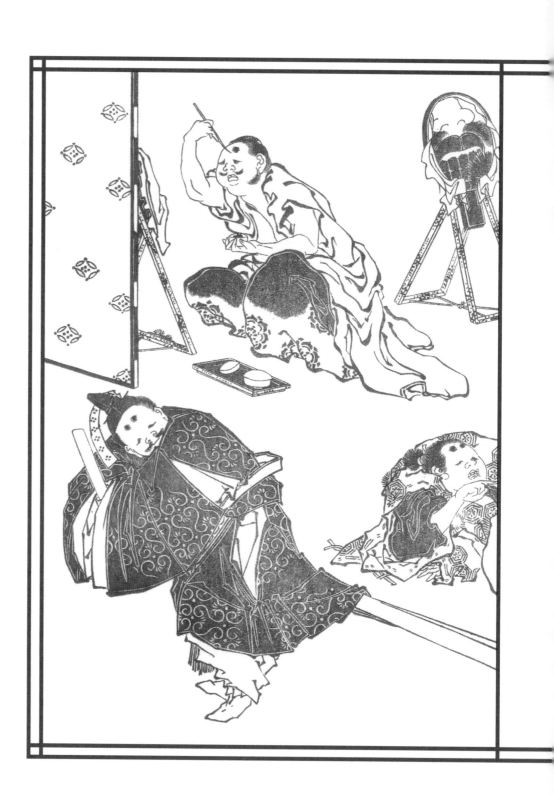

相馬公家

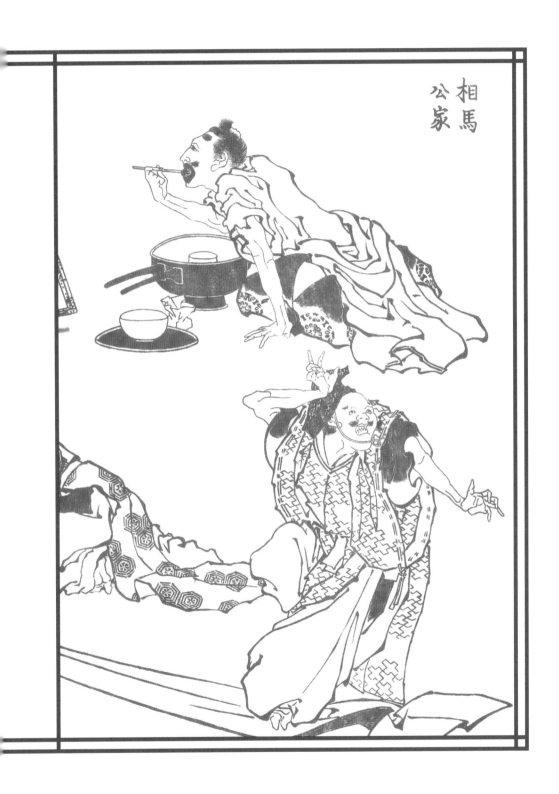

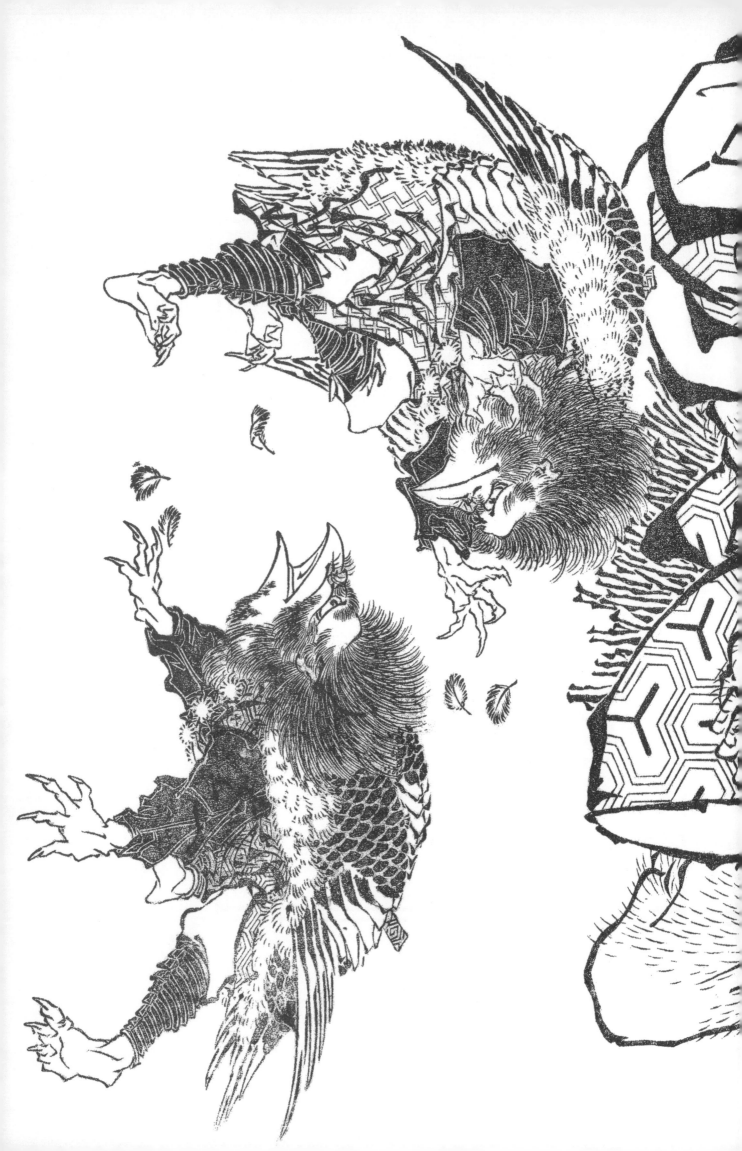

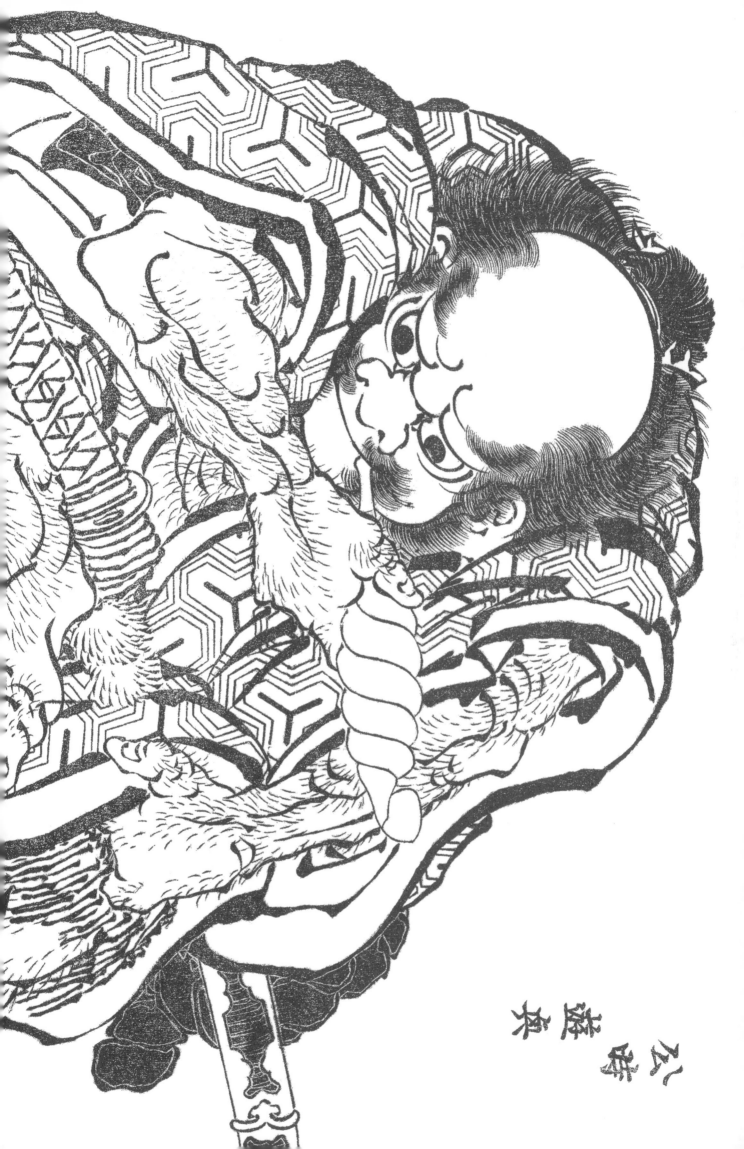

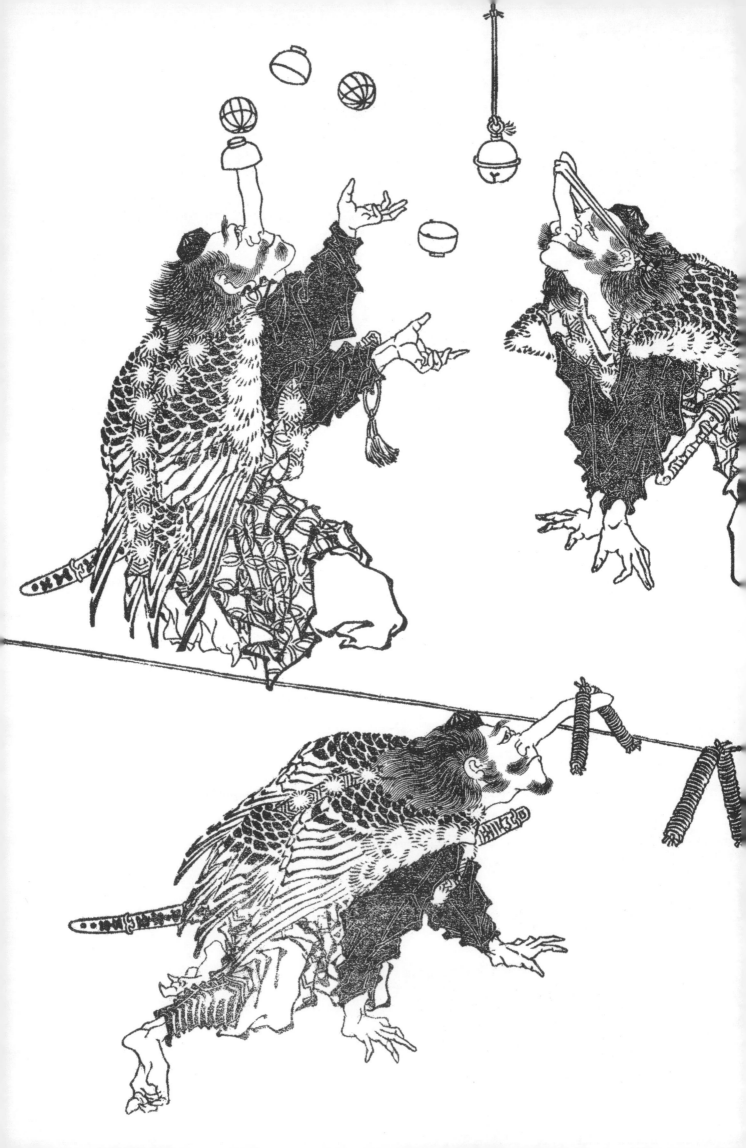

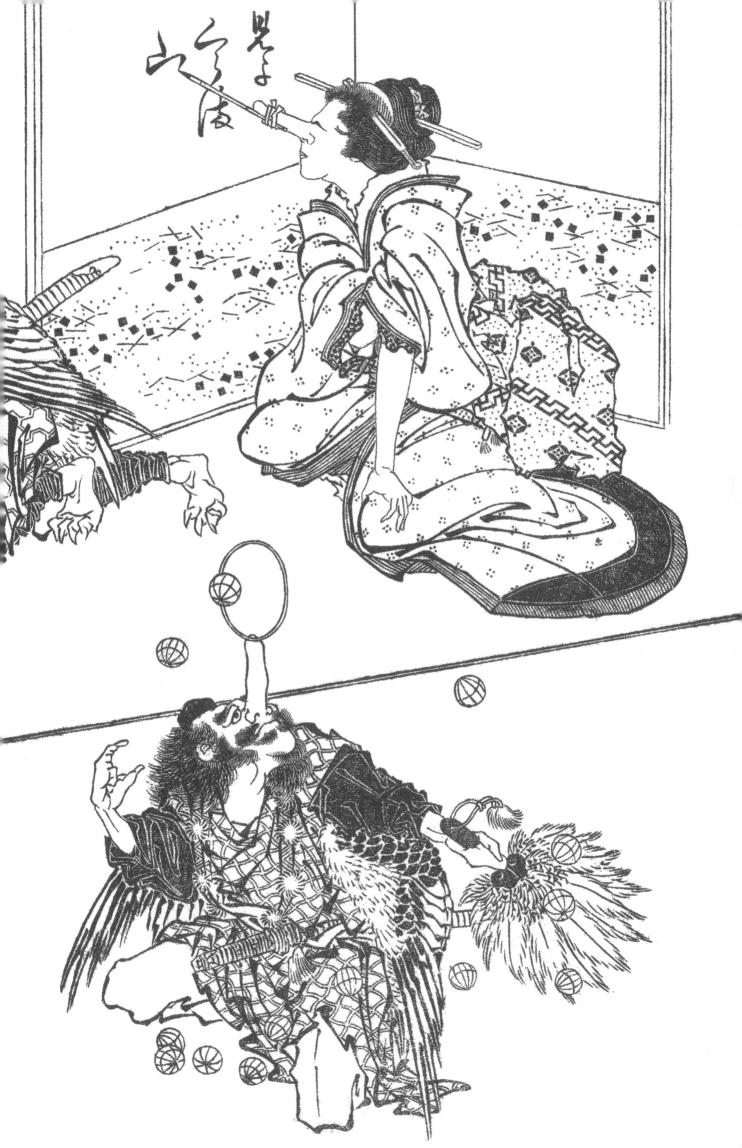

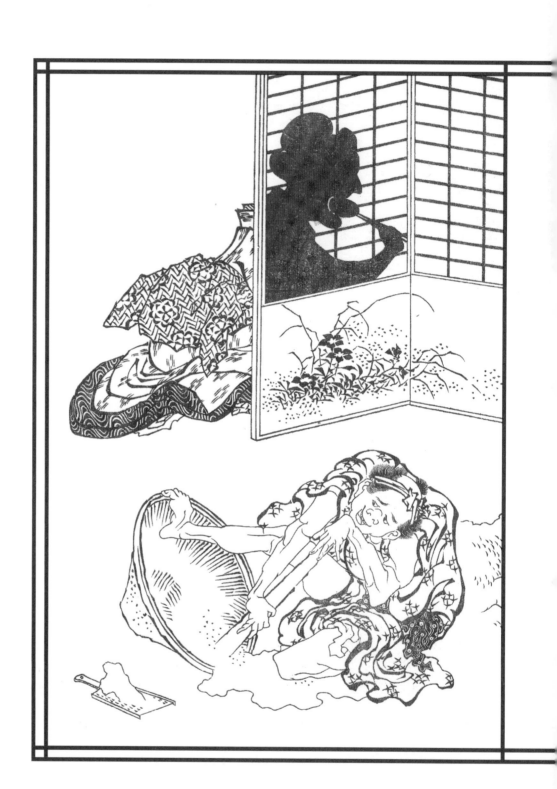

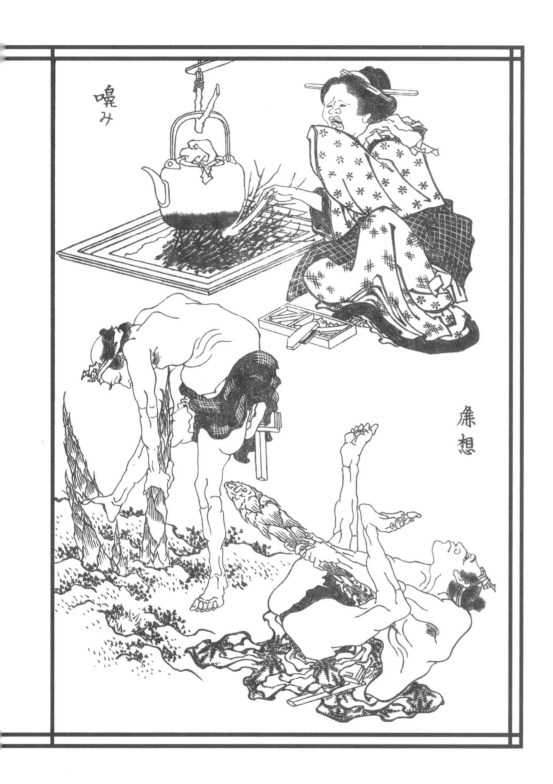
嚔み

廉想

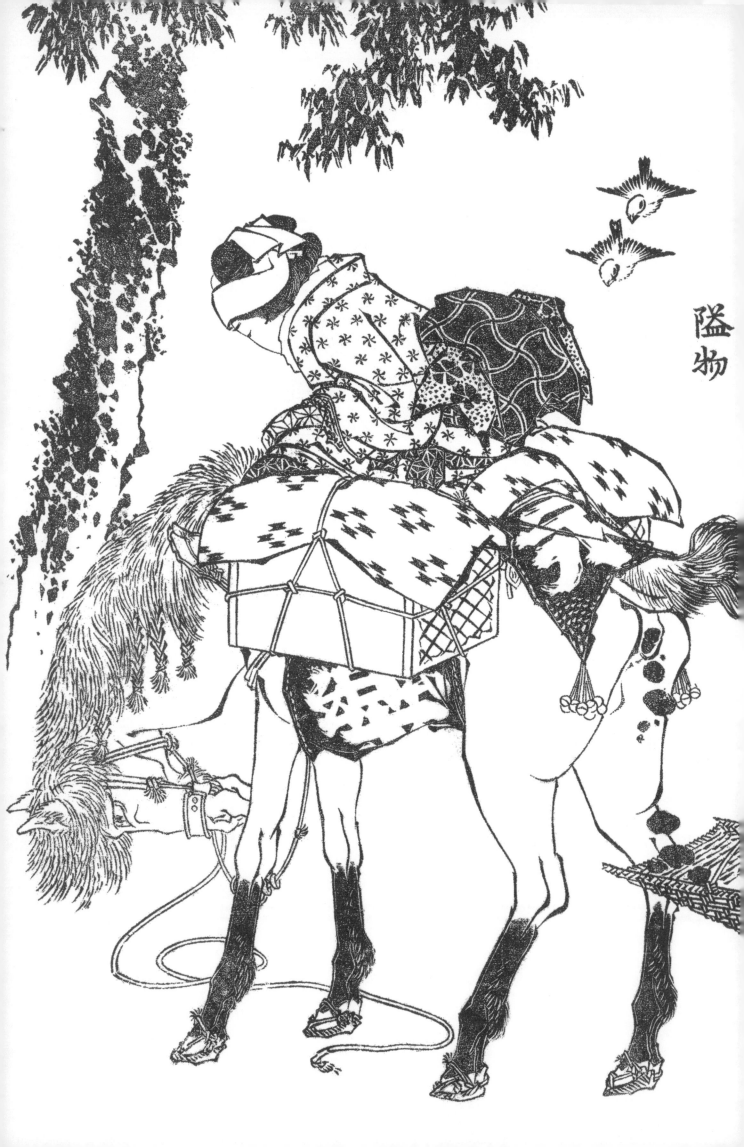

陥物

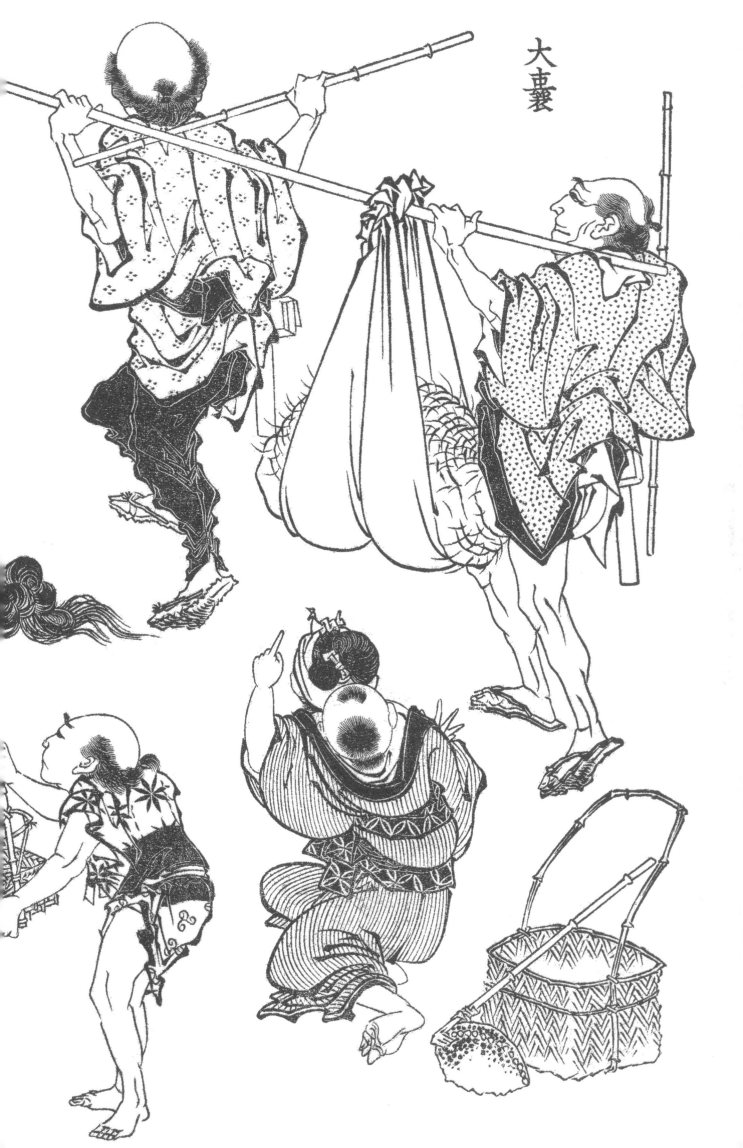

大車囊

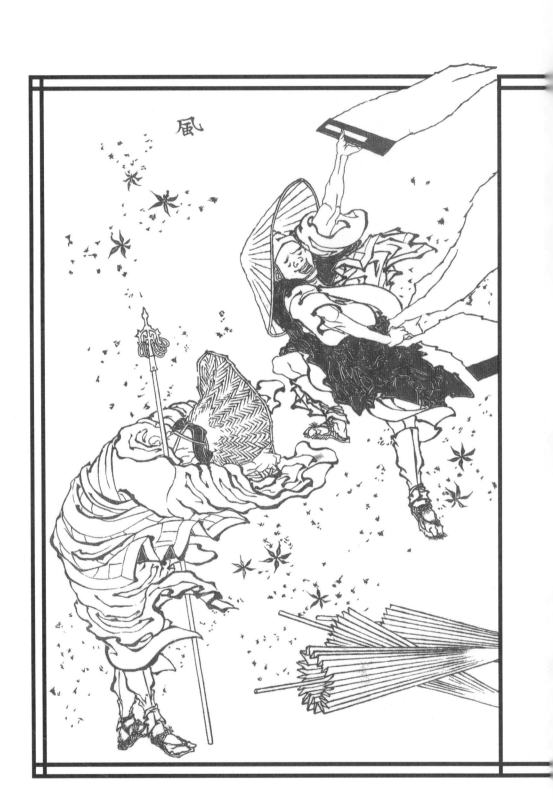

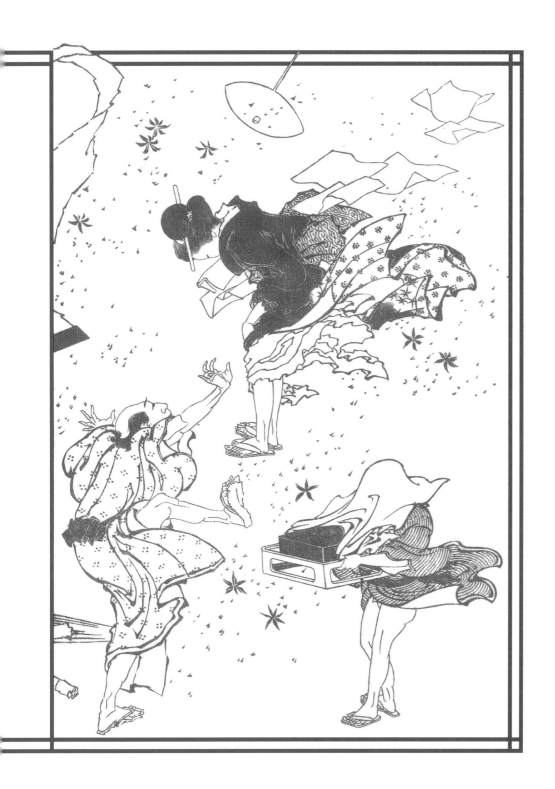

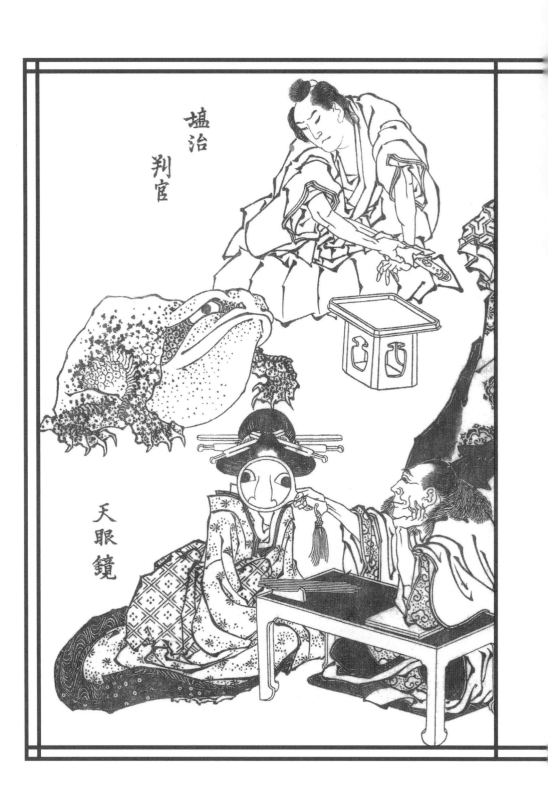

塩治判官

天眼鏡

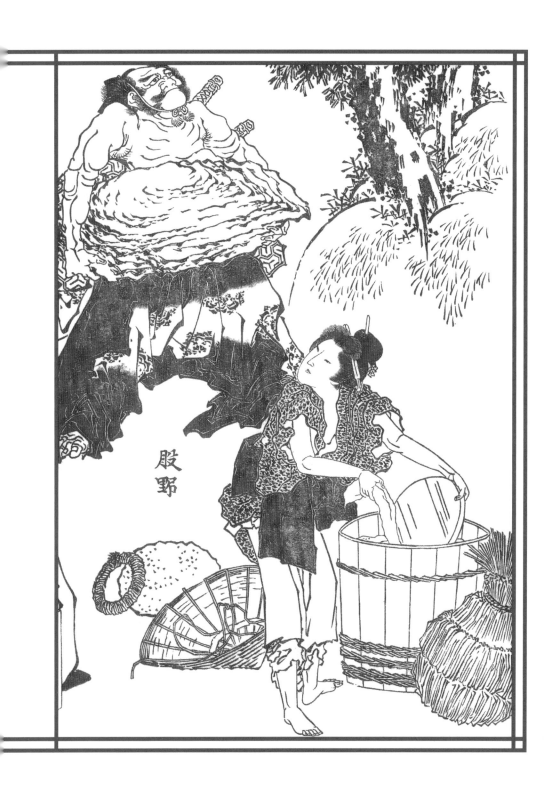

股野

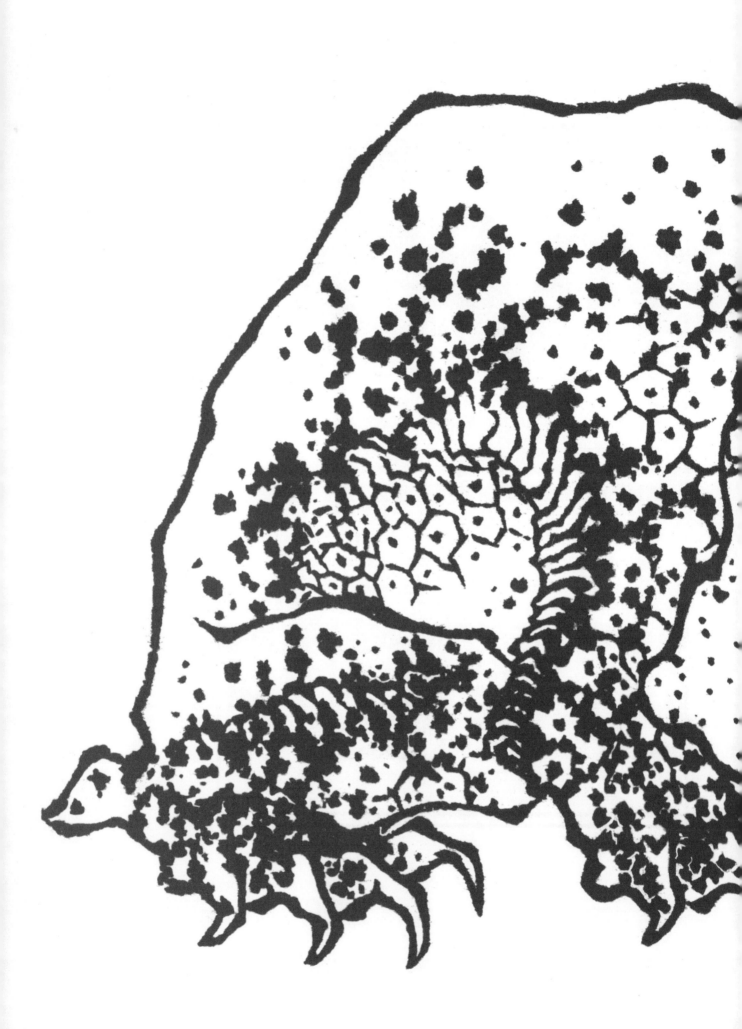

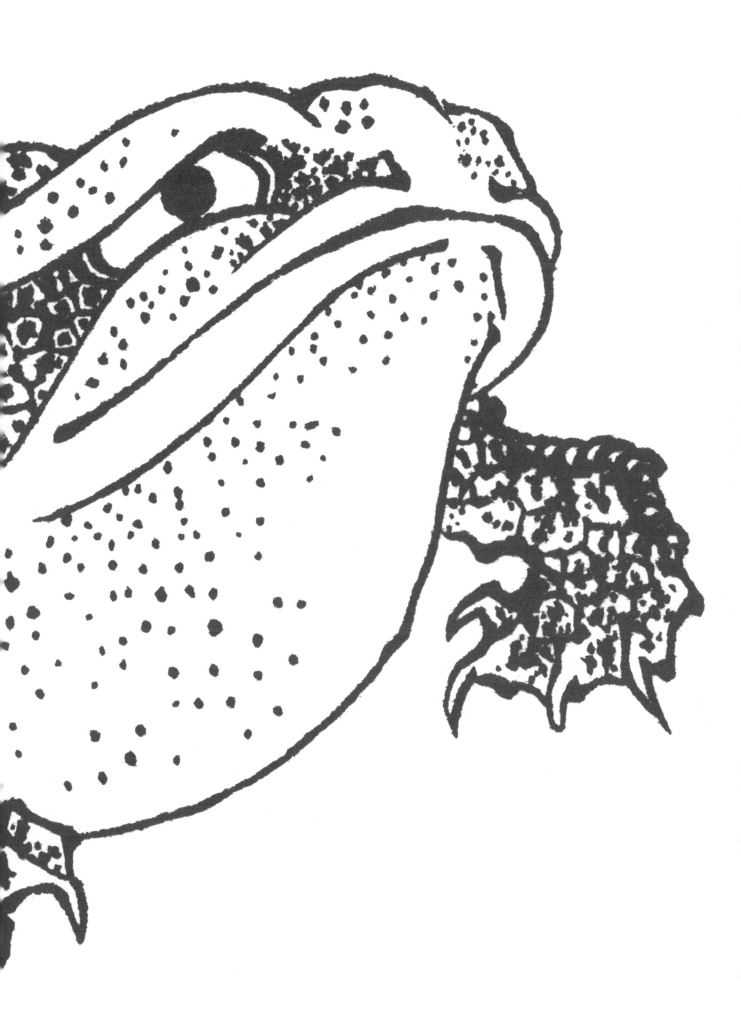

千人切

天狗ノ面を
風呂鋪ニ
包む

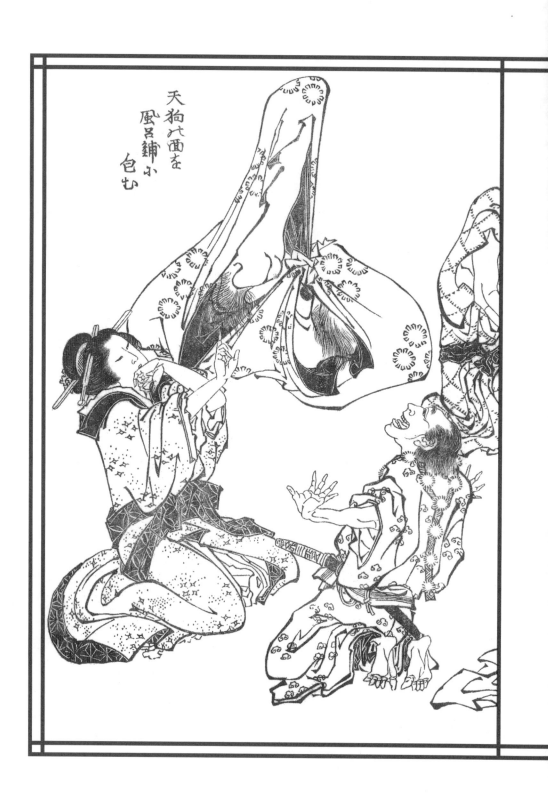

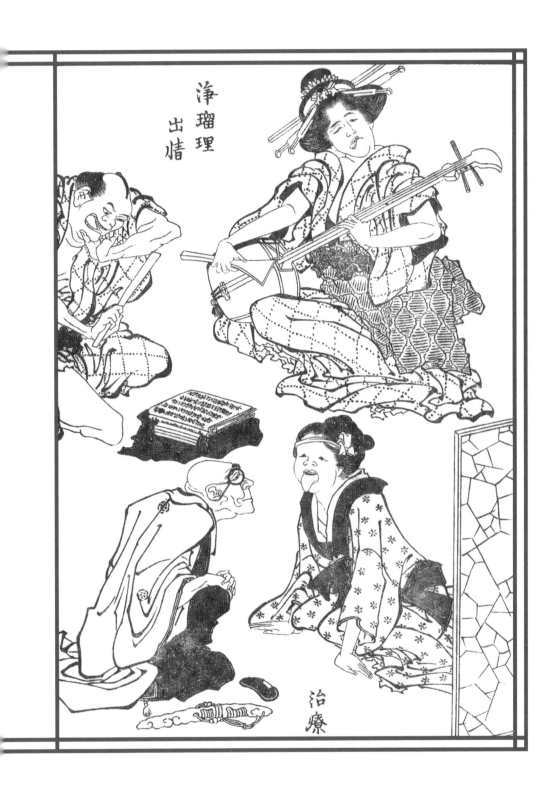

浄瑠璃
出情

治療

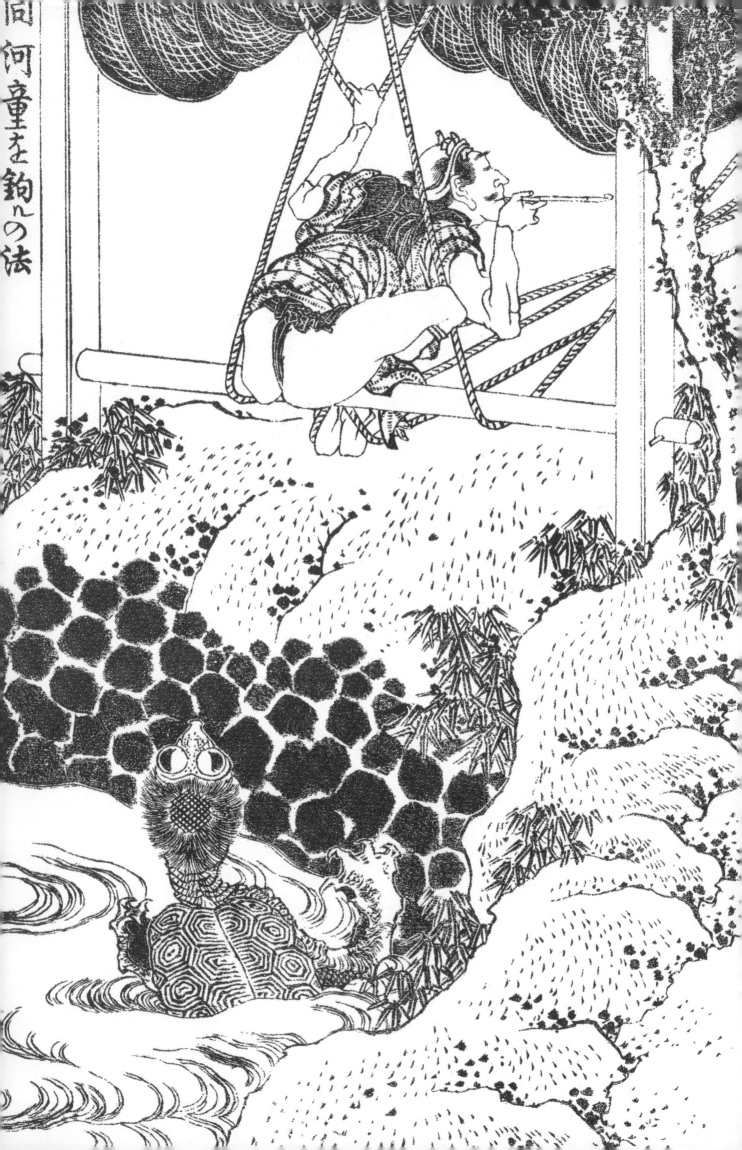

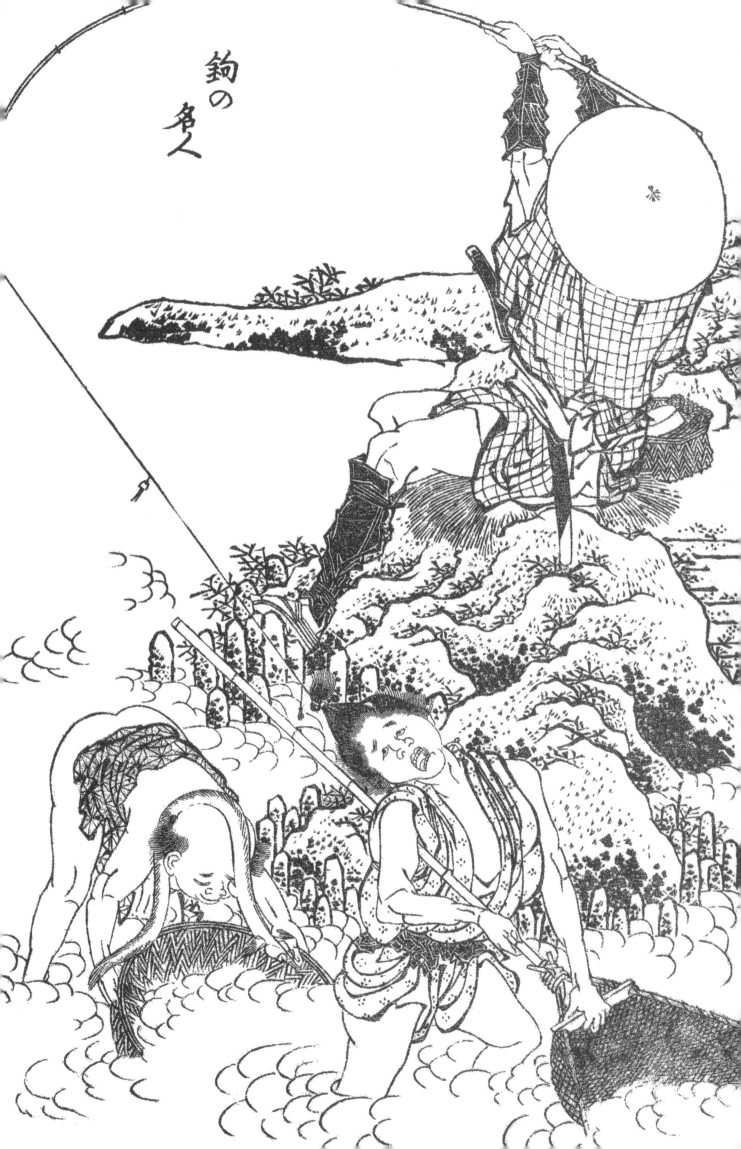

釣の魚人

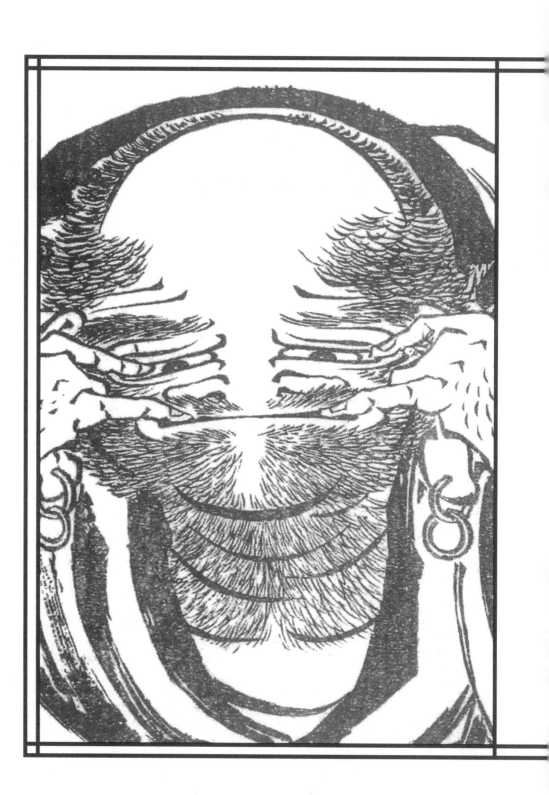

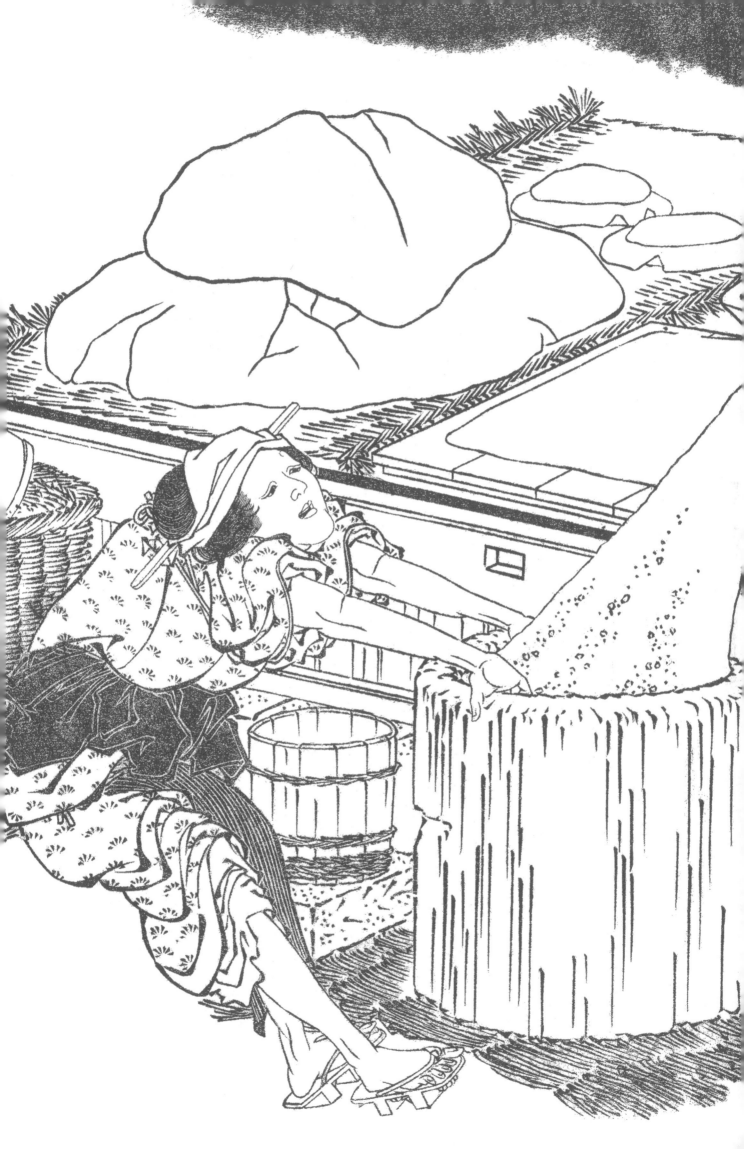

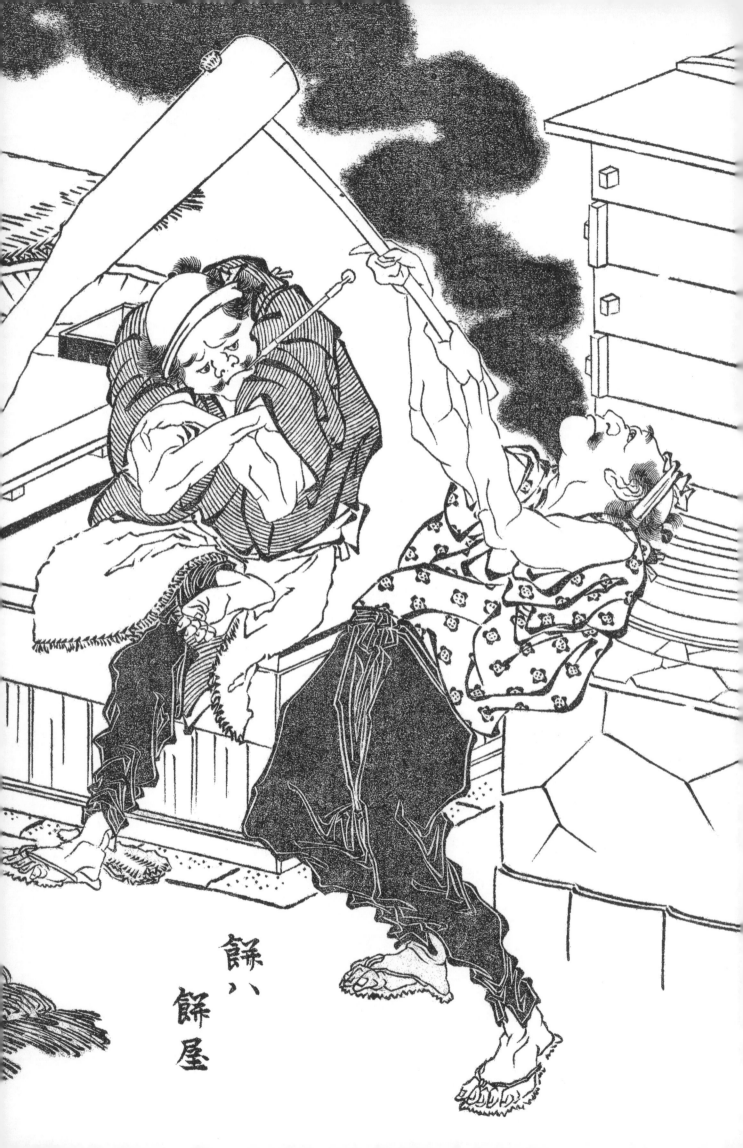

餅八
餅屋

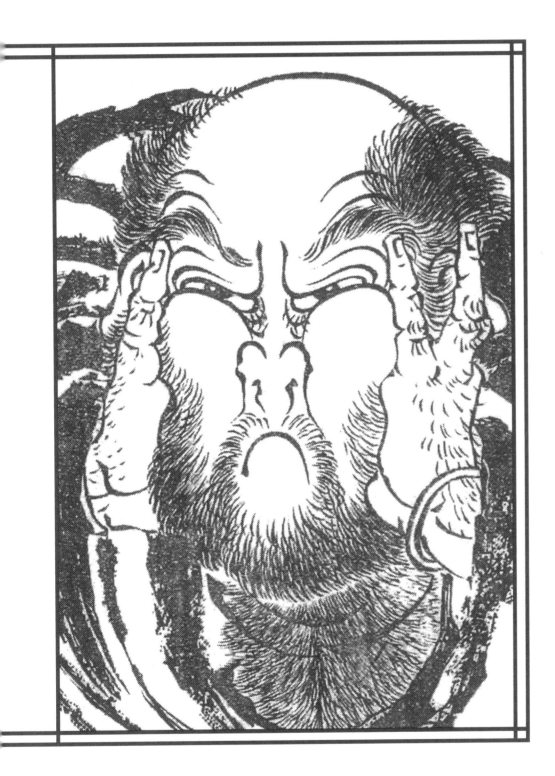

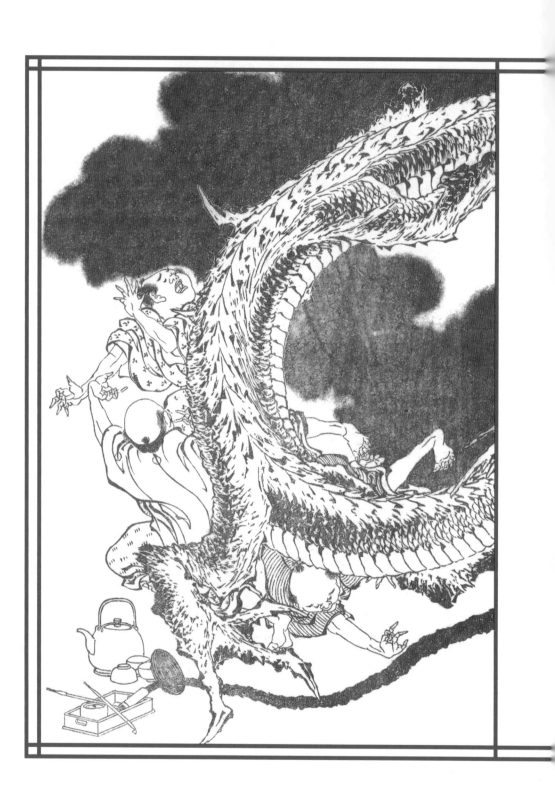

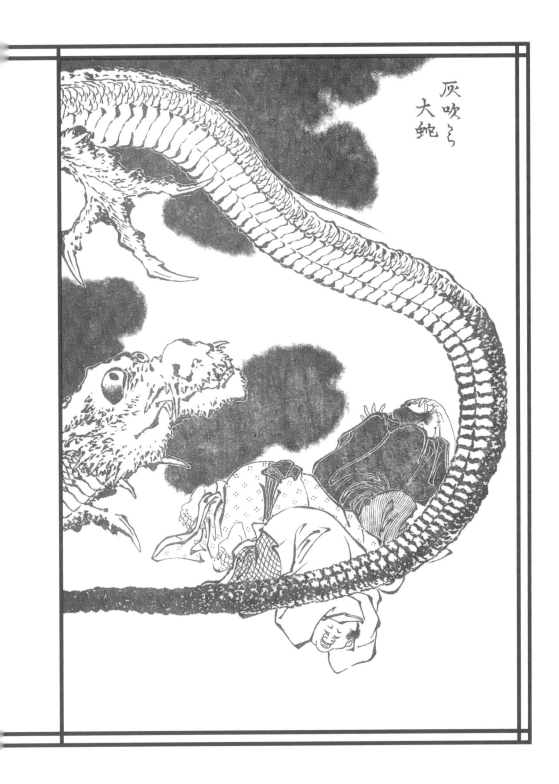

灰吹く
大蛇

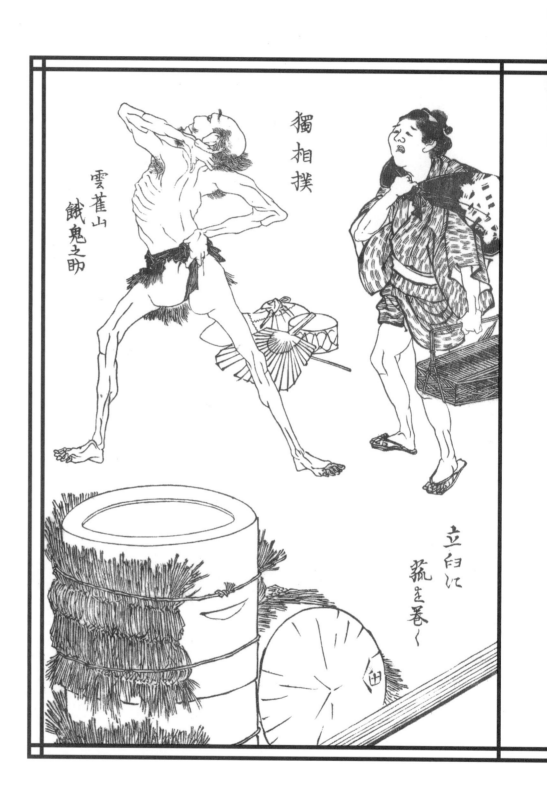

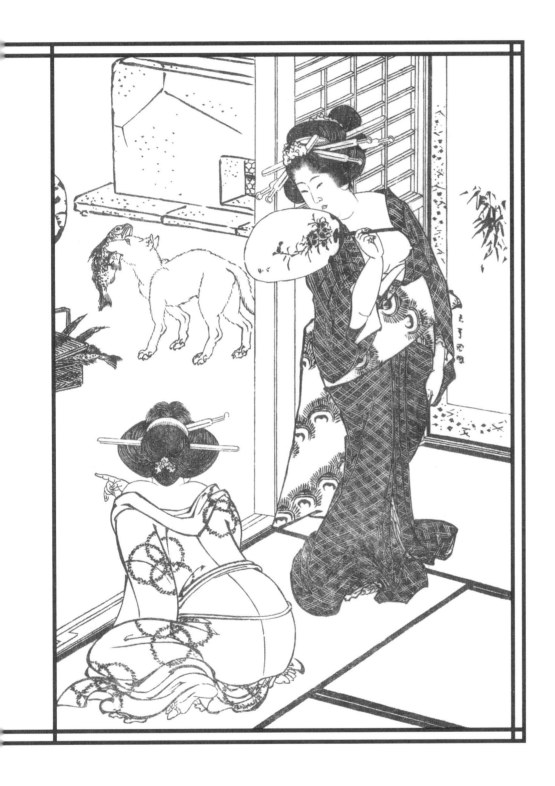

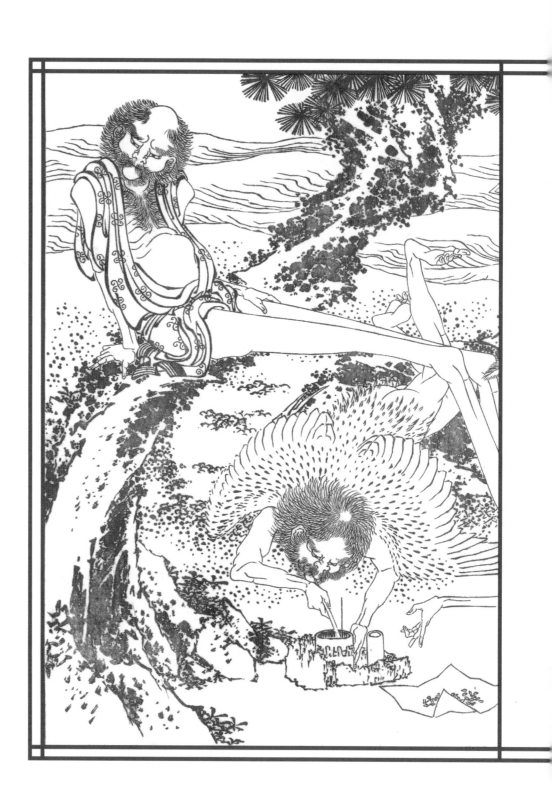

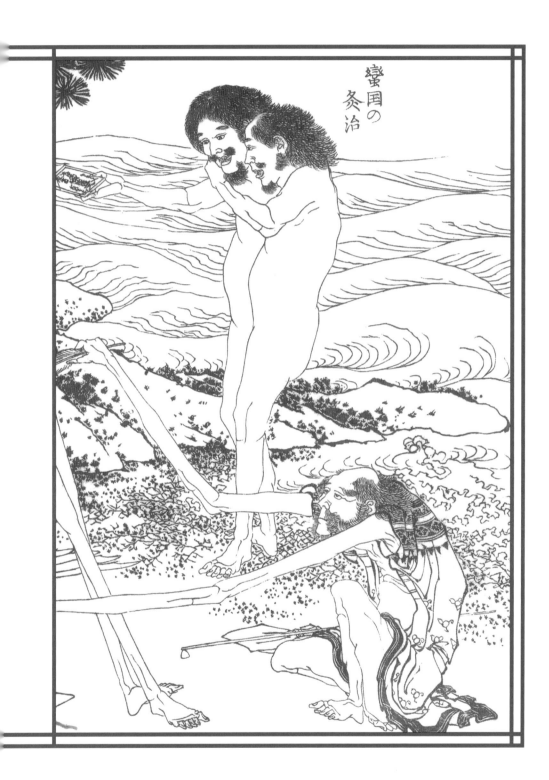

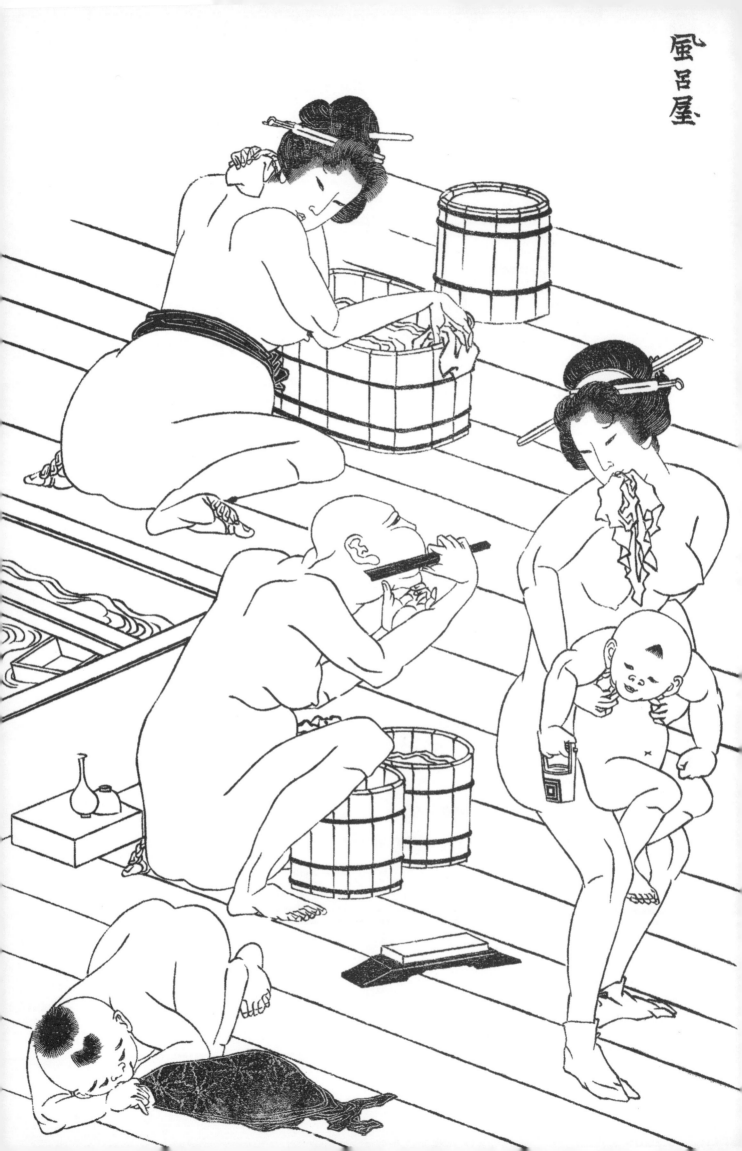

風呂屋

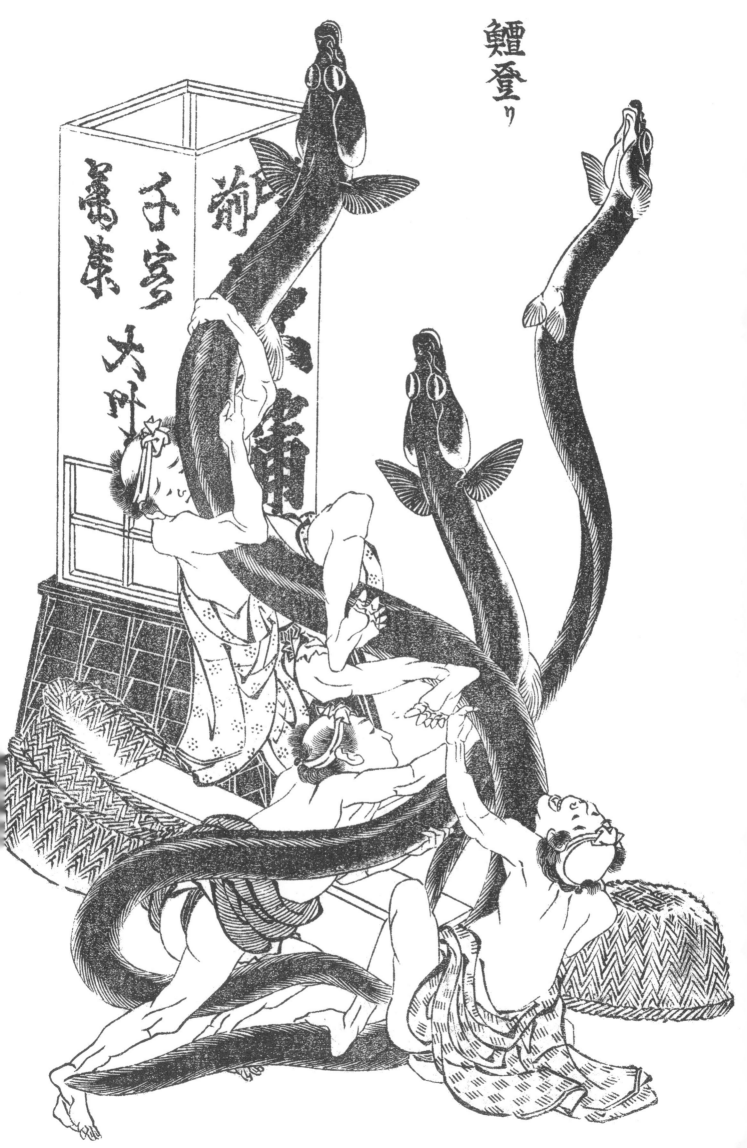

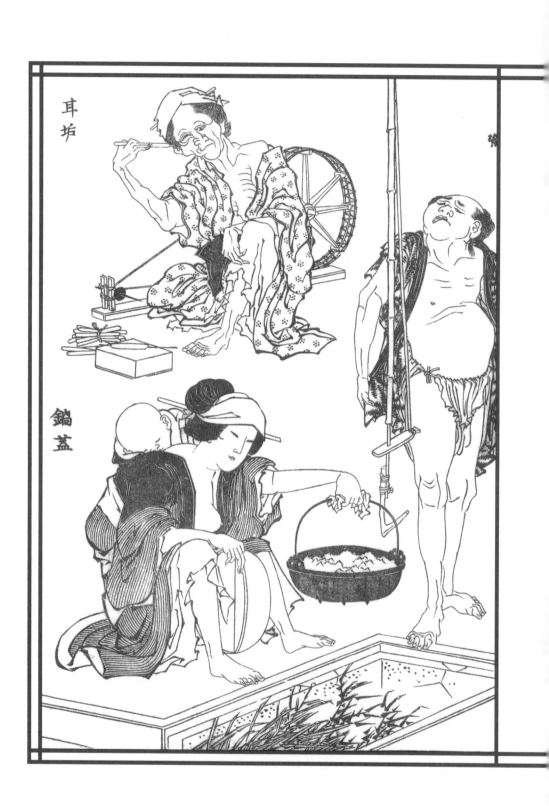

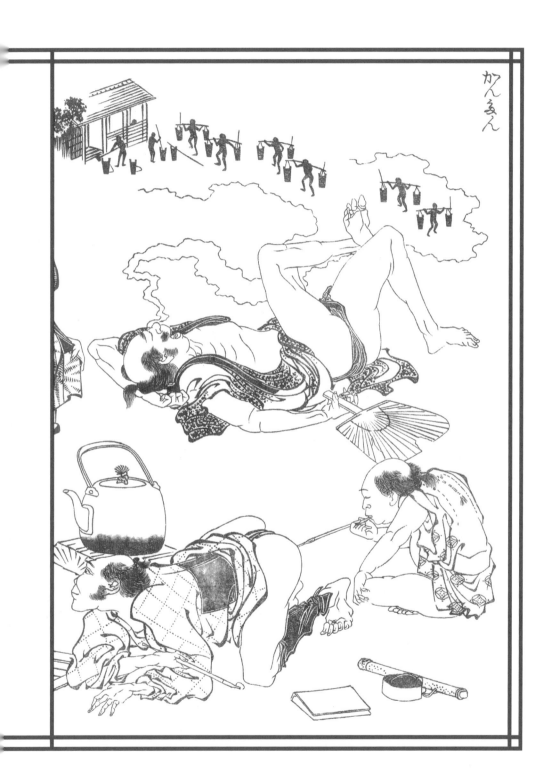
かんゐん

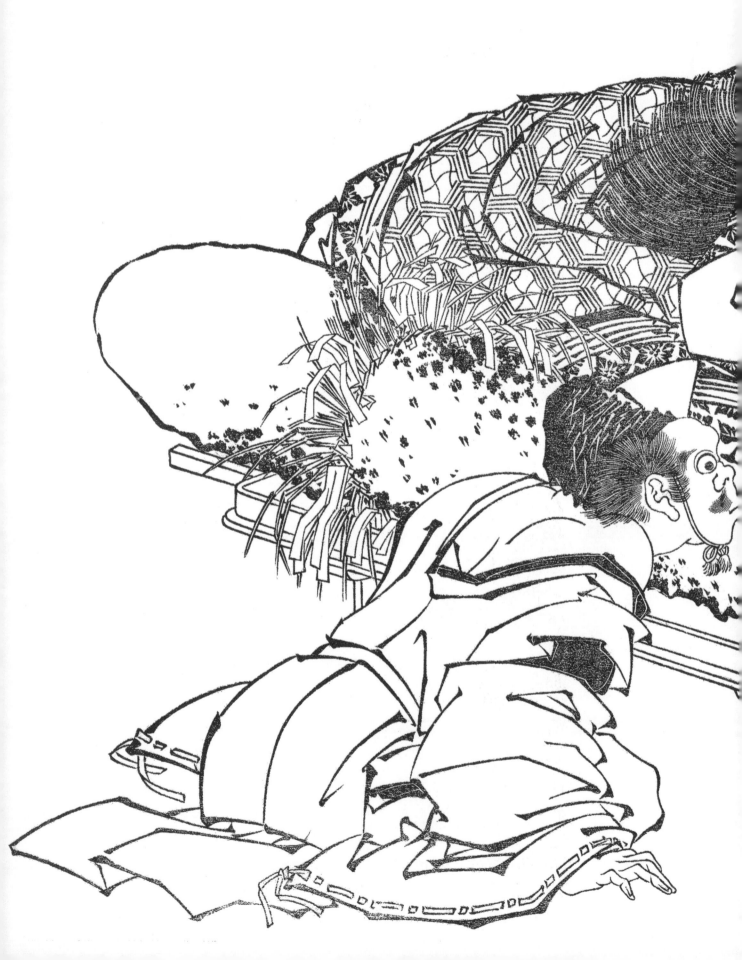

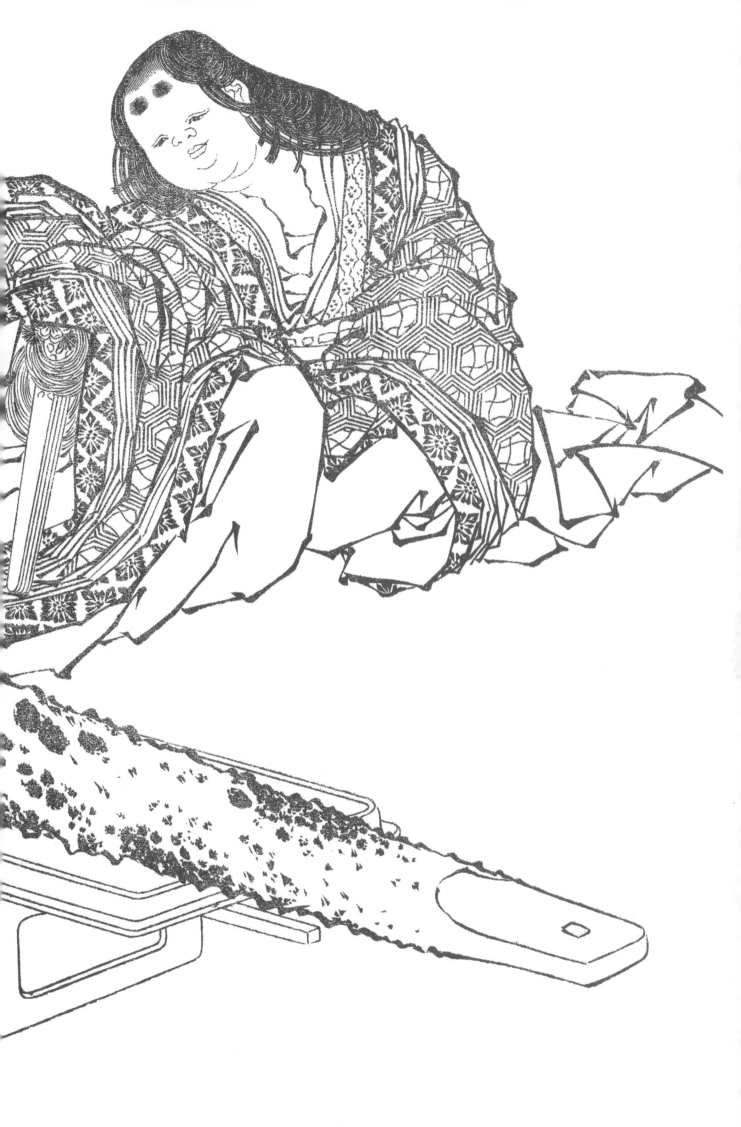

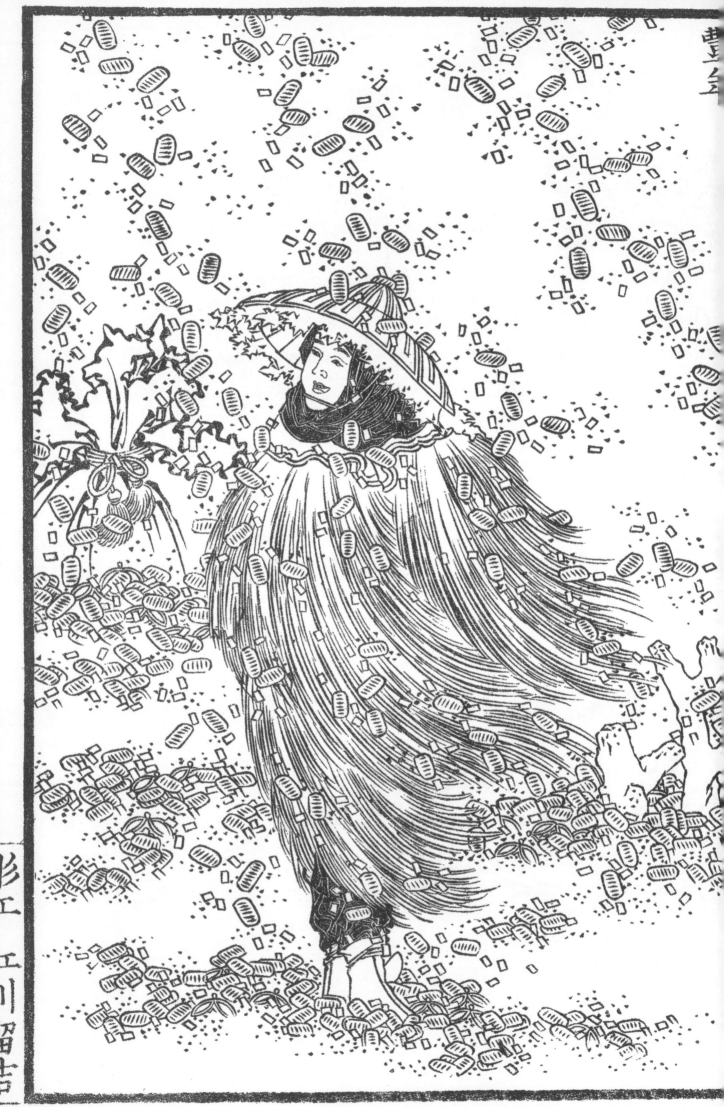

彫工　江川留吉

三面大黒天
さんめんだいこくてん

倶利伽羅不動（くりからふどう）

右ノ劔龍ハ即チ
左リ之索セツ

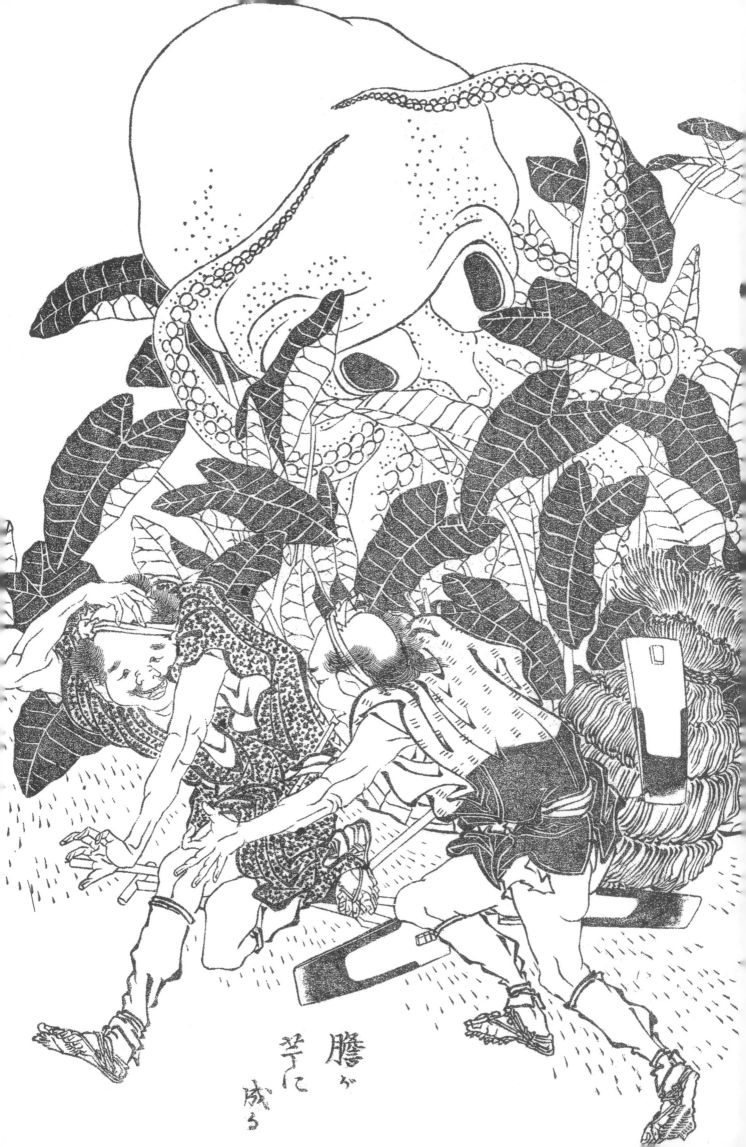

膳が芋に成る

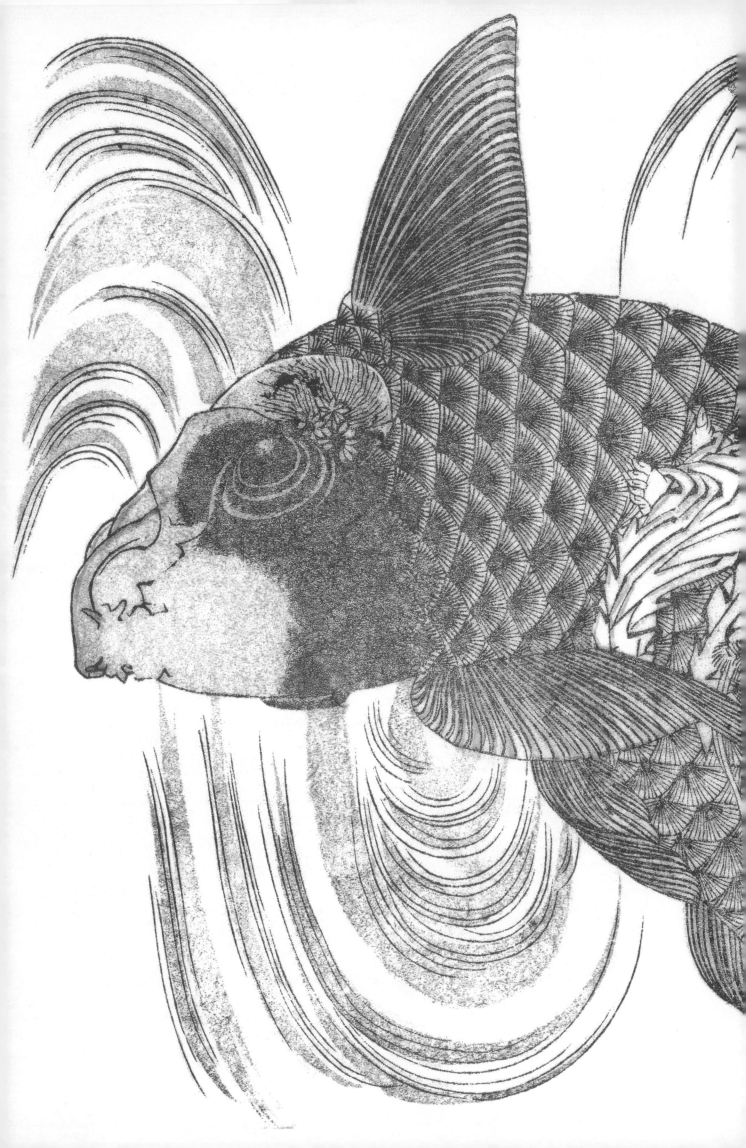

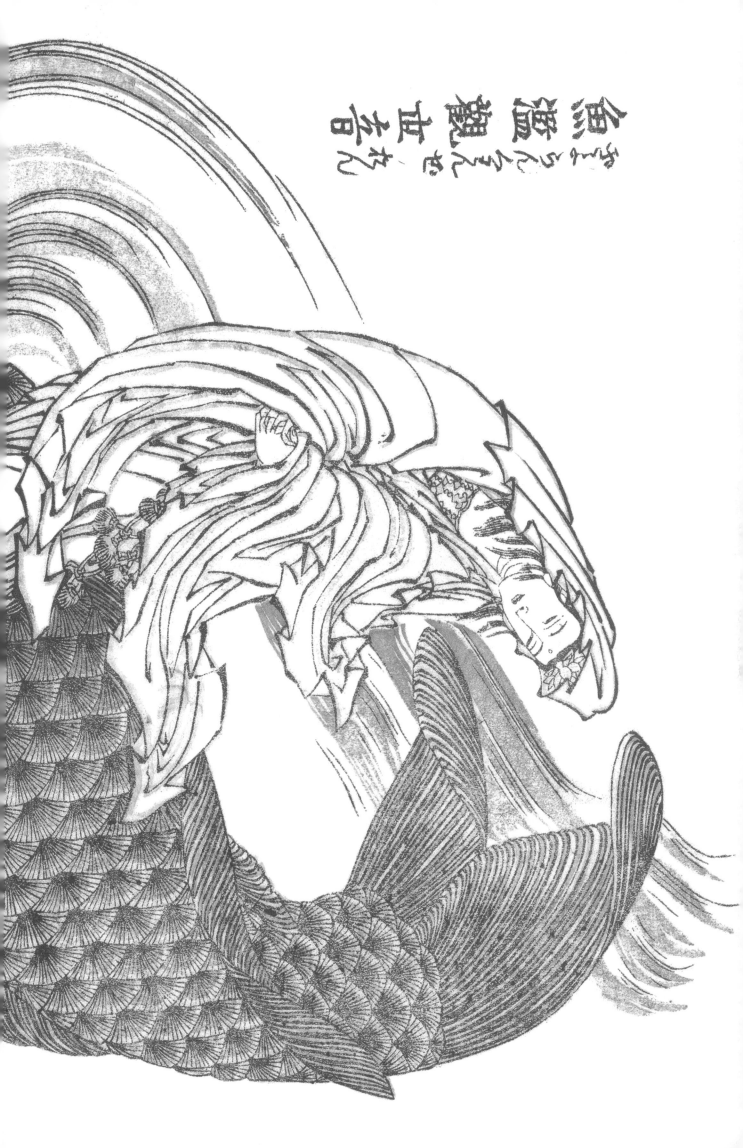

油瓶々
鳴らして
走りか
くる

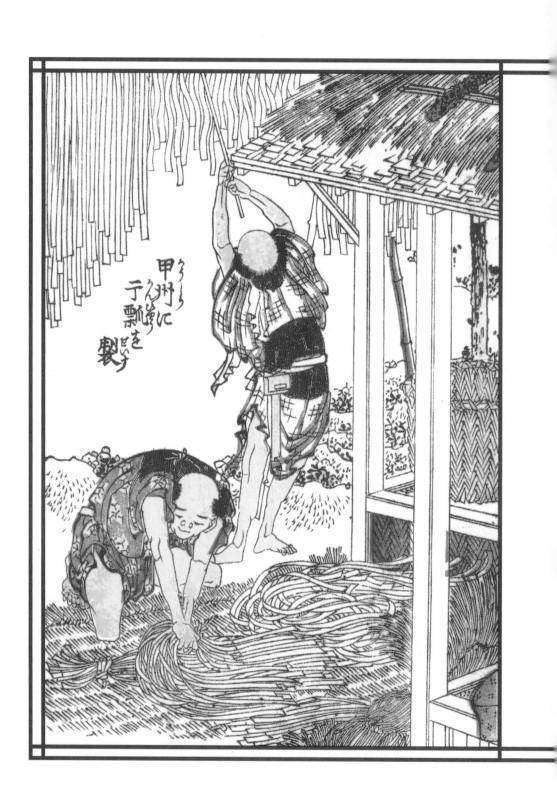

甲州にんぢ丁瓢を製

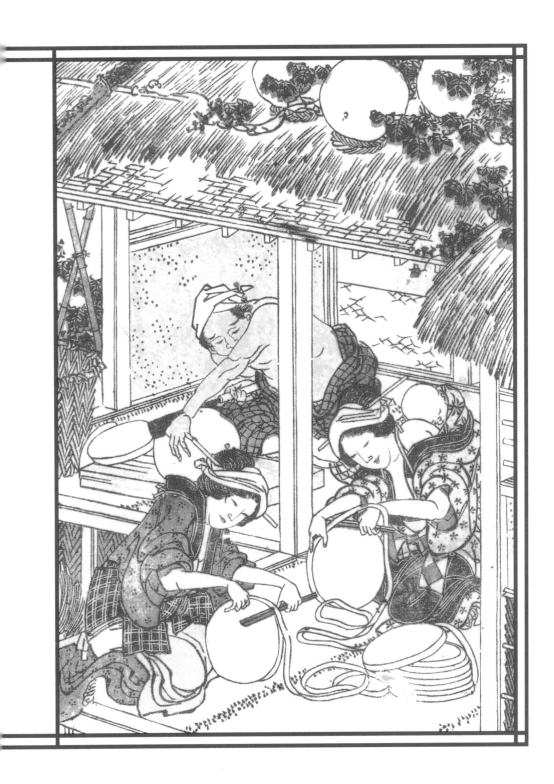

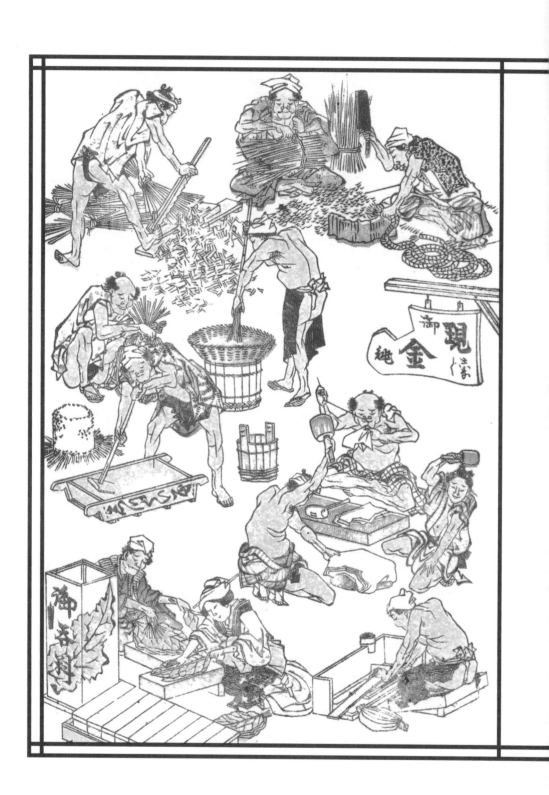

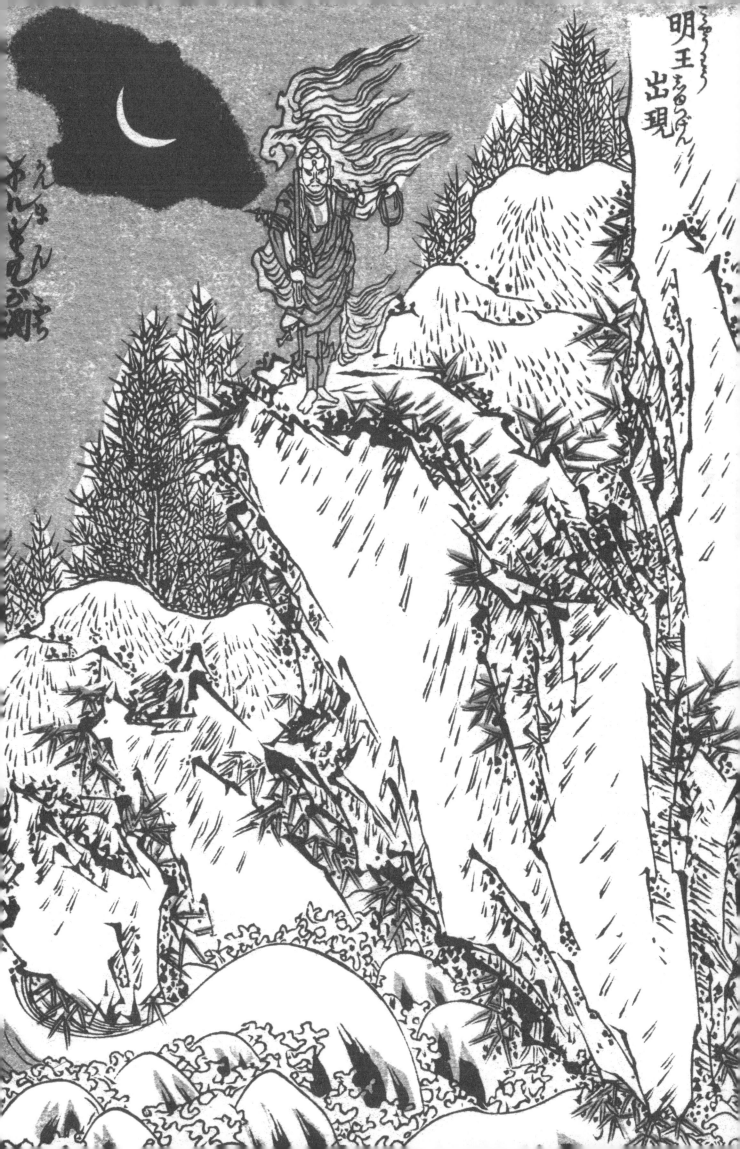

明王
出現

えんそうが淵

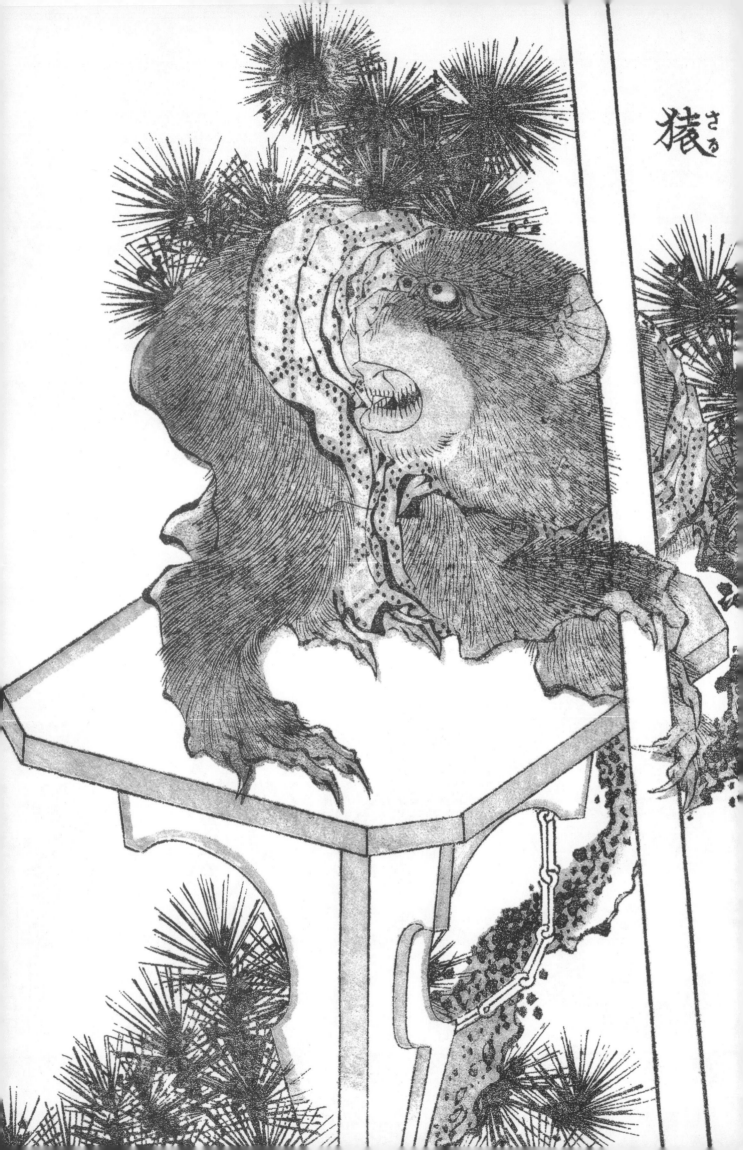

猿さる

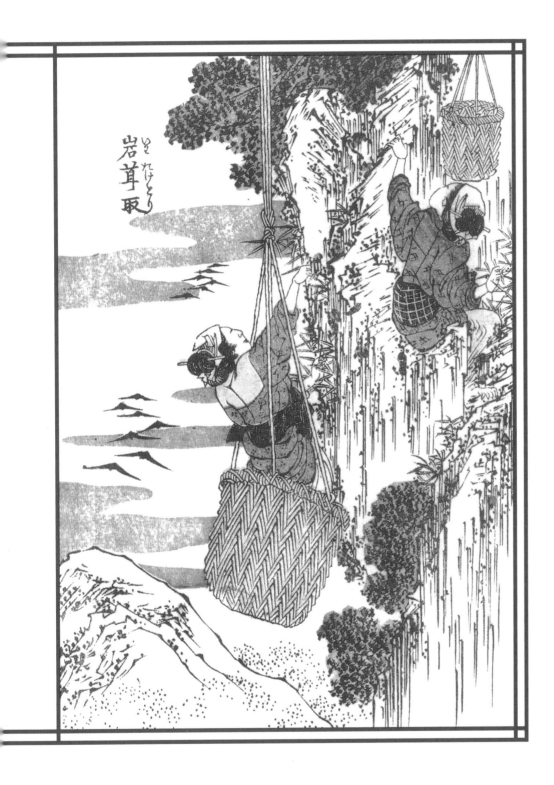

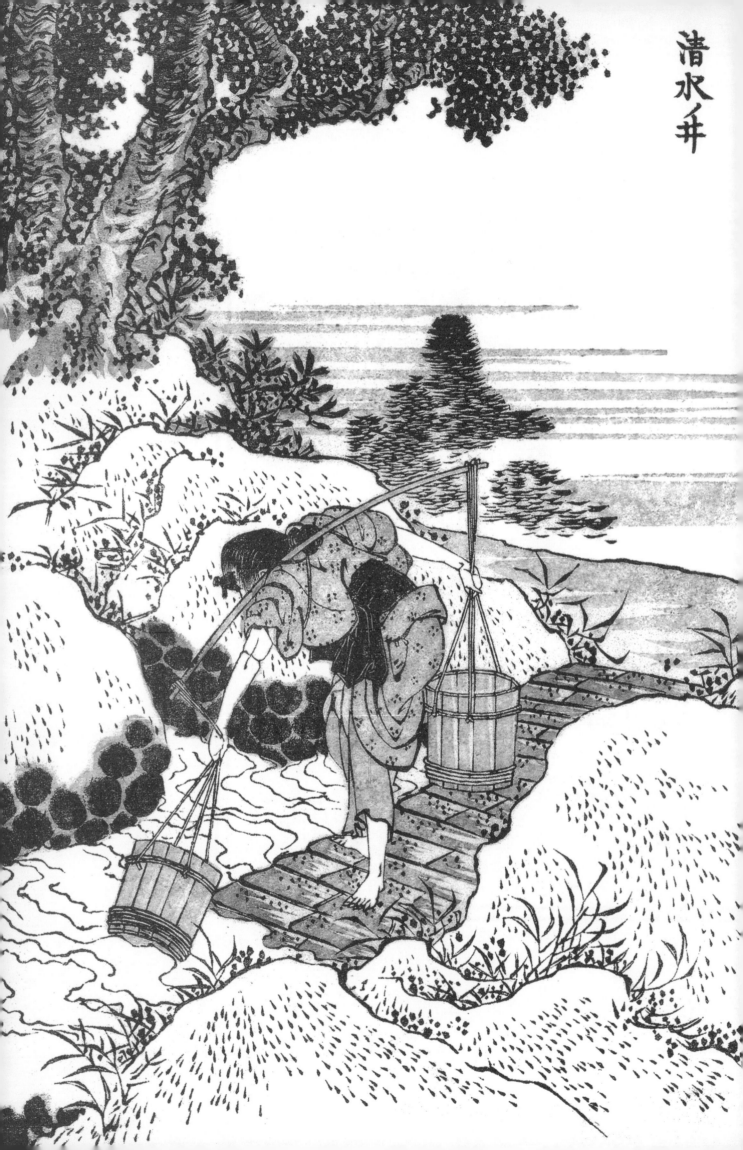

清水ノ井

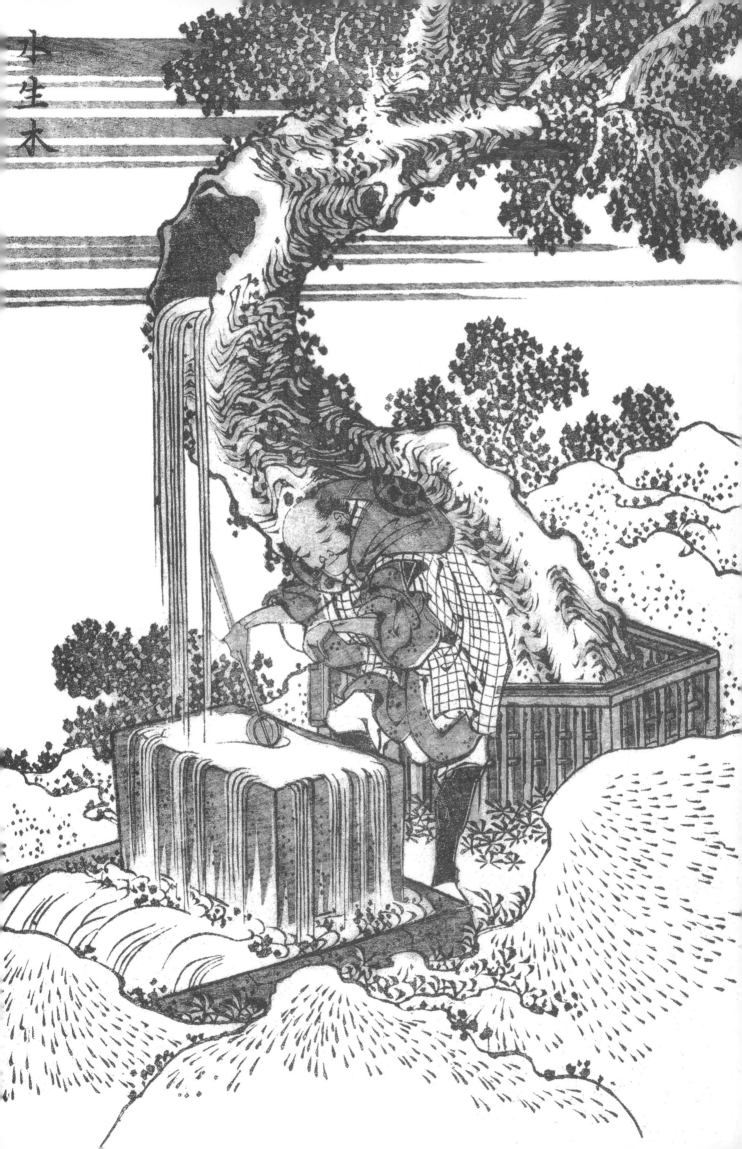

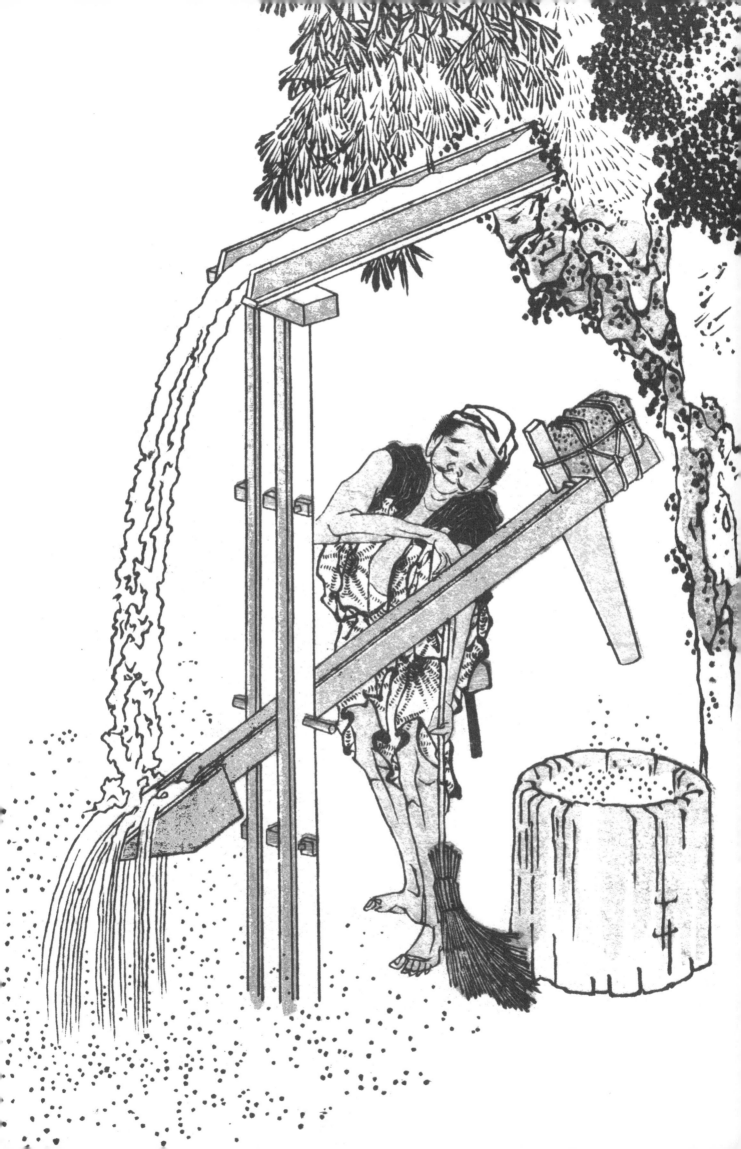

奥列
鯢ヶ嶽

南海
長鮑橋

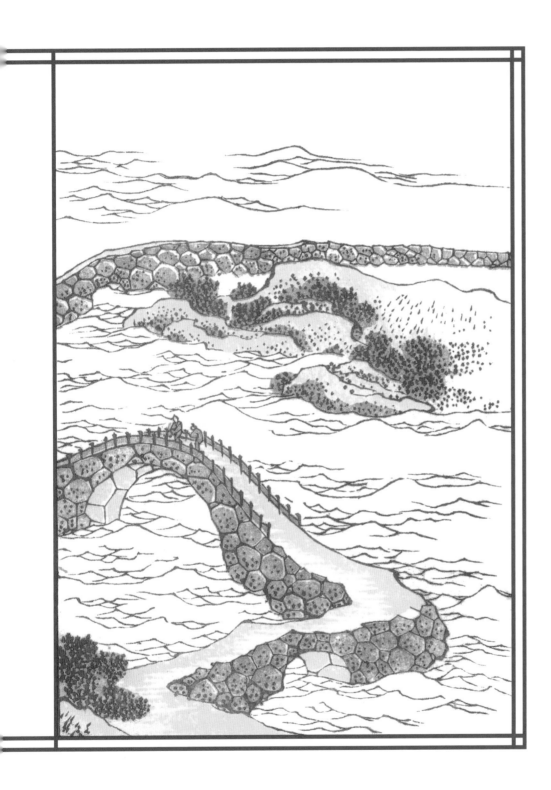

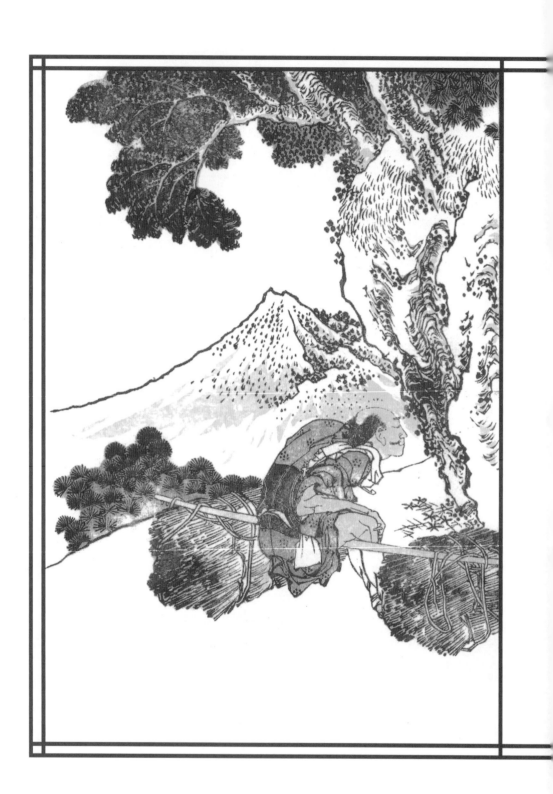

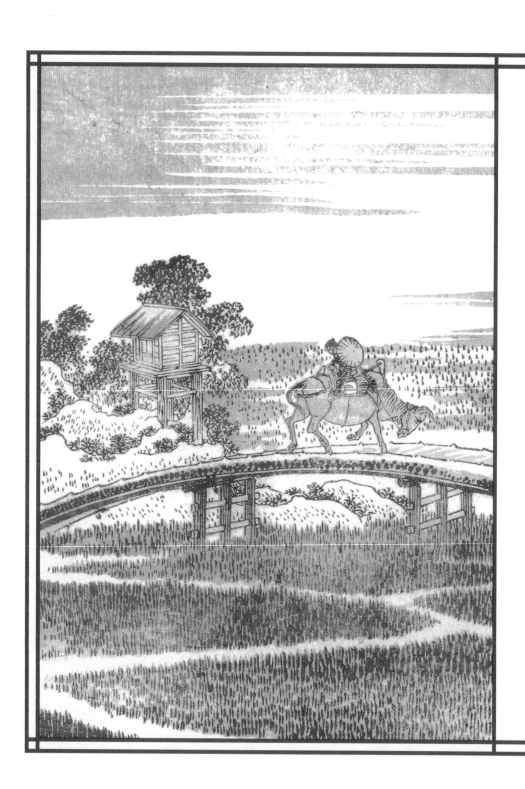

田舎ノ橋

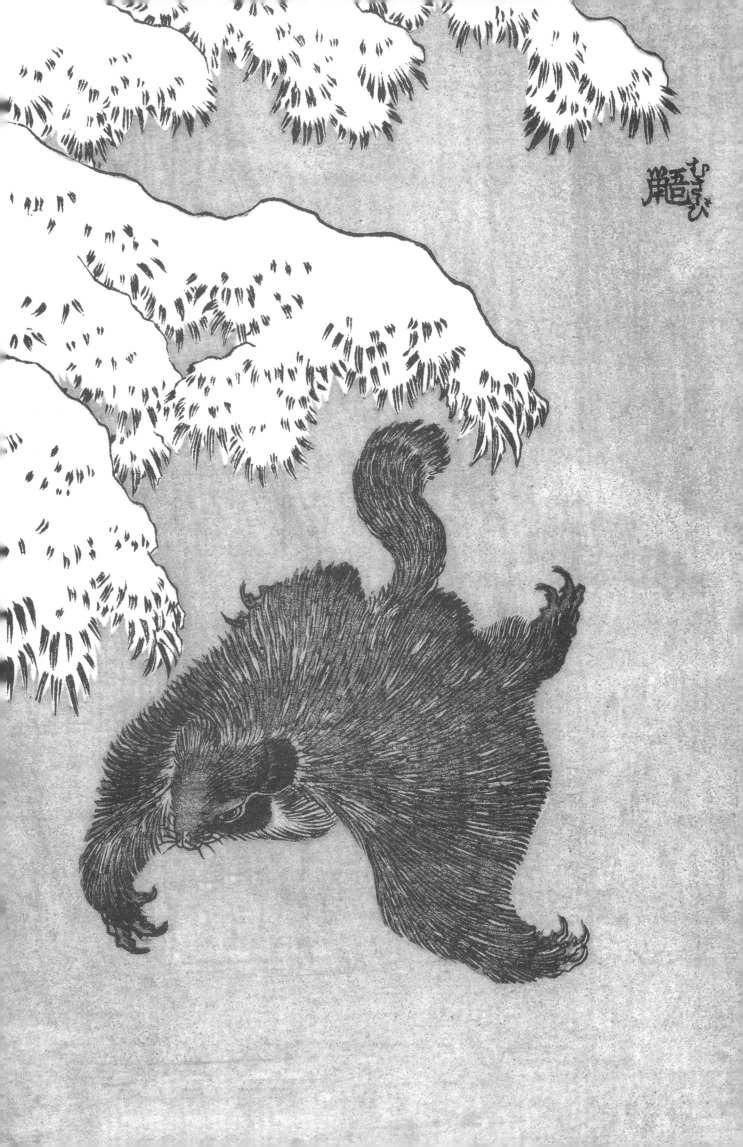

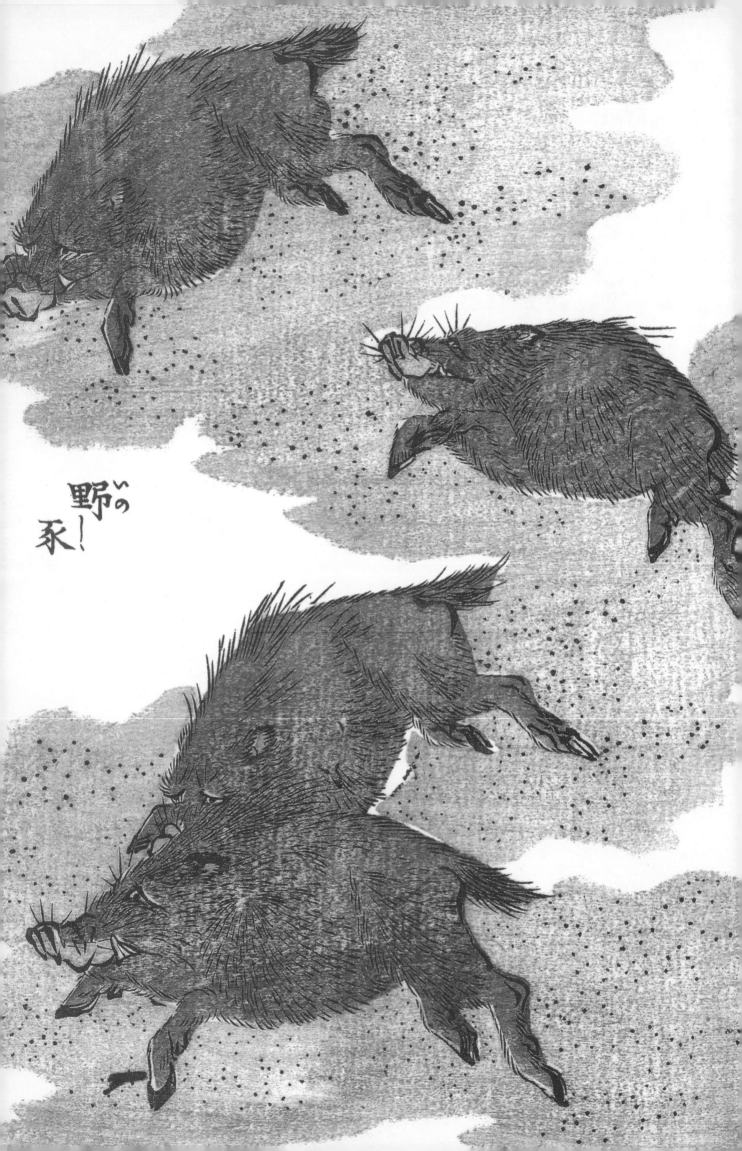

野猪
いの
豕

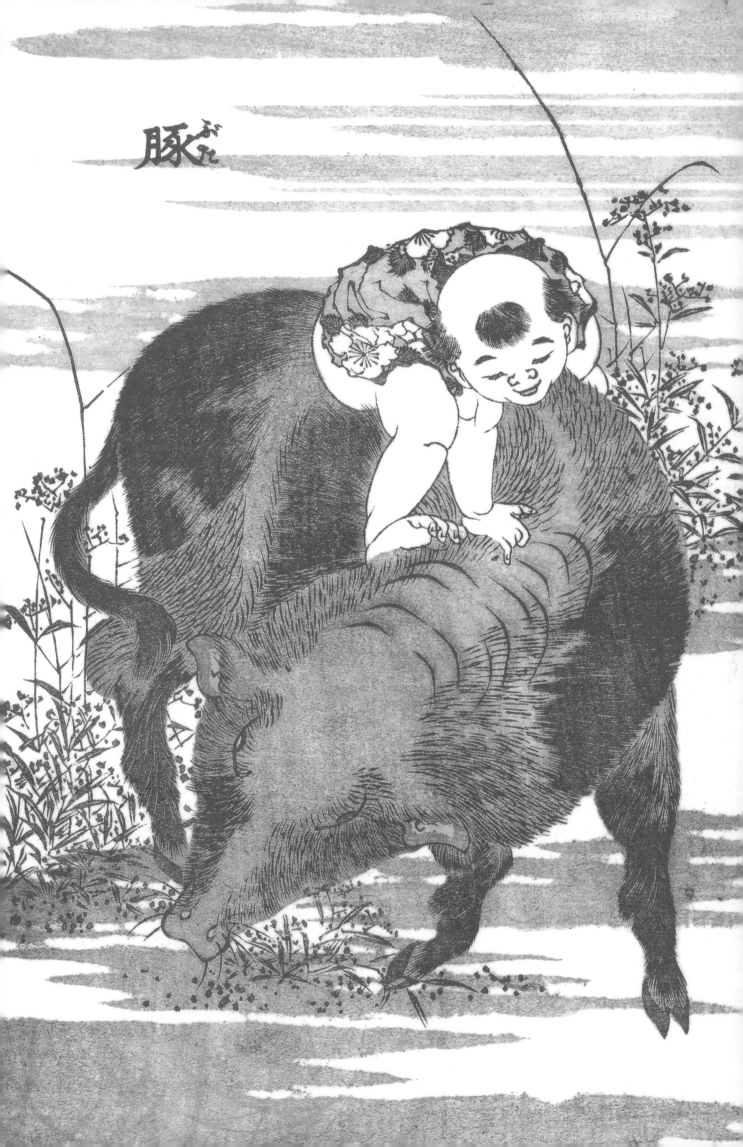
豚ぶた

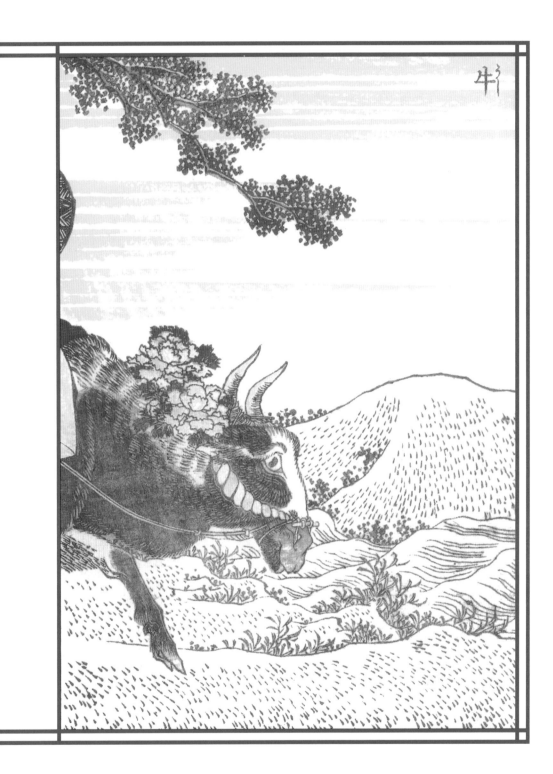

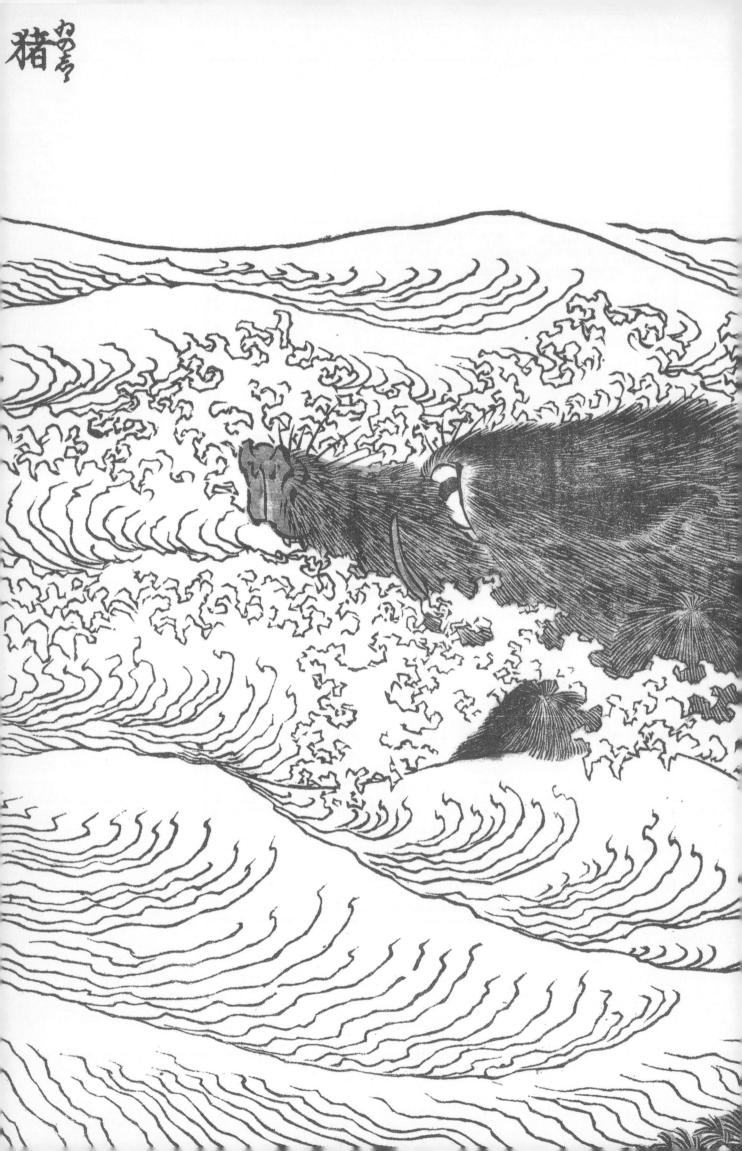

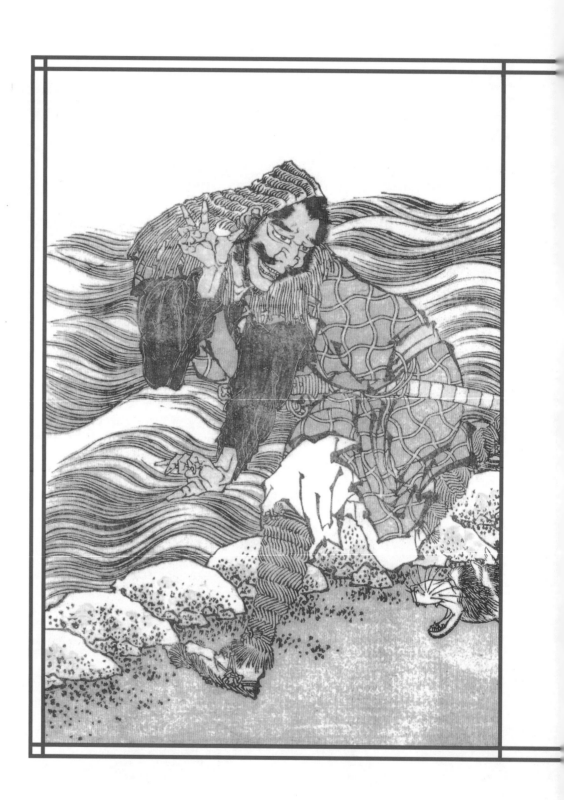

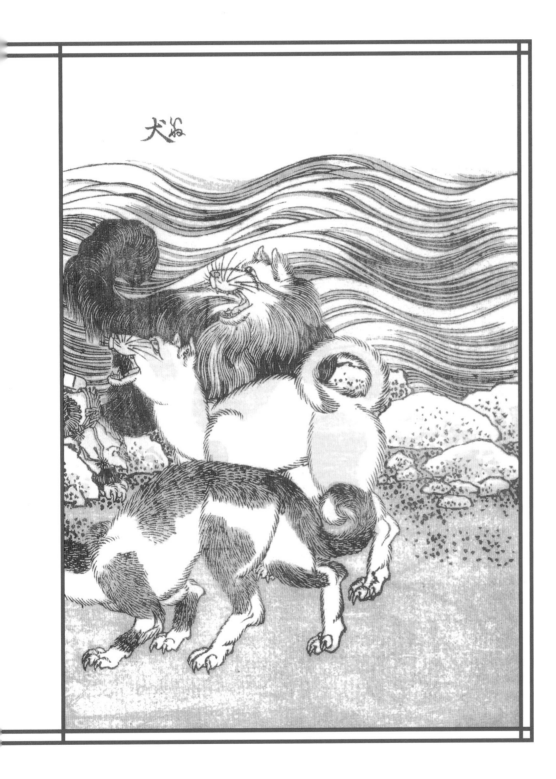

犬ぬ

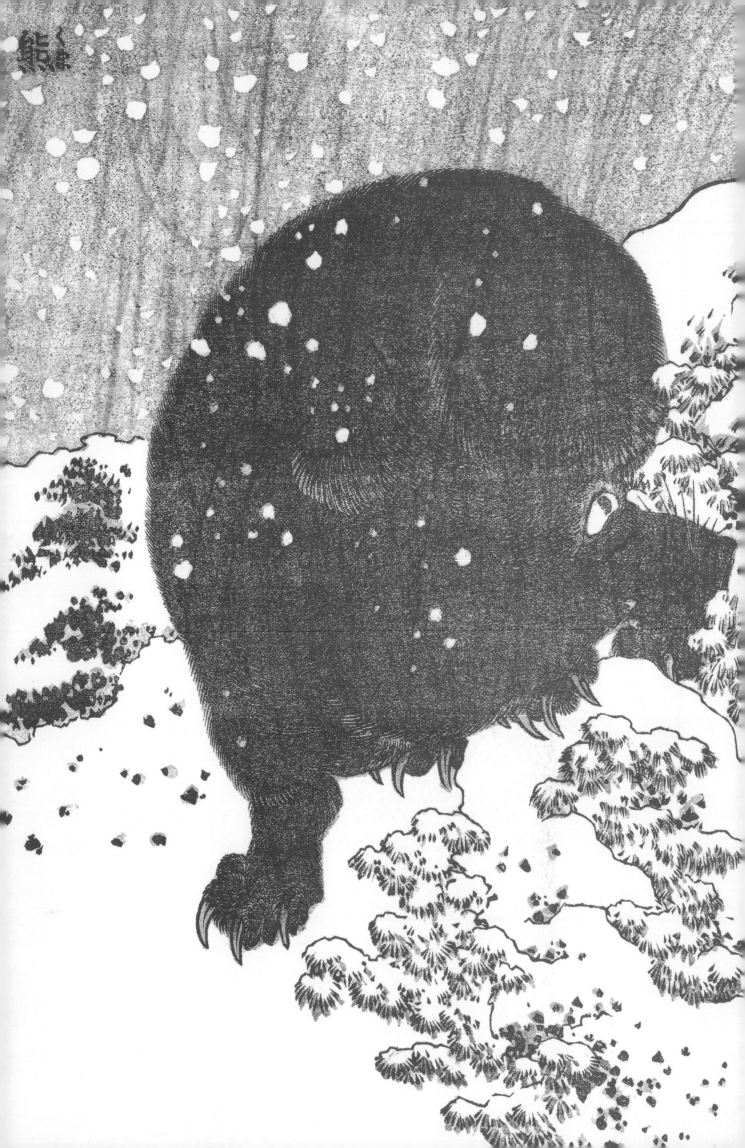

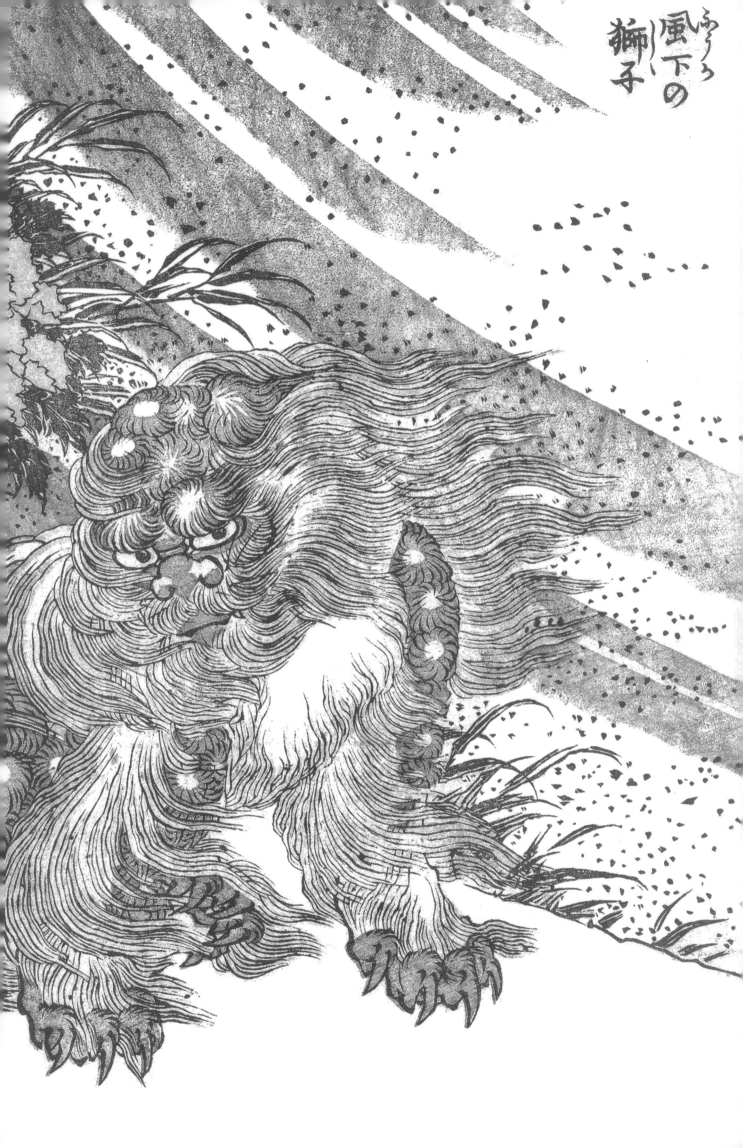

ゆうろ風下の獅子

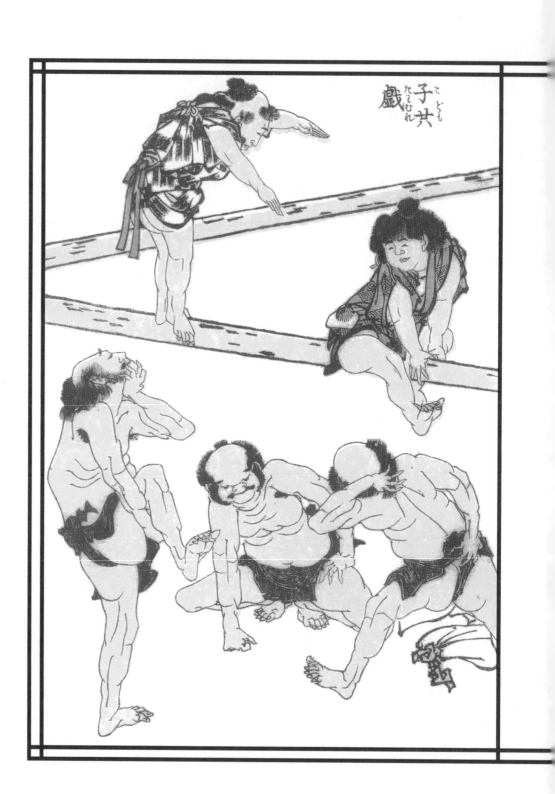

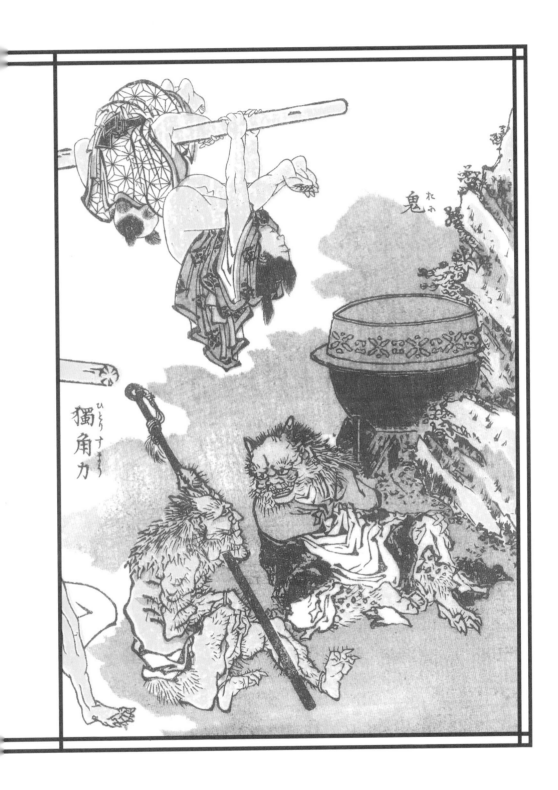

鬼

獨角力

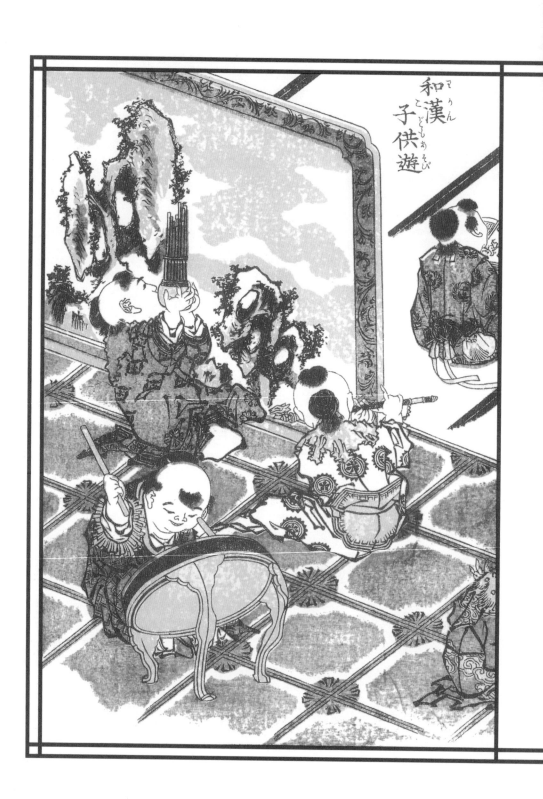

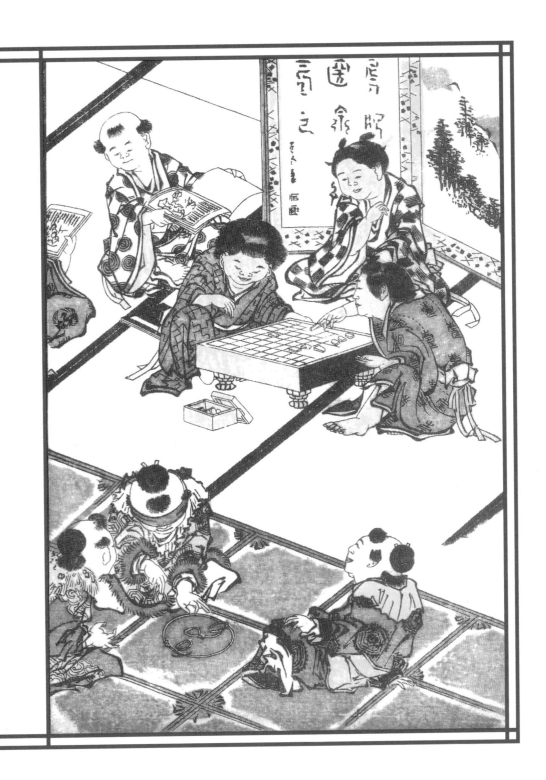

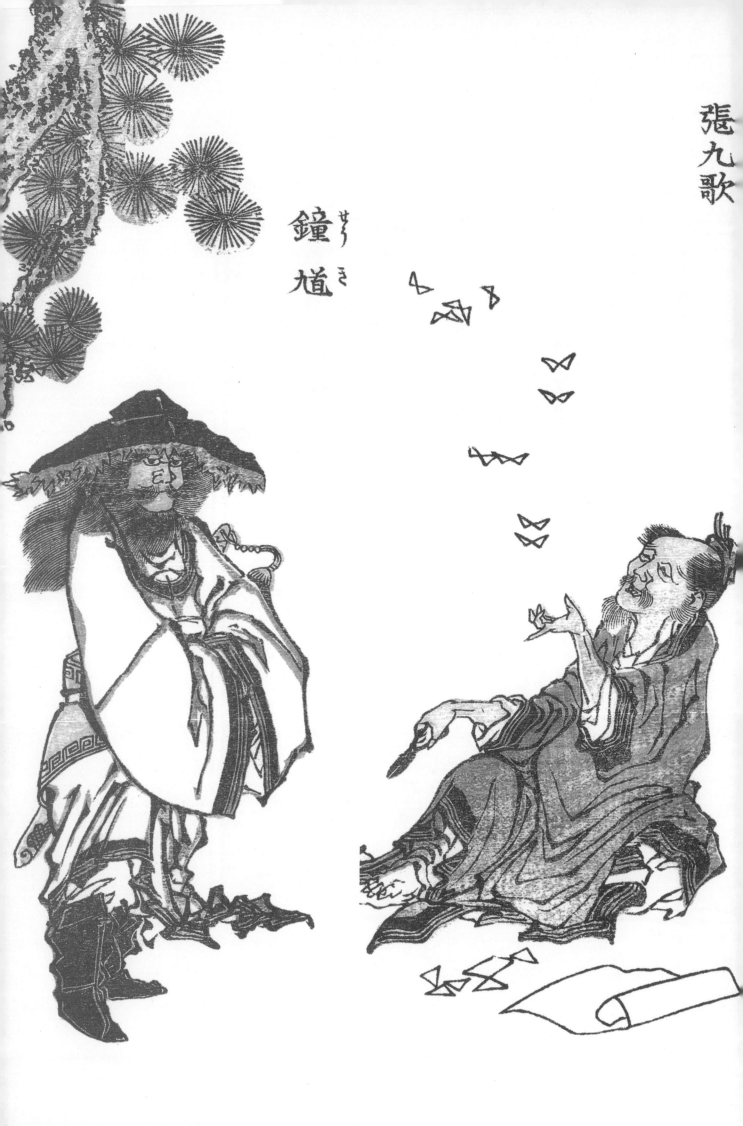

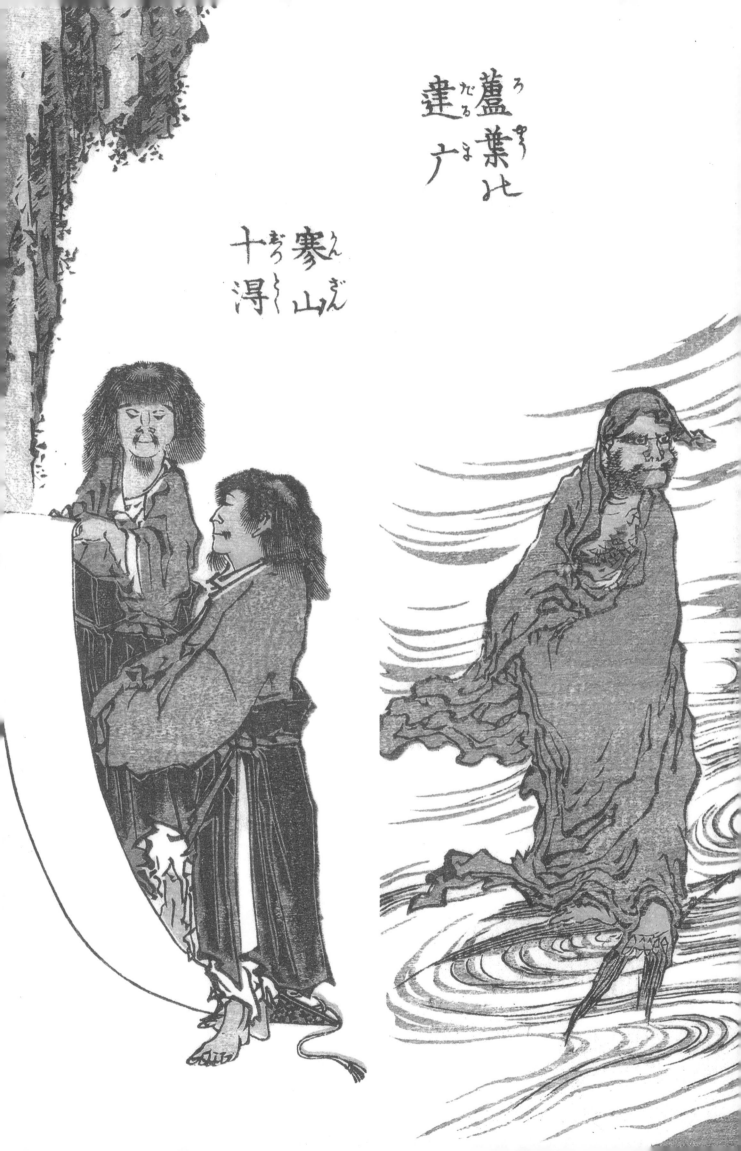

蘆葉此
達广

寒山
十
拾

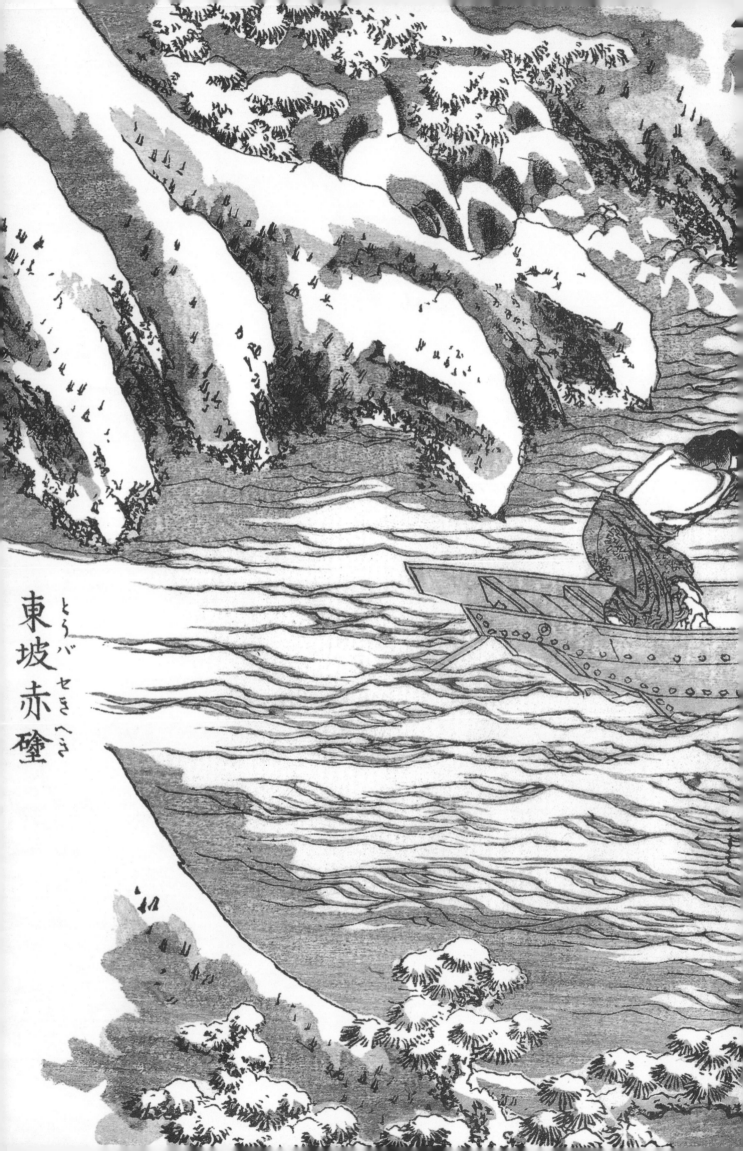

東坡赤壁
とうバせきへき

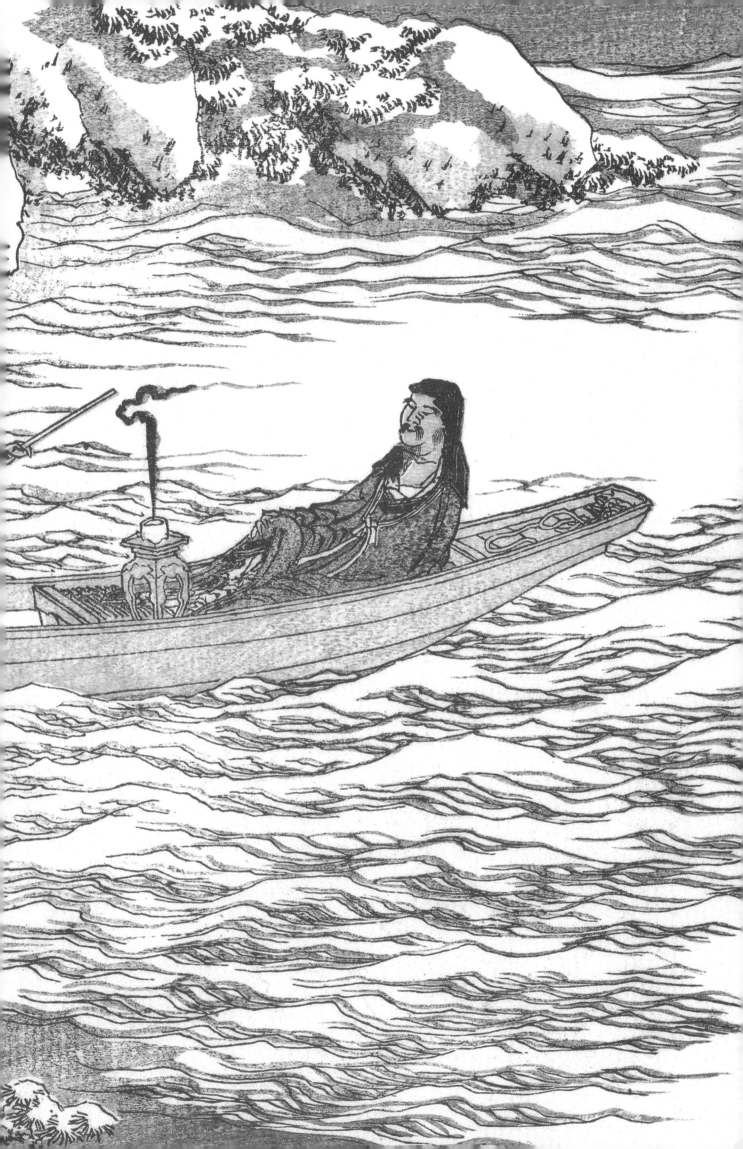

葛飾 北斎（かつしか ほくさい）　宝暦10年（1760）9月23日、江戸本所割下水に生まれる。6歳から描き始め、貸本屋の小僧や彫師修業を経て、安永7年（1778）勝川春章に入門。翌年、春朗と号して役者絵を中心に発表、その後狩野派、土佐派、琳派など様々な画風を学び、さらに中国画、西洋画の技法を習得した。浮世絵版画、読本挿絵、絵手本、肉筆画など幅広くのジャンルに独自の画境を切り開いた。宗理、北斎、戴斗、為一、卍、画狂老人など数多く画号を変えた。代表作に『北斎漫画』（全15編）、『冨嶽三十六景』（全46枚）がある。嘉永2年（1849）4月18日死去、数え年90歳。

高岡一弥（たかおかかずや）　1945年京都府生まれ。アートディレクター。数々のグラフィックデザインと広告を手がける。出版では『千年』（毎日新聞社）で講談社出版文化賞、『和の菓子』（ピエ・ブックス）でグルマンベストデザイン賞、『野菜から見た肉』（パルコ出版）、『女性とエイズ』『Q・O・L』（日本財団）、『katachi』『きんぎょ』『万葉集』『能』『日本の犬』『百人一首』『ポチ袋』他（ピエブックス）、雑誌責任編集『活人』（毎日新聞社）。映像展『彼方へ』『エイズ東京エキシビジョン』等、イベントを主催。日本グラフィックデザイン展金賞、全国カレンダー展内閣総理大臣賞、ADC賞受賞。大阪芸術大学教授。

浦上 満（うらがみみつる）　1951年生まれ。1979年、東京日本橋に東洋古陶磁を専門に扱う（株）浦上蒼穹堂を創業。数多くの企画展を主催し、国公立の美術館や財団法人の美術館、アメリカの美術館にも数多く作品を納めている。学生時代より『北斎漫画』の魅力にとりつかれ、以来40年以上にわたり約1400冊の『北斎漫画』を蒐集し、専門家のあいだでは現在、質・量ともに世界一のコレクションといわれている。現在、（株）浦上蒼穹堂代表取締役、（株）東京美術倶楽部取締役、東京美術商協同組合理事、国際浮世絵学会常任理事、東洋陶磁学会監事、慶應義塾大学特別招聘講師。近著に『古美術商にまなぶ中国・朝鮮古陶磁の見かた、選びかた』（淡交社）がある。

中村英樹（なかむらひでき）　1940年名古屋市生まれ。1963年名古屋大学文学部哲学科（美学美術史）卒業。国際美術評論家連盟会員。名古屋造形大学名誉教授。著書に『日本美術の基軸　現代の批評的視点から』（杉山書店）、『新・北斎万華鏡　ポリフォニー的主体へ』（美術出版社）、『アート・ジャングル　主体から〈時空体〉へ』『生体から飛翔するアート』（以上、水声社）、『〈人型〉の美術史』（岩波書店）など。共著に『カラー版 20世紀の美術』（美術出版社）など。

Katsushika Hokusai Hokusai was born on September 23, 1760 in Edo's Honjo Warigesui district (now the Kamezawa district of Sumida ward in Tokyo). He began painting at the age of six, and following stints as a shop-boy for a book rental shop and training as a woodcarver, in 1778 he became a pupil of ukiyo-e artist Katsukawa Shunsho. One year later he adopted the name Shunro, under which he produced mainly ukiyo-e of Kabuki actors, and thereafter went on to study various styles of painting including Kano School, Tosa School and Rimpa, as well as techniques of Chinese and Western painting. He worked across a range of media that included ukiyo-e prints, illustrations for books, art manuals and paintings, through which he carved out his own artistic niche. He also underwent frequent name changes ranging from Sori and Hokusai to Taito, Iitsu, Manji and Gakyo Rojin (Old man mad about painting). Among his best-known works are *Hokusai manga* (15 volumes) and the *Thirty-six Views of Mount Fuji* (series of 46 prints). Hokusai died on April 18, 1849 at the age of 89 (90 in the old age system).

Takaoka Kazuya Born in 1945 in Kyoto. As an art director, Takaoka has overseen numerous graphic design and advertising projects. Among his published works are *Sennen* (A thousand years; Mainichi Shinbunsha) for which he won the Kodansha Publication Culture Award, *Wagashi* (PIE Books) for which he won the Gourmand Best Design Award, *Yasai kara mita niku* (Meat seen by vegetables; Parco Publishing), *Women and AIDS*, *Q·O·L* (both Nippon Foundation), and *Katachi*, *Kingyo*, *Manyoshu*, *Noh*, *Japanese Dogs*, *Hyakunin Isshu*, *Pochibukuro* (all PIE Books). He has staged events such as the video exhibition *Kanata e* (In the distance) and the *AIDS Tokyo Exhibition*. He is the recipient of the Gold Medal at the Japan Graphic Design Exhibition, the Prime Minister's Award, at the All Japan Calendar Exhibition, and the ADC Award. He is a professor at Osaka University of the Arts.

Uragami Mitsuru Art dealer, specialized Asian art. President of Uragami Sokyu-do Co., Ltd. Director of Tokyo Art Club. Trustee of Tokyo Art Dealers' Association. Executive Director of International Ukiyo-e Society. Trustee of Japan Society of Oriental Ceramic Studies. Executive Guest Lecturer of Keio University. Uragami has been collecting *Hokusai manga* for more than 40 years, ever since he was attracted by their charm in his student days. Among authorities, his collection, which currently includes some 1400 volumes, is said to be the best largest and finest in the world. Uragami's recent books include *Kobijyutsushō ni manabu tyūgoku chōsen kotōji no mikata erabikata* (How to appreciate and select Chinese and Korean antique ceramics: advices from a professional art dealer) (Tankosha).

Nakamura Hideki Born in 1940 in Nagoya. Nakamura graduated in 1963 in Aesthetics and Art History from the Nagoya University School of Letters, Department of Philosophy. He is a member of the International Association of Art Critics and Professor Emeritus at Nagoya Zokei University of Art & Design. Nakamura is the author of *Nihon bijutsu no kijiku: gendai no hihyōteki shiten kara* (Foundation of Japanese art: a contemporary critical perspective) (Sugiyama Shoten); *Shin Hokusai mangekyō : porifonīteki shutai e* (Gazing at Hokusai's constellation: toward polyphonic vision) (Bijutsu Shuppansha); *Ato janguru: shutai kara jikūtai e* (Art Jungle: from subject matter to spacetime matter), *Seitai kara hishō suru āto: 21 seiki no 'kanchikakuteki meta serufu' e* (From the living body art takes flight: towards the 21st-century intersensory metaself) (both Suiseisha) and *Hitogata no bijutsushi* (The human form in art history) (Iwanami Shoten). He is the co-author of numerous books including: *The Concise History of 20th Century Art* (Bijutsu Shuppansha).

北斎漫画
HOKUSAI MANGA
2011年9月7日　初版第1刷発行

アートディレクション・企画・編集
高岡一弥

執筆
浦上 満　中村英樹

デザイン
伊藤修一　松田香月　黒田真雪

英訳
パメラ・ミキ

編集協力
渡辺恭三　西山香代子

制作進行
森山晋平　瀧 亮子

底本提供
浦上蒼穹堂

Art direction/planning/editing
Takaoka Kazuya

Text
Uragami Mitsuru Nakamura Hideki

Design
Ito Nobukazu, Matsuda Kazuki, Kuroda Mayuki

English translation
Pamela Miki

Contributing editors
Watanabe Kyozo, Nishiyama Kayoko

Project management
Moriyama Shinpei, Taki Akiko

Original Books
Uragami Sokyu-do Co., Ltd.

発行元　パイ インターナショナル
〒170-0005 東京都豊島区南大塚 2-32-4（東京支社）
営業　TEL：03-3944-3981　FAX：03-5395-4830
sales@pie.co.jp
〒335-0001 埼玉県蕨市北町 1-19-21-301（本社）

PIE International Inc.
2-32-4, Minami-Otsuka, Toshima-ku, Tokyo
170-0005 Japan
TEL +81-3-3944-3981　FAX +81-3-5395-4830
sales@pie.co.jp

印刷・製本
Daiichi Publishers Co Ltd
制作協力
PIE BOOKS